W9-AQN-164

Zurbarán

The Metropolitan Museum of Art, New York
September 22–December 13, 1987

Galeries Nationales du Grand Palais, Paris
January 14–April 11, 1988

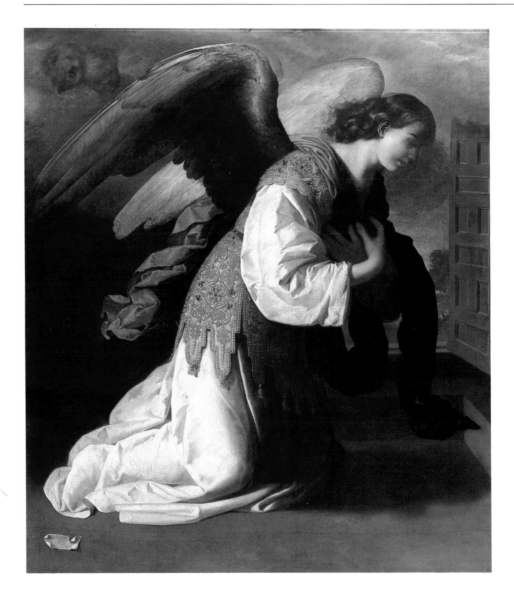

Zurbarán

Jeannine Baticle
Conservateur en Chef Honoraire
Department of Paintings
Musée du Louvre, Paris

with essays by

Yves Bottineau
Inspecteur Général des Musées Chargé
du Musée National des Châteaux
de Versailles et de Trianon

Jonathan Brown
Professor
Institute of Fine Arts
New York University

Alfonso E. Pérez Sánchez
Director
Museo del Prado, Madrid

The Metropolitan Museum of Art, New York
Distributed by Harry N. Abrams, Inc., New York

Published in conjunction with the exhibition *Zurbarán*, held at The Metropolitan Museum of Art, New York, September 22–December 13, 1987, and at the Galeries Nationales du Grand Palais, Paris, January 14–April 11, 1988.

This exhibition has been made possible by Banco de Bilbao.

Additional support has been provided by the National Endowment for the Arts, and by an indemnity from the Federal Council on the Arts and the Humanities.

Published by The Metropolitan Museum of Art, New York
John P. O'Neill, Editor in Chief
Emily Walter, Editor
Bruce Campbell, Designer
Gwen Roginsky, Production

Plans drawn by Jean Blécon

Catalogue translated from the French by Jean-Marie Clarke; and by Ernst van Haagen, Bertrand Languages, Inc.; and Robert Erich Wolfe. "On the Critical Fortunes of Francisco de Zurbarán: Reflections and Inquiries," by Yves Bottineau, translated from the French by Frank Triplett. "The Artistic Milieu in Seville during the First Third of the Seventeenth Century," by Alfonso E. Pérez Sánchez, translated from the Spanish by Ernst van Haagen. "Francisco de Zurbarán: A Chronological Review," by Jeannine Baticle, translated from the French by Jean-Marie Clarke.

Type set in Bembo by Columbia Publishing Company, Baltimore, Maryland
Printed on Alba matte, 135gsm.
Color separations by Reprocolor Llovet, Barcelona, Spain
Printed and bound by Cayfosa, Barcelona, Spain
Second Printing

Photographs were provided by the lenders and institutions cited, and by those noted below:
Arte Palau, Seville: pp. 78 top, 234. Arxiu Mas, Barcelona: pp. 70, 80, 83 top, 94, 120, 132, 146, 149, 166, 167, 202, 212, 215, 218. Sandra Brown: p. 54 right. Giraudon: p. 229. Ray Gregory: p. 210. Guinard (1960, pl. 1): p. 54 left. Laboratorio de Arte, University of Seville: pp. 98, 118, 151 top. J. Tréca Lefébure: p. 134. F. Zubillaga: pp. 174, 179, 194 top.

Cover/jacket: Francisco de Zurbarán, *Saint Francis in Meditation* (cat. no. 53), detail. The Trustees of The National Gallery, London

Title page: Francisco de Zurbarán, *The Annunciation* (cat. no. 58), detail. Philadelphia Museum of Art. W. P. Wilstach Collection

CONTENTS

DIRECTORS' FOREWORD

This catalogue accompanies the first monographic exhibition in the United States and France devoted to the great Spanish painter Francisco de Zurbarán (1598–1664). The last comparable event was in 1964–65 at the Casón del Buen Retiro, in Madrid, where a very different selection of pictures by Zurbarán, brilliantly researched by the prolific Spanish scholar María Luisa Caturla, was shown. The most recent general surveys of the artist's oeuvre also date from a generation ago.

However, it will be evident from the seventy-one catalogue entries by Jeannine Baticle, Conservateur en Chef Honoraire at the Musée du Louvre, and from the present volume's vast bibliography, that in the past twenty years an imposing amount of more specialized research has been dedicated to Zurbarán, his contemporaries, and his patrons. A monograph on Zurbarán and an important study of his patrons by Professor Jonathan Brown, as well as books and articles by younger American scholars, represent a new wave of interest in Zurbarán and other somewhat neglected Spanish Baroque painters. Among the most distinguished forerunners in and current contributors to this flourishing field are the European authorities on Spanish art who have participated in the present project: Yves Bottineau, Inspecteur Général des Musées Chargé du Musée National des Châteaux de Versailles et de Trianon; Alfonso E. Pérez Sánchez, Director of the Museo del Prado, Madrid; and Jeannine Baticle, who selected the paintings exhibited here, wrote the catalogue and one of the four introductory essays, and brought to this work numerous documentary discoveries, new insights, and an unparalleled knowledge of Zurbarán's achievement.

Zurbarán and his great contemporary Velázquez employed naturalistic styles that, however distinctive, are quintessentially Spanish and, in the early years, specifically Sevillian. Indeed, Velázquez's style softened, shifting from a vigorously tactile to a more optical mode of depicting forms, when he moved from Seville to Madrid, where he gained an increasingly sophisticated understanding of courtly taste and international, particularly Italian and Flemish, tendencies in art. Zurbarán was not, with brief exceptions, part of this world of palaces hung with pictures by Titian, Rubens, and Velázquez, nor is his appeal to modern viewers quite the same as that of these masters. His inclination to abstract and simplify—one might say, to condense and thereby intensify realistic forms and the ideas they convey—has been seen by critics as part of Picasso's heritage, much as Zurbarán's often limited palette (above all, in the stiff white robes of monks) and shallow spaces remind us of Cubist and other reductive interpretations of visual experience.

It would be misleading, in the present context, to make too much of this comparison, notwithstanding the force with which some of Zurbarán's paintings have inspired the modern imagination since at least the time of Manet. The research embodied in this catalogue demonstrates repeatedly that Zurbarán's art was both the product and the

perfect expression of his time and place. It is in this light that one can appreciate the exceptional power of Zurbarán's most original inventions and apprehend that the inevitable comparison to Velázquez, indisputably the greatest Spanish painter of the Golden Age, does not do justice to Zurbarán.

One painting in the exhibition that stands out from the others serves to illustrate this point with historical nicety, since Zurbarán painted it in Madrid in 1634 for the Buen Retiro Palace, the decoration of which was supervised by Velázquez. The *Death of Hercules* (cat. no. 24) is the best in the series of ten scenes from the life of Hercules; its dramatic composition sets it apart from Velázquez's subtler style and to some extent obscures the fact, made plain in other pictures from the series, that the nude figure, an indispensable component of mythological pictures, was not Zurbarán's forte. Zurbarán is not the painter of the *Rokeby Venus* or the *Forge of Vulcan,* but it should be stressed that subjects such as these would have been completely uncharacteristic of seventeenth-century Seville.

Zurbarán worked for ecclesiastical—primarily monastic—patrons in southern Spain. While Velázquez's portraits and mythologies may be seen in the cosmopolitan context of courtiers and connoisseurs, Zurbarán's clientele was at once more restricted and more representative of seventeenth-century Spanish society. The great majority of his paintings depict religious subjects, and his approach to spiritual subjects both conventional (such as the Virgin of the Immaculate Conception) and rare (for example, the life of Saint Peter Nolasco; see cat. nos. 6–9) reflects the authority of tradition, the demands of doctrine, and the requirements both of patrons and of a public for whom the story, not the style, was the essence of a work of art.

Given these unworldly limitations, little like the *etiquetas* that Velázquez observed, Zurbarán's achievement is extraordinary, and it was recognized as such at an early moment in his career. In 1629 the artist, who already employed a number of assistants in Llerena, was invited to live in Seville, which, in the words of the city government, "would be honored . . . and favor him . . . since the art of painting is one of the major embellishments of the state."

The artistic importance of Seville is surveyed in the present volume in the essay by Alfonso E. Pérez Sánchez. With the present-day appearance of that city, and of Madrid, in mind, Seville is often called the Florence of Spain, but as a school of painting around 1600 Seville might better be compared with Bologna. The academic manner of Francisco Herrera the Elder coexisted with Velázquez's early experiments in realism and with Zurbarán's recasting of venerable models into modern forms. This widely recognized duality, or synthesis, in Zurbarán's style—of tradition and innovation, of tangible and seemingly timeless forms—expresses the spirit of Counter-Reformation theology, and, more memorably, the spirit of contemporary Spanish society, which, with its dependence on a hard yet rewarding land, could combine a faith in the most mystical concepts with a deep respect for earthly things.

These values, the visionary and the visible, describe the nature of Zurbarán's art more effectively than would a review of his artistic sources, and are profoundly impressive in such early works as the *Christ on the Cross* (cat. no. 2), *Saint Serapion* (cat. no. 5), and *Saint Peter Nolasco's Vision of the Crucified Saint Peter* (cat. no. 6). It is true that these paintings, especially the single-figure compositions, have a monumentality that Zurbarán, like other Sevillian painters, adopted from the painted wood sculptures by Juan Martínez Montañés. Only in Zurbarán's spare, soundless space, however, does the early Baroque tendency to render forms illusionistically create a convincing

evocation of visionary experience.

The course of Zurbarán's highly successful career is triply traced in the following pages. First, Jonathan Brown, in his essay, surveys the patrons and the specific commissions that determined the artist's subjects and their interpretation. Mlle. Baticle's introductory essay reviews the chronology of Zurbarán's life and work with particular reference to surviving documents. And the catalogue of paintings is organized into sections that describe, in chronological order, the major commissions. Insofar as it is possible—given the problems presented by lost or inaccessible paintings, by missing evidence, and by pictures that for various reasons cannot be lent—the organizers of the exhibition have assembled groups of paintings that originally were made to be seen together, either side by side as in the churches, chapels, cloisters, sacristies, and other ecclesiastical structures that Zurbarán decorated, or in the even more precisely planned configuration of a great altarpiece such as the one once at Jerez de la Frontera (see cat. nos. 26–32). Thus the catalogue begins with the commission that first established Zurbarán in Seville, the work of 1626–27 for the Dominican Monastery of San Pablo el Real, which is represented here by the *Saint Gregory* (cat. no. 1), from the Museo de Bellas Artes, Seville, and the extraordinary *Christ on the Cross* (cat. no. 2), from The Art Institute of Chicago. We then proceed to two contemporary and prestigious assignments, the scenes from the life of Saint Peter Nolasco and other canvases, for the Merced Calzada (Order of Mercy) in Seville, and the scenes from the life of Saint Bonaventure, for the Franciscan College of San Buenaventura in Seville. Two magnificent paintings lent by the Louvre are from the latter series, while the Merced Calzada commissions include the famous *Saint Serapion* from the Wadsworth Atheneum, as well as the four large canvases from the Peter Nolasco cycle. Other important commissions, too numerous to mention here, date from the 1630s: the great Jerez altarpiece that, with Zurbarán's work at the Hieronymite Monastery of Guadalupe (see cat. no. 36) and the Carthusian Monastery of Las Cuevas in Seville (see cat. nos. 37, 38), marks the culmination of Zurbarán's career as the Spanish painter par excellence of monastic life. New research conducted by Mlle. Baticle enables us to reassemble major parts of the Jerez altarpiece—four splendid pictures lent by the Musée de Grenoble (cat. nos. 26–29), two from the Museo de Cádiz (cat. nos. 31, 32), and the Metropolitan Museum's *Battle between Christians and Moors at El Sotillo* (cat. no. 30)—and, for the first time, to assign to the Las Cuevas paintings a date and their precise placement in the church—even to identify the frames in which they were held.

About thirty paintings in the exhibition cannot be connected with an ecclesiastical commission and are arranged in chronological order in the closing section of the catalogue. Professor Brown's essay discusses the works that Zurbarán, beginning in the 1630s, painted as private devotional pictures for individual clients. After 1640, when the Spanish monarchy and monasteries found themselves in an impoverished state, Zurbarán and his workshop produced pictures for export to the Spanish colonies of the Americas. This shift in the Sevillian market and the new tendencies in style and expression that encompassed the rise of Murillo and of Francisco Herrera the Younger were to some extent accommodated by Zurbarán in his style of the 1650s, but compelled him nonetheless to move to Madrid in May 1658. He spent the last six years of his life in the capital, at a time and place no longer suited to his temperament.

The eclipse of Zurbarán's reputation was far greater in the decades after his death than during his waning years in Madrid. Major works, isolated in churches and monasteries, became increasingly unfamiliar to collectors and to the general public. These

sites were looted by Napoleon's generals during the Peninsular Wars of 1800–14, which, with the secularization of ecclesiastical property in 1835, made Zurbarán's paintings better known, but robbed them of their original context and much of their meaning. Thus, as demonstrated in the essay by Yves Bottineau, Zurbarán became reestablished as a great artist, but one who seemed to have a narrow repertoire. For the most part, nineteenth- and early twentieth-century viewers have seen him as a painter of severe monks and comely female saints, dressed, respectively, in sackcloth and silk.

These pictures remain compelling, but the exhibition reveals the far richer resources and the extensive range of the artist, as well as the layers of meaning and the cultural context that underlie Zurbarán's long-admired powers of description, abstraction, and expression of Spain's spiritual and worldly ideals.

A monographic exhibition that sets itself such ambitious goals as the regrouping of widely dispersed works of art can succeed only with the good will of a great many institutions and individuals. First and foremost among these, of course, are the many lenders whose generosity alone has made this exhibition possible; to them we extend our sincere and heartfelt thanks.

Zurbarán opens at The Metropolitan Museum of Art at the same time that *Fragonard* opens at the Louvre. Both exhibitions will then travel, *Zurbarán* to Paris and *Fragonard* to New York. This is yet another in a historic series of exchange exhibitions jointly organized and negotiated by the two institutions. Hubert Landais, now retired Directeur des Musées de France, initiated and guided many of these joint ventures, including the early beginnings of *Zurbarán*, and we offer him our affectionate tribute.

<div style="text-align: right">

Olivier Chevrillon
Philippe de Montebello

</div>

Others debts too are immense. We wish particularly to acknowledge the encouragement and assistance of many friends in Spain without whom *Zurbarán* would surely have been a lesser exhibition, and our own strenuous efforts less rewarding. We are grateful to Miguel Satrústegui Gil-Delgado, Director General de Bellas Artes y Archivos, and his colleagues in the Ministry of Culture for their wholehearted support and endorsement of the exhibition: Carmen Giménez, Directora de Exposiciones; Alfonso de Otazu y Llana, Asesor Ejecutivo del Ministro; and Javier Aiguabella have been helpful to the project at various critical stages. Our thanks also to Dr. Alfonso E. Pérez Sánchez, Director of the Museo del Prado and a distinguished contributor to the catalogue; and to Señor Don José M. Pita Andrade, Honorary Director of the Museo del Prado. Other friends have offered invaluable assistance in securing key loans, and it is a privilege to record here our appreciation of their efforts: in Barcelona, Señor Don Ramón Guardans and Doña Helena Cambó de Guardans, and Señor Don Leopoldo Rodés Castañé; and in Madrid, Count Simeon Rylski, the Marqués del Viso, the Counts of Berantevilla, and Doña Carmen de Urquijo.

Important church loans were secured with the kind intervention of Padre José Luis Montes, and Mali Diago provided friendly administrative assistance. Above all, we must thank Señor Don Plácido Arango, who has not only enriched the exhibition by lending it three magnificent pictures but has also been the most gracious of friends. We are grateful to him for innumerable kindnesses.

The museums of France have lent generously to this project. We acknowledge especially the courteous and efficient collaboration of Edouard Pommier, Chef de l'In-

spection Générale des Musées Classés et Contrôlés, Direction des Musées de France. The Honorable Georges Frêche, Mayor of Montpellier, has provided valuable cooperation and diplomatic support.

On this side of the Atlantic, we would like to extend a special word of thanks to Paula Cussi for her ready assistance with an important loan.

Finally, our warm thanks go to the staff members, too many to name individually, of the two museums that are the joint organizers of the exhibition. At the Louvre, the principals to be thanked are Michel Laclotte, Inspecteur Général des Musées Nationaux and Conservateur en Chef in the Department of Paintings; Irène Bizot, Administrateur Délégué de la Réunion des Musées Nationaux; Claire Filhos-Petit, Chef du Services des Expositions de la Réunion des Musées Nationaux; Ute Collinet, Chef du Services des Publications de la Réunion des Musées Nationaux; and Claudie Ressort, Documentaliste in the Department of Paintings.

At the Metropolitan Museum, the exhibition was guided by Mahrukh Tarapor, Special Assistant to the Director for Exhibitions, who negotiated important loans in Madrid and elsewhere in Spain. Ms. Tarapor served as liaison with Everett Fahy, John Pope-Hennessy Chairman of the Department of European Paintings, and with Walter Liedtke, Associate Curator, who coordinated the exhibition, working closely with Jeannine Baticle. The catalogue, under the office of John P. O'Neill, Editor in Chief and General Manager of Publications, was edited by Emily Walter.

We are also grateful to the following people for their special efforts on behalf of the exhibition: Emily Rafferty, Vice President for Development; William S. Lieberman, Chairman, Department of Twentieth Century Art; Gary Tinterow, Associate Curator, Department of European Paintings; John Buchanan, Registrar; Linda M. Sylling, Assistant Manager for Operations; and David Harvey, Designer.

OC PdM

ACKNOWLEDGMENTS

Francisco de Zurbarán is widely regarded, especially in Spain, as one of the three greatest masters of seventeenth-century Spanish painting, the others being Velázquez and Murillo. However, Zurbarán has not been the subject of a monographic exhibition since the one held in 1964, at the Casón del Buen Retiro in Madrid, on the 300th anniversary of his death, and he has never been given such attention outside his native country. The present exhibition is thus an unprecedented opportunity for the public in two countries, France and the United States, to study and to pay homage to a master who, in modern times, has been much admired but not well known.

I am exceedingly grateful to Philippe de Montebello, Director of The Metropolitan Museum of Art, and to Michel Laclotte, Inspecteur Général des Musées Nationaux and Conservateur en Chef in the Department of Paintings at the Musée du Louvre, for their enthusiastic response to the proposal of a Zurbarán exhibition. Hubert Landais, then Directeur des Musées de France, gave the project his strong support. My long and sometimes arduous preparations for the exhibition were frequently facilitated, with the most encouraging kindness and trust, by Philippe de Montebello, and with the greatest possible efficacy by Mahrukh Tarapor, Special Assistant to the Director for Exhibitions, the prime mover of the entire undertaking. Their colleagues at the Metropolitan also deserve my thanks, notably my counterpart in the Department of European Paintings, Walter Liedtke, Associate Curator, who skillfully coordinated the exhibition, and Emily Walter, Editor, whose sensitive and incisive editorial skills were of immeasurable benefit to the catalogue. I would like to offer my deep appreciation to the following people, who assisted me in writing the catalogue entries: Odile Delenda and Denise Devinat, both Chargées de Mission in the Department of Paintings at the Louvre; Véronique Gérard-Powell, Maître-Assistant at the Université de Paris IV; and Claudie Ressort, Documentaliste in the Department of Paintings at the Louvre. Ms. Walter was closely assisted by Dawson Carr, now Assistant Curator at the J. Paul Getty Museum, Malibu, and by Suzanne L. Stratton, Curator at the Spanish Institute, New York. The editing of the Bibliography and the provenances was the careful and thorough work of Jean Wagner. And to Bruce Campbell, I am indebted for the supremely elegant design of the catalogue.

Special thanks are offered to Michel Laclotte, whose well-known efficiency and enthusiasm were an indispensable resource.

I am also grateful to the Spanish friends and colleagues who have contributed so much to the study and appreciation of seventeenth-century Spanish art. Their expertise and generous collaboration have allowed us to reassemble the series of pictures that Zurbarán painted for various monasteries, and that were first described some forty years ago by Paul Guinard, another French scholar devoted to Spain. Seeing this magnificent group of paintings now, along with dozens of individual works, will at

last allow *amateurs* and historians of art to understand the evolution of Zurbarán's career, and to appreciate the solemn beauty of his extraordinary achievement.

Finally, I would like to express my deep gratitude to the following people, who have generously contributed to the catalogue entries: Santiago Alcolea Blandi, Plácido Arango, Rocío Arnaez, Philippe Asselin, Juliet Bareau, José María Benjumea Fernández de Angulo, José María Benjumea Pino, Professor Bartolomé Bennassar, Michèle Bezagu, Montserrat Blanch Alcolea, R.P. Louis-Marie de Blignières, O.P., Agostino Borromeo, Luis Bravo, O. Cart., Arnauld Brejon de Lavergnée, Professor Jonathan Brown, R.P. Robert Brunet, S.J., Christine Chardon, Marie-Claude Chaudonneret, Francisco Croche de Acuña, Jean-François Delenda, Silvia Delgado, Jean-Pierre Etienvre, Luc Fauchon, O. Cart., Dr. Margrit Früch, Professor Nicole Gotteri, Professor Jan de Grauwe, Michael Helston, Dr. James Hoog, Rocío Izquierdo Moreno, Laurence B. Kanter, Dr. Duncan Kinkead, Laurence Lefébure, Professor Giovanni Leoncini, Dr. Juan José Luna, Professor Fernando Marias, Juan José Martín González, Isabel Mateos, Luis Monreale, Priscilla Muller, Professor Jesús Miguel Palomero Páramo, Enrique Pareja López, Dr. Marie Félicie Perez, Professor Alfonso E. Pérez Sánchez, Professor José Manuel Pita Andrade, Nicholas Powell, Francis Reynaud, Fernando Sánchez Rau, R.P. Pierre Sérouet, O.C.D., Professor Juan Miguel Serrera, Jérôme Tréca Lefébure, Professor Enrique Valdivieso, Damien Vorreux, O.F.M. Cap., and R.P. Luis Vásquez, O.D.M.

Jeannine Baticle

LENDERS TO THE EXHIBITION

FEDERAL REPUBLIC OF GERMANY
BERLIN Staatliche Museen Preussischer Kulturbesitz,
 Gemäldegalerie 46

FRANCE
BESANÇON Musée des Beaux-Arts 13
CHARTRES Musée des Beaux-Arts 22
GRENOBLE Musée de Peinture et de Sculpture 26, 27, 28, 29
LANGON Church of Saint Gervais et Saint Protais 70
LYONS Musée des Beaux-Arts de Lyon 69
MONTPELLIER Musée Fabre 11, 15
ORLEANS Cathedral 61
PARIS Church of Saint-Médard 20
 Musée du Louvre 3, 4, 21

GREAT BRITAIN
BOURNE, LINCOLNSHIRE Grimsthorpe and Drummond Castle Trust 35
EDINBURGH National Gallery of Scotland 33
LONDON The Trustees of The National Gallery 43, 53

HUNGARY
BUDAPEST Szépmüvészeti Múzeum 14, 68

MEXICO
MEXICO CITY Museo de San Carlos 51
 Museo Franz Mayer 7

SPAIN
BARCELONA Museu d'Art de Catalunya 42
BILBAO Museo de Bellas Artes de Bilbao 71
CADIZ Museo de Cádiz 31, 32
GUADALUPE Monastery of San Jerónimo 36
JEREZ DE LA FRONTERA Cathedral of San Salvador 60
MADRID Academia de San Fernando 10
 Church of Santos Justo y Pastor 63
 Museo del Prado, 6, 24, 44, 50
 Real Basilica de San Francisco el Grande 41
MARCHENA Church of San Juan Bautista 25

PATRONAGE AND PIETY: RELIGIOUS IMAGERY IN THE ART OF FRANCISCO DE ZURBARAN

Jonathan Brown

It can be said that some artists redefine their milieu and others reflect it. In seventeenth-century Spain, Diego de Velázquez transmuted the stratified life of the Madrid court into images of audacious originality. Francisco de Zurbarán, working in Seville, painted pictures that epitomize the religious beliefs and aspirations of his conservative ecclesiastical clientele.

Yet Zurbarán's career as a religious painter—and he painted but few pictures of secular subjects—was by no means uneventful. He lived and worked during a period of dynamic change and, in the end, fell victim to its volatile circumstances. From humble beginnings he rose to exalted heights, and then drifted slowly down, to a melancholy end. The changes in taste and patronage that occurred in Seville between 1626 and 1658, the dates of Zurbarán's activity in the city, help to explain the trajectory of his career and the character and evolution of his religious art.

EARLY YEARS IN LLERENA AND THE CONQUEST OF SEVILLE

At first sight, Zurbarán's decision to leave Seville at the conclusion of his apprenticeship in 1617 seems hard to understand. Seville, as the richest city of the Spanish monarchy, was a land of opportunity. But its wealth was by no means open to all comers. Commerce in painting, like commerce with the New World, was closely controlled by guilds and family networks, which made it difficult for an outsider to gain a foothold.[1] Thus, Zurbarán, Extremaduran by birth, decided to return to Extremadura to practice his art.

Llerena, his destination of choice, was a market town of modest size and importance.[2] If the opportunites were limited, so was the competition, which consisted of little more than one other painter and one sculptor. Soon after his arrival, Zurbarán married María Páez, whose father was an agricultural official employed by the crown. In the years that followed, he lived the life of an artisan painter, accepting all sorts of minor commissions, for which he received small sums. It was, presumably, a decent life, but for a painter of talent it offered few prospects of future glory.

Zurbarán's artistic salvation was achieved through tragedy, the death of his wife in 1623 or 1624. In 1625, he married again and by so doing dramatically improved his lot. His second wife, Beatriz de Morales, belonged to a local family of landowners and merchants. They may have encouraged the artist to aim for higher goals, and they provided him with the funds to establish a workshop for large-scale commissions. On January 16, 1626, within months of his marriage, Zurbarán signed a contract to execute a large group of pictures for the Dominican Monastery of San Pablo el Real, in Seville.[3] The painter from the provinces now would seek to make his mark in the city where almost ten years earlier he had left no trace.

The commission for the Dominicans of San Pablo is the first turning point of Zurbarán's career. The contract made with the prior, Fray Diego de Bordas, stipulated twenty-one paintings—fourteen of the life of Saint Dominic, portraits of the four Doctors of the Latin Church (Saints Gregory, Ambrose, Jerome, and Augustine), and portraits of Saints Bonaventure, Thomas Aquinas, and Dominic. Of these works only five remain, two of the scenes of Saint Dominic (Church of La Magdalena, Seville) and the portraits of Saints Ambrose, Gregory, and Jerome (Museo de Bellas Artes, Seville). Nevertheless, there is much to be gained by considering the circumstances of the commission.

The question that arises at once is how Zurbarán managed to win the commission. The answer may be found in the amount of his compensation, 4,000 reales for fourteen *historias* and seven portraits. If we count the portraits as equivalent to two *historias* (the cost of a painting was often based on the number of figures it included), we discover that the price per painting was a mere 250 reales, which was well below the customary fee paid to established painters. Furthermore, Zurbarán agreed to accept the token amount of eight reales as an advance against expenses, a fact that tends to confirm that the Morales family was backing his venture into the new market. In other words, the artist was employing a strategy well known in our own time—offering a price concession to win a share of the market.

Another important point concerns the client. By 1626, Seville, then a city of about 120,000 inhabitants, was well stocked with regular clergy.[4] Attracted by its wealth and importance, religious orders had been flocking to the city since the middle of the sixteenth century. It is estimated that by 1600, there were sixteen monasteries for men and twenty-one convents for women. During the first quarter of the seventeenth century, about fifteen new foundations were established. The monasteries and convents of Seville, some of which possessed considerable wealth, had already begun to emerge as important artistic patrons by the time Zurbarán went to work for the Dominicans. Thus, there was a large potential market to be exploited if the work met with approval.

On the other hand, the monastic clients maintained strict control over content. In Counter-Reformation Spain, orthodoxy and decorum were highly valued and explicitly enforced in contracts, as is evident in the contract signed by Zurbarán on January 26, 1626: "And if some of them [the pictures] do not satisfy the said Father Prior, they can be returned to me and I agree to accept [the return of] one, two, or more paintings, which I agree to do over again."

Monastic commissions also followed set patterns. In the churches there would be an altarpiece with scenes from the life of Christ and sometimes an image relating to the order. Sacristies, where vestments were donned for the celebration of the Mass, became increasingly favored as the site for elaborate adornment during the period. Also, the various dependencies of the monastic establishment—cloister, refectory, cells—were decorated with certain types of images. For example, in the cloister the life of the founder was often depicted in a series of canvases, as at San Pablo. Members of the order distinguished for piety, learning, charity, or suffering were memorialized in individual portraits installed in the library or chapter room. The rather uniform requirements of the monasteries and convents had advantages and disadvantages alike. The formulas could lead to repetitiveness, but the painter who interpreted them convincingly could initiate a chain reaction of commissions.

This is not to say that the monks, friars, and nuns were indifferent to quality. They lived every day with the images, often spending hours of prayer in front of them.

Fig. 1. Francisco Pacheco. *Christ on the Cross*, 1614. Fundación Gómez Moreno, Granada

Thus, the pictures had to inspire devotion and movingly express the sacred drama of the life and resurrection of Christ. Also, they had to demonstrate the rewards obtained by those who imitated his example. Mediocre images may inspire lofty thoughts, but beauty is more likely to move the spirit. It should also be remembered that the leaders of the monasteries, especially the ones whose missions were conducted in the world, were usually men of learning and sophistication who could distinguish between good and bad art.

It is a pity that the paintings for San Pablo done in 1626 have largely disappeared or deteriorated, because, as we now know, they launched Zurbarán on a successful career as a religious painter. However, in the following year he provided another picture for the Dominicans that allows us to unlock the secret of his appeal, *Christ on the Cross* (cat. no. 2). The iconography of this painting, which is distinguished by the use of four rather than three nails to hold the body of Christ to the cross, follows the ultra-orthodox prescription formulated by the painter-theorist Francisco Pacheco.[5] In his famous treatise *Arte de la pintura* (Seville, 1649), Pacheco marshaled the arguments of theologians and scholars to support the historical basis of his prescription, and provided a model in a painting of 1614 (fig. 1), which was scrupulously followed by the painters of Seville until after the middle of the century. But Zurbarán's image is cer-

tainly not a lifeless copy of Pacheco; indeed, it is a greater work by far. Zurbarán re-vivifies Pacheco's formula by an inspired blending of uncanny realism and majestic abstraction that tellingly interprets the Saviour as both lifelike and greater than life. Conservative in subject but modern in style, *Christ on the Cross* offers a perfect synthesis of the predominant strains of art and spirituality required by the religious communities of Seville.

Zurbarán remained in Seville at least until the end of August 1626, the date of completion stipulated in his contract with San Pablo. Presumably, he then returned to Llerena. However, by August 28, 1628, he was once more in the city, where he signed a contract with the Monastery of the Order of Mercy (Mercedarios Calzados) for twenty-two scenes of the life of Saint Peter Nolasco to be hung in one of the cloisters.[6] As before, the artist accepted the control of the prior, agreeing to "put into each [painting] the figures and other things that the *padre comendador* orders me [to do], be they few or many." The size of the fee lends support to the suggestion that Zurbarán had offered a concession to the Dominicans of San Pablo, because he was now to receive over three times as much per picture (800 reales, or 16,500 for the entire commission). In addition, the prior agreed to provide room and board in the monastery for the painter and his assistants during the course of execution (September 1628–August 1629).

The Order of Mercy was founded in Barcelona by Peter Nolasco in 1218, when the struggle to reconquer Spain from the Moors was at its height.[7] The purpose of the new order was to redeem Christian captives from the enemy by raising money for ransom or by sending members of the order to take the place of prisoners, some of whom had been sent to the African territories of Islam. These substitute prisoners tended to have short leases on life and often died gruesome deaths in the land of the infidel. With the end of the Reconquest in 1492, the Merced lost much of its original reason for being and became another of the mendicant orders.

A great moment in the history of the Mercedarians occurred in 1628, the year of the founder's canonization. This was the event that led the Merced of Seville to commission the densely illustrated series from Zurbarán, a commission that ultimately was divided with another artist. It appears that the Order of Mercy had anticipated the problem awaiting these and other painters who now would be asked to produce scenes from the life of a saint without an established iconography. In the previous year, Jusepe Martínez, an Aragonese painter then resident in Rome, produced designs for twenty-five scenes from the saint's life, which were to be engraved by local engravers. It is probable that a set of these prints was delivered to Zurbarán and his collaborator, who adapted them for the paintings.[8]

Neither all the prints nor all the paintings survive, but fortunately the engraving that inspired the masterpiece of the series, *Saint Peter Nolasco's Vision of the Crucified Saint Peter* (cat. no. 6), is known. Peter Nolasco was ardently devoted to his namesake, the Apostle Peter, and had long wished in vain to visit his sepulcher in Rome. The Apostle rewarded his devotion by appearing to him in the form in which he had been crucified. He spoke to Peter Nolasco, saying, "I have come to you since you cannot come to me," and urged him to stay in Spain and continue his good work.

From a strictly iconographical standpoint, it can be seen that Zurbarán contributed very little to the formulation of this powerful moment in the life of the saint. Yet as works of religious art, the rather ordinary print and the extraordinary painting are worlds apart. The intense realism of the miraculous apparition in Zurbarán's painting obliterates every trace of the physical setting where it transpires, and overwhelms the

saint and the viewer alike. Peter Nolasco's halting gesture of surprise and amazement captures a moment of spiritual transcendence with the most economical of means imaginable.

Even as he was working for the Mercedarians, Zurbarán received an important commission from another monastic client, the Franciscans of the Convento Grande. As he had hoped and planned, his reputation was gathering momentum. The Convento Grande de los Franciscanos was among the most important religious houses of Seville, in part because its central location near the City Hall proved attractive to donors and benefactors who wished to publicize their generosity. Between 1622 and 1626, the Franciscans had added a college to the sprawling complex of buildings, which was dedicated to the great Franciscan scholar Saint Bonaventure.[9] The artist chosen to decorate the church of the college, the only part of the establishment still standing today, was Francisco de Herrera the Elder, one of the leading painters of Zurbarán's generation. Herrera first created the frescoes and stucco decoration and then, on December 30, 1627, was commissioned to paint a series of six scenes of the life of the patron saint. At some point, however, the commission was expanded to eight pictures and Herrera's share was reduced to four. The remainder was assigned to Zurbarán, one of whose pictures is dated 1629.

There is some reason to believe that the adjustment of the commission occurred in 1628. Herrera had agreed to deliver a picture every ninety days. If he had kept to schedule, he would have completed the first four works and been obliged to deliver the fifth by mid-August 1628, which is when Zurbarán appeared in Seville to sign the contract with the Merced Calzada. These circumstances may explain why the Franciscans changed their plans. Had Herrera failed to meet the deadline just as Zurbarán appeared on the scene, the Franciscans could have seized the chance to dismiss the one and hire the other. For Zurbarán, the opportunity to work for the Franciscans would have been irresistible.

The series of eight pictures is divided into two equal parts, one showing the youth of Saint Bonaventure (by Herrera), the other his life as a distinguished churchman and a scene of his death (by Zurbarán). The interpretation of Bonaventure's life (1221–1274) offered in these works is highly selective. The saint was a man of many parts and accomplishments: philosopher, theologian, administrator of his order, cardinal of the Church, and an exemplar of piety. Given the setting—the church of a Franciscan institution of higher learning—it is strange that Bonaventure's great achievements as a scholastic are virtually ignored.

In *Saint Bonaventure and Saint Thomas Aquinas before the Crucifix* (see illus. on page 83), Bonaventure responds to a question about the source of his knowledge by looking past his books to a lifelike image of the crucified Christ, which he dramatically uncovers behind a curtain. *Saint Bonaventure Inspired by an Angel Regarding the Election of a New Pope* (see illus. on page 83) illustrates an event of 1271, in which he resolved a lengthy deadlock over the election of a new pope. A considerable feat of diplomacy (the College of Cardinals had been deliberating inconclusively for over three years) is here transmuted into an incident of Divine inspiration.

The two remaining scenes illustrate the conclusion of the saint's life. In 1274, Bonaventure presided over the Ecumenical Council of Lyons and achieved a notable if transitory success in reconciling the Greek and Latin Churches. While the Council was still in session, he suddenly died, some said by poisoning. His funeral occurred the following evening and was attended by Pope Gregory X and King James I of Aragon,

both represented in Zurbarán's painting. In these two works (cat. nos. 3, 4), Bonaventure is presented as statesman and as a figure revered by the highest secular and religious authorities.

For all their narrative effectiveness and clarity—and they are considerable—the paintings by Herrera and Zurbarán leave a gap in the life and career of Saint Bonaventure. The emphasis on piety and diplomacy is appropriate, but the absence of learning seems almost inexplicable. However, this lapse is explained by reference to Herrera's fresco decoration. In the cupola, there can be seen eight portraits of Franciscan saints, presided over by Saint Bonaventure, while on the nave vault are portraits of ten great Franciscan scholars, among them John Duns Scotus, William of Ockham, and Alexander of Hales. Here is the missing celebration of Bonaventure as a scholar. Now that the oil paintings are gone from the church, the tightly woven web of meaning has become unraveled. Once restored, it can be seen how paintings and frescoes were meant to offer a well-orchestrated hymn to the glory of Saint Bonaventure.

Even as Zurbarán was executing the paintings for San Buenaventura, he would have heard the news that his conquest of Seville was assured. On Wednesday, June 27, 1629, a motion was read in the City Council to invite the artist to transfer his residence to Seville.[10] Rising to speak to the assembly, Councillor Rodrigo Suárez praised the pictures finished so far for the Merced, and the *Christ on the Cross* painted for San Pablo. From these, it could be judged that Zurbarán was a "consumado artífice destas obras." The motion passed, and by the end of the year the painter and his family were settled in the city.

ILLUSTRATION AND INSPIRATION: THE MONASTIC COMMISSIONS OF THE 1630S

The 1630s were a decade of unsurpassed success in Zurbarán's career as he received commissions from all corners of Seville's religious world; the Carmelites, the Jesuits, the Carthusians, and the Discalced Mercedarians followed the lead given by their brother orders in the late 1620s. Parish churches, religious colleges, the corporation of Indies merchants, and pious individuals also sought to obtain his services. But Zurbarán had established his fame as a monastic painter, and this clientele was to remain the cornerstone of his patronage for the next ten years.[11] With so many commissions to discuss, it would seem hard to choose one over another. However, there is a long-standing consensus that the artist reached the height of his powers in two major commissions: the series for the Carthusian Monastery of Jerez de la Frontera and that for the Hieronymites of Guadalupe, both done over the same short period of time, 1638–40.

The commissions from these two monasteries are indicative of the painter's spreading fame, which attracted clients not only from the outlying towns of Andalusia and the region of Extremadura but also from the kingdom of Portugal. As a consequence, Zurbarán's workshop grew considerably and his personal participation in the output correspondingly diminished. But in these series, the master played a large part in the execution of the works.

The Monastery of Jerez de la Frontera had been founded in 1463 through a pious donation by Alvar Obertos de Valeto.[12] According to the foundation document, the monastery was to be named Santa María de la Defensión in honor of a miraculous appearance of the Virgin Mary in 1370 at the nearby hermitage chapel of El Sotillo. A band of Spanish soldiers was about to be ambushed on the site by a troop of Moors

under the cover of night, when the Virgin shed her light on the scene, allowing the Spaniards to detect and defeat the enemy.

A lawsuit by the heirs of the donor delayed construction of the monastery for over twenty-five years, but eventually the building was finished, including an elegant single-naved church in the late Gothic style. In the 1630s, like many other religious orders in the region, the Carthusians decided to modernize their church, replacing some of the medieval decoration with works in the contemporary style. Among the artists involved in the effort was Zurbarán, who was commissioned to make paintings for three sites: the new high altar, the small altars in the lay brothers' choir, and a passageway leading from the flanks of the high altar to a small retrochapel called the *sagrario*, where the Host was kept. Although no documents of the commission have been found, one painting is dated 1638, another 1639.

For the large three-storied altar, Zurbarán was asked to paint eleven pictures: four scenes from the Gospels, a representation of the miracle at El Sotillo, and portraits of the four Evangelists plus Saints Lawrence and John the Baptist (see illus. on page 175).[13] The iconography of the principal scenes illustrates the life of Christ and also reflects the Carthusians' special devotion to the Virgin Mary, who appears in four of the five major pictures. In the *Annunciation* (cat. no. 26), this devotion is made explicit in the pose of the Archangel Gabriel who, contrary to the prevailing practice, greets Mary with a reverential gesture instead of an arm raised as if to call her attention. Even in the *Circumcision*, where Mary is absent, she is implicitly present.

Zurbarán's version of the Circumcision (cat. no. 29) is unusual in several respects.[14] The scene rarely occurred in seventeenth-century altarpieces, except in Jesuit foundations. Furthermore, the Virgin's absence is noteworthy because she invariably appears in representations of the subject. This omission can be explained by the intention to depict the scene in accordance with Jewish law and custom. The Carthusians were not, of course, interested in correct Jewish observance for its own sake, but rather were attempting to achieve historical accuracy or *decoro*, as it was then called, which was thought necessary to uphold the highest standards of Christian art. Thus, all the participants in the ceremony, and the onlookers too, are given stereotypical Semitic features. And the ritual of circumcision is conducted by a special officiant, the mohel, while the rabbi holds the body of the Infant Christ. In keeping with the desire for accuracy, the Virgin is necessarily absent because Jewish law proscribed a new mother's entering the temple until forty days after the birth of a male child (Leviticus 12:2–4).

Nevertheless, the Virgin Mary was present in spirit because the prayers offered on the feast of the Circumcision (January 1) make special reference to her. In the Office, the responses and antiphons are the ones appropriate to her feasts, while the Collect implores her to lend the powerful assistance of her prayers to the faithful.

The complex significance of the Circumcision also contains a level of meaning appropriate to the Carthusians, or any monastic order. In the Jewish religion, circumcision is a rite that betokens the covenant between God and Abraham and is also interpreted as having saving power, of which Christ, who was incapable of sin, had no need. Yet he accepted the act to demonstrate his submission to the will of the Father.[15] The Circumcision thus resonates with the virtue of obedience, which the Carthusians demanded to a greater degree than any other religious order.

In the lay brothers' choir, the basic themes of the high altar are given new forms. The Carthusian devotion to Mary is restated explicitly in a painting that shows the Virgin of the Rosary as Queen of Heaven adored by the white-robed monks (see illus.

Fig. 2. Francisco de Zurbarán. *Saint Bruno in Ecstasy*, 1638–39. Oil on canvas, 11 ft. 2¼ in. × 6 ft. 4¾ in. (341 × 195 cm). Museo de Cádiz

on page 194), while Saint Bruno, the founder, is depicted in a towering image (fig. 2) that shows him turning away from symbols of learning and Church service (the bishop's miter and staff) and seeking inspiration from heaven above.

The third component of the commission is the most original. Directly behind the high altar was the *sagrario*, which was reached through two narrow passageways, symmetrically disposed to the right and the left of the altar. On the walls were placed, four to a side, individual portraits of distinguished members of the order.[16] In concept the series conforms to an established custom by which monastic orders glorified their history of spiritual and secular achievement with a portrait gallery of exemplary brothers. But in practice the portraits in the passageway are rather loosely strung together.[17] Saint Bruno (Museo de Cádiz) and Saint Hugh of Grenoble (fig. 3) are present as the founder and the first patron, respectively, of the Carthusians. Saints Anthelm and Hugh of Lincoln and the Blessed Nicholas Albergati (figs. 4–6) commemorate members of the order who became high dignitaries of the Church. Saint Arthaud (fig. 7) is a paragon of Carthusian asceticism; although called to be Bishop of Belley at the age of eighty, he renounced the title after two years and returned to the cloister, where he lived yet another twenty-three years. And the Blessed John Houghton (fig. 8) was a Carthusian brother who was brutally martyred by Henry VIII when he refused to subscribe to the Act of Supremacy.

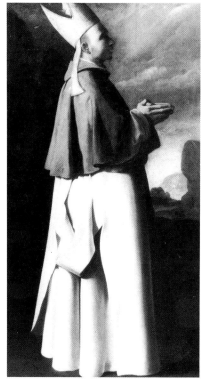

Fig. 3. Francisco de Zurbarán. *Saint Hugh of Grenoble*, 1638–39. Panel, 47¼ × 25⅛ in. (120 × 64 cm). Museo de Cádiz

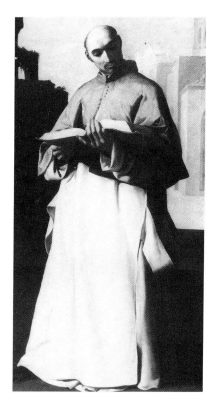

Fig. 4. Francisco de Zurbarán. *Saint Anthelm*, 1638–39. Panel, 47¼ × 25⅛ in. (120 × 64 cm). Museo de Cádiz

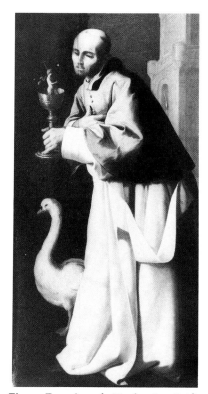

Fig. 5. Francisco de Zurbarán. *Saint Hugh of Lincoln*, 1638–39. Panel, 47¼ × 25⅛ in. (120 × 64 cm). Museo de Cádiz

Fig. 6. Francisco de Zurbarán. *The Blessed Nicholas Albergati*, 1638–39. Panel, 47¼ × 25⅛ in. (120 × 64 cm). Museo de Cádiz

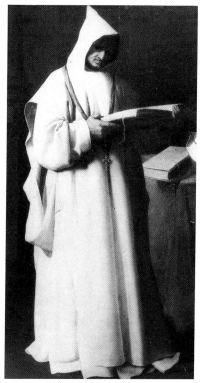

Fig. 7. Francisco de Zurbarán. *Saint Arthaud*, 1638–39. Panel, 47¼ × 25⅛ in. (120 × 64 cm). Museo de Cádiz

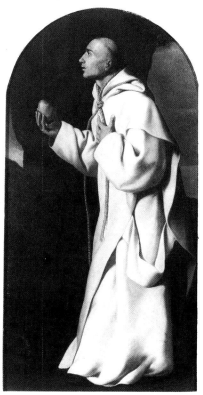

Fig. 8. Francisco de Zurbarán. *The Blessed John Houghton*, 1638–39. Panel, 48 × 26 in. (122 × 66 cm). Museo de Cádiz

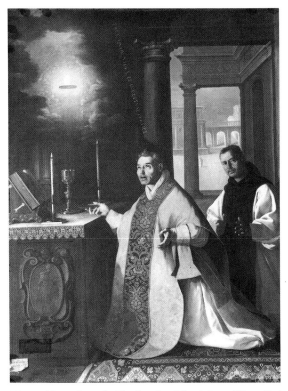

Fig. 9. Francisco de Zurbarán. *The Mass of Fray Pedro de Cabañuelas*, 1638. Oil on canvas, 9 ft. 6¼ in. × 7 ft. 3½ in. (290 × 222 cm). Sacristy, Monastery of San Jerónimo, Guadalupe

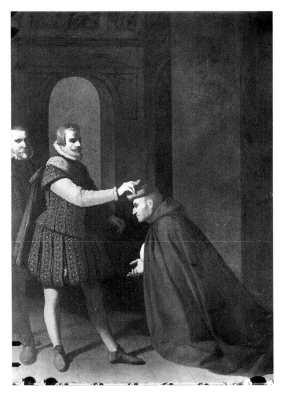

Fig. 10. Francisco de Zurbarán. *Fray Fernando Yañez de Figueroa Refuses the Archbishopric of Toledo*, 1639. Oil on canvas, 9 ft. 6¼ in. × 7 ft. 3½ in. (290 × 222 cm). Sacristy, Monastery of San Jerónimo, Guadalupe

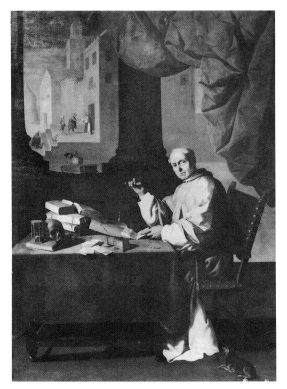

Fig. 11. Francisco de Zurbarán. *Bishop Gonzalo de Illescas*, 1639. Oil on canvas, 9 ft. 6¼ in. × 7 ft. 3½ in. (290 × 222 cm). Sacristy, Monastery of San Jerónimo, Guadalupe

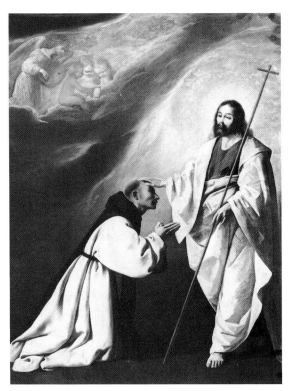

Fig. 12. Francisco de Zurbarán. *The Vision of Fray Andrés Salmerón*, 1639. Oil on canvas, 9 ft. 6¼ in. × 7 ft. 3½ in. (290 × 222 cm). Sacristy, Monastery of San Jerónimo, Guadalupe

It is difficult to believe that these exquisitely calibrated portraits were made to be hung where they were seen only occasionally and under the poorest conditions of light and space. Zurbarán had established his mastery over the imaginary portrait in the splendid series of Doctors of the Order of Mercy, executed earlier in the decade. Here, the variety of physical type and the nuances of personality and expression are even greater and breathe new life into the meaning of Carthusian history.

The majestic paintings for the sacristy of the church at Guadalupe provided another occasion for the artist to display his gifts as an imaginative portraitist. For this series, however, there was a well-constructed program that relates the pictures to each other and to a specific idea.[18] Almost from its beginning in the mid-fifteenth century, the Hieronymite Order had established close ties with the kings of Castile, ties that were strengthened over the years as the rulers came to adopt the Monastery of Guadalupe as one of their primary spiritual centers. The relationship was founded on the belief that the Virgin of Guadalupe could ensure the success of the Spanish crusade to defeat the Moors. With the generous patronage of the rulers, the monastery expanded and prospered during the fifteenth and early sixteenth centuries.

In 1492, Ferdinand and Isabella forced the kingdom of Granada to surrender and brought the Reconquest to a triumphant conclusion. For Guadalupe, the momentous event was bittersweet. As Spain now entered the imperial phase of its history, Guadalupe, situated in a remote part of Extremadura, began to lose its eminence in the secular world. And when Philip II undertook the construction of the Escorial as the new imperial temple (1563), the monks of Guadalupe could take but small consolation in the fact that the king entrusted his new monastery to their order.

One reaction to the reversal of fortune was a program of new construction, which commenced about 1595 and culminated in the building of the sacristy during the years 1638 to 1647. Almost as soon as the plans were drawn, a delegate was dispatched to Seville to contract with Zurbarán for a series of eight large pictures. After Zurbarán successfully completed a trial piece in 1638 (fig. 9), the contract was signed on March 2, 1639. As customary, the artist was furnished with a memorandum on the subjects of the paintings.[19]

In brief, the paintings depict events in the lives of eight monks of Guadalupe. Unlike the series for the Carthusian monastery, these pictures, with one exception, are cast in narrative form. Another difference lies in the fact that no attempt was made to include Hieronymites from other houses or even from any period but the fifteenth century. (The Carthusians represented at Jerez were from French, English, and Italian houses, and lived as early as the eleventh century and as late as the sixteenth.) This narrow focus was determined by a desire to concentrate on the period when Guadalupe was at the height of its worldly influence, a point which is emphasized by pictures such as the one showing Fray Fernando Yañez refusing the archbishopric of Toledo (Spain's primatial see) from King Henry III (fig. 10) and the portrait of Gonzalo de Illescas (fig. 11), who became Bishop of Córdoba and councillor to King John II. Hieronymite spirituality was not forgotten either. The *Apparition of Christ to Fray Andrés Salmerón* (fig. 12), in which Christ appears amid a cyclone of golden clouds, is one of the most affecting representations of a mystical vision painted in seventeenth-century Spain.

The chapel adjacent to the sacristy was dedicated to Saint Jerome, in whose name the order had been established. A small altar holds a copy of the famous statue of Saint Jerome by Pietro Torrigiano, above which is a painting by Zurbarán of the saint's

Fig. 13. Francisco de Zurbarán. *The Flagellation of Saint Jerome*. Oil on canvas, 7 ft. 8½ in. × 9 ft. 6¼ in. (235 × 290 cm). Chapel of San Jerónimo, sacristy, Monastery of San Jerónimo, Guadalupe

apotheosis.[20] For the predella, his assistants made small portraits of unidentified Hieronymites, some of which copy the poses of the portraits for the monastery at Jerez. Fortunately, the rather mediocre quality of the altarpiece paintings is redeemed by two masterpieces honoring the patron saint from Zurbarán's own hand, the *Flagellation of Saint Jerome* and the *Temptation of Saint Jerome* (figs. 13, 14).

Zurbarán's paintings for Jerez and Guadalupe demonstrate how profoundly he penetrated the spirit of monastic life. Despite the important differences in the character of the two orders, the Carthusians and the Hieronymites shared a pride in their past and a desire to serve God with every means at their disposal. Zurbarán's genius in painting for his monastic clientele lay in his ability to express their glorious history and their passionate faith in forms that were at once vivid and inspiring.

THE HERCULES SERIES AND THE LABORS OF ZURBARAN

By 1634, Zurbarán's reputation had reached the court in Madrid, where he was summoned to paint for the king. In the previous year, a new royal palace, called the Buen Retiro, had been constructed on the outskirts of Madrid. The decoration of one

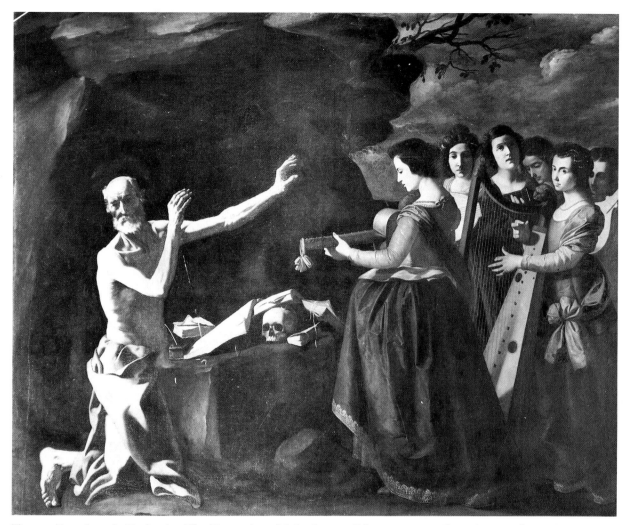

Fig. 14. Francisco de Zurbarán. *The Temptation of Saint Jerome.* Oil on canvas, 7 ft. 8½ in. × 9 ft. 6¼ in. (235 × 290 cm). Chapel of San Jerónimo, sacristy, Monastery of San Jerónimo, Guadalupe

of the principal rooms, which has come to be known as the Hall of Realms, was assigned to the court painters—Velázquez, Vicente Carducho, and Eugenio Cajés—and their assistants. An invitation to join this privileged group was a signal honor; indeed, Zurbarán was the only participant to be invited from outside Madrid.

The decoration of the Hall of Realms was dedicated to promoting the glory of Philip IV and his minister, the Count-Duke of Olivares, and consisted of two parts.[21] Twelve military victories of the reign were commemorated in large battle paintings placed between each two of the ten windows of the room. Above each of the windows was a scene from the life of Hercules, the mythical ancestor of the Spanish Hapsburgs and an exemplar of princely virtue.

Hopes for Zurbarán must have been running high, because he was assigned the largest share of the work, consisting of the ten Hercules scenes (see cat. no. 24) and the *Defense of Cádiz* (fig. 15). From our vantage point, this division of labor is hard to understand. Zurbarán had little experience with the demands of painting the nude figure in action, and no nude figure was ever more active than Hercules. Consequently, it is no surprise that the pictures have always been regarded with less esteem than the artist's religious paintings.

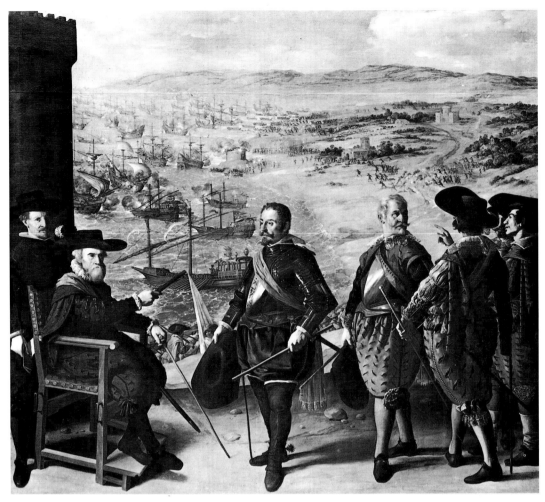

Fig. 15. Francisco de Zurbarán. *The Defense of Cádiz*, 1634. Oil on canvas, 9 ft. 10⅞ in. × 10 ft. 7¼ in. (302 × 323 cm). Museo del Prado, Madrid

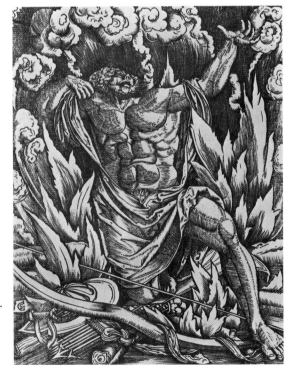

Fig. 16. Master G.S. (Gabriel Salmon?). *The Death of Hercules*. Woodcut. The Metropolitan Museum of Art, New York. Harris Brisbane Dick Fund, 1927

Zurbarán's Hercules is a brutish figure whose tightly bunched muscles seem to lock into place as he struggles to conquer enemies and overcome obstacles. Yet the very awkwardness of the poses, some of which were borrowed from prints (fig. 16), works well when the paintings are considered as schematic emblems of superhuman power rather than as idealized illustrations of a classical hero. Also to be remembered is their placement at some distance above the floor, where the stock poses and strong contrasts between figure and background would have made the scenes easily legible.

A court appointment was the highest hope of many a Spanish painter in the seventeenth century. We shall probably never know whether Zurbarán shared the dream and returned to Seville only because he was not invited to stay in Madrid, or whether he was loath to abandon a near monopoly of artistic commissions in his adopted city. At any rate, by the end of the year he was home again and supplying an apparently insatiable market with further examples of his art.

Private Devotional Paintings

Zurbarán's monastic commissions are now understandably regarded as his major achievement. However, they constitute only a part, and not the largest part, of his output during the 1630s. In fact, much of his production was destined for private clients and took the form of individual devotional pictures. This aspect of Zurbarán's output unfortunately is little documented. But the quantity of existing pictures and the numerous repetitions of certain popular compositions indicate that the workshop was to some extent a factory for devotional images. The number and variety of these pictures are too great for them to be considered in their entirety, but the discussion of selected themes may serve to indicate how Zurbarán satisfied the considerable demand for his work.

No subject was dearer to the hearts of Sevillians than the Virgin of the Immaculate Conception.[22] Its popularity is explained in part by the powerful strain of Marian devotion that had been traditional in Spain, and especially in Seville. But the spark of devotion to the Virgin Immaculate was fanned by a heated controversy over the doctrine of Mary's immaculate conception. This debate revolved around the question of whether Mary had been conceived free of the taint of original sin, or whether she had been conceived in sin and purified by God in the womb of her mother (the so-called Doctrine of Sanctification). For hundreds of years, proponents of the Doctrine of the Immaculate Conception had sought to elevate it to the status of a dogma of the Catholic Church, only to meet fierce resistance from those who believed that Jesus Christ alone had been spared the stigma of original sin.

During the sixteenth and seventeenth centuries, the controversy became a matter of great public concern in Spain, where the monarchs repeatedly petitioned the papacy to rule in favor of the Virgin's immaculate conception. Inspired by the fervor of the crown and its theological advisers, the populace of Seville would take to the streets whenever the doctrine was challenged by its critics or exalted by its proponents. In September 1613, for example, on the feast of the Virgin's birth, a Dominican friar preached a sermon in favor of the Doctrine of Sanctification, which was answered by a mass demonstration in the streets of Seville by the Immaculists. In these circumstances, it is no surprise that paintings of the Virgin of the Immaculate Conception were always in demand.

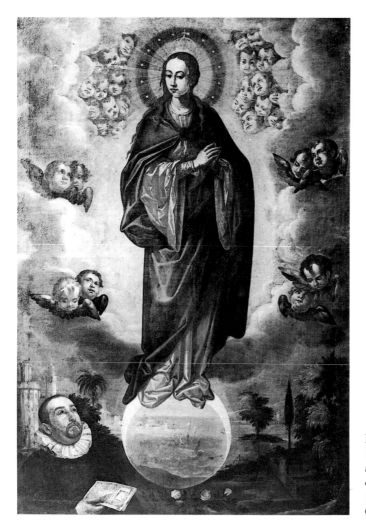

Several of Zurbarán's renditions of the theme made in the 1630s are didactic images that reflect the polemics generated by the debate. Earlier in the century, Pacheco produced versions of the theme incorporating the symbolic apparatus that had evolved in the sixteenth century (fig. 17). This iconography, later codified in Pacheco's treatise, became the standard for painters working in Seville in the first half of the century. Thus, in a painting thought to have been done for the City Council of Seville in 1630 (cat. no. 55), Zurbarán shows the youthful Mary standing on a crescent moon, her head surrounded by a ring of twelve stars, features borrowed from Saint John's vision of the Woman of the Apocalypse (Revelation 12:1–2). She is flanked by symbols of her purity drawn from the prayers known as the Marian litanies—the flawless mirror, the gate of heaven, Jacob's ladder, and the star of the sea. Beneath her feet is a naturalistic landscape that includes additional symbols of purity—the cypress of Zion, the well of living waters, the tower of David, and the enclosed garden, among others. Even more iconic and explicit is a painting of the Virgin Immaculate with two youthful donors (Museu d'Art de Catalunya). On either side of Mary are two putti holding roses and lilies and tablets with quotations from the Song of Solomon 6:10, a text commonly used to exalt the Virgin's purity. Immediately below, set into niches that open in the sky, are some of the familiar symbols from the litanies, more of which are incorporated into the landscape background.

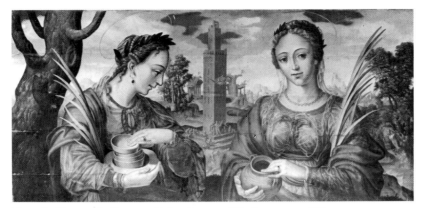

Fig. 18. Hernando Sturm. *Saints Justa and Rufina*, 1555. Oil on canvas. Chapel of the Evangelists, Cathedral, Seville

Another pictorial type that Zurbarán adopted and transformed for his private clients was the virgin martyr in contemporary garb.[23] The subject had been popular in Seville in the late sixteenth and seventeenth centuries, when this glacial example of the type was produced (fig. 18). In Zurbarán's hands, the young martyrs acquire distinctive personalities and modes of attire, the latter of which range from the opulent to the rustic (see cat. no. 43).

Zurbarán also made a specialty of painting individual figures of male saints, either standing or in prayer, of which the best known and most successfully realized are those of Saint Francis. The iconography of this saint had undergone a significant change in the later sixteenth century, when the benevolent man of charity was transformed into a fervent penitent, holding a skull as a reminder of the vanity of earthly

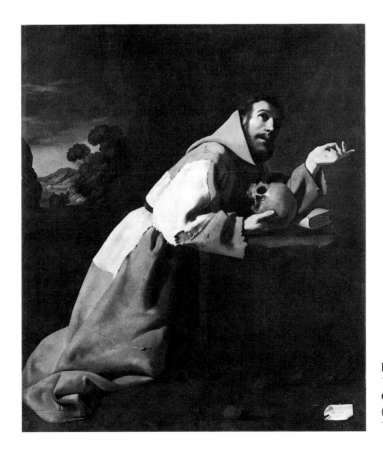

Fig. 19. Francisco de Zurbarán. *The Penitent Saint Francis*, 1639. Oil on canvas, 63¾ × 54 in. (162 × 137 cm). The Trustees of The National Gallery, London

life.[24] In Spain, this version of Saint Francis was popularized by El Greco, but the definitive representation of the type is surely the famous picture by Zurbarán (fig. 19), which effectively combines painstaking realism with monumental solemnity.

NEW MARKETS IN THE NEW WORLD

This review of Zurbarán's patronage from 1626 to 1640 has shown that the artist cultivated three markets for his pictures. Foremost were the religious establishments of Seville, the primary market. Once a painter had made his reputation among this group of patrons, he could expect to receive commissions from all over the surrounding region, as smaller towns sought to emulate the style of the metropolis. Thus, by the mid-1630s, Zurbarán was dominating the secondary regional markets as well. Between 1636 and 1640, he received commissions from Llerena (1636), Marchena (1637), Arcos de la Frontera (1637), and last, but not least, Jerez de la Frontera and Guadalupe (1638–39). The third market was the private sector, individual clients seeking to own a single picture.

In theory, Zurbarán need never have worried again about the demand for his pictures. But in practice, life was not to be so simple. For almost as soon as he had completed his work for Jerez and Guadalupe, the market for ecclesiastical commissions in Seville collapsed. After 1640, the artist never again was asked to produce a major series of paintings for a Sevillian religious order, except perhaps for the Carthusian Monastery of Las Cuevas (see cat. nos. 37, 38).

The explanation for this unexpected development is found in the confluence of political and economic circumstances in Spain during the middle years of the seventeenth century.[25] Since 1627, the monarchy had been fighting wars in Italy, Germany, and the Netherlands, which gradually impoverished the country. In 1635, a long and costly struggle with France commenced, followed in 1640 by the rebellions in Catalonia and Portugal. Desperate measures to raise money to defend the monarchy reduced the economy even further. And the unexpected decline in silver remittances from America was another blow, which was felt acutely in Seville.

Inevitably, the financial problems were experienced by the ecclesiastical establishment. From 1640 to the end of the century, for example, only three new religious houses were founded in Seville, while the endowments of those already in existence were reduced by deflation and poor administration.[26] As conditions worsened, the need for alms increased, effectively preempting funds that might have been spent on artistic projects.

To compensate for the loss of this important patronage, Zurbarán turned increasingly to producing pictures for export to the Spanish colonies in America. Paintings destined for the New World often were made on speculation, although specific commissions were also received.[27] A painter would execute various pictures and consign them to a ship captain to sell on the other side of the Atlantic. On his return to Seville, the captain would remit the proceeds, minus a fee, to the artist. The conditions of this trade did not favor the highest artistic standards because a painter had little incentive to do his best work for an unknown and possibly unappreciative audience. And there was always a risk that the pictures could be lost at sea or damaged in a difficult journey to a remote inland location. The trade also required the master to paint subjects that would appeal to the widest possible audience, thus maximizing the chances for a sale and minimizing the need for originality.

Zurbarán's production from the 1640s to about 1656 reflects these conditions of the colonial market. The themes are simple, the quality of execution often mediocre. The workshop also specialized in making groups of paintings dedicated to a single theme, which allowed the customer to decorate a church or private house with one purchase. Thus, there are series of paintings (usually about a dozen in number, but occasionally twenty or more) dedicated to the founders of religious orders, to the twelve Roman emperors, and to the twelve sons of Jacob, who were thought to be remote ancestors of the native inhabitants of America (see cat. no. 35). Zurbarán also shipped sets of paintings representing Christ and the Apostles and the life of the Virgin to American destinations. Needless to say, this wholesale production of pictures was largely executed by the workshop after designs by the master. But these images did make a considerable impact in the New World, where Zurbarán became the most influential artist of the time.

CHANGING TIMES, CHANGING FORTUNES

The decline in institutional clients and the rise of the American market were accompanied by other changes in the demand for religious pictures in Seville, to which Zurbarán had to accommodate. Beginning in the 1640s, a new taste in religious art became apparent in Seville. During the earlier years of the century, great emphasis had been placed on the accurate representation of Scripture and the correct interpretation of

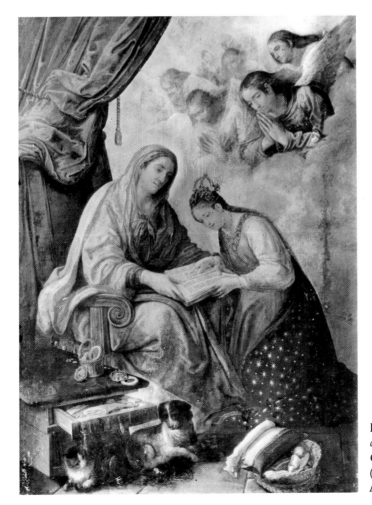

Fig. 20. Juan de Roelas. *The Education of the Virgin*, ca. 1610–15. Oil on canvas, 7 ft. 6½ in. × 5 ft. 7 in. (230 × 170 cm). Museo de Bellas Artes, Seville

19

doctrine in the belief that religious art was intended first to instruct and then to inspire devotion. The requirement of orthodoxy had become paramount in the sixteenth century in order to refute the Protestant reformers, who began to question some of the central tenets of the Catholic faith. To safeguard the faithful, the Inquisition of Seville employed an overseer of images, whose job it was to detect "errors" of doctrine in works of art. From 1616, this position was filled by Francisco Pacheco, that stern protector of orthodoxy, who published his standards of judgment in *Arte de la pintura*.

The third part of this treatise offers detailed guidelines for the iconography of the major themes of Catholic art and allows us to see the mind of the Counter-Reformation at work. In one section, Pacheco considers the subject of Saint Anne teaching the young Virgin Mary how to read.[28] Pacheco notes disapprovingly that the subject began to appear in Sevillian art about 1612 and is eager to stamp it out if he can, for reasons that appear in his discussion of a version of the subject by Juan de Roelas (fig. 20). This apparently innocuous painting is censured for the inclusion of naturalistic details, but principally because it implies the imperfection of the Virgin, who "from the first instant of her conception had perfect use of reason, free will, and contemplation." In other words, she was born knowing how to read and thus needed no instruction from her mother or any other mortal.

Pacheco refers to the subject as one that was "embraced by the vulgar [that is, the unlettered]," an accusation which is not unfounded. In the early years of the Counter-Reformation, Church authorities and theologians had wrestled with the problem of popular devotion, which was characterized by an intensely personal and humanized faith and was susceptible to practices that bordered on superstition.[29] Little by little, however, some of the characteristics of popular devotion were incorporated into conventional Church practice. The result was a marked change in religious imagery away from the doctrinaire to the emotional. This development was abetted by the publication of important new works of devotional literature—the most famous example is Ignatius of Loyola's *Exercitia spiritualia* (Rome, 1548)—which encouraged emotional engagement

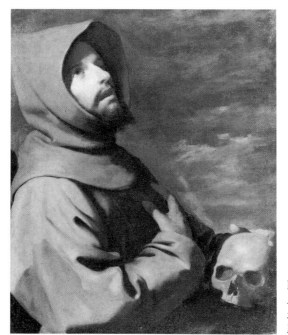

Fig. 21. Francisco de Zurbarán. *Saint Francis*, 1658–60. Oil on canvas, 25¼ × 20⅞ in. (64 × 53 cm). Alte Pinakothek, Munich

Fig. 22. Francisco de Herrera the Younger. *The Allegory of the Eucharist,* 1655. Oil on canvas, 8 ft. 9⅞ in. × 9 ft. 8⅛ in. (269 × 295 cm). Hermandad Sacramental del Sagrario, Cathedral, Seville

in the practice of the faith. In the years before his death in 1644, Pacheco would have been the unhappy witness to the beginnings of the impact of this trend in Sevillian painting, including the works of Zurbarán done from 1640 onward.

Even in the 1630s, Zurbarán had painted the occasional picture that is expressive of new devotional ideas (see cat. no. 48). But after 1640, the exception becomes the rule and the new themes appear more and more frequently in his art. One example is the theme of the Virgin and Child (see cat. no. 66), which surprisingly is unknown in his earlier work but appears in several variations thereafter. Greater emotion is also infused into the representation of Christ (see cat. no. 61), who comes down from the cross where he was so convincingly depicted in 1627 (see cat. no. 2) and seems to plead for the pity of the viewer. And the harsh asceticism of the penitent Saint Francis (fig. 19) is softened in a later version, where a more refined, less rustic physical type is introduced (fig. 21).

Zurbarán's astringent, monumental style was not well suited to these new themes, but he was able with some success to soften his manner. Thus, the gradual emergence

of Bartolomé Esteban Murillo, who would become the complete master of devotional painting, was not initially a threat to Zurbarán's career. The decisive challenge came from another quarter: the energetic, contemporary art of Francisco de Herrera the Younger.

Herrera returned to his native Seville in 1655 and in the same year painted the *Allegory of the Eucharist* (fig. 22) for the Confraternity of the Holy Sacrament. This work, and the *Stigmatization of Saint Francis*, executed in 1657 (fig. 23), introduced a new type of religious art into Seville, in which the surging emotion of private prayer found a convincing visual equivalent.[30] This manner of painting was beyond the reach of Zurbarán, and when his finances collapsed in 1656–57, there seemed to be no choice but to move to Madrid in the hope of improving his luck.[31]

As we now know, this was to hope against hope. Painting in Madrid was, if anything, more advanced than in Seville. Thus, when Zurbarán painted a version of the Virgin and Child (cat. no. 71) based on a print by Albrecht Dürer (fig. 24), he was already conceding defeat.[32] In his paintings of the Virgin of the Immaculate Conception, he eliminated the elaborate didactic machinery of the earlier versions (see, for example, cat. nos. 64, 70), but somehow failed to convey the sense of rapture that the public now demanded of the image.

Looking back over Zurbarán's career, we can see that there was a time when his style meshed perfectly with the temper of his clientele and when he gave lofty and dignified expression to a heroic form of Christian life and devotion. Although we do

Fig. 23. Francisco de Herrera the Younger. *The Stigmatization of Saint Francis*, 1657. Oil on canvas. Cathedral, Seville

Fig. 24. Albrecht Dürer. *Madonna and Child with Monkey*, ca. 1497–98. Engraving. The Metropolitan Museum of Art, New York. Fletcher Fund, 1919

not think of Zurbarán as a learned painter in the manner of Pacheco, the fact is that he was at his best when interpreting Christian history and dogma. As the Catholic faith veered increasingly toward an emotional expression, the synthesis that Zurbarán achieved between ideas and spirituality proved to be of diminishing value to his public. He tried to adapt to the new conditions but could not change enough to make a difference. Thus, in his final years he descended to that twilight region of semiobscurity where the once-in-fashion dwell.

NOTES

The following notes contain only the basic references to matters discussed in the text.

1. For Seville's artistic "dynasties," see Enrique Valdivieso and Juan M. Serrera, *La época de Murillo: Antecedentes y consequentes de su pintura* (Seville, 1982), p. 11.

2. The information on Zurbarán in Llerena comes from María L. Caturla, "Zurbarán en Llerena," *Archivo español de arte* 20 (1947), pp. 265–84.

3. For the contract, see José Hernández Díaz, "Materiales para la historia del arte español," *Documentos para la historia del arte en Andalucía* 2, 1928 (1930), p. 182.

4. The following information is drawn from Antonio Domínguez Ortiz and Francisco Aguilar Piñal, *Historia de Sevilla*, vol. IV, *El barroco y la ilustración* (Seville, 1976), pp. 36–37.

5. Jonathan Brown, *Images and Ideas in Seventeenth-Century Spanish Painting* (Princeton, 1978), pp. 70–71.

6. See Celestino López Martínez, *Notas para la historia del arte: Desde Martínez Montañés hasta Pedro Roldán* (Seville, 1932), pp. 221–22, for the text.

7. For the Order of Mercy and its iconography, see Pedro F. García Gutiérrez, *Iconografía mercedaria: Nolasco y su obra* (Madrid, 1985). A classic source for the history of the order is Tirso de Molina, *Historia general de la Orden de Nuestra Señora de las Mercedes*, 2 vols. (1639; new ed. by Manuel Penedo Rey, Madrid, 1973–74).

8. Santiago Sebastián discusses the series by Martínez and its relationship to the paintings by Zurbarán in "Zurbarán se inspiró en los grabados del aragonés Jusepe Martínez," *Goya*, no. 128 (1975), pp. 82–84. At an unknown date, part of the original commission was assigned to another painter, previously often identified as Francisco Reyna, but now thought to be José Luis Zambrano.

9. Antonio Martínez Ripoll, *La iglesia del Colegio de San Buenaventura: Estilo e iconografía* (Seville, 1976), provides a complete and searching analysis of all aspects of this commission.

10. The text is given by José Cascales y Muñoz, *Francisco de Zurbarán: Su época, su vida, y sus obras* (Madrid, 1911), pp. 202–4. Zurbarán's preferment was unsuccessfully attacked by the painters' guild of Seville.

11. The classic study of Zurbarán as a monastic painter is Paul Guinard, *Zurbarán et les peintres espagnols de la vie monastique* (Paris, 1960).

12. For the early history of the monastery, see Manuel Esteve Guerrero, *Notas extraídas del protocolo primitivo y de la fundación de la cartuja jerezana* (Jerez de la Frontera, 1934), and Hipólito Sancho de Sopranís, *Historia de Jerez de la Frontera desde su incorporación a los dominios cristianos*, 2 vols. (Jerez de la Frontera, 1964–69), I, pp. 308–11.

13. The Evangelist portraits are based on prints by Aldegrever; see J. Serrera, "Aldegrever y Zurbarán: Los evangelistas del Museo de Bellas Artes de Cádiz," *Gades: Revista del Colegio Universitario de Filosofía y Letras de Cádiz*, no. 7 (1981), pp. 107–14.

14. For the iconography of the Circumcision, see Gertrud Schiller, *Iconography of Christian Art*, 2 vols. (Greenwich, Conn., 1971), I, pp. 88–90.

15. The several meanings of the Circumcision are explained in Leo Steinberg, *The Sexuality of Christ in Renaissance Art and in Modern Oblivion* (New York, 1983), pp. 50–56.

16. See César Pemán, "La reconstrucción del retablo de la Cartuja de Jerez de la Frontera," *Archivo español de arte* 23 (1950), pp. 203–27, and *idem*, "Identificación de un Zurbarán perdido," *Archivo español de arte* 30 (1957), pp. 327–29. In addition, the series contained paintings of two angels with censers now in the Museo de Cádiz.

17. There is some confusion in the literature about the identity of the saints here called Arthaud and Anthelm. In my opinion, figure 4 represents Saint Anthelm, Bishop of Belley, who is identified by the purple mozzetta proper to the ecclesiastical rank of bishop. Figure 7, often called Saint Anthelm, is Saint Arthaud, whose appearance of advanced age is consistent with the biography of this long-lived Carthusian. The archbishop's miter on the adjacent table may be placed there to indicate his brief tenure in office. It is hard to accept that the missing portrait represented Saint Ayrald, whose identity is the subject of considerable confusion in the Carthusian hagiography.

18. See Brown 1978, pp. 111–27, for a full discussion of the program.

19. See Peter Cherry, "The Contract for Francisco de Zurbarán's Paintings of Hieronymite Monks for the Sacristy of the Monastery of Guadalupe," *Burlington Magazine* 127 (1985), pp. 374–81. The accompanying *memoria* has disappeared. Nevertheless, Cherry, debating a hypothesis advanced by me in Brown 1978, pp. 123–25, is able to assert that it did not contain instructions about the placing of the pictures in the sacristy.

20. José Milicua, "Observatorio de ángeles," part 2, "Los ángeles de la perla de Zurbarán," *Archivo español de arte* 31 (1958), pp. 6–16, notes that the angels were copied from a print after Rubens's *Assumption of the Virgin* (Kunsthistorisches Museum, Vienna).

21. For the iconography of the Hall of Realms, see J. Brown and J. H. Elliott, *A Palace for a King: The Buen Retiro and the Court of Philip IV* (New Haven and London, 1980), pp. 141–92.

22. The definitive treatment of the subject is Suzanne Stratton, "The Immaculate Conception in Spanish Renaissance and Baroque Art," Ph.D. diss., New York University, 1983, which is the basis for the following discussion.

23. The suggestion by Emilio Orozco Díaz, in his "Retratos a lo divino: Para la interpretación de un tema de la pintura de Zurbarán," in *Temas del barroco* (Granada, 1947), pp. 29–36, that the pictures are portraits, has not found much support. Several writers (Martin S. Soria, "Some Flemish Sources of Baroque Painting in Spain," *Art Bulletin* 30 [1948], pp. 249–59; and Alfonso E. Pérez Sánchez, "Torpeza y humildad de Zurbarán," *Goya*, no. 64–65 [1965], pp. 266–75) have adduced sources in sixteenth-century Flemish prints. However, by the seventeenth century the type had become a commonplace of European art.

Elizabeth du Gué Trapier, "Zurbarán's Processions of Virgin Martyrs," *Apollo* 85 (1967), pp. 414–19, discusses the use of series of the virgin martyrs as church decoration. For interesting observations on the costumes, see María J. Sáez Piñuela, "Las modas femeninas del siglo XVII a través de los cuadros de Zurbarán," *Goya*, no. 64–65 (1965), pp. 284–89.

24. See Emile Mâle, *L'Art religieux . . . après le Concile de Trente* (Paris, 1932), p. 478; and Pamela Askew, "The Angelic Consolation of St. Francis of Assisi in Post-Tridentine Italian Painting," *Journal of the Warburg and Courtauld Institutes* 32 (1969), pp. 280–306.

25. A succinct discussion of these well-known developments can be found in J. H. Elliott, *Imperial Spain, 1469–1716* (New York, 1964), pp. 329–45.

26. For this development, see Domínguez Ortiz and Aguilar Piñal 1976, p. 37.

27. The document is cited in Julián Gállego and José Gudiol, *Zurbarán, 1598–1664* (New York, 1977), p. 176. Some of Zurbarán's dealings with the New World are documented in C. López Martínez, *Notas para la historia del arte: Retablos y esculturas de traza sevillana* (Seville, 1928), pp. 215–16; López Martínez 1932, p. 224; Marqués de Lozoya, "Zurbarán en el Perú," *Archivo español de arte* 16 (1943), pp. 1–6; M. L. Caturla, "Zurbarán exporta a Buenos Aires," *Anales del Instituto de Arte Americano e Investigaciones Estéticas*, no. 4 (1951), pp. 27–30; and Duncan T. Kinkead, "The Last Sevillian Period of Francisco de Zurbarán," *Art Bulletin* 65 (1983), pp. 307–8. For a description of the conditions in the export trade of paintings, see D. Kinkead, "Juan de Luzón and the Sevillian Painting Trade with the New World in the Second Half of the Seventeenth Century," *Art Bulletin* 66 (1984), pp. 303–12.

28. Francisco Pacheco, *Arte de la pintura*, 2 vols. (1649; new ed. with notes by Francisco J. Sánchez Cantón, Madrid, 1956), II, pp. 220–23.

29. The practices of popular religion are discussed in William A. Christian, *Local Religion in Sixteenth-Century Spain* (Princeton, 1981).

30. For the impact of Herrera on painting in Seville, see D. Kinkead, "Francisco de Herrera and the Development of the High Baroque Style in Seville," *Record of the Art Museum, Princeton University* 41, no. 2 (1982), pp. 12–23.

31. The change in Zurbarán's financial fortunes is tellingly analyzed in Kinkead 1983.

32. Diego Angulo Iñiguez, "Cinco nuevos cuadros de Zurbarán," *Archivo español de arte* 17 (1944), p. 8, draws attention to this source.

ON THE CRITICAL FORTUNES OF FRANCISCO DE ZURBARAN: REFLECTIONS AND INQUIRIES

Yves Bottineau

The critical fortunes of a painter may be the result of shortsightedness, bias, or ignorance, though they should rather derive from a continuing effort to comprehend the artist and his works. Ultimately, the master should be increasingly well understood through the knowledge and sensibility of successive generations of critics and historians. In order to conform to this ideal standard, one would have to reconstruct completely the critical fortunes of Francisco de Zurbarán. We do not claim to follow this grand design here, but simply wish to review some of the often paradoxical approaches taken by the artist, as well as certain documentary discoveries and various points of particular significance.

Shortly before his thirtieth year, Zurbarán achieved recognition as a painter of religious and provincial themes, in Extremadura and in Andalusia, especially Seville. Having come to this city from his native Fuente de Cantos, in Extremadura, he trained as an apprentice to Pedro Díaz de Villanueva from 1614 to 1617, when he learned to paint religious subjects and still lifes in an exceptionally convincing manner. It should be recalled that at the same time, Diego de Velázquez was in Seville, absorbing analogous lessons from the people, the objects, and the atmosphere of that city. Zurbarán lived in Llerena from 1617, when he was married first to María Páez, and later to Beatriz de Morales. By maintaining contact with the Andalusian capital, he affirmed his mastery of the style he had begun to develop—a style that was restrained yet distinguished by its sculptural force and by an assurance at once virile and lyrical. This style is strikingly manifest in the paintings cycles that Zurbarán executed at three major Seville monasteries: in 1626–27 at San Pablo el Real, a Dominican monastery that provided rather modest support to beginning painters; in 1628–29 at San Buenaventura, a Franciscan college that paid four times as well (Zurbarán, as is well known, succeeded Francisco Herrera the Elder); and, finally, from 1628 to 1630 at the Merced Calzada.

The *Christ on the Cross* (cat. no. 2), from the sacristy of San Pablo, is particularly striking in its resemblance to sculpture and recalls the art of the sculptor Juan Martínez Montañés. Already at this time, Antonio Palomino wrote that this picture, which hung behind a closed screen, passed for a carved, not a painted, work.[1] The success of these monastic works was clear from the beginning, but the quality of a number of other, contemporaneous independent paintings also contributed to Zurbarán's fame. Unfortunately, the history of the *Virgin and Christ in the House of Nazareth* (cat. no. 48), of about 1630–40, to cite one example, is incomplete; nothing is known of the picture prior to 1821.[2] In any case, the scene, with the Virgin shown beside her son, is compelling and convincing. The work testifies to a talent already ripe and in command of such devices as the play of triangular shapes, of color harmonies, and of religious doctrine, and expressive of everyday life and the trembling dignity of beings and things.

The success of the Merced cycle and the San Pablo *Christ on the Cross* aroused the enthusiasm of certain *amateurs* who approached the City Council of Seville asking that the artist be invited to settle in the city. He did, in fact, take up residence there in 1629, and he stayed, despite opposition from several painters—Alonso Cano in particular. They could not accept the fact that Zurbarán was being permitted to bypass the examination normally required to practice his profession. The issue was peripheral, and was thus soon forgotten. Of more significance is that the art of Zurbarán had made itself felt through its unique style, reaching its full expression in 1638–39, in the cycles at Jerez de la Frontera and Guadalupe. There one finds the qualities that have best been described by Alfonso E. Pérez Sánchez: "While Velázquez, upon coming into contact with the royal collections, promptly transformed his early tenebrist style, Zurbarán remained faithful throughout his life to the principles of a solemn, sculptural monumentality enhanced by shafts of violent light, and to an empathy, in the medieval tradition, for the details of everyday life."[3]

Velázquez's installation at court effectively marked the beginning of a new style, one more open to the influences of international and secular art. By contrast, the works that Zurbarán painted for the Buen Retiro Palace between the spring and the close of 1634 (he went to Madrid expressly for this purpose) constitute a paradox when compared with those in the manner for which he was best known.[4] This contradictory style seems to have been quickly followed by near oblivion at court.

A large number of artists were assembled to decorate the pleasure palace that the Count-Duke of Olivares was having built for Philip IV by Alonso Carbonel. The most vast and sumptuous room, the Hall of Realms, was conceived as the focal point of a program glorifying the monarchy and the dynasty—specifically, the recent victories (1625–33) of Philip IV and, implicitly, of his minister.[5] The escutcheons of the different states ruled by the king were painted on the frieze of the hall, thus explaining its name. Paintings of the Labors of Hercules (the twelve originally intended were reduced to ten as work progressed) were placed above the windows. The hero of antiquity embodied, in general, the struggle of Good against Evil. According to the symbolic thinking of erudite Spaniards, Hercules was considered an ancestor, intimately connected with their national history and that of the monarchy, since the Iberian peninsula had served as the setting for some of his feats. He had conquered Geryon, the tyrant of Gades, and had blocked passage, with his pillars, at the Straits of Gibraltar, thus setting the limits of the known world. Nonetheless, the discoverers and conquerors of America had passed beyond this point, adding new realms to the crown. The Pillars of Hercules were also an imperial device.[6] Decorating the walls of the hall were equestrian portraits of Philip IV, the reigning king; of his wife, Isabella of Bourbon; of their son, Baltasar Carlos, who died prematurely in 1646; and of their immediate predecessors Philip III and Margarita of Austria, the parents of Philip IV. Twelve battle scenes were placed between the windows, along the side walls.

Although the decorative scheme was not determined by Velázquez, his portraits of Philip IV and of Baltasar Carlos, and his *Surrender of Breda*, are among the salon's masterworks.[7] The native of Seville, whose early style was so characteristically Sevillian (the *Old Woman Frying Eggs*, of 1618, in the National Gallery of Scotland, Edinburgh, or the *Water Seller of Seville*, of about 1620, in the Wellington Museum, London, immediately come to mind), nevertheless evolved, with perfect ease, into a painter of historical, secular, and battle subjects. It appears that the importance of the Buen Retiro project had made it necessary to invite many artists to participate, and that the collab-

oration of Zurbarán, who was known to Velázquez in Seville, had been specifically requested. Furthermore, Olivares, an Andalusian, played a central role in the planning of the palace. Zurbarán, however, was engaged to work in a genre very different from that in which he had earned his reputation in Seville. The Labors of Hercules allowed him to employ his majestic tenebrist manner, although the series remains a rather artificial exercise. The most memorable scene represents the death of the hero, who, with an affecting expression, is consumed by the cloak of Nessus in the flashing light and dark of the flames (see cat. no. 24).

Zurbarán also painted two battle pictures in the Hall of Realms. One, the *Expulsion of the Dutch from the Island of Saint Martin*, depicting the victory of the Marqúes de Cadereita in 1633, is lost. The other, the *Defense of Cádiz* (Museo del Prado, Madrid; see fig. 15, page 14), depicting Don Fernando Grion's triumph of 1625, survives. In this composition Zurbarán demonstrates his ability to convey, through the representation of valorous warriors, a sense of calm grandeur, but without the conviction evident in his religious paintings. The court did not forget Zurbarán; he was charged with recruiting gilders in Seville to decorate the boat presented by the Andalusian capital to Philip III for the gardens of the Buen Retiro. Nevertheless, the artist's efforts in the Hall of Realms did not reveal his deeper nature.[8]

This may be why Zurbarán's role in the Buen Retiro project was so quickly forgotten—or at least only hazily remembered. The Labors of Hercules cycle is cited in 1637,[9] but as early as the palace inventory of 1701 the painter's name is not mentioned as the author of the series, and it is also lacking in the case of the two battle scenes.[10] Palomino records only the Labors of Hercules as Zurbarán's work, though he adds a flattering anecdote about Philip IV placing his hand on the artist's shoulder and calling him "Painter to the King and King of Painters!"[11] Ponz also refers to Zurbarán in connection with the Labors of Hercules,[12] but Ceán Bermúdez credits him with only four of the ten pictures.[13] Following the varying opinions of different historians, María Luisa Caturla located the documents concerning the painting; both Ponz and Ceán Bermúdez had attributed the two battle scenes to Eugenio Cajés, but Caturla's discoveries confirmed the intuition of Roberto Longhi, the eminent Italian art historian, who in 1927 had ascribed the *Defense of Cádiz* to Zurbarán.[14]

Zurbarán's critical reception at court, already ambiguous and rather unfavorable at the Buen Retiro, is even more uncertain when one looks beyond this project. Palomino claimed that he "made many other paintings for the Casa de Campo and other royal residences,"[15] but the artist's name does not appear in the 1666, 1686, or 1701 inventory of the Alcázar, or even in the 1701 inventory of the Casa de Campo.[16]

Later, at the time of Philip V's sojourn in Andalusia (1729–33), Elizabeth Farnese discerned the talents of Bartolomé Esteban Murillo, but nothing similar seems to have happened in the case of Zurbarán. One finds certain indications of a better knowledge of his works only at the end of the eighteenth century. A *Saint Margaret* by Zurbarán certainly belonged to Charles IV; whether this is the picture in The National Gallery, London (cat. no. 43), or the one that Ceán cited as in the Royal Palace in Madrid cannot be established. The provenance of the Prado's *Saint Elizabeth of Portugal* (previously known as *Saint Casilda*; cat. no. 44) is also unclear.[17] This situation appears all the more striking when one considers the continuous acclaim accorded Velázquez's work by the Bourbon kings and by their French and Italian court painters.[18]

However, Zurbarán's reputation did, once again, reach Madrid and the realm as a whole in the eighteenth century, as is evident from three well-known publications:

Palomino's *El museo pictórico*, which was issued in the capital between 1715 and 1724, reserves a very high place for the painter; he is also cited frequently in the fifth volume of Ponz's *Viaje de España*, which appeared in 1776;[19] and Ceán devoted a long discussion to the artist in 1800.[20]

But it would be illuminating, rather than to cite only these nationalistic examples, to consider the signs of Zurbarán's recognition elsewhere. The lives of the artists that were written by Palomino were already well known in English, having appeared in London as early as 1739.[21] Since few Spanish paintings seem to have entered British collections before the Spanish War of Independence, the case of a celebrated cycle of pictures by Zurbarán is all the more intriguing. The series, comprising thirteen paintings, represents Jacob and his sons (see pages 208–11), and dates from between 1640 and 1660. The pictures appeared in London in 1756, having perhaps been removed from a ship bound for America. In the same year, the series was acquired from a merchant named Mendez by Trevor, the Anglican Bishop of Durham. He installed the paintings in the episcopal summer residence at Auckland Castle. (Since Mendez had kept the *Benjamin*, Trevor had it replaced by a copy; see cat. no. 35.)[22]

British travelers began to discover Spain at the end of the eighteenth century; among travel books, Joseph Townsend's is one of the best known.[23] Richard Twiss, also a travel writer, who took an interest in painting, regarded Murillo as one of the greatest Spanish masters, while Zurbarán he assigned to the second rank.[24]

A *Saint Francis with a Skull* of 1658 entered the collections of the Elector of Bavaria, in Munich, in 1777. The picture, previously owned by the elector palatinate in Mannheim, passed from that city to the Bavarian capital when Charles Theodore became Elector of Bavaria.[25]

Ten years after it had been published in London, in 1739, Palomino's *Lives* appeared in Paris in a French translation.[26] As Spanish painting became increasingly appreciated, Ribera, Velázquez, and especially Murillo gained in reputation.[27] References to paintings by Zurbarán, however, are rare. The *Saint Francis Standing*, of about 1645 (cat. no. 69), was in a Lyons convent before the French Revolution; sold to J.-J. de Boissieu, an artist and collector, it later passed to the city's museum.[28] The very moving *Christ Carrying the Cross*, of 1653 (cat. no. 61), was probably purchased by the dealer Lebrun, while traveling in Spain in 1807, for Frédéric Quilliet; later it was given to the Cathedral of Orléans.[29]

Finally, the special circumstances of the War of Independence encouraged those with sufficient means to acquire paintings by Murillo, but the situation concerning Zurbarán is much less clear. Spain was becoming better known, in a general way. In 1788 and in 1797, Jean-François de Bourgoing, a diplomat serving as French ambassador to Madrid, published two editions of a study of Spain that seems to have been comparatively successful.[30] The tenure of Lucien Bonaparte as French ambassador to Spain (1801–3) was marked by concerted efforts to comprehend Spanish civilization. No one knows for certain what Spanish paintings Bonaparte took back with him to France,[31] but in Spain he had the advantage of high social connections, and he had been accompanied by the painters Guillaume Guillon Lethière and Jacques Sablet.[32] Another member of the entourage, Alexandre de Laborde, went along to gather information for his *Voyage pittoresque et historique de l'Espagne* (Paris, 1806–20).

The "Intruder King," Joseph I, sent some remarkable paintings by Zurbarán to the Musée Napoléon in Paris: the *Apotheosis of Saint Thomas Aquinas*, of 1631 (Museo de Bellas Artes, Seville), from the Dominican College of Santo Tomás in Seville,[33] and

the *Battle between Christians and Moors at El Sotillo*, of 1638 (cat. no. 30), from the Carthusian Monastery of Nuestra Señora de la Defensión at Jerez de la Frontera. It was also under Joseph I that the monasteries were suppressed. About 1810, Quilliet, as commissioner, assembled about twelve hundred paintings from the monasteries at the Alcázar in Seville.[34] A dubious character, Quilliet would later be dismissed for misusing funds. The *Apotheosis of Saint Thomas Aquinas* was among the paintings at the Alcázar, and from this warehouse Napoleon's generals, beginning with Marshal Soult, drew upon Spain's cultural treasures for their own collections.

The generals must have been guided in their selections, since they made such judicious choices—at least some of the time. Surely an impulse more estimable than simple greed must have aroused in these men, "in general uncultivated and from among the common people, a spontaneous attraction to this simple, animated, and direct form of painting, which was capable of awakening, in some of its principal admirers, such as Marshal Soult and General d'Armagnac, particular memories of their Languedocian or Gascon childhoods."[35] Some of Zurbarán's most important works, transported from the monasteries of Seville to the Alcázar, passed into Soult's hands and helped to form the core of his collection. These included four paintings, of 1629, from the College of San Buenaventura: *Saint Bonaventure and Saint Thomas Aquinas before the Crucifix* (formerly Kaiser Friedrich Museum, Berlin; see illus. on page 83); *Saint Bonaventure Inspired by an Angel Regarding the Election of a New Pope* (Gemäldegalerie, Dresden; illus. on page 83);[36] and two others that remain among the major Spanish works in the Louvre, *Saint Bonaventure at the Council of Lyons* (cat. no. 3) and *Saint Bonaventure on His Bier* (cat. no. 4). Soult also helped himself to paintings in the storerooms of the Alcázar that came from the Carmelite Monastery of San Alberto[37] and from the Merced Descalza, both in Seville.[38] Even such illustrious sources as these did not account for all of the paintings by Zurbarán that passed into Soult's collection;[39] notwithstanding occasional sales, the collection offered Parisian connoisseurs a clear idea of work by the Spanish school—and especially that of Zurbarán—until it was dispersed in 1852 and 1867.

From 1838 to 1848, the Spanish collection of Louis-Philippe was also in Paris. The many imposing works by Zurbarán included in the collection appear to have been quite representative of his personal style. However, contemporary reactions were often biased, the arrangement of the collection and the manner in which the artist was perceived reflecting the aesthetic preconceptions of the period.

The Carlist War of 1833–34 ravaged part of Spain, and religious orders were suppressed in 1835–36. (Isabella II, the daughter of Ferdinand VII, and her mother, the Regent María Cristina, were supported by the liberals, while the absolutists assisted Don Carlos—the late king's brother—who refused to acknowledge the sovereign role of his niece.) The consequent disorder facilitated the frequently illegal acquisition of works of art. Meanwhile, Spanish culture had become fashionable in France, and trips to the Iberian peninsula had become popular. The picture galleries of Soult and his former aide-de-camp, Alexandre Aguado, attracted the attention of Parisian *amateurs*. In the December 1834 issue of the *Revue républicaine*, Louis Viardot pressed for the opening of a museum of Spanish art.

Louis-Philippe, who converted Versailles to a museum dedicated "to all the glories of France," could not remain indifferent to Viardot's demand. He had traveled through Spain in 1810, perhaps with the hope of becoming king and restoring peace to this land ravaged by the War of Independence. In 1846, he devoted considerable attention to

important marriages between the French and the Spanish, such as those of Isabella II and her cousin Francisco d'Asis, and of the queen's sister, Luisa Fernanda, and the Duke of Montpensier, the youngest son of the king of France.

Louis-Philippe also sent Baron Isidore Taylor, royal administrator of the Théâtre Français, south of the Pyrenees on the pretext of gathering information for his *Voyage pittoresque en Espagne, en Portugal, et sur la côte d'Afrique* (Paris, 1826–60). Taylor stayed in Spain from November 1835 to April 1837 and, with funds from the king's civil list, assembled a remarkable collection. Its first formal viewing took place on January 7, 1838, in the galleries of the Colonnade of the Louvre. After the fall of Louis-Philippe, the collection was returned to him, since it had been purchased with his own funds, and sent to London, where it was sold.

For ten years, this unique collection of paintings had been accessible. To what extent did it contribute to an appreciation of Zurbarán?[40] The gallery, augmented by paintings from the Standish collection, possessed the virtue, rare for the period, of being a didactic museum. Visitors were obliged to abandon their traditional predisposition to value Italian paintings above all others. Nonetheless, the collection's influence seems to have been more long-term than immediate. Murillo, especially, was admired. Whether inadequate lighting was detrimental to Zurbarán's darker pictures is difficult to say. In any event, the works of the artist, though admirably represented, were regarded neither objectively nor collectively, but were interpreted through the romantic and pessimistic vision of the time.

Of the 121 items in the Spanish collection that were listed under Zurbarán's name, there are only thirty-five works that modern scholars would not attribute to Zurbarán or that are no longer known firsthand.[41] From the Carthusian monastery at Jerez came the *Annunciation*, the *Adoration of the Shepherds*, the *Adoration of the Magi*, and the *Circumcision* (cat. nos. 26–29), as well as the *Virgin of the Rosary with Carthusians* (Muzeum Narodowe, Poznań; see illus. on page 194) and the *Battle between Christians and Moors at El Sotillo* (cat. no. 30).[42] The *Virgin of the Immaculate Conception with Saints Anne and Joachim* (cat. no. 33) may also have come from Jerez.[43] The *Crucifixion* now in The Metropolitan Museum of Art, New York, was at one time most likely in the sacristy of the Merced Descalza in Seville,[44] while the Metropolitan's *Saint Francis Receiving the Stigmata* was also once part of Louis-Philippe's Spanish collection.[45] The *Saint Francis in Meditation* (cat. no. 53) made a strong impression.[46] The *Saint Bonaventure Inspired by an Angel* was painted for San Buenaventura, in Seville;[47] the pervasive religious feeling that makes this work so moving may have mitigated the seeming austerity of the *Saint Francis in Meditation*, which was offset as well by the modest and charming character of several of the paintings of other saints.[48]

However appealing Zurbarán's work may have seemed, he was not considered to be among artists of the first rank, but rather regarded as a sort of Spanish Caravaggio—a painter of monks who exaggerated their asceticism to the point of torture. The *Saint Francis in Meditation* struck nineteenth-century viewers as particularly characteristic of Zurbarán's work. Théophile Gautier ably expressed the general opinion of his contemporaries. Gautier had traveled through Spain from May to October 1840, with the intention of purchasing pictures. Although unsuccessful, he did put together his well-known *Voyage en Espagne* and the poetry collection *España* (1845). This collection includes the poem "A Zurbarán," which was first published in the January 12, 1844, issue of *La Revue de Paris*.[49] The poem, which had been composed in Seville, begins:

Monks of Zurbarán, white-robed Carthusians who, in the shadows,
Pass silently over the stones of the dead,
Whispering *Paters* and *Aves* without end,

What crime do you expiate with such remorse?
Tonsured phantoms, sallow-faced executioners,
To be treated so, what must your body have committed?

The last verses are no less characteristic:

O monks, now, in carpets fresh and green,
Over graves which you dug for yourselves,
The grass spreads out. Well! What say you now to the worms?

What are your dreams? What are your thoughts?
Do you not regret having exhausted your days
Within these narrow walls, under these icy arches?

What have you done, would you do it forever?

One can still find a trace of this romantic image of the artist in a work in which, given its late date, one would least expect to encounter it: Elie Faure's *Histoire de l'art* (1909–21)—perhaps because the author, who expresses himself so eloquently, favored certain pictures for their austerity. Zurbarán, he writes, "seems to obey monastic rule. The walls of the cells, their tables, their wooden benches, and the fustian of the cowls are not more bare than his strength. The sterility of Spain is in his sepulchral cloisters, where meditation revolves around death's-heads and books bound in skin. The white or gray robes fall as straight as shrouds."[50]

Faure reveals how lasting was the interpretation of Zurbarán's work as enclosed within a somber and tragic rigidity. He also shows how necessary it was to compile a reliable catalogue, and to seek authentic documentation of the artist's life. The first to come to mind is the *Catálogo oficial ilustrado* by Salvador Viniegra that accompanied the Zurbarán exhibition in 1905 in Madrid.

It is generally accepted that the series of important monographs on Zurbarán began with the one by José Cascales y Muñoz in 1911.[51] The subsequent studies by Hugo Kehrer in 1918[52] and by Martin S. Soria in 1953[53] should also be mentioned. Special editions of scholarly reviews contributed substantial new information at the time of the tercentenary of the artist's death.[54] As awareness of Zurbarán's work grew, it was seen as typically Spanish, and art historians and critics elevated him from the second rank to a premier position among Spanish painters. Louis Gillet wrote in 1913: "The most original trait of the people, asceticism, the disdain of mundane things, a keen sense of the void, combined with a taste for the real, and a total absence of creative imagination, is in a sense the main concern of Spanish painting, and this is why one can say of Zurbarán that he is *Spain itself*."[55]

In 1927, Christian Zervos not only affirmed Zurbarán's preeminent position but brought to Zurbarán studies a new vision of the theme of death in the artist's work: "With the exception of El Greco and perhaps Velázquez, to whom he is equal if not superior, Zurbarán stands above all other Spanish painters. His work, furthermore, closely parallels modern tendencies in painting. And yet his oeuvre is not known and appreciated as it should be. . . . The essential character of Zurbarán's work is that it offers all that painting can offer of human truth. . . . In general, Zurbarán represents

his saints and monks in the most precise aspect of physical existence, but nonetheless sanctified by grave spiritual concerns, or the desire to approach God. There is never an element of terror in his work. Death itself is for him nothing to fear."[56]

Among the scholars who have contributed most unerringly and valuably to a resurgent interest in the life and work of Zurbarán, two deserve special mention. María Luisa Caturla, since 1945, has accumulated and published archival documents; notably, she is responsible for the reattribution to Zurbarán of pictures that were painted for the Buen Retiro.[57] And Paul Guinard, long-time French cultural attaché in Madrid, defended a doctoral dissertation published in 1960 that may be described as a masterpiece of comprehension and writing.[58] Inevitably, certain of Guinard's ideas require reconsideration, but on the whole he has done for Zurbarán what Karl Justi did for Velázquez.[59] Guinard's book contains passages that, in their knowledge and love of Zurbarán, monastic life, and Spain, deserve to be collected in an anthology. On the subject of the Guadalupe cycle, for example, Guinard wrote the following lines, which are perfect in their simplicity: "It is not only the richest, most complete chronicle of an order and of a monastery that Zurbarán has left to us. It is also a summation of his art and of his universe. The historic and the miraculous, the exquisite reality of books and of bread, of the green landscape of the Sierra, the young saints and the angels— Zurbarán's entire *repertory* is to be found there coalesced."[60]

But the posthumous life of an artist has no limits: his oeuvre must be refined, and the undisputed works themselves should become better known. The original disposition of the pictures at Guadalupe continues to intrigue us,[61] and it is now well known, through the discovery of the contract, that Zurbarán painted these pictures not *in situ* but in the studio.[62] New studies in Spain and elsewhere have borne fruit; the careful attention given by Alfonso E. Pérez Sánchez to Bolognese and other Italian artists has been particularly instructive.

For Zurbarán scholars, the years 1640–64 constituted, until recently, a sort of endless plane. Documents either were lacking entirely or were difficult to interpret. Masterpieces appeared to be rare, except for a few, such as the *Christ Carrying the Cross*, in Orléans (cat. no. 61). Zurbarán seems to have been frequently troubled by financial and ethical difficulties during this period. Surpassed by the success of the young Murillo, Zurbarán sent mediocre works to the New World, sought to regain favor and to attract a new clientele in Madrid, and died there in paltry lodgings. A comparison of his end with that of Velázquez, who died in his comfortable quarters in the Casa del Tesoro, a building dependent to the Alcázar, would seem to reflect the different fates of the two masters. The truth now appears in a new light, and the notion that Zurbarán experienced an artistic decline during the years 1640–64 seems off the mark, for he continued to paint major works. Baltasar Cuartero y Huerta, for example, disclosed new information in 1950–54 with regard to the Carthusian Monastery of Las Cuevas in Seville that, at the time, appears not to have benefited Zurbarán specialists but is now recognized as significant. The three pictures painted for this monastery— *Saint Hugh in the Refectory* (cat. no. 37), the *Virgin of Mercy of Las Cuevas* (cat. no. 38), and *Pope Urban II and Saint Bruno* (Museo de Bellas Artes, Seville; see illus. on page 224)—would appear to have been painted sometime before 1655, and not 1633, as was previously thought.[63]

The quality of Zurbarán's consignments to America was no doubt uneven, but the works should not be underestimated as a group. Similarly, his relationship with overseas customers should not be considered in a summary manner, since it evolved through various stages.[64]

Finally, those who would interpret the record negatively have exaggerated the impoverished state of the lodgings in Madrid where Zurbarán died. One cannot compare them with Velázquez's residence, since Velázquez's prosperity derived not only from his success as a painter but also from his position as one of the highest officials in the palace.[65]

The high regard in which Zurbarán has now been held for many years (that is, Zurbarán at the peak of his career, according to the view still current) is self-explanatory and not without merit. His color schemes, at their most personal, are incomparable, as are his paintings of religious life in its solemn, emotive, and monumental aspects, and his depictions of elegant yet modest young saints. But Zurbarán's exalted position does not objectively take into account the totality of pictorial art in Spain. Why should Zurbarán be esteemed to the detriment of other masters—notably Murillo, whose work has been accused of being insipid and facile? In his own way, Murillo too was a great inventor, his compositions skillful and harmonious, and a virtuoso colorist, his works sublime in their tenderness. Some critics today, as if conforming to a process of continual evolution in the history of art, are beginning, in private at least, to depreciate the achievement of Zurbarán in deference to Murillo's lyrical eloquence. However, Spanish painting is so rich that any homage rendered one of its greatest exponents surely need not take the form of rank order, subject to changing tastes and opinions, but should follow from an informed and sympathetic assessment of the artist in his cultural context.

NOTES

1. Antonio Palomino, *El museo pictórico y escala óptica* (1715–24; reprint, Madrid, 1947), p. 938: "demás de otras muchas pinturas suyas, hay un Crucifijo de su mano, que lo muestran cerrada la reja de la capilla (que tiene poca luz) y todos los que lo ven, y no lo saben, creen ser de escultura."

2. Paul Guinard and Tiziana Frati, *Tout l'oeuvre peint de Zurbarán* (Paris, 1975), no. 67.

3. Alfonso E. Pérez Sánchez, "Une Vision nouvelle de la peinture espagnole du siècle d'or," *Revue de l'art*, no. 70 (1985), p. 58.

4. The *Surrender of Seville* (cat. no. 9), signed and dated 1634, immediately preceded the artist's departure for Madrid. It confirms the significant difference in quality between Zurbarán the painter of history and Zurbarán the painter of religious subjects. See, concerning this painting, Allan Braham, in London, National Gallery, *El Greco to Goya: The Taste for Spanish Paintings in Britain and Ireland* (exhib. cat., 1981), pp. 75–76, no. 32; and Guinard and Frati 1975, pp. 97–98, no. 148.

5. On the subject of the Buen Retiro Palace, one should consult the already classic work by Jonathan Brown and J. H. Elliott, *A Palace for a King: The Buen Retiro and the Court of Philip IV* (New Haven and London, 1980). The Hall of Realms is discussed on pp. 141–92. Concerning this salon, the time-honored studies by Elías Tormo y Monzó are of continuing interest. They first appeared as an article, "Velázquez: El Salón de Reinos del Buen Retiro y el poeta del palacio y del pintor," *Boletin de la Sociedad Española de Excursiones* 19–20 (1911–12), and were taken up again in *Pintura, escultura, y arquitectura en España* (Madrid, 1949), pp. 127–246.

The Hall of Realms, in one of the two remaining buildings of the Buen Retiro (with the "Casón"), is incorporated today into the Army museum. The Prado possesses all the paintings of the salon, except the *Expulsion of the Dutch from the Island of Saint Martin* (present whereabouts unknown). The arrangement of the paintings is reconstructed in Brown and Elliott 1980, pp. 144–46.

6. Rosa López Torrijos, *La mitología en la pintura española del siglo de oro* (Madrid, 1985), pp. 137–46.

7. We have not concerned ourselves here with problems of attribution or collaboration regarding the equestrian portraits of Isabella of Bourbon, Philip III, and Margarita of Austria. See José López-Rey, *Velázquez: The Artist as a Maker* (Lausanne and Paris, 1979), pp. 58ff.

8. Paul Guinard, *Zurbarán et les peintres espagnols de la vie monastique* (Paris, 1960), pp. 276–78; Guinard and Frati 1975, pp. 96–97.

9. Manuel de Gallegos, *Obras varias al Real Palacio del Buen Retiro* (Madrid, 1637); cited in Tormo y Monzó 1949.

10. Gloria Fernández Bayton, *Testamentaría del Rey Carlos II, 1701–1703*, Inventarios reales, vol. 2 (Madrid 1981), pp. 296–99.

11. Palomino 1715–24 (1947 ed.), p. 938.

12. Antonio Ponz, *Viaje de España* (1772–94; reprint, Madrid, 1947), p. 551.

13. Juan A. Ceán Bermúdez, *Diccionario historico de los más ilustres profesores de las bellas artes en España*, 6 vols. (Madrid, 1800), VI, p. 52.

14. Ponz 1772–94 (1947 ed.), p. 551. Ceán Bermúdez 1800, I, p. 304; Roberto Longhi, "Un San Tomaso del Velázquez e le congiunture italo-spagnole tra il '5 e il '600," *Vita artistica*, no. 1 (1927), pp. 4–11; María L. Caturla, "Zurbarán en el Salón de Reinos," *Archivo español de arte* 18 (1945), pp. 292–300; see also *idem*, "Zurbarán at the 'Hall of Realms' at the Buen Retiro," *Burlington Magazine* 89 (1947), pp. 42–45; and *idem*, "Cartas de pago de los doce cuadros de batallas para el Salón de Reinos del Buen Retiro," *Archivo español de arte* 33 (1960), pp. 333–55.

15. Palomino 1715–24 (1947 ed.), p. 938: "Hizo otras muchas pinturas para la Casa de Campo, y otros sitios reales."

16. See the publication of the Alcázar inventory of 1686 by Yves Bottineau in *Bulletin hispanique*, 1956–58, and that of the "Testamentaría" of Charles II in Fernández Bayton 1981.

17. Guinard and Frati 1975, nos. 157, 158, 348. It should be added that Zurbarán's name is absent from the inventory of Elizabeth Farnese at La Granja in 1746 (Madrid, Archivo General de Palacio, San Ildefonso, doc. 13). The "Testamentaría" of Elizabeth Farnese is still relatively unknown, and Zurbarán's name does not appear in the published extracts. Juan José Luna, "Inventarios y almoneda de algunas pinturas de la colección de Isabel de Farnesio," *Boletín del Seminario de Estudios de Arte y Arqueología* (Universidad de Valladolid) 39 (1973), pp. 359–69, and Y. Bottineau, *L'Art de cour dans l'Espagne des lumières, 1746–1808* (Paris, 1986), pp. 406–16.

18. Y. Bottineau, "La Cour d'Espagne et l'oeuvre de Velázquez dans la première moitié du XVIIIe siècle," in *Varia velazqueña* (Madrid, 1960), I, pp. 553–60.

19. Ponz 1772–94 (1947 ed.), p. 482, calls attention to a *Young Christ Wounding Himself on the Crown of Thorns*, in the Salesas Reales, Madrid, Queen Barbara of Bragance Foundation (Chapel of Saint Teresa).

20. Ceán Bermúdez 1800, VI, pp. 44–52.

21. Antonio Palomino, *An Account of the Lives and Works of the Most Eminent Spanish Painters, Sculptors, and Architects . . .* (London, 1739).

22. Guinard and Frati 1975, nos. 536–48; see also Braham, in London, National Gallery, 1981, p. 13, and no. 35.

23. Joseph Townsend, *A Journey through Spain in the Years 1786 and 1787 . . .* (London, 1791).

24. Richard Twiss, *Travels through Portugal and Spain* (London, 1775); Braham, in London, National Gallery, 1981, pp. 13–20.

25. Guinard and Frati 1975, no. 483.

26. A. Palomino, *Histoire abrégée des plus fameux peintres, sculpteurs, et architectes espagnols . . .* (Paris, 1749).

27. Jeannine Baticle, "Recherches sur la connaissance de Velázquez en France de 1650 à 1830," in *Varia velazqueña* (Madrid, 1960), I, pp. 532–52; Bernard Dorival, "Velázquez et la critique d'art française aux XVIIe et XVIIIe siècles," in *Varia velazqueña* (Madrid, 1960), I, pp. 526–31; and *idem*, "Obras españolas en las colecciones francesas del siglo XVIII," in *Actas del XXIII Congreso Internacional de Historia del Arte* (Granada, 1978), III, pp. 67–94.

28. Guinard and Frati 1975, no. 369.

29. Baticle 1960, p. 546; and Guinard and Frati 1975, no. 477. See also J. Baticle, in Paris, Musée des Arts Décoratifs, *Trésors de la peinture espagnole: Eglises et musées de France* (exhib. cat., 1963), no. 102.

30. Jean-François de Bourgoing, *Nouveau voyage en Espagne . . .* , 3 vols. (Paris, 1788); and *idem*, *Tableau de l'Espagne moderne*, 3 vols., 2d ed. (Paris, 1797).

31. It is therefore likely, although not certain, that Lucien Bonaparte brought back from Spain Velázquez's *Lady with the Fan* (ca. 1645; Wallace Collection, London); it was sold with his collection in London in 1816; see Y. Bottineau and Pietro M. Bardi, *Tout l'oeuvre peint de Velázquez* (Paris, 1969), no. 95.

32. J. Baticle, "Le Portrait de la Marquise de Santa Cruz par Goya," *Revue du Louvre et des musées de France*, no. 3 (1977), pp. 153–63.

33. Guinard and Frati 1975, no. 76.

34. Manuel Gómez Imaz, *Inventario de los cuadros sustraidos por el gobierno intruso en Sevilla el año de 1810* (Seville, 1896; 2d ed., Seville, 1917).

35. P. Guinard, in Paris, Musée des Arts Décoratifs, 1963, p. 18.

36. Guinard and Frati 1975, no. 25.

37. These paintings, dating from 1630 to 1633, were as follows: *Saint Andrew* (cat. no. 14), *Saint Cyril of Constantinople* (cat. no. 16), *Saint Peter Thomas* (cat. no. 17), *Saint Francis Standing with a Skull* (cat. no. 18), and *Saint Blaise* (Muzeul de Arte al R. S. Romania, Bucharest).

38. *Saint Lucy* (cat. no. 22), *Saint Lawrence* (1636; Hermitage Museum, Leningrad), and *Saint Anthony Abbot* (1636; Valdés collection, Bilbao).

39. The following are also cited in Guinard and Frati 1975: no. 163, *Saint Euphemia*, and no. 164, *Saint Ursula* (both 1635–40; Galleria di Palazzo Bianco, Genoa); no. 167, *Saint Rufina* (1635–40; Hispanic Society of America, New York); and *Saint Elizabeth of Portugal* (cat. no. 44).

40. For further information on the arrangement of the Spanish collection, see P. Guinard's study of the two painters who accompanied Taylor, Adrien Dauzats (1804–1868) and Pharamond Blanchard (1805–1873): *Dauzats et Blanchard, peintres de l'Espagne romantique*, Bibliothèque de l'Ecole des Hautes Etudes Hispaniques, no. 30 (Paris, 1967). The fundamental work on the subject, however, is *La Galerie Espagnole de Louis-Philippe au Louvre, 1838–1848*, by J. Baticle and Cristina Marinas, with the collaboration of Claudie Ressort and Chantal Perrier (Paris, 1981). This book, with copious introductory texts, catalogues the paintings in the Galerie Espagnole, their provenance, and their ultimate fate, including (if known) their present locations and, of course, their attributions. This work is the source of the information here.

41. Baticle and Marinas 1981, nos. 331–452.

42. *Ibid.*, nos. 335, 337–39, 341, 365. There was also a simplified version of the *Annunciation* in the Galerie Espagnole, no. 334, which is now in The Bob Jones University Museum of Sacred Art, Greenville, South Carolina.

43. *Ibid.*, no. 342.

44. *Ibid.*, no. 343.

45. *Ibid.*, no. 355.

46. *Ibid.*, no. 356.

47. *Ibid.*, no. 358.

48. *Ibid.*, no. 395, *Saint Marina* (Göteborg Konstmuseum); no. 402, *Saint Lucy* (Hispanic Society of America, New York); and *Saint Rufina* (National Gallery of Ireland, Dublin). Similar paintings of other saints that were in the Galerie Espagnole of Louis-Philippe are now considered to be workshop efforts.

49. Théophile Gautier, *Poésies complètes*, edited by René Jasinski (Paris, 1932), II, pp. 309–11.

50. Elie Faure published *L'Art antique* of his *Histoire de l'art* in 1909, and *L'Art moderne* in 1920. The quotation is from *L'Art moderne*, as is the following passage (E. Faure, *History of Art*, translated from the French by Walter Pach [New York and London, 1924], IV, pp. 121–22): "Round about, the vaults are thick, the pavement is cold, the light is dead. Only at rare intervals does a red carpet or a blue ribbon animate this aridity. The voluptuousness of painting reveals itself in the hard bread and the raw roots of the meal eaten in silence, or in a hand or the earthy face of a cadaver, or in the mortuary cloth of silver-gray. But those spectral visages, those lusterless garments, that bare wood, those protruding bones, those ebony crosses on which not a reflection trembles, those yellow books with their red edges ranged in clear-cut order like the hours which divide up life until the end into periods of dismal observances, all unite in assuming the aspect of an implacable architecture which faith itself imposes upon plastics, forbidding it everything which is not a rigid line, a bare surface, an opaque tone, a straight shadow, or a precise and hard volume. A monk in prayer weighs so heavily upon his knees that his head, when he lifts it, seems to raise the stone of a sepulcher. Those distributing or taking food invest the need to live with a solemnity which carries over into the tablecloth, the glasses, the knives, and the victuals. Those lying on their deathbed imprint upon the life surrounding them the ridigity of death."

51. José Cascales y Muñoz, *Francisco de Zurbarán: Su época, su vida, y sus obras* (Madrid, 1911; 2d ed., Madrid, 1931).

52. Hugo Kehrer, *Francisco de Zurbarán* (Munich, 1918).

53. Martin S. Soria, *The Paintings of Zurbarán* (London, 1953; 2d ed., London, 1955).

54. *Archivo español de arte* 37 (1964); *Goya*, no. 64–65 (1965).

55. Louis Gillet, in Guinard and Frati 1975, p. 12.

56. Christian Zervos, in Guinard and Frati 1975, p. 12.

57. M. L. Caturla, "New Facts on Zurbarán," *Burlington Magazine* 87 (1945), pp. 302–4; *idem*, "Noticias sobre la familia de Zurbarán," *Archivo español de arte* 21 (1948), pp. 125–27; and *idem, Fin y muerte de Francisco de Zurbarán* . . . (Madrid, 1964). Concerning Zurbarán and the Hall of Realms of the Buen Retiro Palace, see note 14 above.

58. Guinard 1960.

59. Justi's study of Velázquez is available in Spanish translation by Pedro Marrades, *Velázquez y su siglo* (Madrid, 1953), revised and with an appendix by Juan A. Gaya Nuño.

60. Guinard 1960, p. 115.

61. J. Brown, *Images and Ideas in Seventeenth-Century Spanish Painting* (Princeton, 1978), pp. 111–27.

62. Peter Cherry, "The Contract for Francisco de Zurbarán's Paintings of Hieronymite Monks for the Sacristy of the Monastery of Guadalupe," *Burlington Magazine* 127 (1985), pp. 374–81.

63. Baltasar Cuartero y Huerta, *Historia de la Cartuja de Santa María de las Cuevas, de Sevilla, y de su filial de Cazalla de la Sierra*, 2 vols. (Madrid, 1950–54), II, pp. 627ff.

64. Duncan T. Kinkead, "The Last Sevillian Period of Francisco de Zurbarán," *Art Bulletin* 65 (1983), pp. 305–11.

65. The twofold nature of Velázquez's position is brought to light in J. Brown, *Velázquez: Painter and Courtier* (New Haven and London, 1986).

Fig. 1. Unknown artist. View of Seville in the late sixteenth century. Oil on canvas. Museo de America, Madrid

THE ARTISTIC MILIEU IN SEVILLE DURING THE FIRST THIRD OF THE SEVENTEENTH CENTURY

Alfonso E. Pérez Sánchez

Francisco de Zurbarán, although born in Extremadura and active there for some years in his early youth, is closely associated with the city of Seville (fig. 1). There he received his professional training, and there he was to gain extraordinary recognition and prestige, until changing tastes and the appearance of a new and formidable rival, Bartolomé Esteban Murillo, younger and more gifted, thrust him from his position of preeminence, so that he left his adopted city to seek a place in the more complex and chaotic world of the court in Madrid.

Zurbarán's strong artistic personality and special sensibility—which shaped a very individual mode of interpreting Catholic devotion through visible reality—matured in Seville and established a vigorous tradition there until the eruption of the High Baroque, dynamic and triumphant, somewhat submerged the artist's gentler idiom. But the export of his work from Seville to the Americas perpetuated some of his models to a very late date—as much in North America, in the Viceroyalty of New Spain (Mexico), as in South America, in the Viceroyalty of New Granada (Colombia) and remote Peru.

Zurbarán, an artist of manifest limitations coupled with remarkable powers, developed as a painter in the Seville of the first third of the seventeenth century. We have little information about his early life, and are ignorant of the true significance of his teacher, Pedro Díaz de Villanueva, whose workshop he entered in 1614, when he was sixteen years old. But we know a good deal about the artistic scene in what was then the first city of Spain—in population, wealth, and cosmopolitan life—and indeed one of the most celebrated cities of Europe.

During the sixteenth century, Seville had been the most important economic center in Spain, and through its monopoly of trade with the recently discovered Indies, it came to surpass the traditional ports of northern Europe. The period of greatest popularity coincided with the last years of the reign of Philip II and the entire reign of Philip III.[1] Zurbarán's formation as an artist coincided with the first signs of a decadence that would reach its dramatic climax in the plague of 1649, a harrowing epidemic that Zurbarán was to witness and in which he was to lose his son Juan, probably his most capable collaborator until that time.

But in the artist's early years, the atmosphere in Seville was still exuberant. The churches and the great houses were filled with works of art. And the workshops of the city bustled with activity. Nearly all the monasteries were in the process of renovation. The traditional presence of artists from abroad, who had come to the city either to work or on their way to the New World, imparted the spirit of a melting pot or of a crossroads. The influx in the sixteenth century of Flemish artists, whose work had left a deep impression on local sensibility, was augmented by the arrival and settlement of Italian artists, not artists of the first rank, but artists acquainted with the newer

idioms forged in the evolution of painting in their native country—ever the guiding teacher—in the very early years of the seventeenth century.

Zurbarán was to garner and develop, in masterly fashion, what was in a sense a popular movement that was guided and fully utilized by the Catholic Church: the return to verisimilitude and intimacy in a religious imagery deeply rooted in the devotional art of the late Middle Ages, and the rediscovery—through the imaginative and conceptual framework of international Roman Mannerism—of an expressive language based on an immediate reality, a language that would infuse the vernacular and the accessories of everyday life with a sovereign authority, impelling the viewer into an atmosphere of such intense immediacy that the world of lived experience would bridge that of biblical or hagiographic narrative with no apparent transition.

The often repeated words of Saint Teresa, "Dios anda entre los pucheros" (God moves among the pots and pans), find a clarion authenticity in the art of Zurbarán, the faithful interpreter of Spanish devotional life. Familiarity with the wonder of the religious act, insistently propounded by an all-powerful and omnipresent Church, imparted a special force to Spanish productions of the time. Zurbarán was to become one of the foremost creators of that art.

But the language of the intimate and the domestic, the invasion of the supernatural into the everyday, and the marvelous transformation of the Divine into the familiar that permeate Zurbarán's compositions were not the invention of the artist; rather, they culminate in his work. The general development of all Spanish painting prior to Zurbarán, especially in Seville, had in fact led in this direction.

The rediscovery of this everyday idiom had its beginnings in Castile, in the remarkable synthesis of styles that occurred at the Escorial. The building and decoration of this vast project were accomplished through the resolute will of Philip II and thanks to the presence of the rich collections of the crown, so abundant in paintings by fifteenth-century Flemish masters, which served as models for the expression of profound religious feeling. In this, it was comparable to the work of the Venetian masters, with their matchless skill in evoking the qualities of things, both living and inanimate, rendering them immediate and visible, tactile and sensuous, and perpetually bathed in a golden light that magically resembles the light of nature.

The teachings of certain sixteenth-century Spanish masters—notably Juan Fernández de Navarrete, called El Mudo (the Mute), and Luis de Carvajal—and of artists from Italy who were active at the Escorial, leaving their mark upon the education of younger artists, adequately prepared the sensibilities of artists, preachers, and believers for the definitive configuration of that language which Zurbarán was to command perhaps better than any other Spanish master of the time.

When Fray José de Sigüenza wrote the much-quoted words "Los Santos se han de pintar de manera que no quiten la gana de rezar en ellos, antes pongan devoción pues el principal efecto y fin de su pintura ha de ser esta" (The saints are to be painted so as not to diminish the desire to invoke them, but rather to inspire devotion, since the chief effect and end of painting them must be this),[2] he was referring to the contrast between the devout, objective images of Navarrete and the images of El Greco, "dotadas de algún afeite o apariencia" (endowed with affectation and outward show). The contrast is the root of the entire process of the "return to perceptible truth" that characterizes Spanish painting in the first third of the seventeenth century—from the measured, academic discretion of Vicente Carducho in Castile to the intense, moving veracity of Francisco Ribalta in Valencia, or the rude and popular sensuality of Juan de

Roelas in the Seville of Zurbarán's early years.[3] The generation of artists born about 1600, to which Zurbarán belongs, as do Jusepe de Ribera, Diego de Velázquez, Alonso Cano, Jerónimo Jacinto de Espinosa, Juan Ribalta, and Juan Andrés Rizi, absorbed a wealth of complex elements in their artistic formation. Most fundamentally, they gained a knowledge of the towering Caravaggio, who, beginning from the same premises, arrived at radical formulations whose profoundly poetic and unabashedly human content were perhaps not easily assimilable in the more tranquil, limited, and confined atmosphere of devout Spanish society.

Only those who left that closed society and entered into direct contact with the international, particularly the Italian, sphere—as did Ribera and Velázquez—had the opportunity to assimilate the classicism of the Carracci, the intellectual complexity of the Bolognese world, and the subtle reelaboration of sixteenth-century Venetian and Parmesan themes in the cultivated circles of Rome, Paris, and Brussels.

Those who remained in Spain, with no patron but the Church, who were rigorously bound to the religious movements of the Tridentine Counter-Reformation and committed to *decoro* and to the idea—stated with precision by Francisco Pacheco—that painting, "in seeking to win men away from vice, leads them to true worship of the Lord our God"[4] were necessarily limited to the more superficial lessons of Caravaggism, its fidelity to perceptible nature and its dramatic use of tenebrism, and to devout and literal narrative, related with an ingenuousness very much in the spirit of medieval storytellers. Much of this special flavor, appealing by virtue of rude simplicity, that constitutes the unique charm of much Spanish painting—severe and simple, but profoundly sincere in its ignorance of foreign sophistications—stems from that isolation and from that connection, deep down, with the medieval spirit. The appearance, toward 1630, of Rubenesque Flemish examples—so powerfully communicative, so rich in dynamic and expressive attitudes, emotions, and effects—no doubt created a commotion that had to be recognized. However, assimilation of these elements, though immediate and rapid, was only partial and fragmentary, and did not result in any decisive transformation of the Spanish artistic scene until another generation—those born between about 1615 and 1630—had mastered the idiom of the High Baroque, and had matured in the latter half of the century.

Against this general background we see the figure of Zurbarán emerging from all the particulars of the Seville of that time. The artist is known to have been already in the city on the Guadalquivir by 1614, when he settled as apprentice to one Pedro Díaz de Villanueva, of whom we know only that he was a *pintor de ymaginería* (painter of imagery), and nothing more.

In those days, the practice of painting in Seville, and more or less everywhere in Spain, was still virtually a medieval institution. The guild of painters was a closed world governed by strict rules requiring the orderly progression, through examinations and controls, from apprentice to journeyman to master. Apprenticeship began very early, when a boy was only eight or ten years old, and might continue until he was eighteen or twenty. Mastership was attained by examination before the council of the guild, and only then was a candidate eligible to open a workshop and practice his craft independently.[5]

There is ample evidence to suggest that such rigorous controls were inconvenient and at times abusive. In Zurbarán's case, there was a departure from the norm, when in 1629 the municipality and the City Council expressly invited him to establish himself in the city of Seville without going through the formality of examination. This elicited

an indignant protest from Alonso Cano in the name of the guild. But nothing came of this, and Zurbarán was able to set up shop without the troublesome examination.

A clear indication that the professional world was a closed circle was the frequency of marriage between members of painters' families. In Seville, this created a network of business and family interests that favored control of the market and of commissions. Often the more important projects (altarpieces, monastic cycles, ephemeral decorations for special occasions) were contracted by the company or half-share system, and subcontracting was a common practice; it is easy to find works contracted by one artist but obviously executed by several different hands.

A high percentage of the work of painters in Seville was for churches, monasteries, and private religious foundations, as well as devotional canvases for the American market. Of the secular genres of major significance in the humanistic world of the sixteenth century, only portraiture is well documented in the early decades of the seventeenth. Those years also witnessed the birth of a new genre of still-life painting, which in Andalusia was to become singularly important, as was landscape, although known examples of this genre are few and poorly documented.[6]

Fresco painting, cultivated in the sixteenth century, lingered into the very early years of the seventeenth, but was all but displaced by the practice of setting huge canvases into walls, vaults, or ceilings framed with wooden moldings inserted in the ornamentation. This was the usual practice in some areas of Italy, particularly Venice. Zurbarán and his contemporaries were unacquainted with the technique of fresco, and limited themselves to painting in oil on canvas or panel.

When Zurbarán went to Seville in 1614, the late Mannerist painters had been active there until quite recently. In Seville and throughout Andalusia, they left work in the tradition of Michelangelo and its sober extravagance that was clever, detached, and whimsical.

In Córdoba, and also in Seville, Pablo de Céspedes (ca. 1540–1608), a friend of Federico Zuccaro's, had shown his rigorous, formal compositions of Roman lineage. This style was also favored by Céspedes's Italian friend Cesare Arbasia. Arbasia appeared in Málaga in 1579 and worked all over Andalusia, at least until about 1595, when he returned to Italy; he died in Turin in 1607. Arbasia's broad, solemn style and his landscape backgrounds treated with coloristic sensitivity owing much to northern artists were likewise esteemed in his day.

Matteo de Lecce (ca. 1547–ca. 1616), called Mateo Pérez de Alesio in Sevillian documents, developed in the Rome of Salviati and Zuccaro. Beginning in 1583, he produced what were considered some of the most monumental and significant works in Seville. The great *Saint Christopher* (1584) in the cathedral is perhaps his best-known work, and the *Saint James* in the Church of Santiago represents a significant innovation. This canvas has been regarded as the earliest great altar picture in Sevillian painting, and it has a powerful dynamic thrust that seems to pass from the Roman Mannerism of the artist's early years toward a Baroque fullness that had not yet become a common means of expression.

Lecce traveled to the Americas sometime before 1590, by which date he was residing in Lima. There he died not long before 1616, when he is mentioned as deceased.[7] His career attests to the attraction the American market must have exerted on many lesser artists, both Italian and of other nationalities, who came to Seville in the hope of making their fortune and returning home rich.

Such was the desire of another Italian, Girolamo Lucenti da Correggio, who reached

Seville in 1602 and remained associated with that city at least until 1624, when he moved to Granada. We then lose track of him, and we do not know whether he died in Granada or returned to his native Lombardy, as he had intended.[8] In what survives of this modest artist's work, we can observe his predilection for the compositional schemes of late Mannerism, modulated perhaps by his Lombard origins and by his taste for certain advances toward realism that conformed well with the general ambience of his time.

About the same period, another Italian, this time a Roman, the quite obscure Juan (Giovanni) Gui, of whom there are documentary records in Seville dating to between 1608 and 1611, displayed a similar stylistic language, though it leans toward a certain Michelangelesque quality tinged with a strong devotional character, and is unmistakably linked to the Roman milieu of Baglione.[9]

This wave of Italianism was superimposed on an old tradition of northern influence, which had been unbroken in Seville and was to persist, more or less subliminally, in all the output of Sevillian painters during these years. The prolonged presence of such artists as Pedro de Campaña (Pieter Kempeneer; fig. 2) of Brussels, in Seville from 1537 to 1563,[10] and Hernando de Esturmio (Hernando Sturm) of Zierickzee, Holland,

Fig. 2. Pedro de Campaña. *The Descent from the Cross*, 1547. Panel. Main sacristy, Cathedral, Seville

41

documented in Seville from 1537 until his death in 1556,[11] exerted a profound influence on Sevillian painting, representing the dramatic and impassioned Flemish approach to biblical and hagiographic narrative. The terse expressionism these artists displayed in much of their work and the almost metallic precision of their drawing became significant components in one sector of Sevillian painting of the late sixteenth century, up to the time of the imposition of Italian influence.

Vasco Pereira of Portugal, who died after 1604, found no difficulty in combining his knowledge of the tradition of northern expressionism with the Italian contribution—either by direct observation of original works or by the use of engravings after paintings, of which he appears to have made liberal use, in the manner that becomes traditional in later Andalusian painting.[12]

Of still greater significance was to be the work of Alonso Vázquez. Born at Ronda in Málaga at an unknown date, he is well documented in Seville from as early as 1590 until 1603, when he went to Mexico in the service of the viceroy, the Marqués de Monteclaros; he died no later than 1608.

Vázquez, whose individuality has begun to emerge more clearly in recent years,[13] may be the most significant of all the artists in Seville in the crucial years at the close of the sixteenth century. Angulo Iñiguez has noted an interesting characteristic of the artist's style that, as he points out, was to persist in the work of such artists as Zurbarán and Gregorio Fernández: a tendency to shroud figures in cascades of stiff fabric with craggy, angular folds that entirely conceal the outlines of the body (fig. 3), forms that had been conspicuous in painting of the preceding period, both in the Michelangelesque excess of nudity and in the harmoniously draped figures of the Raphaelesque tradition.

Along with this pronounced new artifice, whereby cloth takes on an independent value in the composition, with full, brilliant colors and an opulent show of voluminous folds, Vázquez seems also, at least according to written descriptions, to have been one of the first to take an interest in inanimate objects and still life. His contemporaries

Fig. 3. Alonso Vázquez. *The Last Supper.* Oil on canvas, 10 ft. 5⅛ in. × 13 ft. 2¼ in. (318 × 402 cm). Museo de Bellas Artes, Seville

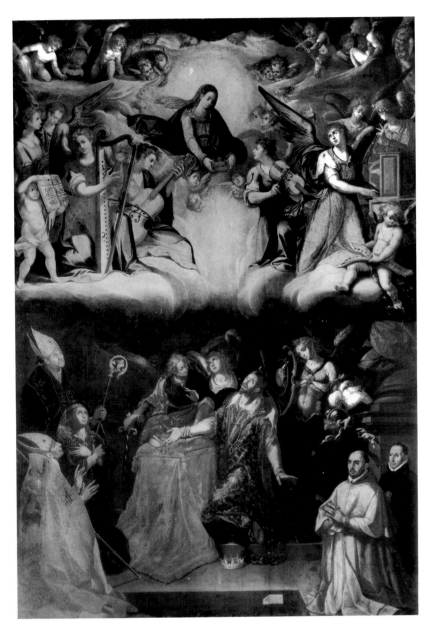

Fig. 4. Alonso Vázquez and Juan de Uceda. *The Martyrdom of Saint Hermenegild*. Oil on canvas, 16 ft. 1¾ in. × 11 ft. 1⅞ in. (492 × 340 cm). Museo de Bellas Artes, Seville

openly praised his compositions in this genre, suggesting, if we read between the lines, both the resurrection of late medieval tastes—linked to the Flemish style—and the advance of naturalism, which was soon to place commonplace objects under the glaring light of Caravaggesque tenebrism.

Vázquez may also be credited with two types of paintings that found quick acceptance. In 1600, he contracted with the prior of the Monastery of the Merced Calzada to execute with Francisco Pacheco a series of canvases depicting scenes from the lives of the founders of the order, Saint Peter Nolasco and Saint Ramón Nonato. This was one of the earliest of the monastic cycles produced in Seville, and it established a pattern that would become common. (Zurbarán was commissioned to execute cycles of paintings not only for the Mercedarians but also for the Carthusians and the Dominicans.) Vázquez is also credited with the creation of one of the first altarpieces to be composed of one enormous canvas rather than several smaller ones (fig. 4). The altarpiece, commissioned by the Hospital de San Hermenegildo, was unfinished when

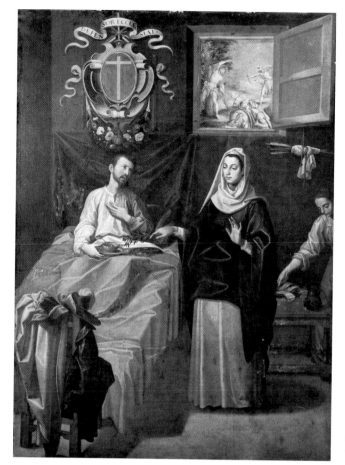

Fig. 5. Francisco Pacheco. *Saint Sebastian Cured by Saint Irene*, 1616. Oil on canvas. Formerly Hospital de Alcalá de Guadaira; present whereabouts unknown

Vázquez departed for Mexico and was completed by Juan de Uceda. This large canvas, with no precedent save for the aforementioned *Saint James* by Pérez de Alessio, may be taken as the point of departure for an entire category of altarpieces conceived in two registers, the terrestrial and the celestial, which became so popular in later years.

Of the artists who were already fully developed by the early seventeenth century and who constituted the mature and dominant generation at the time of Zurbarán's training and early efforts, Francisco Pacheco (1564–1654) perhaps best expresses the continuity of the tradition of Roman Mannerism, which, as we have seen, was established in Seville during the last third of the sixteenth century.[14]

Pacheco—better known today as a theoretician, as the author of *Arte de la pintura* (Seville, 1649),[15] for his *Libro de descripción de verdaderos retratos*, of great documentary interest,[16] and as the father-in-law of Velázquez than for his merits as an artist—was nevertheless in his own time the most respected of the Sevillian masters; the most talented artists of the younger generation born with the century were trained in his studio. While there is no record of any connection between Zurbarán and Pacheco, it is clear that the young Extremaduran—who was later to say that he had known Velázquez almost from childhood—must have known and conversed with Velázquez's teacher, and must have witnessed the production or at least the installation of works that came out of his shop.

Pacheco was born at Sanlucar de Barrameda. He was the nephew of an eminent canon of the Cathedral of Seville, whose pupil and protégé he became. As a man of letters, Pacheco always enjoyed considerable cultural and literary prestige, not like that of the

humanist academics of the Renaissance, but appropriate to the new theological context. He served the Church in the capacity of *veedor de pinturas sagradas* (inspector of sacred paintings), and the precision and rigor of the iconography outlined in his theoretical treatise are reflected in his work; indeed, he initiated a number of the prototypes used by Zurbarán and other artists of the age. The depiction of the Virgin of the Immaculate Conception as a young girl, severe and unspeaking, isolated within a silhouette that is closed and self-contained, with hands joined and head inclined, and borne on a cresent moon, was early defined by Pacheco. The Christ Crucified, serene and grave, pierced by four nails, and with the head dropped forward, is another Pacheco formula (see fig. 1, page 3). It came to be widely used, by Velázquez, by Zurbarán, and by Cano. The combination of household intimacy and the supernatural that was to become the key to Zurbarán's style appears already formulated in such works by Pacheco as the lost *Saint Sebastian* (1616; fig. 5), painted for the Hospital de Alcalá de Guadaira, with its subtle domestic ambience. In the great painting *Christ Served by Angels* (1616), from the Monastery of San Clemente, now in the Castillo de Courzon, there is a delightful abundance of naturalistic detail, ordinary still-life objects that lend charm and intimacy to a complex composition otherwise reminiscent of Mannerism. Pacheco's surviving portraits, both the sketches in the *Libro de . . . retratos* and a few canvases, are similarly a measure of his powers of observation and attention to individual reality. Nevertheless, Pacheco lacked the subtle gifts of grace and delicacy. The hardness of his line and the dryness of his drawing, which is rough and wooden and renders nothing of the softness and fragility of things, keep his art on a level of crudeness. This was noted even by his contemporaries, much as they respected his learning and the prestige of his mastership.

The canvases of the Merced Calzada series, which Pacheco painted between 1600 and 1611, are, along with others by Vázquez (Museo de Bellas Artes, Seville; Museu d'Art de Catalunya, Barcelona; and the Bowes Museum, Barnard Castle), important antecedents for later monastic cycles conceived to express a certain monumental, sculptural quality. His major venture into mythological painting, on the ceilings of the Casa de Pilatos, the palace of the Duke of Alcalá, likewise shows his link to Roman Mannerism in its Flemish version, as it was absorbed into the Sevillian tradition, and his familiarity with certain aspects of the art of the Escorial, especially that of Luca Cambiaso with its spare, sculptural treatment of form.[17]

Next to Pacheco, the strongest personality in the early years of the century was Juan de Roelas (ca. 1558–1625), an entirely different kind of artist, who in Seville represented the emergence of a new sensibility inclining more toward Italy than Flanders, a sensibility imbued with Venetian sensuality and cultivating an incipient naturalism far more expressive of the softness and texture of things and the changing effects of light on materials than of the dry, almost metallic preciosity of drawing.[18]

Roelas must have traveled to Italy, and he was acquainted with the strongly Italianized atmosphere of the court in Madrid and Valladolid between 1597 and 1602. In Andalusia, he was the chaplain of the Church of Olivares in Seville in 1603, and from that year until 1616, when he left to spend some years in Madrid, returning to Olivares, where he died, he figures as a most singular painter in Seville. His large canvases, the *Circumcision* (or the *Naming of Jesus*) and the *Adoration of the Shepherds* (fig. 6), executed in 1604 for the high altar of the Jesuit Casa Profesa in Seville, must have created a sensation. His warm, tempered color, his repertory of profoundly natural faces and attitudes, and the technical freedom and softness of his brushwork were absolutely new, and distinct from the tradition cultivated by Pacheco.

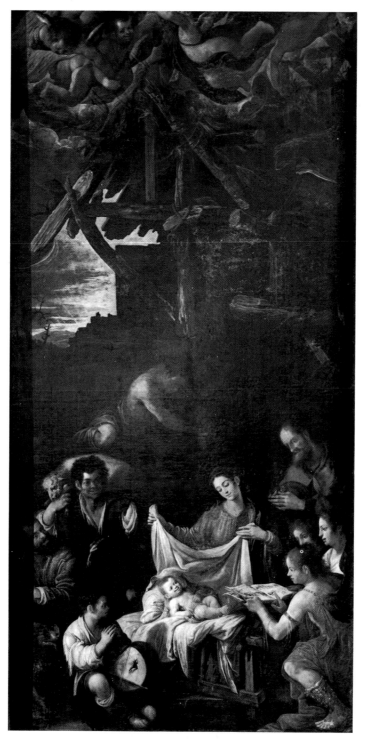

Fig. 6. Juan de Roelas.
The Adoration of the Shepherds,
1604. Oil on canvas. Church
of the University of Seville

The large altar canvases painted by Roelas in the mature middle years of his output (1600–1616), filled with direct observation of nature, rich in poses and expressions, lively and lifelike, with commonplace and anecdotal details, and communicating a new sensibility, were decisive in the history of Sevillian painting and represented a lasting resource. They are conceived in two registers, one of the earth, the repository of day-to-day reality—with intensely natural types, gestures, and attitudes—and one of heaven, the realm of golden celestial light enveloping the blessed, who are almost dissolved in a rare luminous matter that seems to penetrate and dispel the limits of form.

Sympathetic to domestic detail, a master in the treatment of inanimate objects and strong, individual faces, Roelas anticipated many aspects of the naturalism that triumphed in Zurbarán's generation, although he never resorted to the tenebrism of Caravaggesque origin that became one of the hallmarks of the new style. His preoccupation with light was rooted in the study of Venetian art, in the manner of Tintoretto and, above all, in the Bassano school.

If Roelas represents the emergence of Venetian sensualism, his close contemporary Antonio Mohedano (ca. 1563–1626), born at Antequera, Córdoba, perfectly embodies the Roman spirit of *arte senza tempo* (art without time) of Scipione Pulzone or the Cavalier d'Arpino, which was also a component of the Spanish devotional world of the following generation. Serene and severe, preferring compositions of marked symmetry, adept in the treatment of cloth as ample sculptural folds, and with a very personal sense of clear colors in large areas, this artist strongly impressed the young Zurbarán.

Mohedano also played a prominent role in the history of still life, according to written descriptions, notably those by his contemporary Pacheco. His fruits and flowers, both in fresco—in decorations, now lost, reflecting the Italian tradition—and on canvas are praised in the old texts. He has been erroneously credited with the complex paintings on the ceiling of the great hall of the Palacio Arzobispal in Seville, a work of 1604, elaborately allegorical in character and incorporating curious decorative elements. But it would be plausible enough to associate Mohedano's art with the fine still lifes hung in the gallery of the same palace (fig. 7), which prefigure certain types of vegetal representation, especially pictures of fruit, that were later to develop and flourish in Zurbarán's milieu.[19]

Apart from these three masters—Pacheco, Roelas, and Mohedano—the Sevillian panorama in the early years of the century was not what could be described as brilliant. Far less individual as a painter and maintaining a less sustained level of quality was Juan de Uceda (ca. 1570–1631), who in 1603 completed the large painting of Saint Hermenegild that had been left unfinished by Vázquez when he departed for Mexico. Uceda's artistic training surely took place in an environment pervaded by the extreme Mannerism of the later decades of the sixteenth century. He always retained a taste for spare proportions and unstable attitudes, although contact with Roelas influenced his interest in visible reality, his warm palette, and his free technique.

Fig. 7. Antonio Mohedano (?). Detail of decoration, ca. 1604. Tempera and oil on linen. Prelate's gallery, Palacio Arzobispal, Seville

Fig. 8. Francisco Varela. *Portrait of Juan Martínez Montañés*, 1616.
Oil on canvas, 25⅛ × 22 in. (64 × 56 cm). City Hall, Seville

Francisco Varela (d. 1645), whose biographical profile remains vague, appears also to have been active and well esteemed from 1605 on; he was named *veedor de pinturas* and examiner for the painters' guild in 1623. He too was trained in the Mannerist tradition of Flemish origin. His few extant works proclaim him an artist of singular quality, with a precise and energetic draftsmanship and a taste for exaggerated expressiveness, tense and nervous, in faces and hands. A pleasure in strong color and a sense of volume, as well as a flare for portraiture, apparent in his fine portrait of the great sculptor Juan Martínez Montañés (1616; fig. 8), qualify him, as has recently been noted, as a forerunner of Zurbarán, whom he undoubtedly knew.[20]

Of the artists born within the decade of the 1590s, Zurbarán's strict contemporaries, who on occasion shared with him projects and commissions, mention should be made of Pablo Legote, born in Marche, Luxemburg, in 1598, the same year as Zurbarán. Legote went to Seville as a boy, in 1609, and we learn of his activity first as an embroiderer and then as a painter. An undistinguished artist, he enjoyed a misplaced prestige beginning in the early years of the twentieth century through the attribution to him of outstanding works that have since been ascribed to several different hands. In fact, Legote, who must have begun painting at a late date, not before 1630, was no more than a fair painter and an able entrepreneur who expedited the completion of a considerable number of works by sharing commissions or by subcontracting most of the painters of the day. He made extensive use of sources ranging from Mannerist prints, already drawn upon by Uceda and Varela, to engravings after Rubens, which he must have been one of the first in Seville to exploit, always interpreting them in a spirit of crude popular expression. His chief importance perhaps lies in his use of the most orthodox tenebrist mode, through Ribera. His *Saint Jerome* (fig. 9) in the Cathedral

of Seville, signed but not dated, can be accounted for only by direct knowledge of that great master.[21]

Works by Ribera, shipped from Naples, must have appeared quite early in the collections of the Sevillian aristocracy (fig. 10). The Duke of Osuna, in the 1620s, and later the Duke of Alcalá became steady patrons of the master from Játiva. Through their collections his art, with its Caravaggesque tendency and personal interpretation—charged with a sensuousness and a love of materials—was known in Seville and became an essential component in the training of such younger artists as Cano and Zurbarán.

There were two other Sevillian painters, however, remote from Ribera's influence, who were slightly older than Zurbarán but who came into prominence in the same years when the painter from Fuente de Cantos was beginning his career in Seville. Francisco de Herrera the Elder, born about 1590 and documented as active from 1609 at the earliest, was a very strong personality who joined with Roelas in the effort to create a new language, realistic and expressive and based in reality, one that he rendered with energetic veracity in the loose, free brushwork of the Venetian tradition. Although his early works testify to some training in the Mannerism cultivated by Vázquez, Varela, and Uceda, among others, Herrera soon left this behind. While his compositions are always awkward in spatial disposition, they are rich in life and character, with an unusual palette that favors a color scale with a single dominant harmony.[22]

When in 1627 Herrera was commissioned, with Zurbarán, newly established in Seville, to execute a series of canvases for the Franciscan Monastery of San Buenaventura,

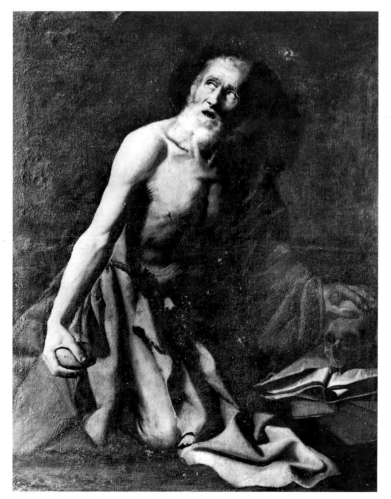

Pág. 49
Fig. 9. Pablo Legote. *Saint Jerome*. Oil on canvas, 5 ft. 10⅞ in. × 4 ft. 5⅛ in. (180 × 135 cm). Cathedral, Seville

Fig. 10. Jusepe de Ribera. *Calvary*, ca. 1626–28. Oil on canvas, 11 ft. ¼ in. × 7 ft. 6½ in. (336 × 230 cm). Collegiate Church, Osuna

his style was perhaps at the peak of its development. It exhibited the rough power of his genius, and was in sharp contrast to the severe monumentality seen in the work of the young Zurbarán, whose rise was just beginning and who very likely appreciated a talent so different from his own.

Juan del Castillo (d. after 1650), whose place and date of birth are unknown, but who must also have been born about 1590, and was active from 1611 on, is an artist of lesser force, although he too attained some eminence in Seville in the early decades of the century. A relative by marriage and an associate of Legote, Castillo had worked with Cano's father and with Cano himself. His extensive oeuvre, just now beginning to be studied in detail, strikes a note of modest assertiveness approaching that of Zurbarán, although it lacks the unique magic of his genius. In its iconography and feeling, it anticipates the work of Castillo's pupil Murillo in the early years of his career. Starting out with a sense of form that was rather hard and dry in the manner of Pacheco, who must have influenced him considerably, Castillo evolved toward the use of softer shapes and textures and a clearer, more luminous palette. It should be noted that Castillo's mature works, the large canvases of the Montesión altarpiece, now in the Museo de Bellas Artes, Seville, were painted about 1634–36—that is, after Zurbarán had executed many of his more innovative productions in Seville.[23]

Concerning the most significant genius among the artists of those years, Diego de Velázquez, it may suffice here to recall his extraordinary precocity. The young Zurbarán, who was to relate that he had known Velázquez during his youthful years in Seville, can hardly have been oblivious to the marvelous precision of that eye and hand. The works of Velázquez's youth, done before he traveled to Madrid, where broad and fertile horizons opened before him, were produced in the same ambience as that experienced by Zurbarán in his early career, indicating a common training and a common taste for the individual and the concrete, viewed in the potent directed light of Caravaggesque tenebrism (fig. 11).

Similarly, the young Alonso Cano (1601–1667), who was so vigorously to insist on Zurbarán's guild examination in 1629, in those years employed the idiom he had learned in Pacheco's studio, receptive as that language was to innovation, despite the limitations of the master himself.

This whole tradition of Sevillian painting constituted the foundation of Zurbarán's development. The young painter was educated in the school of all these masters, immediately preceding or contemporary with him. Other factors also were significant in the evolution of his style: his patrons, drawn to the felt emotion and immediacy of everyday things by the devout teachings of the Jesuits, who stressed that through the concentration of the mind and the senses in meditation one could transport oneself to the scene of a holy event and endow the object of meditation with sensible, visible intensity; and the wide circulation of Flemish and Italian prints, unstintingly employed in the studios as ready substitutes for invention, and at times imposed on the artist by his patrons, who often specified the use of iconographic and devotional features. These too contributed to the artistic milieu of Seville during the first third of the seventeenth century, the horizon against which Zurbarán's silhouette as a painter is delineated.

From that milieu, with its manifest limitations, he distilled the prodigious emotional synthesis of the grand and the rustic, of simplicity and mystery, that constitutes his very personal expression.

Fig. 11. Diego de Velázquez. *Two Men at Table*, ca. 1620–21. Oil on canvas, 25⅛ × 41 in. (64 × 104 cm). Wellington Museum, Apsley House, London

NOTES

1. Antonio Domínguez Ortiz, *Orto y ocaso de Sevilla*, 2d ed. (Seville, 1974).

2. José de Sigüenza, *Historia de la Orden de San Jerónimo*, 3 vols. (Madrid, 1605), III.

3. Alfonso E. Pérez Sánchez, "La crisis de la pintura española en torno a 1600," in *España en las crisis del arte europeo* (Madrid, 1968), pp. 1677ff.

4. Francisco Pacheco, *Arte de la pintura*, 2 vols. (1649; new ed. with notes by Francisco J. Sánchez Cantón, Madrid, 1956), I, p. 214.

5. Juan J. Martín González, *El artista en la sociedad española del siglo XVII* (Madrid, 1984), pp. 20–21.

6. A. E. Pérez Sánchez, in Madrid, Museo del Prado, *Pintura española de bodegones y floreros, de 1600 a Goya* (exhib. cat., 1983), pp. 69–91.

7. For Mateo de Lecce, see the monograph by José de Mesa and Teresa Gisbert, *El pintor Mateo Pérez de Alesio* (La Paz, 1972); and the article by Jorge Bernales Ballesteros, "Mateo Pérez de Alesio, pintor romano en Sevilla y Lima," *Archivo hispalense*, no. 171–73 (1973), pp. 221–71.

8. A. E. Pérez Sánchez, *Pintura italiana del siglo XVII en España*, Madrid, 1965, p. 39. The annotated text appeared in José Hernández Díaz, "Materiales para la historia del arte español," *Documentos para la historia del arte en Andalucía 2*, 1928 (1930), p. 162.

9. Antonio de la Banda y Vargas, "El pintor Juan Gui Romano en Sevilla," *Archivo hispalense*, no. 159–64 (1970), pp. 175–81.

10. Diego Angulo Iñiguez, *Pedro de Campaña* (Madrid, 1951); Nicole Dacos, "Pedro Campaña dopo Siviglia: Arazzi e altri inediti," *Bolletino d'arte*, ser. 6, no. 8 (1980), pp. 1–44.

11. Juan M. Serrera, *Hernando de Esturmio* (Seville, 1983).

12. J. M. Serrera, "Vasco Pereira: Un pintor portugués en la Sevilla del último tercio del XVI," *Archivo hispalense*, forthcoming.

13. For Vázquez, see Manuel Ferrand Bonilla, "Alonso Vázquez," *Anales de la Universidad Hispalense* 12 (1951), pp. 133–47. More rigorous, though in the nature of a summary, is J. M. Serrera, "Pintura y pintores del siglo XVI," in *La catedral de Sevilla* (Seville, 1984), pp. 395–97, and notes 126, 127.

14. Concerning the Sevillian artists of the time, see Enrique Valdivieso and J. M. Serrera, *Historia de la pintura española: Escuela sevillana del primer tercio del siglo XVII* (Madrid, 1985).

15. The intellectual ambience in which Pacheco moved, his aesthetic ideas, and his theoretical background are discussed in Jonathan Brown, *Images and Ideas in Seventeenth-Century Spanish Painting* (Princeton, 1978); and in Francisco Calvo Serraller, *La teoría de la pintura en el siglo de oro* (Madrid, 1981).

16. A manuscript of F. Pacheco's *Libro de . . . retratos* is in the Museo Lázaro Galdiano, Madrid. A fine facsimile edition was prepared by José M. Asensio (Seville, 1881–85), and another was published recently, with a prologue by D. Angulo Iñiguez (Seville, 1984).

17. For Pacheco as a painter, see Valdivieso and Serrera 1985, pp. 16–116, and pls. 1–87.

18. For Roelas, see E. Valdivieso, *Juan de Roelas* (Seville, 1978); also Valdivieso and Serrera 1985, pp. 117–73, and pls. 88–100.

19. On Mohedano, there is an inadequate monograph, afflicted with errors, by Rafael González Zubieta, *Vida y obra del artista andaluz Antonio Mohedano de la Gutierra (1563?–1626)* (Córdoba, 1981). More reliable are the pages devoted to the artist in Valdivieso and Serrera 1985, pp. 174–88, and pls. 141–54.

20. E. Valdivieso, *Historia de la pintura sevillana* (Seville, 1986), p. 145.

21. For Uceda, Varela, and Legote, see Valdivieso and Serrera 1985, pp. 188–227, 228–59, 260–302, and pls. 155–209.

22. There is a useful monograph on Herrera the Elder by Antonio Martínez Ripoll, *Francisco de Herrera "el Viejo"* (Seville, 1978), with full bibliography to that date.

23. For Juan del Castillo, see Valdivieso and Serrera 1985, pp. 303–69, and pls. 210–62.

FRANCISCO DE ZURBARAN: A CHRONOLOGICAL REVIEW

Jeannine Baticle

The existence of important Roman ruins between Merida and Seville and of old command posts of the Knights Templar and the more recent ones of the powerful Order of Santiago in the frontier zone near Portugal must surely have modified the pastoral life of the vast Extremaduran plateau over the centuries. It is not impossible that the vestiges of antique monuments, which abound in the vicinity of Fuente de Cantos, the birthplace of Francisco de Zurbarán, may have oriented the artist unconsciously toward the monumental and stylized forms that characterize his art.

Fuente de Cantos was a town of only five or six hundred inhabitants in Zurbarán's day; it is still a modest country town, though larger than it was then. It is not far from Merida, originally an important Roman colony and still notable as an archaeological site, and only about twelve and a half miles from the border of Andalusia. Llerena is a beautiful Extremaduran town forty miles to the east of Fuente de Cantos. During Zurbarán's youth, Llerena boasted two parish churches, Santiago and Nuestra Señora de la Granada; seven monasteries; and a court of the Inquisition. Llerena was under the ecclesiastical jurisdiction of the Order of Santiago. Seville, the center of Andalusian art in the seventeenth century, was only about two hundred miles to the south. It is thus logical that Zurbarán established himself in Seville at the outset of his career as a painter.

Francisco de Zurbarán, the son of Luis de Zurbarán, a shopkeeper,[1] and of Isabel Márquez, was baptized in the Church of Nuestra Señora de la Granada in Fuente de Cantos (Badajoz) on November 7, 1598. He was probably born the previous day, for it was the custom in Spain to baptize children the day after their birth. We do not know why he later often used the name Zurbarán Salazar.[2]

In the early seventeenth century, boys between the ages of twelve and fifteen who showed a special aptitude in the arts were often placed by their parents with a master as apprentices. In 1611, at the age of twelve, Diego de Velázquez became the pupil of Francisco Pacheco, and in 1616 he was joined in that studio by the fifteen-year-old Alonso Cano. It is remarkable that three of the greatest masters of seventeenth-century Spanish painting were of nearly identical age: Zurbarán was born in 1598, Velázquez in 1599, and Cano in 1601.

According to Antonio Palomino, Francisco de Zurbarán began his apprenticeship with Luis de Morales in Badajoz.[3] On December 19, 1613, Luis de Zurbarán signed a power of attorney authorizing Pedro Delgueta Rebolledo, a Sevillian, to find a painting master for his son, who had just turned thirteen. On January 15, 1614, Pedro Díaz de Villanueva, a *pintor de ymaginería* (painter of images), signed a contract to take on Francisco de Zurbarán as an apprentice for three years.[4] Very little is known about Villanueva, who may have been the brother of the famous altarpiece builder Jerónimo Velázquez.

Street in Fuente de Cantos, birthplace of Francisco de Zurbarán

Zurbarán's house in Llerena

Zurbarán's apprenticeship ended in Seville on January 15, 1617. That is the last documented fact we know about Zurbarán until February 22, 1618, when María, his first child by his wife María Páez, was baptized at the parish church of Nuestra Señora de la Granada in Llerena.[5] María, the daughter of María Jiménez and Bartolomé Páez, was born in 1589.[6] Bartolomé is described as a "gelder" or an "accountant" in a document from 1580.[7] Bartolomé's brother Francisco was a priest. The nineteen-year-old Zurbarán married a woman who was nine years his senior and who had received her dowry from a relative in 1616.[8] He was then living in Llerena.

In the same year, Zurbarán's name appears in the accounts of the City Council for payment for the design of a fountain that was built in Seville.[9]

On November 5, 1619, Zurbarán received payment for a painting executed for the gate of Nuestra Señora de Villagarcía in Llerena.[10] A son, Juan, was baptized on July 19, 1620, in the parish of Santiago.[11]

On August 28, 1622, Zurbarán signed a contract at Fuente de Cantos for a commission for fifteen Mysteries of the Rosary for the decoration of an altar in the Chapel of the Rosary in the parish church of that town.[12] None of these works survive. In fact, no paintings by Zurbarán before 1627 are known to us.[13]

On July 13, 1623, another daughter, Isabel Paula, who appears often in later documents, was baptized in Llerena.[14] María Páez may have died in childbirth at that time, for in 1625 Zurbarán was already remarried to a well-to-do widow from Llerena, Beatriz de Morales, who, like María Páez, was older than he, for she was married for the first time in 1605.[15] The approximate date of Zurbarán's remarriage can be deduced from

a matrimonial inquiry made on the occasion of his third marriage. He was married to Beatriz de Morales for fourteen years, eleven of them spent in Seville, where she died in 1639, and three in Llerena. His second marriage was thus formalized in 1625. They probably had only one child, Jerónima, who died at an early age.

Zurbarán's several marriages were not unusual for the time. The high mortality rate among women in childbirth and the corresponding presence of young children obliged the widower to remarry, often more than once—not only to gain assistance in raising the children from a former marriage but also, in the case of an artist, to tend to the everyday needs of the workshop, which included the lodging and feeding of the apprentices and assistants.[16]

In 1625, Zurbarán executed a large composition for the altarpiece of the church of Montemolín, a town near Llerena, for which he received two payments, one of 100 reales and one of 340 reales. The subject of this lost painting is not known.[17]

The year 1626 was marked by an important event in the young artist's career. On January 17, he signed a contract before a notary in Seville with Fray Diego de Bordas, the prior of the Dominican community of San Pablo el Real in Seville. Zurbarán gave Llerena as his place of residence, although he was then in Seville. He contracted to execute twenty-one paintings in eight months for the sum total of 4,180 reales, or 380 ducats.[18] Only some of these works are extant, so it is not known whether Zurbarán completed his contractual obligations (see cat. nos. 1, 2).

Even in 1626, the sum of 380 ducats for twenty-one paintings was rather low, but it is notable that the Dominicans, one of the most powerful of the religious orders, called upon the services of a young painter from Llerena. In the early years of the seventeenth century, matters were usually the other way around: monasteries in Llerena would hire artists from Seville. For example, between 1598 and 1604, the sculptor and architect Juan de Oviedo the Younger and the painter Juan de Uceda both worked in the Convent of Santa Clara in Llerena. That convent still possesses the *Saint Jerome* executed by the Sevillian sculptor Juan Martínez Montañés.[19]

In 1627, Zurbarán painted the famous *Christ on the Cross* (cat. no. 2) for the oratory of the sacristy of San Pablo el Real. It is his first important signed and dated work painted completely in the tenebrist manner. It was much admired by Zurbarán's contemporaries, and because of it he was invited two years later by the City Council of Seville to establish residency in that city.

From 1628 to 1629, Zurbarán executed a cycle of paintings for the Franciscan College of San Buenaventura (see cat. nos. 3, 4). On August 29, 1628, he signed a contract with Fray Juan de Herrera, the reverend father commander of the Monastery of the Merced Calzada in Seville. In that document he states that he still resides in Llerena, and he describes himself as a *pintor de ymaginería*. He must have had a large workshop at his disposal to be able to handle this avalanche of commissions, which often included large works. The contract with the Merced Calzada required that he execute twenty-two compositions on the life of Saint Peter Nolasco within a year. "To this end," he stated in the contract, "I will come with those I need, the monastery providing me, as well as my helpers and all those who will participate, with food, drink, lodging, beds, and all the necessities for painting, such as canvases, colors, and oils, for the duration of the work."[20] Zurbarán's total fee was now considerably more than in 1626—16,500 reales, or 1,500 ducats. The paintings still extant from this series—the *Saint Serapion* (cat. no. 5), for example, which was not mentioned in the contract, and the two scenes from the life of Saint Peter Nolasco now in the Prado (see cat. no. 6)—give us an idea

of Zurbarán's mastery at this point in his career. Their impact in Seville must have been considerable.

Juan de Roelas, the most important Andalusian painter of the first quarter of the seventeenth century, died in 1625, and neither Francisco Pacheco nor Juan de Uceda, nor even Francisco de Herrera the Elder, who was more able than they, was a match for Zurbarán. Only Alonso Cano was his equal. In the end Cano, who was active as an architect, a sculptor, and a painter, surpassed Zurbarán in the breadth of his enterprises.[21] Cano reportedly had refused the commission for the Merced Calzada.[22] He seems to have had little to do with Zurbarán during their years in Seville. It has been remarked that Pacheco, in his *Arte de la pintura*, seems deliberately to have ignored Zurbarán, even though Zurbarán was a friend of his son-in-law Velázquez. Both Pacheco and Juan de Uceda, who was the uncle of Cano's wife, several times served as *alcades veedores del oficio de pintores* (official inspectors of the painters' profession) and were no doubt very respectful of the rules of the painters' guild.[23] Pacheco's silence may have been a sign of his disapproval of Zurbarán for not having submitted to the guild's examination, which would have officially permitted him to exercise his craft in Seville.

On June 27, 1629, the City Council of Seville, presided over by the *asistente* Diego Hurtado de Mendoza, Viscount of La Corzana,[24] invited Zurbarán to establish himself officially in Seville because, as Rodrigo Suárez, one of the members of the Twenty-Four (the Council), expressed it, "He is a consummate artist, [and] painting is not the least of the adornments of the Republic."[25] Following the centralizing reforms of Philip II, the *asistente* who presided over the City Council of Seville was appointed by the king himself.[26] Nearly all of Zurbarán's protectors were members of the court. In this case, the Viscount of La Corzana was acting more in the spirit of nobleman and patron of the arts than in his capacity as an administrator concerned with enforcing the rules of the guild. Zurbarán accepted the invitation to become a resident of Seville, and on September 19, 1629, he signed a contract with the Monastery of the Trinidad Calzada in which he qualified himself as "master painter of this city of Seville."[27]

This was not to the liking of the painters' guild, which had not conferred this title on him, and on May 23, 1630, Zurbarán was summoned to appear within three days' time before the members of the guild and to pass the examination that would entitle him to call himself a master painter.[28] Zurbarán, evidently quite conscious of his powerful protection, sent a letter the following day to the Council in which he adroitly pointed out that "the approbation of Your Lordships who call me a singular man" has an altogether different value from that of the regents of the guild, which is composed of "painters who are envious of the favor that is granted to me"—granted by higher authorities.[29]

On May 29, Alonso Cano, the head of the painters' guild, addressed a petition to the Council demanding that Zurbarán submit to the examination.[30] Zurbarán's response was simply to send a letter to the Viscount of La Corzana that same day, informing him that the commission Corzana had entrusted to him for the sacristy of San Pablo would be ready in three weeks.[31] Cano's petition was quietly filed away, and nothing more was said on the matter. On June 8, 1630, as a further sign of confidence in Zurbarán, the Council itself commissioned him to paint a *Virgin of the Immaculate Conception* for the lower room of the City Hall.[32]

Thus, from the very beginning of his career in Seville, Zurbarán was the protégé of an important member of the junior branch of the family of the Dukes of El Infantado.[33]

Zurbarán, who is generally thought of in relation to his many monastic commissions, was in fact patronized as well by the nobility throughout his career.[34]

Zurbarán thus became a citizen of Seville, where he was accepted as a master painter by admirers who were conscious of his genius. For the Jesuits he painted the moving *Vision of the Blessed Alonso Rodríguez*, signed and dated 1630 (Academia de San Fernando, Madrid). Soon thereafter, he executed, for the Dominicans, the monumental *Apotheosis of Saint Thomas Aquinas*, signed and dated 1631 (Museo de Bellas Artes, Seville), a lively and powerful work in which tenebrism begins to give way to natural lighting. The famous *Still Life with Lemons, Oranges, and Cup* (Norton Simon Foundation, Pasadena), which is signed and dated 1633, still reflects Zurbarán's early tenebrist style.

In 1634, there came another major event in Zurbarán's life, undoubtedly the most important in his career for the influence it would have on his style: a sojourn in Madrid, the approximate length of which may be determined from several documents. On March 11, 1634, the painter was still in Seville, for he cosigned with his wife, Beatriz de Morales, a power of attorney for the settlement of a will in Llerena.[35]

On June 12, 1634, Zurbarán was in Madrid to receive an advance of 200 ducats toward the 1,100 ducats (12,100 reales) that he would receive for the cycle of twelve paintings of the Labors of Hercules for the Buen Retiro Palace. On August 9, he received another 200 ducats, and again on October 6; and then, on November 13, he signed a receipt for the last payment. The total eventually covered only ten pictures of the Labors of Hercules and two large compositions of the Defense of Cádiz, executed for the Hall of Realms in the Buen Retiro (see pp. 160–65).[36]

Did Zurbarán return to Seville at that time, or did he stay on in Madrid? Between November 1635 and August 1636, Zurbarán's career is documented only by the portrait *Don Alonso Verdugo de Albornoz* (cat. no. 46), on which the age of the sitter (born in 1623) is given as twelve years. Zurbarán was thus thirty-six years old when he went to the court of Madrid; he was already a recognized master in Seville. A commission from Philip IV was certainly an attraction. Furthermore, he knew that his friend Velázquez had won the favor of the king and that he enjoyed the protection of the all-powerful minister and favorite, the Count-Duke of Olivares, who was of Andalusian origin and had a particular predilection for things Sevillian.

This was a seminal trip for Zurbarán. Velázquez's example led him to renounce the tenebrist manner, and he could see for himself that Caravaggism was out of style at court. Italian painters such as Vicente Carducho and Angelo Nardi, or Italianate Spaniards such as Eugenio Cajés and Juan Bautista Maino, who were working at the court and for the religious communities of Castile at the time, all subscribed instead to a Tuscan brand of classicism sometimes mixed with Venetian influences. The Florentine Nardi particularly interested Zurbarán. We know that Nardi worked for a monastery in Jaén (Andalusia) and that he served, along with Velázquez's father, as a witness in Seville for Luis Méndez de Haro.[37] Finally, the work of the Bolognese painter Guido Reni must surely have represented an ideal for Zurbarán. His later works clearly reveal the inspiration of Reni's example.

Beginning in 1635–36, a distinct change in treatment and lighting may be observed in Zurbarán's work, even though the forms continue to be static and monumental and the compositions spare and simply ordered. The paintings for the altar of the Chapel of San Pedro in the Cathedral of Seville are dated to about 1635–36 for stylistic reasons. The light-colored skies and the more gently contrasting tonalities differ from Zurbarán's early style. Moreover, the mandorla of angels in the *Virgin of the Im-*

maculate Conception of about 1635–37 (cat. no. 25) seems to be partially inspired by the angels in Reni's 1627 version of the subject, which was later given by the king's sister to the Cathedral of Seville.[38]

On August 19, 1636, Zurbarán signed a contract for an altarpiece for the Church of Nuestra Señora de la Granada, in Llerena. In the preliminary information addressed by the parish priests to the supervisor of the military order of San Marcos de León, on whose jurisdiction they depended, they point out that Zurbarán is "Painter to the King," demonstrating that he already had this title at that date. According to the documents, Zurbarán offered to execute the paintings without remuneration out of devotion to the Virgin of Granada.[39]

In the same year, Zurbarán signed and dated the two famous canvases for the Church of San José of the Discalced Mercedarians, in Seville: *Saint Lawrence* (Hermitage Museum, Leningrad) and *Saint Anthony Abbot* (formerly Valdés collection, Bilbao), both of which feature luminous landscape settings. In 1637, he received payment for paintings executed for the parish church of Marchena, the fief of the Dukes of del Arcos.[40] During this period, commissions from outside Seville began to increase.

The first of these was the main altarpiece for the church of the Franciscan Monastery of La Encarnación at Arcos de la Frontera, a small town about forty miles from Jerez de la Frontera, where the Carthusians of Nuestra Señora de la Defensión had a large rural estate. Zurbarán signed the contract for this ensemble on May 26, 1637; it was finished in August 1638, but has unfortunately been lost.[41] Also in 1637, along with Alonso Cano[42] and Francisco de Arce, Zurbarán gave guarantees for the sculptor José de Arce, who was entrusted with work on the main altarpiece of the church of the Carthusian Monastery of Jerez de la Frontera. For that monastery, Zurbarán executed in 1638–39 a series of paintings (cat. nos. 26–33). In an inscription in the *Adoration of the Shepherds* (cat. no. 27), the artist specifies that he is painter to Philip IV. This series of works reveals an increasingly Italianate manner in the handling and classical drawing of certain forms, in particular the hands. However, the palette, the lighting, and the facial types are unique to Zurbarán.

Zurbarán's career in 1638 is richly documented. On March 5, 1638, his older daughter married Josef Gasso, a Valencian. According to the marriage contract, the artist's daughter was given a dowry valued at 2,000 ducats, or 22,000 reales.[43] The dowry evidently left Zurbarán in financial difficulty, for twelve days later he borrowed the same sum from a resident of Utrera. The loan was facilitated by the intervention of the Dominican friar J. B. Janel, from the Monastery of San Pablo el Real in Seville.[44] Of particular interest is the first documentary evidence of commissions for the colonial market, in the form of a power of attorney given to a resident of Lima to collect sums owed to the painter.[45] In 1638, Zurbarán signed and dated the magnificent *Saint Romanus and Saint Barulas* (Art Institute of Chicago), in which the figures appear to be placed in a real landscape setting. The year was one of wide-ranging activity; Zurbarán even participated in the decoration of a ship, a gift of the city of Seville to Philip IV.[46]

In early 1639, Zurbarán was waiting to receive 3,950 reales if "the galleons [from the Americas] return." The war between France and Spain that started in 1635 had a negative effect on maritime shipping between Spain and its possessions in the New World. This contributed to a fifteen-year decline in the economy of Seville, which had hitherto been the center of Spain's Atlantic trade.

The recently discovered contract for the paintings for the decoration of the sacristy

of the Hieronymite Monastery of San Jerónimo in Guadalupe was signed on March 2, 1639, by Zurbarán and Fray Felipe de Alcalá, vicar of the Hieronymite Monastery of Buenavista in Seville and agent for the prior of Guadalupe. The document demonstrates that this superb ensemble was executed in Seville, according to instructions sent by Fray Diego de Montalvo.[47] Evidently, monasteries of the same order could sometimes act as intermediaries between artists and patrons in distant regions. The undertaking took years to complete. Payment continued by installments until 1647. Certain works referred to have not been located. Zurbarán's paintings for the monastery at Guadalupe have the rare distinction of being the only large series by the artist to have remained *in situ*.

On May 29, 1639, the funeral of Beatriz de Morales was held at the Church of La Magdalena in Seville;[48] she was probably in her fifties, having first been married in 1605. Zurbarán did not remarry immediately. There were no longer any young children in the house, his elder daughter was married, and his second daughter and son Juan were unmarried and probably lived with him. On October 8, 1639, Zurbarán, who had maintained his relations with the court, wrote to the Marqués de las Torres, superintendent of the royal palaces, to confirm the dispatch to Madrid of twelve craftsmen skilled at gilding, "according to Your Lordship's orders . . . and to please the Count of Salvatierra [a relative of the Counts of Puebla del Maestre]." Clearly, Zurbarán's opinion in matters of gilding was highly regarded in Madrid, for he was entrusted with choosing the best *doradores*.[49] That same year, he signed and dated two superb works, the *Christ at Emmaus* (Museo de San Carlos, Mexico) and the *Penitent Saint Francis* (The National Gallery, London; see fig. 19, page 17).

On August 18, 1641, the twenty-year-old Juan de Zurbarán married Mariana de Quadros in the parish church of Santa Cruz in Seville.[50] The bride brought with her a comfortable dowry. Zurbarán's son was interested in improving his social status, for he began to frequent the dance academy and composed a sonnet in honor of Juan de Esquivel, the author of the *Discursos sobre el arte del danzado*, published in Seville in 1642. Juan de Zurbarán is now known as a painter of still lifes, but he must have undertaken the normal range of painting subjects as well. Some evidence for this is offered by the 1644 commission from the Confraternity of the Rosary of Carmona for the execution of two paintings.[51] He must also have served as an assistant to his father.

On February 10, 1642, Paula de Zurbarán filed a lawsuit against her father because of his unauthorized sale in 1640 of the house in Llerena that she had inherited from Beatriz de Morales.[52] She qualifies herself as a *doncella*, and so she had not yet married Captain Pedro Martínez de Soto, the mayor of Las Aduanas Reales, mentioned in 1659 as her husband.[53]

On January 17, 1643, there was a major political upheaval at court that had serious consequences for the Andalusian protégés of the Count-Duke of Olivares. Olivares, who had been the king's favorite, was exiled to Loeches and then to Toro, where he died. His request to be sent to San Lúcar la Mayor, near Seville, had been denied by Philip IV. Olivares's contemporaries were very harsh in their judgment of him, but modern historians have restored his reputation as a great statesman. "His twenty years in power represented Spain's last—and unsuccessful—effort at maintaining her position in Europe and avoiding catastrophe."[54] Olivares suppressed the attempted secession of Andalusia in 1641, banishing its leader the Duke of Medina Sidonia, captain-general of Andalusia, and executing one of his accomplices. The political suppression of Andalusia, coupled with a decline in maritime trade, contributed to the economic

problems of Seville. Then, too, many ecclesiastic and civil figures were deprived of the munificence and protection of Olivares. In the decade 1640–50, unemployment and poverty in Seville attained disquieting proportions, perhaps contributing to the spread of the plague in Andalusia in 1649.[55] A comparison between the volume of artistic commissions contracted for in Seville before 1640 with that from 1640 to 1650 reveals a definite downward trend. Murillo's series (ca. 1645–46) for the *claustro chico* (small cloister) of the Monastery of San Francisco el Grande, in Seville, is often cited as proof that the arts continued to thrive, but the young painter's remuneration was modest, and his emerging importance lent consequence to the project that it would not have had had it been executed by a minor artist.

The social and political environment of Seville had a significant effect on Zurbarán's circumstances at the time. Zurbarán was in no way at the rear guard of artistic taste, as has often been claimed, but was instead working entirely in the mode of the time. The exuberant Spanish Baroque style that developed between 1660 and 1680, inspired by the rediscovery of Rubens and Titian, was a later phenomenon. Spanish artists and patrons of the 1640s and 1650s favored the classicizing forms of the Italian Baroque that had developed around Andrea Sacchi (1599–1661). It was the style to which Zurbarán then subscribed. In this decade, therefore, he was perfectly in step with the aesthetic sensibilities of his day. If he decorated fewer churches, it was simply because there were fewer patrons and there was less money to be spent upon the arts, not because his style was passé.

On May 16, 1643, Don Alonso de Salas Parra, an important figure in the town of Zafra (Badajoz), founded the Chapel of Nuestra Señora de los Remedios in the local collegiate church. Zurbarán was commissioned to execute the paintings for the altarpiece, which was finished in 1644 and is still today *in situ*.[56]

In the summer of 1643, Leonor de Tordera, the daughter of a goldsmith and the widow of Diego de Sotomayor (who had died in Puebla, Mexico), moved to the parish of La Magdalena in Seville, not far from Zurbarán's house. On January 24, 1644, Zurbarán received official permission to marry her, and the wedding was held on February 7.[57] Leonor de Tordera was twenty-eight years old, Zurbarán forty-six. The witnesses were Josef Gasso and Juan de Zurbarán. Leonor's brothers pledged to reconstitute the dowry of 27,300 reales that had gone into her first marriage. In spite of the couple's many changes of residence in Seville, six of their children were baptized in the parish church of the Sagrario, a dependency of the Cathedral of Seville. The first child, a daughter, Micaela Francisca, was born in 1645; a son, José Antonio, was born the following year.[58]

During the three first years of his marriage, Zurbarán continued to receive payments from the Monastery of Guadalupe.[59] In 1647, there are records of important commissions from Peru. Zurbarán signed a receipt for 2,000 pesos (16,000 reales) from the abbess of the Convent of La Encarnación, in the city of Los Reyes (Lima), for thirty-four paintings to be completed by the spring of 1648; among them were twenty-five life-size images of virgin saints.[60] On the same day, the painter was paid 1,000 pesos for paintings that were also destined for sale in Los Reyes.[61] In September of that year, Zurbarán gave power of attorney to Antonio de Alarcón, of Lima, to collect payment for twelve representations of Caesar on horseback entrusted to Captain Andrés Martínez for sale in Peru;[62] and during 1647, the painter continued to receive sums from Captain Valverde, agent for the Convent of La Encarnación in Los Reyes (the same city in which Antonio de Morales, a brother of Beatriz de Morales, had es-

tablished himself).[63] The colonial market thus constituted an important part of Zurbarán's activity, as it had for the ten years preceding, possibly because of the diminishing flow of commissions in Seville during that decade. Murillo received no more important commissions before 1652; Alonso Cano moved to Madrid in 1638; and Herrera the Elder was working in Madrid probably from 1650 on. Patrons must have been hard to come by in Seville at the time.

In July 1647, Zurbarán gave power of attorney to a correspondent in Llerena to collect a debt and to use the money to buy 50 fanegas of wheat (about 80 bushels) to be sent to him in Seville "for the needs of my household."[64] Perhaps the food shortage in Seville was such that the artist had to have provisions sent from his native Extremadura. In any case, Zurbarán's family was growing: on February 9, 1648, another daughter, Juana Micaela, was baptized in the parish church of the Sagrario.[65]

Zurbarán's life is sparsely documented in 1648, except for financial claims, either from his landlords or to his clients. For example, he requested permission from the administrators of the Alcázar to transfer to his heirs the house he had leased "for life" in 1645, because of the expenses he had incurred for improvements.[66]

On December 3, 1648, he received an advance of 1,152 reales from Lorenzo de Cardenas, the Count of la Puebla del Maestre, Royal Governor of Seville, for "all of the paintings that I have sold to him until this day,"[67] which suggests, as Guinard surmised, that Cardenas was a regular patron. And if so, he was a patron who represented the royal house, and not merely a high official of Seville.

On February 28, 1649, Zurbarán's correspondents in Buenos Aires signed a receipt of sale for an interesting order: fifteen pictures of "Virgin Martyrs," fifteen "Kings and Famous Men," twenty-four "Saints and Patriarchs" (all life-size), nine "Dutch Landscapes," three kilos of pigments, and some paintbrushes. Several canvases arrived in damaged state.[68] Considering the difficulty of transporting goods at that time, Zurbarán's commerce with the New World is astounding. He must surely have had a large number of apprentices or assistants to fill these orders.

In the middle of the seventeenth century, a plague again ravaged western Europe. It reached Spain between 1649 and 1652, and England in 1655. Seaports were nearly always hardest hit, because boats trading with the Orient, where the plague was pandemic, returned with infected vermin in their shipments. In April 1649, the flooding of the Guadalquivir—which submerged the Seville neighborhood of Triana—and the hot season that followed caused the dramatic spread of the epidemic in Seville. In just a few months, more than half the population of the city perished. Entire families were wiped out, houses were abandoned, and commerce was paralyzed. Survivors fended for themselves as best they could, each day burying their dead. In the spring of 1649, those stricken with the disease did not even have time to draw up their wills, and postmortem inventories were no longer taken.[69]

In June and July of 1649, the plague seems to have reached its climax. One of its victims may have been Juan de Zurbarán, the painter's twenty-nine-year-old son. He died June 8, 1649, leaving two small children.[70] We do not know whether any of Zurbarán's then living children by Leonor de Tordera succumbed to the disease. There is no further trace of their existence in the following years. Nor are there any documents or letters that bear witness to the dark hours that the painter must have lived in that terrible year.

In 1650, however, another son, Marcos, was born; he was baptized on April 9, as usual in the Sagrario parish church.[71] This is the only known document relating to

Zurbarán's life in that year, except for a payment voucher for the sum of 600 reales dated March 28, 1650, for the portraits of the sons of the Marqués de Villanueva del Rio.[72]

Between early April 1650 and May 31, 1652, there are no known documents relating to Zurbarán. The trip to Madrid in 1650 mentioned by Palomino cannot be substantiated.[73] In any event, the *Annunciation* (cat. no. 58) painted for Gaspar de Bracamonte, Count of Peñaranda, is signed and dated 1650 and was sent to the Church of Peñaranda in 1658.[74] The painting is an important work; it proves that by that date, Zurbarán had completely adopted a softer sfumato treatment, relaxing the rigidity of forms that he had earlier employed.

On May 31, 1652, Zurbarán transferred his house at the Alcázar to Manuel Guías for the sum of 22,000 reales.[75] He was then living on Calle San Gregorio, between the Casa de Contratación and the College of Maese Rodrigo, not far from the cathedral, which is why his children were baptized in the Sagrario parish. There a son named Eusebio was baptized on November 8, 1653.[76] That year, Zurbarán signed and dated the *Christ Carrying the Cross* (cat. no. 61). It is thought to have been painted in Madrid and displays a marked evolution in style and a softer handling.

In 1655, another daughter was born. Agustina Florencia was baptized on November 2.[77] Zurbarán was fifty-seven years old. In the same year, Zurbarán painted, for the Carthusian Monastery of Las Cuevas, in Seville, the three large compositions that decorated the sacristy (see pp. 218–33).[78] The contract for this commission has not been found, and the style and handling of these works have given rise to a lively debate that is far from being settled. We know that the Carthusians of Seville played an important role in the struggle against the plague from 1649 to 1652 and that they helped many victims. The plague had not taken a great toll among the monks, so they may, out of gratitude, have commissioned Zurbarán to paint these works as a sort of ex-voto.

Duncan Kinkead's research in the archives of Seville has helped us to fill in the gaps in the years 1655 to 1658, during which time Zurbarán seems to have conducted many real-estate transactions. In January 1655, he leased to Francisco Borio, a baker, a bread oven he owned in the San Gregorio court;[79] on February 27, 1655, Antoine Martin, a Frenchman living in Seville, leased a millstone and two lodgings (or rooms) belonging to Zurbarán;[80] on March 12, 1655, Juan Gonzales, a trader, leased a house with a shop on Calle San Gregorio, the street on which Zurbarán lived;[81] and on May 18, 1655, the painter sublet the *casas principales* on Calle San Rosario for two years to Francisco de Salas Infante for the sum of 2,500 reales per year.[82]

In 1656, Zurbarán signed and dated a *Virgin of the Immaculate Conception* (cat. no. 64), the lower portion of which is based on an engraving after Guido Reni; the painting thus stands as a kind of artistic manifesto in homage to the Bolognese school. The model for the figure of the Virgin in this painting may have been Zurbarán's daughter Manuela. Manuela is mentioned in a deed signed on October 19, 1657, by Zurbarán's wife, Leonor de Tordera, and the cathedral chapter, making her and Manuela (then aged about seven) tenants for life of the main houses owned by the chapter on Calle Abades.[83] The street, on the right side of the Bishop's Palace, was considered a prestigious address. The Zurbarán family was living on Calle Abades as early as 1656.[84] They continued to live there in 1657 and 1658.[85]

Between spring and autumn 1658, four of the leading Andalusian painters of the period were in Madrid. The three elders were Diego de Velázquez, *aposentador* of the royal palaces; Alonso Cano, who, after a hard struggle and with the protection of the king, had just obtained the position of *racionero* (prebendary) at the Cathedral of Gra-

nada, and who had been living in the capital since February or March 1657;[86] and Francisco de Zurbarán, who testified on December 23, 1658, for Velázquez in the investigation of Velázquez's qualifications for membership in the Order of Santiago.[87] At that time, Zurbarán declared that he had been in Madrid for seven months, that is, since late May 1658. The presence of the somewhat younger Bartolomé Esteban Murillo (1617–1682) in Madrid is attested between April 30 and December 1, 1658,[88] although he probably arrived there earlier. Zurbarán may have gone to Madrid to seek work, but this is not proven. However, Murillo, following his triumphant *Saint Anthony*, done for the Cathedral of Seville in 1655, probably did not then have to look for commissions elsewhere. This congregation of Sevillian artists in Madrid may reflect Velázquez's intention of gathering his old colleagues to work on the decoration of the royal palaces. In any event, Cano returned to Granada on June 25, 1660, six weeks before the death of Velázquez.[89] Zurbarán alone remained in Madrid. The legendary jealousy of Zurbarán for Murillo is belied by a letter that Zurbarán addressed to the younger painter in Madrid and on the back of which the latter did a fine drawing for a *Virgin of the Immaculate Conception* (Museo del Prado, Madrid).[90]

In Madrid, Zurbarán resumed painting in 1658. The signed and dated works from this point in his career were generally dismissed by his early critics, but they merit reappraisal, for they demonstrate that the artist's creative powers were not dulled by the years, despite political, social, and economic upheavals, and that he was able to evolve toward a bold new style. Most of these late paintings are smaller than the great compositions of the Seville period and were probably intended for private chapels; their original locations have not been determined.[91] We also know that Zurbarán worked for the Monastery of San Diego de Alcalá, in Alcalá de Henares; two paintings from that commission are the *Visit of Saint Thomas Aquinas to Saint Bonaventure* (cat. no. 41) and the *Saint James of the Marches* (Museo del Prado, Madrid).

On August 1, 1659, Zurbarán and his wife sent their power of attorney from Madrid to Jerónimo de Tordera, Leonor's uncle, in order to settle the problem of the house on Calle del Rosario, rented jointly with Zurbarán's daughter Paula in 1641, which belonged to the Monastery of San Jerónimo de Buenavista, in Seville. In 1655, Zurbarán had sublet this house for two years. Perhaps he had not been able to find a new tenant thereafter, because in August 1659 he was three and a half years overdue on the rent, for a total of 6,000 reales. He proposed to reimburse this sum to the monastery in the form of twenty paintings that were in his possession: twelve "Patriarchs" of 2 varas each, an "Archangel Saint Michael" and a "Virgin with an Angel Offering Her Flowers" (probably an *Annunciation*) of 2½ varas each, " Saint Peter's Vision of Christ at the Column," a "Child Christ in the Arms of the Virgin," two pictures of the "Flight into Egypt" of 2 varas, an "Our Lady of the Waters," and an "Our Lady" of ⅔ vara—all of which would become the property of Fray Sebastián de Villanueva if the 6,000 reales were not paid by December. In another legal document, Zurbarán rescinded the lease that had bound him to the Hieronymite monastery in Seville "for life."[92]

In 1660, Zurbarán had still not received the money owed to him for the shipment of paintings made to Buenos Aires back in 1649. He renewed his claim in 1662, giving power of attorney to his brother-in-law Miguel de Tordera.[93]

On May 1, 1663, having probably decided that he would not return to Seville, Zurbarán and his wife gave up the house on Calle Abades that had been leased "for life" by Leonor de Tordera and Manuela, the only surviving child from his third marriage. In this action, he gave power of attorney to his eldest daughter, María, his child by María Páez.[94]

On July 24, 1664, he was entrusted with the evaluation of the property of the ambassador to Poland, Francisco Bivoni, a task that was interrupted by Zurbarán's death on August 27, 1664; he was sixty-five years and nine months of age, and had drawn up his will before a notary on the eve of his death.[95] On his deathbed, the painter was yet strong enough to proclaim his faith, stating: "Praised be the Most Holy Sacrament and the pure and spotless Conception of Our Lady the Virgin Mary, conceived without stain of original sin." He added that he was sick and bedridden, "but of sound mind," and that he wished to be buried at the Madrid Church of the Discalced Augustinians (the famous Recollects who had a chapel dedicated to the Virgin of Copacavana, whose cult was very popular in Madrid).[96] He then listed his debtors, in particular his daughter María, married to Josef Gasso, who was then in the West Indies and owed him 8,000 reales. He asks his wife to pardon him for not being able to restore her dowry and entreats his two daughters not to trouble her before this debt is repaid. The will makes clear that Zurbarán's two daughters by his first marriage were his only surviving children; all his children from his third marriage had died.[97]

Leonor de Tordera probably did not leave Madrid immediately after Zurbarán's death, because although the postmortem inventory of his estate was taken in 1664, the final evaluation of his property was not made until 1665.[98] Some scholars, surprised at the apparent paucity of household furnishings owned by Zurbarán at his death, have concluded that he died in poverty. But in fact, the painter's house was as well furnished as that of any of his contemporaries of the same social class.[99] Zurbarán had acquired several valuable pieces, including two large tortoiseshell cabinets with bronze mounts, an ebony cabinet decorated with mother-of-pearl, two mirrors, six chairs upholstered with brocatelle, velvet and damask cushions for a dais, a Cairo carpet more than three meters long, and seven narrative tapestries (some worn).[100] Nor are these all the precious furnishings Zurbarán owned when he died. In the preliminary inventory of 1664, Leonor de Tordera mentions jewels and other precious objects in her possession, and the final evaluation of Zurbarán's property, done the following year, suggests that his fiscal worth was no different from that of Murillo, for example, or of Goya in 1812. It is important to remember that at his death Zurbarán was a creditor, not a debtor. Evidently, he did not contract any debts in Madrid, so he must have had a regular income. In addition, there were several paintings left in Zurbarán's workshop.[101] The inventory also mentions nine primed canvases, a stone for grinding pigments, two easels, and about sixty engravings.

Zurbarán lost wives and children with a painful frequency little experienced today. His private woes must have been exacerbated by the death in 1660 of his faithful and all-powerful friend Velázquez, the decline from 1660 to 1665 of Philip IV, and the trend in Spanish art of the last third of the seventeenth century toward dramatic religious imagery, a trend little suited to Zurbarán's reserved but powerful mode of expression. None of these difficult circumstances, however, interfered with his creative capacities. In this last period, when the contribution of his workshop, once so significant, had become almost negligible, Zurbarán himself filled his canvases with poetic visions, aided by a flawless mastery of the art of painting acquired over many years of untiring labor. Guinard describes this time as "a last stage, when the virile painter of ascetics and mystics, now a weary old man, withdrew, hestitated, and sang his song before advancing into the mysterious shadows of night."[102] Withdrew? Perhaps Zurbarán had rather embarked on a new aesthetic exploration.

NOTES

1. In a document dated May 4, 1600, Luis de Zurbarán is described as a *tendero* (merchant). Antonio Manzano Garías, "Aportación a la biografía de Zurbarán," *Revista de Extremadura* (Badajoz), suppl. 1947, pp. 20–21.

2. Zurbarán's baptismal certificate was published for the first time (in facsimile) by Salvador Viniegra, in Madrid, Museo del Prado, *Catálogo oficial ilustrado de la exposición de las obras de Francisco de Zurbarán* (exhib. cat., 1905), p. 5. There the painter's father is clearly called Luis de Zurbarán. The artist later signed many documents "Zurbarán Salazar" (not "y Salazar"), but we do not know where he got the name "Salazar."

3. Antonio Palomino, *El museo pictórico y escala óptica* (1715–24; reprint, Madrid, 1947), p. 194.

4. José Cascales y Muñoz, *Francisco de Zurbarán* (Madrid, 1911), pp. 197–201.

5. María L. Caturla, "Zurbarán en Llerena," *Archivo español de arte* 20 (1947), p. 266. It is supposed that they were married the previous spring, but no marriage certificate has been found in Llerena. Most of what we know of Zurbarán's biography we owe to María L. Caturla, who devoted many years to searching patiently in the archives for documents concerning the painter and his family.

6. *Ibid.*, p. 268.

7. *Ibid.*, p. 269. M. L. Caturla was not herself able to consult the parish archives of Llerena; the document was communicated to her by Arturo Gazul, the local archivist, who assured her that in the register of the Confraternity of Vera Cruz, the profession of Bartolomé Páez was corrected from *capador* (gelder) to *contador* (accountant). The profession of *capador* was not an insignificant one in sixteenth-century Spain. In later documents, María Páez added "Siliceo," the name of an important family in the region, to her name.

8. M. L. Caturla, in Madrid, Casón del Buen Retiro, *Exposición Zurbarán en el III centenario de su muerte* (exhib. cat., 1964), p. 17.

9. Caturla 1947, p. 281.

10. *Ibid.*, p. 284.

11. *Ibid.*, p. 270.

12. Manzano Garías 1947, pp. 19–20.

13. Recent examinations have proven that the *Virgin of the Immaculate Conception* in the Arango collection, previously thought to be dated 1616, is in fact dated 1656; see cat. no. 64. August L. Mayer, *Historia de la pintura española*, 2d ed. (Madrid, 1942), p. 328, mentions a *Christ before the Column with a Dominican Donor* in a private collection in Hamburg, described as in the tenebrist style and supposedly dated 1620, but the painting is known only through a poor photograph.

14. Caturla 1947, p. 270.

15. On February 27, 1624, Beatriz de Morales is still mentioned as the legal wife of Francisco Benavente, her first husband. On July 17, 1626, another document states that García de Morales had given power of attorney to Beatriz de Morales, "mujer que fué de Francisco de Benavente difunto y agora lo es de Francisco de Zurbarán" (the wife of the late Francisco de Benavente and now of Francisco de Zurbarán).

16. Jesús M. Palomero Páramo, *El retablo sevillano del Renacimiento* (Seville, 1983), p. 30.

17. Caturla, in Madrid, Casón del Buen Retiro, 1964, p. 22.

18. Archivo de Protocolos, Seville, *Oficio* 19, Alonso de Alarcón, 1626, book 1, fol. 352, cited in José Hernández Díaz, "Materiales para la historia del arte español," *Documentos para la historia del arte en Andalucía* 2, 1928 (1930), p. 182.

19. Palomero Páramo 1983, p. 368.

20. Archivo de Protocolos, Seville, *Oficio* 11, Aug. 29, 1628, cited in Celestino López Martínez, *Notas para la historia del arte: Desde Martínez Montañés hasta Pedro Roldán* (Seville, 1932), p. 221.

21. Harold E. Wethey, *Alonso Cano: Pintor, escultor, arquitecto* (Madrid, 1983), p. 25; and Hernández Díaz 1930, p. 189.

22. Lázaro Díaz del Valle y de la Puerta, "Origen yllustración del nobilissimo y real arte de la pintura y dibujo . . . ," in Francisco J. Sánchez Cantón, *Fuentes literarias para la historia del arte español* (Madrid, 1933), II, pp. 387–90.

23. Enrique Valdivieso and Juan M. Serrera, *Historia de la pintura española: Escuela sevillana del primer tercio del siglo XVII* (Madrid, 1985), p. 40. Francisco Pacheco's *Arte de la pintura* was published in 1649, five years after the death of the author. On the important cultural role played by Pacheco, see the essential study by Jonathan Brown, *Images and Ideas in Seventeenth-Century Spanish Painting* (Princeton, 1978), pp. 21–83.

24. Don Diego Hurtado de Mendoza belonged to a junior branch of the family of the Dukes of El Infantado, reputed for its culture and artistic taste. He became Viscount of La Corzana in 1639.

25. Cascales y Muñoz 1911, p. 202.

26. Paul Guinard, *Zurbarán et les peintres espagnols de la vie monastique* (Paris, 1960), p. 63, note 90.

27. C. López Martínez, *Notas para la historia del arte: Retablos y esculturas de traza sevillana* (Seville, 1928b), pp. 6–8.

28. José Gestoso y Pérez, *Ensayo de un diccionario de los artífices que florecieron en Sevilla desde el siglo XIII al XVIII inclusive*, 3 vols. (Seville, 1899–1908), II, p. 125.

29. *Ibid.*

30. Guinard 1960, p. 44.

31. Mariano Rodríguez de Rivas, "Autógrafos de artistas españolas," *Revista española de arte* 1 (1932), p. 238.

32. P. Guinard, "Los conjuntos dispersos o desaparecidos de Zurbarán: Anotaciones a Ceán Bermúdez," *Archivo español de arte* 22 (1949), p. 9. The conception of the present exhibition owes much to the series of articles published by Paul Guinard between 1946 and 1949 on the reconstruction of the ensembles painted by Zurbarán.

33. This might explain the presence later of paintings by the artist not far from Guadalajara (Castile), the fief of the Mendozas. We know that the ducal palace of the Infantados is in Guadalajara. There are two paintings by Zurbarán preserved in the province of Guadalajara, a signed *Christ after the Flagellation*, 1661 (parish church, Jadraque), and a *Virgin of the Immaculate Conception* (cat. no. 55).

34. It may have been through the Viscount of La Corzana that Zurbarán came into contact with Alonso Verdugo de la Cueva y Sotomayor, one of the Twenty-Four of Seville and a brother-in-law of Cardinal Gil de Albornoz. Moreover, Francisco Dávila, Marqués de la Puebla de Ovando, who was later related to the family of the Counts of Puebla del Maestre, was an *asistente* of Seville before 1629, and it was a Marquesa de la Puebla de Ovando who gave to the Convent of the Esclavas Concepcionistas in Seville the beautiful *Virgin of the Immaculate Conception* by Zurbarán that is today in the Prado. See José Sebastián y Bandarán, "Una Inmaculada de Francisco de Zurbarán," *Archivo hispalense*, no. 64–65 (1954), p. 1. Also, Francisco Páez, the artist's brother-in-law, had power of attorney for a Mendoza, the dowager Countess de la Puebla, and later Zurbarán would refer to the many commissions from the Count of Puebla de Maestre. Archivo de Protocolos, Seville, *Oficio* 16, Dec. 3, 1648, book 2, fol. 563, cited in Guinard 1960, p. 65, note 157.

Finally, Alfonso de Bracamonte, the father of Gaspar de Bracamonte, Count of Peñaranda (Castile), for whom Zurbarán worked in 1650, was Captain General of Seville at the time. The names of these noblemen and their descendants figure at the end of Zurbarán's career. It would therefore be useful to review the history of these various Castilian patrons, for it might explain the reasons—apart from the presence of Velázquez in Madrid—for Zurbarán's trips to the court in 1634, 1650, and 1658.

35. C. López Martínez, *Notas para la historia del arte: Arquitectos, escultores, y pintores vecinos de Sevilla* (Seville, 1928a), p. 215.

36. See M. L. Caturla, "Cartas de pago de los doce cuadros de batallas para el Salón de Reinos del Buen Retiro," *Archivo español de arte* 33 (1960), pp. 333–55.

37. *Varia velazqueña*, edited by Antonio Gallego y Burín, 2 vols. (Madrid, 1960), II, p. 330.

38. Alfonso E. Pérez Sánchez, *Pintura italiana del siglo XVII en España* (Madrid, 1965).

39. Guinard 1960, p. 64, note 111.

40. J. Hernández Díaz, "Los Zurbaranes de Marchena," *Archivo español de arte* 26 (1953), pp. 31–36.

41. López Martínez 1932, p. 222; Guinard 1960, p. 64, note 118.

42. López Martínez 1928a, p. 25.

43. The marriage contract, which tells us that the mother of María de Zurbarán was named Páez and not Morales, was the starting point for María L. Caturla's research on the genealogy of the Páez family. See Caturla 1947, p. 265, and Guinard 1960, p. 62, note 61. The marriage contract, dated January 16, 1638, has not yet been fully published.

44. Guinard 1960, p. 51 and p. 65, note 126.

45. *Ibid.*, p. 50 and p. 64, note 123.

46. Narciso Sentenach y Cabañas, "Francisco de Zurbarán, pintor del Rey," *Boletín de la Sociedad Española de Escursiones* 17 (1909), p. 195.

47. Peter Cherry, "The Contract for Francisco de Zurbarán's Painting of Hieronymite Monks for the Sacristy of the Monastery of Guadalupe," *Burlington Magazine* 127 (1985), pp. 378–81. Peter Cherry, now preparing his doctoral dissertation "Still-Life and Genre Painting in Spain in the First Half of the Seventeenth Century," discovered this important document: Archivo de Protocolos, Seville, *Oficio* 18, 1639, book 5, pp. 603–8. The contract mentions only seven paintings, although there are eight in the present ensemble. One of them, the *Mass of Father Cabañuelas*, is signed and dated 1638. Zurbarán therefore executed and was paid for a first work prior to the contract for the other pictures. He received 1,050 reales for each of the seven paintings in the contract.

48. Gestoso y Pérez 1899–1908, II, p. 126. The house on Calle del Rosario, which was in the parish of La Magdalena, was probably leased to Zurbarán by the Hieronymites of Seville, possibly at the time of the commission for Guadalupe.

49. Sentenach y Cabañas 1909, p. 197; Archivo General de Palacio, Madrid, box 9393, doc. 5. Our thanks to Véronique Gérard-Powell for providing us with the manuscript text of this document.

50. M. L. Caturla, *Don Juan de Zurbarán* (Madrid, 1957), p. 9, believes that the father of Mariana de Quadros was a moneylender, although the evidence for this is slight.

51. *Ibid.*, p. 21.

52. *Oficio* 13, 1640, and *Oficio* 21, 1642, both cited in López Martínez 1932, p. 223.

53. Duncan T. Kinkead, "The Last Sevillian Period of Francisco de Zurbarán," *Art Bulletin* 65 (1983), p. 310.

54. Jean P. Le Flem *et al.*, *La frustración de un imperio (1676–1714)*, Historia de Espagna, vol. 5, edited by Manuel Tuñon de Lara (Barcelona, 1982), p. 225. See also J. H. Elliott, *The Count-Duke of Olivares: The Statesman in an Age of Decline* (New Haven and London, 1986).

55. Antonio Domínguez Ortiz, *Orto y ocaso de Sevilla* (Seville, 1946), p. 86.

56. M. L. Caturla, "Conjunto de Zurbarán en Zafra," *A.B.C.* (Madrid), Apr. 20, 1948; and *idem*, "A Retable by Zurbarán," *Burlington Magazine* 94 (1952), pp. 44–49.

57. Santiago Montoto, "Zurbarán: Nuevos documentos para ilustrar su biografía," *Arte español* 5 (1921), p. 403.

58. Guinard 1960, p. 54.

59. Arturo Alvarez, "Madurez de un arte: Los lienzos de Guadalupe," *Mundo hispánico*, no. 197 (1964), pp. 51–57, publishes documents from the archives of Guadalupe which demonstrate that payments were made between 1638 and 1647. In 1638, Zurbarán received for a painting the first payment of 1,299 reales; between

April and August 1639, a second payment of 15,700 reales; in 1640, payment of the balance for the sacristy, 1,040 reales; in 1643, payment of 449 reales; in 1645, 2,961 reales for a *Saint Jerome*; in 1646, 1,000 reales for a painting of angels, the balance of which, 200 reales, was paid in 1647.

60. Archivo de Protocolos, Seville, *Oficio* 14, cited in López Martínez 1932, p. 224.

61. Archivo de Protocolos, Seville, *Oficio* 8, cited in López Martínez 1932, p. 224.

62. López Martínez 1932, pp. 224–25.

63. F. Castón, "Zurbarán y la casa de los Morales-Llerena," *Revista de Extremadura* 3 (1947), p. 438.

64. Archivo de Protocolos, Seville, *Oficio* 8, cited in López Martínez 1932, p. 224.

65. Guinard 1960, p. 54.

66. Montoto 1921, p. 403.

67. Archivo de Protocolos, Seville, *Oficio* 16, Dec. 3, 1648, book 2, fol. 563, cited in Guinard 1960, p. 56, and p. 65, note 157.

68. M. L. Caturla, "Zurbarán exporta a Buenos Aires," *Anales del Instituto de Arte Americano e Investigaciones Estéticas*, no. 4 (1951), pp. 27–30.

69. Caturla 1957, p. 22.

70. *Ibid.*, p. 21.

71. Guinard 1960, p. 54.

72. Archivo de Protocolos, Seville, *Oficio* 21, Mar. 28, 1650, book 1, fol. 669, cited in Guinard 1960, p. 56, and p. 65, note 158.

73. Palomino 1724 (1947 ed.), p. 938.

74. The date 1650, discovered by Jonathan Brown and cited in J. Brown, *Francisco de Zurbarán* (New York, 1974), p. 140, is proof that the picture was painted eight years before it was sent to Peñaranda. Gaspar de Bracamonte had been the ambassador plenipotentiary of Spain to the Congress of Münster in 1648 for the signing of the Peace of Westphalia; he was considered one of the best diplomats of Spain. It should be noted that if Zurbarán made a trip to Madrid between 1650 and 1652, it would surely have been at the request of someone of the stature of Bracamonte, and not Velázquez, who had by then left for Italy.

75. Unpublished document found in the Archivo de Protocolos by C. López Martínez, cited in Guinard 1960, p. 65, note 162.

76. Archives of the Sagrario parish, Baptism, book 41 (1651–55), fol. 115, cited in Guinard 1960, p. 57, note 166.

77. Archives of the Sagrario parish, Baptism, book 42 (1655–60), fol. 1, cited in Guinard 1960, p. 57, note 166.

78. Baltasar Cuartero y Huerta, *Historia de la Cartuja de Santa María de las Cuevas, de Sevilla, y de su filial de Cazalla de la Sierra*, 2 vols. (Madrid, 1950–54), II, pp. 16, 17.

79. Kinkead 1983, p. 308, doc. 1. Kinkead demonstrates (p. 305) that Andrés M. Calzada y Echevarría and Luys Santa Marina, in their book *Estampas de Zurbarán* (Barcelona, 1929), used and misinterpreted documents from archives without citing their references.

80. Kinkead 1983, p. 309, doc. 2.

81. *Ibid.*, docs. 3, 4.

82. *Ibid.*, doc. 5.

83. *Ibid.*, doc. 6.

84. Montoto 1921, p. 401.

85. In 1657, Manuel Rodríguez, a fifty-year-old painter, acted as a witness in a suit between the Morales heirs. He stated that he had seen members of the Morales family at the home of Zurbarán and his wife Beatriz de Morales, where he was then living and learning the art of painting. See Castón 1947, p. 440.

86. Wethey 1983, p. 32.

87. *Varia velazqueña*, 1960, II, p. 329.

88. Diego Angulo Iñiguez, *Murillo: Su vida, su arte, su época*, 3 vols. (Madrid, 1981), II, p. 45.

89. Wethey 1983, p. 33.

90. D. Angulo Iñiguez, "Murillo: Varios dibujos de la *Concepción* y de *Santo Tomás de Villanueva*," *Archivo español de arte* 35 (1962), pp. 233–36.

91. These paintings are the *Virgin Nursing the Christ Child* (Pushkin State Museum of Fine Arts, Moscow), the *Veil of Saint Veronica* (cat. no. 65), and the *Virgin and Child with Saint John the Baptist* (cat. no. 66), all of which are signed and dated 1658; the *Repentance of Saint Peter* (Museo José Luis Bello, Puebla, Mexico), the *Virgin and the Sleeping Christ Child* (private collection, Madrid), *Saint Francis Kneeling with a Skull* (cat. no. 67), and the *Rest on the Flight into Egypt* (cat. no. 68), all signed and dated 1659; the *Portiuncula* (private collection, New York), *Christ after the Flagellation* (parish church, Jadraque), the *Virgin of the Immaculate Conception* (Szépművészeti Múzeum, Budapest), and the *Virgin of the Immaculate Conception* (cat. no. 70), all signed and dated 1661; and the *Virgin and Child with Saint John the Baptist* (cat. no. 71), signed and dated 1662.

92. Kinkead 1983, p. 302, docs. 9, 10, 12.

93. Caturla 1951, p. 28.

94. Kinkead 1983, p. 302, doc. 11.

95. M. L. Caturla, *Fin y muerte de Francisco de Zurbarán* (Madrid, 1964). In this book, Caturla publishes Zurbarán's last will and testament and the postmortem inventory of his property.

96. Antonio Ponz, *Viaje de España* (1772–94; reprint, Madrid, 1947), p. 425. In the church of the Recollects, there was the tomb of one of the descendants of the Counts of Salvatierra.

97. Caturla 1964, p. 15; Leonor de Tordera declares in the first paragraph of the 1665 inventory that she is without children from her marriage with Zurbarán ("sin dejar hijos del matrimonio").

98. *Ibid.*, p. 19.

99. *Ibid.*, p. 24. M. L. Caturla, in her biography of Zurbarán, in Madrid, Casón del Buen Retiro, 1964, writes (p. 56), "This document [the postmortem inventory] shows the poverty in which the painter found himself at his death . . . everything is worn or secondhand." However, after studying Zurbarán's inventory for her subsequent publication, *Fin y muerte de Francisco de Zurbarán*, she revised her opinion: "We should observe with some astonishment that this was not the home of a poor man . . . there were pieces of furniture of a certain luxury . . . two of them made of tortoiseshell" (Caturla 1964, p. 24).

100. Daniel Alcouffe, Conservateur en Chef, Department of Decorative Arts, Musée du Louvre, Paris, a specialist in seventeenth-century Spanish furniture, has confirmed the importance and rarity of such furniture in a seventeenth-century middle-class interior.

101. The "Virgin and Child and Saint Joseph," described as being "2 varas," is a bit too large to correspond to the painting now in Budapest. The *Inmaculada* of 2½ varas could be either the *Virgin of the Immaculate Conception* of 1656 in the Arango collection (cat. no. 64), or that of 1658 in a private collection in London.

102. Guinard 1960, p. 60.

MAJOR COMMISSIONS

*Catalogue written by Jeannine Baticle,
with the assistance of Odile Delenda,
Denise Devinat, Véronique Gérard-
Powell, and Claudie Ressort.*

THE MONASTERY OF SAN PABLO EL REAL, SEVILLE

According to tradition, the Dominican Monastery of San Pablo el Real, in Seville, was founded in the thirteenth century by Ferdinand III. In 1353, King Peter I favored it with generous alms to be used for repairs. Contrary to what has often been claimed, the church of the monastery (today the parish church of La Magdalena) was not entirely destroyed and then rebuilt at the end of the seventeenth century. In fact, only the cupola collapsed. This, however, resulted in the ruin not only of the choir but also of the crossing and the adjoining sections. In 1691, Fray Juan de la Barrera was designated by the community to be administrative supervisor for reconstruction, and he in turn called in the great Sevillian architect Leonardo de Figueroa. The architectural plan was determined by the existing structures; Figueroa respected the basilical plan with three naves, and he preserved the polygonal apse and the lateral chapels that opened at right angles on the arms of the transept. To preserve the sections of the wall on the right side, which dated to the Middle Ages, he was obliged to heighten the vaulting over the lateral naves and to give unusual height to the new cupola over the crossing.[1] Thus, the sacristy was not altered and, according to both Ponz and Ceán Bermúdez, still included a small oratory.[2] This is also supported by a document of 1629 which states that a painting had just been completed for "the sacristy of the Monastery of San Pablo," which had itself been built only five years earlier.[3]

Like most other orders in Seville in the first third of the seventeenth century, the Dominicans of San Pablo decided to glorify their monastic founder. Accordingly, on January 17, 1626, Zurbarán was commissioned to provide "twenty-one pictures for 4,000 reales, fourteen on the life of Saint Dominic, four of the Doctors of the Church, and one each of Saint Bonaventure, Saint Thomas, and Saint Dominic." This contract, published only in 1930, is of primary importance; it is the earliest known document concerning one of Zurbarán's commissions, and it informs us that in 1626 the artist was qualified as a *pintor de ymaginería* (painter of imagery) and was still living in Llerena.[4]

Only three of the four paintings of the Doctors of the Church have come down to us (see cat. no. 1), and the series on the life of Saint Dominic seems to have disappeared (nor is it listed in the 1810 inventory of the Alcázar of Seville). It is also possible that Zurbarán did not carry out this part of the contract, because the two canvases that remain in the church, the *Miraculous Cure of the Blessed Reginald of Orléans* and the *Apparition of the Virgin to a Monk of Soriano*, cannot be strictly considered episodes from the life of the founder, although they are associated with the orthodoxy of the order. The *Miraculous Cure*—the only known representation of that miracle—recounts a vision of a contemporary of Saint Dominic's. As a result of the apparition, the habit worn by Dominican friars was changed: "Previously, the religious of that order, like Saint Dominic, were dressed in a single white tunic with the black cope and nothing more [*sic*], but after the vision of the Blessed Father Reginald it became the custom to wear a white scapular over the tunic as shown by the Holy Virgin."[5] The *Apparition of the Virgin*, which treats a subject that was often represented, relates the

View of the interior of the church (today the Church of La Magdalena), Monastery of San Pablo el Real

appearance in 1530 of the Virgin of the Rosary accompanied by Saints Mary Magdalene and Catherine to a Dominican of the Monastery of Soriano (near Viterbo) to entrust to him the true portrait of the founder of the order holding a lily and a book bound in red.[6] Only a description of the church before the collapse of the cupola could tell us whether these paintings were originally part of the series.

The choice of subjects made by the Dominican prior of San Pablo is typical of programs of the Counter-Reformation. The Doctors of the Church are, by definition,

Oratory

Sacristy

0 10 m

Groundplan, church of the Monastery of San Pablo el Real, Seville (today the Church of La Magdalena)

guarantors of the ancient tradition of Catholic theology and respond to four criteria: orthodoxy of doctrine, personal sanctity, importance of theological writings, and formal recognition by the Church. Since the eighth century, special recognition had been given to four principal Latin Doctors: Saints Ambrose, Jerome, Augustine, and Gregory. To them the prior quite naturally added Saint Dominic as founder of the Order of Preachers, Saint Thomas Aquinas as the most brilliant glory of the order and much honored by the Council of Trent, and Saint Bonaventure, who also made significant contributions at the Council of Trent.

Zurbarán also painted, for the sacristy of the church, the *Christ on the Cross* (cat. no. 2). Not part of the contract of 1626, it was first mentioned in a document of 1629. It is also described throughout the eighteenth century, from Palomino to Ceán Bermúdez.[7] Ceán further states that there were other paintings in the sacristy which represented "various bishop saints" (*varios santos obispos*).[8]

NOTES
1. Pleguezuerlo Hernández, in Seville, Museo de Artes y Costumbres Populares, 1983, p. 157.
2. Ponz 1780 (1947 ed.), p. 785; Ceán Bermúdez 1800, VI, p. 50.
3. Hernández Díaz 1980, p. 208.
4. Hernández Díaz 1930, p. 182.
5. *La Vie du bien-heureux père Reginald . . .*, 1608, p. 190.
6. Réau 1958, III, p. 394.
7. Palomino 1724 (1947 ed.), p. 938; Ceán Bermúdez 1800, VI, p. 50.
8. Ceán Bermúdez 1800, VI, p. 50.

1.
Saint Gregory

ca. 1626
Oil on canvas, 78 × 49¼ in. (198 × 125 cm)
Inscribed, upper left: s GREGŎ.
Museo de Bellas Artes, Seville

Original location: Seville, Monastery of San Pablo el Real,
 sacristy of the church
Date of contract: January 17, 1626
*Location before 1808 according to early sources: Ponz 1780,
 in situ, with paintings in the style of Zurbarán, perhaps by
 his disciple Polanco; Ceán Bermúdez 1800, *idem*

Saint Gregory I, called "the Great," was one of the
most illustrious popes. Born in Rome in 541 to a vir-
tuous patrician family, he was senator and prefect of
the city before joining the Order of Saint Benedict.
In his own house in Rome he founded the Monas-
tery of Saint Andrew, and there he took the habit in
575.[1] He was elected abbot, and then cardinal, and
finally, in 590, supreme pontiff. As pope, he combined
enlightened zeal with a deep concern for the holiness of
the clergy and the maintenance of ecclesiastical disci-
pline. He played a significant role in the development
of the Roman liturgy, and his name is still associated
with the codification of plainsong: the Gregorian
chant. His commentaries on the Scriptures have exer-
cised considerable influence on Christian thought.
Africa, Spain, and the Gauls were chief objects of his
concern, and he is considered the apostle of Britain,
to which he sent a mission with a legate and forty
monks. He died on March 12, 604. The Roman
Church honors him as one of its four great Doctors
and celebrates the anniversary of his death. He was a
patron of musicians and learned men, and his pa-
tronage was extended after the Council of Trent to
the pious confraternities devoted to the solace of souls
in purgatory.

Zurbarán represents the saint in the costume of a
contemporary pope, with no concern for historical
accuracy. Over the scarlet cassock, he wears a finely
pleated white surplice and a ceremonial cope orna-
mented by a broad band of braid, embroidered in
gold, that bears oval medallions representing saints;
Saint Peter, the first pope, is depicted in the first me-
dallion. Because the pope was also the Bishop of
Rome, the ends of the scarlet stole hang parallel, as
was customary for bishops. He wears the tiara com-
posed of three superimposed crowns which was
adopted in the fourteenth century and reserved for

* Napoleon's armies invaded Spain in 1808, after which date
many paintings in the monasteries and convents of Spain were
confiscated and dispersed.

the exclusive use of the pope. Doubtless to recall the
great number of his writings, he is shown consulting
a large book.

As mentioned above, Zurbarán's contract with the
Dominicans in 1626 called for a series of pictures de-
picting four Doctors of the Church, specifically
Gregory, Ambrose, Jerome, and Augustine. Only
the *Saint Ambrose* and the *Saint Gregory* are listed in
the 1810 inventory of the Alcázar, as nos. 225 and
226, each measuring 2½ varas high by 1¼ varas
wide, and thus similar to the dimensions of the three
extant paintings. The *Saint Jerome* and the *Saint
Gregory* reappear in the 1840 inventory of the Museo
Provincial de Bellas Artes, Seville, but not the *Saint
Ambrose*. The *Saint Augustine* has never been found.

The same four Doctors of the Church appear with
different physiognomies in the *Apotheosis of Saint
Thomas Aquinas*, of 1631 (Museo de Bellas Artes, Se-
ville). In the present work, the figure of Saint Greg-
ory offers the same pose of the head, with the face
viewed almost in full; he wears a short white beard,
while in the *Apotheosis* he is clean-shaven.

At the close of the eighteenth century, Ponz and,
even more explicitly, Ceán Bermúdez considered
these four paintings as possibly from Zurbarán's
workshop.[2] The artist's first biographers, in the be-
ginning of the twentieth century (Cascales y Muñoz,
Kehrer, and others), however, had judged the brilliant
execution of the *Saint Gregory* to be one of the mas-
ter's prime achievements, superior to that of the paint-
ings at Las Cuevas, for example (see cat. nos. 37, 38),
which those writers considered cold and rigid. Such
purely subjective changes in taste have unfortunately
often worked against a true understanding of Zurba-
rán's work.

In this first period of his career, Zurbarán was still
responsive to the rich "Venetian" coloring of Juan de
Roelas (ca. 1560–1625), as here, where he indulges
in a dazzling exercise in reds and golds without los-
ing sight of the plasticity and monumentality of the
forms. The paint is thickly applied, and the treat-
ment is close to that used for certain figures in the
Apotheosis of Saint Thomas Aquinas.

NOTES
1. Pétin 1850, col. 1244.
2. Ponz 1780 (1947 ed.), p. 785; Ceán Bermúdez 1800, VI, p. 50.

PROVENANCE
Monastery of San Pablo el Real, Seville; Alcázar, Seville, 1810,
Room 7, no. 226; Monastery of San Pablo el Real, Seville; Museo
Provincial de Bellas Artes, Seville, 1835 (inv. 1840, no. 704).

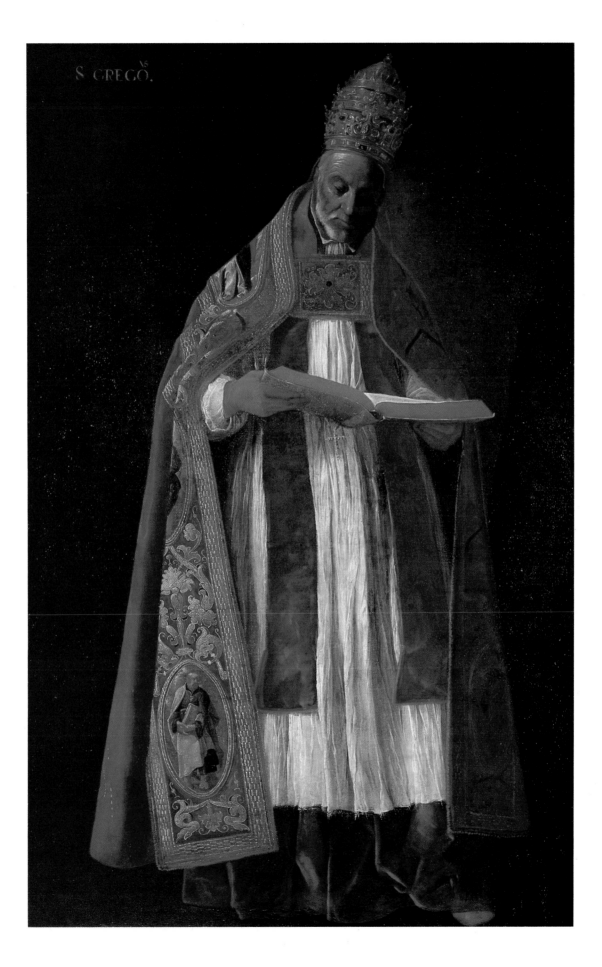

S. GREGÓ.

LITERATURE
Palomino 1724 (1947 ed.), p. 938; Ponz 1780 (1947 ed.), p. 785; Ceán Bermúdez 1800, VI, p. 47; Matute 1887b, p. 337, no. 48; Gómez Imaz 1896, no. 226; Cascales y Muñoz 1911, p. 82; Kehrer 1918, p. 62; Hernández Díaz 1928, p. 182; Soria 1944a, p. 40; Guinard 1947, p. 195; Mayer 1947, p. 336; Soria 1953, no. 14; Guinard 1960a, no. 220; Caturla 1964c, pp. 293–97; Sanz Pastor, in Madrid, Casón del Buen Retiro, 1964, no. 13; Hernández Díaz, in Seville, Museo Provincial de Bellas Artes, 1967, no. 155; Brown 1974, p. 24; Guinard and Frati 1975, no. 20; Gállego and Gudiol 1977, no. 6; Munich, Haus der Kunst, 1982, no. 98.

EXHIBITED
Seville 1964, no. 155; Madrid 1964–65, no. 13; Munich and Vienna 1982, no. 98.

2.
Christi on the Cross

1627
Oil on canvas, 9 ft. 6⅝ in. × 5 ft. 5 in. (291 × 165 cm)
Signed and dated on a scrap of paper painted at the foot of the cross: Fran⁰ Dezur fa[t?] 1627
The Art Institute of Chicago. Waller Fund

Original location: Seville, Monastery of San Pablo el Real, oratory of the sacristy
Date of contract: Not part of the contract of 1626
Location before 1808 according to early sources: Rodrigo Suárez 1629, oratory of the sacristy; Ponz 1780, sacristy; Ceán Bermúdez 1800, sacristy

EXHIBITED IN NEW YORK ONLY

Following the Council of Trent, the "vast Crucifixions of the past, those grand tableaux vivants that proliferated in the Middle Ages, became rare."[1] More frequently represented was the figure of Christ on the cross in isolation, as this was believed to enhance devotional concentration on the primary mystery of the Catholic faith. Accordingly, Zurbarán was commissioned to paint the figure of Christ alone. The exegetes of the Counter-Reformation had discussed at length the details of the Crucifixion, and they decreed that painted or sculpted representations of Christ on the cross should be historically accurate. In 1616 a monumental work, *De sancta cruce*, by the Jesuit Jacob Gretser, was devoted to the subject of the cross and took into consideration controversies surrounding painted and sculpted images of the crucified Christ; among them was the problem of the actual number of nails that had fixed Christ's hands and feet to the cross. Francisco Pacheco, in his great treatise *Arte de la pintura* (Seville, 1649), argued for the legitimacy of four nails, basing his hypothesis on the earliest images of the crucifix (see fig. 1, page 3).[2] Vicente Carducho, on the other hand, accepted the possibility that either three or four nails were used, recalling that the number four was cited in the *Revelations* of Saint Bridget.[3] Because no agreement was reached in this controversy, most theorists concluded, with Molanus, that the individual artist should be accorded the freedom to make his own decision.[4] Generally speaking, the formula of four rather than three nails, which resulted in Christ's legs being shown parallel and not crossed, was more common in Spain, no doubt as a result of Pacheco's influence. For Zurbarán, however, the decision rested ultimately with those who commissioned his services, and in most of his depictions of Christ on the cross, he was directed to follow the iconography as revealed in Saint Bridget's vision.

Rarely in the history of art does one find a series of early sources so much in agreement as those for the *Christ on the Cross*. The painting is signed and dated 1627, making it Zurbarán's earliest known documented work. In a document dated 1629, it was hailed as an outstanding work only two years after it was painted. The document concerns the proposal made by Rodrigo Suárez to the City Council on June 27, 1629, to invite Zurbarán to settle in the Andalusian capital: "Rodrigo Suárez makes known to the city how the Monastery of Mercy has brought from the city of Llerena Francisco de Surbaran painter, who is to make the pictures that are to be placed in the new cloister. By those that are completed and by the painting of *Christ* which is in the sacristy of San Pablo, one can judge that he is a consummate artist."[5]

A century later, in 1724, Palomino echoed the admiration elicited by the San Pablo *Christ on the Cross*: "In the sacristy of the Monastery of San Pablo . . . there is a crucifix from his hand which is shown behind the grille [*reja*] of the chapel (which has little light), and everyone who sees it and does not know

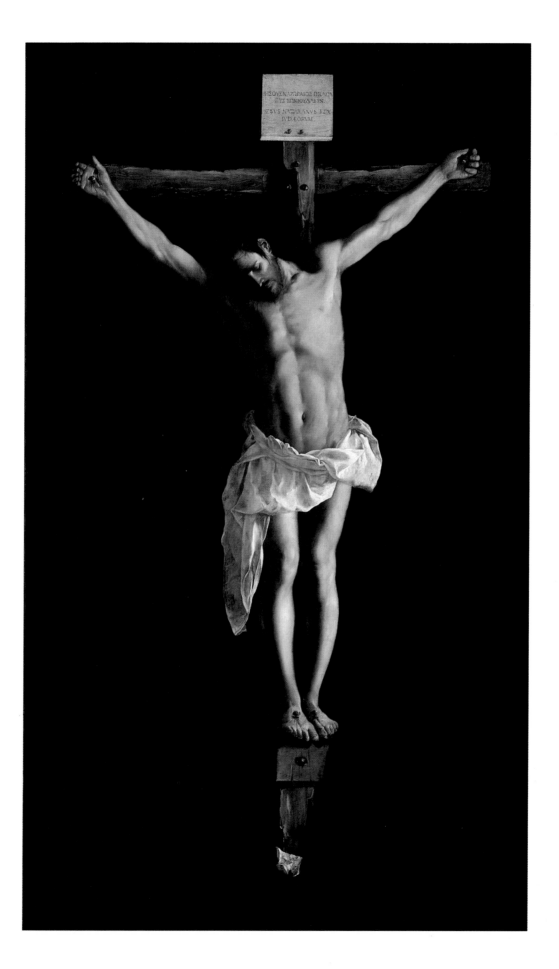

Groundplan, oratory of the sacristy. The arrow indicates the wall on which Zurbarán's *Christ on the Cross* was installed.

Former oratory of the sacristy, Monastery of San Pablo el Real, Seville, which today serves as the parish office for the Church of La Magdalena.

Reconstruction drawing of the installation of Zurbarán's *Christ on the Cross* on the wall of the oratory of the sacristy, Monastery of San Pablo el Real, Seville

believes it to be sculpture."[6] In 1780, Ponz added the following observation: "In a chapel of the sacristy there is a crucifix by Francisco Zurbarán, a painting of stupendous relief. It is signed 'Franciscus de Zurbaran f. 1627.'"[7]

In 1810, the *Christ on the Cross* was registered as no. 224 in the Alcázar inventory, preceding the *Saint Ambrose* and the *Saint Gregory*, also from San Pablo. It is described as measuring 4 varas high by 2 varas wide, dimensions that are the same in width but slightly greater in height than those of the present work. After 1810, the celebrated picture is lost sight of. It is not mentioned in any book or catalogue. Unlike the *Saint Ambrose*, the *Saint Gregory*, and the *Saint Jerome*, as well as a *Saint Dominic* and a *Sainted Bishop*, all of which are listed in the 1840 inventory of the Museo Provincial de Bellas Artes, Seville, it was never returned to its original location.

One hundred forty-two years later, in 1952, the *Christ on the Cross* turned up on the French art market, and then in Switzerland, where the individual who acquired it declared that he had bought it from the Jesuit College of Chantilly in 1951. According to Soria, the painting had been given in 1880 to the Jesuit College of Canterbury by the Duke of Alba, after which it went to the Jesuit College of Jersey, and in 1951 it was in Chantilly.[8]

When it belonged to the Jesuits, the *Christ on the Cross* was said to have had a landscape background, which has since disappeared, and indeed Milicua discovered a copy in an Andalusian collection in which a landscape can be distinguished.[9] In any case, laboratory examinations carried out by David Rosen in 1954, when the picture was purchased by The Art Institute of Chicago, revealed no remaining trace of such a background.

Both Milicua and Caturla note an important detail: the upper part of the picture was initially rounded off, and one can easily make out the corners that were added to transform the shape of the canvas into a rectangle.[10] On the basis of this information, it was possible to discover the painting's initial location on the wall of the oratory of the sacristy (today the parish office), where one can still see the traces of a rounded shape.

We do not share Caturla's opinion that the date inscribed on the canvas, 1627, is unclear. To us it appears perfectly legible. The recent cleaning has restored the powerful effect of relief it had when it was viewed by Palomino and Ponz.

The work today is still overwhelming. Few Spanish paintings of Zurbarán's time can compare with its power and majesty. Even the figure of Christ in Velázquez's *Christ on the Cross*, of about 1630 (Museo del Prado, Madrid), with its less massive body and more elegant forms, cannot transcend the dramatic force of Zurbarán's image. Christ's face, bent low over his shoulder, expresses inner suffering and sublime resignation; the body is heavy on the base and arms of the cross. The effect is one of deep poignancy. Unlike crucifixions in the Italian tradition, and according to the recommendations of Pacheco, here Christ is represented not in collapse but with the legs still straight, each foot firmly nailed, and with the full weight of the lifeless body supported by the outstretched arms. More than realism, one can speak here of surrealism, for Zurbarán shows an idealized representation of the crucified Christ, in no way seeking to display the horror and physical degradation of a tortured body. The violent lighting produces a pronounced three-dimensional vision of the forms, heightening the sense of surreality.

It is the expression of the artist's aesthetic convictions through the image of the crucified Christ that explains how this completely new and original treatment of Caravaggesque tenebrism could have aroused so much passion among the art lovers of Seville.

Now that the *Virgin of the Immaculate Conception* in the Arango collection (cat. no. 64), previously dated 1616, has been correctly dated to 1656, the *Christ on the Cross* has become Zurbarán's earliest documented work. It is now possible to trace the logical evolution of the artist's oeuvre from tenebrism to light. In only ten years, he would convert to a light palette under the influence of Velázquez and of the Florentine and Bolognese models that he would come to know in 1634 at the court in Madrid, and recalling as well the superb works of art collected in Italy by the great Andalusian lords, such as the Duke of Alcalá, who installed them in his Sevillian palace, the Casa de Pilatos.

Ponz had remarked on the relationship of the present painting with a sculpted *Christ on the Cross* in the Church of San Lorenzo, Seville, which he believed was by Juan Martínez Montañés, but which recently discovered documents prove was executed by Felipe de Ribas after 1645.[11] This is a strong indication that, contrary to what has so often been claimed, it was the plastic force of Zurbarán's paintings that inspired sculptors, and not the reverse.

NOTES
1. Mâle 1932 (1972 ed.), p. 275.
2. Pacheco 1649 (1956 ed.), pp. 393–99.
3. Carducho 1633 (1979 ed.), p. 343.
4. Mâle 1932 (1972 ed.), p. 271.
5. Cascales y Muñoz 1918, p. 137.
6. Palomino 1724 (1947 ed.), p. 938.
7. Ponz 1780 (1947 ed.), p. 785.
8. Soria 1955a, no. 225.
9. Milicua 1953, p. 179.
10. *Ibid.*; Caturla 1964c, p. 299.
11. Ponz 1780 (1947 ed.), p. 785.

PROVENANCE
Monastery of San Pablo el Real, Seville; Alcázar, Seville, 1810, Room 7, no. 224; Jesuit College of Canterbury, gift of the Duke of Alba, ca. 1880; Jesuit College of Jersey; Jesuit College of Chantilly, 1951; collection of A. Frankhauser, Basel, 1952; purchased by The Art Institute of Chicago in 1954.

LITERATURE
Palomino 1724 (1947 ed.), p. 938; Ponz 1780 (1947 ed.), p. 785; Ceán Bermúdez 1800, VI, pp. 47–50; Gómez Imaz 1896, no. 224; Gestoso y Pérez 1900, II, pp. 124–25; Cascales y Muñoz 1911, p. 51; Kehrer 1918, pp. 18, 36, 37; Guinard 1947, pp. 193–99; Milicua 1953, pp. 177–86; Milicua 1955; Soria 1955a, no. 225; Soria 1955c, pp. 48–49; Guinard 1960a, no. 90; Chicago, Art Institute of Chicago, 1961, no. 489; Caturla 1964c, pp. 298–301; Brown 1974, p. 66; Guinard and Frati 1975, no. 23; Gállego and Gudiol 1977, no. 8.

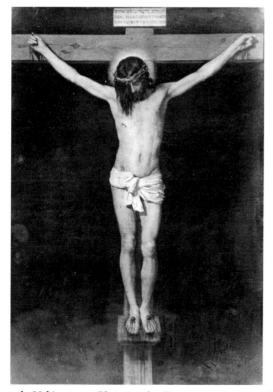

Diego de Velázquez. *Christ on the Cross*, ca. 1631–32. Oil on canvas, 8 ft. 1⅝ in. × 5 ft. 6½ in. (248 × 169 cm). Museo del Prado, Madrid

THE COLLEGE OF SAN BUENAVENTURA, SEVILLE

The College of San Buenaventura in Seville was the Franciscan center of theological studies in Spain. This institution of higher learning, established according to the precepts of the Council of Trent, served for the instruction of the Friars Minor and as a center for the propagation of the faith. The buildings, on Calle de los Catalanos (today Calle Carlos Canal), were connected by extensive gardens on the east to the Casa Grande de San Francisco, the city's principal monastery, which was demolished in 1841 to create the present Plaza Nueva.

Founded in the early years of the seventeenth century, the college was indebted to the generosity of two benefactors, Doña Isabel de Sira, widow of a Corsican nobleman, and, following her in 1626, Don Tomás Mañara de Leca y Colonna, a wealthy merchant who traded in the Indies and was the father of Miguel Mañara, the founder of the Hospital de la Caridad.

Of the seventeenth-century conventual buildings that ranged around the two cloisters, only the church survives today, though it was somewhat altered in the nineteenth century by the demolition of the northern chapels. Construction began in 1622 under the direction of the architect Diego López Bueno, and it was almost completed by May 4, 1626, when Juan Bernardo de Velasco and Juan de Segarra arrived to execute the stucco ornamentation of the walls and vaulting, designed by Francisco de Herrera the Elder.[1] The church is of moderate size; the central nave, measuring approximately 9 meters wide by 29 meters long, is divided into five bays and vaulted

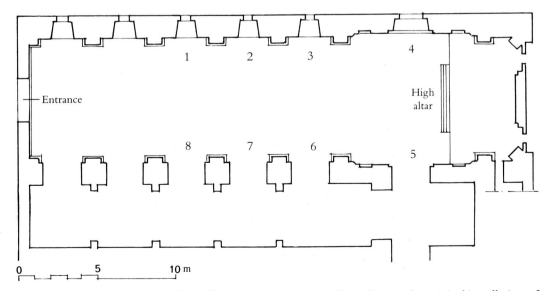

Groundplan, church of the College of San Buenaventura, Seville, indicating the original installation of paintings (see pp. 84–85)

with semicircular arches; the crossing has no transept arms but is defined by the dome surmounting it. The architectural simplicity of the boxlike form (*cajón puro*) contrasts with an interior of monumental fluted pilasters and exuberant plaster decoration (*yesería*), with vegetal motifs, garlands, and cherubs' heads placed between the oval and the rectangular frames of frescoes painted by Herrera. These paintings represent in the cupola the eight principal saints of the Franciscan Order, and in the pendentives the coats of arms of benefactors. In the vault of the nave, figures of Franciscan doctors and theologians alternate with a series of illustrations of Bible subjects and Christian maxims taken from the writings of Saint Bonaventure, outlining his *Itinerarium mentis in Deum* (1259). Ripoll, in his analysis, sees the paintings in this complex iconographic program as interpretations of the ideas of Fray Luis de Rebolledo, under the direction of Fray Damián de Lugones.[2]

Probably upon the completion of the frescoes, Herrera signed a contract, on December 30, 1627, with Alonso Guerrero, the father procurator of the college, undertaking to paint six scenes from the life of Saint Bonaventure. The stretchers for the canvases were already in the church. According to the contract, Herrera was to begin work on January 1, 1628, and to complete one painting every month and a half, for the sum of 900 reales for each composition. If the painter did not meet these terms, the father procurator was free to give the commission to another artist. Herrera seems to have completed no more than four paintings.[3]

The following year, 1629, Zurbarán was called in, on terms that remain unknown. The year is established by the date on one of the paintings, the *Saint Bonaventure and Saint Thomas Aquinas before the Crucifix* (formerly Kaiser Friedrich Museum, Berlin; destroyed in 1945). Why was Zurbarán brought in? It may have been that the Franciscans turned to another artist because they had received only four works from Herrera. They may have taken advantage of this apparent breach of contract in order to increase the number of paintings in the cycle from six to eight, so that pictures could be placed not only in the nave but also on the two walls of the crossing.

In trying to account for Herrera's withdrawal, it should be noted that he was at this time overwhelmed with commissions in Seville. During the year 1628, besides the San Buenaventura project, he was occupied with the main altar and with various decorations for the Franciscan Monastery of Santa Inés, and in July he undertook the monumental *Last Judgment* for the Church of San Bernardo, in Seville, for the Confraternity and Brotherhood of the Most Holy Sacrament and Blessed Souls in Purgatory.

In that same year, Zurbarán too was much engaged, but he must have had a larger and better-staffed studio at his command than did his rival, in order to be able to accept commissions not only for twenty-two scenes from the life of Saint Peter Nolasco at the Merced Calzada but also for the four scenes from the life of Saint Bonaventure.

We can only speculate about the disposition of the paintings in the nave, for they were removed from the church by order of Joseph Bonaparte in 1810. The pictures were among the 999 works stored in the Alcázar with the intention of founding a museum in Madrid and forming the nucleus of a collection of Spanish paintings at the Musée Napoléon in Paris. Before that date (according to Ceán Bermúdez and Matute), four pictures by Herrera were hung on the Gospel, or left, side of the nave, facing four by Zurbarán on the Epistle, or right, side.[4]

The titles of these works are first given in the Alcázar inventory drawn up between February and June 1810 by José Miguel Alea, archivist general to the crown, and Antonio de Aboza and published in 1896 by Gómez Imaz. This list, which is not without

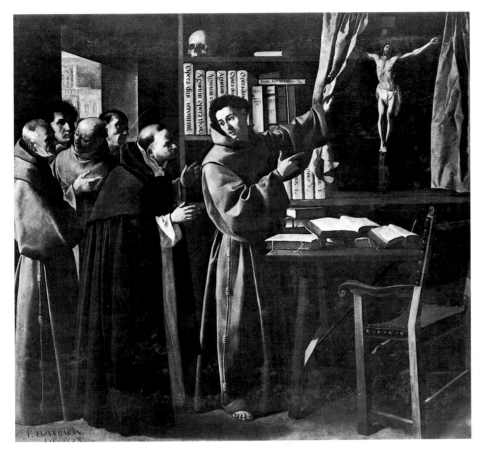

Francisco de Zurbarán. *Saint Bonaventure and Saint Thomas Aquinas before the Crucifix*, 1629. Oil on canvas, 7 ft. 5 in. × 8 ft. 5 in. (226 × 256 cm). Formerly Kaiser Friedrich Museum, Berlin; destroyed in 1945

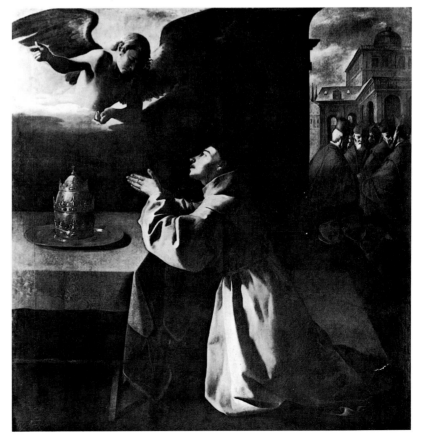

Francisco de Zurbarán. *Saint Bonaventure Inspired by an Angel Regarding the Election of a New Pope*. Oil on canvas, 7 ft. 10 in. × 7 ft. 3 in. (239 × 222 cm). Gemäldegalerie, Dresden

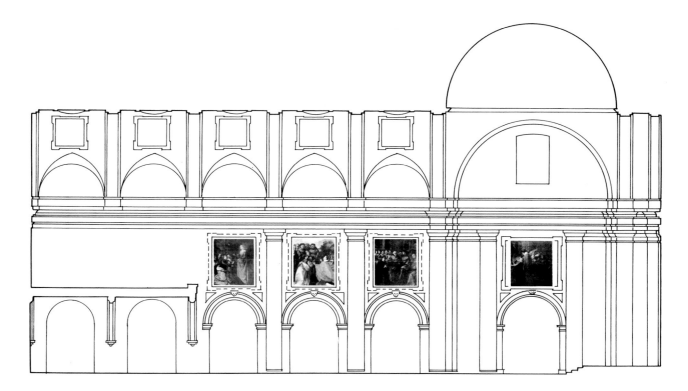

Section of the nave, church of the College of San Buenaventura, Seville, showing the installation of Juan de Herrera's paintings on the south wall

errors, has been useful to historians in identifying works that are now dispersed throughout the world. The latest studies, by Martínez Ripoll and by Gudiol, suggest a possible arrangement.[5] The cycle divides into two narrative series that correspond to the two lessons devoted to Saint Bonaventure in the Roman Breviary as reformed by Pius V in 1568. The first, comprising Herrera's four pictures, depicts scenes in the Franciscan's early life and vocation. The second, comprising Zurbarán's four paintings, illustrates events in his mature life, as Doctor of the Church, and also his death.

On entering the church and walking along the wall of the nave on the Gospel side as far as the choir and then returning on the Epistle side, one would have encountered the following scenes:

Francisco de Herrera the Elder
1. *The Apparition of Saint Catherine to the Family of Saint Bonaventure*, 90 × 74 in. (229 × 188 cm). Not listed in the Alcázar inventory. Formerly Louis-Philippe collection; Bob Jones University, Greenville, South Carolina
2. *The Young Bonaventure Cured by Saint Francis*, 92 × 86 in. (234 × 218 cm). Alcázar, Room 2, no. 78; acquired by Julian Williams; Carvallo collection; Musée du Louvre, Paris
3. *Saint Bonaventure Taking the Habit of the Franciscan Order*, 93 × 85 in. (235 × 215 cm). Alcázar, Room 2, no. 76; acquired by Julian Williams; Carvallo collection; Museo del Prado, Madrid
4. *Saint Bonaventure Receiving Communion from the Hand of an Angel*, 92 × 86 in. (234 × 218 cm). Alcázar, Room 2, no. 77; acquired by Julian Williams; Carvallo collection; Musée du Louvre, Paris

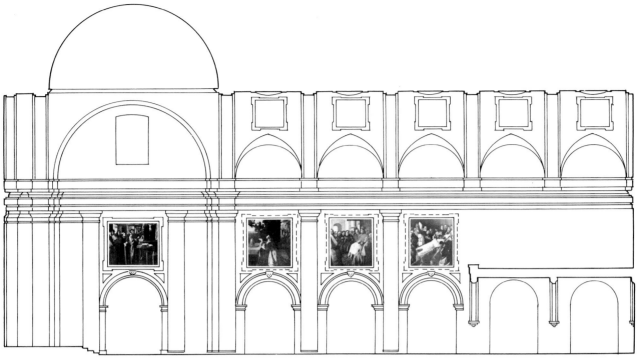

Section of the nave, church of the College of San Buenaventura, Seville, showing the installation of Zurbarán's paintings on the north wall

0 1 2 3 4 5 m

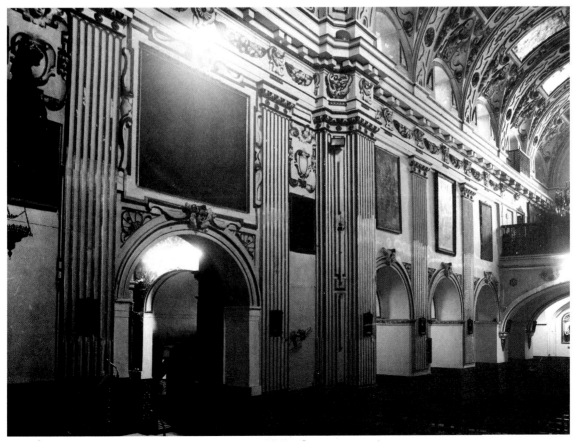

View of the nave, church of the College of San Buenaventura, Seville

Francisco de Zurbarán

5. *Saint Bonaventure and Saint Thomas Aquinas before the Crucifix*, dated 1629, 89 × 101 in. (226 × 256 cm). Alcázar, Room 2, no. 65; Soult collection; formerly Kaiser Friedrich Museum, Berlin; destroyed in 1945

6. *Saint Bonaventure Inspired by an Angel Regarding the Election of a New Pope*, 94 × 87 in. (239 × 222 cm). Alcázar, Room 2, no. 70; Louis-Philippe collection; Gemäldegalerie Alte Meister, Dresden

7. *Saint Bonaventure at the Council of Lyons*, 98½ × 90 in. (250 × 225 cm). Alcázar, Room 2, no. 69; Soult collection; Musée du Louvre, Paris (cat. no. 3)

8. *Saint Bonaventure on His Bier*, 96 × 87 in. (245 × 220 cm). Alcázar, Room 2, no. 64; Soult collection; Musée du Louvre, Paris (cat. no. 4)

The reconstruction calls for the following remarks. Herrera's first painting, the *Apparition of Saint Catherine to the Family of Saint Bonaventure*, is not listed in the Alcázar inventory. The *Apparition of Saint Catherine* is 30 centimeters narrower than the other paintings in the series—an important point because, according to the contract, the artist was to use stretchers that were already installed, and he no doubt worked with the stucco frames already in place in the nave. It should therefore be ascertained whether the canvas was cropped, most likely on the left side.

Painting no. 5, probably the first to be painted by Zurbarán, since it was signed and dated, measured some 40 centimeters wider than the other paintings, suggesting that it could have been made to fit into the transept bay, which is wider than the bays along the nave.

Finally, a ninth painting, the *Last Communion of Saint Bonaventure* (Palazzo Bianco, Genoa), larger in size (290 × 307 cm) but long thought to belong to this cycle, was probably in the sacristy of the church, where Matute notes a *Dying Saint Francis Surrounded by Angels* by Zurbarán.[6] This painting is today attributed to an assistant.[7]

While isolated representations of Saint Bonaventure became common after his canonization, narrative scenes are very rare.[8] The most complete series is found in an engraving by Adriaen Collaert (Antwerp, ca. 1560–1618) after Pieter de Jode I (Antwerp, 1570–1634), which represents Saint Bonaventure as a cardinal; it is surrounded by ten scenes from his life, all of which are surmounted by the depiction of the discovery in 1434 of his relics.[9] Iconographically, this sixteenth-century narrative cycle is exceptional. It may be regarded as the first important illustration of the life of Saint Bonaventure corresponding to the renewed recognition of his teaching among the Friars Minor after Pope Sixtus V (r. 1585–90) ranked him Doctor of the Church, ordered his works to be printed, and founded a chair in his name at the Conventual Franciscan College of the Twelve Apostles in Rome.[10]

The life of Saint Bonaventure, common knowledge to Franciscans in the seventeenth century, is less familiar to us today. Born in 1221 or 1222 at Bagnoregio in Tuscany, Giovanni Fidanza was cured of a mortal illness in early childhood through the intercession of Saint Francis of Assisi, who is said to have named him Bonaventure (Good Fortune). Pledged by his mother to the Order of the Friars Minor, he studied with the Franciscans of his native town, and later became a brilliant scholar at the University of Paris under Alexander of Hales, father of the Franciscan school of theology. Master of arts in 1243, he took the habit of the order probably at that date. After giving his much acclaimed commentary on the *Sententiarum libri* of Peter Lombard, he received the licentiate and doctorate of the university. Bonaventure's piety, gentle-

Adriaen Collaert after Pieter de Jode I. *Saint Bonaventure and Scenes from His Life.* Engraving from Hendricus Sedulius, *Imagines Bmi. P. Francisci Assisiatis* (Antwerp, 1614). Bibliothèque Nationale, Paris

ness, and humility, together with his vast knowledge, led to his election, at the age of thirty-five, as minister general of the order. In 1260, he codified for the chapter of Narbonne a new set of constitutions, creating convents of study that received dispensation from the rule of poverty to permit them to own books. His intellectual prestige and his ascendancy in the Church helped him to restore unity to the order. He was created Cardinal Bishop of Albano in 1273, and consecrated bishop in November of the same year. The following year, he died suddenly at the Council of Lyons, where he had been the guiding spirit. He was buried on July 16, 1274, in the presence of the pope.

Despite the great influence Bonaventure exercised during his lifetime, he was not canonized until 1482, by Sixtus IV, himself a Franciscan. A century later, on March 14, 1588, another Franciscan pope, Sixtus V, proclaimed him a Doctor of the Church, with the title Doctor Seraphicus. The clarity of Bonaventure's doctrine endeared him to the theologians of the Counter-Reformation.

NOTES
1. López Martínez 1928a, pp. 209–10.
2. Martínez Ripoll 1976, pp. 18–24.
3. Matute 1887b, p. 371.
4. Ceán Bermúdez 1800, II, p. 278; Matute 1887b, p. 371; Carriazo 1929, p. 165.
5. Martínez Ripoll 1976, pp. 66–74; Gállego and Gudiol 1977, p. 75.
6. Matute 1887b, p. 371.
7. Soria 1944a, p. 41; Herzog and Schlegel 1960, pp. 96–98, ill.
8. Petrangeli Papini 1974.
9. Sedulius 1614, p. 5.
10. *Dictionnaire de théologie catholique*, XVI, 1924, no. 1, cols. 982–83.

3.
Saint Bonaventure at the Council of Lyons

ca. 1629
Oil on canvas, 98½ × 88½ in. (250 × 225 cm)
Musée du Louvre, Paris

Original location: Seville, church of the College of San
 Buenaventura, right side of the nave
Date of contract: Not known
Location before 1808 according to early sources: Ponz 1780,
 in situ; Matute ca. 1800, *idem*; Ceán Bermúdez 1800, *idem*

Known by various titles in the nineteenth century,
this painting was not correctly interpreted until
early in the twentieth century. When it was stored in
the Alcázar of Seville, it was listed in the 1810 inven-
tory as *A Council*, and in the Soult collection cata-
logue, engraved by Reveil, it appears under the title
Saint Peter Nolasco and Saint Raymond of Peñafort,
doubtless confused with the contemporaneous cycle
of the Merced Calzada. In 1883, Justi recognized the
figure as Saint Bonaventure, but interpreted the
scene as the presiding of the saint over a chapter of

the Franciscan Order, an error repeated in the cata-
logues of the Louvre until Matrod in 1922 discovered
the precise subject: Saint Bonaventure disputing at
the Council of Lyons with the envoys of the Emper-
or Palaeologus.[1]

The Fourteenth Ecumenical Council, convoked at
Lyons in 1274 on the initiative of Pope Gregory X,
pursued a threefold aim: reform of the Church, rec-
onciliation of the Latin and Greek Churches, and re-
lief of the Holy Land. "The saint's achievement par
excellence," according to the Franciscan Breviary,
"was the union with the Greeks. For before the
meeting of the fathers, he had counseled Gregory X
to send Girolamo d'Ascoli, later Pope Nicholas IV,
and three other Friars Minor as nuntii to the Emper-
or Palaeologus; their embassy had been fruitful, and
at the sessions of the Council itself he was so persua-
sive . . . that the emperor, and the East, returned in
obedience to the Apostolic See."

On June 3, 1273, Bonaventure was created Cardinal
Bishop of Albano by Gregory X. And in November
of the same year, the two men went to Lyons, where
the first session of the Council was to open in the
primatial Church of Saint-Jean on May 7, 1274. It
was an unprecedented gathering of a thousand prel-
ates, five hundred bishops, seventy abbots, two Lat-
in patriarchs, and one aged king, James I of Aragon.[2]

In the painting, the Seraphic Doctor is seated in
the place of honor, recalling the text of the bull of
canonization of 1482, "In concilio Lugdunensi prae-
sidens . . ." (At the Council of Lyons presiding . . .).
Nevertheless, it is unlikely that the picture shows a
session of the Council, as this would be indicated by
the presence of the pope.[3] The scene represented is
probably one of the preparatory meetings with the
Greek ambassadors, who arrived on June 24: "As
soon as the Greeks had arrived, our saint was charged
to converse with them. . . . They heard him and
submitted to all that he proposed."[4] Four days after
the arrival of the envoys from Michael VII Palaeolo-
gus, the representatives of the Greek Church joined
in the papal Mass, during which Saint Bonaventure
gave the sermon."[5]

Zurbarán depicts the Seraphic Doctor surrounded
by prelates. Two of them wear the white pallium with
six black crosses, the insignia of jurisdiction of the
patriarchs and a characteristic attribute of Greek doc-
tors in seventeenth-century Spanish iconography.
Bonaventure wears the Franciscan frock, visible be-
neath the white rochet and red mozzetta of a cardi-
nal; his scarlet biretta is shown in the reduced form

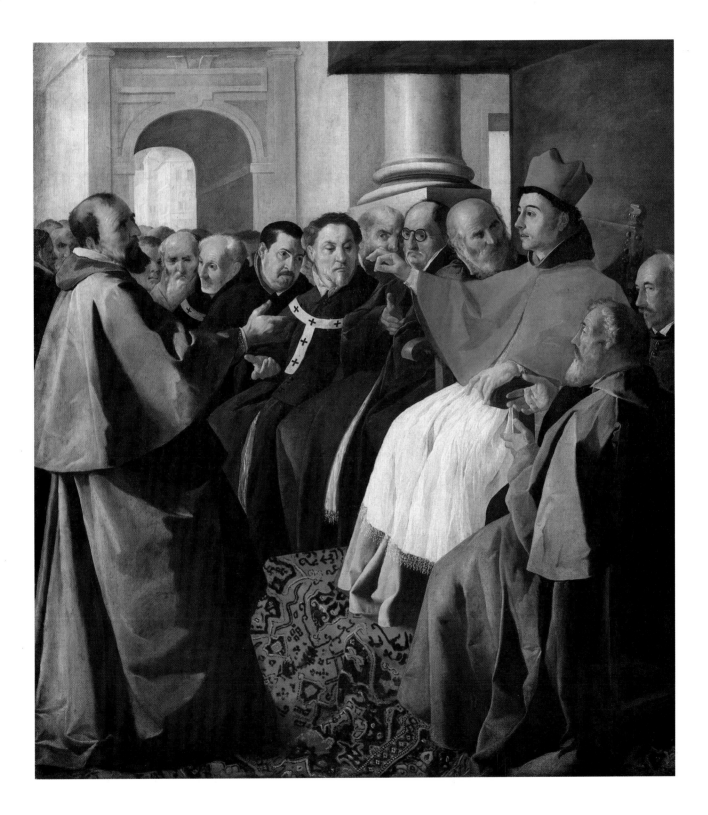

Dabo vobis os, et sapientiam, cui non poterunt resistere. Luc. 21.15.

Ut nihil Norberto deesset ad exercitium patientiæ, præter complures tam publicas quam priuatas, quod Dei gloriam zelaret, et peccata acriter perstringeret, sibi factas molestias; in Concilio Friteslariensi coram Conone Cardinale Prænestino causam dicere iussus, Spiritu sancto patrocinante de aduersarijs triumphat.

8.

Theodore Galle. *Saint Norbert at the Council of Fritzlar.* Engraving from Van der Sterre, *Vita S. Norberti* (Antwerp, 1605). Bibliothèque Nationale, Paris

theless set apart by the hangings of the cardinal's canopy and by the carpet with Mudéjar designs. The prelates are ranged along an oblique line marked by the edge of the dais and accentuated by the perspective of a porch open to the outside. The source for this arrangement may have been an engraving. Soria notes comparable elements (a cardinal under a canopy, a standing orator, a bishop seated in three-quarter view, and an arcade in the background) in a plate engraved by Theodore Galle in 1605 representing Saint Norbert at the Council of Fritzlar.[10] Or perhaps, as Justi suggests, Zurbarán was inspired by Herrera's *Saint Bonaventure Taking the Habit of the Franciscan Order* (Museo del Prado, Madrid), which hung on the other side of the nave.[11]

Zurbarán's version of the scene has an enlarged scale by virtue of the *di sotto in su* perspective, indicated by the foreshortening of the two figures in the foreground. This effect must have been more pronounced when the painting hung in the church.

The attitudes and expressions of those in attendance—thoughtful, articulate, attentive, and questioning—are painted with a spontaneity and elegance that are divorced from the stereotyped and coarse faces in Herrera's static composition. The sharpness of the debate is dramatized by the contrast between the dynamic figure of the interlocutor, partly concealed in shadow, and the serene and luminous countenance of Bonaventure. The saint's youthful charm expresses the persuasiveness of his words and the truth of his discourse. The rich purple of his mozzetta and biretta harmonizes with the gray of the Greek emissaries' robes, and a lightly applied glaze provides a sculptural depth to the long panels of fabric, lending a note of distinction and sumptuousness to the assembled company.

adopted late in the sixteenth century. The very specific gesture of his right hand signifies approval,[6] while those around him turn their open hands outward in token of their "acknowledgment of his person and of their total adherence to his authority."[7] Bonaventure was fifty-three years old at the time, but Zurbarán portrays him with a youthful face, in conformity with engravings that illustrate the Franciscan Chronicles,[8] and probably to express the saint's proverbial angelic purity.

The column in the background perhaps alludes to the metaphor coined by Gregory X in his eulogy of the saint at the opening of the fifth session of the Council: "Cecidit columna Christianis" (A pillar of Christianity is fallen).[9]

Zurbarán's compositional scheme reflects the preeminence of Bonaventure over those assembled. Not actually isolated from the crowd, the figure is never-

NOTES
1. Justi 1883, pp. 152–62; Matrod 1922, pp. 164–65.
2. Hefele and Hergenröther 1914, VI, 1, pp. 159–72.
3. *Ibid.*, p. 179.
4. Boule 1747, p. 127.
5. *Ibid.*, p. 173.
6. Bulwer 1644, p. 94e.
7. Garnier 1982, p. 174.
8. Sedulius 1602, fig. 5.
9. Boule 1747, p. 140.
10. Soria 1948b, p. 253, fig. 6.
11. Justi 1883, pp. 152–62.

PROVENANCE
Church of the College of San Buenaventura, Seville; Alcázar, Seville, 1810, Room 2, no. 69 (as *A Council*); collection of Marshal Soult, Paris; Soult sale, Paris, May 1852, no. 22 (as *Saint Peter Nolasco and Saint Raymond of Peñafort*); ceded by the Soult heirs with four other paintings to discharge a debt of 300,000 francs to the state; the painting entered the Musée Royal au Louvre on Oct. 12, 1858 (archives of the Musée du Louvre, P4 1858).

LITERATURE
Palomino 1724 (1947 ed.), p. 938; Ponz 1780 (1947 ed.), p. 789;
Ceán Bermúdez 1800, VI, p. 48; Réveil and Duchesne 1828,
no. 957; González de León 1844, p. 203; Mercey 1852, p. 812 (as
Saint Peter Nolasco at the Chapter of Barcelona); Duranty 1877,
pp. 179–80; Justi 1883, pp. 152–62 (as *Counsel General of the
Franciscans*); Matute 1887b, p. 371; Gómez Imaz 1896, no. 69;
Cascales y Muñoz 1911, p. 177; Ricci, in Paris, Musée du Louvre,
1913, no. 1738; Kehrer 1918, pp. 47–52; Matrod 1922, pp. 164–
65 (as *Reception of the Ambassadors of the Paleologist Emperor*);
Kleinschmidt 1926, pp. 3–16; Carriazo 1929, pp. 159, 160, 165,
166; Soria 1944a, p. 41; Guinard 1946, pp. 266–70; Picault 1946,
pp. 71–72; Mayer 1947, p. 334; Soria 1948b, pp. 253–55; Mâle
1951 (1984 ed.), p. 415; Soria 1953, no. 26; Gaya Nuño 1958,
no. 2988; Guinard 1960a, no. 380; Baticle, in Paris, Musée des
Arts Décoratifs, 1963, no. 89; Torres Martín 1963, no. 34; Brown
1974, p. 19; Guinard and Frati 1975, no. 27; Martínez Ripoll 1976,
pp. 66–74, 92–94, 112; Gállego and Gudiol 1977, no. 18; Baticle
1981, p. 125.

EXHIBITED
Paris 1963, no. 89.

4.
Saint Bonaventure on His Bier

ca. 1629
Oil on canvas, 96 × 87 in. (245 × 220 cm)
Musée du Louvre, Paris

Original location: Seville, church of the College of San
 Buenaventura, right side of the nave
Date of contract: Not known
Location before 1808 according to early sources: Ponz 1780,
 in situ; Matute ca. 1800, *idem*; Ceán Bermúdez 1800, *idem*

On July 7, 1274, the day following the fourth session
of the Council of Lyons, Bonaventure was stricken
with a devastating illness. Exhausted by overwork, he
was too weak to resist the attack. Racked by convul-
sions, he is believed nevertheless to have miraculous-
ly received communion, the Host entering directly
into his breast.[1] The pope himself administered the
sacrament of extreme unction, as is attested by an in-
scription, still legible in 1733,[2] on the door of the cell
where Bonaventure died, on the night of July 14.

Zurbarán portrays the Seraphic Doctor on his
bier, wearing the insignia of his rank and clad in the
liturgical vestments of the artist's time—a Roman
chasuble, a miter, and the white gloves of a prelate.
His red cardinal's hat is at his feet. The Friars Minor
of the Franciscan Monastery of Lyons, where Bona-
venture was enshrouded the day of his death, sur-
round his body. To the left, eminent personages of
the Council stand conversing. Pope Gregory X ad-

dresses King James I of Aragon, the only sovereign
at Lyons (he had in fact returned to Spain by June 7).[3]
Standing behind the pope, the aged prelate wearing
a miter may plausibly be identified as Pierre de Ta-
rentaise, Cardinal Bishop of Ostia and Archbishop
of Lyons, who was to celebrate the funeral Mass and
deliver the eulogy. As an unparalleled honor, the
pope ordered that all the priests of Christendom cel-
ebrate a Mass for the soul of the departed.[4]

Zurbarán's cycle depicting the story of Saint Bona-
venture ends with a work that is exceptionally somber
in both iconography and composition. The subject,
doubtless chosen by the Franciscans, is not the banal
representation of a dying man, which was thought
to be inappropriate to the dignity of such a personage,
but the evocation of the funeral obsequies. In the mon-
asteries of Seville, wakes were held in the Sala de Pro-
fundis, where the body would lie in state before burial.
It was for such a hall that Zurbarán had painted the
Saint Serapion (cat. no. 5) at the Merced Calzada the
previous year.

On the right side of the nave of the College of San
Buenaventura, this last painting in the series echoes
the general arrangement of the two preceding scenes,
with the body of the saint turned toward the high al-
tar. The oblique scheme, indicated in the *Saint Bona-
venture at the Council of Lyons* (cat. no. 3) by the line
of the canopy and the dais, is here marked by the force-
ful diagonal of the body in its dazzling white robe.

Zurbarán's source of inspiration for this painting
is found not in Flemish engravings, as in the *Saint Bona-
venture at the Council of Lyons*, but rather in Gothic
funerary sculpture. Models were not lacking in the
Cathedral of Seville. One of the more striking exam-
ples would have been the austere effigy of Cardinal
Cervantes in the Chapel of San Hermenegildo, carved
by Lorenzo Mercadante de Bretaña in the mid-fifteenth
century.

Visitors at the Council, from the most illustrious
bishops and prelates to the humblest friars, are
shown pressing around the bier. They are divided
into groups of two: the king and the pope relegated
to the left of the composition; two Franciscans at the
center, their casual manner contrasting with the stiff
solemnity of those beside them; two other Francis-
cans, their faces counterbalanced by those of two
young pages at the far right; and two Friars Minor,
in prayer in the foreground.

A brilliant light sets off this gallery of portraits
from a dark background (scarcely broken by the out-
lines of three columns). The lined faces of those as-
sembled around the bier, modeled in broad patches
of color, contrast with the bronzed and masklike
countenance of the dead man.

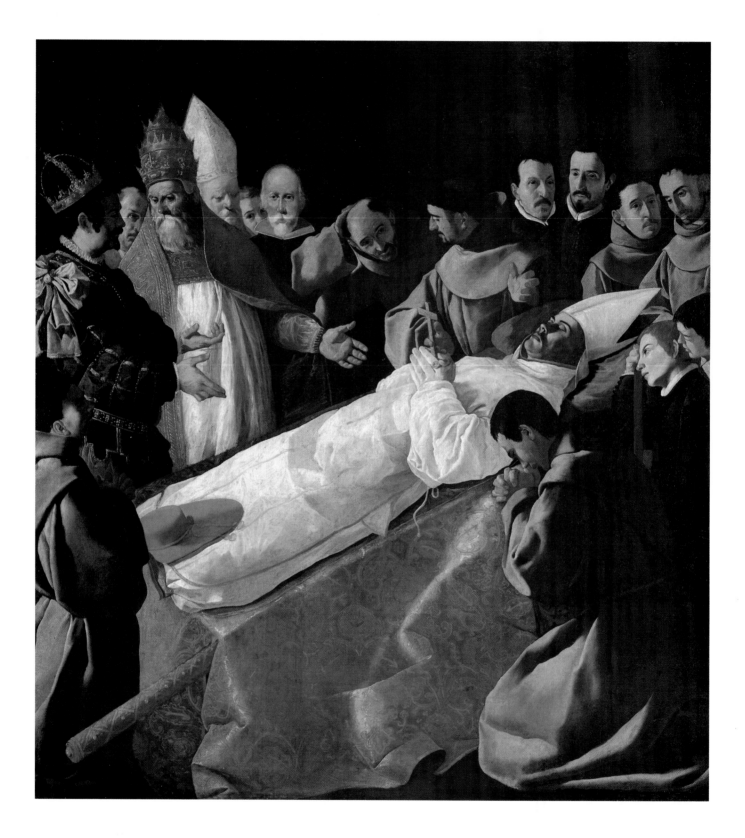

The expressive power of the scene emerges from its depth of feeling, a synthesis beautifully described by Guinard:

Aside from [El Greco's] *Burial of the Count of Orgaz* [1586; Santo Tomé, Toledo]—unique for opening upon the supernatural world overhead—there is nothing to be found in post-Renaissance painting that offers a comparable image of the death of just men and of its grandeur, not as the individual drama of a believer but in its social aspect, for its value as an example. . . . There is nothing lacking in this homage, not even the note of splendor: the russet pall draped in the foreground, generously deploying its folds over the lowly bearing pole, supplies the obbligato bass, the accompaniment of muted trumpets, that this great "funeral and triumphal symphony" required.[5]

NOTES

1. Boule 1747, p. 130.
2. *Ibid.*, p. 138.
3. Hefele and Hergenröther 1914, VI, 1, p. 170.
4. *Ibid.*, pp. 178–80.
5. Guinard 1960a, p. 80.

PROVENANCE
Church of the College of San Buenaventura, Seville; Alcázar, Seville, 1810, Room 2, no. 64 (as *Saint Bonaventure Deceased*); collection of Marshal Soult, Paris; Soult sale, Paris, May 1852, no. 24; ceded by the Soult heirs with four other paintings to discharge a debt of 300,000 francs to the state; the painting entered the Musée Royal au Louvre on Oct. 12, 1858 (archives of the Musée du Louvre, P4 1858).

LITERATURE
Palomino 1724 (1947 ed.), p. 938; Ponz 1780 (1947 ed.), p. 789; Arana de Varflora 1789, p. 56; Ceán Bermúdez 1800, VI, p. 48; González de León 1844, p. 203; Mercey 1852, p. 812 (as *Funeral of a Bishop*); Justi 1883, pp. 160–62; Matute 1887b, p. 371; Gómez Imaz 1896, no. 64; Cascales y Muñoz 1911, p. 177; Ricci, in Paris, Musée du Louvre, 1913, no. 1739; Kehrer 1918, pp. 47–52; Kleinschmidt 1926, pp. 3–16; Carriazo 1929, pp. 159, 160, 165, 166; Soria 1944a, p. 41; Guinard 1946, pp. 266–70; Picault 1946, pp. 72–73; Mayer 1947, p. 334; Soria 1953, no. 27; Gaya Nuño 1958, no. 2989; Guinard 1960a, no. 382; Baticle, in Paris, Musée des Arts Décoratifs, 1963, no. 90; Torres Martín 1963, no. 35; Angulo Iñiguez 1971, p. 125; Brown 1974, pp. 72–74; Guinard and Frati 1975, no. 28; Martínez Ripoll 1976, pp. 66–74, 94–95, 113–15; Gállego and Gudiol 1977, no. 19; Baticle 1981, p. 125.

EXHIBITED
Paris 1925, no. 119 (as *The Interment of the Bishop*); Paris 1963, no. 90.

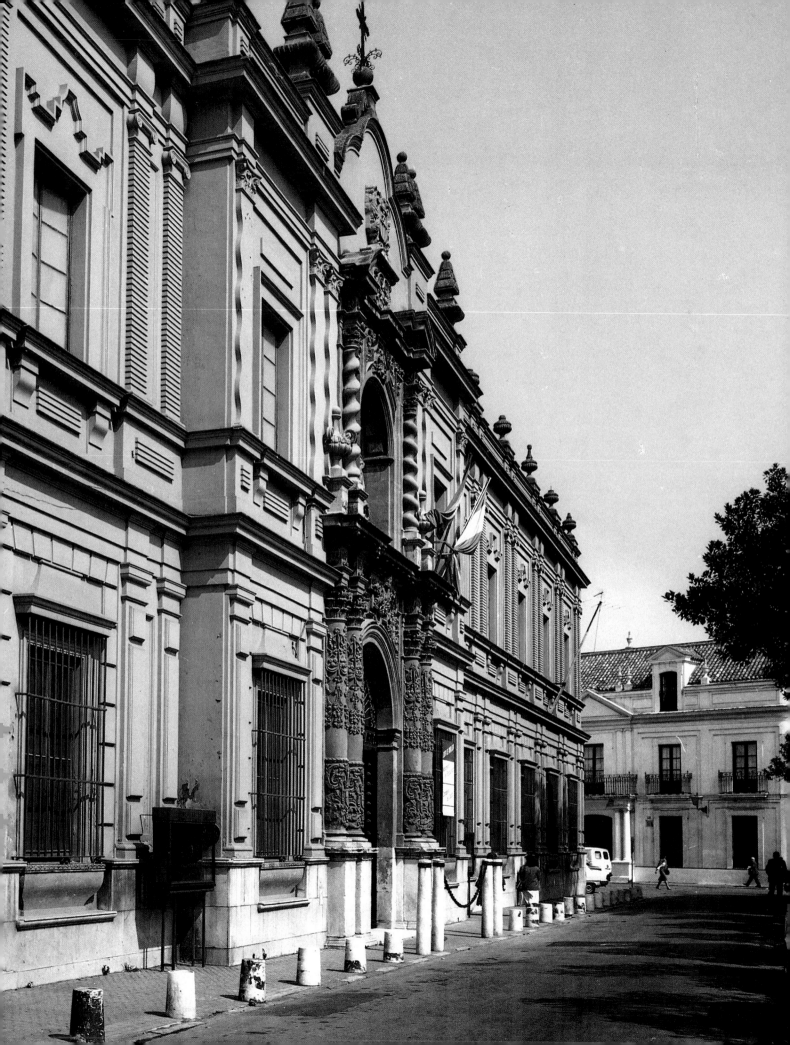

THE MONASTERY OF THE MERCED CALZADA, SEVILLE

The Monastery of Nuestra Señora de la Merced, in Seville, was founded by Ferdinand III of Castile and León in 1249 at the instance of Peter Nolasco, who had accompanied the king at the recapture of Seville in 1248. The Order of Our Lady of Mercy, committed to ransoming Christians held captive by the Moslems, required a community in the Andalusian capital, having already established itself in Barcelona and Valencia.

In 1602, the buildings dating from medieval times were demolished; they were replaced by the classical edifices erected according to the plans of Juan de Oviedo y de la Bandera (1565–1625), and completed in their main features in 1612. Fray Juan Guerrero, in the mid-seventeenth century, noted the perfect unity and order, both architectural and decorative, of the several parts of the monastery.[1] Built at the south side of the church, the structures are organized around a group of three main cloisters and a monumental double staircase opening onto the first two courtyards. The fabric today houses the Museo de Bellas Artes, and despite renovations made in the eighteenth century and demolition in the nineteenth, it essentially retains its seventeenth-century character. A rough plan drawn up by B. Corrales in 1835, when the ecclesiastical holdings were secularized, enables us to determine where the parts of the monastery were before the novitiate was demolished in 1841 to create the Plaza del Museo.[2]

In the course of the seventeenth century, the decoration of the interior was entrusted to Seville's foremost artists: the sculptors Francisco Dionisio de Ribas and Alfonso Martínez for the altarpiece of the high altar, Juan Martínez Montañés for a *Christ Bearing the Cross*, the painters Francisco Pacheco and Alonso Vázquez for the pictorial history of the order in the Grand Cloister, and Juan de Roelas and Francisco de Herrera the Elder for various altarpieces and panels.

Zurbarán set his hand to almost every part of the monastery. His work holds a modest place in the church, where two half-length figures of saints (not positively identified today) are attributed to him, but he is certainly responsible for the paintings in the second cloister and in the library, and he executed major works for the Sala de Profundis and the Sala de Láminas.

SALA DE PROFUNDIS

Adjoining the refectory, the Sala de Profundis served as a mortuary chapel where deceased monks lay in state before burial. According to Guerrero, it contained a surrounding stone bench and was finished in white stucco.[3] The altar was consecrated to the Passion of Christ.

Several paintings were hung on the walls, apparently at random: a *Virgin and Child* by Francisco de Herrera the Elder; a *Saint Joachim* and a *Saint Joseph* by Juan de Roelas; and four paintings by Frans Frutet, formerly parts of an altarpiece. Ponz mentions two paintings of Holy Martyrs by Zurbarán, facing each other near the refectory door;[4] these subjects are more in keeping with the function of the sanctuary. By the nine-

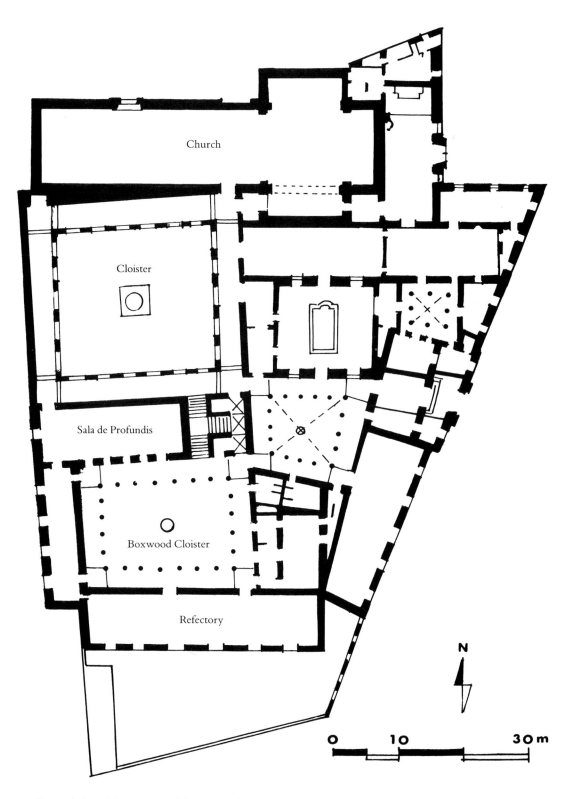

Groundplan, Monastery of the Merced Calzada, Seville

teenth century, one painting of a Holy Martyr seems to have disappeared, because Ceán Bermúdez mentions only a *Saint Serapion*.[5] Matute gives its date as 1623 (probably misreading the last digit), and identifies the work as a portrait of a superior of the order in the style of Zurbarán.[6]

THE BOXWOOD CLOISTER: SCENES FROM THE LIFE OF SAINT PETER NOLASCO

Erected between 1602 and 1612 by Juan de Oviedo y de la Bandera, the Claustro de Bojes, or Boxwood Cloister, so named for the shrubs planted there, retains its original architecture: in an irregular plan (17 to 18 meters wide by 25 meters long), a set of arcades of the Tuscan order is supported by white marble columns, and a second enclosed level with fenestration is adorned with green and gilded balconies.

On the walls of the lower gallery were the paintings commissioned from Zurbarán on August 29, 1628, by Juan de Herrera, the reverend father commander of the monastery. By this contract, Zurbarán undertook to paint in one year twenty-two pictures, each measuring 2 varas high by 2½ varas long (168 × 210 cm), illustrating the life of Saint Peter Nolasco, the founder of the order, and he agreed to follow the iconographic program drawn up by the father commander. The commission was of great importance to Zurbarán because it enabled him to leave the small town of Llerena and settle in Seville. The Mercedarian community was to provide accommodations for the artist and his assistants, and to pay the sum of 1,500 ducats in three installments—at the commencement of work, on delivery of the first eleven paintings, and on completion. Despite these provisions, the work was not carried out within the specified time. Although several paintings were delivered by August 1629, among them *Saint Peter Nolasco's Vision of the Crucified Saint Peter*, dated 1629 (cat. no. 6), others were executed after the stipulated date: the *Presentation of the Image of the Virgin of El Puig to King James I of Aragon* (cat. no. 8) is dated 1630, and the *Surrender of Seville* (cat. no. 9) is dated 1634. Very likely not all twenty-two paintings called for by the contract were executed. On this point, Juan Guerrero's account sheds no light and the testimonies of scholars do not agree. Ponz in 1780 saw fifteen paintings; Ceán Bermúdez saw only twelve in 1800; and Matute, correcting Ponz's figure, also cited twelve.[7] Mention should also be made of a record of 1732, a *memoria* of the paintings and sculptures in the monastery, which, if reliable, complicates the problem. Besides the scenes from the life of Saint Peter Nolasco, that source lists eight ovals representing the founders of the order, half-length and set in the corners of the cloister; the author attributes them to Zurbarán.[8] Could this be an editorial error, since it would appear that the painter never used the oval format?

Finally, in 1844, González de León mentions a suit brought by the Dominicans against the Mercedarians over three paintings in which Raymond of Peñafort, a Dominican and cofounder of the Mercedarian Order, is portrayed wearing the habit of the regular clergy rather than the robe of Saint Dominic. The Mercedarians lost the case, and allegedly they concealed the three canvases rather than have them altered.

The number is far short of that specified in the contract by the father commander. What happened? Perhaps he felt that the twelve canvases delivered were sufficient adornment for the cloister, and did not require that the series be completed. Indeed, it is difficult to see how twenty-two paintings of such size could have been accommodated in the space, given the grand staircase and the passageways. Another explanation for Zurbarán's not completing the commission has been suggested by Guinard. He notes that Zurbarán, engaged with the commission for the Church of San Buenaventura, was overburdened with work at this time, and suggests that the painter may have asked to be released from his commitment, promising that he would later decorate another room, the library, which had not been named in the contract.[9]

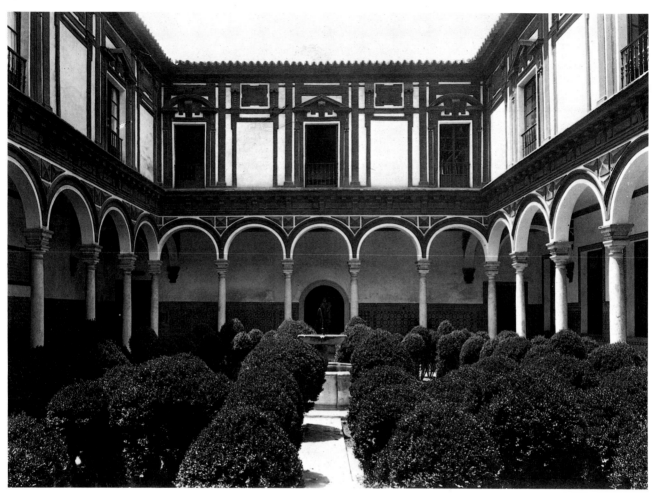

Boxwood Cloister, 1602–12. Monastery of the Merced Calzada, Seville

Ten paintings answering to the specifications for the cloister are preserved today. In the chronological order of the life of Saint Peter Nolasco, they are:

The Birth of Saint Peter Nolasco (Musée des Beaux-Arts, Bordeaux)
The Departure of Saint Peter Nolasco for Barcelona (cat. no. 7)
The Appearance of the Virgin to Saint Peter Nolasco in the Choir of the Cathedral of Barcelona (Cathedral, Seville)
The Presentation of the Image of the Virgin of El Puig to King James I of Aragon (cat. no. 8)
Saint Peter Nolasco's Vision of the Crucified Saint Peter (cat. no. 6)
The Vision of the Heavenly Jerusalem (Museo del Prado, Madrid)
The Surrender of Seville (cat. no. 9)
Saint Ferdinand Presenting the Image of the Virgin of Mercy to Saint Peter Nolasco (Cathedral, Seville)
The Miracle of the Barque (Cathedral, Seville)
The Death of Saint Peter Nolasco (Cathedral, Seville)

Not all these paintings were executed solely by Zurbarán, and a continuing problem is that of attribution. The service of assistants is acknowledged in the contract,

which mentions accommodations for "oficiales y demás gente" (assistants and other staff). They are explicitly recognized in the *memoria* of 1732, which names four paintings done by one of Zurbarán's pupils, Francisco Reyna: the *Presentation of Our Mother to Our Patriarch Saint by King Saint Ferdinand*, the *Barque*, the *Sepulcher of Saint Raymond*, and the *Miracle of the Choir*. The *memoria* also mentions a painting designated the "first," in which it had been necessary to "change the story"; the name of the painter is not given.

Ponz and Ceán Bermúdez accept the testimony of the *memoria*, but Matute attributes the four paintings not to Reyna but to Polanco. All four (assuming that the *Sepulcher of Saint Raymond* is to be identified with the *Death of Saint Peter Nolasco*) are today in the Cathedral of Seville. In 1982, when one of the canvases, the *Death of Saint Peter Nolasco*, was being restored, Enrique Valdivieso noticed traces of a signature, which he read as that of Juan Luis Zambrano (born in Córdoba, died in Seville about 1639). No work of that artist's Seville period had been known up to that time.

Saint Peter Nolasco (d. 1249), whose feast is celebrated on January 28, was the founder of the Order of Our Lady of Mercy. He was canonized on September 30, 1628, during the pontificate of Urban VIII, after a seventy-day trial that had been in preparation for two years. The advocates for canonization were two distinguished Mercedarians, Fray Luis de Aparicio for the Calced Fathers and Fray Diego de San Ramón for the Discalced. A compilation of the documents assembled in the canonization cause, in the form of ten sewn signatures of manuscript, is preserved at the University of Seville. The eighth signature, which is crucial to our knowledge of the saint's iconography, describes a *Vida de San Pedro Nolasco en estampes*, composed of twenty-five engravings. Eight of them have been rediscovered in the Biblioteca Nacional in Madrid. They were engraved by Johann Friedrich Greuter, Matthäus Greuter, and Luca Ciamberlano from drawings by Jusepe Martínez (1601–1682), an Aragonese artist who went to Rome in 1620 and was probably still there in 1627, the date of two of the surviving prints.

We know that these prints are the ones mentioned in the Seville manuscript because the description in Spanish of each engraving is accompanied by two inscriptions in Latin that also appear on the prints in the Biblioteca Nacional. One, in capital letters, is a brief quotation from Scripture, apposite to the subject, contained in a cartouche at the top of each print. The other, in minuscule, provides a title and the literary source for each scene and is placed below the picture, usually with the legend "S. Petrus Nolasco Fund" (Saint Peter Nolasco, Founder). Delgado Varela, who published the manuscript and the engravings in 1956, notes four prints of smaller size (Sancho Blanco collection) belonging to another series engraved by "Corn[elio] Cobrador," evidently copied from the first but with the inscriptions in Spanish.[10] Three of these are reversed relative to the original series, which was probably executed not long before.

Engraved a year before the canonization and mentioned in the *summarium* of the trial, the prints provide most of the scenes from the life of Saint Peter Nolasco in the chronological order that has been accepted by most biographers. The sources cited in minuscule are the principal early historians of the Mercedarian Order: Nadal Gaver (1445), Francisco Zumel (1588), and Bernardo de Vargas (1619, 1622). They are described at length in the indispensable *Historia general de la Orden de Nuestra Señora de la Merced*, by Alonso Remón, published in two volumes in Madrid in 1618 and 1633.

In Seville, festivities celebrating the canonization of the founder began on May 27, 1629. Without waiting for the conclusion of the trial begun on July 21, 1628, Herrera commissioned Zurbarán to paint the twenty-two scenes, probably in anticipation of

the festivities. Might he not then, as Santiago Sebastián has suggested, have forwarded the series of prints from Cobrador's engravings for the artist's use?[11]

LIBRARY

On the second story, near the dormitories and the cells of the superiors, were housed the archives and the library. This room of "harmonious proportions, well lighted," held thousands of volumes.[12] The walls were decorated with eleven life-size portraits of learned men of the order and a *Christ Crucified with Maestro Fray Silvestre de Saavedra at His Feet*.

This group, which is not mentioned in the contract of 1628, is attributed to Zurbarán by the author of the *memoria* of 1732, by Ceán Bermúdez, and by Matute.[13] Most of the pictures must have been removed from the monastery before the arrival of Napoleon's troops. Five of them were taken to Madrid by Manuel de Godoy about 1802. When his collection was sequestered by Ferdinand VII in March 1808, the paintings were given to the Real Academia de San Fernando, Madrid. These large canvases (203 × 122 cm), in a monumental style, represent theologians and teachers of the Mercedarian Order. Four are identified by inscriptions in the upper right: M. F. GERONIMO PEREZ, M. F. PEDRO DE MACHADO, M. F. FRANCISCO ZUMEL, and M. FR. FERNANDO DE STIAGO PICO DE ORO (the Golden-Mouthed). The fifth bears no inscription, but is perhaps a portrait of Fray Alonso de Sotomayor.

In 1950, the Marqués de Lozoya discovered, in a convent of Mercedarian nuns in Seville, a painting bearing the inscription: D. F. PEDRO DE ONA—OBISPO DE GAETA (Fray Pedro de Oña, Bishop of Gaeta), which may have been part of this series.[14] The work was purchased by the municipality and is now on permanent loan to the Museo de Bellas Artes, Seville.

Except for Fray Hernando de Santiago, who posed for the artist, as the words *vera efigie* following his name suggest, these illustrious men of letters were not alive during the time of Zurbarán. The artist must have relied on friars in the monastery for the distinguishing features of each subject. López-Rey correctly observes that one individual served as model for two symmetrically placed paintings, the *Fray Francisco Zumel* and the *Fray Pedro de Machado*.[15]

While these figures are all conceived according to the same scheme—standing slightly at an angle against a dark background—they do not all exemplify the same quality of execution. It may be assumed that the execution of the cycle extended over at least two or three years, and that Zurbarán delegated some of the work to his assistants, as in the scenes from the life of Saint Peter Nolasco for the decoration of the Boxwood Cloister.

Soria suggests that another portrait of an unnamed subject may have been part of this series: *A Bishop* (Musée des Beaux-Arts, Pau); and Guinard concurs, adding a second portrait, *A Mercedarian*, perhaps a copy of a lost original (formerly collection of the Marqués de Martorell, Madrid).[16] That leaves three portraits and the *Christ Crucified with Maestro Fray Silvestre de Saavedra at His Feet* to complete the cycle as described by the eighteenth-century historian. But the five paintings today in the Real Academia de San Fernando give us some idea of what must have been the striking effect of the eleven white-robed forms, guarding the Merced as "keepers of the city of books."[17]

NOTES

1. Pérez Escolano 1982, pp. 545–58.
2. Archivo Histórico Municipal, Madrid, cited in Pérez Escolano 1982, pl. 1.
3. Pérez Escolano 1982, pp. 545–58.
4. Ponz 1780 (1947 ed.), p. 790.
5. Ceán Bermúdez 1800, VI, p. 49.
6. Matute 1887b, p. 377.
7. Ponz 1780 (1947 ed.), p. 789; Ceán Bermúdez 1800, VI, p. 49; Matute 1887b, p. 376.
8. Sánchez Cantón 1922, pp. 209–16.
9. Guinard 1960a, p. 95.
10. Delgado Varela 1956, pp. 265–95.
11. Sebastián 1975, p. 82.
12. González de León 1844, p. 161.
13. *Memoria*, 1732; Ceán Bermúdez 1800, VI, p. 49.
14. Lozoya 1950.
15. López-Rey 1971, p. 122.
16. Soria 1953, no. 58; Guinard 1960a, nos. 421, 422.
17. Guinard 1960a, p. 97.

5.
Saint Serapion

1628
Oil on canvas, 47½ × 40½ in. (120 × 103 cm)
Signed and dated on a cartouche, at right: Fran^{co} de Zurbaran
 fabt. 1628
Inscribed: B[eatus] Serapius
Wadsworth Atheneum, Hartford, Connecticut. The Ella
 Gallup Sumner and Mary Catlin Sumner Collection

Original location: Seville, Monastery of the Merced Calzada,
 Sala de Profundis
Date of contract: Not mentioned in contract of August 29,
 1628

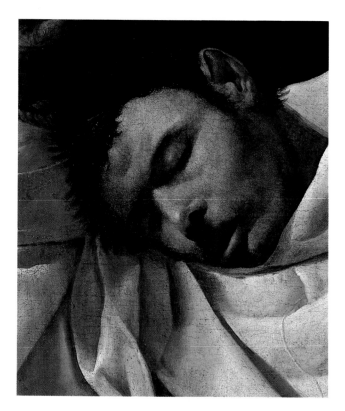

In addition to the traditional vows of poverty, chastity, and obedience, the Mercedarian friars took a vow "of redemption, or blood," whereby they pledged to act as hostages to ransom Christian captives in danger of losing their faith. Accordingly, the Mercedarians possessed a rich martyrology, of which Saint Serapion is an early ornament. Born in England toward the close of the twelfth century, Peter Serapion went to Spain and bore arms against the Moors beside Alfonso IX of Castile. He entered the recently founded Mercedarian Order and made several voyages to North Africa to liberate Christian captives. He later became director of novices, and attempted without success to establish the order in England. While sources agree upon his life story, there are three different versions of his martyrdom. According to one, he was martyred in Algiers by Moslems who wound his entrails on a winch; and according to another, he was beaten to death by French pirates in Marseilles. But the most authoritative account, and the most commonly accepted in the seventeenth century, derives from the early annals of the lives of the Mercedarians. Captured in Scotland by English pirates, Serapion was bound by the hands and feet to two poles, and was then beaten, dismembered, and disemboweled. Finally, his neck was partly severed, leaving his head to dangle.[1] In Zurbarán's painting, the scapular conceals these horrors, but the composition as a whole conforms to the third version. On the cartouche, the artist designates the Mercedarian as the B[eatus] (Blessed) Serapius. Martyred in 1240, Serapion was not in fact canonized until 1728, by Benedict XIII. Benedict XIV entered the saint's name in the Roman martyrology.

An example of the Christian acceptance of suffering and of resignation before death, the image of the Blessed Serapion was offered to the Mercedarians as a subject of meditation in their funerary chapel.

Zurbarán adopts a close-up view of the martyr, eliminating the other participants in the drama as well as its morbid details. The light cast on the ample white habit provided Zurbarán with the opportunity to represent realistically, in an almost illusionistic manner, the deep folds of the cowl and the three panels of the cape falling vertically to the lower edge of the picture. In the dark background, the two ill-hewn halves of the gibbet tree are barely discernible.

The victim's head, like that of Christ on the cross, falls to one shoulder. The face, with disheveled hair, swollen forehead, closed eyes, and half-open mouth, is treated with cruel truthfulness. No drop of blood stains this white harmony, only two spots of carmine on the eyelid and the lip. Pinned to the breast of the cape, in the center of the picture, is the scarlet, white, and gold shield of the Mercedarian Order.

The painting, dated 1628, is not mentioned in the commission for the Boxwood Cloister of August 29, 1628. Was it perhaps, as Guinard suggests, a trial piece requested before the signing of the contract?[2] If so, the friars had every reason to be pleased by what is now held to be the masterpiece of the artist's first Seville period.

NOTES
1. Remón 1618, fols. 165–66.
2. Guinard 1960a, p. 94.

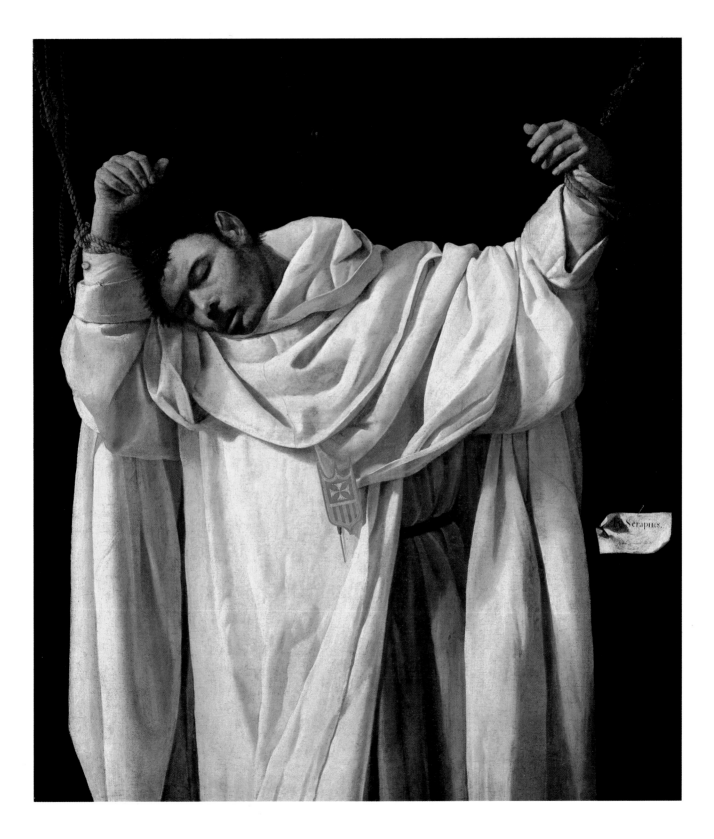

PROVENANCE
Monastery of the Merced Calzada, Seville; Alcázar, Seville, 1810, Room 7, no. 227; collection of Julian Williams, British consul, Seville; purchased in Seville by Richard Ford about 1832; Ford sale, Mr. Rainy, Auctioneer, London, June 9, 1836, no. 33, to Sir Montague John Cholmeley, Easton Hall, Grantham, Lincolnshire; purchased by David Koetser, New York, 1947; acquired by the Wadsworth Atheneum, Hartford, 1951.

LITERATURE
Ponz 1777 (1947 ed.), p. 790; Ceán Bermúdez 1800, VI, p. 49; Matute 1887b, p. 377; Guinard 1947, pp. 172–73; Pemán 1949, pp. 207–8; Soria 1953, no. 28; Guinard 1960a, no. 411; Sanz Pastor, in Madrid, Casón del Buen Retiro, 1964, no. 10; Sutton 1965, pp. 322–25; Brown 1974, p. 68; Guinard and Frati 1975, no. 33; Gállego and Gudiol 1977, no. 9.

EXHIBITED
Madrid 1964–65, no. 10.

6.
Saint Peter Nolasco's Vision of the Crucified Saint Peter

1629
Oil on canvas, 70½ × 88 in. (179 × 223 cm); 8 cm added on all four sides
Signed and dated, bottom center: FRANCISCUS DE [in ligature] ZURBARAN [AN in ligature] / FACIEBAT 1629
Museo del Prado, Madrid

Original location: Seville, Monastery of the Merced Calzada, Boxwood Cloister
Date of contract: August 29, 1628

The biographies of Saint Peter Nolasco, the founder of the Mercedarian Order, tell of two visions that he had, one of Saint Peter crucified and the other of the Heavenly Jerusalem. Both episodes, portrayed by Zurbarán in paintings now at the Prado, are represented in the *Vida de San Pedro Nolasco en estampes*, nos. 13 and 14, engraved in 1627 after drawings by Jusepe Martínez. Alonso Remón, the seventeenth-century historian of the Mercedarian Order, in his *Historia general de la Orden de Nuestra Señora de la Merced* (Madrid, 1618–33), describes in detail the circumstances of the vision of the crucified Saint Peter. Peter Nolasco eagerly desired but was unable to make a pilgrimage to Rome, to the tomb of the Apostle Peter, his illustrious patron saint. The Apostle then appeared to him in a dream on three successive nights, consoling him for being unable to make the journey. On the third night, as Peter Nolasco was kneeling in prayer, the Apostle showed himself as he had been crucified, upside down, and counseled him not to leave Spain, where his labors were so effective.

Zurbarán had certainly seen the astonishing oblique composition by Martínez, but he adopted the scheme of the second engraving after the drawing by Cornelio Cobrador (Sancho Blanco collection), not the first engraving, by Johann Friedrich Greuter (Biblioteca Nacional, Madrid).

Saint Peter Nolasco is represented here as a young man, in accordance with descriptions given in most of his biographies; he appears much older in both the engravings. It is very likely that the artist received specific instructions from the reverend father commander of the Merced Calzada, who would have supplied the engravings to guide him.

Zurbarán's composition skillfully evokes the supernatural intrusion. An incandescent cloud accompanies the apparition, invading the entire picture space and completely obscuring the background, so that the two figures are seen in isolation. They face each other along the same plane, but the monk is shown with his head inclined, contrary to convention, in order that he may behold the object of his vision and hear his message. The singular representation of the head of the crucified, resting on the

Johann Friedrich Greuter after Jusepe Martínez. *Saint Peter Nolasco's Vision of the Crucified Saint Peter*, 1627. Engraving. Biblioteca Nacional, Madrid

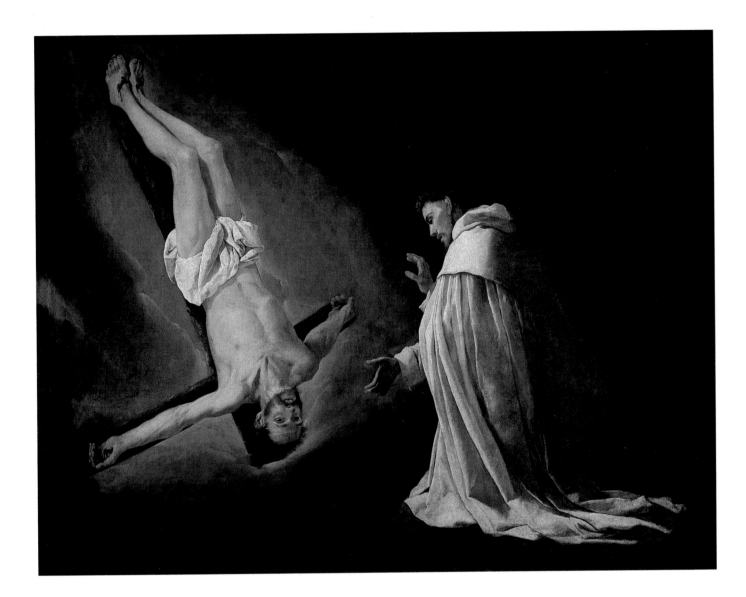

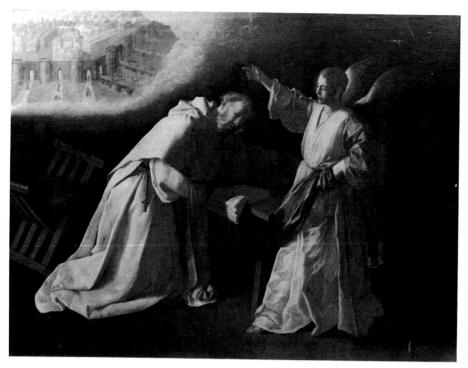

Francisco de Zurbarán. *Saint Peter Nolasco's Vision of the Heavenly Jerusalem*, ca. 1629. Oil on canvas, 5 ft. 10½ in. × 7 ft. 3¾ in. (179 × 223 cm). Museo del Prado, Madrid

floor, recalls Caravaggesque renditions of Saint Peter's crucifixion. The face is depicted with remarkable veracity. Jonathan Brown has noted a telling detail: "The apostle's eyes are opened wide and seem to bulge out under the pressure of the blood that rushes to his head."[1] The bare body, modeled in broad orange patches, is girt with a cloth of blinding white that vies in tactile force with the Mercedarian's heavy cloak, which dissolves gradually into the surrounding shadow.

The painting, executed in 1629, is the earliest of the Boxwood Cloister series. It is related in both subject and style to the *Vision of the Heavenly Jerusalem*, which has, however, a cooler tonality and more highly contrasted chiaroscuro. Until these two paintings, which interact like pendants because of their visionary subject matter, Zurbarán had not juxtaposed the human world and the Divine with so natural an effect.

NOTE
1. Brown 1974, p. 70.

PROVENANCE
Monastery of the Merced Calzada, Seville; sold before 1808 by the Mercedarians to Canon López Cepero, Seville; given by him to Ferdinand VII in exchange for a portrait by Velázquez, 1821; Royal Collections, Madrid.

LITERATURE
Palomino 1724 (1947 ed.), pp. 937–38; Ponz 1780 (1947 ed.), p. 106; Ceán Bermúdez 1800, VI, p. 49; Madrazo, in Madrid, Museo del Prado, 1872, p. 648; Matute 1887b, p. 375; Viniegra, in Madrid,

Museo del Prado, 1905, no. 112; Cascales y Muñoz 1911, p. 105; Kehrer 1918, pp. 42–43; Sánchez Cantón 1922, pp. 209–16; López Martínez 1932, pp. 221–22; Guinard 1947, pp. 161–71; Salas 1950, pp. 229–34; Soria 1953, no. 31; Delgado Varela 1956, pp. 265–95; Guinard 1960a, no. 399; Brown 1974, pp. 70–71; Guinard and Frati 1975, no. 40; Sebastián 1975, pp. 82–84; Gállego and Gudiol 1977, no. 12; Madrid, Museo del Prado, 1984, no. 1237; García Gutiérrez 1985, p. 44.

EXHIBITED
Madrid 1905, no. 112.

7.
The Departure of Saint Peter Nolasco for Barcelona

ca. 1629–30
Oil on canvas, 67½ × 83½ in. (171 × 212 cm)
Museo Franz Mayer, Mexico City

Original location: Seville, Monastery of the Merced Calzada, Boxwood Cloister
Date of contract: August 29, 1628

This scene was incorrectly identified in the nineteenth century as an episode from the Legend of the Bell, or the Presentation of the Image of the Virgin of El Puig (see cat. no. 8). As recently as 1960, it was still interpreted in this way by Guinard, who viewed the dog's pointing as a sign of where the image of the Virgin was hidden.[1] Soria describes it more accurately as *Saint Peter Nolasco with Three Nobles*.[2]

106

Cornelio Cobrador after Jusepe Martínez. *The Departure
of Saint Peter Nolasco for Barcelona*, ca. 1627. Engraving.
Formerly Sancho Blanco collection

An engraving in the *Vida de San Pedro Nolasco en
estampes*, of 1627, correctly described in the Univer-
sity of Seville manuscript, solves the riddle.[3] The ep-
isode, taken from Alonso Remón's *Historia general de la
Orden de Nuestra Señora de la Merced*, is from the life
of Saint Peter Nolasco. Born to an aristocratic family
in the region of Narbonne, Peter Nolasco lost his
parents when he was about fifteen years old. He then
went to live with his aunt in Toulouse, and there he
became associated with the future James I of Aragon.
The Dominican Raymond of Peñafort was his con-
fessor. Under Simon de Monfort, he fought the Al-
bigensian heretics, but in view of the limited success
of the campaign, he decided to sell his goods, leave
Toulouse, "sin bastar los ruegos y persuasiones de
muchos caballeros mozos" (ignoring the urgings and
persuasions of many young companions), and go to
Barcelona. He arrived in that city between 1203 and
1213.[4] In all probability, Peter Nolasco was the proc-
urator of Raymond of Peñafort's lay confraternity
for ransoming Christian captives from the Moors.[5]

On August 1, 1218, the Virgin Mary appeared si-
multaneously to Peter Nolasco, James I of Aragon,

and Raymond of Peñafort, and in response to her re-
quest, the Order of Our Lady of Mercy was offi-
cially founded in Barcelona on August 10, 1218. On
January 17, 1235, the order was approved and placed
under the Augustinian rule of Pope Gregory IX.

The painting depicts Peter Nolasco being detained
from his departure for Barcelona by "the urgings
and persuasions of many young companions." Two
engravings of this episode are known. The first, by
Johann Friedrich Greuter after a drawing by Jusepe
Martínez, shows Peter Nolasco leaving his cape with
his three companions (Biblioteca Nacional, Madrid).
The second, also after Martínez, is by Cornelio Co-
brador. Zurbarán was undoubtedly inspired by the
drawing as engraved by Cobrador. A comparison of
the painting with the engraving is quite instructive.
From an anecdotal and lively subject, the artist created
a work that is subdued, quiet, and static. Of the six
figures in the engraving, he retained only four, sim-
plified their gestures, and reduced the long city walls
to one small stronghold. This economy gives the scene
a more focused intensity.

The figure of Saint Peter Nolasco stands out at the
center of the composition. The light emphasizes the
elongated oval of his face, the sharp lines of his cos-
tume, and the flat colors of his cape. Palomino noted
the "sleeves of silvery woolen cloth," but the dog es-
pecially caught his attention, "painted so true to life
that one fears she may attack the viewer."[6] The
saint's three companions are not of the same quality;
they are slighter, with small, round, crudely mod-
eled heads. Both Soria and Guinard, in emphasizing
the weak points of the picture, which is disfigured
by overpainting, have suggested that Zurbarán left
the execution of these secondary figures to one of his

Francisco de Zurbarán (?). *The Birth of Saint Peter Nolasco*.
Oil on canvas, 5 ft. 5¼ in. × 6 ft. 11½ in. (166 × 212 cm).
Musée des Beaux-Arts, Bordeaux

assistants.[7] The observation is supported by Gudiol's discovery of another painting in the series, the *Birth of Saint Peter Nolasco*, in which the same hand can be recognized.[8] Indeed, the dappled modeling, the heads set awkwardly on the shoulders, and the abrupt movement toward the center of the picture (where X rays reveal an alteration of the composition) are in distinct contrast to the more refined treatment of the saint.

NOTES

1. Guinard 1960a, no. 400.
2. Soria 1953, no. 33.
3. Delgado Varela 1956, p. 285.
4. Remón 1633, fol. 39.
5. *New Catholic Encyclopedia*, 1967, XI, p. 225.
6. Palomino 1724 (1947 ed.), p. 194.
7. Soria 1953, no. 33; Guinard 1960a, no. 400.
8. Gállego and Gudiol 1977, p. 74.

PROVENANCE

Monastery of the Merced Calzada, Seville; Galerie Espagnole, Musée Royal au Louvre, Paris, 1838; Louis-Philippe sale, Christie's, London, May 20, 1853, no. 415 ("from a convent near Granada"), to J. C. W. Sawbridge Erle Drax, London, for £35; Drax sale, Christie's, London, May 10, 1935, no. 153, to A. Seligmann, Rey and Co., New York, for £252; collection of William Randolph Hearst, New York, 1944; International Studio Art Corporation, 1953; collection of H. E. Stewart, Dallas; collection of Franz Mayer, Mexico City, 1959.

LITERATURE

Palomino 1724 (1947 ed.), p. 937; Ponz 1777 (1947 ed.), p. 790; Ceán Bermúdez 1800, VI, p. 49; Paris, Musée du Louvre, 1838, no. 397 (1st ed.), no. 407 (4th ed.); Ford 1853; Matute 1887b, p. 376; Guinard 1947, pp. 168–71; Soria 1953, no. 33; Guinard 1960a, no. 400; Guinard and Frati 1975, no. 41; Sebastián 1975, p. 83; Gállego and Gudiol 1977, no. 13; Baticle and Marinas 1981, no. 407.

EXHIBITED

Paris 1838–48, no. 397 (1st ed.), no. 407 (4th ed.).

8.
The Presentation of the Image of the Virgin of El Puig to King James I of Aragon

1630
Oil on canvas, 65 × 82 in. (165 × 208 cm)
Signed and dated, lower left: FRAN^co DE ZURB FATI. / 1630
The Cincinnati Art Museum

Original location: Seville, Monastery of the Merced Calzada, Boxwood Cloister
Date of contract: August 29, 1628

From its founding in 1218 until 1317, the Order of Our Lady of Mercy was principally of a military and lay character. Thus, Saint Peter Nolasco was with James I of Aragon, called "the Conquerer," at the taking of Valencia in 1238. The miracle represented by Zurbarán in this painting occurred shortly before the capture of the city, news of which was brought to the king by the Mercedarian founder. One evening, the watchmen on duty at the Castle of El Puig saw seven lights fall from the sky and disappear under the ground, on what is now the site of the Mercedarian Convent of Nuestra Señora del Puig. This phenomenon was seen three times in succession. When it was reported to Peter Nolasco, he realized that the lights were stars, and had the earth excavated at the site. First a great bell was found, very old and bearing images of the Apostles Peter, Paul, and James. Beneath the bell was buried a stone relief representing the Virgin and Child, which became known as the Virgin of El Puig.[1]

The legend recounts that the image had been carved by angels in the stone of the Virgin's tomb in Jerusalem and brought to El Puig by Benedictine monks, who founded a convent there at the fall of the Roman Empire. Hidden by the Goths to save it from profanation during the Moslem invasion, it was revealed to the Christians at the time of the reconquest of Spain from the Moors.[2]

After the miracle, the king of Aragon, much devoted to the cult of the Virgin, built a rich and important monastery, El Puig de Santa María, which he offered to the Mercedarians.

Zurbarán represents the discovery of the image of the Virgin in the presence of both James I, in armor and bearing the baton of command, and Peter Nolasco, clothed in the white robe of the order. This is the earliest representation of the episode. The series engraved after Jusepe Martínez in 1627 (see cat. no. 6) also included a print (no. 18) that depicts the scene just before the discovery of the relief — the falling stars and Peter Nolasco preparing to dig into the earth.

In their heroic proportions, the monumental figures in the painting occupy the entire surface of the canvas. They are divided into two groups on either side of the relief, revealing the hole dug in the ground. Breaking the verticality of the secondary figures, the two central figures, the king and the peasant who discovered the sculptured stone, are adroitly united by the gestures of their right arms, extended to show the image of the Virgin.

The falling light emphasizes the angular forms of features and apparel; it also serves to enliven the static composition with highlights on the armor and contrasts between the grays of the soldiers' uniforms and the creamy white of the monastic garb.

Zurbarán here presents a whole gallery of portraits, juxtaposing the coarse and highly colored faces of

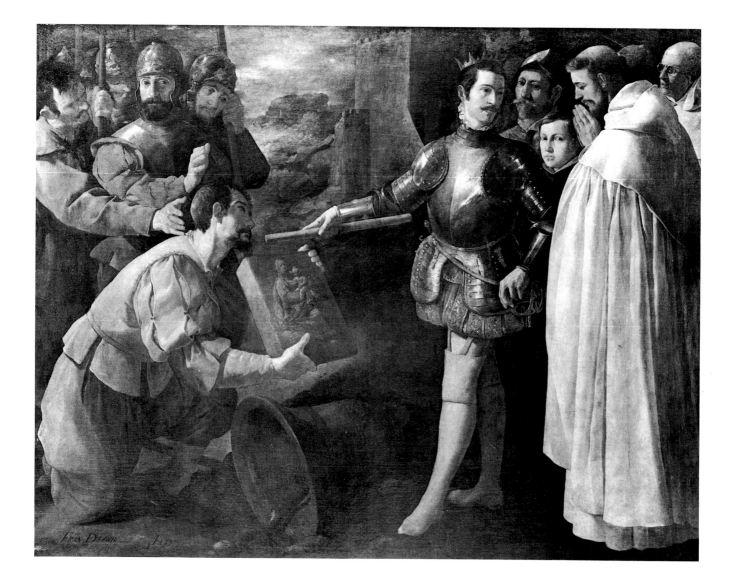

the men-at-arms with the sparer countenances of James I and Peter Nolasco. The young boy who turns toward the viewer between these two figures is perhaps, as Soria suggests, the artist's son Juan, then ten years of age.[3]

NOTES
1. Remón 1633, II, fol. 62.
2. García Gutiérrez 1985, pp. 27–30.
3. Soria 1953, no. 32.

PROVENANCE
Monastery of the Merced Calzada, Seville; Galerie Espagnole, Musée Royal au Louvre, Paris, 1838; Louis-Philippe sale, Christie's, London, May 20, 1853, no. 416 ("from a convent near Granada"), to William W. Pearce for £65; Pearce sale, Phillips, London, Apr. 23, 1872, no. 500, to Myers for £79; collection of Charles T. D. Crews, Billingbear Park, Berkshire; Crews sale, Christie's, London, July 2, 1915, no. 232, to A. J. Sulley and Co. for £294; donated by Miss Mary Hanna, Mr. and Mrs. Charles P. Taft, and Stevenson Scott to The Cincinnati Art Museum in 1917.

LITERATURE
Palomino 1724 (1947 ed.), pp. 937–38; Ponz 1780 (1947 ed.), p. 106; Ceán Bermúdez 1800, VI, p. 49; Paris, Musée du Louvre, 1838, no. 398 (1st ed.), no. 408 (4th ed.); Matute 1887b, p. 375; Vázquez 1929, pp. 286–89; López Martínez 1932, pp. 221–22; Robinson 1936, pp. 16–27; Gudiol, in Toledo, Ohio, Toledo Museum of Art, 1941, no. 69; Soria 1944a, pp. 36, 37, 49; Guinard 1947, pp. 164–69; Soria 1953, no. 32; Guinard 1960a, no. 401; Guinard and Frati 1975, no. 42; Gállego and Gudiol 1977, no. 14; Rogers 1978, pp. 30–32; Baticle and Marinas 1981, no. 408; García Gutiérrez 1985, p. 30.

EXHIBITED
Paris 1838–48, no. 398 (1st ed.), no. 408 (4th ed.); Toledo, Ohio, 1941, no. 69.

9.
The Surrender of Seville

1634
Oil on canvas, 63 × 82 in. (160 × 208 cm)
Signed and dated, lower right: $\frac{CO}{F}$ DE [in ligature]
 ZURBARAN 1634
His Grace the Duke of Westminster T.D.

Original location: Seville, Monastery of the Merced Calzada, Boxwood Cloister
Date of contract: August 29, 1628

The Mercedarians, as a military order, participated throughout the Reconquest not only under James I of Aragon but also under King Saint Ferdinand III of Castile and León (canonized in 1671), who little by little regained the south of Spain. After taking Córdoba in 1236, Ferdinand seized Jaén and the kingdom of Murcia. He marched on Seville, which he took from the Moors after a siege of sixteen months, where he was joined by James I of Aragon, accompanied by Peter Nolasco and many friars and knights of the Mercedarian Order. On December 22, 1248, the Christians entered the city.[1]

Zurbarán here portrays the moment when Achacaf, the Moorish governor of Seville, kneeling, presented the keys of the city to Ferdinand, in armor and with his right hand resting on the staff of command. To the king's right stand the knights of the order, also in armor but bearing the Mercedarian escutcheon: the white cross of Saint John of Jerusalem on a field of gules (the emblem of Barcelona Cathedral) and, below the arms of the House of Aragon, four pales of gules on a field of gold. These arms, granted by James I and the Bishop of Barcelona on the day of the founding of the order, August 10, 1218, were also worn on the white habits of the monks.

To the king's left, Peter Nolasco, shown here as much older than in *Saint Peter Nolasco's Vision of the Crucified Saint Peter* (cat. no. 6), is flanked by a Mercedarian friar and a Dominican, recalling the close bonds between the two orders and the steadfast support of Raymond of Peñafort, master general of the Order of Preachers and cofounder of the Mercedarians. Behind Achacaf, a Spanish soldier bears the standard of Ferdinand III, on which can be discerned the armorial ensigns of his kingdoms—the tower of Castile and the lion of León in gold, quartered on a field of silver. In the background, the camp of the besiegers is seen under the walls of Seville, the famous Giralda Tower of the Cathedral of Seville making the city immediately recognizable.

A painting of the same series in the Cathedral of Seville, attributed to Francisco Reyna, completes the history of the capture of the city. In that painting, Ferdinand is shown presenting Peter Nolasco with a statue of the Virgin for the Mercedarian monastery to be founded in Seville shortly after the Reconquest. The founder of the order is portrayed kneeling, surrounded by Mercedarian knights and friars. This event, recounted by Remón, takes place in the Christian camp.[2]

As in the other surviving paintings illustrating the life of Saint Peter Nolasco, there is no attempt here at historical accuracy. Wearing the dress of contemporary Spain, the figures are intended to render the action immediate and to encourage viewers to emulate the exemplary life set before them.

The subject of the surrender of Seville does not appear in the Martínez engravings of scenes from the life of Saint Peter Nolasco. Understandably, the Mercedarians chose to include it in the decoration of their cloister, to celebrate the part played by the king and

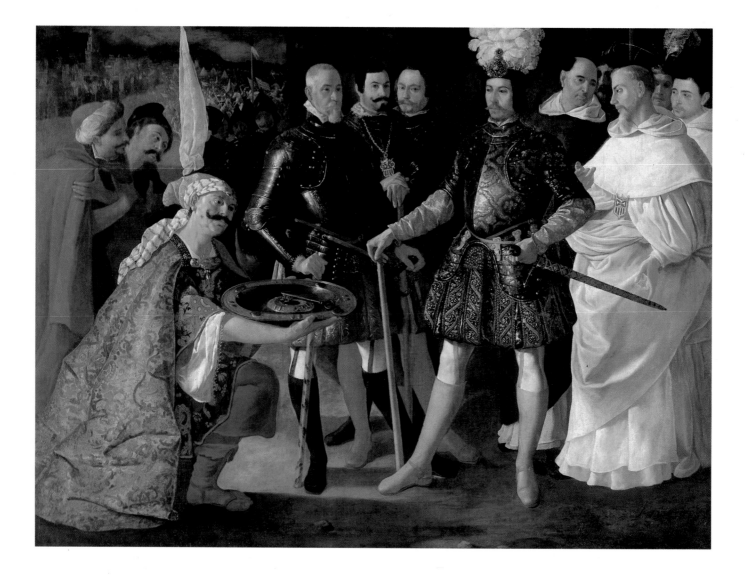

their founding saint in the reconquest of the Andalusian capital.

Zurbarán adopted another model, the *Surrender of Seville*, known today through two paintings: one on copper, commissioned by the cathedral from Francisco Pacheco in 1633; the other anonymous, noted by López-Rey, in the collection of Manuel López Cepero.[3]

With the characteristic disposition of figures, the scene fits into the cycle commissioned for the Boxwood Cloister, analogous as it is in composition to the *Presentation of the Image of the Virgin of El Puig* (cat. no. 8), executed four years earlier. As in the latter, the frieze of portraits is enlivened in the foreground by the curve of a man kneeling, in this case the Moorish prince Achacaf. But the effect of light is different in the *Surrender of Seville*. More evenly distributed over the composition as a whole, it distin-

Francisco Pacheco. *Surrender of Seville*, 1633. Oil on canvas, 19⅝ × 15¾ in. (50 × 40 cm). Cathedral, Seville

guishes each figure and, by the play of shadows cast on the ground, gives an indication of depth.

These new studies in the effects of light and the suggestion of space mark an advance in the artist's development. Dated 1634, the *Surrender of Seville* was to be the last scene from the life of Saint Peter Nolasco painted by Zurbarán before he departed for Madrid. It is known that in June 1634 he was at court, where he received an advance payment for the Labors of Hercules series (Museo del Prado, Madrid; see cat. no. 24), commissioned by Philip IV to decorate the Buen Retiro Palace.

NOTES
1. Salmerón 1646, p. 37.
2. Remón 1633, II, fol. 74.
3. López-Rey 1965, pp. 24–25.

PROVENANCE
Monastery of the Merced Calzada, Seville; collection of Prime Minister Manuel de Godoy in 1808 (Quilliet 1808, inv., without no., published in Wagner 1983, p. 425); probably in the collection of the Duke of Westminster since early in the nineteenth century (Braham, in London, National Gallery, 1981, no. 32).

LITERATURE
Palomino 1724 (1947 ed.), pp. 937–38; Ponz 1780 (1947 ed.), p. 106; Ceán Bermúdez 1800, VI, p. 49; Matute 1887b, p. 375; López Martínez 1932, pp. 221–22; López-Rey 1965, pp. 23–25; Brown 1974, p. 24; Guinard and Frati 1975, no. 48; Gállego and Gudiol 1977, no. 15; Braham, in London, National Gallery, 1981, no. 32; Wagner 1983, p. 425.

EXHIBITED
London 1981, no. 32.

10.
Fray Jerónimo Pérez

After 1630
Oil on canvas, 80¼ × 48 in. (204 × 122 cm)
Inscribed, upper right: M[aestr]o F[ray] GERONIMO PEREZ
Academia de San Fernando, Madrid

Original location: Seville, Monastery of the Merced Calzada, library
Date of contract: Not mentioned in the contract of 1628

EXHIBITED IN NEW YORK ONLY

Vicar general of the Mercedarian Order in the mid-sixteenth century, Maestro Fray Jerónimo Pérez was a professor of theology and philosophy at the University of Valencia. His learning and his Thomist scholarship led in 1546 to his being selected by Francis Borgia, the future third father general of the Society of Jesus, to teach at the college he had founded in that city. This college, the first Jesuit teaching institution for the young, soon became a university. Alonso Remón devotes several folios in his *Historia general de la Orden de Nuestra Señora de la Merced* to the signal honor of this appointment, and marvels at the erudition of his illustrious confrere. He states that Fray Jerónimo died peacefully at a great age. Zurbarán represents him in the garb of the fathers of the Order of Our Lady of Mercy—a white robe with white scapular and hood—writing the treatise he composed in 1548 on Saint Thomas Aquinas.[1]

Among the eight extant portraits from the series of theologians set as exemplars before the studious Mercedarians in the library, that of Fray Jerónimo Pérez stands out for its nobility and for the superb quality of execution. The table, covered with a scarlet cloth and placed slightly behind the figure rather

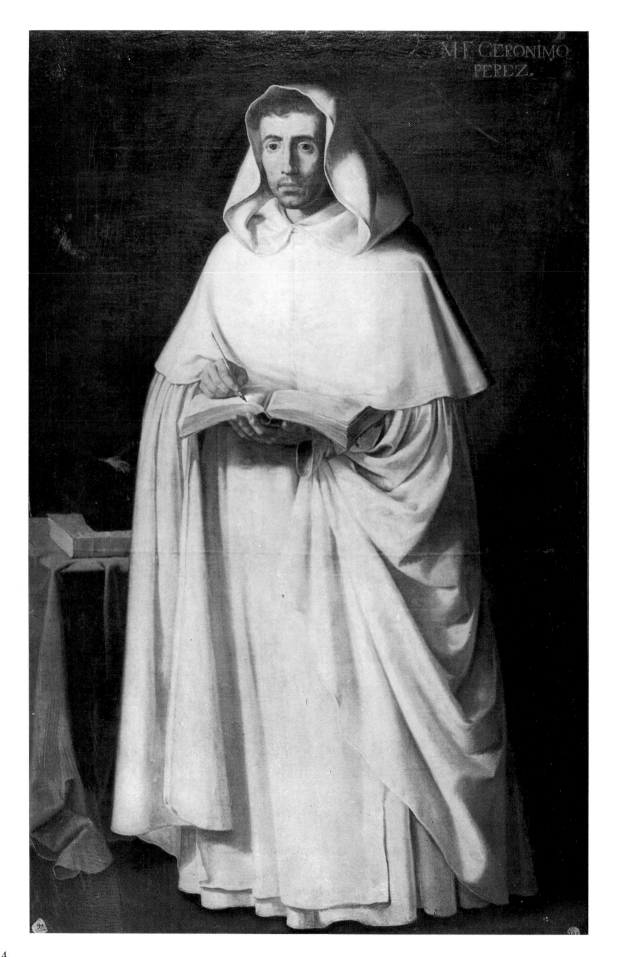

M.F. GERONIMO
PEREZ.

114

than at the side as in the other portraits, adds depth to the composition and accentuates the fullness of the white cape. The nearly frontal presentation of the figure (the only one in the series with a raised hood) is underscored by the foreshortening of the book, and suggests that the picture may have occupied a special place in the center of the gallery. The long face is framed by the wavy line of the hood, and the large eyes rimmed with deep lids emphasize the fixed gaze that reflects intense concentration. The realism of the features, the supple modeling and bone structure of the hands, and the movement of the draperies, marked by light gray shadows, suggest a dating after 1630.

The strong tenebrism of the *Saint Serapion* (cat. no. 5), in which the figure is swathed in a cloak with deep folds delineated by patches of brown, and with which the Merced Calzada cycle began in 1628, is followed toward 1633 by the more open, luminous style so evident in the present work.

NOTE
1. Remón 1618, fols. 184–88.

PROVENANCE
Monastery of the Merced Calzada, Seville; collection of Prime Minister Manuel de Godoy in 1808 (Quilliet 1808, inv., without no., published in Wagner 1983, p. 431; inv. 1813, no. 10); entered the Real Academia de San Fernando with the confiscated Godoy collection in 1813.

LITERATURE
Memoria, 1732 (1789 copy); Ceán Bermúdez 1800, VI, p. 49; Madrid, Real Academia de San Fernando, 1819, p. 19; Matute 1887b, p. 381; Viniegra, in Madrid, Museo del Prado, 1905, no. 3; Cascales y Muñoz 1911, p. 112; Kehrer 1918, pp. 57, 145; Tormo y Monzó 1929, p. 26; Mayer 1936, p. 44; Soria 1944a, p. 46; Guinard 1947, pp. 172–75; Caturla, in Granada, II Festival Internacional de Música y Danza, 1953, no. 9; Soria 1953, no. 79; Guinard 1960a, pp. 95–96, 199, no. 416; Torres Martín 1963, no. 96; Pérez Sánchez, in Madrid, Real Academia de San Fernando, 1964, no. 667; Gudiol 1965, pp. 148–51; López-Rey 1965, pp. 120–25; Brown 1974, p. 100; Guinard and Frati 1975, no. 47; Pérez Sánchez, in London, Royal Academy of Arts, 1976, no. 37; Gállego and Gudiol 1977, no. 182; Wagner 1983, p. 431.

EXHIBITED
Madrid 1905, no. 3; Granada 1953, no. 9; Bordeaux 1955, no. 75; Stockholm 1959–60, no. 113; Madrid 1964–65, no. 20; London 1976, no. 37; Paris 1976, no. 66.

11.
Saint Agatha

Before 1634
Oil on canvas, 51 × 24 in. (129 × 61 cm)
Musée Fabre, Montpellier

Original location: Seville, Monastery of the Merced Calzada (?)
Date of contract: Not known

Saint Agatha, the celebrated Sicilian virgin martyr, is one of the seven saints recommended to painters by Gabriele Paleotti in his famous *Discorso intorno alle imagine sacre e profane* (Bologna, 1582), which sets forth the doctrines of the Council of Trent on the subject of sacred iconography.[1] Two cities of Sicily, Catania and Palermo, claim to be the birthplace of this young martyr, whose story follows the traditional pattern of cruel suffering.

As beautiful as she was young and rich, Agatha devoted herself to God from childhood. The prefect Quintianus, a covetous and licentious pagan, tried in vain to seduce her and force her to renounce her faith. Mad with rage, he subjected the young girl to the ritual rape practiced by the Romans, whose laws prohibited a virgin from being put to death. But Agatha's virginity was miraculously preserved. She then submitted to further cruel torments while she proclaimed her faith and her joy at being so tried. Quintianus in a fury ordered that her breasts be cut off and her body crushed, and threw her into prison. There Saint Peter appeared to her and healed all her wounds. Again, she was subjected to torture. Finally, she commended her soul to God. At that very moment, there was an eruption of Mount Etna. The people of Catania, filled with veneration for the young martyr, successfully implored her to preserve them from the fires of the volcano. She thus became the patroness of the city.

Saint Agatha is honored on the fifth of February, and her name appears in the canon of the Mass. No later than the tenth century, a proper Office was assigned to her, with versicles and responses taken from the Acts of the Apostles. The old liturgies are filled with poetic compositions glorifying the young virgin. Saint Isidore of Seville composed two hymns in her honor, which are inserted in the saint's Office according to the Mozarabic liturgy. In the *Flos sanctorum* (Madrid, 1593), Alonso de Villegas Selvago compares her to the little sister in the Song of Solomon (8:8): "Es de poca edad y no tiene pechos" (We have a little sister, and she hath no breasts);[2] in the *Horas devotíssimas* (Madrid, 1605), on the other hand, Francisco Ortiz Lucio, a prolific and popular author, advises wet nurses to pray to her for milk.[3]

Following Paleotti, who maintained that the attributes of saints must be depicted not only so that the saints would be easily recognizable, but also as trophies or tokens of their glory,[4] Zurbarán represents Saint Agatha with the emblems of her martyrdom, her breasts carried on a tray, which she seems to present to the faithful, like canting arms.

Notwithstanding the devotion awarded her by Saint Isidore of Seville, Saint Agatha was not often portrayed in the decorous Spain of the Counter-Reformation, doubtless because of the emblem of her martyrdom, the amputated breasts. Pacheco, as *verificator* for the tribunal of the Inquisition, was not unaware of the sensual power of certain sacred images, and he never painted this subject—nor did Alonso Cano or Bartolomé Esteban Murillo. They preferred Saint Agnes and Saint Catherine, whose attributes—the lamp and the wheel—were innocuous.

Saint Agatha was occasionally represented in Castile during the first quarter of the seventeenth century, most notably by Luis Tristán at the parish church of Yepes and by Matías Ximeno at the collegial church of Pastrana. And in Madrid, the Mercedarian Order chose to commemorate her martyrdom. She was also invoked by hospital convents, as protectress of lactation.

Zurbarán's *Saint Agatha* is not usually included in the Merced Calzada cycle. Guinard places it with the altarpiece at San Alberto (see pp. 133–41),[5] but Zurbarán's paintings for that altarpiece were considerably smaller.

In the Alcázar inventory of 1810, no. 232 (in Room 7) is identified as a *Saint Agatha* measuring $1\frac{1}{4} \times \frac{2}{3}$ varas (about 105 × 56 cm), which agrees fairly well with the dimensions of the Montpellier *Saint Agatha*. Of the three other paintings of Saint Agatha by Zurbarán or from his workshop, one is a half-length portrayal, another is smaller than the one listed in the inventory, and the third is larger.[6]

In the inventory, paintings of like provenance are often grouped together. The *Saint Agatha* is listed only a few numbers away from the *Saint Serapion* (cat. no. 5) and from the picture of an unidentified Mercedarian saint. Thus, it may have been commissioned by a Calced or a Discalced Mercedarian monastery, like the *Saint Apollonia* (cat. no. 21) or the *Saint Lucy* (cat. no. 22). It should be noted that it is rounded at the top like the two just cited, although it is five inches greater in height.

The *Saint Agatha* is an especially engaging painting, one that caught the attention of Paul Valéry.[7] The inclined attitude is extremely graceful. The head, coiffed in simple bands and bent over the right shoulder, and the musing expression of the face make a poetic image. Zurbarán's realism is tempered by decorum, and with his customary tact he represents this difficult subject very judiciously. The lovely breasts, their milky reflection in the metal platter suggesting a close observation of form, introduce an ambiguous note that is not without charm.

With Saint Agatha's elegant apparel, which clearly evokes the wardrobe of the theater, Zurbarán contrived to assemble rare colors that work in harmony: the duck blue of the bodice, the blouse in bright yellow, the mauve skirt changing to purple in shadow, and the dramatic red of the cloak, with a cabbage knot at the shoulder.

Although the treatment of the folds shows a development toward a Bolognese stylization of the drapery in the manner of Guido Reni, the rather hard brushwork without any real modeling—in the hands and face, for example—as well as the dark background and contrasted lighting effects, would seem to favor a date prior to 1634.

NOTES
1. Paleotti 1582, book IV, chap. 15.
2. Villegas Selvago 1593, fol. 97.
3. Ortiz Lucio 1605, p. 594.
4. Paleotti 1582, book I, fols. 188–89.
5. Guinard 1960a, no. 230.
6. *Ibid.*, nos. 231–33.
7. Paul Valéry, cited in Guinard and Frati 1975, p. 11.

PROVENANCE
Monastery of the Merced Calzada (?), Seville; Alcázar, Seville, 1810, Room 7, no. 232; collection of Marshal Soult, Paris; Soult sale, Paris, May 1852, no. 34, to the Musée Fabre, Montpellier, for 1,540 francs (from the proceeds of the Collot sale).

LITERATURE
Delacroix 1828 (1931–32 ed.), I, p. 91; Joubin, in Montpellier, Musée Fabre, 1929, no. 171; Soria 1948b, pp. 256–57; Soria 1953, no. 46; Gaya Nuño 1958, no. 2208; Guinard 1960a, no. 230; Baticle, in Paris, Musée des Arts Décoratifs, 1963, no. 93; Guinard and Frati 1975, no. 92; Gállego and Gudiol 1977, no. 220.

EXHIBITED
Paris 1939, no. 105; Paris 1963, no. 93.

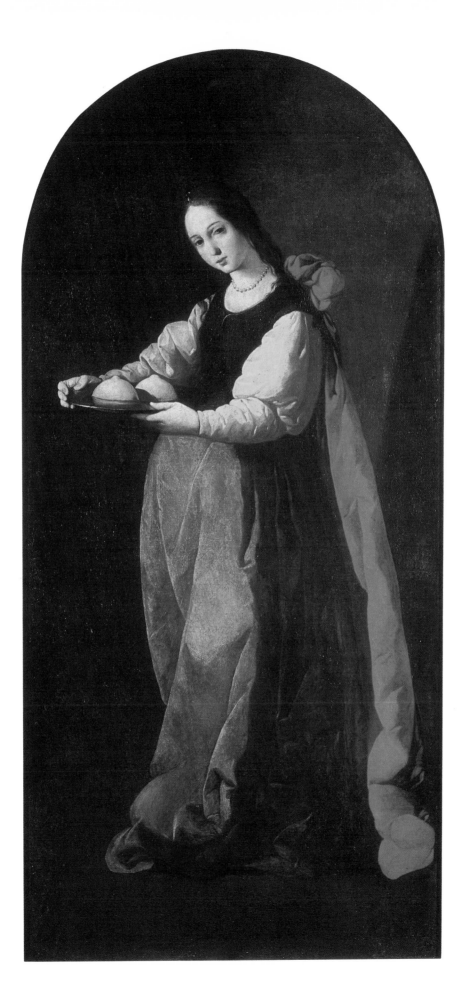

117

THE MONASTERY OF THE TRINIDAD CALZADA, SEVILLE

Centuries of fighting between the Moslem and the Christian worlds resulted in an increasing number of captives taken on both sides. At the end of the twelfth century, in the family chapel of Maurice de Sully, Archbishop of Paris, Jean de Matha, a Provençal monk, had a vision while celebrating his first Mass. As he elevated the Host, he saw an angel, dressed in white and standing above the altar, with his hands crossed above the heads of two captives, a Moor and a Christian. This revelation led to the foundation, in 1198, of an order for the exchange and redemption of captives, the Order of the Most Holy Trinity. Jean de Matha, the founder of what soon became a flourishing order, died in Rome in 1212.

The Trinitarians thus played a role of considerable importance in Spain because of the centuries-old effort to eradicate the Moorish presence. The Mercedarian Order, founded in the thirteenth century with a similar mission, also became firmly established on the Iberian peninsula.

The Monastery of the Trinidad Calzada was situated outside the city walls of Seville, not far from the Puerta del Sol, to the northwest. It still exists, although in considerably altered state, on Calle Muñoz de León, and houses the Order of Saint Francis of Sales.

The monastery took pride in having preserved the underground prison in which Saints Justa and Rufina, virgin martyrs and patron saints of Seville, had been incarcerated. The church, a superb edifice of vast proportions with a single nave, is still standing, although the interior was completely devasted during the French invasion in 1810. Early in the eighteenth century, González de León had deplored the dismantling of the main altarpiece, which suggests that the church had at that early date already been modified.[1] Nevertheless, we know that the altarpieces on either side of the high altar were extant at the end of the century, because Ponz noted that on the altarpiece at the right were paintings by Zurbarán showing scenes from the lives of the Virgin and of Saint Joseph.[2] Ponz mentions further a "Christ Child" by Zurbarán, on the small ciborium door of the altar; Ceán Bermúdez also notes this painting, describing it as "gracioso."[3]

The contract for this ensemble, dated September 26, 1629, is unfortunately not very detailed and deals mostly with the gilding and painting of the altarpiece. Zurbarán was to be paid the rather small sum of 130 ducats, or 1,430 reales, for an altarpiece dedicated to Saint Joseph.[4] González de León, however, asserts that Zurbarán's contribution was eight pictures—the altarpiece on the right side, with scenes from the life of Saint Joseph, and the one on the left, with scenes from the life of the Virgin.[5] Interestingly, notes sent to Ponz by the Count of Aguila state that the altarpiece on the right was assigned to Francisco Herrera the Elder.[6]

Attempts to reconstruct the altarpiece are hampered by a total lack of information about the works it held; most of the proposals are based on purely subjective assump-

View of the interior of the church, Monastery of the Trinidad Calzada, Seville

tions and need not be reviewed here. Nor is there any documentary evidence that the Besançon *Flight into Egypt* (cat. no. 13) was originally from the Trinidad Calzada; the only argument to support this claim is the painting's subject, and the central role played by Joseph; there are, however, two other pictures attributed to Zurbarán that depict the same scene.

On the other hand, we are fairly certain that the *Christ Child Blessing* now in Moscow (cat. no. 12) was indeed the picture seen by Ponz and Ceán. It is listed, with dimensions identical to those of the Moscow picture, as no. 280 in the Alcázar inventory of 1810.

In the sacristy of the church, the Trinitarians preserved, like a relic, a very old carved figure of the Christ Child, which was said to have been given to the monastery by King Ferdinand III during the Reconquest. This sculpture was later venerated as a symbol of the Twenty-Four—the members of the City Council of Seville.

NOTES
1. González de León 1844, II, p. 144.
2. Ponz 1780 (1947 ed.), p. 799.
3. Ceán Bermúdez 1800, VI, p. 50.
4. López Martínez 1928b, pp. 6–8.
5. González de León 1844, II, p. 144.
6. Carriazo 1929, p. 180.

12.
The Christy Child Blessing

ca. 1635–40
Oil on panel, 16½ × 10⅝ in. (42 × 27 cm)
On the reverse is a phoenix carved on a gold ground
Pushkin State Museum of Fine Arts, Moscow

Original location: Seville, church of the Monastery of the
Trinidad Calzada, altarpiece of Saint Joseph. Ponz 1780 and
Ceán Bermúdez 1800 both mention a "Christ Child" on
the ciborium door of the altarpiece.
Date of contract: Not known

The cult of the childhood of Christ appeared among the Cistercians through Saint Francis of Assisi, Saint Claire, and Saint Bonaventure and then became part of the Franciscan tradition. This very old cult was renewed by mystics of the Counter-Reformation, such as Saint Teresa of Avila and the Cardinal of Berulle, and became widespread during the seventeenth century. Spain, which had provided the most characteristic aspects of the cult of the Christ Child in the second half of the sixteenth century, became the direct source for this popular devotion in France in the seventeenth century. Carved statues of the Christ Child were objects of veneration from the late sixteenth century on, a veneration that was especially intense during the seventeenth century.[1] The imagery of the Christ Child was not that of the charms of childhood, as we might suppose today. Saint Thomas Aquinas had written that "at the moment of his conception, the Christ's first thought was for his cross," an idea that was taken up by many Dominicans of the sixteenth and seventeenth centuries, especially Luis de Granada.[2] The severe theologians of the Catholic reform were moved by the condition of childhood, "the most vile and abject of human states," according to Berulle.[3] In a book published posthumously in 1665, Father Blanlo, a Sulpician professor of philosophy, clearly summarized the ideas of his times: "The natural childhood of the Divine Jesus is a mysterious image of Christian perfection"; Christians must meditate on the mystery of "smallness, purity, innocence, sweetness, silence, loving captivity, and growth."[4]

Ana de San Agustín, a Carmelite reformed by Saint Teresa of Avila, had had visions of Jesus between the ages of three and seven, and she insisted in her meditations on "the favors received from the image of the Infant Jesus."[5]

Zurbarán excelled in representations of child saints. Here, the Infant Jesus giving blessing, seen against a golden cloud, already bears his cross; the cruciform nimbus echoes the meditation of his Passion. To represent the seamless tunic woven by the Virgin that replaced the swaddling clothes and adapted in size to the Child as he grew, Zurbarán clothed the figure in an oversize robe.[6] He shows him at the age of about three or four years, unlike Pacheco and Juan de Uceda, who depicted him at the age of seven or eight.[7]

In Seville, during the first quarter of the seventeenth century, the Christ Child was often represented on tabernacle doors, in one of two ways: nude or half-covered with a cloth, as in two works of 1605–6 by Juan de Roelas (church of the former Jesuit University of Seville; and private collection, Seville);[8] or clothed in a tunic, as depicted by Pacheco and by Juan de Uceda, in paintings dating to 1610–20. All these works are on panel. Roelas represents a puffy-cheeked "putto," shown frontally, with a somewhat old-fashioned expression inspired by Italian models; and Pacheco and Juan de Uceda, in their pictures, are more concerned with *decoro* than with realism.

In contrast, Zurbarán, in spite of the small format common to this subject, manages to endow the figure with an amazing monumentality. The exceptional quality of this painting should have inspired Zurbarán scholars to recognize it as a work by the master; yet until 1930, it was attributed, for no apparent reason, to Francisco Meneses Osorio, a follower of Murillo. The Russian historian Kseniya Malitzkaya was the first to identify the painting as by Zurbarán.[9] If we compare it to the representations of the Christ Child as the Good Shepherd painted by Murillo in the second half of the seventeenth century, the difference is obvious. Murillo's charming urchins with elegant forms and graceful gestures, who gaze languorously at the heavens, were designed more to soften hearts than to inspire emotion. The Christ Child as painted by Zurbarán, on the other hand, appears strikingly natural, the features lively and full of benevolence, expressing the Saviour's love for suffering humanity. The harmonious proportions, the unaffected attitude, the assurance in the gesture of the small arm raised in blessing, and the round-cheeked head leaning slightly to the right are innovations not found elsewhere in Spanish painting in the 1640s, except in the work of Velázquez. This painting appears to have been executed between 1635 and 1640.

The blond hair and the silvery blue tunic of heavy cloth that falls in ample folds contrast with the orange-tinged clouds in a marvelously refined color scheme, achieved with a limited number of hues. The handling is characterized by delicacy but firmness. The brushstrokes are smoothly applied, flowing from form to form, and modeling with assurance. The light,

perfectly distributed with unerring skill, unifies the composition.

NOTES
1. *Dictionnaire de spiritualité*, 1960, IV, part 1, cols. 658–64.
2. Cited in López Estrada 1966, p. 46.
3. Berulle, cited in Mâle 1932 (1972 ed.), p. 327.
4. Blanlo 1665, p. 103.
5. San Jerónimo 1668, fol. 31.
6. Pacheco 1649 (1956 ed.), pp. 264–65.
7. Valdivieso and Serrera 1985, nos. 57, 113.
8. *Ibid.*, figs. 95, 139.
9. Malitzkaya 1930, pp. 16–21.

PROVENANCE
Monastery of the Trinidad Calzada, Seville; Alcázar, Seville, 1810, Room 9, no. 280; collection of Countess Schuvalova, Leningrad; Hermitage Museum, Leningrad, 1924 (as *Saint John the Baptist*, by Meneses Osorio); Pushkin State Museum of Fine Arts, Moscow, 1930.

LITERATURE
Ponz 1780 (1947 ed.), p. 799; Ceán Bermúdez 1800, VI, p. 50; González de León 1844, II, p. 144; Cascales y Muñoz 1911, p. 50; Konopleva 1923, no. 50 (as *Saint John the Baptist*, by Meneses Osorio); López Martínez 1928b, pp. 6–8; Malitzkaya 1930, pp. 16–21 (attributed to Zurbarán); Guinard 1947, pp. 189–91; Malitzkaya 1947, p. 109; Pemán 1948, pp. 155–56; Soria 1953, no. 13; Gaya Nuño 1958, no. 2981; Guinard 1960a, no. 59; Torres Martín 1963, no. 5; Malitzkaya 1964, p. 109; Guinard and Frati 1975, no. 31; Gállego and Gudiol 1977, no. 27; Kouznetsova, in Moscow, Pushkin State Museum of Fine Arts, 1986, no. 96.

13.
The Flight into Egypt

ca. 1636–40
Oil on canvas, 49¼ × 41⅓ in. (125 × 105 cm)
Musée des Beaux-Arts, Besançon

Original location: Seville, church of the Monastery of the Trinidad Calzada (?), altarpiece of Saint Joseph (?)

As told in the Gospel According to Saint Matthew (2:13–14), following the visit of the three Wise Men to Bethlehem, the angel of the Lord appeared to Joseph in a dream, warning him of Herod's intention to destroy the Child Jesus. And when Joseph arose, "he took the young child and his mother by night and departed into Egypt." This episode was supposed to fulfill the prophecy in the Old Testament, "then I . . . called my son out of Egypt" (Hosea 11:1). The exegetes of the Counter-Reformation allowed artists to make limited use of references in the Apocrypha to miracles that occurred on the journey to Egypt (the story of the palm tree, for example, and

the story of the fall of the idols); although not historically based, these poetic incidents were useful as lessons to the faithful.[1] But Pacheco, following Molanus, advised strict adherence to the Gospels, and Zurbarán was scrupulous in respecting his instructions: The Virgin should be "seated on a small donkey, wearing her blue mantle, rose-colored dress, and straw hat; the child [is] wrapped in her arms. . . . Saint Joseph is in the background."[2] In Zurbarán's painting, Joseph, dressed in traveling clothes, appears to be talking to the Virgin, perhaps explaining the reason for their hasty departure.

This charming picture was once part of the Gigoux collection, which was bequeathed to the Musée des Beaux-Arts, Besançon, in 1894. Jean Gigoux, one of the few nineteenth-century French painters to have taken an interest in Spanish painting, owned many pictures from this school, including two famous works by Goya.

A *Flight into Egypt* by Zurbarán was sold in Paris on May 24, 1839, at a time when the market for Spanish painting was very active, following the secularization of Church property in Spain. It is not known if that was the picture acquired by Jean Gigoux.

The Besançon *Flight into Egypt* was not catalogued by Soria, who considered it a workshop piece. It was first ascribed to Zurbarán in 1954 by Angulo Iñiguez, although his attribution has not found general acceptance.[3] It should be noted that there are two canvases of the same subject that are generally considered workshop productions.[4] This work lacks the cohesion, force, and monumentality of Zurbarán's masterpieces. The volumes are not fully developed, and although the group of the Virgin and Child on the donkey is more successful than the somewhat elongated figure of Saint Joseph, the scene is treated not in a realistic but in an anecdotal fashion. Zurbarán's figures are rarely depicted looking directly at the viewer; rather, they maintain a dialogue within the confines of the composition. And yet here, as in works by more artificial painters, the Virgin stares into space, apparently oblivious both of her child and of Joseph.

On the other hand, as Angulo points out, Zurbarán's use of color is highly effective: "The play is between brown and deep green. In the figure of the Virgin, the purplish ocher of the tunic and the deep blue of the mantle—two very closely related dark colors—dominate. Harmonized with them are the bluish gray of Joseph's cloak and breeches, a dark color that offsets the light blue of the tunic placed boldly between them; we do not know if this was done for purely chromatic reasons or as a reflection of reality. But the most fortunate consequence of this fine and original color scheme, the focus of

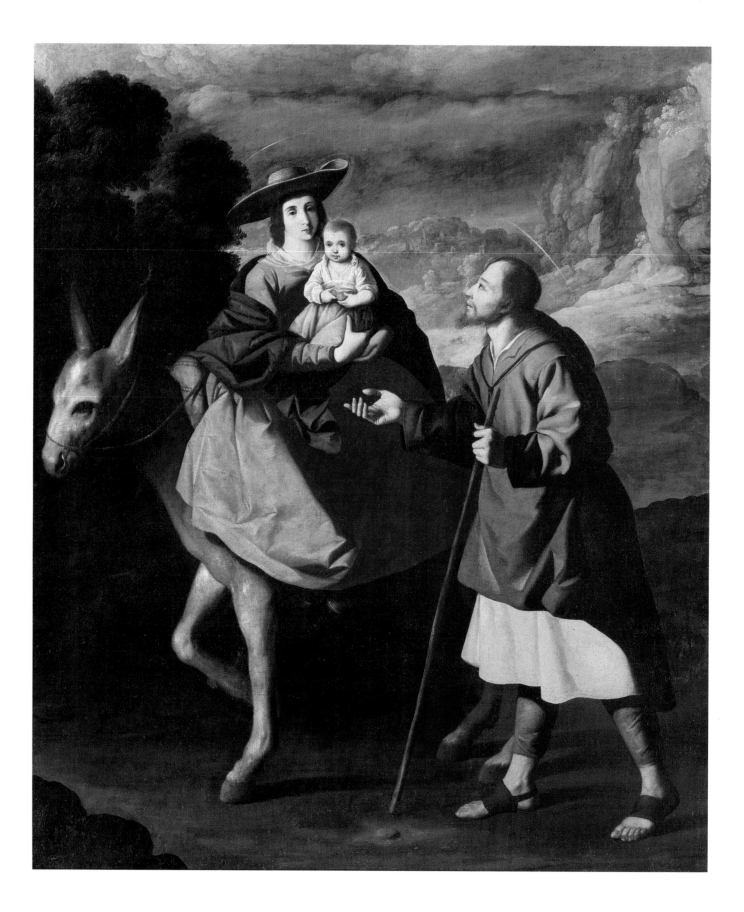

which is the deep blue, is that, surrounded by the great somber mass of the thick treetops on the left, the faces of the Virgin and of the Child stand out vividly, as does the expressive hand of Saint Joseph. In the back and to the right, the composition opens into a landscape delimited by steep rocky cliffs, which provide a background of light green."[5]

The landscape recalls iridescent hills in a *Virgin of the Immaculate Conception* by Zurbarán that is signed and dated 1636 (New York art market), which suggests a dating between 1636 and 1640.

There is no *Flight into Egypt* of corresponding dimensions listed in the Alcázar inventory of 1810; but a painting of the subject by Murillo, probably the one in the Palazzo Bianco, Genoa, considered to be a work from the 1650s, is listed as no. 296.

NOTES
1. Pascal 1856, I, pp. 134–35.
2. Pacheco 1649 (1956 ed.), II, p. 263.
3. Angulo Iñiguez 1954, pp. 315–16.
4. Guinard 1960a, nos. 45, 46.
5. Angulo Iñiguez 1954, p. 316.

PROVENANCE
Monastery of the Trinidad Calzada, Seville (?); collection of the painter Jean Gigoux, Paris; bequeathed to the Musée des Beaux-Arts, Besançon, in 1894.

LITERATURE
Ponz 1780 (1947 ed.), p. 799; Ceán Bermúdez 1800, VI, p. 50; González de León 1844, II, p. 144; Cascales y Muñoz 1911, p. 50; López Martínez 1928b, pp. 6–8; Angulo Iñiguez 1954, pp. 316–17 (attributed to Zurbarán); Gaya Nuño 1958, no. 3002; Guinard 1960a, no. 44; Baticle, in Paris, Musée des Arts Décoratifs, 1963, no. 104 (workshop of Zurbarán); Guinard and Frati 1975, no. 535; Gállego and Gudiol 1977, no. 24.

EXHIBITED
Toulouse 1950; Paris 1963, no. 104.

THE COLLEGE OF SANTO TOMAS, SEVILLE

As noted in connection with the College of San Buenaventura (see pp. 80–93), in Seville at the start of the seventeenth century certain religious orders, such as the Franciscans and the Carmelites, founded schools as adjuncts to their monasteries in order to promote the new orthodoxy imposed by the Council of Trent. The Carthusians and the Dominicans had such institutions from as far back as the Reconquest.

The Dominican Archbishop of Seville, Diego de Deza (1444–1523), founded in Seville the college named for Saint Thomas Aquinas.[1] It was completed in 1517, and early descriptions tell us that the church belonging to it was sumptuously decorated in the seventeenth century. The monastery was destroyed after the dissolution of the religious orders in 1836, and the summary records that survive do not give a precise idea of the disposition of the sanctuary. On the city plan by Olavide, of 1771, the college appears halfway between the Lonja, or Exchange (now housing the Archivo de las Indias), and the Hospital de la Caridad, and thus was situated where the present Avenida de la Constitución intersects Calle Santo Tomás and Calle Almirantazgo. The church was not accessible to lay worshippers, and the descriptions left by the few historians who managed to visit it are very imprecise. According to González de León, who sums up the old documentation, the college situated on Plaza Santo Tomás was fairly large for this type of establishment and included two spacious cloisters and large study halls. Access to the college was by a vestibule, at the right of which was a small patio onto which opened the door of the church. The church itself was said to be "a little larger than a private room," although it possessed a *coro alto*.[2] But the dimensions could not be as modest as González de León reports, because the high altar was adorned with Zurbarán's immense *Apotheosis of Saint Thomas Aquinas* (Museo de Bellas Artes, Seville), which measures 5.2 × 3.46 meters. The canvas was enclosed in a stucco frame that was attached to the wall.

The Flemish chapel (so called because it was used by the Flemings in Seville), which was to the left of the little vestibule, was also large enough for the no less monumental *Martyrdom of Saint Andrew* (Museo de Bellas Artes, Seville), by Juan de Roelas, which also measures 5.2 × 3.46 meters. The chapel was dedicated to Saint Andrew, probably because the Dominicans held him in particular veneration, as did the Flemings. The brother of Saint Peter, Saint Andrew is often associated with the mystery of the Incarnation. The College of Santo Tomás was, with the exception of the church and the hermitage of San Andrés and the Chapel of San Andrés in the cathedral, the only religious institution in Seville to dedicate a chapel and an important altarpiece to this Apostle.

No mention is made before 1808 of a *Saint Andrew* or a *Saint Gabriel* by Zurbarán in any church or monastery in Seville. Both are listed for the first time in the 1810 inventory of the Alcázar of Seville, which often recorded in groups works that came from the same monastery. Listed as in Room 2, immediately after an *Apotheosis of Saint Thomas Aquinas*, are a *Saint Gabriel* (no. 62) and a *Saint Andrew* (no. 63) with identical

dimensions: $1\frac{1}{2} \times \frac{2}{3}$ varas. These dimensions correspond more or less with those of the *Saint Andrew* in Budapest (cat. no. 14) and the *Saint Gabriel* in Montpellier (cat. no. 15): 147 × 61 centimeters. Marshal Soult made off with the *Apotheosis*, which he later offered to the Musée Napoléon, and kept for himself the *Saint Andrew* and the *Saint Gabriel*. The *Saint Andrew* was in the collection of the Duke of Sutherland as early as 1835, and the *Saint Gabriel* was in the Soult sale of 1852, where it was acquired by the Musée Fabre, Montpellier. It is obvious that they are companion pieces, for the figures face each other and the works share dimensions, style, and treatment. It is also evident that they were not made for the altarpiece of the Church of San Alberto (see pp. 132–41).

It is curious that two such exceptional paintings did not attract the attention of early historians. However, part of the church was *in clausura*, so they may have been in a sacristy and therefore inaccessible to visitors.

NOTES
1. González de León 1844, I, p. 129.
2. *Ibid.*, p. 127.

14.
Saint Andrew

ca. 1635–40
Oil on canvas, 57¾ × 24 in. (146.7 × 61 cm)
Szépmüvészeti Múzeum, Budapest

Original location: Seville, College of Santo Tomás (?)
Date of contract: Not known

The feast day of Saint Andrew, November 30, inaugurates the Proper of Saints of the Breviary as reformed by Pius V. Saint Andrew, a fisherman from Galilee and disciple of John the Baptist, was the first follower of Christ, and designated by the Baptist as the Lamb of God. After his first meeting with Jesus, he took his brother Simon Peter to meet him (John 1:35–42). Obeying their new master, the two fishermen abandoned their nets to become "fishers of men" (Matt. 4:18–20). Practically nothing is known of Andrew's life, but when he reappears in the Gospels, it is again as an intermediary for Jesus (John 6:8–9, 12:20–22). According to Christian tradition, Andrew evangelized in Achaea (Greece) and died at Patras. The Acts of his martyrdom, set down by Abdias, the first Bishop of Babylon, contain marvelous accounts of his loyalty to Jesus and his love for the cross, which made him the Apostle of the Crucifixion. The authenticity of the Acts, contested by Protestants and by Catholic critics in the sixteenth and seventeenth centuries, was accepted by most of the theologians of the Counter-Reformation, in particular Cesare Baronius, whose *Annales ecclesiastici* were considered authoritative.

A patron saint of Greece, Andrew was also honored in the West. His head has been preserved as one of the four principal relics of Saint Peter's, Rome, since the fifteenth century. (The other three relics of the basilica are the Veil of Veronica; the spear of the centurion Longinus, with which he pierced the side of Christ; and a fragment of the True Cross, found by Saint Helen.) Other cities, especially Milan and Amalfi, are also believed to possess relics of Saint Andrew, brought back from the Crusades. Charles V is credited with introducing to Spain the cult of Saint Andrew, because the saint is a patron, along with the Virgin, of the Order of the Golden Fleece, which was established in 1429 by one of Charles's forebears, Philip the Good, Duke of Burgundy.

In keeping with tradition, Zurbarán represents Saint Andrew with a physiognomy similar to that of his brother, Saint Peter. He holds a book, the attribute of the Apostles, and leans against a rough cross in the shape of an X, the instrument of his martyrdom.

The X-shaped cross, so closely associated with Saint Andrew that it was given his name, came into general use as his attribute only in the thirteenth century.[1]

The technical and spiritual achievement manifested in this painting suggests a dating to between 1635 and 1640.

NOTE
1. Mâle 1958, pp. 126–28.

PROVENANCE
College of Santo Tomás, Seville (?); Alcázar, Seville, 1810, Room 2, no. 63; collection of Marshal Soult, Paris; sold in 1835 to the Duke of Sutherland, Stafford House, London; Sutherland sale, Christie's, London, July 11, 1913, no. 144, to Knoedler and Co., London; collection of Baron Hatvany, Budapest; collection of Leopold M. Herzog, Budapest; entered the Szépmüvészeti Múzeum, Budapest, in 1949.

LITERATURE
Palomino 1724 (1947 ed.), p. 938; Ponz 1780 (1947 ed.), p. 789; Ceán Bermúdez 1800, VI, pp. 48–49; Waagen 1854, II, p. 67; Gómez Imaz 1896, no. 63; Mayer 1911, p. 150; Kehrer 1918, p. 110; Soria 1944a, p. 44; Guinard 1946, pp. 270–73; Garas 1949, pp. 24–27, 46–47; Soria 1953, no. 47; Gaya Nuño 1958, no. 3037; Guinard 1960a, no. 178; Torres Martín 1963, p. 44; Haraszti-Takács 1966, p. 64; Pigler, in Budapest, Szépmüvészeti Múzeum, 1967, p. 788; Guinard and Frati 1975, no. 90; Gállego and Gudiol 1977, no. 222; Haraszti-Takács, in Budapest, Szépmüvészeti Múzeum, 1984, no. 1.

EXHIBITED
London 1837, no. 63; London 1870, no. 137; Budapest 1919, III, no. 6; Lugano 1985, no. 22.

15.
Saint Gabriel the Archangel

After 1634
Oil on canvas, 57½ × 24 in. (146 × 61 cm)
Musée Fabre, Montpellier

Original location: Seville, College of Santo Tomás
Date of contract: Not known

EXHIBITED IN NEW YORK ONLY

Devotion to the angels grew considerably during the Counter-Reformation. At the summit of the hierarchy of angels are the seven archangels, according to the Apocryphal Book of Tobit (12:15). Three of the best known maintain a particular relation with the Trinity: Michael with the Father, Gabriel with the Son, and Raphael with the Holy Spirit. The Archangel Gabriel, whose name means "force of God," delivered, ac-

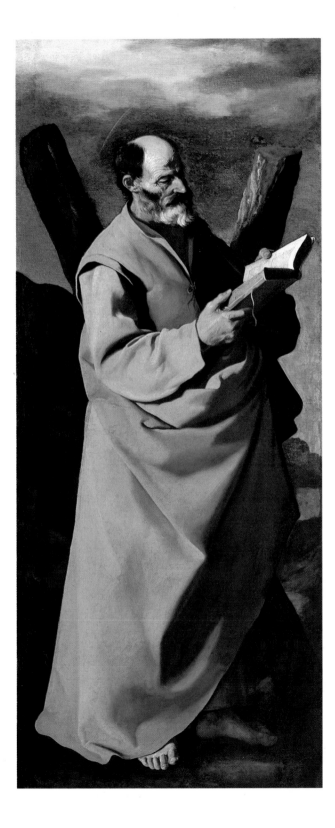

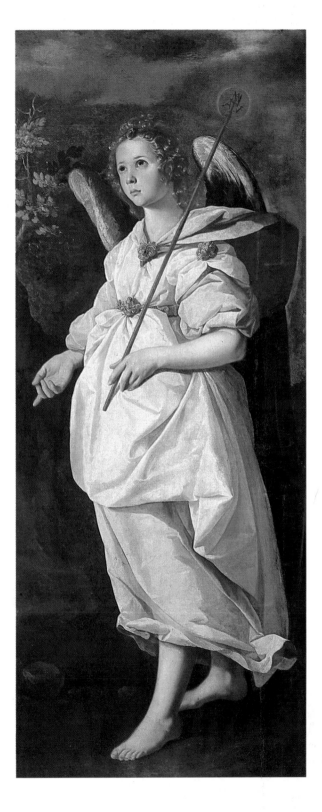

cording to the Bible and the interpretations of exegetes, three messages related to the Incarnation of Christ. In the Old Testament, he explains to Daniel the meaning of a mysterious vision connected with the birth of the Messiah (Daniel 8:15–27, 9:20–27). In the New Testament, he announces to Zachariah the coming into the world of his son, John the Baptist, the precursor of Christ (Luke 1:11–20). His role as celestial messenger culminates in the Annunciation to Mary that she will become the mother of the Saviour (Luke 1:26–38).

Honored on March 26 by the Greek Orthodox Church, Saint Gabriel is generally honored by Roman Catholics on March 24; in certain countries, Spain among them, his feast falls on March 18. The Spanish *Flos sanctorum* of the sixteenth and seventeenth centuries includes his feast in the Proper (special Masses) of the saints of Spain.[1]

The Archangel Gabriel is most often represented in the scene of the Annunciation. In Sevillian painting of the first third of the seventeenth century, he rarely appears as an isolated figure. If he does, it is in half-length, corresponding to a figure of the Virgin on the same scale, as in the painting by Pablo Legot for the altarpiece of the parish church of Lebrija or that by Juan del Castillo for the parish church of Brenes (Seville).[2] Besides the fact that the present painting is the only known representation of Gabriel by Zurbarán depicted isolated and full-length, its quality alone would suffice to make it exceptional.

The Archangel is here represented walking or striding forward, with his eyes fixed on heaven. He is identified by his long scepter (the insignia of heralds) terminated by a cross within a luminous nimbus on which are the monogram *M* of the Virgin and the first letters, *A V*, of Gabriel's salutation to Mary at the Annunciation (that is, *Ave Maria*). He has a youthful appearance, as recommended by Pacheco,[3] inspired perhaps by the choirboys in the Corpus Christi processions in Seville. There, dressed in long white girdled robes, the young boys would perform dances composed of "slow and solemn movements of the feet without participation by the hands."[4] Perhaps Zurbarán's Dominican patrons suggested that he use as his model the adolescent who played the role of Gabriel in a procession or a theatrical *auto sacramental*; painters and sculptors often had their part in such performances.

In the first part of Zurbarán's career, until the 1640s, his angels were depicted in religious scenes as imposing youths: in the *Vision of the Blessed Alfonso Rodríguez*, of 1630 (Academia de Bellas Artes de San Fernando, Madrid); in the *Flagellation of Saint Jerome by the Angels*, of about 1640 (Monastery of San Jeró-

nimo, Guadalupe); and in the *Annunciation* (cat. no. 26) and the *Adoration of the Shepherds* (cat. no. 27), from Jerez, of 1638–40. After that date, large angels disappear almost entirely from Zurbarán's oeuvre. The few examples cited here enable us to make comparisons with the *Saint Gabriel* and also help us to date it stylistically.

The figure of Gabriel is less elongated than the angels painted in 1629 and 1630; his garments are more soberly draped and less crumpled. He wears a pinkish tunic under a sort of white alb draped at the waist. The cloak fastened at the neck by a rich and heavy jewel is of a rare pinkish mauve. The figure stands out against a vigorously treated landscape, with highly refined effects of shadow. Above the rocks is a stormy sky, allowing the artist to focus the light on the model. The same sky and lighting effects are found in the painting's companion piece, the Budapest *Saint Andrew* (cat. no. 14). The workmanship is meticulous, the impasto almost buttery, and the modeling of the face, arms, hands, and feet less summary than usual, for which reasons we propose a date later than 1634. The childlike and ecstatic facial expression beneath the crown of curly golden hair is one of Zurbarán's greatest achievements. Like Velázquez and, later, Goya, he knew how to capture the innocent expressions of his young models, avoiding the stereotyped images so common in religious paintings done on commission.

As noted earlier, both the *Saint Andrew* and the *Saint Gabriel* may have come originally from the College of Santo Tomás, in Seville. The identical dimensions of the canvases and the similarity in the style and scale of the figures suggest that these two remarkable works were intended as pendants. Grouped together in the 1810 inventory of the Alcázar of Seville, and then associated in the collection of Marshal Soult, who often purchased entire ensembles, they likely remained together from the beginning.

As usual, Zurbarán and his patrons played on the opposition between two figures. The figure of Saint Andrew is turned to the right, while that of Saint Gabriel is turned to the left. The lighting effects and color schemes are complementary; and the landscapes, whether under stormy or clear skies, share the same character.

The painting originally on the left, the *Saint Andrew*, depicts an old man meditating on the Scriptures; the painting originally on the right, the *Saint Gabriel*, depicts a youth illuminated by grace, listening to the voice of God. Here is shown the contrast between youth and old age, darkness and light, and knowledge acquired directly and knowledge acquired through reflection.

There is in these two works an obvious evolution in style and handling toward a more elaborate and symbolic conception of religious art; yet Zurbarán maintains his realist—or rather hyperrealist—vision, so intensely lifelike are the figures, their costumes, and their attributes.

The paintings can also be appreciated—as are works of modern art—by leaving aside the subject matter to consider only the colors, the volumes set off by the light and intensified by stormy skies, and the handling, with which, using only a few basic colors, Zurbarán managed to create the impression of an infinite range of nuances.

NOTES
1. Villegas Selvago 1593, p. 364.
2. See Valdivieso and Serrera 1985, pls. 190, 211.
3. Pacheco 1649 (1956 ed.), p. 475.
4. Reynaud 1974, p. 138.

PROVENANCE
College of Santo Tomás, Seville; Alcázar, Seville, 1810, Room 2, no. 62; collection of Marshal Soult, Paris; Soult sale, Paris, May 1852, no. 29, to the Musée Fabre, Montpellier, for 1,540 francs (from the proceeds of the Collot sale).

LITERATURE
Cascales y Muñoz 1911, p. 50; Paris, Musée de l'Orangerie, 1939, no. 104; Soria 1944a, p. 44; Guinard 1946, p. 273; Soria 1953, no. 48; Guinard 1960a, no. 298; Baticle, in Paris, Musée des Arts Décoratifs, 1963, no. 94; Guinard and Frati 1975, no. 91; Gállego and Gudiol 1977, no. 221.

EXHIBITED
Paris 1939, no. 104; Paris 1963, no. 94.

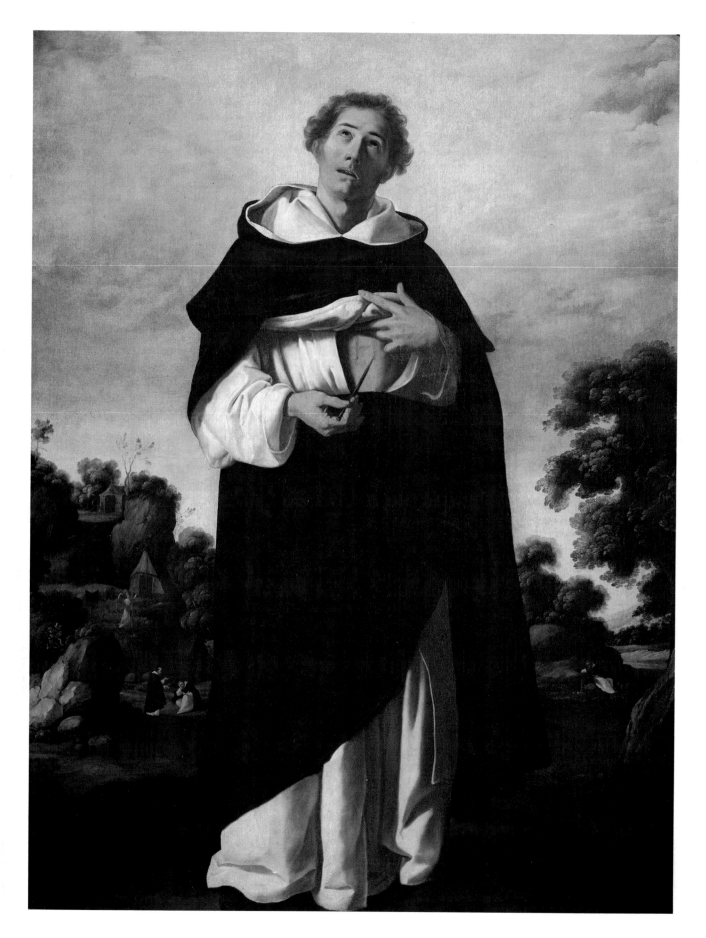

THE MONASTERY OF THE MERCED DESCALZA

Most religious orders have at some time in their history been divided by reform movements, and the Order of Our Lady of Mercy is no exception. In 1603, a group of Mercedarians resolved to reform themselves under Carmelite influence and became known as the Discalced, or Unshod, Mercedarians. That their contact with the Carmelites had over the years become increasingly close is evident from both doctrinal and historical developments. Fray Rodriguez de Torres, for example, was for a long time associated with the Carmelite Saint Teresa of Avila (1515–1582), and Fray Juan de Reyna testified at the canonization trial of Saint John of the Cross (1542–1591), also a Carmelite.[1] The establishment of the Discalced Mercedarians as a distinct order dates from 1621, and was approved in 1648 by Innocent X.

As did the sixteenth century, the seventeenth and eighteenth centuries witnessed a remarkable expansion of the Mercedarian Order as a whole—with the ransom of Christian captives in Africa, the establishment of missionary settlements in the New World, and the wide dissemination of Mercedarian writings. The Discalced Mercedarians also spread rapidly, founding many monasteries, for both monks and nuns, in Spain and in Italy. At the same time, the order gained in wealth and began to devote part of its revenues to the adornment of its monasteries. Rivaling orders that had long been attentive to the embellishment of their churches and monasteries, they called upon the services of the foremost artists of Spain—Zurbarán, and later Jerónimo Jacinto de Espinosa (1600–1667) and Bartolomé Esteban Murillo (1617–1682).

The Monastery of San José of the Discalced Mercedarians, founded in 1623, was in the Judería, the old Jewish quarter of Seville, not far from the Alcázar and opposite the Merced Calzada. It included a church of simple but elegant proportions (today still standing), at the corner of San José and Lieves. The conventual buildings comprised two cloisters, a spacious refectory, and a handsome library. The monastery was stripped of most of its works of art in 1810, and suppressed in 1835 at the time of the secularization of religious establishments. In 1936, the church interior was destroyed by fire.

Palomino mentions only the paintings in the cloister as being from the hand of Zurbarán, whereas Ponz and Ceán Bermúdez speak of works by Zurbarán in the church as well, including the celebrated *Saint Lawrence* (Hermitage Museum, Leningrad) and the *Saint Anthony Abbot* (formerly Félix Valdés collection, Bilbao), each bearing the date 1636.[2]

It would seem that the main altarpiece of the church, which included, in addition to paintings by Zurbarán, statues by Juan Martínez Montañés, was altered in the eighteenth century by a *retablista* named Cayetano de Acosta (1710–1780)—an important point that was passed over by González de León but noted by Matute.[3] According to Ponz, the arrangement of paintings by Zurbarán in the altarpiece was changed, for he mentions in his description a "Father Eternal," two "Saints," and four "Heads of Martyrs," adding that "in the center there are said to have been other canvases [by Zurbarán]."[4] Ceán is not very clear in his description of the altarpiece, nor does he

enumerate the paintings that he saw; however, he states that an altarpiece in the monastery dedicated to Saint Catherine held canvases by Zurbarán, and that in the Chapel of Saint Catherine was a "Martyrdom of Saint Catherine" and a "Burial of Saint Catherine on Mount Sinai."[5]

Several of these works are listed in the Alcázar inventory of 1810. The first group of paintings by Zurbarán is noted as in Room 2, the second group in Room 7, and the third in Room 14. The first group included no. 71, the *Burial of Saint Catherine*, 2½ × 1 varas (210 × 84 cm), of which four copies are known; no. 72, the *Decollation of Saint Catherine*, of the same dimensions (present location unknown); no. 73, the *Father Eternal*, 3 × 3 varas (252 × 252 cm) (Museo de Bellas Artes, Seville); and no. 74, a *Birth of the Virgin*, 1¼ × 1 varas (105 × 84 cm) (perhaps the painting in the Norton Simon Museum, Pasadena, reputedly from the Monastery of the Trinidad Calzada, Seville). In Room 7 were nos. 219 and 220, *Saint Lawrence* and *Saint Anthony Abbot*. In Room 14 were no. 321, *Saint Lucy*, 1¼ × ¾ varas (105 × 63 cm) (cat. no. 22); no. 322, *Saint Apollonia*, also 1¼ × ¾ varas (cat. no. 21); and nos. 323 and 324, *Saint Peter Nolasco*, and *Saint Raymond Nonat*, both 1¼ × ¾ varas (location of both unknown). Elsewhere in the Alcázar was the series of Holy Martyrs of the order, small works purchased by Baron Isidore Taylor for the Galerie Espagnole of Louis-Philippe.

While it is comparatively easy to follow the provenance of some of the works from the Merced Descalza, there is no trace, prior to the Aguado sale of 1843, of the *Child Jesus Walking with Saint Joseph* (cat. no. 20), and so we must proceed by deduction. To recall Ponz's remark, written in 1780, "In the center [of the altarpiece] there are said to have been other canvases [by Zurbarán], removed to make way for the unfortunate ornament we see today."[6] Thus, it is not impossible that the painting, having been taken from the altarpiece before 1780, was put aside somewhere in the monastery, whence no one thought to remove it before 1810. Probably in 1836, when the properties of the monasteries were liquidated, the painting was discovered during a visit by government officials, who permitted it to be sold to Aguado.

NOTES

1. *Dictionnaire de spiritualité,* 1980, x, cols. 1031–32.
2. Palomino 1724 (1936 ed.), p. 194; Ponz 1780 (1947 ed.), p. 790; Ceán Bermúdez 1800, VI, p. 49.
3. González de León 1844, II, p. 164; Matute 1887b, p. 381.
4. Ponz 1780 (1947 ed.), p. 790.
5. Ceán Bermúdez 1800, VI, p. 49.
6. Ponz 1780 (1947 ed.), p. 790.

20.
The Child Jesus Walking with Saint Joseph

ca. 1635–40
Oil on canvas, 94 × 68 in. (238 × 172 cm)
Church of Saint-Médard, Paris

Original location: Seville, Monastery of the Merced Descalza, high altar of the church (?)
Date of contract: Not known

All but ignored in the Middle Ages, Saint Joseph became one of the most popular saints of the Counter-Reformation. Devotion to him developed progressively in the Universal Church starting with a fundamental text written early in the fifteenth century by the theologian John Gerson. Called the *Josephina*, this poem in Latin consisted of nearly 3,000 lines glorifying the foster father of Christ. In the sixteenth and seventeenth centuries, many exegetes confirmed his great sanctity, and his place as the first saint of the New Law was affirmed. Following Saint Teresa of Avila, who had taken Saint Joseph as her patron and intercessor, his cult flourished in Spain, and with it his iconography. Another *Josephina*, one of the more renowned treatises on Joseph, written in 1597 by a Spanish Discalced Carmelite, Jerónimo Gracián de la Madre de Dios, was published in some thirty editions in several languages in the early seventeenth century and contributed to the popularity of Saint Joseph in Spanish art. The feast of Saint Joseph, instituted in Rome by Sixtus II and celebrated on March 19, was decreed a day of obligation by Gregory XV in 1621.

The *Child Jesus Walking with Saint Joseph* no doubt represents one of the Holy Family's journeys to Jerusalem for the celebration of Passover (Luke 2:41). A contemporary of the artist, María de Agreda, a member of the Discalced Nuns of the Order of the Immaculate Conception who had visions of the life of the Virgin, relates that on these occasions the Virgin would take the Child by the hand, and "the glorious Patriarch Saint Joseph occasionally received the same privilege."[1] Zurbarán would later also represent the three figures together, in what the post-Tridentine exegetes call the Earthly Trinity, in the altarpiece of the Church of Santa María, in Zafra.

The hagiographers of the Counter-Reformation were critical of the representation of Saint Joseph as an old man, a tradition favored by artists of the Middle Ages. "When he wedded the Most Holy Virgin, he was *vir*, which is to say a man robust and of competent age, not too young, not too old, but in between, as he ought to be."[2] Zurbarán's representation of Joseph bears an astonishing resemblance to his con-

temporaneous depictions of the adult Christ. This is accounted for by Gracián, who wrote in the *Josephina* that Saint Joseph was "hermoso de rostro" (of a beautiful countenance), and was "el hombre más semejante a Christo . . . en rostro, habla, complexión" (the man most like Christ . . . in face, speech, complexion).[3] The Child's rod is surmounted by a small cross; Joseph's is shown with a flower at the top. This attribute, the blossomed rod, is taken from the Apocrypha. It is at once a sign to the priests that Joseph had been chosen as the husband of Mary and a symbol of his purity.

It was natural that representations of Saint Joseph should be placed at the high altar of a church which was dedicated to him; and indeed, statues—larger than life—of Joseph, the Virgin, and the Child Jesus by Martínez Montañés were to be seen there before the remodeling in the eighteenth century.[4] In Zurba-

Angelo Nardi. *Saint Joseph Walking with the Child Jesus*, 1634. Oil on canvas. Convent of Las Bernardas, Jaén

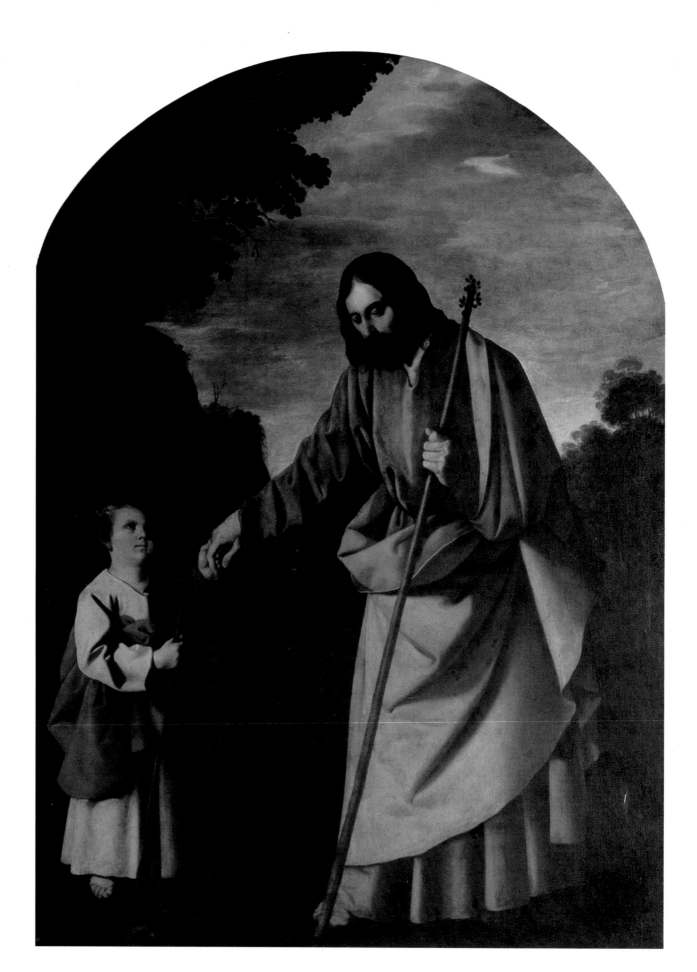

rán's day, the Discalced Mercedarians, perhaps in order to better honor their patron saint, commissioned the artist to paint the *Child Jesus Walking with Saint Joseph*. The theme was quite popular in Spain in the first half of the seventeenth century, and had earlier been brilliantly treated by El Greco in the Chapel of San José, in Toledo. In 1602, Pacheco defined the iconography for Andalusia in a painting in the Church of Santiago, in Seville. That iconography was employed by Montañés in 1609 in the *Trinity* in the Church of San Ildefonso, also in Seville. Other works of the same subject done at about this time include examples by Felipe Diriksen in the Chapel of Mosén Rubín, Avila (1627–29); by Pedro Orrente in the Church of San Francisco, Yeste (1629); and, in particular, by Angelo Nardi in the high altar of the Convent of Las Bernardas, Jaén (1634), where the figure of the Child is very similar in the attitude of the head and the position of the body to that by Zurbarán. It will be recalled that Zurbarán also drew upon Nardi for the angel of the *Annunciation* at Jerez (cat. no. 26). Nardi, who was of a noble Florentine family, had come to Spain at the age of twenty-three. Fifteen years later, he was to become the protégé and friend of Velázquez, on whose behalf he would testify in Madrid in 1658 at the inquiry concerning the Spanish painter's admission to membership in the Order of Santiago. At that time, he declared that he had met Velázquez's father when he was in Seville. It is possible that Zurbarán made Nardi's acquaintance when Nardi was in Seville, or when he was working in Jaén. They would later meet in Madrid, where Zurbarán went to decorate the Buen Retiro Palace.

Zurbarán's composition of the *Child Jesus Walking with Saint Joseph* has great strength and great beauty of plastic design, superbly adapted to the rounded-top format. In this it is analogous to the *Saint Lawrence* (Hermitage Museum, Leningrad), which is signed and dated 1636 and which, like the present painting, has a landscape background and an open, luminous sky. Interestingly, Saint Joseph's posture here is similar to that of Saint Anthony Abbot in the ex-Valdés painting, also signed and dated 1636 and pendant to the *Saint Lawrence*. Thus, in clarity of composition, monumentality of form, lighting, landscape, color, and treatment of drapery, there is an undeniable analogy between this painting and the other two, of undoubted Merced Descalza provenance. This supports a common origin, as we suggested in 1963, a conclusion with which Guinard concurs.[5]

It is all but impossible to ascertain where and how Aguado acquired the Spanish paintings in his collection; probably with the discreet assistance of Baron

View of the high altar as it exists today, Monastery of the Merced Descalza, Seville

Reconstruction drawing of the installation of Zurbarán's *Child Jesus Walking with Saint Joseph*, Monastery of the Merced Descalza, Seville

Taylor, especially since the *Child Jesus Walking with Saint Joseph*, which does not appear in the Alcázar inventory, assuredly remained hidden in the Monastery of the Merced Descalza until 1835.

It may be added, in support of our thesis, that in the present church, which has had no altarpiece since 1936, there is an arched opening above the main altar whose curve at the top appears to match that of the present picture.

This splendid painting, whose pietistic subject tends to obscure the nobility and skill of its execution, must have failed to please in the eighteenth century by reason of the static attitudes of the figures, animated only by the touching expressions of their faces in the light of a setting sun. Yet it is here that Zurbarán excels.

NOTES
1. Agreda 1670 (1684 ed.), V, p. 19.
2. Ribadeneyra 1624 (1983 ed.), III, p. 306.
3. Gracián de la Madre de Dios 1597 (1629 ed.), fols. 12, 128.
4. Ceán Bermúdez 1800, III, p. 92.
5. Baticle, in Paris, Musée des Arts Décoratifs, 1963, no. 95; Guinard and Frati 1975, no. 180 bis.

PROVENANCE
Monastery of the Merced Descalza, Seville; collection of Alexandre Aguado; Aguado sale, Paris, Mar. 20–28, 1843, no. 159, sold for 150 francs; collection of the Church of Saint-Médard, Paris.

LITERATURE
Baticle, in Paris, Musée des Arts Décoratifs, 1963, no. 95; Guinard 1964, pp. 118–20; Brown 1974, p. 31; Guinard and Frati 1975, no. 180 *bis*; Gállego and Gudiol 1977, no. 20.

EXHIBITED
Paris 1963, no. 95.

21.
Saint Apollonia

ca. 1635–40
Oil on canvas, 45½ × 26 in. (116 × 66 cm)
Inscribed, lower left: .S.POLO / NIA.
Musée du Louvre, Paris

Original location: Seville, Monastery of the Merced Descalza, high altar of the church
Date of contract: Not known
Location according to early sources: Ponz 1780, main altarpiece

Nothing is known of the early life of Apollonia, virgin martyr of Alexandria. The primary account, drawn by the historian Eusebius of Caesarea in the fourth century from a letter by Saint Dionysius, Bishop of Alexandria, is limited to a few lines describing her martyrdom. He writes of the virgin Apollonia, noted for her modesty, a woman already "of advanced age" when the Christians were first persecuted in Alexandria in the year 249. Chosen as one of the first victims, Apollonia preached the True God as she was taken to venerate the idols. Her persecutors responded by breaking and knocking out her teeth. Rather than abjure her faith, she threw herself upon the flames of the pyre that was awaiting her, and, as stated in the Roman Breviary, "her most pure spirit ascended to heaven and the everlasting crown of martyrdom."

A popular saint, Apollonia was invoked as protection against toothache, and was called upon "to incite the mouth to divine praise."[1] Her feast is celebrated on the ninth of February.

As usual, Zurbarán—doubtless under the direction of his patrons—adheres to the post-Tridentine canon of Cardinal Paleotti. The saints he portrays are shown with their crowns of martyrdom;[2] he avoids the use of gratuitous accessories and undignified poses;[3] and he paints only the blessed.[4] Saint Apollonia has in her right hand a forceps holding a tooth, her traditional attribute. And delicately, she bears the long palm frond of the beatified, emblem of immortality. Her crown of flowers represents the martyr's recompense, and is associated also with medieval rites of the consecration of virgins. Apollonia is not depicted as an older woman because, as Juan Interián de Ayala explains in his famous treatise for painters, *El pintor christiano y erudito*, "virgins, with age, lose neither their charm nor their beauty."[5]

Guinard was the first to suggest that the two saints noted by Ponz as in the main altarpiece in the church of the Merced Descalza were the present *Saint Apollonia* and the *Saint Lucy* (cat. no. 22), neither of which is mentioned by Ceán Bermúdez.[6] These two paintings, grouped together in the 1810 inventory of the Alcázar of Seville (as nos. 322 and 321) and again in the catalogue of the Soult sale of 1852, were, in all likelihood, both commissioned by the Discalced Mercedarians. Their dimensions are the same, and both are rounded at the top, which is easily discernible despite the present framing. The visible difference between the rounding of the two canvases is due to an early alteration in the *Saint Apollonia*, but X rays of the painting have shown that the original outline was the same as that of the *Saint Lucy*. In general, the Alcázar inventory tends to place paintings of like origin in groups of two or more. In Room 14, for example, were four paintings by Zurbarán of the same dimensions: *Saint Lucy* (no. 321), *Saint Apollonia* (no. 322), *Saint Peter Nolasco* (no. 323), and *Saint Raymond Nonat* (no. 324). The first two can be identified with the two saints mentioned by Ponz as in the church of the Merced Descalza, and because the latter two were de-

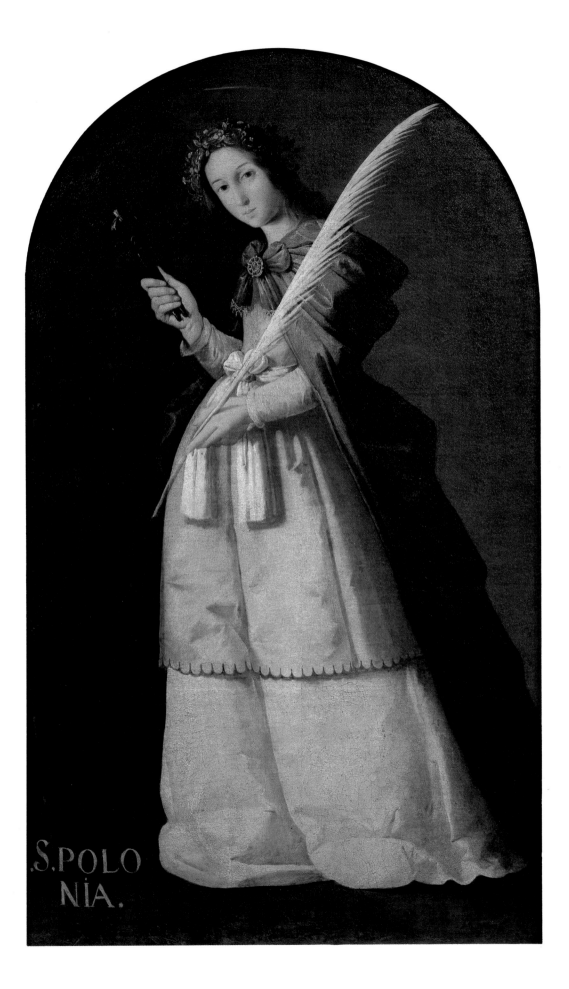

S.POLO
NIA.

scribed by Ceán as in the same church, their common origin is likely.

A quick survey of the representation of female saints in Spain during the first third of the seventeenth century reveals that in general their costumes, and even their poses, derive chiefly from Italian Renaissance models, transplanted to Spain by the Italian painters recruited by Philip II to decorate the Escorial. Thereafter, Spanish artists often took their ideas from imitators of Rubens, who portrayed saints wearing secular attire borrowed from contemporary fashion, as in the engravings of Pieter de Baillin.[7]

Of the traditional female saints, Mary Magdalene, Margaret, Catherine, Cecilia, Agnes, and Clare appear more often in Spanish art of this time than do Agatha, Lucy, or Apollonia, and saints native to the Iberian peninsula—Casilda, Elizabeth of Portugal, Rufina, and Justa, for example—are rarely portrayed. Thus, Zurbarán's selection of these subjects in general reflects the lively nationalistic concerns of his patrons. Caturla sees them as deriving from the processions of Corpus Christi, which were like theatrical productions in which actors, assigned the roles of saints, paraded through the streets. She concludes that depictions of virgin martyrs in this tradition would not have appeared in altarpieces; rather, they would have been disposed along the nave, as if in a procession. In support of her thesis, she cites the decoration of the church of the Convent of Santa Clara at Carmona, where the frieze of female saints from Zurbarán's workshop on either side of the nave appears to be advancing toward the altar.[8] Caturla's statement seems too categorical; indeed, the main altarpiece of the collegiate church of Pastrana (Guadalajara) provides a case to the contrary. It was recently discovered that the series of female saints on that altarpiece, attributed to Matías Ximeno, a disciple of Vicente Carducho, was given to the church of Pastrana in 1635.[9] The ten paintings in the altarpiece represent Saints Margaret, Apollonia, Agatha, Eugracia, Agnes, Barbara, Matrona, and three others that have not been identified.

Aside from examples by the Andalusian school, Saint Apollonia is seldom represented in Spain in the first half of the seventeenth century. A superb painting now in a private collection in Seville, thought to portray Apollonia and signed by Pedro Núñez del Valle (d. 1654), follows the classical canon dear to Pacheco—that is to say, the subject wears a simple tunic and draped cloak. By contrast, Zurbarán's Saint Apollonia, elegantly attired in silk, wears a pale pink jacket, a golden yellow skirt, a delicately shaded light green mantle, and a wreath of fresh flowers in her hair. This costume bears no resemblance to the heavy attire of women in high society. Apollonia's natural grace emphasizes, by contrast, the strangeness of the tooth and forceps.

Zurbarán's gifts as a colorist, his effective handling, and his way of achieving a seemingly effortless "truth in nature" completely rejuvenate the theme, to the extent that it seems almost an original invention.

The style and handling of the *Saint Apollonia*, similar to those of the Leningrad *Saint Lawrence*, which is dated 1636, suggest that it was painted in the years 1635 to 1640. Because Zurbarán was working during this period for the Discalced Mercedarians, it is highly probable that the painting was commissioned for the Monastery of the Merced Descalza.

NOTES
1. Ortiz Lucio 1608, p. 591.
2. Paleotti 1582, I, p. 260.
3. *Ibid.*, p. 271.
4. *Ibid.*, p. 230.
5. Interián de Ayala 1782, II, p. 115.
6. Guinard 1960a, p. 196; Ponz 1780 (1947 ed.), p. 194; Ceán Bermúdez 1800, VI, p. 49.
7. Soria 1948b, p. 256.
8. Caturla, in Madrid, Casón del Buen Retiro, 1964, p. 50.
9. Angulo Iñiguez and Pérez Sánchez 1983, p. 378.

PROVENANCE
Monastery of the Merced Descalza, Seville; Alcázar, Seville, 1810, Room 14, no. 322; collection of Marshal Soult, Paris; Soult sale, Paris, May 1852, no. 52; Soult heirs' sale, Hôtel Drouot, Paris, Apr. 17, 1867, no. 5, to the Musée du Louvre for 6,000 francs.

LITERATURE
Ponz 1780 (1947 ed.), p. 790; Kehrer 1918, p. 148, pl. 62; Hautecoeur, in Paris, Musée du Louvre, 1926, no. 1740; Nicolle, in Paris, Musée du Louvre, 1929, p. 11; Guinard 1947, pp. 178–79; Mayer 1947, p. 339; Soria 1948b, pp. 256–57; Soria 1953, no. 119; Gaya Nuño 1958, no. 3031; Guinard 1960a, p. 236, no. 240; Baticle, in Paris, Musée des Arts Décoratifs, 1963, no. 97; Guinard and Frati 1975, no. 181; Gállego and Gudiol 1977, no. 245; Paris, Musée du Louvre, 1981, no. MI 724.

EXHIBITED
Paris 1963, no. 97.

22.
Saint Lucy

ca. 1635–40
Oil on canvas, 45½ × 27 in. (115 × 68 cm)
Inscribed, lower right: .s.LUCIA
Musée des Beaux-Arts, Chartres

Original location: Seville, Monastery of the Merced Descalza, high altar
Date of contract: Not known
Location according to early sources: Ponz 1780, main altarpiece

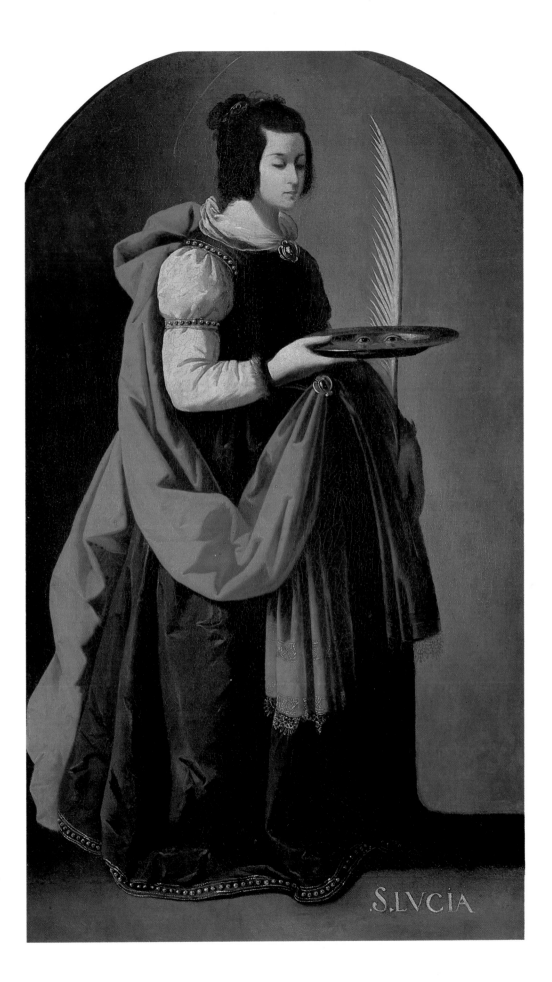

Lucy was the name of several virgin martyrs. The most well known, Lucy of Syracuse, suffered martyrdom in that city very early in the fourth century. A Christian of patrician family, Lucy as a young girl is said to have healed her mother of an incurable disease at Catania with the intercession of Saint Agatha, whom she had beheld in a dream, "resplendently and richly clad."[1] Dedicated to Christ, Lucy distributed her goods to the poor, bringing upon herself the wrath of her suitor, who denounced her as a Christian during the persecutions of Diocletian. Condemned to be sold into prostitution, she responded to her judges, according to the Roman Breviary, by saying that she would thus obtain a "double crown." Her virginity miraculously preserved, she died by strangulation after being subjected to atrocious torture and receiving last communion— one of the more original features of her martyrdom.

Like her precursors Agnes, Cecilia, and Agatha, Saint Lucy is privileged in having her own liturgical Office, which has a poetic, musical, and religious quality that is in harmony with Zurbarán's exquisite portrayal. Her feast is celebrated on December 13, during Advent, when the Church prepares for the celebration of Christ's birth; the name Lucia, from the Latin *lux*, or light, heralds the approach of the Light of the World. Because of her name, she is invoked against disorders of the eye. The use of eyes as her attribute, either in the hand, threaded on a stick, or more often displayed on a plate, as here, gave rise to various interpretations during the Counter-Reformation. These images were explained by the legend that she had torn out her eyes and sent them to her fiancé in order that he would turn from her.[2] It was also believed that her torturers had inflicted this punishment. But serious hagiographers objected to such unsubstantiated stories.[3] According to Cardinal Federico Borromeo, Saint Lucy was invoked in cases of impaired eyesight only because of the similarity of her name to that of Lucina, a divinity called upon by the ancients in such circumstances.[4] Molanus, followed by most other theoreticians of sacred art, explains that Saint Lucy was invoked to cure disorders of vision quite naturally, since her name expresses the idea of light.[5] Such is the prevailing opinion at the present time. Whereas popular belief has made Lucy out to be an "oculist saint," seventeenth-century devotees invoked her in seeking the Divine light.[6]

In our discussion of the *Saint Apollonia* (cat. no. 21), we listed the reasons in support of a common provenance for the two pictures, namely the altarpiece of the church of the Merced Descalza, in Seville. Both paintings have the same dimensions and are rounded at the top. Furthermore, the figure of Saint Lucy faces to the right, thus making the painting pendant to the *Saint Apollonia*, in which the figure is shown facing to the left.

While Saint Apollonia's attribute, the tooth and forceps, changed little since the Middle Ages, that of Saint Lucy, the eyes, generally came to be represented in a surrealistic fashion (one of the more charming images of this type is by Francesco del Cossa, in the National Gallery, Washington, D.C., where a flowered stem forms a kind of lorgnette with symbolic eyes). The most common representation shows the eyes on a plate presented vertically. This arrangement is found as late as the early seventeenth century in Andalusia, in Antonio Mohedano's *Saint Lucy* (Museo Municipal de Antequera, Málaga), where the figure is shown full-face, attended by two angels, one of whom holds a kind of moon-shaped plate pierced for two eyes, like a mask.

In contrast, Zurbarán shows Saint Lucy carrying in her hand a copper plate on which the two eyes rest, and walking along as casually as if carrying two chestnuts. This probably reflects an attempt on the part of the Mercedarians to bring the symbolism of the martyrdom closer to the unlettered faithful by eliminating the abstract character it had had in the Middle Ages.

Saint Lucy's attire, like Saint Apollonia's, is most elegant; clearly it owes nothing to contemporary fashion, where the ladies of the court were swathed in stiff, heavy skirts, the neck enclosed in a ruff and later in a sort of plaited collar. Here, the sleeves recall those of sixteenth-century Venetian robes as depicted, for example, by Veronese. Wearing a soft skirt of silk, a handsome draped mantle with a modest neckline, and a light kerchief held by an imposing brooch— in Seville from 1630 to 1640, who but Zurbarán's saints were so appareled?

NOTES
1. Ribadeneyra 1624, pp. 838–39.
2. Villegas Selvago 1593, fol. 343.
3. Ribadeneyra 1624, p. 841.
4. Borromeo 1625 (1932 ed.), book 2, chap. 11.
5. Molanus, in Beaugrand 1893, p. 185.
6. Ortiz Lucio 1608, p. 590.

PROVENANCE
Monastery of the Merced Descalza, Seville; Alcázar, Seville, 1810, Room 14, no. 321; collection of Marshal Soult, Paris; Soult sale, Paris, May 1852, no. 31, for 485 francs; collection of Camille Marcille; Marcille sale, Hôtel Drouot, Paris, Mar. 6–9, 1876, purchased by the Musée des Beaux-Arts, Chartres, for 510 francs.

LITERATURE
Ponz 1780 (1947 ed.), p. 790; Kehrer 1918, p. 106; Jusselin, in Chartres, Musée des Beaux-Arts, 1931, no. 248; Guinard 1947, pp. 178–79; Mayer 1947, p. 339; Caturla, in Granada, II Festival Internacional de Música y Danza, 1953, no. 53; Soria 1953, p. 15, no. 120; Gobillot, in Chartres, Musée des Beaux-Arts, 1954,

no. 112; Gaya Nuño 1958, no. 3032; Guinard 1960a, no. 270; Baticle, in Paris, Musée des Arts Décoratifs, 1963, no. 96; Guinard and Frati 1975, no. 182; Gállego and Gudiol 1977, no. 244.

EXHIBITED
Paris 1925, no. 120; Granada 1953, no. 53; Bordeaux 1955, no. 76; Paris 1963, no. 96.

23.
The Burial of Saint Catherine on Mount Sinai

ca. 1630–40
Oil on canvas, 6 ft. 6¾ in. × 4 ft. 5⅝ in. (200 × 137 cm)
Collection of the Count of Ibarra, Seville

Original location: Seville, Convent of San José (?)

Saint Catherine of Alexandria, whose feast is celebrated November 25, was martyred about the year 310, during the reign of Maxentius. Ancient accounts relate that she confounded a group of sages who tried to argue her out of her faith in Christ. She was condemned to die on the wheel, but the wheel broke, and she was decapitated. Then, "so that her body would not remain in the possession of her brutal executioners [as she had feared], it was carried by angels to the top of Mount Sinai, where it was buried."[1] Catherine is one of the fourteen "auxiliary" saints, invoked by the faithful for her wise counsel; she is also the patron saint of Christian philosophers and orators, and was often represented in Christian art. However, Cesare Baronius, an important Counter-Reformation ecclesiastical historian, believed that some elements of her hagiography were questionable.[2] Protestant theologians and Launoy, the great seventeenth-century debunker of saints, even denied her historical existence. According to legend, the perfectly preserved body of a woman thought to be Saint Catherine was discovered atop Mount Sinai in the ninth century. Zurbarán was probably commissioned to paint this subject in commemoration of that event. His painting reproduces exactly the composition of a 1575 engraving by Cornelis Cort.[3] This is the only known instance of Zurbarán's exact copying of a print, suggesting that he was given very precise instructions concerning the representation of this miracle.

According to Ponz, there was an altar devoted to Saint Catherine decorated with paintings by Zurbarán in the Discalced Mercedarian Church of San José in Seville.[4] Ceán Bermúdez later observed that the altarpiece of Saint Catherine, which featured small figures, was placed on an altar to one side of the high altar:

"The Martyrdom and the Burial of Saint Catherine were in her chapel."[5]

The Alcázar inventory of 1810 lists two paintings by Zurbarán on the theme of Saint Catherine: no. 71, a Saint Catherine Being Interred by Angels, of 2½ × 1½ varas (210 × 126 cm); and no. 72, a Decollation of Saint Catherine, of the same dimensions, which is now lost.[6] However, as Angulo Iñiguez has shown, there are five known versions of the Burial of Saint Catherine, four of them based on the 1575 engraving by Cornelis Cort.[7] The first is the present work, in the collection of the Count of Ibarra (200 × 137 cm);[8] the second (199 × 133 cm) is in the Nelson-Atkins Museum of Art, Kansas City;[9] the third, whose present whereabouts is unknown, was once part of the Lázaro Galdiano collection;[10] the fourth, of small dimensions, is in the Church of San Ginés, in Seville.[11] The fifth, in the Alte Pinakothek, Munich, is of dimensions similar to those of the first three, but differs in several ways: the scale of the figures is slightly smaller, there are angels hovering above, the angel in the center is shown in three-quarter view, the angel on the right almost frontally, and the saint is crowned with roses.[12]

To determine which painting originally came from the Convent of the Discalced Mercedarians, we need to retrace the history of each of these versions. We know that the picture owned by the Count of Ibarra was given to his grandfather before 1921 by the mother superior of the Convent of San José, which was situated on Plaza San Bartolomé, in Seville, not far from the Monastery of San José, of the same religious order.[13] Prior to that, it was reportedly seen in the Beaterío de La Trinidad, a seminary founded in the eighteenth century. (One wonders why it would have been transferred from a Trinitarian establishment to a convent of the Discalced Mercedarians.) González de León does not refer to the painting in his 1844 description of the Beaterío; he did not visit the Mercedarian convent, and thus makes no mention of the work at all.[14]

The version in Kansas City was purchased from the descendants of Marshal Soult by an American collector who gave it to the Nelson-Atkins Museum in 1961. According to Ralph T. Coe, it was removed from a sale in 1854. The Soult sale, however, took place two years earlier, in 1852; furthermore, it did not include any paintings of the subject.[15]

We know that Soult acquired a number of paintings from the Church of San José: the Saint Lawrence of 1636 in the Hermitage, the Saint Anthony Abbot formerly in the Valdés collection, the Saint Apollonia in the Louvre (cat. no. 21), and the Saint Lucy in Chartres (cat. no. 22), which argues strongly in favor of a Mercedarian provenance for the Kansas City picture. As

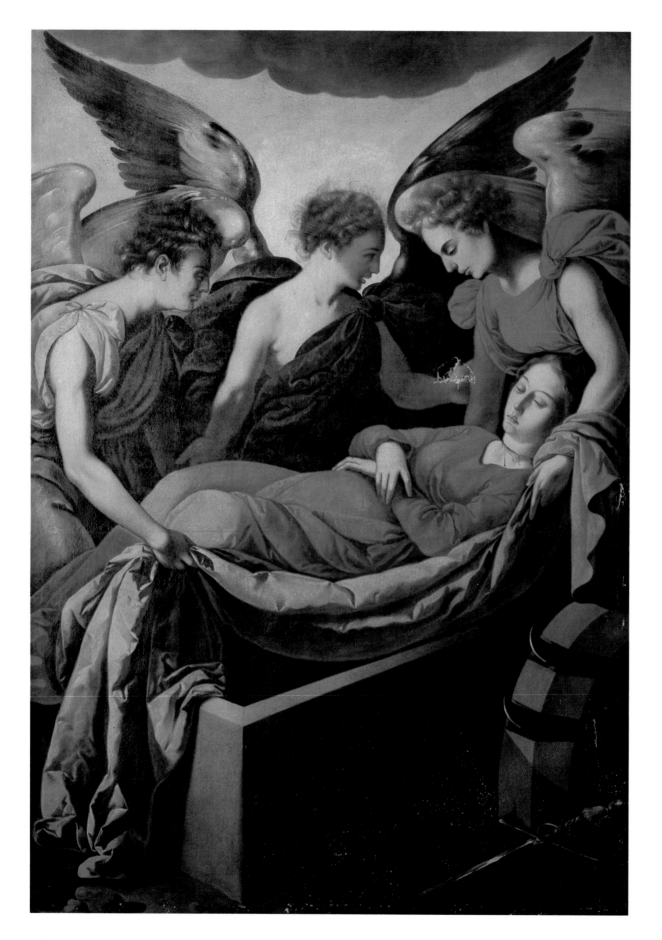

Cornelis Cort. *Entombment of Saint Catherine*, 1575.
Engraving. Bibliothèque Nationale, Paris

for the versions formerly in the Lázaro Galdiano collection and in the Church of San Ginés, there is no trace of their history. The painting in Munich once belonged to the Duke of Padua, who assembled his collection after the Napoleonic Wars.[16] Formerly in the Caraman collection, it has a smooth, enamel-like execution, with soft, transparent colors not found in the works from 1630 to 1635. It must therefore have been a later commission, of about 1640–50, possibly from a Sevillian patron who had seen the painting in the Chapel of Saint Catherine and asked for a modified version.

For stylistic reasons, we believe that the *Burial of Saint Catherine* in the Ibarra collection may be the first version: the manner is still very tenebrist, the colors are strong and saturated, and there is only slight modeling; stylistically, it resembles works of about 1630–35. One thing is certain, however, and that is its Mercedarian origin, either in the Convent of San José or in the monastery of the same name and order.

Zurbarán's use of Cornelis Cort's engraving is not surprising, for he often took his inspiration from such sources.[17] But here again, Zurbarán transcends his model through a vitality all his own—an extraordi-

nary realism, an intense poetry. The face of Saint Catherine expresses ineffable peace while the angels solemnly go about their tasks. Like Cort, Zurbarán depicts the angels half-clothed, perhaps an indication that the Discalced Mercedarians were less conservative on this point than other religious orders. The musculature of the angels' arms seems to have been observed from life. The colors—intense yet muted reds, bright yellows, deep violets, soft pinks—and the iridescence of the shroud are characteristic of Zurbarán's palette.

Before the eighteenth century, it was common practice for appreciative patrons to ask painters to make copies of their works; and these were not necessarily executed by their assistants. The profound spirituality of this painting suggests that it is most likely the work of Zurbarán himself.

NOTES
1. Ribadeneyra 1624 (1984 ed.), p. 404.
2. Baronius 1592, III, year 307.
3. Angulo Iñiguez 1931, p. 65.
4. Ponz 1780 (1947 ed.), p. 790.
5. Ceán Bermúdez 1800, VI, p. 49.
6. Gómez Imaz 1896, nos. 71, 72.
7. Angulo Iñiguez 1931, p. 65.
8. Sebastián y Bandarán 1921, p. 19.
9. Coe 1972, p. 494.
10. Lázaro Galdiano 1800, II, p. 32.
11. Angulo Iñiguez 1931, p. 67.
12. Steingräber 1985, p. 129.
13. Confusion often arises in the literature because it is forgotten that the Order of the Discalced Mercedarians had two establishments in Seville, both called San José, one for men and one for women.
14. González de León 1844, p. 419.
15. Coe 1972, p. 494.
16. The Spanish collections of the Duke of Padua were kept in the Château de Courson, near Paris, and became the property of the Counts of Caraman. Our research (unpublished) into the provenance of these paintings has shown that most were acquired between 1820 and 1840, often in Paris.
17. For Cort's sources, see Coe 1972, p. 494, and Steingräber 1985, p. 129.

PROVENANCE
Convent of San José (?), Seville; given by the mother superior of the convent to the grandfather of the Count of Ibarra before 1921; collection of the Count of Ibarra.

LITERATURE
Ponz 1780 (1947 ed.), p. 790; Ceán Bermúdez 1800, VI, p. 49; Gómez Imaz 1896, no. 71 (?); Sebastián y Bandarán 1921, p. 19; Angulo Iñiguez 1931, p. 65; Caturla, in Granada, II Festival Internacional de Música y Danza, 1953, no. 38; Guinard 1960a, no. 247; Coe 1972, p. 496; Guinard and Frati 1975, no. 186; Steingräber 1985, p. 131.

EXHIBITED
Granada 1953, no. 38.

THE HALL OF REALMS, BUEN RETIRO PALACE, MADRID

It was probably at the urging of the Count-Duke of Olivares, the favorite of Philip IV, that the construction of a new royal residence was undertaken. The new palace, called the Buen Retiro, was intended mainly for the diversions of the court—tournaments, corridas, and especially theatrical productions—and, considering its impressive size, was quickly built. It was begun in 1632. The main axis was formed by the north wing, the only section of the palace still standing, though only partially (it now houses a military museum). The north wing had three main rooms: one to the west called the Colomba, one to the east for the Guard, and in the middle the largest room, variously referred to as the Salón de Comedias, the Salón Dorado, the Salón de Reyes, the Saloncete, or the Saloncete de Comedias.[1] After the fire in the Alcázar in 1734, Philip V and his court moved to the Buen Retiro while the new Royal Palace was being built. The Salón de Comedias—then used as the throne room and for the assembly of the Cortes, the reception of ambassadors, and diverse state functions—was renamed the Salón de Reinos, or Hall of Realms.[2] The decoration of the Hall of Realms was devoted to the glorification of Philip IV. The hall itself was shaped like a gallery; it was more than three times longer than it was wide (34.6 × 10 m) and received abundant light from twenty windows. The eight-meter-high ceiling was elaborately decorated with gilded grotteschi; in the lunettes were painted emblems of twenty-four Spanish monarchs. Between the windows on either side of the gallery were twelve large paintings representing contemporary Spanish military victories, all executed by Spanish artists under Philip IV. Zurbarán painted two of these large battle pictures, as well as ten smaller pictures representing scenes from the life of Hercules, the latter placed above the windows. The paintings were begun in 1634, and the salon was reported completed on April 28, 1635.[3] The paintings remained in the Buen Retiro Palace until the nineteenth century; they were transferred to the Prado shortly after it opened in 1819.

In 1637, Manuel de Gallegos praised the Hercules paintings, but did not name their author; Palomino was the first writer to credit Zurbarán. Opinions later diverged over the number of works in the Hall of Realms attributable to Zurbarán.[4] The controversy

Groundplan, Hall of Realms, Buen Retiro Palace, Madrid

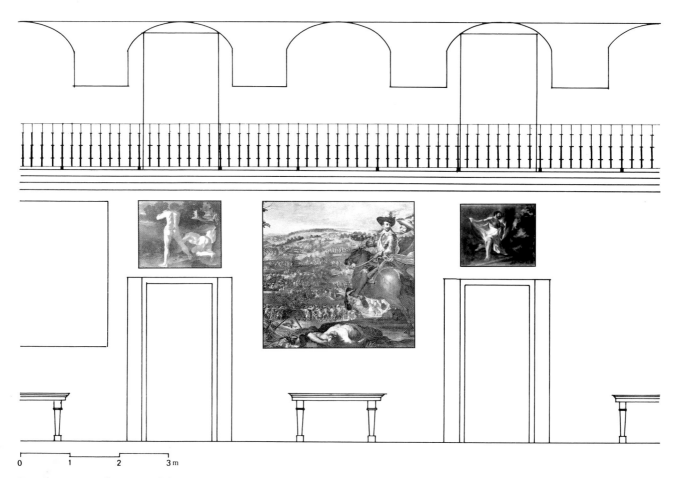

Reconstruction drawing of the original elevation of the south wall, Hall of Realms, Buen Retiro Palace, Madrid

was settled in 1945, when Caturla published a document dated November 13, 1634, in which Zurbarán confirms the receipt of an extra 500 ducats above the sum of 1,100 ducats for "ten compositions on the Labors of Hercules and two large canvases representing the Defense of Cádiz," done for the Great Hall at the Buen Retiro.[5] In 1960, the same author published the pay records for the work in the Hall of Realms, which of course mention Zurbarán. Thus we know that on June 12, 1634, the artist received a payment on account for the Hercules series that he had already begun.[6]

THE LEGEND OF HERCULES

Hercules was the son of Zeus, the husband of Hera, and Alcmene, the wife of Amphitryon. Hercules became the object of Hera's wrath because he was the child of her unfaithful husband, and he was forced to serve King Eurystheus of Tiryns, who ordered him to perform a series of feats, the Twelve Labors, which established his prowess and enduring fame. Hercules's exploits, which made him one of the most popular heroes of classical mythology, were recounted by several fifteenth- and sixteenth-century Spanish authors.[7] He defeated seemingly invulnerable foes: the Nemean lion; the Hydra of Lerna, which sprouted two new heads for each head that was cut off; the Stymphalian birds, which destroyed crops and ate human flesh; the Arcadian stag; the Erymanthian boar; the Cretan bull; the horses of Diomed; the centaur Pholos; and so forth. These powerful adversaries presented repeated challenges to Hercules. The ensuing

exploits demonstrated not so much Hercules's personal qualities as the supernatural assistance that was interpreted as a sign of Divine grace. The legend of Hercules demonstrated the possibility of establishing a link between mortals and the realm of the gods, for Hercules was a mortal man imbued with Divine powers. A model of virtue, he was the only demigod to be admitted into the ranks of the immortals on Mount Olympus, and his exploits came to be adopted as iconographic adjuncts of monarchs who claimed rule by Divine right. In the sixteenth century, he symbolized the Prince.[8] Moreover, he was the father of seventy children, nearly all of them male; most of the ruling families of Europe claimed to descend from him. Spain thus had its Hercules Hispanicus, who, it was written in 1600, "having freed these tribes [of Spain] from their servitude, established his son Hispalus as their monarch, and his nephews have since acceded to the throne of Navarre."[9]

The choice of events from the life of Hercules with which to decorate the Hall of Realms was made with specific programmatic reference to the Spanish monarchy. Hercules's defeat of Geryon, the subject of one of Zurbarán's paintings, was thought to have actually occurred on Spanish soil. Only seven of the twelve canonical Labors of Hercules were chosen. The three secondary scenes relate specifically to Spain: Hercules Separating the Mountains of Caspe and Abylla, which symbolized the Strait of Gibraltar; Hercules Wrestling with Antaeus, who was described by modern authors as a Moorish giant; and the Death of Hercules, which alluded to the legitimacy of the dynasty.[10] The program was thus designed to glorify Philip IV, heir to the throne of Charles V and a descendant of Hercules both through the kings of Castile and through the House of Burgundy. This lineage was firmly believed in in seventeenth-century Spain, as it was held that Hercules himself had founded several important Spanish cities, including Barcelona, Urgel, Segovia, and Seville.[11]

NOTES
1. López Torrijos 1985, pp. 137–38.
2. The use and decoration of this hall, the most remarkable in the palace, has been studied in detail in Brown and Elliott 1980, pp. 141–92.
3. *Ibid.*, p. 142.
4. Díaz Padrón, in Brussels, Palais des Beaux-Arts, 1985, II, p. 444.
5. Caturla 1945b, p. 298.
6. Caturla 1960a, pp. 341–43.
7. López Torrijos 1985, p. 136.
8. Brown and Elliott 1980, p. 162.
9. Cited in Gállego 1968, p. 160.
10. Brown and Elliott 1980, pp. 166–67.
11. López Torrijos 1985, p. 117; Espinosa de los Monteros 1627, I, chap. I.

24.
The Death of Hercules

1634
Oil on canvas, 53½ × 65¾ in. (136 × 167 cm)
Museo del Prado, Madrid

Original location: Madrid, Buen Retiro Palace, Hall of
Realms, south wall, above a window
Date of contract: On June 12, 1634, Zurbarán signed a receipt
for payment on account of 200 ducats for twelve composi-
tions on the Labors of Hercules commissioned for the salon of
the Buen Retiro.
On August 9, 1634, Zurbarán, residing at the court, received
200 ducats in payment on account for the paintings he was
executing for the salon of the Buen Retiro.
On October 6, 1634, Zurbarán, residing at the court, signed
another receipt for the compositions he was painting for the
salon of the Buen Retiro.[1]
On November 13, 1634, Zurbarán signed a receipt for 500
ducats, the balance of the 1,100 ducats owed for ten paintings
on the Labors of Hercules and two large compositions on the
Defense of Cádiz for the grand salon at the Buen Retiro.[2]
Location before 1808 according to early sources: Description of
the Hall of Realms by Manuel de Gállegos, 1637 (cited in
Tormo y Monzó 1912)

Hercules and Deianira, on their way home after their
wedding, came upon a river that had overflowed its
banks. Hercules swam across the river, entrusting his
bride to the centaur Nessus, who carried travelers
across. When Nessus tried to violate the young wom-
an, Hercules shot an arrow through his heart. The dy-
ing centaur told Deianira to take his blood with her as a
sure means of preserving the love of Hercules. Later,
afraid of being replaced by Iole, Deianira had a white
cloak soaked in the blood of the centaur and sent to
Hercules. The poisoned cloak stuck fast to his skin,
burning him unbearably; in his agony, Hercules threw
himself on a pyre built for him on Mount Oeta. Be-
cause of his exploits, his valor, and especially his suf-
fering, he was granted immortality and admitted to
Mount Olympus.

In the *Death of Hercules* painted by Zurbarán, Her-
cules is not depicted burning on the pyre, but rather
according to another version of his death, in which,
tormented in the blood-soaked cloak, he is set afire by
the sun.[3] Zurbarán's representation of Hercules as a
giant with powerful limbs and curly, disheveled hair
accords with tradition. The club that is Hercules's
usual attribute lies at his feet.

The many representations of Hercules in sixteenth-
century Spanish art—usually small, freestanding
sculptures—depict him either as the founder of Spanish
cities or as a model of humanist virtue. In the seven-
teenth century, he began to appear in more ambitious

compositions or cycles of paintings intended primar-
ily as royal propaganda. In 1603, for example, Fran-
cisco Pacheco executed an *Apotheosis of Hercules* for
the Duke of Alcalá on a ceiling of the Casa de Pilatos,
in Seville. The cycle painted by Zurbarán for the Buen
Retiro marks the beginning of a long series of paint-
ings of Hercules that served to glorify the Spanish
monarchy.[4]

Mythological subjects were relatively rare in
seventeenth-century Spanish painting; the court was
the principal patron for such allegorical themes. The
very fact that Zurbarán received a commission from
the court suggests that he was considered far more
than merely a provincial artist.

Zurbarán's pictures for this mythological series
have often been criticized. Guinard remarks that
Hercules was a "theme for which [Zurbarán] was not
very well suited."[5] These heroic exploits certainly
presented new challenges for Zurbarán, and he used
a number of compositional sources to create images
that were without precedent in his own oeuvre. Soria
discovered several sources for the *Death of Hercules*,
in particular the statue *Saint Jerome in Penitence* by
Torrigiano (Museo de Bellas Artes, Seville); the head
and gesture may derive from a 1528 wood engraving
by Master G.S. (see fig. 16, page 14), and the figure
of the centaur from an engraving by H. S. Beham
dated 1542.[6] Guinard considers the first two analo-
gies "debatable," and also remarks on the "powerful
chiaroscuro produced by the flames."[7]

The *Hercules Slaying the Nemean Lion* ultimately de-
rives from Titian or Tintoretto, and the subject was
also represented by Guercino. But Zurbarán did not
simply replicate other sources. Surely he worked di-
rectly from a model, for he pictures the Olympian
god as "a vigorous peasant with a body tinged by the
golden light of the setting sun."[8] His unidealized de-
piction of the legendary hero is akin to the anoma-
lous *Mars* (Museo del Prado, Madrid), by Velázquez.
It undoubtedly pleased the king. Palomino later re-
ported that Philip IV often went to watch Zurbarán
work while he was painting this series: "He went up
to him one day and, putting his hand on his shoul-
der, called him 'Painter of the King, and King of
Painters!'"[9]

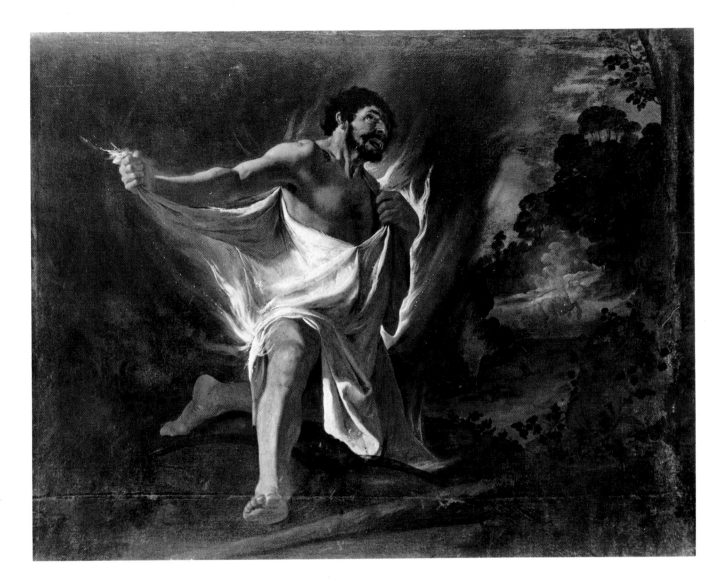

NOTES
1. Caturla 1960a, pp. 341–42.
2. Caturla 1945b, pp. 298–99.
3. Grimal 1979, pp. 202–3.
4. López Torrijos 1985, pp. 128–85.
5. Guinard 1960a, no. 47.
6. Soria 1953, no. 102.
7. Guinard 1960a, p. 277, and no. 47.
8. Baticle 1981, p. 99.
9. Palomino 1724 (1947 ed.), p. 938.

PROVENANCE
Hall of Realms, Buen Retiro Palace, Madrid; transferred to the Museo del Prado, Madrid, shortly after its founding in 1819.

LITERATURE
Palomino 1724 (1947 ed.), p. 938; Ponz 1780 (1947 ed.), p. 551; Ceán Bermúdez 1800, VI, p. 52; Madrazo, in Madrid, Museo del Prado, 1872, pp. 649–50; Cascales y Muñoz 1911, p. 107; Tormo y Monzó 1911b, p. 28; Kehrer 1918, pp. 77–78; Soria 1944a, pp. 43–48; Caturla 1945b, pp. 292–300; Guinard 1949, pp. 29–30; Soria 1953, no. 102; Caturla 1960a, pp. 333–55; Guinard 1960a, pp. 194–95, no. 569; Torres Martín 1963, no. 125; Brown 1974, pp. 27, 102; Guinard and Frati 1975, no. 145; Gállego and Gudiol 1977, no. 106; Brown and Elliott 1980, pp. 149–70; López Torrijos 1985, pp. 137–46.

EXHIBITED
Madrid 1905, no. 21; Granada 1953, no. 26; Stockholm 1959–60, no. 119.

THE CHURCH OF SAN JUAN BAUTISTA, MARCHENA

The Andalusian city of Marchena is situated southeast of Seville, about halfway to the city of Osuna. In the sacristy of the Church of San Juan Bautista, a group of nine paintings by Zurbarán and his workshop is preserved in the setting for which it was created. Documents in the parish archives indicate that an enlargement of the sacristy was envisioned as early as 1618, but the work was not begun until 1629. Construction was finished by 1633, when it was decided to decorate the new space, but once again the realization of the plan was delayed. It was not until about 1635 that the paintings were ordered from Zurbarán. By 1637, the works had been delivered and installed in the sacristy; the artist was paid 33,600 reales. They were then forgotten outside Marchena until they were published in 1953 by José Hernández Díaz.[1]

The program for the series is as follows: a *Christ on the Cross* and a *Virgin of the Immaculate Conception*, two of the most popular images of the Spanish Counter-Reformation; a *Saint John the Baptist*, the titular saint of the church; and representations of six Apostles, *Saint Peter, Saint Paul, Saint John, Saint Andrew, Saint Bartholomew*, and *Saint James the Greater*. The paintings are not well preserved, making it difficult to determine the extent of Zurbarán's direct participation in the actual painting of the series.[2]

NOTES
1. Hernández Díaz 1953, pp. 31–36.
2. Guinard 1960a, pp. 197–98.

View of the sacristy, Church
of San Juan Bautista, Marchena

25.
The Virgin of the Immaculate Conception

1635–37
Oil on canvas, 6 ft. × 3 ft. 6⅛ in. (183 × 107 cm)
Church of San Juan Bautista, Marchena

Original location: Marchena, Church of San Juan Bautista, sacristy
Date of contract: Not known

In the feast of the Immaculate Conception, which falls on December 8, the Church honors the unique privilege conferred on the Virgin Mary that preserved her from original sin. The idea of the Immaculate Conception goes back to the sixth century and inspired theologians of the fourteenth and fifteenth centuries, especially in France and England. The doctrine was defended by the Franciscans against the Dominicans, who argued that Mary, like John the Baptist, had been sanctified in her mother's womb after conception, rather than having been sinlessly conceived. The belief in the Virgin's spotless conception was encouraged by the Synod of Basel in 1439 and approved by the Franciscan Pope Sixtus IV in 1476. As early as the close of the fourteenth century, the Castilian monarchs had taken their stand with the so-called Immaculists.[1] Decades later, the devoutly Catholic Spanish kings Philip III and Philip IV declared themselves champions of the *Concepción Purísima*. Since no firm decision had been reached by the Council of Trent regarding the longstanding controversy about the Immaculate Conception, the old quarrel between the Dominicans and the Franciscans flared up again on Spanish soil. From 1613 to 1616, there was an extraordinary upsurge of Immaculist piety in Seville. Uniting clergy and populace, and drawing on the participation of artists and poets, it culminated in Pope Paul V's brief of August 21, 1617, in favor of the Immaculate Conception; five years later, Gregory XV laid a ban on the teaching of the Dominicans' contrary doctrine of sanctification, without, however, himself defining the dogma.

On September 8, 1613, a Dominican father preached from the pulpit the sanctification doctrine of the Maculists, the opponents of the idea of the Immaculate Conception. An unprecedented scandal ensued. The Sevillians decided to avenge the honor of the *Purísima* by solemn festivities that lasted a full four years. At the urging of Canon Vásquez de Leca, the poet Miguel Cid composed a verse, printed about 1615, whose refrain became the rallying cry of popular piety:

> Everyone in general
> In a clamorous cry, Elect Queen,

> Declares that you are conceived
> Without original sin.[2]

Cid's poem was sung in the Cathedral of Seville on February 2, 1615, at the feast of the Purification, and was followed by a great procession through the streets of the city in honor of the Immaculate Conception. The event was illustrated in 1616 by the painter Juan de Roelas in a grandiose allegory commissioned by Philip III and now in the Museo de la Pasión, Valladolid. That same year, the city of Marchena took part in the ceremonies of reparation and in the Marian festivities.[3]

Zurbarán painted the *Virgin of the Immaculate Conception* for the city of Marchena. The figure of the Virgin, although reversed in pose and more gracious in character, brings to mind that by Roelas, notably in the radiating nimbus, not usually found in Zurbarán's paintings on this subject. If the idea of Mary's undefiled conception was established slowly in theology, the liturgy, and popular devotions, it took even longer to find its visual form. It was anything but easy to represent the sinless conception of the Virgin. After the complex symbolic representations used by artists in the Middle Ages,[4] the austere reforms that followed the Council of Trent succeeded increasingly in imposing a simple and direct image, a poetic allegory that gradually dispensed with the emblems and accessories that made it explicit to the broad public. In the very first years of the sixteenth century, there appeared simultaneously in France[5] and in Spain[6] the engraved image of a young girl with long hair unbound, profoundly innocent and meditative, floating against a sky strewn with the symbols of the Marian litanies. She is identified as the Shulamite of the Song of Solomon by the inscription "Tota pulchra est Amica mea, et macula non est in te" ("Thou art all fair, my love; there is no spot in thee"; Song of Solomon 4:7). That image was later joined to Saint John's vision of the Apocalyptic Woman crowned with stars, standing on a crescent moon and enveloped in sunlight (Revelation 12:1). About 1568 in Valencia, fountainhead together with Seville of the devotion to the *Inmaculada*, a visionary Jesuit inspired Juan de Juanes to execute the first painting of this type.[7] About the same time, there appeared in Seville a *Virgin of the Immaculate Conception* by an anonymous Hispanic-Flemish painter (now in the Church of Santa Ana, Triana), doubtless derived from the same engraving as the picture by Juan de Juanes. This was the first popular image of an iconic model in the seventeenth century. Before becoming established, that model

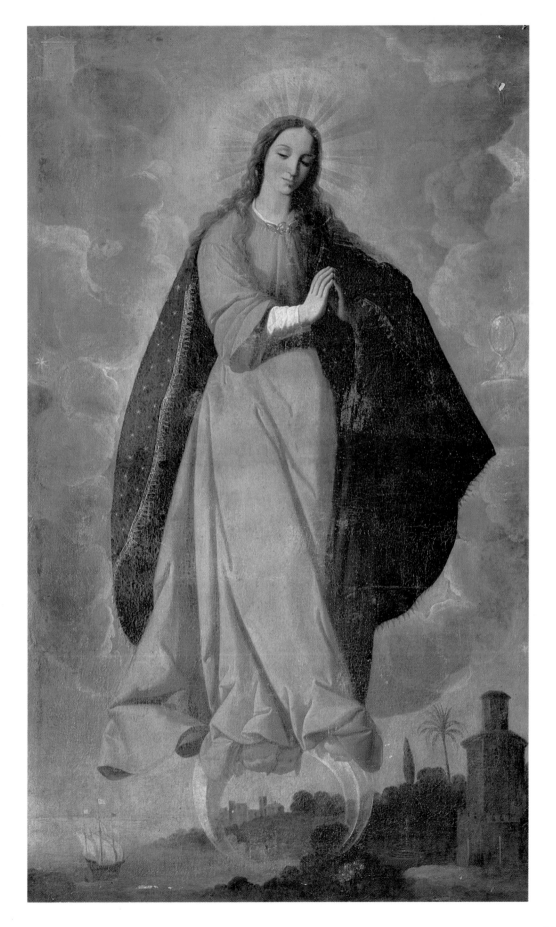

went through certain modifications. At the start of the seventeenth century, both Spanish and Italian artists who worked for the clergy and the monasteries produced more or less definitive images of the *Purísima*. Thus, the Cavaliere d'Arpino executed one of the finest images for the college of the Jesuits in Seville, where it was installed in 1615 (it is now in the Real Academia de Bellas Artes de San Fernando, Madrid). In the 1630s Zurbarán, as always the scrupulous interpreter of the directives of the ecclesiastical authorities, painted several versions of the Virgin Immaculate; he would repeat this delicate vision tirelessly into his advanced years.

In the painting for Marchena, Zurbarán portrays the Virgin in the traditional rose gown of the Seville school. He himself had only once depicted her mantle covered with stars, but it was nevertheless frequently shown thus in works datable to between 1610 and 1630; two such examples are by Eugenio Cajés in the Cathedral of Toledo and by Juan Sánchez Cotán in the Church of Santiago, Valladolid. To the left and right of the Virgin are symbols drawn from the Marian litanies; other symbols are represented in the landscape over which she soars.

This enchanting picture marks a documented phase in how the theme of the Immaculate Conception evolved in Zurbarán's hands. It would appear that the first known work by Zurbarán on this subject is one now in the Prado. It is still very close to the model established by Velázquez, with effects of powerful relief, a buttery rich impasto, tenebrist effects, and no angels under the Virgin's feet. As in the paintings by Pacheco, the Virgin wears a rose tunic and is swathed in a great blue mantle with neat and tidy folds.

The Marchena *Virgin of the Immaculate Conception* marks a clear change from the first work. From documents, we know it was painted for the Duke of Arcos between 1635 and 1637. The columnlike statuary pose has been abandoned in favor of a gracious silhouette in almost three-quarter view, with the legs crossed and the mantle broadly open on the tunic. The Seville landscape is lightly indicated.

Following the Marchena picture, Zurbarán probably painted the *Virgin of the Immaculate Conception* in the Chapel of San Pedro in the Cathedral of Seville (whose altarpiece but not its paintings was commissioned in 1625). Here, too, the Virgin is shown wearing a rose gown, but the luminous effects, the treatment of the draperies, and the pose are freer than two years earlier.

In the superb example in Edinburgh (cat. no. 33), the Virgin is again shown gowned in rose. As in the cathedral picture, her pose is relaxed and her joined hands are pointed toward the right of the composition. She is placed within a mandorla of angels lacking sym-

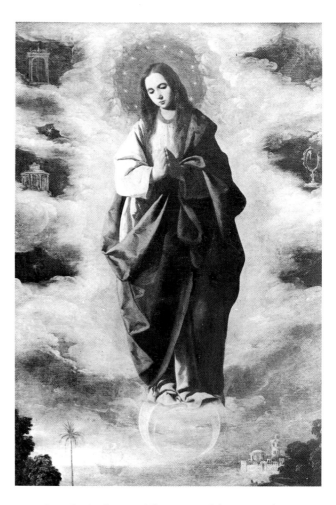

Francisco de Zurbarán. *The Virgin of the Immaculate Conception.* Oil on canvas, 54¾ × 41 in. (139 × 104 cm). Museo del Prado, Madrid

bolic attributes. The flap-ends of the mantle on the left now begin to flutter in small swirls.

Probably from the same period is the canvas now in the parish school of Nuestra Señora del Carmen, Jadraque. Then, in the last fifteen years of the painter's activity, the mantle billows out even more and the position of the hands is treated more freely. Two other compositions are very similar in the pose of the Virgin and in the draperies, one in the Museo Cerralbo, Madrid, the other in the Seville City Hall. (The latter came from the magnificent Augustinian Monastery of Nuestra Señora del Pópolo, Seville; the community was dissolved and the convent damaged in the nineteenth century.) The Cerralbo Virgin, dressed in rose, has a long face with large, almond-shaped eyes, while the Virgin in Seville, also in rose, has a broad face with full cheeks and round eyes.

In 1656, Zurbarán painted the Virgin as a young girl with a white gown and blue mantle (National Gallery of Ireland, Dublin). She is seen full-face, in

an only slightly relaxed pose, and she crosses her hands on her chest like certain of Murillo's Virgins. Whereas the other Virgins by Zurbarán all have the eyes lowered or the head bent down, here the eyes are lifted to heaven, as in the painting in the Seville City Hall. She is enveloped in a cloud of angels who form a halo, but the symbols of the Virgin no longer appear.

The last two examples date from 1661. The one in Langon (cat. no. 70) has full cheeks, lowered eyes, and hands joined, with the swirls of the cloak forming complicated loops. The other, in the Szépmüvészeti Múzeum, Budapest, is a ravishing young girl with arms wide, palms open, and wearing a mantle with swirls and volutes. The opalescent coloring, the grace of the silhouette, and the sfumato treatment are entirely different from what one finds in the first, tenebrist examples from the 1630s.

NOTES
1. Tormo y Monzó 1914, p. 185.
2. *Ibid.*, p. 190.
3. Salvago de Aguilar 1953, pp. 227–34.
4. Mâle 1908 (1969 ed.), pp. 208–11.
5. *Ibid.*, fig. 111.
6. Tramoyeres Blasco 1917, p. 114.
7. *Ibid.*, pp. 113–28.

PROVENANCE
Still *in situ*.

LITERATURE
Hernández Díaz 1953, pp. 31–36; Soria 1955a, no. 228; Guinard 1960a, no. 10; Torres Martín 1963, no. 136; Guinard and Frati 1975, no. 217; Gállego and Gudiol 1977, no. 116.

Groundplan, presbytery of the church, Monastery of Nuestra Señora de la Defensión, Jerez de la Frontera, showing the disposition of the original altarpiece.

Façade of the church, Monastery of Nuestra Señora de la Defensión, Jerez de la Frontera

seventeenth century work abated, but it was resumed under the direction of Juan Martínez Montañés, the famous Sevillian architect and sculptor, who drew up plans for the lay brothers' cloister in 1620. In 1636 the prior, Sebastián de la Cruz, decided to replace the medieval altarpiece in the apse of the church with one of modern design. This project was entrusted to Alejandro de Saavedra as designer and engineer, to José de Arce as sculptor, and to Francisco de Zurbarán as painter.

Unfortunately, the fabulous ensemble that resulted—certainly one of the finest of Spain's Golden Age—was completely dismantled in the nineteenth century. There would not be so many unanswered questions about the original disposition of Zurbarán's paintings if at least the architecture of Saavedra's altarpiece still existed. Hence the special importance of the investigation made by César Pemán after the Carthusians returned to Jerez in 1948. Pemán conceived the idea of having an architect survey the whitewashed walls and the pavement of the apse for any remaining traces of the altarpiece. From the surveys published by Pemán, it has been possible to reconstruct the main body of the altarpiece as well as the dimensions of the whole.[1] The altarpiece was approximately 15 meters high and 10 meters wide and had two main stories surmounted by a large attic. Responding to the curvature of the apse, the architecture was not dis-

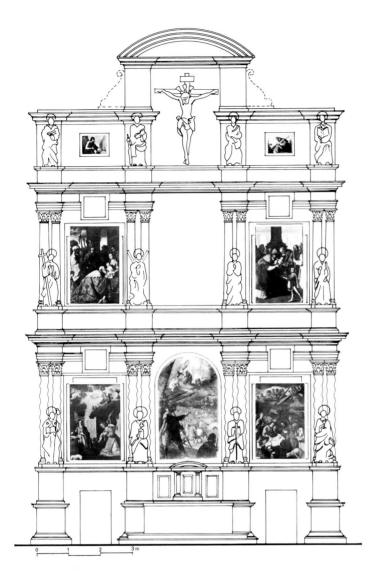

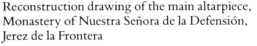

Reconstruction drawing of the main altarpiece,
Monastery of Nuestra Señora de la Defensión,
Jerez de la Frontera

posed in a flat plane. The altarpiece somewhat resembled a large triptych with a center
section flanked by two lateral wings set at angles to the central core.

A passage in the *Historia de Xerez de la Frontera* by Esteban Rallón Mercado, a Hieron-
ymite monk, which was probably written before 1640, and was published in part in 1926,
gives a fairly clear idea of the altarpiece, although the artists are not named; this source
enabled Pemán to suggest an ideal reconstruction. Fray Rallón described an altarpiece
in three parts (he counted the attic as a third part), with Solomonic columns in the first
story, where the *Battle between Christians and Moors at El Sotillo*, now in The Metropolitan
Museum of Art, New York (cat. no. 30), occupied the center compartment, and was
flanked and surmounted by scenes from the life of Christ in the first and second stories,
while the third story supported a sculpture of the crucified Christ. In front of each pair
of columns was a statue representing an Apostle, so that the three stories constituted a
complete *Apostolado* (a series of representations of the twelve Apostles).[2] The altarpiece,
according to Rallón, had not yet been gilded.

When they returned to the monastery in 1948, the Carthusians found in their ar-
chives an inventory dated September 5, 1835, that had been drawn up in anticipation
of the *desamortización* of 1836, which culminated in the decrees suppressing the mon-

asteries in Spain and resulted in a great number of confiscated masterpieces being sold on the European art market. The inventory, an excerpt from which was published by Pemán, describes the arrangement of the paintings of the main altarpiece as they probably appeared after 1808, when two of them had been taken out of Spain.[3] According to that document, in the center of the first story was a statue of the Virgin; to the statue's left, an *Annunciation* (cat. no. 26), measuring 3 varas high by 2 varas wide, or about 252 × 168 centimeters; to the right, of the same dimensions, a *Nativity* (cat. no. 27). In the second story, in the center compartment, was a *Saint Bruno* on canvas, of the same dimensions as an *Adoration of the Magi* at the left (cat. no. 28) and a *Circumcision* at the right (cat. no. 29). The altarpiece also included paintings of the four Evangelists, each measuring ¾ vara, or about 63 centimeters wide, and a *Saint Lawrence* and a *Saint John the Baptist*. The six last-mentioned paintings are now in the Museo de Cádiz, and the dimensions given agree rather closely with their actual measurements.

After this discovery, Pemán undertook a new reconstruction of the altarpiece as it might have been in the seventeenth century.[4] He suggested that in the second story, above the *Battle between Christians and Moors at El Sotillo*, was the *Saint Bruno in Ecstasy*, also now in Cádiz, a work measuring 340 × 195 centimeters, similar in size and rounded at the top like the New York painting.

This proposal seems to call for the following comments. First, it would appear that until the seventeenth century the altarpieces of the high altars of Carthusian churches were essentially devoted to images of the life of Christ. A painting of Saint Bruno would not therefore have been placed at the center; such an image would have had its own chapel and would have appeared at the doorway of the church. Many such examples are to be found—at Las Cuevas and El Paular, for example. Second, it seems technically implausible that in a two-story altarpiece, the designer would have centered, one above the other, two large compositions of the same size, both rounded at the top. Most altarpieces of the period show a canvas with a rounded top surmounted by a canvas that is rectangular in shape.

If we know, thanks to Rallón, that the *Battle between Christians and Moors at El Sotillo* was originally in the main compartment of the first story, we can infer nothing concrete from the brief passage regarding the second story, described as "in the same manner" as the first; in any case, Rallón omits any mention of a *Saint Bruno* in the second story, among the scenes from the life of Christ, something that would have struck him as unusual, because Saint Bruno, whose feast was introduced to the liturgy only in 1623, was the founder of the order.

Finally, Ponz and Ceán Bermúdez, who enumerate the paintings by Zurbarán in the charterhouse, mention only one *Saint Bruno*, painted by the artist but hung in the sacristy.[5] Furthermore, the *Saint Bruno in Ecstasy* in Cádiz, of lesser quality than the Grenoble masterpieces, measures 24 centimeters higher and 20 centimeters wider than Zurbarán's four scenes from the life of Christ, whereas the inventory of 1835 specifies that the *Saint Bruno* in the second story is of the same dimensions as the four scenes surrounding it.

There is no documentary evidence to indicate at what date the Carthusians removed the *Battle between Christians and Moors at El Sotillo* from the center of the main altarpiece. Both Ponz, in 1792, and Ceán Bermúdez, in 1800, noted its presence on a wall of the lay brothers' choir.[6] Its removal is confirmed by the inventory of 1835, which mentions the presence of two paintings on "two altars past the screen of the lay brothers' choir, one gilded, with a painting of the Virgin of the Rosary, four varas high and two

wide [336 × 168 cm], rounded at the top, and the other a painting of the Battle of the Moors, of the same dimensions as the preceding."

It would seem that this change occurred in Zurbarán's time, because the *Virgin of the Rosary*, now in the Muzeum Narodowe, Poznań, must have been intended as a pendant to the *Battle between Christians and Moors*; their dimensions are exactly the same, and both have the same rounding at the top. They must therefore have been installed at the same time on the two side altars, and recessed in niches of like shape. These altars are always placed in the part of the church reserved for the laity, "past the screen of the lay brothers' choir," as the inventory so precisely states. Ponz, followed by Ceán, was in fact mistaken in placing the paintings in the lay brothers' choir, since there were only stalls along the side walls, and no altar.

The original placement of the two paintings was recently examined by Jesús M. Palomero Páramo. Above the nineteenth-century altars that have replaced the original altars, he found traces of the early rounding of the arcatures of the niches; furthermore, the dimensions—488 × 310 centimeters—agree with those of both paintings. (The height must of course be reduced by one meter to allow for the height of the altar on which the paintings rested; and the width must be reduced by the width of the frame, generally 25 centimeters on each side.)

At some indeterminate date, in the space left vacant in the first story by the removal of the *Battle between Christians and Moors*, the prior had installed a niche for a statue of the Virgin. We know that such a statue did exist. It was replaced in the eighteenth century, since Ponz in 1792 speaks of an earlier sculpture as being finer than the modern statuette that had taken its place "in the principal niche."[7] This work was removed in 1795, to be replaced by a large statue of the Virgin by José Esteve y Bonet, the celebrated sculptor of the reigns of Charles III and Charles IV; today, Esteve's sculpture adorns the present altarpiece, which was installed in the church in 1968.

These successive changes made by the monks, well before the vicissitudes of the Napoleonic Wars, greatly complicate any attempt to reconstruct the ensemble in its original state. On the other hand, the inventory of 1835 does definitively place the four canvases now in Grenoble, and this for a simple technical reason. In 1963, it was discovered that the corners of the Grenoble canvases had been cut out at the top, the *Annunciation* and the *Adoration of the Shepherds* horizontally, the *Adoration of the Magi* and the *Circumcision* vertically; furthermore, the dimensions of the first two are slightly smaller than those of the second two. So when they were replaced after 1815, they were quite naturally fitted into their original frames according to their respective cutouts, the *Annunciation* and the *Adoration of the Shepherds* in the first story, as the 1835 inventory indicates, and the *Adoration of the Magi* and the *Circumcision* in the second.[8]

One example of this type of framing is also found in the first story of the altarpiece of the Chapel of San Pedro in the Cathedral of Seville, where Zurbarán's paintings were left in place; another is an altarpiece by Martínez Montañés in the Church of San Isidoro del Campo in Santiponce, a suburb of Seville.

The contract for Zurbarán's work for the Jerez altarpiece, which included four compositions to be devoted to the infancy of Christ, has not been found. However, two documents serve to identify the period during which he worked at the monastery. First, on November 7, 1637, Zurbarán, Alonso Cano, and Francisco de Arce jointly guaranteed the work of the sculptor José de Arce (a Fleming who settled in Seville in 1636), who on October 31 of the same year had undertaken to execute all the sculptures to be displayed on the altarpiece "que se hace" (being made) for the church of the charter-

house at Jerez.[9] Another document, dated December 27, 1637, discovered at Cádiz, states that the construction of the altarpiece was ordered in 1636 from Alejandro de Saavedra, a renowned *ensemblador* (woodworker) in the Cádiz region.[10] Also, two of Zurbarán's paintings for this project are signed and dated: the *Adoration of the Shepherds* in 1638 and the *Circumcision* in 1639. The construction of the altarpiece had been decided upon by the prior, Sebastián de la Cruz, who obtained a loan of 1,000 ducats for the purpose from Sebastián Rodríguez de Per . . . (?), someone about whom nothing more is known.[11]

In the absence of further documentation, it is impossible to say for what reasons a new altarpiece was ordered. According to the unpublished *protocolo* of the monastery, Sebastián de la Cruz died on January 10, 1639, and more than a year passed before the new prior, Juan de Zapata, was named, on February 19, 1640; but he, says the *protocolo*, "took much care to see to the completion of what had been begun, the altarpiece, the sanctuary. . . ."[12] According to the same document, Sebastián de la Cruz during his priorate had embarked on a grand program for the renovation of the monastery, of which the construction of the main altarpiece was to be the crowning achievement. Its execution, however, was to meet with many setbacks. Fray Rallón, for example, noted before 1640 that it had not yet been gilded. Possibly also there was a shortage of funds, or reneging on the part of artists. Again according to the *protocolo*, the total cost of the altarpiece, including construction, gilding, sculptures, and paintings, amounted to 18,058 ducats.[13]

In 1660, Fray Pedro del Pinar produced drawings of the ornamentation for the new façade of the church, conceived as an altarpiece and bearing a curious resemblance to the main altarpiece. Its sculptures are the work of Francisco de Gálvez of Seville, who seems to have based them on Zurbarán's series of Carthusian figures painted for the passageway leading to the *sagrario*, or tabernacle, behind the altarpiece. But in the second half of the seventeenth century, maintenance must have been relaxed, since the archdeacon José de Valles, in his history of the Carthusian establishments of Spain, published in 1663, states that the monastery buildings were already dilapidated.[14] Major renovations were undertaken during the eighteenth century, beginning in 1730, according to a date inscribed on the door of the passageway between the lay brothers' and the monks' choirs, and continuing in 1760; the large screen was put up in 1760, and Ponz in 1792 mentions alterations made to the church "some years ago," suggesting that it would have been better to preserve its former Gothic style.[15] The late eighteenth-century descriptions by Ponz and Ceán Bermúdez hardly differ from those of the 1835 inventory, and they therefore afford no clues to the original arrangement of the works in the seventeenth century. All are rather vague as to the placement of the four canvases of the Evangelists, as well as of the *Saint John the Baptist* and the *Saint Lawrence*. Finally, we note that Ponz, well versed in architecture, describes a two-story altarpiece, apparently confirming the reconstruction by Pemán, with a rather high attic that less-informed visitors often mistook for a third story.

A few years after the last testimony, that of Ceán Bermúdez, a Frenchman, Alexandre de Laborde, the brother of Nathalie de Noailles, journeyed to Spain; there he met Chateaubriand. The following year, he published a lively travelogue. He may have been guided to Seville and Cádiz by Frédéric Quilliet, who was closely connected in Cádiz with the Alcalá Galiano family and was probably the sponsor of the removal of Zurbarán's paintings to Paris in 1813. Laborde visited the monastery, describing the gardens with enthusiasm, but he relied on Ponz to refresh his recollections of the church.

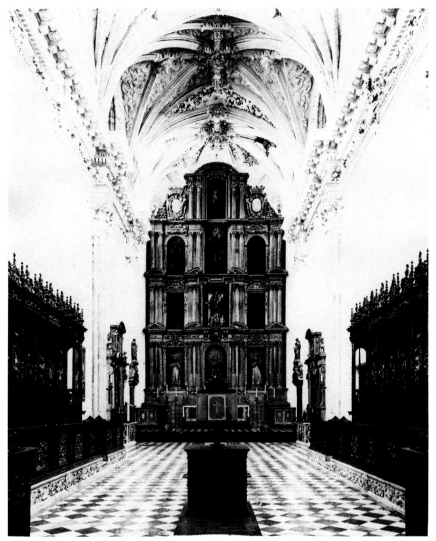

View of the high altar, church of the Monastery of Nuestra Señora de la
Defensión, Jerez de la Frontera

In any case, he was the first Frenchman to appreciate the work of Zurbarán *in situ*. The
three Zurbarán paintings selected from Jerez for the Musée Napoléon were the *Adora-
tion of the Magi* (Inventaire Napoléon, no. 380), the *Circumcision* (no. 381), and the *Battle
between Christians and Moors at El Sotillo* (no. 349). They were restored to Spain after
1814, and exhibited until 1823 at the Real Academia de San Fernando, Madrid, after
which they were returned to Jerez, though not for long.

It remains to relate how Baron Taylor managed to acquire this prestigious group of
paintings in 1837. It is well known that historians have vilified the unfortunate Antonio
Mesas, a painter who acted as the intermediary in the Taylor sale. But Elías Tormo
explained in 1909 that Mesas had been the tool of one Minister Mendizabal, and that
despite debates in the Cortes and vehement protests from the Academia de Bellas
Artes in Cádiz, the Spanish Minister of the Interior had officially authorized the sale
of the Jerez Zurbaráns to Louis-Philippe. If the Spanish experts of the time had been
more familiar with the history of what was often the monstrous destruction of monu-
ments in Europe, they might not have been so critical of the negligence of their own
countrymen.

Having been exhibited for ten years, from 1838 to 1848, in the halls of the Galerie Espagnole of Louis-Philippe, installed on the first floor of the Colonnade of the Louvre, Zurbarán's four scenes from the life of Christ and the *Battle between Christians and Moors at El Sotillo* were put up for sale at Christie's, London, in 1853, after the king's death. The four life of Christ canvases were purchased by the Duke of Montpensier, who took them to the Palacio San Telmo, in Seville. Later, they went back to his daughter, the Countess of Paris, at the Château de Randan, in the Auvergne. They were then purchased by General de Beylié, and he in turn gave them, in 1904, to the Musée de Peinture et de Sculpture, Grenoble. Thus ended over a century of wanderings, which had, inexorably, brought Zurbarán's masterpieces three times to France. In 1853, the *Battle between Christians and Moors at El Sotillo* became the property of an English collector, Henry Labouchère (later Baron Taunton), and his descendants sold it in 1920 to The Metropolitan Museum of Art. As for the smaller canvases of the altarpiece, they were brought together by the Academia de Bellas Artes in Cádiz and entered that city's museum.

NOTES

1. Pemán 1950, pp. 204–7.
2. *Ibid.*, p. 226.
3. Pemán 1964, p. 103.
4. *Ibid.*, p. 102.
5. Ponz 1792 (1947 ed.), p. 1549; Ceán Bermúdez 1800, VI, p. 51.
6. Ponz 1792 (1947 ed.), p. 1548; Ceán Bermúdez 1800, VI, p. 51.
7. Ponz 1792 (1947 ed.), p. 1548.
8. Baticle and Laclotte, in Paris, Musée des Arts Décoratifs, 1963, no. 98.
9. López Martínez 1928a, p. 25; Archivo de Protocolos, Seville, *Oficio* 4.
10. Pemán 1964, p. 102.
11. Bravo 1980, pp. 1, 2.
12. *Ibid.*, p. 7.
13. *Protocolo*, p. 209, archives of the Monastery of Nuestra Señora de la Defensión, Jerez de la Frontera.
14. Cabello Lapiedra 1918, p. 247.
15. Ponz 1792 (1947 ed.), p. 1548.

26.
The Annunciation

ca. 1638–40
Oil on canvas, 105 × 73 in. (267 × 185 cm)
Musée de Peinture et de Sculpture, Grenoble

Original location: Jerez de la Frontera (Cádiz), Monastery
of Nuestra Señora de la Defensión, main altarpiece,
first story, left compartment
Date of contract: Not known

Since the founding of their order at the close of the eleventh century, the Carthusians accorded high devotion to the Virgin Mary, their first patron, honored as "Mother." Thus, the Annunciation and the Nativity were celebrated with special solemnity in the Carthusian liturgy. The Carthusians multiplied votive Masses and angelic salutations. "Salute Mary thrice," wrote Jean Gerecht to a young colleague in the sixteenth century, "giving her not as some do the title of Patroness General, but that of Mother";[1] and after the Council of Trent, new statutes provided for a quadruple Angelus.[2]

The *Annunciation* painted by Zurbarán for the Carthusians of Jerez complied with the precepts of the Counter-Reformation. This triumphal work unites heaven and earth. The iconographic type, which was established in Italy in the sixteenth century, spread throughout Catholic Europe in the seventeenth.[3] In his *Discorso* (Bologna, 1582), Cardinal Gabriele Paleotti wrote that "to contemplate the Annunciation as painted by a great artist is not merely to enjoy the pleasures afforded by lines and colors, but is to comprehend and then to love the goodness of God."[4] The angelic salutation was no longer conceived without the presence of many angels; all heaven came to accompany the Archangel Gabriel in his mission: "The celestial Prince descended from the empyrean attended by a multitude of other angels in human form, with splendor proportionate to his high rank."[5] To be historically accurate, the scene had to take place in a humble dwelling in Nazareth. Molanus stated that it was likely that "the Holy Virgin was on her knees, meditating the mysteries of the Redemption, when the angel presented himself before her."[6] He was followed in this by Pacheco, whose suggestions seem to have been observed to the letter by Zurbarán:

> The most holy Lady must be on her knees, as is most likely, with a sort of stand or bench before her, on which she has an open book . . . ; the angel . . . must be suitably clad, with both knees on the ground . . . and [the Virgin] humble and modest

of the age we have said of fourteen years and four months, most beautiful, her hair neat and covered with a light veil, the cloak blue and dress rose, girded with a belt . . . the angel will have handsome wings and shining white robes of changing brilliance. . . . At the top it is usual to paint . . . many seraphim and angels and the Holy Spirit in the figure of a dove casting forth resplendent rays of light.[7]

The cluster of lilies, an emblem of Mary's innocence and of Divine Majesty,[8] is placed in a vase; the angel holds his hands crossed on his breast in an attitude of contemplation before the mystery here fulfilled.

Having retired from her handiwork at nightfall, continues Pacheco, the Virgin has left her work in a basket at her feet. At her right, a column joins heaven and earth. The tree of life, the axis of the world, it

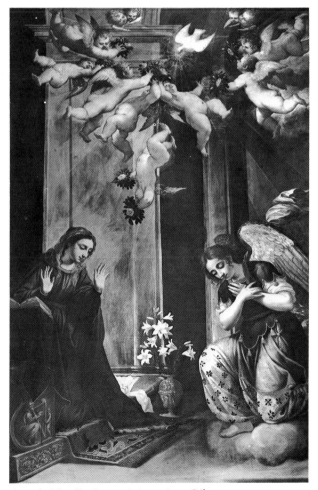

Angelo Nardi. *Annunciation*, 1634. Oil on canvas.
Convent of Las Bernardas, Jaén

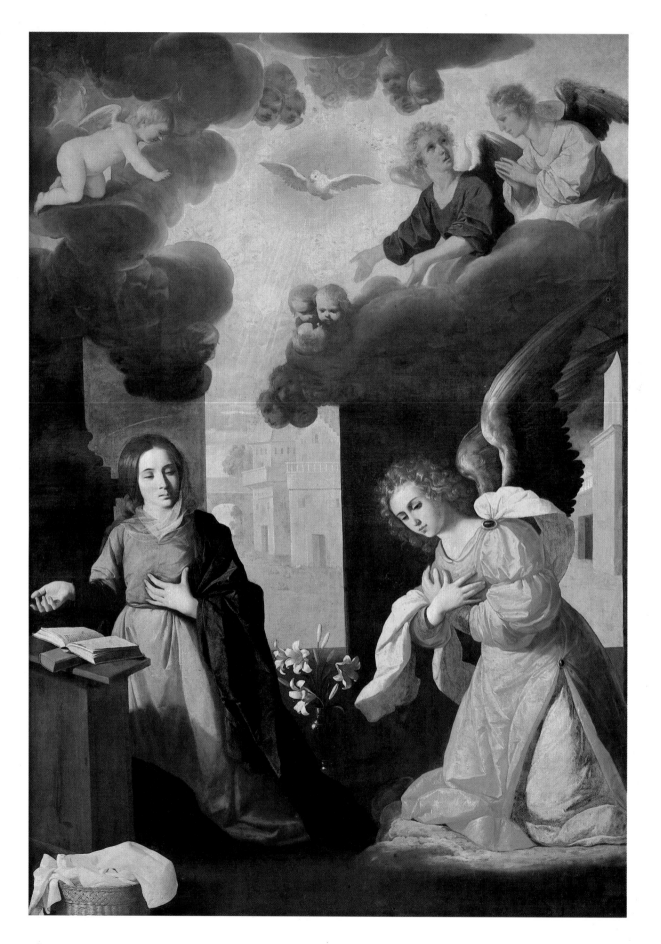

has the solidity of an edifice and symbolizes Faith, Hope, Constancy, Strength, and Chastity.[9]

As mentioned in the introduction to this section, the *Annunciation* shows cutouts at the top of the canvas, on the right and the left, measuring about 18 × 22 centimeters, similar to those of the *Adoration of the Shepherds* (cat. no. 27). According to the monastery inventory of 1835, the *Annunciation* was placed in the left compartment of the first story of the altarpiece.[10]

Zurbarán here attains near perfection, both in the construction of forms and in the almost classical sense of balance. The placement of the Virgin in relation to Gabriel creates a kind of psychological space, its nuances at once forcefully and delicately expressed. Contrary to the disposition of figures in most traditional Flemish and Italian Annunciations, where the angel is shown with his arm extended and his finger pointing toward Mary in a gesture of counsel, while she inclines, with her hands crossed on her breast, Zurbarán and his patrons adopted the arrangement seen in an *Annunciation* by Pacheco painted about 1632 for the Church of Santiago, in Seville, in which the customary design is reversed.[11] Here, Gabriel crosses his hands over his heart and the Virgin extends her half-opened right hand as a sign of acceptance, her head turned toward him. An *Annunciation* signed by Angelo Nardi, painted in 1634 for the Convent of Las Bernardas in Jaén, shows an angel in nearly the same position (see illus. on page 181).

The faces of the two protagonists are seen frontally. The still life has been reduced to three objects: the workbasket in the foreground, the book on the lectern, and the vase of lilies, of great beauty, in the middle ground. Also to be noted are the monumentality of the setting, the discreet and poetic insertion of the celestial scene, and the lighting, which, like a film projector, spotlights the essential elements of the scene. The heterogeneous elements form an integrated whole, worthy of the best Renaissance masters.

Zurbarán gives the viewer a symbolic vision of the Annunciation, at once grand and contemplative, shorn of the agitation associated with the Baroque and of the highly decorative qualities of Mannerism. The reserved, unaffected grace of the angel accords with the grave dignity of the Virgin in her primordial role. She is neither humble nor frightened, as she is sometimes shown, but already aware of the great mission with which she has been entrusted. The Raphaelesque purity of her features (which nonetheless remain Andalusian in type), her distinctive meditative expression, her modestly bound hair, and her exquisitely drawn hands, together with the naturalness of her pose and the simplicity of her attire, create an unforgettable image.

As to dating, it is quite possible that Zubarán painted the *Annunciation* last of the cycle, for it presents a Florentine quality—in the refined modeling and subtle coloring in rare tones—quite different from the sharp colors and the dense, abrupt manner of the years prior to 1634. It is on this very point that Zurbarán's development is difficult to trace. While his manner changed beginning in 1634, the time of his first contact with the royal collections, and especially under the Italianizing influence of Vicente Carducho and Juan Bautista Maino in Madrid, this manner, oriented toward sfumato and gradually eliminating juxtaposed planes, produces visually the same plastic effects as the works of the earlier period: spareness and monumentality of forms, powerful relief, naturalism of figures and objects, and polychromatic unity skillfully modulated in light.

The altarpiece was still not completed by 1640, the date of the election of the new prior, Juan de Zapata, and in the absence of any record of payment, the date of the completion of the cycle remains unknown. But to judge by the work done for the sacristy of Guadalupe, whose payments extended over ten years, it may well be that Zurbarán did not execute all the compositions for Jerez within the space of one year, as the signatures on the *Adoration of the Shepherds* (cat. no. 27) and the *Circumcision* (cat. no. 29) might indicate. This would account for the differences in technique evident in these scenes from the life of Christ.

NOTES
1. Gerecht, cited in Gourdel 1952, p. 6.
2. *Statuta nova*, 1582, part I, chap. 5., no. 6; Gourdel 1952, p. 30.
3. Mâle 1932 (1972 ed.), p. 240.
4. Paleotti 1582, book I, chap. 23.
5. Agreda 1670 (1976 ed.), p. 100.
6. Molanus 1570, p. 64.
7. Pacheco 1649 (1956 ed.), II, pp. 232–33.
8. Droulers [1949], p. 129.
9. *Ibid.*, p. 44.
10. Pemán 1964, p. 103.
11. Valdivieso and Serrera 1985, no. 74.

PROVENANCE
Monastery of Nuestra Señora de la Defensión, Jerez de la Frontera (inv. 1835, p. 1); sold by José Cuesta of Seville to Baron Isidore Taylor through Antonio Mesas at Cádiz, June 26, 1837, for the sum of 40,000 reales (archives of the Real Academia de Bellas Artes de San Fernando, Madrid), royal order authorizing the sale, dated July 9, 1837 (Tormo y Monzó 1909, p. 33); Galerie Espagnole, Musée Royal au Louvre, Paris, 1838; Louis-Philippe sale, Christie's, London, May 1853, no. 157, sold to Colnaghi for the Duke of Montpensier, Palacio San Telmo, Seville; collection of the Countess of Paris, Château de Randan, Auvergne; purchased in 1904 by General de Beylié as a donation to the Musée de Peinture et de Sculpture, Grenoble.

LITERATURE
Ponz 1792 (1947 ed.), p. 1548; Ceán Bermúdez 1800, VI, p. 51; Paris, Musée du Louvre, 1838, no. 325 (1st ed.), no. 335 (4th ed.); Ford 1853; Tormo y Monzó 1909, pp. 31–32; Cascales y Muñoz 1911, p. 75; Grenoble, Musée de Peinture et de Sculpture, 1911, no. 559; Kehrer 1918, pp. 87–89; Mayer 1947, p. 338; Guinard 1949, pp. 16–20; Pemán 1950, pp. 203–27; Soria 1953, no. 137; Gaya Nuño 1958, no. 3046; Guinard 1960a, no. 31; Baticle, in Paris, Musée des Arts Décoratifs, 1963, no. 98; Pemán 1964, p. 104; Brown 1974, p. 116; Guinard and Frati 1975, no. 253; Gállego and Gudiol 1977, no. 122; Bravo 1980, p. 5; Baticle and Marinas 1981, no. 335.

EXHIBITED
Paris 1838–48, no. 325 (1st ed.), no. 335 (4th ed.); Seville 1866, no. 186; Boston 1874, no. 1; Paris 1935, no. 74; Zurich 1946, no. 31; Paris 1963, no. 98.

27.
The Adoration of the Shepherds

1638
Oil on canvas, 105 × 73 in. (267 × 185 cm)
Signed, inscribed, and dated, in a rectangular cartouche, lower left: Fran^co de Zurbaran. Philipi III Regis Pictor Faciebat 1638 a.d. [Francisco de Zurbaran, Painter to Philip III made this in 1638 A.D.]. (Presumably a fourth "I" has disappeared, because at that date the king was Philip IV.)
Musée de Peinture et de Sculpture, Grenoble

Original location: Jerez de la Frontera (Cádiz), Monastery of Nuestra Señora de la Defensión, main altarpiece, first story, right compartment
Date of contract: Not known

This type of representation of the birth of Christ, combining two separate episodes from the New Testament—the angels singing Gloria in Excelsis Deo (Luke 2:14), and the Adoration of the Shepherds (Luke 2:16–20)—is another iconographic innovation from Italy and serves, here again, to associate the earthly life of the Divine Child with the heavenly realm. Late medieval Nativity scenes had placed emphasis on the Virgin in meditative adoration before Jesus as the Son of God, but in the seventeenth century this scene had merged with that of the Adoration of the Shepherds. Already a century earlier, the image of the Virgin uncovering the Child was prevalent. Mary lifts the cloth, which prefigures the shroud in which Jesus will be laid to rest, and shows her son to the shepherds, revealing the universal mission of the Redeemer. Simple shepherds were thus the first to marvel at the vision of the Word Incarnate. The tidings

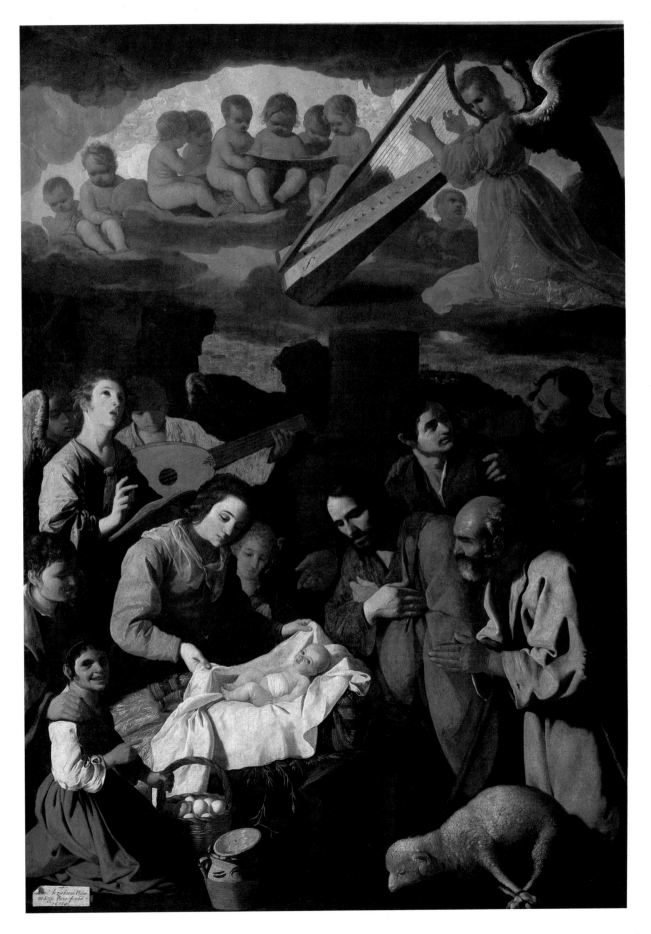

had been brought to them by an angel who, according to many of the mystic writers, especially in Spain, was Gabriel himself. "He appeared to them in human form, resplendent with light," wrote María de Agreda.[1] Zurbarán, in depicting this harp-playing angel in the same costume as the Archangel in the *Annunciation* (cat. no. 26), seems to have followed this tradition. According to María de Agreda, the Saviour's every action in the manger was accompanied by the celestial music of ten thousand angels. There is no mention of these choirs of angels in the New Testament, but many of the Church fathers recommended the imitation of the angelic life to those taking vows. Saint Basil wrote to an aspiring monk that he should, "like the cherubim, sing the praises of the Lord day and night."[2]

The mystic writers always described the birth of Christ as taking place at night, his body illuminating the darkness. With Correggio, artists began representing the Infant Jesus with a luminous body, casting its own light on the nocturnal scene; and indeed, in Zurbarán's painting, there is no other apparent source of light for the earthly scene. Unlike the more prudish Pacheco, Zurbarán chose to represent the Child's nakedness. He lavishes great care on painting the traditional domestic objects of seventeenth-century Spanish Adorations, such as may be seen already in 1603 in a work by Juan Pantoja de la Cruz.[3] The lamb with bound feet, a natural offering for shepherds, presages the Lamb of God that will be delivered over to man. The basket of eggs, which signifies fertility, is also a symbol of expiation.[4] Near the center of the painting, the column disappearing into the clouds creates a link between heaven and earth, but may also be explained by a passage from the famous *Meditations on the Life of Christ*, by the Pseudo-Bonaventure, which relates that Mary gave birth leaning against a column.[5]

The work has the same dimensions as the *Annunciation*, except that the cutouts are slightly higher, and the one on the left is 26 centimeters wide.

The *Adoration of the Shepherds* is characterized by the same quality of integration noted in the *Annunciation*, as if all the actors and accessories of the scene were interconnected in the manner of a rigorously coherent and perfectly legible puzzle. It is more tenebrist than the other three paintings in the series, but this could be taken as a sign of Zurbarán's aesthetic flexibility in meeting the requirements of an assigned subject, here a nocturnal event in which the body of the Saviour is to serve as a source of light, according to the formula in use since Correggio.

The lower half of the composition is inscribed within two large triangles fitted one inside the other;

Zurbarán liked oblique lines. The effect of depth is obtained not by linear perspective but by a scrupulous observation of volume and color. Here again, in contrast to many works of the Counter-Reformation, the Virgin and Saint Joseph occupy the greater part of the composition at the center, with the shepherds placed only to the left and right in the middle ground. Twelve years later, Ribera would accord full prominence to the shepherd on the right in his superb *Nativity* (Musée du Louvre, Paris). Zurbarán, however, presents a naturalistic rendition of the version of this theme painted by Juan de Roelas in 1602 for the Jesuit Church of Casa Profesa in Seville (now Antigua Universidad), and taken up again by Juan del Castillo in 1634–36 at the Church of Montesión, also in Seville. Zurbarán represented Mary and Joseph as common people, in modest garb and grave and simple attitudes. Only Joseph's manly beauty, the Virgin's lovely countenance, and the discreet grace of her gesture as she gently lifts the cloth on which the Child lies create a subtle contrast with the shepherds, who, despite their rusticity, are imbued with great dignity.

Zurbarán's realism derives from his desire to treat familiar, commonplace objects with veracity and compassion, and not from a wish to patronize their low estate. Thus, the pottery, the basket of eggs, the musical instruments, the coarse woolen robes of the shepherds, and the lamb's fleece are endowed with a sort of hyperreality that casts an ecstatic spell upon the beholder. Here we may see the influence of Zurbarán's Carthusian patrons, whose rule prescribed agricultural tasks, and who very likely attached considerable importance to the still-life elements.

The skill and refinement of the color harmony, in which the nocturnal effect attenuates the brilliance of the colors—mauves, greens, and ochers in perfect accord—constitute one of Zurbarán's decisive contributions to the Golden Age of Spanish painting.

NOTES
1. Agreda 1670 (1976 ed.), p. 153.
2. Migne 1844–65, col. 31448.
3. Pita Andrade 1965, p. 249.
4. Droulers [1949], p. 159.
5. Pseudo-Bonaventure (1958 ed.), p. 40.

PROVENANCE
Monastery of Nuestra Señora de la Defensión, Jerez de la Frontera (inv. 1835, p. 1); sold by José Cuesta of Seville to Baron Isidore Taylor through Antonio Mesas at Cádiz, June 26, 1837, for the sum of 40,000 reales (archives of the Real Academia de Bellas Artes de San Fernando, Madrid), royal order authorizing the sale, dated July 9, 1837 (Tormo y Monzó 1909, p. 33); Galerie Espagnole, Musée Royal au Louvre, Paris, 1838; Louis-Philippe sale, Christie's, London, May 1853, no. 159, sold to Colnaghi for the Duke of Montpensier, Palacio San Telmo, Seville; collection

of the Countess of Paris, Château de Randan, Auvergne; purchased in 1904 by General de Beylié as a donation to the Musée de Peinture et de Sculpture, Grenoble.

LITERATURE
Ponz 1792 (1947 ed.), p. 1548; Ceán Bermúdez 1800, VI, p. 51; inventory of 1835, archives of the Monastery of Nuestra Señora de la Defensión, Jerez de la Frontera (Pemán 1964, p. 103); Paris, Musée du Louvre, 1838, no. 327 (1st ed.), no. 337 (4th ed.); Ford 1853; Tormo y Monzó 1909, pp. 31–32; Cascales y Muñoz 1911, p. 75; Grenoble, Musée de Peinture et de Sculpture, 1911, no. 560; Kehrer 1918, pp. 88–89; Mayer 1947, p. 338; Guinard 1949, pp. 16–20; Pemán 1950, pp. 203–27; Soria 1953, no. 138; Gaya Nuño 1958, no. 3047; Guinard 1960a, no. 38; Baticle, in Paris, Musée des Arts Décoratifs, 1963, no. 99; Pemán 1964, p. 104; Guinard and Frati 1975, no. 250; Gállego and Gudiol 1977, no. 123; Bravo 1980, p. 5; Baticle and Marinas 1981, no. 337.

EXHIBITED
Paris 1838–48, no. 327 (1st ed.), no. 337 (4th ed.); Seville 1866, no. 179; Boston 1874, no. 2; Seville 1896, no. 26; Paris 1935, no. 73; Zurich 1946, no. 56; Paris 1963, no. 99.

28.
The Adoration of the Magi

ca. 1638–40
Oil on canvas, 104 × 69¼ in. (264 × 176 cm)
Musée de Peinture et de Sculpture, Grenoble

Original location: Jerez de la Frontera (Cádiz), Monastery of Nuestra Señora de la Defensión, main altarpiece, second story, left compartment
Date of contract: Not known

"At the sacred mystery of the Epiphany," writes Ribadeneyra, "the Holy Church celebrates that happy day when the Son of God, invested with our flesh, manifested himself to the Magi, as the first among the gentiles. . . . He wanted to be known to those who were near and far, native and foreign, shepherds and kings, simple and learned, poor and rich, Hebrew and pagan, Jew and gentile, and to unite those who were so opposed in religion by the knowledge of one God."[1] The Gospel According to Saint Matthew does not specify the number of the Magi as three, and Luther denies that those who visited the Child were kings. But because the Council of Trent condemned only those religious scenes that were in opposition to orthodoxy or were susceptible to heresy, the traditional iconography of the Adoration of the Magi was not radically transformed in the Counter-Reformation.

Zurbarán's Adoration of the Magi was placed in the left compartment of the second story of the main altar-piece and had cutouts in the upper left and right corners matching those in the Circumcision (cat. no. 29), which was in the right compartment of the second story. Its dimensions are slightly less than those of the paintings in the first story—3 centimeters in height and 9 centimeters in width.

Like most Catholic artists, Zurbarán continued to paint the Magi in sumptuous exotic costumes, one king having come from Asia, another from Africa, the third from Europe, thus emphasizing the universal character of Christ's divine revelation and redemption. Doubtless, he knew that Melchior was to be painted as an old man with white hair and a long beard, that Gaspar was supposed to be a self-assured young man, and that Balthasar was to be black and bearded, according to the Venerable Bede.[2] Although Molanus accepted the traditional Flemish representation of the three ages of man, again confirming the universality of Christ, artists appear to have abandoned this approach.[3] Zurbarán, like Velázquez in his Adoration (Museo del Prado, Madrid), shows only one old man and two middle-aged men. Both artists were inspired, in the general scheme of their compositions, by Pacheco's recommended formula. This was illustrated in the Humanae salutis monumenta, by Benito Arias Montano (Antwerp, 1571), with an engraving, reversed relative to the Velázquez and Zurbarán Adorations. As stated by María de Agreda, the Divine Child must be on his mother's lap, because "she held him always in her arms."[4]

Here again, as in the Adoration of the Shepherds (cat. no. 27), Zurbarán inscribed the group of the kneeling king, the Virgin, the Child, and Saint Joseph in a great triangle, almost dividing the composition in two. Such an arrangement is in the tradition of medieval art, but Zurbarán as usual breathes so much strength and vitality into the composition that it seems altogether different. Perhaps he had seen the engraving by Gerard Seghers dedicated to the Marqués de Santa Cruz, for the engraving is comparable in the disposition of the figures, and especially in the attitude of the Virgin and of the Child, who leans forward to touch the king.

The palette is less modulated than in the Adoration of the Shepherds; only the great lavender patch of Balthasar lends a softer note, contrasting with the gilded splendor of Melchior's brocade robe. Strangely, Gaspar is shown in armor, helmet on head, possibly to suggest the chivalrous Ferdinand III, favored in combat by the miraculous image of the Virgin at El Sotillo (see cat. no. 30).

Light from two sources (a device Zurbarán used rather frequently), with a daylight landscape in the background, enlivens the composition and creates,

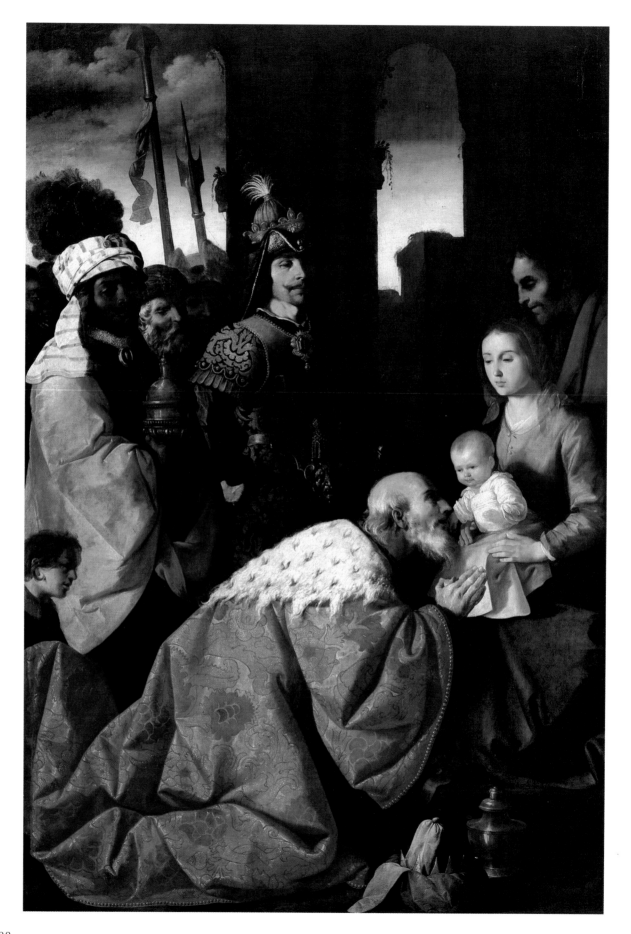

without linear perspective, the effect of depth. The Virgin, grave and lovely, and the Child, lively and engaging, provide the link between heaven and earth through their unfeigned naturalness, affirming the truth of the revelation.

NOTES

1. Ribadeneyra 1624 (1982 ed.), I, p. 116.
2. Pascal 1856, I, p. 125.
3. Molanus, cited in Pascal 1856, I, p. 123.
4. Agreda 1670 (1976 ed.), p. 161.

PROVENANCE

Monastery of Nuestra Señora de la Defensión, Jerez de la Frontera; Musée Napoléon, Paris, 1813, inv. no. 380; Real Academia de Bellas Artes de San Fernando, Madrid, 1818, no. 20; Monastery of Nuestra Señora de la Defensión, Jerez de la Frontera (inv. 1835, p. 1); sold by José Cuesta of Seville to Baron Isidore Taylor through Antonio Mesas at Cádiz, on June 26, 1837, for the sum of 40,000 reales (archives of the Real Academia de Bellas Artes de San Fernando, Madrid), royal order authorizing the sale, dated July 9, 1837 (Tormo y Monzó 1909, p. 33); Galerie Espagnole, Musée Royal au Louvre, Paris, 1838; Louis-Philippe sale, Christie's, London, May 1853, no. 160, sold to Colnaghi for the Duke of Montpensier, Palacio San Telmo, Seville; collection of the Countess of Paris, Château de Randan, Auvergne; purchased in 1904 by General de Beylié as a donation to the Musée de Peinture et de Sculpture, Grenoble.

LITERATURE

Ponz 1792 (1947 ed.), p. 1548; Ceán Bermúdez 1800, VI, p. 51; inventory of 1835, archives of the Monastery of Nuestra Señora de la Defensión, Jerez de la Frontera (Pemán 1964, p. 103); Paris, Museé du Louvre, 1838, no. 328 (1st ed.), no. 338 (4th ed.); Ford 1853; Tormo y Monzó 1909, pp. 31–32; Cascales y Muñoz 1911, p. 75; Grenoble, Musée de Peinture et de Sculpture, 1911, no. 561; Kehrer 1918, pp. 89–90; Mayer 1947, p. 338; Guinard 1949, pp. 16–20; Pemán 1950, pp. 203–27; Soria 1953, no. 139; Gaya Nuño 1958, no. 3048; Guinard 1960a, no. 40; Baticle, in Paris, Musée des Arts Décoratifs, 1963, no. 100; Pemán 1964, p. 104; Brown 1974, pp. 118–20; Guinard and Frati 1975, no. 252; Gállego and Gudiol 1977, no. 125; Baticle and Marinas 1981, no. 338.

EXHIBITED

Paris 1813, no. 380; Paris 1838–48, no. 328 (1st ed.), no. 338 (4th ed.); Seville 1866, no. 189; Boston 1874, no. 3; Paris 1935, no. 75; Zurich 1946, no. 57; Paris 1963, no. 100.

29.
The Circumcision

1639
Oil on canvas, 104 × 69½ in. (264 × 176 cm)
Signed and dated, bottom center: Fran[co] de Zurbaran faci / 1639
Musée de Peinture et de Sculpture, Grenoble

Original location: Jerez de la Frontera (Cádiz), Monastery of Nuestra Señora de la Defensión, main altarpiece, second story, right compartment
Date of contract: Not known

The circumcision, a rite of initiation practiced among many ancient peoples, was performed by Jews on the eighth day following the birth of a male child, and was associated with the naming of the child by his father. It testified to the male child's membership in the people of the Covenant and to his right to participate in their worship. Catholic theology regards circumcision, as practiced up to the time recorded in the Old Testament, as a prefiguration, until the ministry of Saint Paul, of Christian baptism (Romans 2:25–29). In the New Testament, Mary, the mother, and Joseph, the father by right of marriage, submit the Christ Child to the prescription of the law, and Joseph gives him the name Jesus (Matthew 1:21; Luke 2:21).

Artists did not begin to represent the rite of circumcision (which may have seemed barbaric to Christians) until the mystic writers began to emphasize the sufferings of the Infant Christ and the first spilling of his blood for the redemption of sinners. Most exegetes of the circumcision of Christ supposed it to have taken place in the very manger in Bethlehem where Christ was born, or at its entrance, with Joseph and even Mary as officiants. Artists preferred to place the scene in the synagogue, usually with both parents present. By the seventeenth century, Paleotti's dictates concerning decorum and the ever increasing pomp of the Catholic Church began to accentuate the distance separating Creator from creature and Eternal from temporal, and the temple became a more suitable locale than the manger.

In the altarpiece, the *Circumcision* was placed in the right compartment of the second story. It has the same dimensions and cutouts in the upper left and right corners as the *Adoration of the Magi* (cat. no. 28).

Despite the recommendations of Pacheco to place the scene in the manger, Zurbarán was directed by the Carthusians to follow the interpretation set forth by Cristóbal de Fonseca, an Augustinian in Toledo whose writings, widely used in church services, were well known. His most popular work, *Primera parte*

José de Arce. *The Circumcision*, ca. 1641. Polychromed and gilded wood. Main altarpiece, Church of San Miguel, Jerez de la Frontera

cal figure is to be found in a bas-relief of the same theme by José de Arce in the altarpiece of the Church of San Miguel, in Jerez, for which the sculptor, subcontracted from Martínez Montañés in 1641, made panels of scenes from the life of Christ. This was not the only case where figures painted by Zurbarán, so close to sculpture in the round, served as models for sculptors. In Jerez itself, the façade of the church, rebuilt between 1660 and 1667, displays striking examples of such quotations, notably the statues of the founding saints of the order, which are sometimes, in their poses, virtual imitations of the figures in the *sagrario* series done by Zurbarán for the charterhouse church.

The palette is less brilliant in the *Circumcision* than in the other paintings, and plays upon whites, grays, and greens, with some accents of red and ocher. The strongly lighted portico in the background provides effects of penumbra and backlighting, in which Zurbarán became particularly interested after his return from Madrid, and which he must have admired in the work of Velázquez.

PROVENANCE

Monastery of Nuestra Señora de la Defensión, Jerez de la Frontera; Musée Napoléon, Paris, 1813, inv. no. 381; Real Academia de Bellas Artes de San Fernando, Madrid, 1818, no. 3; Monastery of Nuestra Señora de la Defensión, Jerez de la Frontera (inv. 1835, p. 1); sold by José Cuesta of Seville to Baron Isidore Taylor through Antonio Mesas at Cádiz, June 26, 1837, for the sum of 80,000 reales (archives of the Real Academia de Bellas Artes de San Fernando, Madrid), royal order authorizing the sale, dated July 9, 1837 (Tormo y Monzó 1909, p. 33); Galerie Espagnole, Musée Royal au Louvre, Paris, 1838; Louis-Philippe sale,

de la vida de Christo Señor Nuestro (Toledo, 1596), recounts that Mary and Joseph, aware of the impoverishment of the manger, "determined that Saint Joseph should bring the Child to the Synagogue . . . and present Him to a priest, so that the Divine Will might be done" (fol. 167). The same text, describing the ceremony in vivid terms, mentions the attendants' astonishment at the Child's beauty.

Zurbarán represents the Child on a sort of altar, evoking the sacrifice of the Mass. A high priest in sumptuous sacerdotal vestments performs the ritual operation, while Joseph is relegated to the right background. As in the *Adoration of the Shepherds* (cat. no. 27), a boy turns to the viewer, inviting him to enter the scene. He is a young page bearing a costly ewer on a tray, perhaps an allusion to the holy water of the baptism. Near the center of the picture, above the Child, a column, more imposing here than in the earlier paintings of the commission, confirms that Christ, at once man and God, forms the link between heaven and earth.

The boy bearing the ewer must have attracted the attention of contemporary artists. An almost identi-

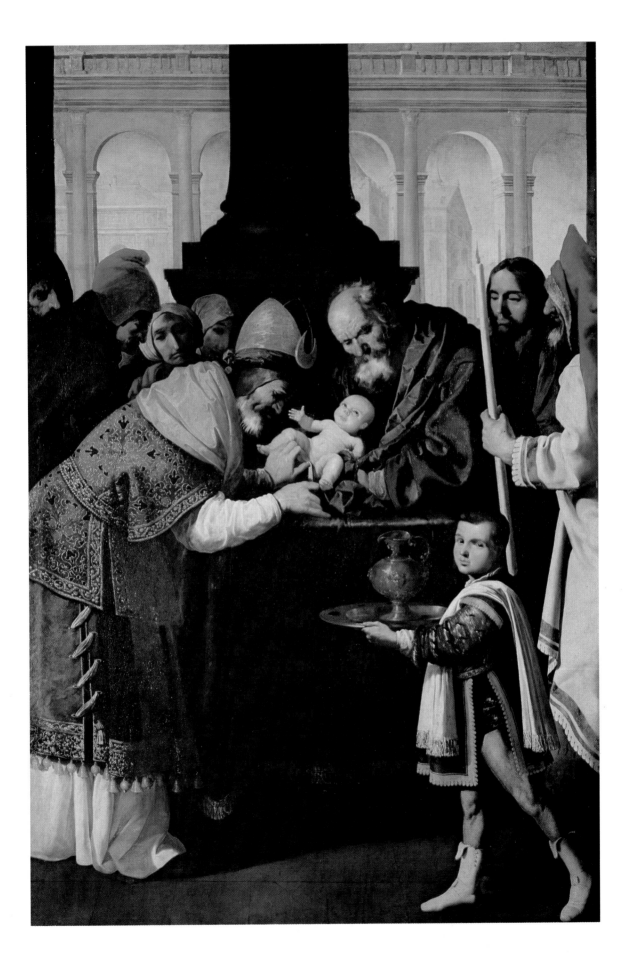

Christie's, London, May 1853, no. 140, sold to Colnaghi for the Duke of Montpensier, Palacio San Telmo, Seville; collection of the Countess of Paris, Château de Randan, Auvergne; purchased in 1904 by General de Beylié as a donation to the Musée de Peinture et de Sculpture, Grenoble.

LITERATURE
Ponz 1792 (1947 ed.), p. 1548; Ceán Bermúdez 1800, VI, p. 51; inventory of 1835, archives of the Monastery of Nuestra Señora de la Defensión, Jerez de la Frontera (Pemán 1964, p. 103); Paris, Museé du Louvre, 1838, no. 329 (1st ed.), no. 339 (4th ed.); Ford 1853; Tormo y Monzó 1909, pp. 31–32; Cascales y Muñoz 1911, p. 75; Grenoble, Musée de Peinture et de Sculpture, 1911, no. 562; Kehrer 1918, p. 90; Mayer 1947, p. 338; Guinard 1949, pp. 16–20; Pemán 1950, pp. 203–27; Soria 1953, no. 140; Gaya Nuño 1958, no. 3049; Guinard 1960a, no. 42; Baticle, in Paris, Musée des Arts Décoratifs, 1963, no. 101; Pemán 1964, p. 104; Guinard and Frati 1975, no. 255; Gállego and Gudiol 1977, no. 124; Baticle and Marinas 1981, no. 339.

EXHIBITED
Paris 1813, no. 381; Paris 1838–48, no. 329 (1st ed.), no. 339 (4th ed.); Seville 1866, no. 174; Boston 1874, no. 4; Paris 1935, no. 76; Zurich 1946, no. 58; Paris 1963, no. 101.

30.
The Battle between Christians and Moors at El Sotillo

Before 1640
Oil on canvas, 131⅞ × 75¼ in. (335 × 191 cm)
The Metropolitan Museum of Art, New York. Kretschmar Fund, 1920

Original location: Jerez de la Frontera (Cádiz), Monastery of Nuestra Señora de la Defensión, main altarpiece, first story, center compartment
Date of contract: Not known

The scene represented by Zurbarán in the *Battle between Christians and Moors at El Sotillo* commemorates the miraculous intervention of the Virgin that enabled Christian forces to escape an ambush by Moorish knights. A detailed description of this battle appears in a history of Jerez, *Santos Honorio, Eutichio, Estevan, patronos de Xerez de la Frontera, nombre, sitio, antigüedad de la ciudad* (Seville, 1617), written by Martín de Roa early in the seventeenth century. Roa, a Jesuit author of numerous tracts often consulted by Pacheco, relates that the Carthusian Monastery of Santa María de la Defensión was founded in El Sotillo (the Little Grove), and was so named because a hermitage had been built there in memory of a battle won over the Moors by the knights of Jerez, supported by the protection of the Virgin. The Moors, hiding near a river

in an olive grove and concealed by the darkness of the night, were preparing to fall upon the Christian knights. Suddenly, the sky was aglow with a great light, revealing the ambush to the Christians. While the army of Jerez decimated the Moors, the Christians "wondered where the light came from, and saw that it was from the Most Holy Virgin." A hermitage was built on the spot, "and for a memorial they painted [the Virgin's] image in the midst of a resplendent cloud, with the nobles of Jerez, armed and on horseback, their faces turned toward the thicket where the Moors were discovered."[1] Roa states that this painting still existed at the time he was writing and that it was worshiped with great devotion by the people. He adds that the ancient hermitage was made part of the monastery, though it remained outside the enclosure so that it could be worshiped before battle. Ferdinand III was said thus to have won many victories.

If Roa's information is accurate, the ambush at El Sotillo took place at the time of the first reconquest of Jerez, in 1248. Jerez continued, however, to be ravaged by the Moors until the end of the reign of Pedro the Cruel in 1369. Esteban Rallón Mercado, who wrote the *Historia de Xerez de la Frontera* before 1640, places the miraculous intervention of the Virgin at El Sotillo in 1368, the year the city was finally recaptured. Rallón, like Roa, describes the fresco painted "on the chapel wall outside the enclosure" and mentions its state of deterioration.

While the date of the battle remains uncertain, the miracle itself was well known in the seventeenth century and could still be seen depicted in the hermitage painting. To judge by contemporary descriptions, it is quite possible that Zurbarán was inspired directly by that image for his own grand composition.

The *Battle between Christians and Moors at El Sotillo* was originally situated in the center of the first story of the main altarpiece. It was later removed, though it is not known at what date. However, the presence of two altarpieces behind the lay brothers' screen in the front of the church (they can still be seen there today), which held this painting and the *Virgin of the Rosary with Carthusians* (Muzeum Narodowe, Poznań) and was mentioned in the inventory of 1835, raises several questions. As noted earlier, it would appear that the niches already existed, and that Zurbarán executed the *Virgin of the Rosary* as a pendant to the *Battle between Christians and Moors*. It has been supposed that the *Immaculate Conception* in Edinburgh (cat. no. 33) was originally a pendant to the Poznań painting, but this seems hardly possible, since the former measures 74 centimeters more in height than the latter and is rounded to a different shape at the top. Besides, the *protocolo* of 1640 mentions an *Assumption of*

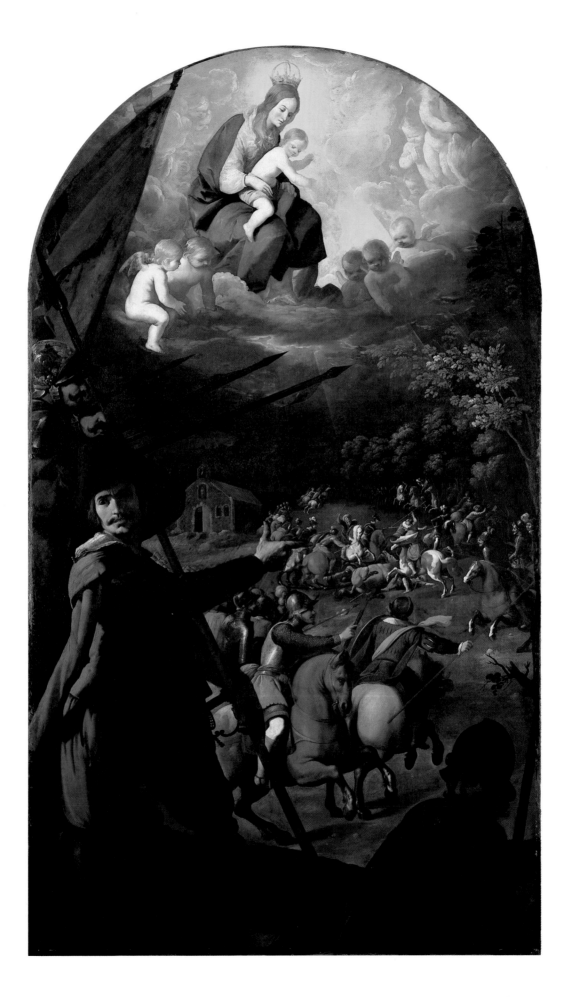

had the opportunity in Madrid, in the winter of 1634–35, to admire that work by his compatriot. But for the verticality of the lances in the Velázquez painting Zurbarán substitutes his own version, in which the long staves are placed at oblique angles, forming whole series of triangles that occupy, from the top to the bottom of the canvas, a third of the composition, creating an extraordinary geometrical effect. In the sky, the enchanting angels surrounding the Virgin and Child are reminiscent of those by Carlo Saraceni. Recent restoration has revealed the beautiful transparency of tones and the effects of shade beneath the trees. Zurbarán in this imaginary landscape shows himself to be a sensitive and original landscape artist.

Lay brothers' choir, Monastery of Nuestra Señora de la Defensión, Jerez de la Frontera. Located behind the screen are the two altars where Zurbarán's *Battle between Christians and Moors at El Sotillo* and the *Virgin of the Rosary with Carthusians* were displayed in the nineteenth century.

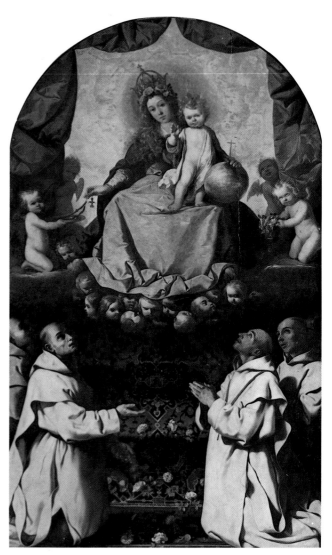

Francisco de Zurbarán. *Virgin of the Rosary with Carthusians.* Oil on canvas, 10 ft. 8 in. × 6 ft. 2¾ in. (325 × 190 cm). Muzeum Narodowe, Poznań

the Virgin in the main chapel, and the inventory of 1835 includes a *Conception* in the altarpiece of the chapter hall. Lacking more specific information, we can only conjecture.

The representation of the subject is most interesting. Zurbarán monumentalizes the composition, conceiving it as in a sort of grand picture book in which the great pikeman at the left begins the tale by pointing to the battle below, thus enabling the artist to render more dramatic the intervention of the Virgin in the upper register. Soria's assumption that the scene was taken from an engraving by Schelte à Bolswert is hardly convincing, for other models can be found in contemporary Spanish art.[2] On the other hand, it is apparent that the pikeman was inspired by the harquebusier at the extreme left in Velázquez's *Surrender of Breda* (Museo del Prado, Madrid), a figure that, like Zurbarán's soldier, faces the viewer, wears a large hat, and stands with legs apart; indeed, Zurbarán

NOTES
1. Roa 1617, fol. 146.
2. Soria 1953, p. 165.

PROVENANCE
Monastery of Nuestra Señora de la Defensión, Jerez de la Frontera; Musée Napoléon, Paris, 1813, inv. no. 349; Real Academia de San Fernando, Madrid, 1818, no. 81; Monastery of Nuestra Señora de la Defensión, Jerez de la Frontera (inv. 1835, p. 3); sold by José Cuesta of Seville to Baron Isidore Taylor through Antonio Mesas at Cádiz, June 26, 1837, for the sum of 40,000 reales (archives of the Real Academia de San Fernando, Madrid), royal order authorizing the sale, dated July 9, 1837 (Tormo y Monzó 1909, p. 33); Galerie Espagnole, Musée Royal au Louvre, Paris, 1838; Louis-Philippe sale, Christie's, London, May 1853, no. 405 ("the picture of the day"), for £160, to Farrer for Henry Labouchère (later Baron Taunton), Stoke (near Windsor); collection of Mary Dorothy Labouchère (later Mrs. Edward James Stanley), Cross Hall, Lancashire, and Quantock Lodge, Bridgwater, Somerset, 1869; collection of Captain R. Langton Douglas, London, 1920; acquired by The Metropolitan Museum of Art, New York, in 1920.

LITERATURE
Rallón Mercado, ms. before 1640 (Pemán 1950, p. 226); Gutiérrez, ms. 1787 (1886 ed.), pp. 231–32; Ponz 1792 (1947 ed.), p. 1549; Ceán Bermúdez 1800, VI, p. 51; inventory of 1835, archives of the Monastery of Nuestra Señora de la Defensión, Jerez de la Frontera (Pemán 1964, p. 103); Paris, Museé du Louvre, 1838, no. 355 (1st ed.), no. 365 (4th ed.); Ford 1853; Romero de Torres 1908, p. 100; Tormo y Monzó 1909, pp. 31–32; Cascales y Muñoz 1911, pp. 72, 88, 89; Cabello Lapiedra 1918, p. 242; Kehrer 1918, pp. 71ff; Wehle 1920, pp. 242–45; A. L. Mayer, letter of 1921, archives of The Metropolitan Museum of Art, New York (identifies this work as no. 355 of the Galerie Espagnole); Gutiérrez de Quijano y López 1924, p. 40; Beroqui 1932, p. 97; Wehle, in New York, Metropolitan Museum of Art, 1940, p. 235; Soria 1944a, p. 48; Soria 1948b, p. 255; Guinard 1949, pp. 16–20; Pemán 1950, pp. 203–27; Soria 1953, no. 133; Gaya Nuño 1958, no. 3044; Guinard 1960a, no. 570; Guinard 1961, p. 369; Pemán 1961b, pp. 284–85; Torres Martín 1963, no. 195; Caturla and Angulo Iñiguez, in Madrid, Casón del Buen Retiro, 1964, pp. 42–43, 70–75; Pemán 1964, p. 103; Lipschutz 1972, pp. 125, 133, 225, 319; Brown 1974, p. 114; Salas 1974, pp. 117–18, 124–27; Guinard and Frati 1975, no. 251; Gállego and Gudiol 1977, no. 126; Baticle and Marinas 1981, no. 365.

31.
Saint John the Baptist

Oil on canvas, 24 × 31¾ in. (61 × 80.8 cm)
Museo de Cádiz

Original location: Jerez de la Frontera (Cádiz), Monastery of Nuestra Señora de la Defensión, main altarpiece, upper story, left compartment (?)
Location before 1800 according to early sources: Ponz 1792 and Ceán Bermúdez 1800 both mention the altarpiece in the monastery
Date of contract: Not known

Saint Bruno and his first six followers established the Carthusian monastery near Grenoble close to the date of the feast of Saint John the Baptist, which falls on June 24; hence their choice of the Precursor of Christ as their patron saint. A man of the wilderness and a great penitent, Saint John possessed a character that was austere, self-effacing, and graced with simplicity. Purified and strengthened by solitude, he humbly stepped aside to make way for the Saviour. For the Carthusians, he personified the ideal spiritual son of the Virgin, the first patron of their order. This double patronage is expressed in the profession of faith recited by the members of the Order of Saint Bruno.

Zurbarán's *Saint John the Baptist*, like the *Saint Lawrence* (cat. no. 32), was originally on the main altarpiece of the church of the Carthusian monastery at Jerez. The recorded descriptions of the disposition of these paintings on the altarpiece are not as precise as those of the four scenes from the life of Christ (cat. nos. 26–29), so it is difficult to know whether they were in fact beneath the attic, as stated by both Guinard and Pemán.[1] Considering their small dimensions, it seems odd that they would have surmounted the principal compositions.

Zurbarán here succeeds in imparting in a small painting great expressive force. The Baptist is shown in the wilderness, seated and visible down to his knees. The model is slightly older than in the version in the Cathedral of Seville, and stronger musculature is evident even though the figure is more fully clothed. The head is bowed and silhouetted against the sky, and the drawn face, half-shaded and in profile, displays the traces of self-inflicted privations; the tense and grave expression owes much to the *Saint John the Baptist* sculpted by Alonso Cano in 1634 (Güell collection, Barcelona).

The composition is simple and effective, constructed on diagonals like the *Saint Lawrence*, the handle of the grille being replaced here by Saint John's emblem, the staff surmounted by a cross. The Baptist, however, is lighted from behind and placed in a rocky setting, while Saint Lawrence is seen in the full light of an open landscape. The paintings were placed on the left and the right side of the altarpiece, so that the two figures faced inward.

Here again, Zurbarán displays a rare ability to unite the physicality of a figure—the vigor of his features and the forms of his body—with the intense spirituality that motivates him. It is deeply moving to behold the meditative expression of Saint John as he places his left hand in a sign of acceptance on the head of the lamb—an allusion to the Lamb of God, who will "take away the sins of the world"—and indicates with his

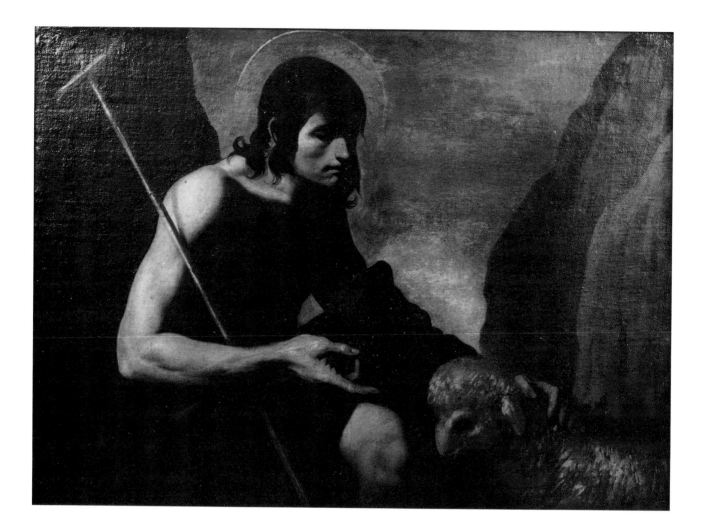

right hand the mission entrusted to him by God. Unlike painters of theatrical religiosity, Zurbarán does not directly address the faithful: he asks them not to participate in the miracle, but rather to attend it.

NOTE
1. Guinard 1960a, no. 135; Pemán 1964, p. 103.

PROVENANCE
Monastery of Nuestra Señora de la Defensión, Jerez de la Frontera (inv. 1835, p. 1); Museo Provincial de Bellas Artes, Cádiz, 1852.

LITERATURE
Gutiérrez, ms. 1787 (1886 ed.), pp. 231–32; Ponz 1792 (1947 ed.), p. 1548; Ceán Bermúdez 1800, VI, p. 51; inventory of 1835, ar-chives of the Monastery of Nuestra Señora de la Defensión, Jerez de la Frontera (Pemán 1964, p. 103); Romero de Torres 1908, p. 100; Cascales y Muñoz 1911, p. 75; Kehrer 1918, p. 75; Guinard 1949, pp. 16–20; Pemán 1950, pp. 220–21; Pemán, in Cádiz, Museo Provincial de Bellas Artes, 1952, p. 59; Soria 1953, no. 136; Guinard 1960a, no. 226; Torres Martín 1963, no. 200; Madrid, Casón del Buen Retiro, 1964, no. 47; Pemán, in Cádiz, Museo Provincial de Bellas Artes, 1964, no. 67; Brown 1974, p. 122; Guinard and Frati 1975, no. 257; Gállego and Gudiol 1977, no. 133.

EXHIBITED
Granada 1953, no. 35; Madrid 1964–65, no. 47.

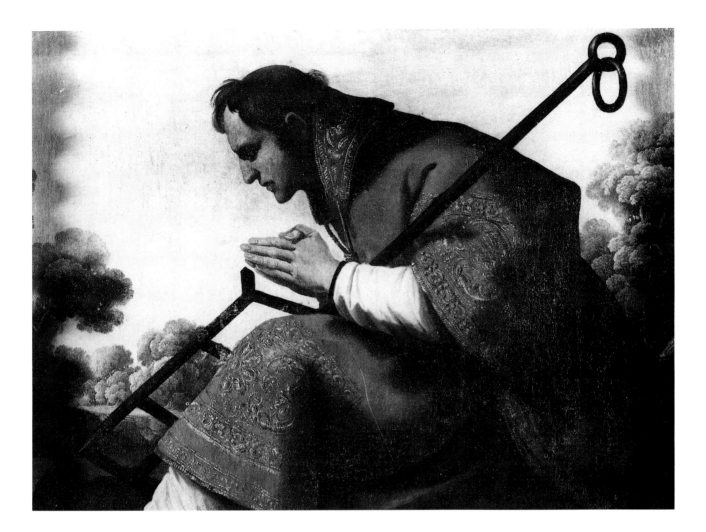

32.
Saint Lawrence

Oil on canvas, 24 × 31¾ in. (61 × 80.8 cm)
Museo de Cádiz

Original location: Jerez de la Frontera (Cádiz), Monastery of
Nuestra Señora de la Defensión, main altarpiece, upper story,
right compartment (?)
Location before 1808 according to early sources: Ponz 1792
and Ceán Bermúdez 1800 both mention the altarpiece in
the monastery
Date of contract: Not known

The tenth of August is dedicated to the memory of
Saint Lawrence, one of the most famous martyrs of
the third century. A Spanish deacon, Lawrence was
condemned to perish by fire during the persecutions
of Valerian, at the time of the decline of the pagan
world. His martyrdom was described by most of the
Roman fathers, and his feast day is surrounded by
solemn ceremonies, including a vigil, an octave, spe-
cial prayers, and Masses. In a famous sermon, Saint
Maximus ranked him as equal to the Apostles.[1] As
for the Carthusians, they commemorated this great
martyr with as much pomp as they did the Apostles
or the Evangelists, who were represented on the
same altarpiece.[2] As a symbol of the triumph of
Christianity over paganism, Saint Lawrence was an
obvious subject for an altarpiece illustrating the vic-
tory of the Christians over the Moors.

A native of Huesca, in the province of Aragon, Saint Lawrence was appointed Archdeacon of Rome by Pope Sixtus II and given the responsibility of administering the Church treasury and providing alms to the poor. When the pontiff was seized by the Romans, Lawrence was summoned by the Roman prefect to surrender the property in his trust, but instead of obeying he immediately distributed it among the poor. Enraged, the prefect condemned the young archdeacon to torture; Lawrence accepted with serenity. The martyr was finally bound to a grille, which was placed over hot coals, and burned alive; he died August 10, in the year 258. (This account of his martyrdom is often discounted by modern historians.)

The popular Spanish saint is shown with his hands joined, bowing toward the Christ on the altarpiece as if offering his martyrdom, which is evoked by the iron grille. He wears, over a white surplice, a deacon's dalmatic, sumptuous and red—the liturgical color of martyrdom.

By representing the saint seated in profile, with his upper body leaning forward, Zurbarán skillfully managed to include nearly the entire figure in the picture. Part of the grille is visible behind the figure, its handle cleverly positioned along a diagonal.

Like the *Saint John the Baptist*, the *Saint Lawrence* possesses great monumentality, in spite of its small scale. The aquiline profile is set against an open sky, which brings out the superb bone structure of the face, a technique borrowed from Velázquez, who often reworked dark contours with the lighter tones of the background. In this way, Zurbarán was able to accentuate the saint's concentrated and intensely mystical expression. The handling of the richly embroidered dalmatic, in warm, deep reds heightened with gold, makes palpable the thickness and weight of the material. The only light area is the sleeve of the white surplice, which gives emphasis to the carefully joined hands. Here again, Zurbarán shows himself to be a faithful and masterly interpreter of religious sentiment in seventeenth-century Spain. His naturalistic treatment of sacred figures nearly always serves to underscore the spiritual conviction of those he portrays. It is this fervor combined with naturalism that constitutes one of Zurbarán's greatest accomplishments.

NOTES
1. Ribadeneyra 1624 (1984 ed.), VIII, p. 176.
2. Pemán 1950, p. 222.

PROVENANCE
Monastery of Nuestra Señora de la Defensión, Jerez de la Frontera (inv. 1835, p. 1); Museo Provincial de Bellas Artes, Cádiz, 1852.

LITERATURE
Gutiérrez, ms. 1787 (1886 ed.), pp. 231–32; Ponz 1792 (1947 ed.), p. 1548; Ceán Bermúdez 1800, VI, p. 51; inventory of 1835, archives of the Monastery of Nuestra Señora de la Defensión, Jerez de la Frontera (Pemán 1964, p. 103); Romero de Torres 1908, p. 100; Cascales y Muñoz 1911, p. 75; Kehrer 1918, pp. 89–90; Mayer 1947, p. 338; Guinard 1949, pp. 16–20; Pemán 1950, pp. 220–21; Pemán, in Cádiz, Museo Provincial de Bellas Artes, 1952, no. 66; Soria 1953, no. 135; Guinard 1960a, no. 135; Torres Martín 1963, no. 199; Pemán, in Cádiz, Museo Provincial de Bellas Artes, 1964, no. 66; Guinard and Frati 1975, no. 256; Gállego and Gudiol 1977, no. 132.

EXHIBITED
Madrid 1905, no. 4; Madrid 1964–65, no. 46; Florence 1986, no. 52.

33.
The Virgin of the Immaculate Conception with Saints Anne and Joachim

ca. 1639–40
Oil on canvas, 98⅞ × 67¾ in. (251 × 172 cm)
National Gallery of Scotland, Edinburgh

Original location: Jerez de la Frontera (Cádiz), Monastery of Nuestra Señora de la Defensión (?)
Date of contract: Not known

EXHIBITED IN PARIS ONLY

From its earliest years, the Carthusian Order celebrated four great solemnities of the Virgin Mary: the Annunciation, the Nativity, the Purification of the Christian Temple, and the Assumption. In 1332, the Carthusian Monastery of Saint-Omer, in the diocese of Arras, France, was authorized to celebrate the feast of the conception of Mary, and the following year the authorization was extended to the entire order. In the fifteenth century Denys de Lewis, known as Denys the Carthusian, in his writings defined the essential role of the Virgin. His Mariological work anticipated the great thesis of the Immaculate Conception, and after him many Carthusians became champions of the concept of the spotless Virgin.[1]

Beginning in 1494, a major work by the German humanist Tritenheim on Saint Anne, the mother of the Virgin, had given a special impetus to the cult of Saint Anne. In the next century, in 1568, following the Council of Trent, Pope Pius V, in an effort to correct factual inaccuracy and to rid art, liturgy, and popular belief of apocryphal tales, suppressed the feast of Saint Anne, and four years later he removed from the Breviary the Office of Saint Joachim, the father

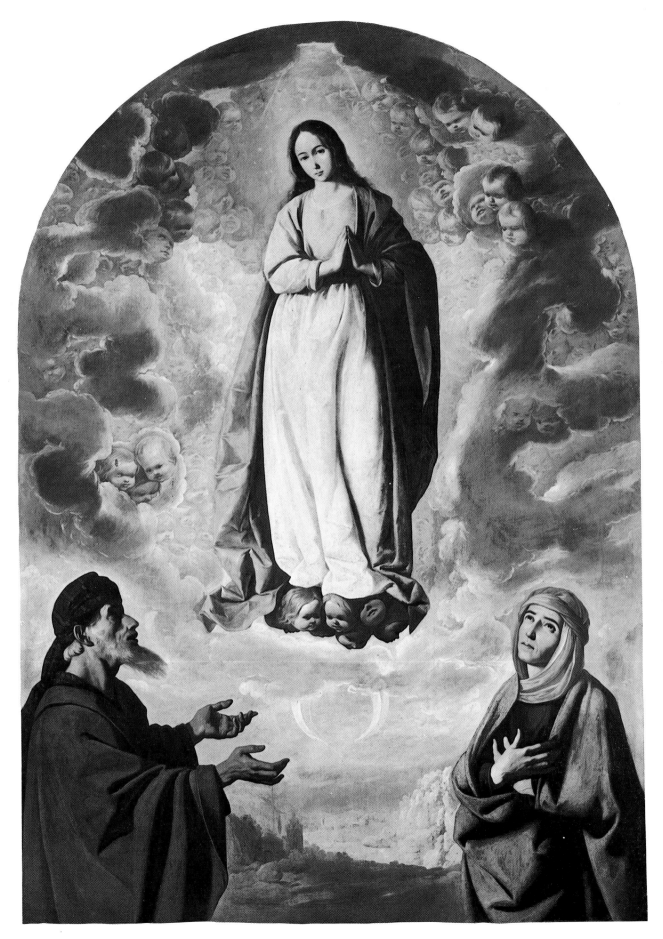

of the Virgin;[2] simple believers were shocked by these decisions and little inclined to renounce the marvelous tales.

After the rigorous Pius V, more conciliatory theologians decided to accept some of the popular beliefs in which the faith of the people was so profoundly rooted, arguing that such beliefs, although lacking historical proof, could do no harm either to the faith or to public morality. Thus, in 1584, Gregory XIII reinstituted both the feast of Saint Anne and the feast of Saint Joachim, which the Carthusians had in fact never ceased to observe.

The scheme of Zurbarán's *Virgin of the Immaculate Conception with Saints Anne and Joachim*, a pyramidal composition with three figures, was no doubt chosen by his patrons to follow the tradition, which had existed since the end of the sixteenth century, of depicting the Virgin Immaculate with two donors. Federico Zuccaro had used this composition in a painting for the Franciscan church in Pesaro, and for the Franciscan church in Urbino, Federico Barocci had painted a *Virgin of the Immaculate Conception* of the same type, which was then engraved by Thomassin in 1591. By about 1645, the image of the Virgin Immaculate was sufficiently well known that it was no longer necessary to include her attributes, and here are only barely sketched into the landscape.

Most of Zurbarán's canvases representing the Virgin of the Immaculate Conception do not exceed a height of 2 meters. The exceptions are the painting in the Cathedral of Seville, which is nearly 3 meters high, and the present painting, now in Edinburgh, which is slightly over 2½ meters high; this work is also the only one of his representations of the theme that is rounded at the top.

The Edinburgh canvas has a special beauty. The classical motif of the central figure raised aloft and adored by two saints, depicted in half-length, takes on a new life with Zurbarán—as always, because of the simplicity of the composition, the naturalness of the models, and the monumentality of the forms.

This painting was included in the Galerie Espagnole of Louis-Philippe in 1838. However, unlike the compositions of the main altarpiece of the church at Jerez, the *Virgin of the Immaculate Conception with Saints Anne and Joachim* is only reputed to have come from the same monastery; no trace of payment or any other document has been found as confirmation. Guinard, following Pemán, was convinced that the painting was in one of the two altars behind the screen of the lay brothers' choir, but Brigstocke has argued that, in the absence of any concrete proof, the reasons advanced by Guinard are too subjective to be considered.[3]

As noted earlier, the *Battle between Christians and Moors at El Sotillo* (cat. no. 30), which was removed from the main altarpiece, was installed in one of these two altars as a pendant to the *Virgin of the Rosary with Carthusians*, now in Poznań (see illus. on page 194): it has the same dimensions and is similarly rounded at the top. The Edinburgh canvas is considerably smaller; nonetheless, it is not impossible that it was part of the ensemble Zurbarán painted for Jerez, because the *protocolo* of 1640 indicates that under the priorate of Sebastián de la Cruz, in 1639, an *Assumption of Our Lady* was painted for the main chapel or for the sacristy (the wording is not clear).[4] Moreover, according to an inventory of 1835, in the lay brothers' choir there was an altarpiece on the altar with a frame approximately 3 × 2 varas (about 252 × 168 cm) without a canvas,[5] that is to say, a picture frame without a painting in it that was exactly the dimensions of the Edinburgh canvas. Obviously, however, these measurements do not in themselves provide sufficient proof of this version of the *Virgin of the Immaculate Conception*'s having been in one of the altarpieces. It is necessary to look for more conclusive evidence in the archives of the region of Jerez. The fact, in association with their devotion to the Immaculate Conception, that the Carthusians never ceased to honor Saints Anne and Joachim offers further support for a possible Carthusian origin for this work.

The style and treatment of the Edinburgh canvas are in accord with those of paintings done in 1639 and 1640. Compared with paintings from the main altarpiece, the palette is markedly lighter, and the forms, though similar, are more supple. To be noted is a close resemblance between the features of Mary in the Edinburgh *Virgin of the Immaculate Conception* and those of Mary in the *Virgin of Mercy of Las Cuevas* (cat. no. 38), also painted for a Carthusian monastery. The former is depicted as younger than the latter, but the shape of the face and the position of the head, and the nose, mouth, and eyebrows, and, above all, the melancholy expression of the eyes offer a singular analogy.

The face of Saint Anne has its own special appeal, because, for one thing, the depiction of mature women is rare in Zurbarán's work. The position of the hands recalls that of the angel in the *Annunciation* (cat. no. 26). The Virgin wears a pale pink tunic that harmonizes delicately with the wide blue mantle. The cloudlike angels around her are not yet completely golden as they will be later on. The *Virgin of the Immaculate Conception with Saints Anne and Joachim* is an important work in that it marks the transition between Zurbarán's tenebrist phase and his use of a new and lighter palette.

NOTES
1. Gourdel 1952, pp. 14, 22.
2. Stubbe 1958, p. 129.
3. Pemán 1950, pp. 218–19; Guinard 1960a, p. 200 and no. 11;
Brigstocke, in Edinburgh, National Gallery of Scotland, 1978,
p. 196.
4. *Protocolo* of 1640; excerpt provided to the author by Father
Luis Bravo, 1986.
5. Inventory of 1835, not published in its entirety, but excerpted
in Pemán 1964, p. 103.

PROVENANCE
Monastery of Nuestra Señora de la Defensión, Jerez de la Frontera(?);
Galerie Espagnole, Musée Royal au Louvre, Paris, 1838; Louis-
Philippe sale, Christie's, London, May 1853, no. 143, sold for
£90, to Hickman for Lord Elcho; acquired by the National Gallery
of Scotland, Edinburgh, in 1859.

LITERATURE
Ponz 1792 (1947 ed.), p. 1549; Ceán Bermúdez 1800, VI, p. 51 (?);
Paris, Musée du Louvre, 1838, no. 332 (1st ed.), no. 342 (4th ed.);
Cascales y Muñoz 1911, pl. 29; Pemán 1950, pp. 218–19; Soria
1953, no. 143; Gaya Nuño 1958, no. 3050; Guinard 1960a, no. 11;
Torres Martín 1963, no. 196; Guinard and Frati 1975, no. 272;
Gállego and Gudiol 1977, no. 144; Brigstocke, in Edinburgh,
National Gallery of Scotland, 1978, no. 340; Baticle and Marinas
1981, no. 342.

EXHIBITED
Manchester 1857, no. 793; Edinburgh 1951, no. 41.

THE CHURCH OF NUESTRA SEÑORA DE LA GRANADA, LLERENA

The city of Llerena (Badajoz) was seized from the Moors in the mid-thirteenth century by the Knights of Santiago. In the fifteenth century, it became the seat of a priory of that military order, exercising jurisdiction over many villages; and it prospered in the sixteenth century, by which time many monasteries had been founded. Zurbarán lived in Llerena from 1617 to 1625, and was twice married there.

Alongside the family house, La Casa Morales, on the Plaza Mayor, was the parish church of Nuestra Señora de la Granada, an imposing medieval edifice that was re-modeled several times in the course of the sixteenth and eighteenth centuries. To re-place the high altar, which had fallen into ruin, Zurbarán was commissioned in 1631 to provide a new altarpiece. Documents in the parish and municipal archives give an indication of how impressive this altarpiece was in the seventeenth century.

The contract, signed on August 19, 1636, with the majordomo of the church, Cris-tobal Zaperuzas, specified that Zurbarán, "as son of this city and greatly devoted to the Virgin, has offered to do all the painting, without conditions [for no more than his expenses], so long as the altarpiece will be constructed by Jerónimo Velázquez." The two artists were engaged, for a fee of 3,150 ducats, to complete the work within two and one-half years. The guidelines for the sculptor were quite specific in terms of the wood to be used, the decoration of the frames, and the style of the columns (Corin-thian and Composite columns with twisted shafts). For Zurbarán, instructions were more vague: "[The paintings] must all be from the hand of Zurbarán, who will put his name to them, and he will be given the list of saints he is to depict."[1]

The altarpiece was still not completed by the end of 1644. The delay can perhaps be explained by the financial difficulties of the parish. Two years after the contract was signed, on July 16, 1638, the mounting of the framework was interrupted, and it was only on August 30, 1639, that Velázquez received his payment of 14,850 reales.[2] Did Zurbarán take even longer to fulfill the contract? On May 4, 1641, he empowered Velázquez to collect 1,575 ducats, the balance owed him for his work. And on December 19, 1644, gifts were solicited to pay for gilding, as it was considered improper for the structure to remain in an unfinished state for so long.[3]

In 1700, scarcely fifty years after it was completed (if indeed it ever was), the ensemble was dismantled in order to make room for a Baroque niche that was more to the taste of the time and intended as a more appropriate setting for the statue of the Virgin of Granada, which had been set into the altarpiece.

Without additional documentation, it is difficult to reconstruct the original disposi-tion of the paintings in the altarpiece. Three paintings by Zurbarán, discovered in the church in 1953 by Soria, may have been included: a *Christ on the Cross*, on panel and measuring approximately 150 × 75 centimeters, no doubt the pinnacle (parish church, Llerena); a *Virgin in Glory*, on canvas and measuring 180 × 103 centimeters; and a pic-

ture of the Risen Christ holding the cross, on panel and perhaps constituting the door of the tabernacle in view of its small dimensions, 51 × 36 centimeters (both Museo Provincial de Bellas Artes, Badajoz). Guinard has proposed not unconvincingly to add a fourth painting, the *Martyrdom of Saint James* (cat. no. 34), which would have been placed at center, directly above the statue of the Virgin.

The other paintings in the commission, which according to the contract were to represent saints, have not been identified. Soria has suggested that they were to form an *Apostolado*, a specialty of Zurbarán's workshop; the full-length, life-size figures would have occupied the lateral sections.[4] But this hypothesis is open to question. Without offering any documentary support, Soria states that there were probably fifteen paintings in the ensemble, and he associates the *Virgin in Glory* with a painting of the Virgin in an *Apostolado* in the sacristy of Nuestro Padre San Francisco de Jesús, in Lima.

NOTES

1. Municipal archives, Llerena, 1636, fol. 200, published in Caturla 1964d.
2. Peña Gómez, forthcoming, in *Revista de estudios extremeños*.
3. *Ibid.*
4. Soria 1953, nos. 112–14.

34.
The Martyrdom of Saint James

ca. 1639
Oil on canvas, 8 ft. 3¼ in. × 6 ft. 1¼ in. (252 × 186 cm)
Signed, lower right: Fran^{co} de Zurbaran
Collection of Mariano Castells Plandiura, Barcelona

Original location: Llerena (Badajoz), parish church of Nuestra
 Señora de la Granada, high altar
Date of contract: August 19, 1636

The Apostle James, son of Zebedee, called "the Greater" to distinguish him from James the Less, the cousin of Christ, is honored by the Church on July 25. The Synoptic Gospels recount the calling of the first four disciples, chosen by Jesus among the fishermen of the Sea of Galilee. James and his brother John are associated with Peter as forming the circle of intimates of Christ and witnesses to his Transfiguration. James's martyrdom, in the year 42 or 43, is described briefly in the New Testament and constitutes the only account of the death of one of the twelve Apostles: "Now about that time Herod the king stretched forth his hands to vex certain of the church. And he killed James the brother of John with the sword" (Acts 12:1–2).

According to a tradition taken up by the Church in Spain, James is said to have brought Christianity to that country, and is thus described as the "luz y patrón de las Españas" (light and patron of the Spains).[1] His relics, taken by his disciples into Galicia, were discovered in Compostela, and became the object of one of the most celebrated pilgrimages of the Middle Ages. Especially because of the saint's miraculous interventions in battles against the Moors, James the Greater became the patron saint of Spain, where he is called Santiago. In 1170, Ferdinand II instituted the Order of the Knights of Saint James of the Sword, an order that later took an active part in the Reconquest (of Spain from Moorish domination). At the end of the sixteenth century, doubts were cast on the veracity of James's early missionary activity in Spain, for the earliest mention of it dates only from the end of the seventh century.[2] Among those who rejected the theory of James's activity in Spain was Pedro Garcia de Loaysa, in his *Collectio conciliorum hispania* (Madrid, 1593). His argument drew the support of Cardinal Cesare Baronius (*Annales*, IX, 1600), who had originally accepted the theory (*Annales*, I, 1588). But protests both from the crown and from several Spanish ecclesiastical authorities led to the acknowledgment, in the Breviary of 1603, of "the existence of a tradition favorable to Spanish teaching."

Zurbarán's patrons, rather than choose a scene from Saint James's life that might later be deemed apocryphal, directed him to depict the saint's martyrdom, an unquestionably historical episode, whose factual basis is emphasized by the artist. While the Apostle is dressed in a long robe like that worn by Christ, the executioner and the helmeted soldiers are shown in seventeenth-century costume, establishing an analogy between the martyrdom of the Christians at the hands of the pagans and the continuing efforts of Catholic Spain against the Protestants. Herod Agrippa wears a curious turban surmounted by a crown, doubtless an allusion to the non-Christian world. An infant cherub in flight brings to Saint James the crown of martyrdom and the palm of immortality.

A painter of the mystical and contemplative life, Zurbarán was only occasionally a chronicler of scenes of martyrdom. But in his work there are no bloodstained heads rolling on the headsman's block; rather, victims are shown in prayer, in total submission to their torturers.

The gesture of Saint James's executioner is stopped midway, like the gestures of the angels in the *Flagellation of Saint Jerome* (Monastery of San Jerónimo, Guadalupe). The only violent note in the scene is the manner in which the headsman seizes the Apostle by the hair. The diagonal created by the sword and the Apostle's body traverses the entire picture without disrupting the composition or even disturbing the serenity of the onlookers, whose eyes are fixed on the ground. The oblique composition, the static character of the figures, and the elegance of the Oriental costumes suggest comparison with the *Adoration of the Magi* from the main altarpiece at Jerez (cat. no. 28) and, on that basis, a date close to that of the Jerez painting, about 1639. At that time, Zurbarán was placing more emphasis on anatomical vigor and on facial structure than he had in the preceding decades. In this respect, the faces of the two figures at the far right are highly individualized and compensate somewhat for the banal character of the figures in Herod's escort. The dog's head, at right, is superb. Guinard was reminded by its masterly quality of the portraits of Philip IV and other members of the royal family at the hunt that Velázquez was painting at the same time.[3]

NOTES
1. Ribadeneyra 1624, fol. 470.
2. Duchesne 1900, pp. 145–79.
3. Guinard 1960a, text opp. pl. 51.

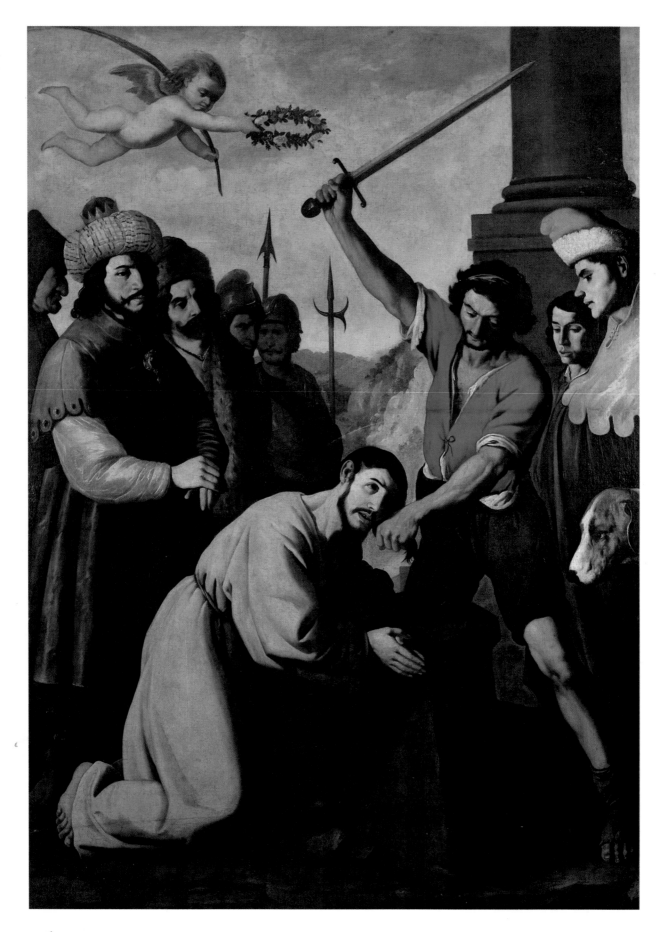

206

PROVENANCE

Church of Nuestra Señora de la Granada, Llerena (Badajoz); Ga-
lerie Espagnole, Musée Royal au Louvre, Paris, 1838 (as *Martyr-
dom of Saint Julian*); Louis-Philippe sale, Christie's, London, May 6,
1853, no. 68 ("This work which comes from a monastery in Ex-
tremadura was much appreciated in Spain"), sold to Sharpe for
£70; collection of Julia Martínez Ibañez, Madrid; collection of
Mariano Castells Plandiura, Barcelona, after 1939.

LITERATURE

Paris, Musée du Louvre, 1838, no. 352 (1st ed.), no. 362 (4th ed.)
(as *Martyrdom of Saint Julian*); Blanc *et al.*, 1869, p. 8; López Mar-
tínez 1932, p. 223; Guinard 1949, pp. 25–26 (as *Martyrdom of Saint
James*); Caturla, in Granada, II Festival Internacional de Música y
Danza, 1953, p. 38; Guinard 1960a, no. 188; Torres Martín 1963,
no. 131; Caturla 1964d; Madrid, Casón del Buen Retiro, 1964,
no. 71 ("signed"); Guinard and Frati 1975, no. 213; Gállego and
Gudiol 1977, no. 325; Baticle and Marinas 1981, no. 362.

EXHIBITED

Paris 1838–48, no. 352 (1st ed.), no. 362 (4th ed.); Madrid 1964–
65, no. 71.

JACOB AND HIS SONS

Historians have been amazed by the appearance of this important series of thirteen biblical subjects in London at the beginning of the eighteenth century, at a time when Zurbarán was practically unknown outside Spain. In his 1948 study of this series, Pemán suggests that these pictures, which were probably destined for the colonies in South America, may have been seized by pirates and taken to Great Britain.[1] Romantic though it may seem, this hypothesis is entirely plausible, for acts of piracy are known to have occurred in 1656–57.[2] Furthermore, representations of biblical Patriarchs were of particular interest to the native populations of the Americas, who were then believed to have descended from the ten lost tribes of Israel founded by ten of Jacob's sons.[3] Four series of the Patriarchs are known from existing documents; two of them were very likely painted by Zurbarán. The first is mentioned in a receipt, dated 1649, for a shipment to Buenos Aires.[4] The second was part of a deposit left with the Hieronymites of Buenavista in 1659.[5] Finally, twenty-four representations of Patriarchs are mentioned in a contract signed in Seville in 1665 (one year after Zurbarán's death) concerning a sale in the Americas.[6] In addition to these archival references, there are two series of Jacob and His Sons, now in Peru and in Mexico. The first (Orden Tercera de San Francisco, Lima) seems to be a fairly close replica of the London series; the other (Academia de Bellas Artes, Puebla) is a more distant and awkward imitation. The series now in Lima may be the one mentioned in the receipt of 1649.

But only the series in London was probably executed by Zurbarán himself. It is first mentioned with regard to the sale, about 1722, of the collection of William Chapman. The series was later dispersed at the posthumous sale of James Mendez of Mitcham, held on February 21, 1756; twelve of the paintings were acquired by Richard Trevor, Bishop of Durham, while the thirteenth, the *Benjamin* (cat. no. 35), went into the collection of Lord Willoughby of Eresby. It is not known why the bishop did not acquire this last painting, but that same year he commissioned Arthur Pond to make a copy of it, which he hung in his dining room at Auckland Castle, to complete the series.

The Sons of Jacob were rarely depicted by Spanish painters. When they were, it was usually within a narrative framework, as in paintings by Ribera and Velázquez. Instead, Zurbarán represents each of the sons on a separate canvas, in the decorative epic style in which he excelled. He thus transforms the Sons of Jacob into a series of processional figures of impressive scale, decked out in fascinating Oriental garb complete with turbans and ornamental trimmings. These exotic trappings may have been inspired by the costumes worn in religious celebrations in Seville on the *carros* (parade floats) of the feast of Corpus Christi or in the *máscaras*, the holy day processions of Patriarchs, kings, and allegorical figures. Other motifs were surely drawn from the sets of Flemish and German prints that often served painters as sources of inspiration. Soria refers to several engravings in this context: one by Maerten van Heemskerck dated 1559, and two others engraved by Johan Sadeler and Pieter de Jode (1575) after Crispin van den Broeck.[7]

Zurbarán's figures, however, despite similarities with those in Flemish prints, are not directly based on them.

The series was probably designed to satisfy the didactic needs of the monasteries. It is related to the many series of the Apostles and of the founding members of religious orders painted in Zurbarán's workshop with a greater or lesser degree of participation by the master. The series of Jacob and His Sons is characterized by very light backgrounds and open landscapes dominated by vast skies, and may have been executed slightly later than those of the Apostles and of the Founders in Lima, dated about 1638 by Soria.[8]

NOTES
1. Pemán 1948, pp. 153–72.
2. Elliott 1966, p. 183.
3. Kinkead 1983b, p. 307.
4. Caturla 1951, pp. 27–30.
5. Kinkead 1983b, p. 310.
6. Kinkead 1983a, pp. 73–101.
7. Soria 1948b, p. 257.
8. *Ibid.*

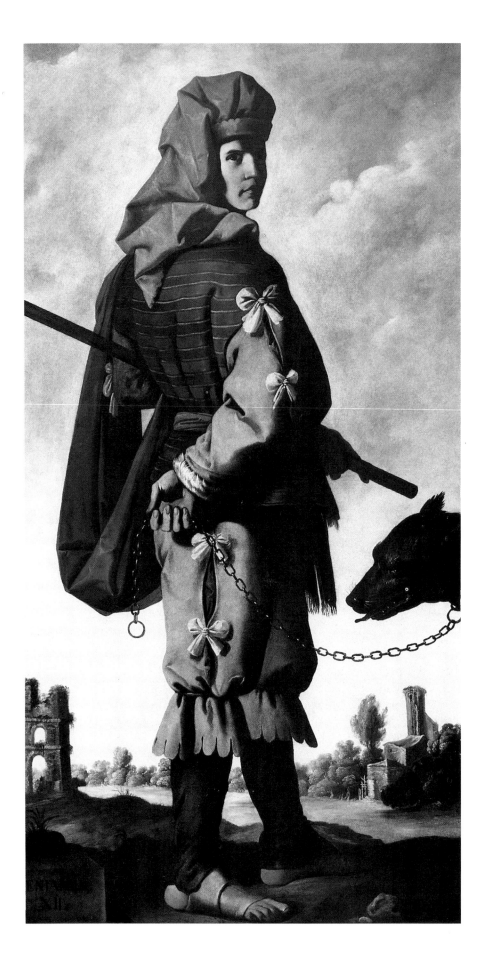

35.
Benjamin

ca. 1650–60
Oil on canvas, 6 ft. 7⅜ in. × 3 ft. 5 in. (200.7 × 104.1 cm)
Inscribed on a stone marker, at left: BENJAMIN, / XII.
Grimsthorpe and Drummond Castle Trust, Bourne,
 Lincolnshire

Original location: Not known
Date of contract: Not known

Benjamin was the twelfth and last son of Jacob. Joseph and Benjamin, Jacob's sons by Rachel, his favorite wife, were dearly loved by their father. Rachel, who died after giving birth to this last son, called him Ben-oni, "son of my pain," but Jacob changed his name to Benjamin, "son of good fortune" (Genesis 35:18). Joseph was sold into slavery in Egypt by his jealous brothers, but he managed to gain the trust of the pharaoh and even to become his adviser. When his brothers, driven by famine, went to Egypt from Canaan to buy grain, Joseph eventually revealed his identity and invited them to settle in Egypt with their father. Before his death, Jacob assembled his twelve sons and told them of the destiny of the tribes that would bear their names. Of his youngest son he said, "Benjamin shall raven as a wolf: in the morning he shall devour the prey, and at night he shall divide the spoil" (Genesis 49:27). And indeed, this fierce, warlike aspect characterized the later history of Benjamin's tribe.

With his youthful features and elegant forms, Benjamin is one of the most appealing figures in this series of canvases. He is shown walking, with his face turned toward the viewer, in the dress of a "country gentleman."[1] On his shoulder, he carries the sack in which Joseph has hidden the silver cup that had led to Benjamin's recognition by his brothers. And in his left hand, he holds a chain attached to an animal that may serve as a visual analogue to the rapacious wolf of Jacob's prophecy. (Guinard argues convincingly that it is simply a hunting dog.)[2] His informal pose contrasts with the more ponderous attitudes of his brothers in some of the other paintings in the series—especially those of Levi, Judah, and Joseph, stuffed into their rich attire. His costume, though more rustic, is refined by a multicolored striped vest and large bows on his sleeves and breeches. The strong lighting accentuates the woolen texture of the drapery, the angular folds of the voluminous hood, and the firm modeling of the face, half hidden in shadow.

The attribution of this series to Zurbarán has been contested by some[3] and questioned by others, but it is now generally assigned to Zurbarán and his workshop. However, the fine quality of the figure of Benjamin, the lighting, the attention to the costume, and the treatment of the folds argue strongly in favor of the painting's being an autograph work.

Two copies are known. One, in the Orden Tercera de San Francisco, in Lima, is an exact copy; its poor condition, however, prevents a sure judgment of its execution, which appears fairly rough and unskilled. The other copy is very faithful to the original but of much later vintage, having been commissioned by the Bishop of Durham and painted by Arthur Pond in 1756.

The version in the Academia de Bellas Artes, Puebla, Mexico, presents important differences: the figure is shown frontally and holds a pitchfork. It was probably the work of a local artist.

NOTES
1. Guinard 1960a, no. 558.
2. *Ibid.*
3. Soria 1948b, p. 257.

PROVENANCE
Collection of Sir William Chapman; undated sale (ca. 1722), no. 53; collection of James Mendez of Mitcham, London; posthumous sale by Langford, Feb. 21, 1756, no. 33; acquired by Lord Willoughby of Eresby; collection of the Earl of Ancaster, Grimsthorpe Castle, Scotland; Grimsthorpe and Drummond Castle Trust, Bourne, Lincolnshire.

LITERATURE
Mayer 1936, p. 43; Pemán 1948, pp. 158–68; Soria 1948b, p. 257 (attributed to followers of Zurbarán); Pemán 1949, pp. 209–13; Gaya Nuño 1958, no. 3122; Guinard 1960a, pp. 55, 133–34, no. 558 (attributed to Zurbarán and his workshop); Torres Martín 1963, no. 202; Bonet Correa 1964, pp. 164–67; Pemán 1964, p. 94; Pérez Sánchez 1965c, p. 273; Torres Martín 1965, p. 294; Harris 1967, p. 484; Young, in Barnard Castle, Bowes Museum, 1967, discussed in nos. 63–66; Young 1967, p. 31; Guinard and Frati 1975, no. 548; Gállego and Gudiol 1977, p. 38, no. 477; Braham, in London, National Gallery, 1981, discussed in no. 35.

EXHIBITED
London 1853, no. 108; London 1920–21, no. 63.

THE MONASTERY OF SAN JERONIMO, GUADALUPE

The Monastery of San Jerónimo, in Guadalupe, is situated in the northeast part of Extremadura (Cáceres), in the heart of a mountainous and wooded region on the southeast slope of the Sierra de las Villuercas. Legend, history, and the nature of the region itself all had their part in the choice of this site. Oral tradition places the origin of the monastery in 1329, when a shepherd discovered a statue of the Virgin that Christian Visigoths had hidden in order to avoid its profanation or destruction by the conquering Moors. Close by the original chapel raised in honor of the statue, Alfonso XI built a Benedictine monastery as an action of grace for the victory of Salado in 1340, when the Moors of Andalusia and Morocco met with defeat. In 1389, Enrique III summoned to the site the Hieronymite Order that had been founded only a few years before and was confirmed in 1373. The new community at Guadalupe came from the mother house, the Monastery of San Bartolomé, in Lupiana (Guadalajara). By the end of the fourteenth century and at the start of the fifteenth, the monastery and the small town that had grown up in its shadow already formed an architectural ensemble and an important art center thanks to the activity of Fray Fernando Yáñez de Figueroa and Fray Fernando de Talavera. The first general chapter of the order was held in 1415 in the Monastery of Guadalupe. In 1561, Philip II summoned the prior and twenty Hieronymite monks from Guadalupe and installed them in the newly built monastery of the Escorial. After 1835, the Hieronymite Order died out as a result of the suppression of the monasteries. The order itself had not expanded very much outside the Spanish frontier, and was always closely linked to the Spanish monarchy. Since 1908, the Monastery of Guadalupe has been occupied by Franciscan monks.

Guadalupe was both a monastery and a fortress. Its complex architectural ensemble dates from the fourteenth and fifteenth centuries. The Gothic main façade opens on a large square and is framed by two towers, whose style might be more appropriate to a military edifice than a religious one: the Tower of the Portal at the left, and the Tower of Saint Anne (the clock tower) at the right. In front of the church is the Chapel of Saint Anne, built on a rectangular plan. A depressed arch gives access to the church, which comprises three naves and a transept in Spanish Gothic style dating to the fifteenth century and renovated in the eighteenth. A niche in an altarpiece holds a sculpture of the Virgin of Guadalupe.

The sacristy was built between 1638 and 1640 on the initiative of the prior, Diego de Montalvo. Inspired by the sacristy in the Escorial, it amplifies the Escorial plan with a large chapel dedicated to Saint Jerome. Zurbarán was commissioned to paint a series of canvases to adorn the sacristy and the rear chapel. The paintings are still *in situ*, having escaped the dismantling and dispersal common to most other ensembles in Spain. The fundamental idea of the program was the glorification of the patron saint of the Hieronymite Order and of those members of the community who were known for their piety. With the exception of *Fray Fernando Yáñez de Figueroa Refuses the Arch-*

bishopric of Toledo, all eight scenes in the sacristy are set in the fifteenth century in the Monastery of Guadalupe itself.

Zurbarán painted the canvases in Seville; it is very doubtful that he ever went to Guadalupe to see for himself the site for which they were destined. The contract that was drawn up between the painter and Fray Felipe de Alcalá is dated March 2, 1639.[1] It concerns seven paintings, five of which are signed and dated 1639:

> *The Vision of Fray Andrés Salmerón*
> *Bishop Gonzalo de Illescas*
> *Fray Fernando Yáñez de Figueroa Refuses the Archbishopric of Toledo*
> *The Charity of Fray Martín de Vizcaya*
> *Fray Juan de Carrión Awaiting Death in Prayer*

And two of which are unsigned:

> *The Vision of Fray Pedro de Salamanca*
> *The Temptation of Fray Diego de Orgaz*

The eighth painting, the *Mass of Fray Pedro de Cabañuelas*, is signed and dated 1638 and may have been done as a trial for the commission. The paintings (all of which measure 290 × 222 cm), imbued with gravity and an intensity of religious feeling, stand out against a lavish decoration of mirrors, gilded wooden frames, carved cartouches, and Italianate printed ornamentation. Lighted by two large windows at the south, the ensemble retains all its original richness, harmony, and warmth.

This imposing series of portraits of holy men culminates in the Chapel of San Jerónimo. There, in a reduced space, paintings that relate episodes from the life of the titular saint are augmented by cherubim, arabesques, and garlands of greenery and fruits. In the center of the chapel hangs the lantern of the Turkish flagship captured in the Battle of Lepanto (1571), in which the Turks were resoundingly defeated by allied Christian forces.

For the chapel, Zurbarán produced two large paintings, the *Temptation of Saint Jerome* and the *Flagellation of Saint Jerome* (each measuring 235 × 290 cm), to be placed at either side of the altar, as well as works for the predella—small figures of seven monks and one nun—and the attic of the altarpiece (now preserved in the treasury of the monastery). In the center of the altarpiece is a copy of the sculpture *Saint Jerome Penitent* (Museo de Bellas Artes, Seville), by Pietro Torrigiano (1472–1528), and in the apex is the *Apotheosis of Saint Jerome* (cat. no. 36).

NOTE
1. Archivo de Protocolos, Seville, *Oficio* 18, 1639, fols. 603–88, published in Cherry 1985, pp. 374–81.

View of the Chapel of San Jerónimo from the sacristy, Monastery of San Jerónimo, Guadalupe, showing Zurbarán's *Apotheosis of Saint Jerome*

36.
The Apotheosis of Saint Jerome

ca. 1646
Oil on canvas, 57⅛ × 40½ in. (145 × 103 cm)
Monastery of San Jerónimo, Guadalupe

Original location: Guadalupe (Cáceres), Monastery of San
Jerónimo, Chapel of San Jerónimo, attic of the main
altarpiece

The Hieronymite monks belonged to a contemplative order that placed great emphasis on learning. Saint Jerome, their patron saint and one of the four great Doctors of the Church, was born in 347 at Stridon near Aquileia in Dalmatia, and died at Bethlehem in 420. In 373, he made a pilgrimage to the Holy Land, and from 375 to 378 he lived as an ascetic in the Syrian desert, devoting himself to scriptural studies. After a sojourn in Antioch, he went to Rome, where he was named papal secretary to Pope Damasus. The pope later requested that he translate the Bible into Latin; this version of the Bible is known as the Vulgate. In 386, Jerome settled in Bethlehem, where he remained until his death.[1]

In Zurbarán's painting, Saint Jerome is shown in the habit of his order, raised to heaven and the presence of the Holy Trinity by a choir of cherubs. The subject is drawn from an autobiographical account in which Jerome describes a visionary experience. As a subject, it is rare in seventeenth-century art; representations of Saint Jerome penitent in the desert, flagellated by angels or under temptation, are more common.

The monastery archives show that Zurbarán received payments for his canvas until 1647, the date pertaining to "the picture of the angels," which refers either to the present *Apotheosis* or to the *Flagellation of Saint Jerome*, the two paintings on either side of the altar.

The influence of Ribera can be detected in the saint's face, and the influence of the Italian masters is reflected in the infant angels. Zurbarán may also have used Flemish engravings, notably those after Rubens's paintings of 1614 and 1626 of the Assumption (Kunsthistorisches Museum, Vienna; and Cathedral, Antwerp). The three horizontal planes of the composition—the earthly landscape, the choir of small angels, and the Trinity reigning at the summit of the heavens—are intersected by the vertical formed by the saint himself.

Only stylistic analysis can tell us something about the period in which the painting was conceived. The high point of Zurbarán's career was in the years 1636 to 1639, when he executed major commissions for

the Church of Nuestra Señora de la Granada, at Llerena, and for the Convent of La Incarnación, at Arcos de la Frontera; in 1638–39, he worked both for the Carthusians of Jerez de la Frontera and for the Hieronymites of Guadalupe.

The *Apotheosis of Saint Jerome* does not reveal the compositional skill of the works from 1636 to 1639. The saint's ascension is lacking in élan despite the agitated chorus of cherubs; the kneeling saint occupies the center of the composition, and the symmetry that results paralyzes the sense of movement. The earthly landscape, however, is more luminous than the heavens swept by storm clouds, giving the impression of a heightened reality, broadly treated as in the works from the Madrid period. But where Zurbarán truly excels is in the saint's face and hands. While the face expresses a serene ecstasy imbued with sweetness, the painter made no effort to idealize it; nor is the saint graced by the presence of a halo. Natural light alone suffices both to bring out the whiteness of the robe against the deep brown of the scapular and to define the volume and modeling of the forms.

NOTE
1. Réau 1958, III, pt. 2, pp. 740–41.

PROVENANCE
Still *in situ*.

LITERATURE
Ponz 1780 (1947 ed.), p. 108; Ceán Bermúdez 1800, VI, pp. 46, 51–52; Tormo y Monzó 1905a, p. 50; Gaya Nuño 1951, p. 55; Pemán 1951, pp. 160–61; Soria 1953, p. 32; Guinard 1960a, pp. 48–51, 110, no. 488; Alvarez 1964a, pp. 51–57; Guinard 1965, p. 212; Carrascal Muñoz 1973, pp. 154–70; Guinard and Frati 1975, no. 285; Gállego and Gudiol 1977, no. 157; Cherry 1985, pp. 374–78.

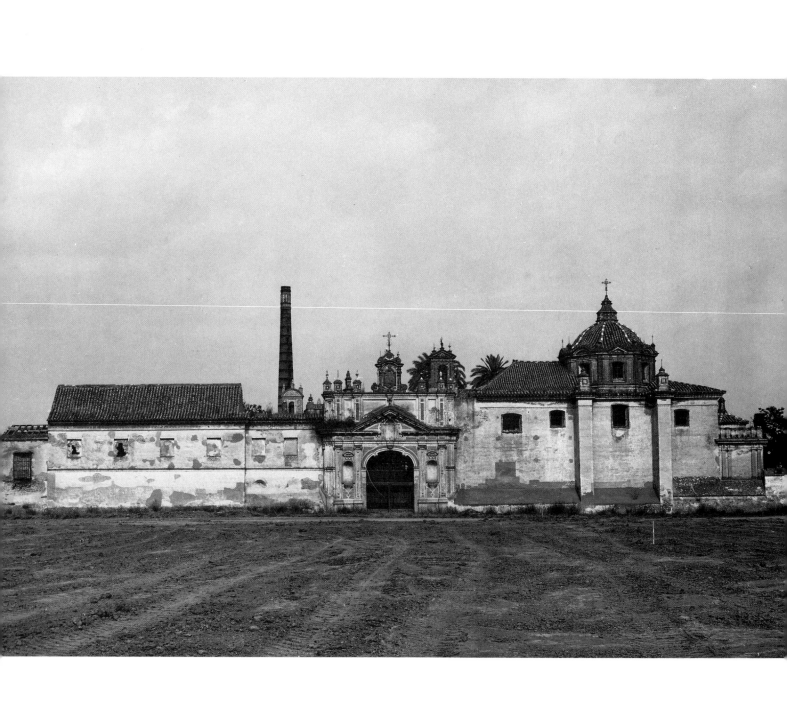

THE CARTHUSIAN MONASTERY OF SANTA MARIA DE LAS CUEVAS

The Carthusian Monastery of Santa María de las Cuevas is situated on the right bank of the Guadalquivir, at the north end of the suburb of Triana. It was badly damaged during the French occupation in the Peninsular Wars (1808–14), and in 1841, following the Secularization Act of 1836, it was transformed into a ceramics factory. In 1983, it was purchased by the government of the province of Andalusia, which plans to restore the remaining buildings and create a national monument.

The manufacture of ceramics at Triana goes back at least as far as the Middle Ages, for the miraculous apparition of the Virgin of Las Cuevas took place in 1249 in one of the many caves (*cuevas*) from which clay was extracted. A hermitage was built at the site of the apparition, and in 1394 it was established as a monastery of the Third Order of Franciscans. In 1400, the Archbishop of Seville, Gonzalo de Mena y Roelas, transferred the Franciscans to another church and founded the Carthusian Monastery of Las Cuevas, which began as a small community composed of several fathers and a lay brother from El Paular (Castile). When the archbishop died, funds to build the church were donated by Per Alfán de Ribera, an ancestor of the Dukes of Alcalá, in exchange for the *jus patronatus* of the sanctuary and the right of burial for himself and his de-

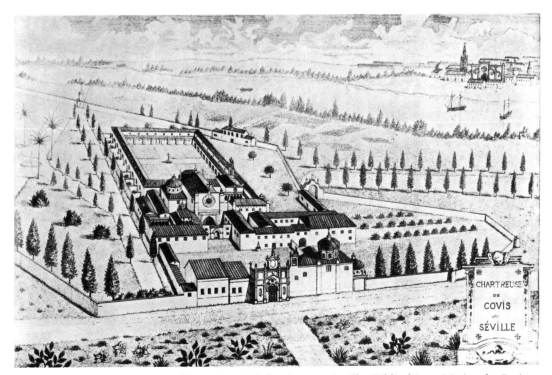

Perspective view, Monastery of Santa María de las Cuevas, Seville. Bibliothèque Nationale, Paris

scendants. The church was inaugurated in 1420. At the end of the fifteenth century, Christopher Columbus was a frequent visitor to the monastery, for he was a friend of Father Gorricio, a learned astronomer and expert in navigation; in fact, a sapodilla tree that he brought back from America was planted there and still thrives today. In 1507, the prior built the Chapel of Saint Anne to receive the remains of Columbus, which were transferred there in 1509. The Monastery of Las Cuevas thus enjoyed the patronage of two powerful families, the descendants of Columbus and the Dukes of Alcalá, who continued to endow it.

For the first hundred years, the monks of Las Cuevas contented themselves with a sacristy of modest dimensions, but in 1537, the prior decided to build a larger one with a noble architecture. This sacristy still exists and is situated on the left, or Gospel side, of the choir. It is almost square in plan (7.38 × 6.52 m) and has an octagonal cupola that was added in 1655. Light is provided by a bull's-eye window set above the altar, which is at the far end and to the right as one enters the church. On three of the walls, at a height of 3.88 meters from the ground, there are ornate built-in stone frames with the following dimensions: 259 × 328 centimeters, 268 × 398 centimeters, and 270 × 315 centimeters.[1] These dimensions correspond, within a few centimeters, to those of Zurbarán's three paintings for the sacristy: *Saint Hugh in the Refectory* (cat. no. 37), the *Virgin of Mercy of Las Cuevas* (cat. no. 38), and *Pope Urban II and Saint Bruno* (Museo de Bellas Artes, Seville).

The existence of these built-in frames, which had been ignored by scholars until very recently, proves that Zurbarán's paintings were designed as an ensemble, Guinard's doubts notwithstanding.[2] Further proof of this is the fact that each of the paintings symbolizes one of the Carthusian virtues: abstinence, represented by *Saint Hugh in the Refectory*; prayer and faith in the Virgin Mary, by the *Virgin of Mercy of Las Cuevas*; and silence, by *Pope Urban II and Saint Bruno*. These three subjects are also presented, in the same sequence, in the *Vita S. Brunonis* (Brussels, 1639), written by the famous Carthusian scholar Laurentius Surius (1522–1578), whose works opened a new era in hagiography after the Council of Trent.[3]

We know that Juan de Baeza, the learned prior of the Carthusian Monastery of El Paular, provided Vicente Carducho with very detailed instructions for the fifty-six pictures that he was commissioned to paint there (1626–32).[4] We have no reason to suppose that the prior of Las Cuevas, Blas Domínguez, would have been any less explicit. Blas Domínguez served two times as prior of Las Cuevas, from 1644 to 1648 and from 1652 to 1657. It was probably during his first term that he commissioned Zurbarán's paintings, and during the second that he embellished the sacristy and had stone frames made for the canvases. His extravagance, however, eventually caused him to be removed from office. He died in 1677 at the age of eighty, and was remembered as a man of energy, action, and conviction. If the contracts of his commissions are ever discovered, the extent of his contribution will perhaps finally be known.

It is safe to assume that when they commissioned paintings, the priors took subjects from the authoritative texts of Surius, but they could also have referred artists to a more accessible source in Spanish, *Vida del seráfico padre San Bruno* (Valencia, 1596), by Juan de Madariaga, a monk of the Carthusian Monastery of Portacoeli. This text, which included new and more detailed scenes than Surius, inspired a great number of representations in the Carthusian monasteries of Spain. In the second part of the book, Madariaga discusses the virtues that Saint Bruno inculcated in his disciples by his exemplary life: abstinence, the observance of silence, and devotion and gratitude to the

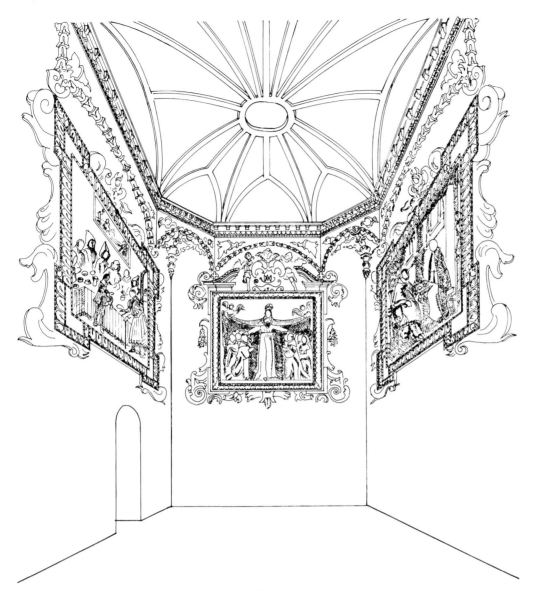

Reconstruction drawing of the installation of Zurbarán's paintings
in the sacristy, Monastery of Santa María de las Cuevas, Seville

Groundplan, sacristy of the church, Mon-
astery of Santa María de las Cuevas, Seville

0 1 2 3 m

Virgin.[5] The choice of these three themes for the decoration of the sacristy, the focal point of the monastic community at Las Cuevas, was therefore entirely appropriate and logical.

The importance of this sacristy has been underestimated by many historians, even though two primary seventeenth-century sources, Pacheco and Ortiz de Zúñiga, gave special attention to this part of the monastery in their descriptions of its treasures. Pacheco, who mentions the date of his visit—May 31, 1632—notes that in the sacristy he saw some very precious Italian illuminated manuscripts, as well as two panels attributed to Albrecht Dürer which were given by the Marqués de Tarifa.[6] In 1671, Ortiz de Zúñiga wrote that "the richness, beauty, and interest of the sacristy are marvelous; it has a great store of relics in costly tabernacles, exquisite paintings, and other works of great value and workmanship."[7]

Palomino, writing at the beginning of the eighteenth century, makes no mention of the paintings by Zurbarán at Las Cuevas, unlike Père Jean Labat, who visited the monastery in 1706 and admired its rich library and the magnificence of the church, "though it is not very big."[8] Ponz, in 1778, had nothing but praise for the sacristy, in which he saw the three "famosísimos" paintings by Zurbarán and the small altarpiece attributed to Dürer.[9] A list sent to Ponz by the Conde de Aguila about 1779 mentions paintings by Zurbarán in the sacristy and others in the library.[10] Zurbarán's three paintings are mentioned as being "in the upper part of the sacristy" in a note sent from Seville to Ceán Bermúdez for his *Diccionario*.[11] In this last work, Ceán devotes an admiring commentary to these same three pictures and describes their subjects as "Saint Bruno seated before Pope Urban II, Saint Hugh in the refectory, and Our Lady sheltering the monks beneath her mantle."[12]

In the 1810 inventory of the storerooms of the Alcázar, the three paintings are listed together in Room 7 as nos. 221, 222, and 223, with dimensions given as 3 varas high by 3½ varas wide (about 252 × 294 cm).[13] The pictures were returned to the monastery in 1814, but when religious communities were abolished in 1836, they were appropriated by the state and deposited in the newly created Museo Provincial de Bellas Artes, Seville. In the museum's first inventory, they are listed as nos. 1944, 1974, and 1989.

When early twentieth-century art historians began to take an interest in Zurbarán's work, the dating of the Las Cuevas pictures did not raise any controversy; tastes had changed since the eighteenth century, and the pictures were relegated to a minor rank in his production. The first monograph on Zurbarán, published in 1911 by Cascales y Muñoz, summarizes contemporary views on the evolution of the artist's style. Writing at the time of the rediscovery of Caravaggism, the author, who judged the *Virgin of Mercy of Las Cuevas* as being particularly weak, gives preference to works in the tenebrist style, such as the cycle of Saint Peter Nolasco (see cat. nos. 6, 7) or the *Apotheosis of Saint Thomas Aquinas* (Museo de Bellas Artes, Seville), to the detriment of the Las Cuevas series. Furthermore, Cascales asserted, without any documentary evidence, that the latter had been painted in 1629.[14]

Trouble began in 1934, when the Marqués de San José de Serra, the owner of the ceramics factory occupying the buildings of the former monastery, announced the discovery of an eighteenth-century *protocolo* in which the Las Cuevas pictures are said to have been executed in 1655. Unfortunately, the marqués, who lacked training as an historian, gave such a poor defense of his discovery that the value of the document was completely ignored. The *protocolo*, 738 pages long (today in the Real Academia de la Historia, Madrid), was later published by Baltasar Cuartero in his remarkable *His-*

toria de la cartuja de Santa María de las Cuevas, which appeared in Madrid from 1950 to 1954, only to be overlooked by most students of the history of Spanish painting, including Paul Guinard.[15] Cuartero, however, provided documentary evidence of the exactitude of the *protocolo,* which had been written in 1744–49 by Father José María Rincón. Rincón, a painter and master glazier, was a close friend of the sculptor Pedro Duque Cornejo, who was the grandson of Pedro Roldán, also a sculptor, and so there is no reason to doubt his statement that the prior of Las Cuevas "expended with good taste 17,000 reales on the cupola and on the fine plasterwork that adorns the sacristy, the carving of which is by the excellent hand of Don Pedro [Duque] Cornejo. For the three main canvases, he summoned the celebrated Zubdarán [*sic*],[16] who lavished upon them his draftsmanship and the delicacy of his brush and palette, and his figures of monks are true portraits of Father Don Blas Domínguez and his vicar Don Martín Infante, elder fathers or officers."[17] Roldán, who arrived in Seville in 1647 at the age of twenty-three, could very well have worked on the Las Cuevas sacristy in 1655. Traces of the plasterwork may still be seen today, along with the three great frames decorated with shell motifs that held Zurbarán's paintings.

As for the crucial matter of the dating, we have already noted that the chronology of Zurbarán's oeuvre has suffered from the misreading of dates and from the fact that many important documents were not discovered until the last two decades. The date has therefore been arrived at more often by deduction than by stylistic analysis. There is no more documentary support for dating the Las Cuevas group to 1635–40, the same period as the paintings of the altarpiece of Jerez and of the sacristy of Guadalupe, than for dating it to 1655. According to the formal and stylistic evidence, none of the latter works displays the "Byzantine" hieraticism or the luminosity that are so striking in the paintings from Las Cuevas.

To date these three paintings early in the artist's career because of their supposedly Gothic character does not make much sense either. And it is an historical and aesthetic contradiction to think that the stiffness of the forms and the awkwardness of certain compositions by Zurbarán indicate a resurgence of so-called Gothic art, which at the beginning of the seventeenth century was no longer a reference for European artists. In this connection, Brejon de Lavergnée correctly observes that "the Italian Baroque engendered its own opposite: a pietistic art, medieval in spirit (but not in style), in which the artist intentionally limited the means of expression."[18] Carlo Dolci, Guido Reni (in certain religious works), and Sassoferrato were the principal exponents of this movement, which reached Spain in the middle of the seventeenth century. The same historian also quotes Francesco Scannelli, the author of *Il microcosmo della pittura* (Cesena, 1657), who was told by an artist that he had abandoned his dark manner because of criticism from his patrons: "They complain that the eyes, mouths, faces, limbs, and even the actions of the figures are hidden by too much shadow, and they even think that the works are not finished technically."[19]

It is obvious that in these paintings Zurbarán abandoned the tenebrist manner and that he sought to imitate the "lightened" Caravaggism of Juan Bautista Maino or Carlo Saraceni. His brushwork is meticulous, and the flat colors applied earlier in violent juxtapositions of light and dark are replaced by a smooth modeling. The face of Mary in the *Virgin of Mercy of Las Cuevas* is treated in a sfumato manner, and the handling of her robe imitates the color effects of the Bolognese and Florentine painters. The chiaroscuro of the heads of the monks beneath the Virgin's mantle is masterfully rendered. In *Saint Hugh in the Refectory,* Zurbarán evidently tried to rival the luminous effects of Velázquez,

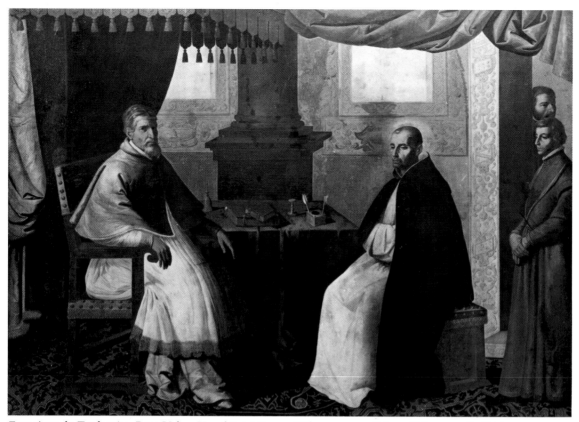

Francisco de Zurbarán. *Pope Urban II and Saint Bruno*. Oil on canvas, 8 ft. 11⅛ in. × 10 ft. 8⅜ in. (272 × 326 cm). Museo de Bellas Artes, Seville. This work is the third painting executed for the sacristy of the Monastery of Santa María de las Cuevas, Seville.

although he used different technical means. And in *Pope Urban II and Saint Bruno*, there is also a smooth and refined modeling, and the unusual and gently combined colors are a far cry from, for example, the dense and bright reds of the *Saint Gregory* of about 1626 (cat. no. 1), which was so admired by Zurbarán's biographers in the first half of the twentieth century.

Two more points argue in favor of a later dating. In *Saint Hugh in the Refectory*, the young page wears a collar in the Italian style that came into vogue in Spain between 1640 and 1650, and his long doublet and close-fitting hose also belong to the fashion of this late period. Then there is the curious similarity between the pose, and even the facial expression, of Pope Urban II and that of Pope Innocent X in the portrait painted by Velázquez in 1650 (Galleria Doria-Pamphili, Rome). This raises the question of a second trip to Madrid that Zurbarán would have made sometime between 1650 and 1652; Palomino mentions one in 1650, and for now there is no documentary evidence either to prove or to disprove this claim. Domínguez Ortiz has shown that the plague of 1649 caused many people to flee Seville (in Zurbarán's parish, the Sagrario, there were three times more dead in the spring of 1649 than in the entire preceding year).[20] Zurbarán could very well have left at that time; in any case, there is no trace of his presence in Seville between March 1650 and April 1652.

It was once thought that in the last decade of his life, Zurbarán fell on hard times and that he was in competition with Murillo. The evidence provided by recent research tells a different story. We know that between 1650 and 1658, Zurbarán worked for patrons from noble Castilian families. In 1650, for example, he painted an *Annun-*

ciation (Philadelphia Museum of Art) for Gaspar de Bracamonte, Count of Peñaranda, who died in Madrid in 1676; another member of the Bracamonte family married the aunt of Juan de Zapata, who was a prior at Jerez until 1643. But how Zurbarán came by these commissions is a question that awaits further study. As for Murillo, in 1650 he had yet to receive the important commissions that were to bring him fame; the decoration of the Franciscan cloister had been entrusted to him because he was a beginner, and so could be had for a lesser fee. As it is, Murillo's graceful and poetic style must not have been to the liking of the Carthusians, for he was never commissioned to work for them.

NOTES

1. Our recent visit to the sacristy of the Monastery of San Jerónimo was made possible by the kind cooperation of the architect J. M. Benjumea Pino, who also took the measurements of the frames.

2. Guinard 1960a, p. 101.

3. Surius's most famous and popular work, *De probatis sanctorum historiis . . .* , 6 vols. (Cologne, 1570–75), a compendium of the lives of the saints organized by month and day according to the Roman calendar, marks the beginning of modern hagiography. His chief concern was not erudition but helping to stimulate piety by providing members of the clergy and religious communities, especially preachers, with accounts freed of apocryphal stories or dubious legends. His revision was applauded by Pope Pius V and Pope Gregory XIII, as well as by most other eminent figures at the end of the sixteenth century. It was not until the Dutch publications of the 1640s that stricter rules of historical criticism were applied. Villegas Selvago and Ribadeneyra, the authors of the renowned Spanish *Flos sanctorum*, drew largely on the work of Surius.

4. Baticle 1958, p. 19, note 18.

5. Madariaga 1596, chap. 9, fol. 130; chap. 10, fol. 168; and chap. 14, fol. 187. According to the account of the life of Saint Bruno by Surius, which Ribadeneyra followed closely and which Madariaga developed, Saint Bruno and six companions were established in 1084 by Saint Hugh, Bishop of Grenoble, in the "wilderness" of the Grande Chartreuse, where they built the Church of Sainte-Marie de Casalibus, as well as several huts for the monks. They lived an austere life and took the vow never to eat meat. In 1089, Pope Urban II, a former disciple of Saint Bruno, summoned the founder of the Carthusian Order to Rome. His followers tried to join him there, but they were sent back to the monastery by the pope, who named Laudouin as prior. Deprived of their master, the monks fell into despair over the austerity of their existence and were ready to leave their hermitage, when the vision of an old man, probably Saint Peter, enjoined them to put themselves under the protection of the Virgin to find peace in their solitude. They therefore took the Virgin Mary as their special protectress, and their rule, dictated by Saint Bruno, was approved in the presence of the bishops of Grenoble and Lyons.

6. Pacheco 1649 (1956 ed.), II, pp. 36, 37.

7. Ortiz de Zúñiga 1677, p. 726.

8. Palomino 1724 (1947 ed.), p. 938; Labat 1730, p. 360.

9. Ponz 1778 (1947 ed.), p. 740.

10. Carriazo 1929, p. 178.

11. Salas 1964b, p. 136.

12. Ceán Bermúdez 1800, VI, p. 50.

13. Gómez Imaz 1896, p. 74.

14. Cascales y Muñoz 1911, p. 39.

15. Cuartero y Huerta 1954, II, pp. 16–17. Many authors who had not read Cuartero's book on the Monastery of Las Cuevas gave erroneous information on the condition of mid-eighteenth-century *protocolos*. Rincón nowhere mentions their poor state of preservation, although he does say that certain fifteenth-century books and Father Galeas's *Becerro* (finished in 1635) showed water damage.

16. The note sent to Ceán before 1800 for his dictionary and published by Salas in 1964 seems to have been based on a misreading of Rincón's *protocolo* transmitted orally: instead of writing that Zurbarán was summoned ("hizo venir al celebre Zurbarán"), he substituted a sentence which says: "To this effect, Zurbarán left his native Fuente de Cantos" ("para es efecto Zurbarán se traje de su patria Fuente de Cantos"), which could not have been the case, because the artist was then a resident of Llerena. Ceán had no knowledge of the documents recording Zurbarán's dealings with the municipality of Seville in 1628.

17. Cuartero y Huerta 1954, II, p. 17.

18. Brejon de Lavergnée 1979, p. 127.

19. *Ibid.*

20. Domínguez Ortiz 1946, p. 86.

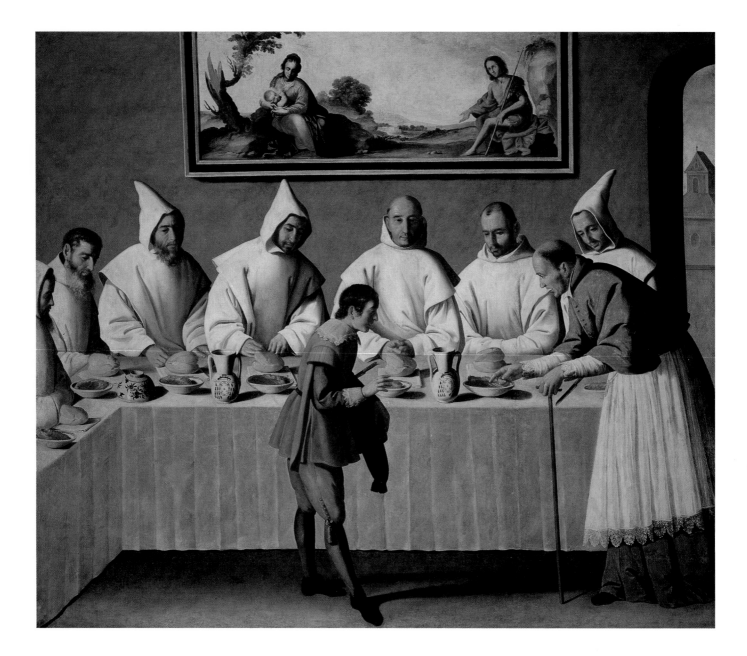

37.
Saint Hugh in the Refectory

ca. 1645–55
Oil on canvas, 8 ft. 9 in. × 10 ft. 5 in. (268 × 318 cm)
Museo de Bellas Artes, Seville

Original location: Seville, Carthusian Monastery of Santa María
de las Cuevas, sacristy of the church
Date of contract: Not known
Location before 1800 according to early sources: *Protocolo* of
1749, *in situ*; Ponz 1778, *idem*; Ceán Bermúdez 1800, *idem*

To represent the Carthusian virtue of abstinence from eating meat, Zurbarán was commissioned to depict the miracle that the founders of the order had interpreted as a sign of Divine approval of their rule. Juan de Madariaga recounts the event in his *Vida del seráfico padre San Bruno* (Valencia, 1596).[1] The seven founders of the Carthusian Order had been provisioned through the generosity of Hugh, Bishop of Grenoble. One Shrove Sunday before the rule against eating meat had been officially adopted, the bishop sent the Carthusians some meat for their dinner. The monks, accustomed to a frugal diet, deliberated whether they should or should not practice abstinence, following the example of the early anchorites John the Baptist, Saint Paul, and Saint Anthony. In the course of the debate, the seven Carthusians fell into a deep trance that lasted through Lent. It was at this time that Hugh, completing his episcopal rounds, decided to spend Maundy Thursday with the monks. On the Wednesday before Easter—forty-five days after Shrove Sunday—he sent a servant to announce his coming. The young man, shocked to find the Carthusians at table with plates of meat before them during Holy Week, when meat was strictly forbidden, returned to the bishop and reported what he had seen. Not believing his servant, Hugh sent a second and then a third messenger before going to the monastery himself. One of the Carthusians, Bruno, was just beginning to awaken. The bishop addressed him with the question, "What day is today?" Matter-of-factly, the monk replied, "Shrove Sunday," and told the bishop of the discussion about abstinence. In disbelief, Hugh turned his attention to the meat, and to his amazement it disintegrated into ashes before his eyes. In this miracle the monks saw an expression of Divine will, and they vowed to abstain from eating meat thenceforward.

In the painting, Bruno is shown full-face in the center, Hugon the chaplain and Etienne de Thiène to his right, and Laudouin and Etienne de Bourg to his left. At the far left are two lay brothers, Guérin and André. Hugh and his page, just arriving in the refectory, are portrayed contemplating the meat on the table. The monks are about to awaken from their long sleep. A similar hierarchical composition is found in the engraved frontispiece of the *Vita S. Brunonis* by Surius (Brussels, 1639).

Zurbarán's hieratic frieze emphasizes the solemnity of the moment. By using the time-honored scheme of a picture-within-a-picture, the artist has introduced the holy patrons of the Carthusians—the Virgin Mary,

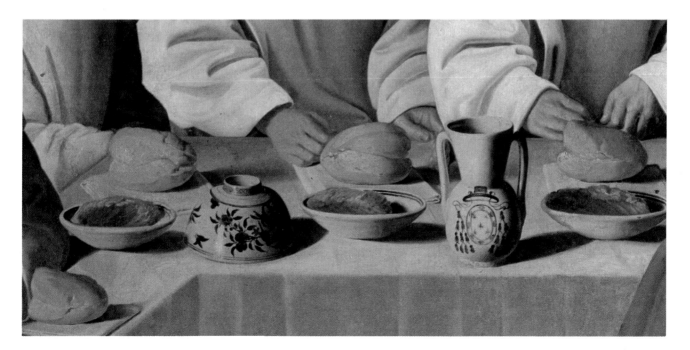

on the flight into Egypt, and Saint John the Baptist, alone in the wilderness—as images of austerity. (Having been installed at the Grande Chartreuse on Saint John's feast day, the Carthusians had taken Saint John as their advocate, intending to emulate his penitential devotion and abstinence.)[2]

As with the *Virgin of Mercy of Las Cuevas* (cat. no. 38), Zurbarán was required to follow the dictates of his patrons. Doubtless, the prior requested a composition in the medieval tradition of the Last Supper, seen in Italian works of the fourteenth and fifteenth centuries. These compositions, by Giotto, for example, display similar devices—a table parallel both to the picture plane and to the background wall. There are only a few representations of the Last Supper in the school of Seville, and only in Valencia do these Italianate compositions date from the sixteenth century. Soria has suggested that Zurbarán's composition derives from Bernardino Passeri's engravings in the *Vita et miracula sanctissimi patris benedicti* (Rome, 1579).[3] Analogies have also been suggested with Vicente Carducho's painting (destroyed) of the same theme for El Paular. However, neither of these suggestions is convincing.

It is apparent that the patrons made three important recommendations: that the artist be sparing of decoration; that he limit the number of persons represented; and that he record their devotion to the Virgin and to Saint John the Baptist. Accordingly, Zurbarán constructed a very straightforward composition in three planes, with minimal use of linear perspective. The foreground is occupied by Hugh and his page, the middle ground by the symbolic repast, and the third plane by five of the seven holy men. According to the *protocolo* of 1749, the features of the central figures were to be based on those of the prior, Blas Domínguez, and his vicar, Martín Infante. The *protocolo* is illustrated with small pen-and-ink sketches attributed to Pedro Duque Cornejo and drawn from portraits of the priors that had been kept at the monastery since its founding. They do not, however, help to identify the central figure of Zurbarán's canvas.

Similarly, the stiff and heavy postures of the monks, their sluggish gestures, and their hands posed as if paralyzed are not due to any lack of skill on Zurbarán's part; surely their immobility reflects the instructions given to the artist by the Carthusians, prompting him to consider how best to suggest this awakening, the miraculous emergence from the deep lethargy that had lasted for six weeks. With the same "verdad en lo natural" (truth to nature), to borrow Pacheco's expressive phrase, Zurbarán firmly brushes in the facial planes, bathing the wasted

features as if with moonlight, with a moving emphasis on the marks of fatigue from long fasts and mortifications (the Carthusian rule being among the strictest). Despite the ill-shaven chins, cropped heads, and rough beards, and despite the expressions of humility and meditation, the scene is imbued with a grace and dignity rarely equaled for its power and restraint.

The painting-within-the-painting, depicting the Virgin and Child and Saint John the Baptist, works almost like a window open to the sky. Zurbarán frequently made use of Flemish engravings, which were abundant in Seville at the time, as a source of secondary figures and details; his figure of the Virgin is taken from an engraving by Boetius à Bolswert after Abraham Bloemaert. Thus, he probably had no need of preliminary sketches; indeed, the fact that there are no extant drawings by Zurbarán suggests that he did not use them.

Further comment on the costume of the page is of interest because it relates to the problem of dating. As has already been noted, the Italian style of the collar, the long-skirted doublet, and the less voluminous knee breeches belong to a period later than 1635. For example, the *Portrait of Philip IV at Fraga* by Velázquez (Frick Collection, New York), generally dated to 1644, shows a style of doublet and collar very similar to that of Zurbarán's page. A mid-seventeenth-century portrait by an anonymous artist (Museo del Prado, Madrid), which represents a boy, probably the son of the jurist Ramos del Manzano (d. 1683), is placed by Pérez Sánchez in the decade 1640 to 1650;[4] the long doublet with Italianate collar is like that of the page, and quite different from the very short jackets and ruff collars worn until 1630. As for the ample breeches seen in Zurbarán's portrait of 1634 of the young Alonso Verdugo y Albornoz (cat. no. 46), by 1640 these had become closer fitting, as in the *Portrait of Prince Baltasar Carlos at Age Sixteen* (Museo del Prado, Madrid), painted by Juan Bautista del Mazo in 1645. Another clue to the dating may be found in a detail of the tableware. The coat of arms on two pieces of Talavera pottery similar in shape to the pitchers represented here was identified by Mudge as being that of the natural daughter of Rudolph II, who took her vows in 1628 and died in 1694.[5] Those pitchers bear the emblem of the Franciscans, while the ones painted by Zurbarán bear those of the Carthusians.

Stylistic connections with the paintings of Juan Sánchez Cotán at the Carthusian Monastery of Granada are often cited. But Cotán's meticulous brushwork, the simplicity of his lighting effects, and the softness of his figures are far removed from the ten-

Giotto. *The Marriage Feast at Cana*, detail. 1305–6. Fresco. Arena Chapel, Padua

sion and vigor of Zurbarán's style. The palette of *Saint Hugh in the Refectory*, essentially white and gray, is, however, reminiscent of studies by Velázquez, particularly the transparent bluish hues and the scumbled execution of the tablecloth and the background wall. The arrangement of the crockery on the table and the care with which it is treated recall Lamartine's proverbial line "objets inanimés, avez-vous donc une âme" (things inanimate, have you thus a soul), as the painter has contrived to invest these modest objects with symbolic significance. Despite the constraints laid upon Zurbarán—or perhaps because of them—every facet of the artist's skill as a colorist is displayed: in the garb of the Virgin and of Saint John, in the brilliant white of the robes and scapulars, in the fine silk of the bishop's apron, and in the ocher and mauve of the page's costume.

It may be noted in conclusion that in the Aguado sale of March 20–28, 1843, the painting listed as no. 158, which was sold for 4,725 francs, was entitled *Saint Hugh Transforming the Carthusian Repast*. Although larger than the present work (it measured 233 × 365 cm), the painting represented the same scene and included the same number of figures. To our knowledge, there is no mention in the early literature of a replica of the original.

NOTES
1. Madariaga 1596, fols. 146–49.
2. Ribadeneyra 1624 (1984 ed.), X, p. 100.
3. Soria 1953, no. 69.
4. Pérez Sánchez, in Madrid, Museo del Prado, 1983a, no. 180.
5. Mudge, in Chicago, University of Chicago, Smart Gallery, 1985, p. 48.

PROVENANCE
Monastery of Santa María de las Cuevas, Seville; Alcázar, Seville, 1810, Room 7, no. 221; Monastery of Santa María de las Cuevas, Seville, 1814; Museo Provincial de Bellas Artes, Seville, 1836 (inv. 1840, no. 1944).

LITERATURE
Ponz 1778 (1947 ed.), p. 740; Ceán Bermúdez 1800, VI, p. 51; González de León 1844, II, p. 253; Gómez Imaz 1896, no. 221; Cascales y Muñoz 1911, p. 83; Seville, Museo Provincial de Bellas Artes, 1912, no. 203; Kehrer 1918, pp. 66–67; Serra y Pickman and Hernández Díaz 1934, pp. 29–30; Guinard 1949, pp. 1–6; Serra y Pickman 1950, p. 209; Soria 1953, no. 69; Cuartero y Huerta 1954, II, pp. 16–17, 627; Guinard 1960a, p. 194, no. 458; Bravo and Pemán 1963a, pp. 5–13; Caturla, in Madrid, Casón del Buen Retiro, 1964, pp. 19, 153–54; Salas 1964b, p. 136; Hernández Díaz, in Seville, Museo Provincial de Bellas Artes, 1967, no. 150; Caturla 1968; Brown 1974, p. 60; Guinard and Frati 1975, no. 119; Gállego and Gudiol 1977, no. 299; Brussels, Palais des Beaux-Arts, 1985, pp. 581–83.

EXHIBITED
Madrid 1964–65, no. 56; Brussels 1985, no. C78.

38.
The Virgin of Mercy of Las Cuevas

ca. 1645–55
Oil on canvas, 8 ft. 9 in. × 10 ft. 8 in. (267 × 325 cm)
Museo de Bellas Artes, Seville

Original location: Seville, Carthusian Monastery of Santa María
de las Cuevas, sacristy of the church. The stone frame in
front of the bull's-eye window still bears on the top the letters
of the Virgin's cipher, an *M* inscribed in a *V*—proof of the
original location.
Date of contract: Not known
Location before 1808 according to early sources: *Protocolo* of
1749, *in situ*; Ponz 1778, *idem*; Ceán Bermúdez 1800, *idem*

EXHIBITED IN NEW YORK ONLY

The image of the Virgin sheltering the faithful beneath her outspread mantle (called the Virgin of Mercy, or the Madonna della Misericordia), a symbol of Marian protection, is of Cistercian origin. In his *Dialogus miraculorum*, written about 1230–40, Caesarius of Heisterbach relates that a monk of Cîteaux had a vision of the Virgin in heaven covering the members of his order with her large mantle to show her preference for the Cistercians. The symbol of the protecting mantle was probably derived from medieval rites of marriage or of adoption.[1] This image had such a strong appeal that the Dominicans adopted it about the middle of the thirteenth century. Most of the other religious communities followed suit in the fourteenth century, and by the sixteenth century the image of the Virgin of Mercy was in general use.[2]

Like the other orders, the Carthusians sought to express the special protection of the Virgin, and the earliest known representation of the Virgin of Mercy for this order is on a fourteenth-century seal.[3] Accounts of the Virgin's beneficent intercession in favor of the disciples of Saint Bruno subsequently filled their annals and chronicles. Before the Dominicans, the Carthusians claimed that the Virgin had revealed the gift of the rosary to the Carthusians. According to the Carthusians, it was Dominique Hélion, established at the monastery in Trier in 1409, who first proposed the meditation on the mysteries of the life of Christ associated with the recitation of the Ave Maria. This devotion was continued in the fifteenth century by Jean de Rhodes, a prior of this same monastery. In Spain, where the cult of the Virgin was strong, the Carthusian scholar Juan de Madariaga wrote at great length in his *Vida del seráfico padre San Bruno* (Valencia, 1596) on the favors accorded his order by the Virgin, including her revelation of the rosary. Hence the many representations of Marian themes in the Carthusian monasteries of Spain: a *Virgin Presenting the Rosary to Saint Bruno* was painted by Juan Sánchez Cotán for the monastery in Granada (Museo de Bellas Artes, Granada); Vicente Carducho painted the *Virgin as Protectress of the Carthusians* for the monastery in El Paular (Museo de Bellas Artes, La Coruña); and Zurbarán, the *Virgin of the Rosary with Carthusians* for the monastery in Jerez de la Frontera (Muzeum Narodowe, Poznań; see illus. on page 194).

The painting for Las Cuevas seems to combine two iconographical types, the Virgin of Mercy and the Virgin of the Rosary. The Virgin in this picture shelters two groups of Carthusians and blesses the two figures in the foreground by placing her hand on their foreheads. Judging by the roses strewn on the ground, an allusion to the rosary, these two figures could be portraits of Dominique Hélion and Jean de Rhodes; their beards are unshaven because their rule allowed them to shave only six times a year.

Zurbarán scholars of the past fifty years have made a certain number of errors in their reading of the iconography and style of the *Virgin of Mercy of Las Cuevas*. Most credit Zurbarán with the composition of the painting, forgetting that the Virgin of Mercy had been an iconographic type since the Middle Ages and, although out of vogue in seventeenth-century Spain, was still subscribed to by the Carthusians.

Accordingly, Zurbarán simply reproduced a version of the medieval Virgin of Mercy, one of the supreme examples of which is the one executed by Enguerrand Quarton for the church of the Celestines in Avignon: the Virgin is depicted holding her mantle open like a pair of outspread wings to shelter a group of patron saints. We know that in the library at Las Cuevas were several medieval French illuminated manuscripts, some of which came from Avignon; the prior could easily have chosen a model from one of these manuscripts. It is equally possible that Zurbarán had in mind a ceramic decoration executed in 1577 by Cristóbal Augusta, in which the Virgin of the Rosary is represented protecting Dominican monks with her mantle, which is held by angels (Museo de Bellas Artes, Seville). An obvious source of inspiration was an engraving in the *Vie de Saint Augustin* (Paris, 1624),[4] illustrated by Schelte à Bolswert, in which we find the same kind of angels. The same swayed pose—arms held apart from the body—and the same disposition of the mantle are to be seen in the *Virgin of the Carmelites* painted by Juan Valdés Leal about 1655 (altarpiece of the Church of the Calced Carmelites, Córdoba), which indicates that the two painters may

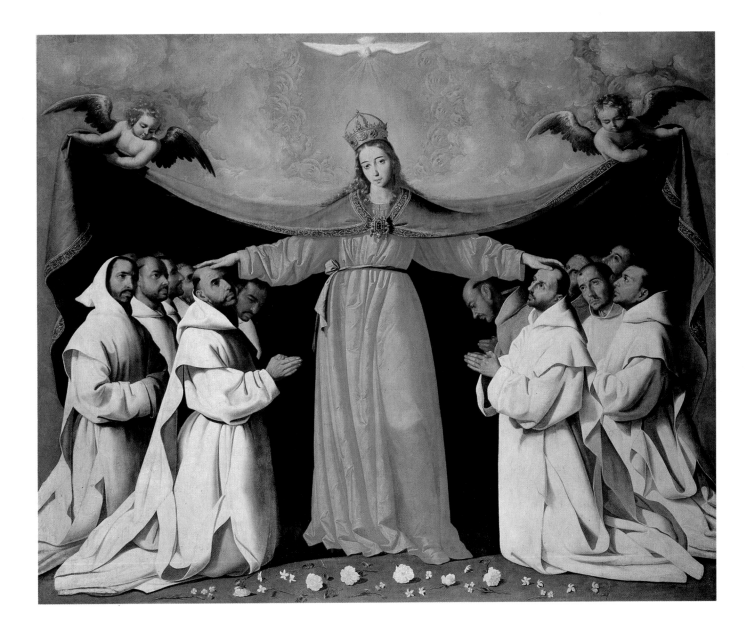

Enguerrand Quarton. *The Virgin of Mercy of the Cadard Family*, ca. 1452. Panel transferred to canvas, 26 in. × 6 ft. 1⅝ in. (66 × 187 cm). Musée Condé, Chantilly

Schelte à Bolswert. *Saint Augustine as Protector of the Clergy*, 1624. Engraving. Bibliothèque Nationale, Paris

well have drawn upon the same iconographic source.

This masterpiece by Zurbarán found little favor among Spanish art historians of the early twentieth century, and was even criticized as being "Gothic" and "archaic," which only obscured the issue of its dating. Cascales y Muñoz considered it "weak" because the expression of the Virgin lacked gentleness and piety, while the monks seemed "too impassive."[5] Other authors found the lighted parts too "harsh" and the dark passages too "monotonous."[6] One of the painting's sole champions in his day, Gabriel Rouchès, declared that, in his opinion, there were few more compelling works in the Seville Museo de Bellas Artes. For him, the beautiful colors of the Virgin's costume and the spiritual expressions of the monks, despite their coarse features, were nothing

less than extraordinary.[7] Rouchès's opinion has a special significance, for he was a leading expert on Italian art, the Carracci in particular; perhaps he saw in this work a reflection of the Bolognese art that was so close to his heart. Finally, it should not be forgotten that no less an apostle of Neoclassicism than Ponz, who had long sojourned in Seville, ranked the Las Cuevas pictures among Zurbarán's best works and praised the artist's "great skill, his naturalness, and the power of his chiaroscuro."[8]

To an unbiased observer today, the *Virgin of Mercy of Las Cuevas* stands as a unique work, indeed even an innovative one, for Zurbarán managed to avoid the pitfalls of the medieval model, thanks to his sense of the monumental and his attention to naturalistic detail. Like his friend Velázquez and after having seen

Italian works in Madrid, he sought to render relief in full light, without resorting to hard shadows; his modeling is more precise than in earlier works, following the forms closely, and the passage from light to shade is judiciously graded.

A born colorist, Zurbarán chose colors for the mantle and robe that harmonize perfectly to set off the white of the stiff Carthusian habits, which, when seen close up, look like an exercise in abstract painting. The exquisitely rendered roses and jasmines strewn on the ground demonstrate Zurbarán's skill as a *bodegonista*, or painter of still life. The chiaroscuro effects display a consummate mastery: each of the faces beneath the mantle has just the right degree of light and shade required by its position. One could almost evoke a connection with the Lombard school.

The Virgin's features are plain, but she wears a touching, melancholy expression that is quite natural. The intent faces of the monks, who seem to be struck with awe at the miracle before them, are no less admirable. This is not a grand religious spectacle like the famous *Apotheosis of Saint Thomas Aquinas* (Museo de Bellas Artes, Seville), but rather a work of great inwardness in which Zurbarán gives expression to the subtleties of the spiritual life and to the stillness of the Carthusian cloisters. Indeed, the austerity of Carthusian life no doubt made a deep impression on the painter and had an influence on his art. Zurbarán must in turn have been appreciated by his religious patrons, for, with great naturalness and without modifying his style, he depicted on his canvases the visions that he was asked to paint and not his own.

The date of the painting that has generally been accepted by art historians, with the exception of Gudiol, is 1635; but, as we have already pointed out, there is no conclusive evidence for this. To contend that the composition is archaic in style merely because it is based on a medieval model is not very convincing. It should be remembered that the Carthusian Order had remained faithful to its rule from the Middle Ages, and so had not been obliged to reform after the Council of Trent like most of the other orders. In the case of this commission, the prior simply asked the painter to work according to a traditional iconographic scheme, and Zurbarán's treatment, which is anything but Gothic, is in line with that of his contemporaries who were influenced by Italian art of the 1650s. One last point to consider is that laboratory examinations have revealed that the painting was executed on a light gray-brown ground, in the manner of Velázquez, and not on a dark brown ground like the works of Zurbarán's early period.

The frame that held Zurbarán's *Virgin of Mercy of Las Cuevas*, sacristy, Monastery of Santa María de las Cuevas, Seville

NOTES
1. Perdrizet 1908, pp. 21–23.
2. *Ibid.*, pp. 54–55.
3. Vallier 1891, pl. xiv, fig. 4.
4. Maigreto 1624, pl. 28.
5. Cascales y Muñoz 1911, p. 174.
6. *Ibid.*
7. Rouchès, course lecture given at the Ecole du Louvre, Paris, 1942.
8. Ponz 1778 (1947 ed.), p. 740.

PROVENANCE
Monastery of Santa María de las Cuevas, Seville; Alcázar, Seville, 1810, Room 7, no. 222; Monastery of Santa María de las Cuevas, Seville, 1814; Museo Provincial de Bellas Artes, Seville, 1836 (inv. 1840, no. 1989).

LITERATURE
Ponz 1778 (1947 ed.), p. 740; Ceán Bermúdez 1800, VI, p. 51; González de León 1844, II, p. 253; Gómez Imaz 1896, no. 222; Cascales y Muñoz 1911, p. 174; Seville, Museo Provincial de Bellas Artes, 1912, no. 194; Kehrer 1918, pp. 65–71; Serra y Pickman and Hernández Díaz 1934, pp. 19–20; Guinard 1949, pp. 1–6; Serra y Pickman 1950, p. 209; Soria 1953, no. 68; Cuartero y Huerta 1954, II, pp. 16–17, 627; Guinard 1960a, no. 473; Bravo and Pemán 1963a, pp. 5–13; Caturla, in Madrid, Casón del Buen Retiro, 1964, p. 19; Salas 1964b, p. 136; Hernández Díaz, in Seville, Museo Provincial de Bellas Artes, 1967, no. 151; Caturla 1968; Brown 1974, pp. 60–62; Guinard and Frati 1975, no. 118; Gállego and Gudiol 1977, no. 298.

EXHIBITED
Seville 1964, no. 151; Madrid 1964–65, no. 64.

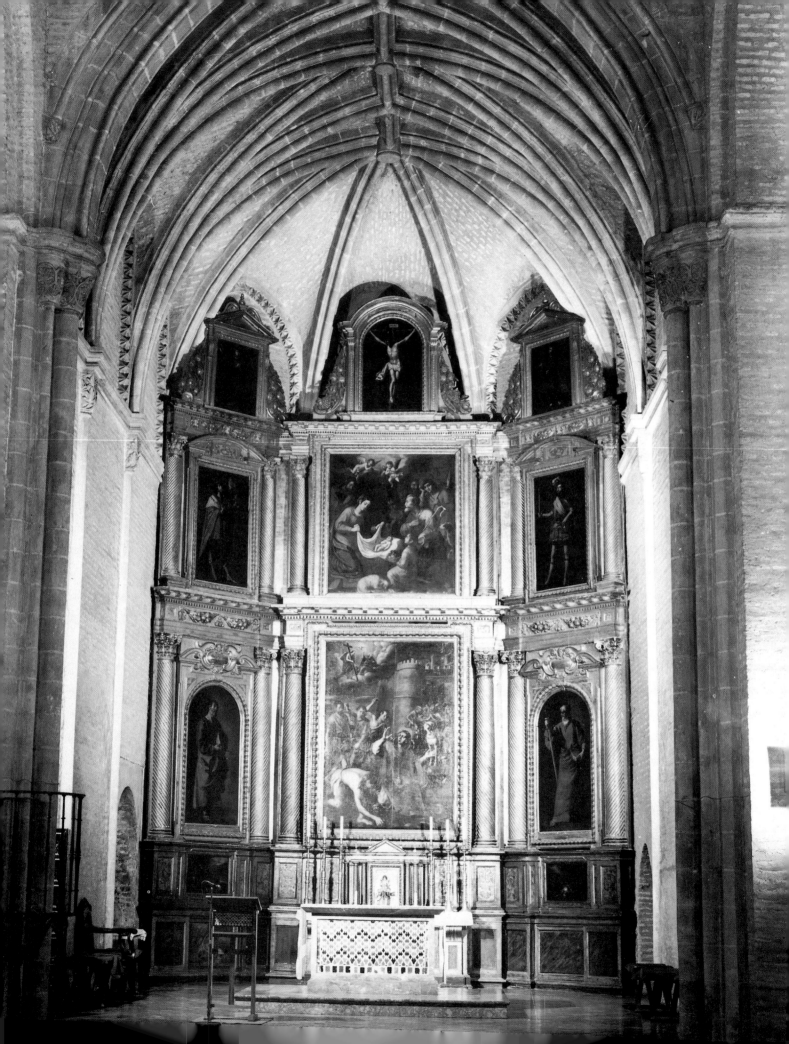

THE CHURCH OF SAN ESTEBAN, SEVILLE

According to Arana de Varflora, the parish church of San Esteban in Seville, situated not far from the Casa de Pilatos, was at one time a mosque.[1] During the fourteenth and fifteenth centuries, it was remodeled with piers and dried-brick arches.

The church has remained almost intact—which is rare for a church in Seville—and the recently restored gilded wood altarpiece of the high altar, which bears the date 1660, still holds the original seventeenth-century paintings. The central composition, which represents the martyrdom of Saint Stephen, used to be attributed without foundation to Zurbarán. But neither does it seem to be the work of his pupils the Polanco brothers, as some have claimed.

The *Saint Peter* (cat. no. 39) and the *Saint Paul* (cat. no. 40), however, which occupy, respectively, the left and the right compartments of the first story of the altarpiece are undoubtedly by Zurbarán. The small pictures of the predella are of very inferior quality. The contract for these works, which are stylistically related to the production of Zurbarán's last ten years in Seville, has not been found.

NOTE
1. Arana de Varflora 1766 (1978 ed.), p. 41.

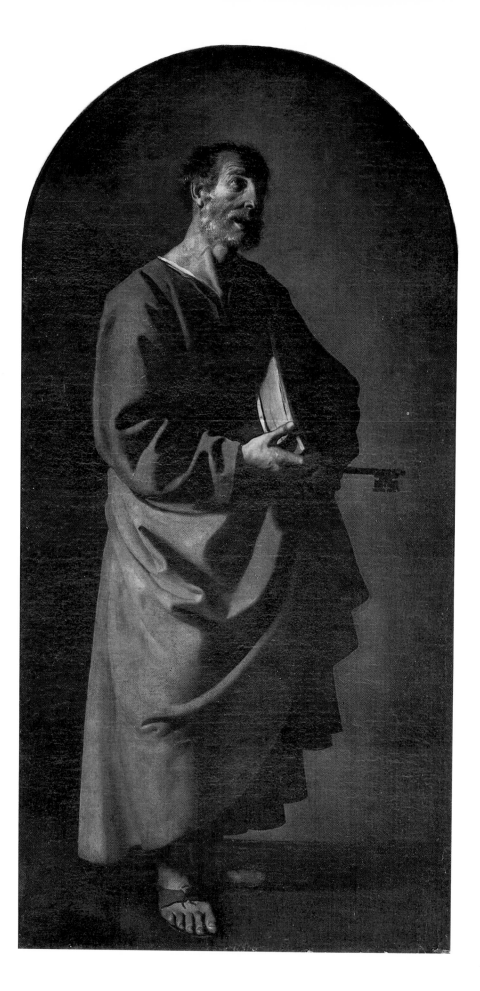

39.
Saint Peter

ca. 1650
Oil on canvas, 70⅞ × 43⅓ in. (180 × 110 cm)
Church of San Esteban, Seville

Original location: Seville, Church of San Esteban, main altarpiece, first story, left compartment
Date of contract: Not known. In April 1628, Luis de Figueroa was commissioned to make an altarpiece.
Location before 1808 according to early sources: Ponz 1780, *in situ*; Ceán Bermúdez 1800, *idem*; Matute, after 1800, *idem*

Saint Peter, designated by Christ as the head of the Church, and Saint Paul, the champion of the Christian faith among the Gentiles, have since earliest times been regarded with as much veneration as all the other Apostles together. The Church celebrates the martyrdom of these two saints on the same day, June 29; and they have thus long been represented together in art. Traditionally, Saint Peter is placed on the viewer's left, Saint Paul on the viewer's right. The exegetes of the Counter-Reformation, Molanus and Pacheco, took great care to explain this disposition, as it might have seemed inappropriate;[1] indeed, one would think that Peter, as the leader of the Church, should occupy the place of honor, on the right. The explanation lies in the saints' being placed to the right and to the left of the altar—that is, the Divine presence. Peter, who participated in the life of Christ, is therefore on Christ's right (that is, the viewer's left), on the Gospel side of the altar, so called because the priest reads the Gospel, an account of Christ's life, from the lectern on this side of the church. Paul is on Christ's left (the viewer's right), or the Epistle side of the church, because his famous letters are read from the lectern on this side.

In his *Ecclesiastical History*, written in the fourth century, Eusebius of Caesarea reported that portraits of the two saints had been painted by pagans whom they had converted. Pacheco mentions copies of the original portraits in Granada and Seville.[2] Thus it was known that Peter had short, thick, curly hair; dark eyes reddened by tears; and a rather large nose; and that he was clothed in blue and in orange robes. Zurbarán portrays the saint in keeping with this long-established convention and with his traditional attributes, the keys to the Kingdom of Heaven and the Gospel to spread the message of Christ.

A comparison between the present *Saint Peter*, in the Church of San Esteban, and the version painted for the altarpiece of the Chapel of San Pedro, in the Cathedral of Seville, gives a good idea of Zurbarán's development as an artist.

The *Saint Peter* in Seville Cathedral displays the heavy forms, the stiff gestures, the awkward attitude taken from a stereotyped model, the somewhat sketchy execution, and the opaque colors characteristic of Zurbarán's paintings from 1630 to 1635; in the San Esteban *Saint Peter*, the attitude of the figure is more relaxed, the volumes are more balanced, and the figure conforms more naturally to the shape of the compartment. Similarly, the San Esteban *Saint Peter* is more natural and less tenebrist than the one painted for the *Apostolado* in the Museu Nacional de Arte Antiga, Lisbon, which is signed and dated 1633. Advancing calmly, the figure seems absorbed in a mystical dialogue, alert but free of anxiety. The superb color scheme is limited to the blue-green of the tunic, the ocher of the mantle, and the grays of the transparent background and slightly disheveled beard, with a touch of white visible at the collar. The naturally falling drapery forms a cascade of cup-shaped folds in the shadows on the right. With a skillful lighting scheme, Zurbarán obtains the effect of high relief without resorting to tenebrist techniques. The handling is sure, and rich without excessive impasto, and creates with the same efficacy as in the earlier works the play of light on three-dimensional forms, with the difference that now transitions from dark passages to full light are produced through the use of half-shadows and glazes.

NOTES
1. Molanus 1570, book 3, chap. 34; Pacheco 1649 (1956 ed.), II, p. 313.
2. Pacheco 1649 (1956 ed.), II, p. 314.

PROVENANCE
Church of San Esteban, Seville; the altarpiece was dismantled at the beginning of the nineteenth century, and the paintings were dispersed throughout the church; in 1972, the paintings were restored and the altarpiece reconstructed.

LITERATURE
Ponz 1780 (1947 ed.), p. 782; Ceán Bermúdez 1800, VI, p. 48; González de León 1844, pp. 236–37; Matute 1887b, p. 76; Gestoso y Pérez 1889, I, p. 255 (description of the original order of the altarpiece); Mayer 1911, pp. 160–61; Guinard 1946, pp. 260–62; Caturla 1959, p. 342; Guinard 1960a, no. 154; Torres Martín 1963, no. 40; Guinard and Frati 1975, no. 149; Gállego and Gudiol 1977, no. 329; Morales *et al.* 1981, pp. 119–20.

40.
Saint Paul

ca. 1650
Oil on canvas, 70⅞ × 43⅓ in. (180 × 110 cm)
Church of San Esteban, Seville

Original location: Seville, Church of San Esteban, main altar-
piece, first story, right compartment
Date of contract: Not known. In April 1628, Luis de Figueroa
was commissioned to make an altarpiece.
Location before 1808 according to early sources: Ponz 1780,
in situ; Ceán Bermúdez 1800, *idem*; Matute, after 1800, *idem*

The iconography of Saint Paul was as well estab-
lished as that of Saint Peter, and Zurbarán scrupu-
lously respected the conventions for the Apostle's
appearance. He was to be represented bald, slightly
stooped, and with a pale complexion; he was to have
a long, rather thick beard flecked with white, and to
appear slightly older than he was. The color of his
clothing was to be red and green.[1] His traditional at-
tributes were a book and a great sword, the instrument
of his martyrdom; Saint Paul, as a Roman citizen,
was decapitated.

Generally speaking, Zurbarán had more facility in
representing figures in three-quarter view than fron-
tally. As placed on the altarpiece, the figure of Saint
Paul appears to be advancing toward the viewer, his
torso bent slightly forward. Although the painting
does not express the tranquil power of the *Saint Peter*
of the same altarpiece (cat. no. 39), the figure dis-
plays a nobility and monumentality not found in the
Apostolados that Zurbarán painted for the Latin Ameri-
can colonies. The figure is more formal than the one
in the picture at the Monastery of San Francisco de
Jesús, in Lima, who is shown reading, with his elbows
resting on a table; and he is less rustic than the figure
in the version at the Museu Nacional de Arte Antiga,
Lisbon. Here, he appears as the unquestioned spokes-
man for the Christian faith; his face, with pensive
gaze, is like that of an old scholar. Zurbarán had now
mastered the construction of forms and could liber-
ate himself from conventional formulas.

The position of the right arm, which throws a
shadow on the saint's chest, creates a chiaroscuro ef-
fect accentuated by tonal values graded according to
the degree of light cast at each given point, a tech-
nique learned from Velázquez that conveys the im-
pression of high relief. Since the figure is shown
frontally against a uniform background, its shadow
would not normally be visible behind it; nor would
the deep shadows of the folds on the right be them-
selves sufficient to make the volumes "turn" if they

were not complemented by contrasting effects on
the left.

Zurbarán tried to animate the compositions of the
Saint Peter and the *Saint Paul* not only by varying the
poses of the figures but also by contrasting the cool
colors of one with the warm tones of the other. The
refinement of Zurbarán's conception, along with the
rich brushwork and the expertly modulated coloring,
suggests a dating late in his career.

We would point out in closing that in 1639 the al-
tarpiece of the high altar was still in the course of ex-
ecution and that it was not completed before 1660.
This would suggest that the paintings were not put
in place until shortly before this date.

NOTE
1. Pacheco 1649 (1956 ed.), II, p. 314.

PROVENANCE
Church of San Esteban, Seville; the altarpiece was dismantled at
the beginning of the nineteenth century, and the paintings were
dispersed throughout the church; in 1972, the paintings were re-
stored and the altarpiece reconstructed.

LITERATURE
Ponz 1780 (1947 ed.), p. 782; Ceán Bermúdez 1800, VI, p. 48;
Matute 1887b, p. 76; Guinard 1960a, no. 161; Torres Martín 1963,
no. 41; Guinard and Frati 1975, no. 151; Gállego and Gudiol 1977,
no. 330.

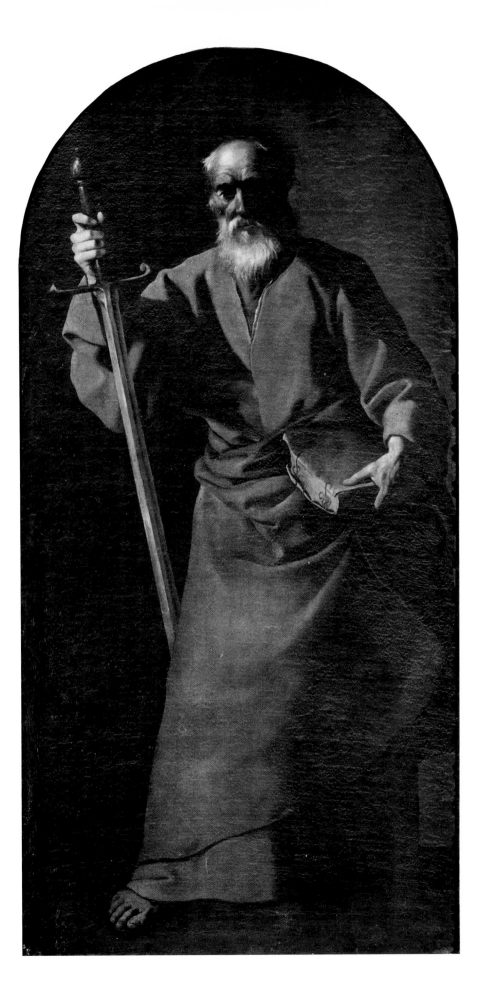

THE MONASTERY OF SAN DIEGO DE ALCALA, ALCALA DE HENARES

Shortly after moving to Madrid in 1658, Zurbarán received a commission from the community of Franciscan Observants at the Monastery of San Diego de Alcalá, in nearby Alcalá de Henares. For the chapel dedicated to the titular saint, he painted the *Visit of Saint Thomas Aquinas to Saint Bonaventure* (cat. no. 41) and the *Saint James of the Marches* (Museo del Prado, Madrid). For the same chapel, Alonso Cano painted *Saint Anthony with the Christ Child* (Real Basilica de San Francisco el Grande, Madrid), of the same dimensions, and the *Stigmatization of Saint Francis* (whereabouts unknown).

According to Palomino, the Franciscans first commissioned Cano to paint the entire ensemble; however, he completed only the *Saint Francis*, leaving the *Saint Anthony* unfinished. Palomino also noted that Bartolomé Román completed the *Saint Anthony* and painted the other pictures in the chapel.[1] Ponz repeated these attributions for the four large paintings that decorated the side walls of the chapel.[2]

The first mention of the two paintings by Zurbarán occurs in the inventory of the Museo de la Trinidad, Madrid, where the paintings were deposited when Church property was confiscated in 1835. In that document, the *Visit of Saint Thomas Aquinas to Saint Bonaventure* and the *Saint James* are noted as signed by Zurbarán. In 1882, the pictures were turned over to the Real Basilica de San Francisco el Grande. The *Visit of Saint Thomas Aquinas* was catalogued by Cruzada Villaamil in 1865 as by Román and Zurbarán.[3] Forty years later, at the time of the monographic exhibition of 1905 at the Prado, the signature was again noted and the work attributed to Zurbarán alone, although specialists continued to have their reservations. In 1927, Tormo y Monzó judged it "stylistically close to [Zurbarán], but not authentic."[4] Guinard, in 1960, suggested that Zurbarán completed the painting after the death of Román, which he placed in 1659.[5] In 1976, Pérez Sánchez affirmed the true importance of the work.[6] The attribution to Zurbarán, already attested by the signature, was finally confirmed by the discovery that Román actually died in 1647, thus eliminating all possibility of a collaboration. On the basis of that discovery, Wethey pushed back the dating of Cano's two pictures to 1658 or 1659, during that artist's last sojourn in Madrid.[7] Palomino's assertion that Román succeeded Cano in the commission is now disproved; instead, it appears that Zurbarán succeeded Cano, producing both the *Visit of Saint Thomas Aquinas* and the *Saint James* in about 1659–60. The style of these pictures, moreover, is indeed characteristic of Zurbarán's last years in Madrid.

NOTES
1. Palomino 1724 (1947 ed.), p. 885.
2. Ponz 1780 (1947 ed.), p. 118.
3. Cruzada Villaamil, in Madrid, Museo del Prado, 1865, no. 314.
4. Tormo y Monzó 1927, p. 95.
5. Guinard 1960a, no. 393.
6. Pérez Sánchez, in Paris, Petit Palais, 1976, no. 72.
7. Wethey 1983, pp. 82, 133.

41.
The Visit of Saint Thomas Aquinas to Saint Bonaventure

ca. 1659–60
Oil on canvas, 9 ft. 6¾ in. × 5 ft. 5 in. (291 × 165 cm)
Signed, lower right: Franᶜᵒ de Zurbaran
Real Basilica de San Francisco el Grande, Madrid

Original location: Alcalá de Henares, Monastery of San Diego,
 Chapel of San Diego de Alcalá
Date of contract: Not known

In 1629, for the church of the Franciscan monastery in Seville, Zurbarán painted the meeting of two of the great thirteenth-century theologians, Saint Bonaventure, the Doctor Seraphicus of the Franciscans, and Saint Thomas Aquinas, the Doctor Angelicus of the Dominicans. The painting, *Saint Bonaventure and Saint Thomas Aquinas before the Crucifix* (formerly Kaiser Friedrich Museum, Berlin; see illus. on page 83), shows the learned Franciscan indicating to his Dominican friend the crucifix as the sole source of all his knowledge.

The present painting, done for the Franciscan monastery at Alcalá de Henares, depicts another celebrated episode in the friendship of the two "princes of scholastic theology." Fellow students at the University of Paris, they studied together with the Franciscan theologian Alexander of Hales, and both received their degrees in 1248. Sixtus V, who in 1585 declared Saint Bonaventure a Doctor of the Church, described the strong bond between the two great sages: "There exists between them a perfect union, a marvelous similitude of virtue, sanctity, and merit."[1]

At the chapter general of the Franciscan Order, held in Narbonne in 1260, the capitulary fathers asked Bonaventure, then the general of the order, to write a complete life of Saint Francis in order to fix the traditions that had grown up around their founder and to promote a deeper and more meaningful image of him than that conveyed by the early biographers. Bonaventure set to work immediately, interviewing persons still living who had known the saint, and making pilgrimages to the sites where Francis had lived or that he had visited.[2] After three years of research, he wrote in 1266 the *Legenda maior*, the only biography of Saint Francis authorized by the chapter general of Pisa.

In this painting, Saint Bonaventure is shown seated at his table, writing his life of Saint Francis. While he is ecstatically engaged in his work, a Franciscan monk ushers Saint Thomas Aquinas into the room. The Dominican begs the friar not to disturb his friend,

uttering the celebrated phrase "Let a saint work for a saint."[3] Both words and image attest to the perfect friendship of the two great theologians, whose methods differed more than their conclusions.

The *Visit of Saint Thomas Aquinas to Saint Bonaventure* is iconographically similar to Zurbarán's other portraits of churchmen shown in their studies. As in the *Bishop Gonzalo de Illescas*, 1639 (see fig. 11, page 10), painted for the Monastery of San Jerónimo in Guadalupe, the saint is shown seated at a table on which are books, an inkwell, and a crucifix. A biretta completes the remarkable still life on Saint Bonaventure's table. The treatment of the face and of the

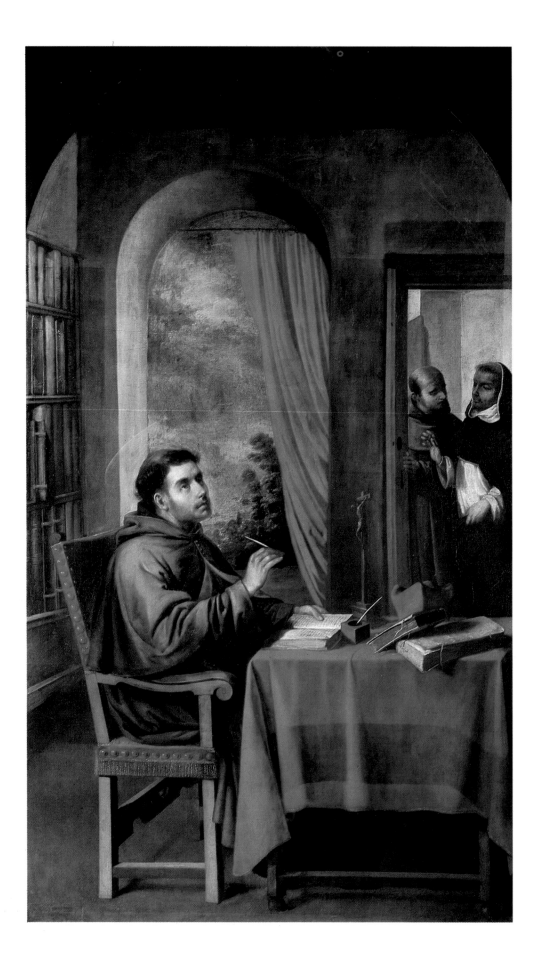

hand holding the pen do not, however, convey the same character and expressiveness, and in the architectural background, the opening onto the landscape and the scene in the doorway obey different rules of perspective. But the light and the delicately nuanced treatment of the landscape, the suppleness of the folds in the sumptuous red hanging, and the play of warm colors are characteristic of the best works of this period in Madrid, when Zurbarán both assimilated new stylistic currents and strengthened his innate talent as a colorist.

NOTES

1. *Dictionnaire de théologie catholique*, 1923, II, 1, col. 981.
2. Clop 1922, p. 74.
3. Boule 1747, p. 71.

PROVENANCE

Monastery of San Diego, Alcalá de Henares; Museo de la Trinidad, Madrid, 1835; Real Basilica de San Francisco el Grande, Madrid, since 1882.

LITERATURE

Palomino 1724 (1947 ed.), pp. 885, 988; Ponz 1780 (1947 ed.), p. 118; Ceán Bermúdez 1800, IV, p. 245 (attributed to B. Román); Madrid, Museo de la Trinidad, 1835 (Gaya Nuño 1947, p. 59); Cruzada Villaamil, in Madrid, Museo del Prado, 1865, no. 314; Viniegra, in Madrid, Museo del Prado, 1905, no. 53; Tormo y Monzó 1927, p. 95 ("stylistically close to [Zurbarán], but not authentic"); Guinard 1960a, p. 255, under no. 393 ("perhaps completed by Zurbarán after the death of Román in 1659"); García Barriuso 1975, p. 510, no. 47 (as *Saint Bonaventure and the Visit of His Friend Saint Thomas Aquinas*); Pérez Sánchez 1976, pp. 77–80; Pérez Sánchez, in Paris, Petit Palais, 1976, no. 72 (calls attention to signature); Gállego and Gudiol 1977, no. 526; Wethey 1983, pp. 82, 133.

EXHIBITED

Madrid 1905, no. 53; Madrid 1927, no. 33; Paris 1976, no. 72.

INDEPENDENT WORKS

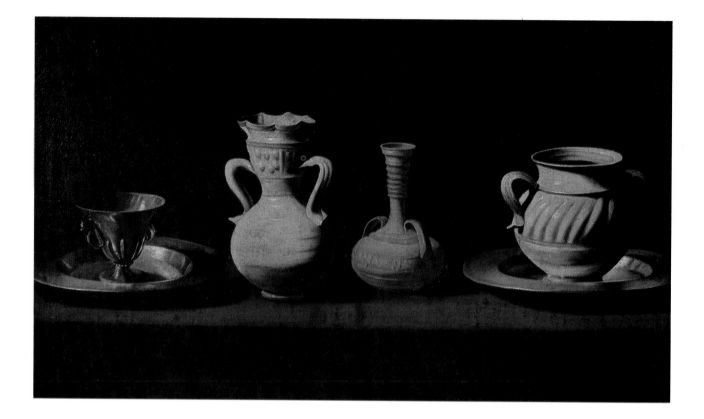

42.
Still Life with Pottery and Cup

ca. 1635–40
Oil on canvas, 18⅛ × 33⅛ in. (46 × 84 cm)
Museu d'Art de Catalunya, Barcelona

Throughout his career, Zurbarán took great care in the representation of simple objects: from the rose and cup that appear in one of his first known paintings, the *Miraculous Healing of the Blessed Reginald of Orléans* (Church of La Magdalena, Seville), to the fruits in a pewter dish in the *Virgin and Child with Saint John*, dated 1662 (Museo de Bellas Artes, Bilbao). Still-life elements in religious scenes can be interpreted as symbolic of the accompanying figures; thus, the lilies often shown with the Virgin serve as a symbol of her purity.

Given Zurbarán's interest and expertise in the representation of still-life elements, it is surprising that there is only one known independent signed still life in Zurbarán's oeuvre, the *Still Life with Lemons, Oranges, and Cup*, dated 1633 (Norton Simon Foundation, Pasadena). This stunning work, which is mentioned for the first time in 1924 in connection with the Contini Bonacossi collection in Rome, has been widely

appreciated for the purity of the forms and the simplicity of the composition, and for its transcendent and mystical character.

The *Still Life with Pottery and Cup* is a closely related work, characterized by the same rigor in the frieze-like disposition of the objects, the same attention to the rendering of volume, and the same way in which the objects are brilliantly lighted against a dark background. The symmetry here, less apparent than in the Norton Simon picture with its three elements, is provided by the two pewter plates set on either side of the pair of jars, which receive the full light. The alternation of colors and the variety in the forms of the handles lend rhythm to the otherwise severe alignment of objects unrelieved by the perfume of a flower or the aroma of a fruit. The austere disposition of the still-life elements, which the Italian art historian Roberto Longhi so rightly compared to the disposition of liturgical vessels on an altar,[1] is also seen on the tables in the *Saint Hugh in the Refectory* (cat. no. 37) and the *Supper at Emmaus* (cat. no. 51).

In spite of the kinship between this still life, the Norton Simon *bodegón*, and the terra-cotta vessels in

the religious paintings, the picture's attribution has been questioned. This reservation may be explained by the existence of an identical painting now in the Museo del Prado, Madrid, which is considered to be of superior quality. Both works formerly belonged to the Catalan collector Francisco Cambó, who gave one picture to the Prado and the other to the Museu d'Art de Catalunya, Barcelona. Until they can be compared side by side, the differences in the two works would seem to be negligible—the metallic reflections and the texture of the pots are, for example, more accentuated in the Barcelona picture. Both Pemán and Guinard, observing some awkwardness in the execution of the pewter plates, have suggested the collaboration of Zurbarán's son Juan.[2] The short career of this painter, who died in 1649 at the age of twenty-nine, is becoming better known thanks to the existence of three signed and dated works: the *Still Life with Grapes*, 1639 (Lung collection, Bordeaux); the *Chocolate Service*, 1640 (Museum of Western and Oriental Art, Kiev); and the *Basket of Fruit with Artichoke*, 1645 (Mänttä Gösta Serlachius Fine Arts Foundation, Finland). However, the number of objects in Juan de Zurbarán's still lifes and the dark atmosphere surrounding them differ markedly from the Barcelona picture. William Jordan noted in particular that the flange of the silver plate with the grapes in the *Still Life with Grapes* is handled in a stiffer manner than are the edges of the two saucers under the jars in the present work, an observation that argues against an attribution to Juan de Zurbarán.[3]

The dating of the *Still Life with Pottery and Cup* is also controversial. Pérez Sánchez notes a similar long-necked red jug, of a type rarely found in Andalusia, in a still life by the Madrid painter Franciso Palacios (Harrach collection, Vienna), and he suggests that Zurbarán could have executed his own still life in Madrid during a stay prior to his visit in 1634.[4] Jordan, noting that the drawing has lost the sharpness of the 1630s, favors a later dating, possibly about 1650, because the jar on the right may also be seen in Zurbarán's *Virgin of the Annunciation* in the March collection, Palma de Mallorca, which is contemporary with the Philadelphia *Annunciation* (cat. no. 58), dated 1650.[5] Further clues about the date of execution may be provided by the other objects: the white terra-cotta jug, called an *alcarraza*, is of a type of pottery that was commonly produced at Andújar (Jaén) and Triana (Seville); and the gilded metal cup has highlights rendered by small parallel brushstrokes similar to those of the pincers held by Saint Apollonia in the painting dated to about 1635–40 (cat. no. 21).

Zurbarán was very likely influenced by certain works by Sánchez Cotán and by Juan van der Hamen that he could have seen in Granada or Seville. The picture was probably executed in Seville, a few years after the 1633 *Still Life with Lemons, Oranges, and Cup*, thus between 1635 and 1640.

NOTES
1. Longhi, in Rome, Gal. Nazionale d'Arte Moderna, 1930, no. 65.
2. Pemán 1958, p. 203; Guinard 1960a, pp. 181–82.
3. Jordan, in Fort Worth, Kimbell Art Museum, 1985, p. 225.
4. Pérez Sánchez, in Madrid, Museo del Prado, 1983b, p. 86.
5. Jordan, in Fort Worth, Kimbell Art Museum, 1985, p. 227.

PROVENANCE
Collection of Francisco Cambó, Barcelona; donated to the Museu d'Art de Catalunya, Barcelona, in 1941.

LITERATURE
Seckel 1946, pp. 287–88; Soria 1953, no. 74; Sánchez Cantón 1955, pp. 82–84; Pemán 1958, pp. 193–211; Soria 1959b, pp. 273–80; Guinard 1960a, no. 610; Torres Martín 1963, no. 108; Buendía 1965, p. 278; Guinard and Frati 1975, no. 104; Gállego and Gudiol 1977, no. 542; Munich, Haus der Kunst, 1982, no. 100; Pérez Sánchez, in Madrid, Museo del Prado, 1983b, pp. 76, 86; Jordan, in Fort Worth, Kimbell Art Museum, 1985, pp. 222, 223; Mena Marqués, in Florence, Palazzo Vecchio, 1986, no. 46.

EXHIBITED
Munich and Vienna 1982, no. 100; Barcelona 1983, no. 4; Florence 1986, no. 46.

43.
Saint Margaret of Antioch

Before 1635?
Oil on canvas, 6 ft. 4⅜ in. × 3 ft. 8 in. (194 × 112 cm)
The Trustees of The National Gallery, London

The cult of Saint Margaret of Antioch—called Marina in the East—one of the fourteen "auxiliary" saints, was brought back from the Orient by the Crusaders in the eleventh century and was particularly popular in the Late Middle Ages.

Margaret's fame rests on a legend of dubious historical veracity. The only daughter of a pagan priest during the reign of Diocletian, she lost her mother at an early age and was raised in the country by a nurse who gave her instruction in the Christian religion. The prefect Olybrius, struck by her beauty, wanted to wed her. Margaret refused his advances, whereupon he denounced her as a Christian, subjecting her to imprisonment and torture, such as having her sides torn by "claws of steel."[1] In the dungeon cell, the Devil appeared to Margaret in the form of a dragon, but she repulsed him by making the sign of

the cross. She was beheaded in the late third century. Her feast day is July 20.

According to a medieval legend, she was swallowed by the dragon, but was able to pierce her way out of his bowels with a small cross; thus, she became the patron saint of women in childbirth, who invoked her aid so that their children might emerge as easily as she had from the dragon's belly!

Zurbarán's representation of Saint Margaret takes these traditions into account. The figure's attire alludes both to her high birth and to her rural upbringing. The book she holds signifies her education and her devotion to the Gospel, and the shepherd's crook refers to her early occupation. The vanquished dragon roars impotently behind her.

The rustic costume worn by Saint Margaret, an exceptional feature among Zurbarán's pictures of virgin martyrs, suggests that the painting is the "Portrait of a Peasant Girl," no. 191 in the inventory of paintings in the apartments of the Prince of Asturias (the future Carlos IV) at the Casita del Príncipe of the Escorial in 1789.[2] It may have been one of the three paintings given by Queen Isabella II to the 2d Baron Ashburton,[3] in whose family it remained until it was purchased by The National Gallery in 1903. The picture was obviously painted in Seville, as can be seen by comparing it with the *Saint Agatha* (cat. no. 11) executed by Zurbarán for the Monastery of the Merced Calzada a few years after his arrival in that city: the same model posed for both pictures, the figure leans forward in the same way, and the same strong lighting offsets the figure against a dark and uniform background. The bright light brings out the milky complexion heightened by the rosy cheeks and the flawless modeling. Soria rightly compares the flat treatment of the face with that in the portrait of an unidentified Mercedarian friar (Alonso de Sotomayor?) painted about 1631 for the library of the Merced Calzada (and now in the Academia de San Fernando, Madrid).[4]

This picture is larger than the *Saint Apollonia* (cat. no. 21) or the *Saint Lucy* (cat. no. 22), both of which were altar paintings, and it does not seem to belong to a series, which would have entailed the collaboration of Zurbarán's workshop. It should therefore be considered an isolated work, a devotional subject on which the artist lavished special attention. The colors of the country garb are rendered with great skill and refinement, and the dense textures of the wool skirt and leather vest contrast with the delicate pleats of the blouse adorned with fine cords that frame the coral-and-jet necklace. The dark blue jacket sets off the colored bands of the *alforjas* (a sort of double-sided cloth saddlebag), and the curves of the straw hat are repeated in the undulations of the head and tail of the dragon, which the saint seems either to disdain or to ignore.

Ceán Bermúdez mentions a *Saint Margaret* in the Royal Palace, Madrid, that is known today only through a 1794 engraving by Bartolomé Vázquez.[5] That picture was smaller (156×91 cm) than the London version and presented several differences too obvious to be attributed to León Bueno, the draftsman who copied it for the engraver (the figure, for example, was shown thrusting a pike into the monster's jaws).[6]

The charming and elegant figure of Saint Margaret seems to have stepped off a theater stage. Historians often mention as possible sources of inspiration the religious processions and parade platforms drawn through the streets of Seville on holy days, but Zurbarán may have been no less inspired by the *comedias de santas* that were performed in Seville. Heroines such as Saint Joan and Saint Margaret in *comedias* by Tirso de Molina and Enciso were always young and beautiful, their beauty considered a gift from heaven, a mysterious emanation of the soul.[7]

NOTES
1. Ribadeneyra 1624, p. 459.
2. "Uno cuadro de 2 varas y media de caida y 5 quartas de ancho; Retrato de una Paisana con unas Alforjas colgadas del brazo, en cuya Mano tiene un librito: Original de Fran.co de Zurvaran." Cited in MacLaren and Braham, in London, National Gallery, 1970, p. 140, after the nineteenth-century copy of the inventory in the possession of the Duke of Wellington.
3. Letter from Lord Northampton dated 1951, cited in MacLaren and Braham, in London, National Gallery, 1970, p. 140.
4. Soria 1953, no. 56.
5. Ceán Bermúdez 1800, VI, p. 52.
6. A pre-1808 engraving by E. Longee is reproduced in Laborde 1820, IV, p. 66.
7. Roux 1974, pp. 144–47.

PROVENANCE
Collection of the Prince of Asturias (later Carlos IV), Casita del Príncipe, El Escorial (?) (inv. 1789, no. 191); probably given by Queen Isabella II to the 2d Baron Ashburton; collection of Lady Ashburton, London, 1871; acquired by The National Gallery from the 5th Marquess of Northampton, Lady Ashburton's daughter-in-law, in 1903.

LITERATURE
Kehrer 1918, p. 106; Soria 1944a, p. 167; Gaya Nuño 1948, p. 173; Soria 1948b, pp. 256–57; Guinard 1949, pp. 30–31; MacLaren, in London, National Gallery, 1952, pp. 85–87; Soria 1953, no. 56; Gaya Nuño 1958, no. 3004; Guinard 1960a, pp.148–49, no. 275; Torres Martín 1963, no. 53; Sáez Piñuela 1965, pp. 285–89; Trapier 1967, p. 417; MacLaren and Braham, in London, National Gallery, 1970, pp. 138–40; Brown 1974, pp. 104–6; Guinard and Frati 1975, no. 157; Gállego and Gudiol 1977, no. 180.

EXHIBITED
London 1871, no. 74; London 1947, no. 41.

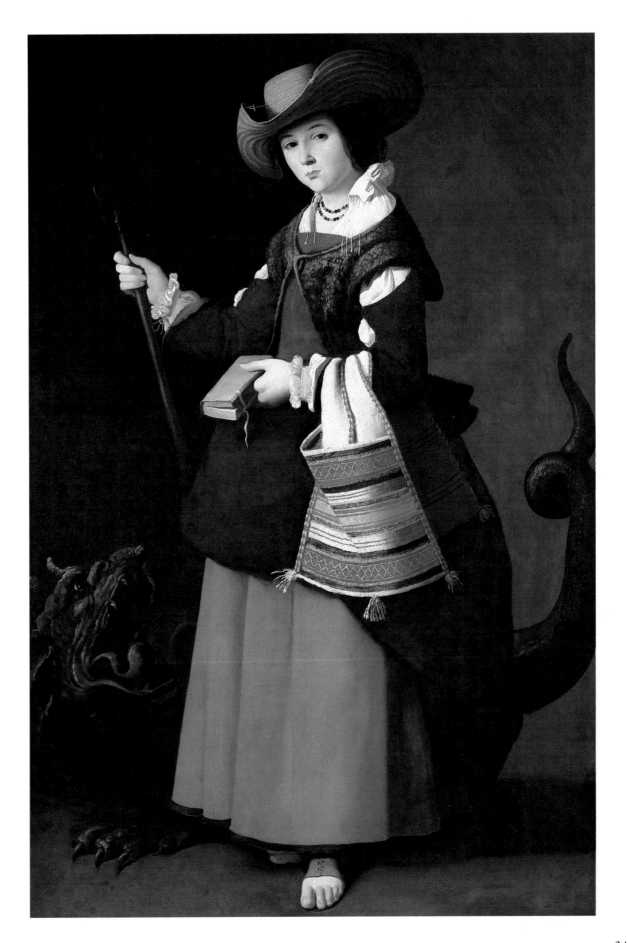

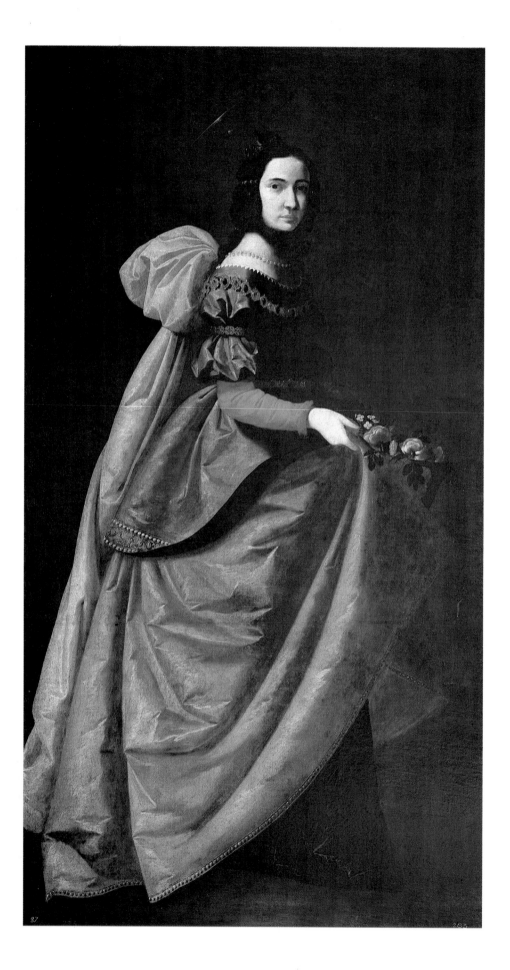

44.
Saint Elizabeth of Portugal

ca. 1630–35
Oil on canvas, 6 ft. ½ in. × 35⅜ in. (184 × 90 cm)
Museo del Prado, Madrid

The "pearl of the House of Aragon," Saint Elizabeth, the daughter of Peter III of Aragon, was born in 1271. She was named after her great-aunt, Saint Elizabeth of Hungary, who lived from 1207 to 1231 and was canonized in 1235. The young Aragonese princess was married at the early age of twelve to King Dinis of Portugal. Modeling her life on that of her celebrated relative, she practiced self-mortification and charity, patiently endured the outrages of a quarrelsome husband who openly deceived her, and courageously intervened in the military conflicts that flared up between her husband and their son, Afonso IV. King Dinis died in 1325, having at last recognized his wife's virtues. His widow joined the Order of Saint Clare and set about building a convent of Poor Clares in Coimbra, where she lived until her death. Her last foundation, a sanctuary in the Convent of La Trinidad in Lisbon, was one of the earliest to venerate the doctrine of the Immaculate Conception. As reward for her devotion, the Virgin appeared to Elizabeth just before her death on July 4, 1336.

The legend depicted is that of the miracle of the roses, which was also experienced by Saint Casilda and Saint Diego de Alcalá. The miracle is reported in the *Vida de la gloriosa Santa Isabel de Portugal* (Madrid, 1625), which was translated from the Italian by Antonio de Vera y Zúñiga after an anonymous original text probably composed at the time of her canonization. According to that account, Elizabeth was carrying concealed in her clothing a large sum of money intended for charity. Encountering her husband, an unbeliever who was set against her almsgiving, she pretended to be carrying roses. And although it was winter, she did indeed show the king roses hidden in her garments. In art she is traditionally depicted bearing roses in her skirt.

Elizabeth of Portugal was honored by the diocese of Coimbra in 1516. When her tomb was opened, her body was found to be uncorrupted. This second miracle no doubt favored the petition for canonization submitted to Rome by the kings of Portugal; she was canonized by Urban VIII in 1626. Inscribed in the Proper of the saints of Spain for the date of July 8, Elizabeth was particularly venerated in that country and in Portugal. That devotion and her recent canonization surely engendered the considerable number of paintings produced in her honor in Spain in the seventeenth century.

Although traditionally identified as Casilda, the saint in the Prado painting is much more likely to be Elizabeth of Portugal. When Zurbarán painted Casilda, the daughter of a Moorish king, he pictured a more youthful figure, with hair unbound and clasped only by a row of pearls (as in the *Saint Casilda* in the Plandiura collection, Barcelona). Here, instead, we have an older woman of majestic bearing, royally clad in contemporary dress, and wearing a crown, perhaps the very one Elizabeth of Portugal donated to the sanctuary of Santiago de Compostela on the death of King Dinis.

The *Saint Elizabeth of Portugal*, noted for the first time in 1814, when it was in the Hall of the Fireplace in the Royal Palace, Madrid, is a work of Zurbarán's early years. How it came to Madrid from Seville is unclear. It has been suggested that it was acquired by Queen Isabella Farnese in the eighteenth century, but it does not bear her royal mark of ownership. Nor is there any documentary evidence that it was taken to Madrid during the War of Independence. Perhaps it was acquired by Carlos IV when the court sojourned in Andalusia in the early months of 1796. Carlos IV, a great admirer of seventeenth-century Sevillian painting, is known to have commissioned copies of Sevillian works, especially those by Murillo. In addition, the king regularly saw to it that pictures he liked entered the royal collections, one way or another. He appreciated the work of Zurbarán and already owned a portrait of "a peasant girl" attributed to the painter, which was in the Casita del Príncipe of the Escorial. Furthermore, the veneration of Saint Elizabeth of Portugal was a special devotion of the Spanish Bourbons. The picture entered the Prado from the Royal Palace.

The painting is probably not one of the series of female saints produced by Zurbarán and his workshop, because the canvas is higher and narrower than the usual format and because of its exceptional pictorial qualities. Guinard suggests that it was done for the Hospital de la Sangre in Seville about 1640–50.[1] However, the style is more like that of works done between 1630 and 1635. The figure stands out against a somber background, brilliant light casting the face and neck into sharp relief. The folds of the drapery are vigorously rendered, and the face with long nose and dimpled chin is highly individualized, suggesting that this is a portrait of an actual model.

The picture is comparable in many respects to the *Saint Casilda* in Lugano (cat. no. 45): both figures are

shown stepping forward against a dark brown background; their costumes—with trains, heavy skirts lifted, and red sleeves—have an identical line; the hands are rendered with the same curious lack of modeling; and both figures look directly at the viewer.

Zurbarán here displays his skill in juxtaposing unusual and luminous colors, his taste for the careful representation of objects (in this case, the jewels adorning the costume), and his capacity for deftly transforming the miraculous roses into an effective still life.

NOTE
1. Guinard 1960a, p. 236.

PROVENANCE
First recorded in 1814 in the Hall of the Fireplace, Royal Palace, Madrid; transferred to the Museo del Prado, Madrid.

LITERATURE
Cascales y Muñoz 1911, pp. 54, 111; Kehrer 1918, p. 107; Soria 1948b, p. 256; Sánchez Cantón, in Madrid, Museo del Prado, 1949, p. 745; Gómez Castillo and Grosso Sánchez 1950, p. 64 ("by Ayala"); Soria 1953, no. 181; Guinard 1960a, no. 242; Torres Martín 1963, no. 231; Sáez Piñuela 1965, pp. 284–89; Guinard and Frati 1975, no. 348; Gállego and Gudiol 1977, no. 310; Munich, Haus der Kunst, 1982, no. 104; Madrid, Museo del Prado, 1984, no. 1239.

EXHIBITED
Madrid 1905, no. 1132; Geneva 1939, no. 111; Munich and Vienna 1982, no. 104.

45.
Saint Casilda

1630–35
Oil on canvas, 66⅞ × 42⅛ in. (171 × 107 cm)
Thyssen-Bornemisza Collection, Lugano, Switzerland

The identification of the saint pictured here is problematic. Guinard, along with Gállego and Gudiol, identifies her as Saint Elizabeth of Portugal, while both Brown and Rosenbaum identify her as Saint Casilda because of the youthfulness of the figure and the fact that she wears a diadem and not a crown.[1]

Saint Casilda was the daughter of Adhemos, the Moorish king of Toledo, "pagan in religion, cruel enemy to the Christians," who was notorious for condemning his prisoners to death by starvation.[2] The sympathetic young princess, in defiance of her father, brought the prisoners meat and bread hidden in her skirt.[3] Surprised by Adhemos one day while

on such a charitable errand, she told him she was carrying only flowers, whereupon the bread concealed in her skirt was miraculously transformed into roses. The miracle induced Casilda's conversion to Christianity. Later she was cured of a dire illness by bathing in the Lake of San Vicente, near Burgos, which was in Christian territory. There she built an oratory and a small house, where she retired to a saintly life, and died in 1407. Much loved by the people of Spain, she is honored on April 9 and has her place in the Proper of Spanish saints.

The figure in this painting is almost certainly the young Moorish princess. A similarly youthful model is found in the Saint Casilda in the Plandiura collection, Barcelona; it is highly unlikely that either of the paintings represents Saint Elizabeth of Portugal, because Elizabeth was married and thus is traditionally shown as older than Casilda when a very similar miracle occurred to her. On the other hand, the sumptuously garbed princess in the present painting wears a costume similar to that seen in the Prado Saint Elizabeth of Portugal (cat. no. 44), itself formerly believed to depict Saint Casilda.

Marshal Soult, commander general of the French Army in Spain during the Peninsular Wars of 1808–14, acquired in Andalusia most of the 109 paintings that would constitute his collection of Spanish masters. Among them were four pictures of female saints: Saint Agatha (cat. no. 11), Saint Rufina (The Hispanic Society of America, New York), Saint Apollonia (cat. no. 21), and the present Saint Casilda. When Soult's holdings were sold in 1852, the Saint Casilda passed to a Parisian private collection before being acquired by the Ehrich Gallery in New York, which sold it in 1913 to the great Canadian collector William Van Horne. When Van Horne's collection was dispersed in 1978, the painting was purchased by its present owner.

Like the Saint Elizabeth of Portugal, the painting is characteristic of Zurbarán's first important commissions in Seville. The marked play of light and shadow on the face and neck and the monochrome background suggest that it must have been painted between 1630 and 1635. It is stylistically very close to and of nearly identical dimensions as the Saint Rufina. In both paintings, there is as well a similar treatment of the face: delicate features, a clearly defined profile, and a porcelain complexion. The thick wavy hair that frames the face and the way the body bends forward lend gentleness to the image. The roses are sketchily rendered, in contrast to the minute handling of the precious stones, the almost tactile cloth, and the pattern of the damask gown. A few touches of red and the luminosity of the pearls masterfully heighten the range of muted colors.

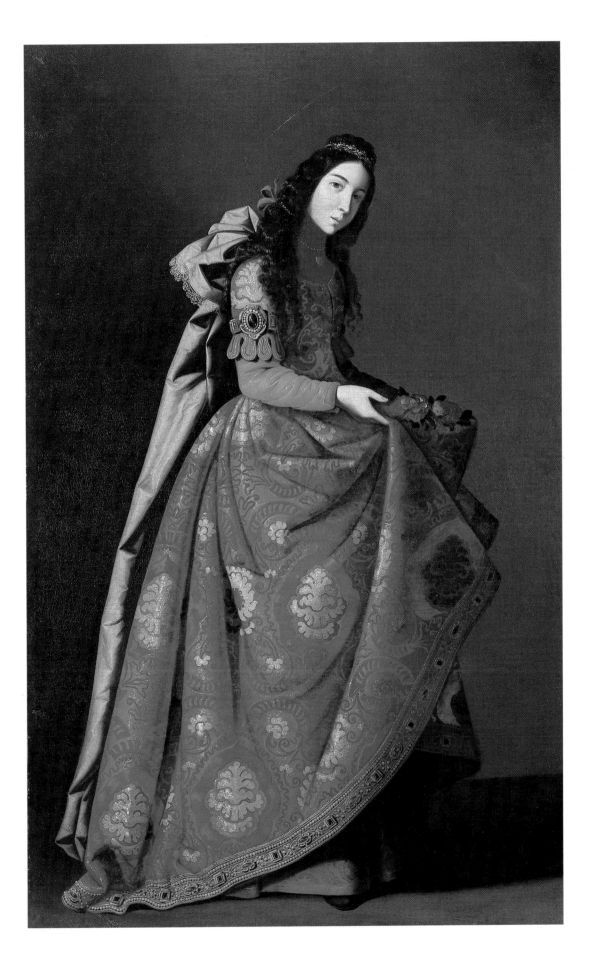

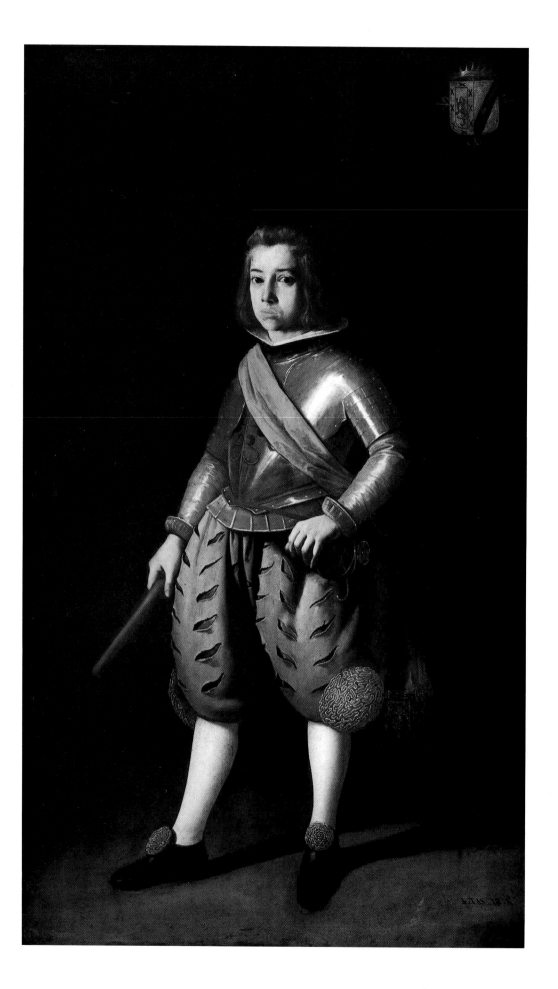

NOTES

1. Guinard 1960a, no. 260; Gállego and Gudiol 1977, no. 445;
Brown 1974, p. 163; Rosenbaum, in Paris, Petit Palais, 1982,
no. 59.
2. Ribadeneyra 1624, p. 194.
3. Villegas Selvago 1593, fol. 399.

PROVENANCE

Collection of Marshal Soult, Paris; Soult sale, Paris, May 19–22,
1852, no. 35, to Count Duchâtel, Paris; Ehrich Gallery, New
York, before 1913; collection of William Van Horne, Montreal,
1913; acquired by Baron Hans Heinrich Thyssen-Bornemisza in
1978.

LITERATURE

Loga 1913, pp. 101, 103; Mayer 1916a, pp. 6, 8; Mayer 1916b,
p. 221; Kehrer 1918, p. 147; Soria 1944a, p. 167; Soria 1944b,
pp. 130–31; Mayer 1947, p. 249 (*Saint Dorothy*); Soria 1948b,
p. 256; Soria 1953, no. 179; Guinard 1960a, no. 260; Brown
1974, p. 163; Guinard and Frati 1975, no. 349; Gállego and
Gudiol 1977, no. 445 (*Saint Elizabeth of Portugal*); Rosenbaum, in
Paris, Petit Palais, 1982, no. 59.

EXHIBITED

Montreal 1933, no. 23; Paris 1982, no. 59.

46.
Don Alonso Verdugo de Albornoz

ca. 1635
Oil on canvas, 6 ft. ⅞ in. × 3 ft. 4⅝ in. (185 × 103 cm)
Inscribed, lower right: Franco dezurbaran. f. /
AETAS 12. A[nno]ˢ
Staatliche Museen Preussischer Kulturbesitz,
Gemäldegalerie, Berlin

Don Alonso Verdugo de Albornoz (1623–1695) was
born in Carmona. His father, Alonso Verdugo de la
Cueva y Sotomayor, was a Knight of Santiago and
one of the Twenty-Four, the City Council of Seville.
His mother, Juana de Albornoz, was the sister of
Cardinal Gil de Albornoz, an influential minister at
the court of Philip IV and later governor of Milan.
At the age of five, Alonso, their only son, was re-
ceived into the Order of the Knights of Alcántara,
whose insignia, a green cross, is painted on the breast
plate and under the coat of arms at the upper right
corner of the picture. By special favor of the king,
the twelve-year-old Alonso was named captain of
his uncle's guard; it was to commemorate this occa-
sion that Zurbarán was commissioned to paint his
portrait.

The sitter wears the traditional attributes of his
rank: sword, armor, red sash, and officer's baton.
His stance and bearing are those of a mature man

conscious of his authority, rather than those of a boy
of twelve. Zurbarán had been able to observe solemn
and affected poses for this type of court portraiture
when he visited Madrid in 1634. The composition and
subtle lighting indicate the influence of Velázquez. The
date of the portrait, which was probably executed in
Seville in 1635, can be deduced by the inscription,
AETAS 12. A[nno]ˢ, since the year of the sitter's birth is
known to be 1623.

The figure is set in a fairly large space against a
dark brown wall; depth is subtly indicated by the
cast shadow and the progressive shading of the light.
These perspective effects were absent in the early
figures of the Mercedarians that were painted for
the library of the Monastery of the Merced Calzada
in Seville before 1634. The originality and strength
of Zurbarán's brushwork are visible in the treatment
of the sitter's face and hands, and in the textures of
his costume. The colors are laid down in flat tones,
and the warm brown tonality of the ground brings
out the harmonious color scheme of the young Al-
bornoz's costume and armor.

PROVENANCE

Collection of Alphonse Oudry, Paris; Oudry sale, Hôtel Drouot,
Paris, Apr. 16–17, 1869, no. 155, for 2,400 francs, to Prince Jérôme
Napoléon; Napoléon sale, Christie's, London, May 9–11, 1872,
no. 327, for £178, to Holloway, London; collection of Alfred
Morrison, London; acquired by the Kaiser Friedrich Museum
(now the Staatliche Museen Preussischer Kulturbesitz), Berlin,
in 1906.

LITERATURE

Kehrer 1918, pp. 84–85; Saltillo 1928, pp. 33–34; Soria 1944a,
p. 48; Soria 1953, no. 104; Gaya Nuño 1958, no. 3026; Caturla
1960b, p. 467; Guinard 1960a, no. 585; Torres Martín 1963, p. 157;
Lopez-Rey 1971, pp. 122–24; Brown 1974, p. 108; Guinard and
Frati 1975, no. 155; Gállego and Gudiol 1977, no. 107; Berlin,
Staatliche Museen Preussischer Kulturbesitz, 1978, no. 404c.

EXHIBITED

Madrid 1981–82b, no. 53; Munich and Vienna 1982, no. 102.

47.
The Young Virgin

ca. 1635–40
Oil on canvas, 46 × 37 in. (116.8 × 94 cm)
The Metropolitan Museum of Art, New York.
Fletcher Fund, 1927

From earliest Christian times, the very brief pas-
sages in the canonical texts regarding the Virgin
Mary were insufficient to satisfy the curiosity of the
devout. The relative silence of the Gospels on the life

of the Virgin was soon rounded out by numerous apocryphal writings, most of which were eventually condemned as excessively imaginative. In the year 397, a definitive list of authentic texts was established by the Church at the Council of Carthage. The list was reviewed again in the sixteenth century by the Council of Trent.[1] On the whole, the Church was fairly tolerant of legends that contained nothing contrary to the faith and that might in fact encourage popular piety.

The Protoevangelium of James (6:1–8:1) exerted considerable influence on the iconography of the Virgin. According to that text, the Virgin was brought to the Temple at the early age of three to be reared there. Another Apocryphal text, the Gospel of Pseudo-Matthew, completed the story of the child Mary in the Temple: "Not being yet aged three . . . she applied herself so to working the wool, and even what aged women could not contrive to do she at such a tender age succeeded in."[2] Since this tale of Mary's sojourn in the Temple was linked by exegetes to a line in the authorized Apocryphal Ecclesiasticus—"In the holy tabernacle I served before him" (24:10)—the Church authorities allowed the story, and thus the image, to flourish. And the Sevillian Jesuit Francisco Arias, who was known for his theological rigor, recommended in his treatise "on the imitation of Our Lady" a meditation on the Virgin in the Temple.[3]

Zurbarán's devotional image thus responds to current meditational practice. He paints the "little sister" of the Song of Solomon (8:8) as she was imagined by the mystic poet Nieva Calvo: "In the beauty of a pure child [she embroidered] in the Temple the sacred ornaments . . . in white wool, [but] the time thus spent did not prevent her long meditations with holy and pure soul on the lesson of the Scriptures."[4] Framed by drawn curtains that evoke the curtain of the Temple, Mary sits in the pose of the Madonna of Humility. She is presented for the contemplation of the faithful on a dais that forms an altar.[5] Objects both familiar and sumptuous are charged with symbolic meaning: the gold vase (a sacred vase of the Temple?) holding the traditional lilies and roses, blue flowers (emblematic of fidelity) and yellow flowers (intelligence and maturity),[6] a basket of white linen (work and purity), and an earthenware cup containing virginal water.

The date of execution of a group of paintings produced by Zurbarán and his workshop showing the Virgin as a little girl remains uncertain. All the paintings represent a child of four or five years seated on a chair, her hands clasped and her eyes raised heavenward, with a piece of needlework or a cushion to be sewn resting on her lap. The two best examples of this type are the *Virgin as a Child*, in the Hermitage Museum, Leningrad, and the present work. An especially fine variant, which shows the child asleep, is in the Cathedral of Jerez de la Frontera. The paintings of the young Virgin sewing are of two compositional types. In one, exemplified by the present work, Mary is shown frontally. In the other, exemplified by the Hermitage canvas, she is seen in a three-quarter pose, turned toward the right. In general, the Hermitage version and its derivatives are smaller and are assigned a later date. They share the same kind of embroidery on the blouse or on the collar and cuffs, although the facial traits are different. In the New York painting, the Virgin bears a curious resemblance to Mary in the *Virgin of the Immaculate Conception* of 1656 in the Arango collection (cat. no. 64): a childlike face, round eyes, a nose that is rather pronounced and shiny at the tip, and a heart-shaped mouth.

Almost nothing is known about the origin of most of these compositions. They are not listed in early publications on Zurbarán, and except for the *Sleeping Virgin* in Jerez do not seem to come primarily from Andalusia. Only a copy of the Hermitage version, now in the Fundación Rodríguez, Granada, is reputed to have come from a convent in Medina del Campo, where Manuel Gómez Moreno is said to have discovered it. The New York picture was once in the collection of Aureliano de Beruete y Moret, who also owned the *Saint Francis Kneeling with a Skull*, signed and dated 1659 (cat. no. 67), a work that would have been produced in Madrid, since Zurbarán had been there for a year by that date.

It is striking that the majority of the *Immaculate Conceptions* portraying the Virgin as a child were painted in the final years of Zurbarán's career—the Arango picture, for example, and the canvas in Budapest, dating to 1661. When Zurbarán died in 1664, only his two daughters from his first marriage, María and Paula, were still alive. His other children, by his third wife, Leonor de Tordera, probably died at an early age, because he makes no mention of them in his will, whereas in an earlier document of 1663, he speaks of "una hija nuestra que tenemos," probably Manuela, who was about seven in 1657.[7]

It is tempting to believe that Manuela was the model for her father, who by this time had reached the age of a grandfather. But if this hypothesis can be held with regard to the pictures of the Virgin of the Immaculate Conception of the final period and the *Virgin as a Child* in Leningrad, the style and workmanship of the New York painting suggest that it dates to no later than 1640, and Manuela was not born until about 1650. In 1640, María and Paula were, respectively, twenty-two and seventeen, and there

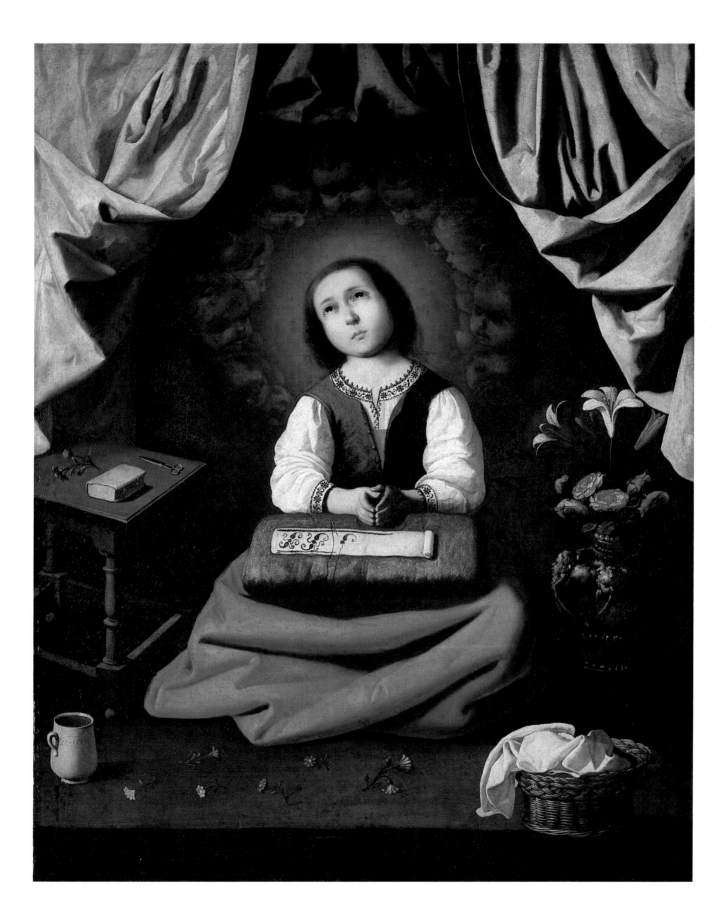

257

seems to have been only one child, who died young, by Beatriz de Morales.

The *Young Virgin* is an exquisite work, one in which the painter's sincerity, his innate taste for *bodegón*, and his love for pleasingly complementary colors are merged with his characteristic use of bright reds, milky blues, and deep blue greens. The rose and mauve silk curtains are elegantly rendered. The young girl, with a gentle and ecstatic expression, prays with all her heart. There is nothing here of the sentimentality, stereotype, and conventional rendering commonly seen in the work of the Romanizing painters; it is, rather, a picture that is unique in its sense of poetry.

NOTES

1. Daniel-Rops 1952, p. 11.
2. *Ibid.*, p. 67.
3. Arias 1630, p. 234.
4. Nieva Calvo 1625, fols. 54–60.
5. Gállego and Gudiol 1977, p. 47.
6. Droulers [1949], pp. 30, 114.
7. Kinkead 1983b, p. 309.

PROVENANCE
Probably the painting mentioned in the collection of Ramón Despuig y Fortuny, Count of Montenegro, Palma de Mallorca, 1845 (Bover 1845, no. 44); collection of Aureliano de Beruete y Moret, Madrid, by 1911; collection of Dario de Regoyos, Madrid, 1927; acquired by The Metropolitan Museum of Art, New York, in 1927.

LITERATURE
Bover 1845, no. 44; Cascales y Muñoz 1911, pp. 103–4; Mayer 1911, p. 158; Kehrer 1918, p. 64; Mayer 1922, p. 321; Loga 1923, p. 267; Mayer 1924, p. 212; Longhi and Mayer, in Rome, Galleria Nazionale d'Arte Moderna, 1930, no. 64; Wehle, in New York, Metropolitan Museum of Art, 1940, pp. 234–35; Gudiol, in Toledo, Ohio, Toledo Museum of Art, 1941, p. 107; Soria 1944a, p. 45; Seckel 1946, pp. 292–93; Gaya Nuño 1948, no. 43; Pompey 1948, pp. 45, 49–53; Soria 1953, no. 67; Gaya Nuño 1958, no. 3009; Guinard 1960a, no. 23; Torres Martín 1963, no. 55; Madrid, Casón del Buen Retiro, 1964, no. 22; Standen, in New York, Metropolitan Museum of Art, 1970, p. 55; Angulo Iñiguez 1971, pp. 119, 134; Gregori and Frati 1973, no. 67; Brown 1974, p. 94; Guinard and Frati 1975, no. 67; Gállego and Gudiol 1977, no. 214.

EXHIBITED
London 1920–21, no. 44; Detroit 1951; Toronto 1951; Saint Louis 1952; Seattle 1952; Milwaukee 1953; Austin 1953; Madrid 1964–65, no. 22; Boston 1970; Leningrad and Moscow 1975, no. 30.

48.
The Virgin and Christ in the House of Nazareth

ca. 1640
Oil on canvas, 5 ft. 4⅞ in. × 7 ft. 2⅝ in. (165 × 220.2 cm)
The Cleveland Museum of Art. Purchase, Leonard C. Hanna, Jr., Bequest

The spirituality of a period is expressed not only in established doctrines but also in popular legends and stories. In Christianity, one manifestation of popular piety was an early interest in the childhood of Christ. That interest was reflected in pilgrimages, liturgical feasts, compositions in verse and prose, and representations in the visual arts. In the sixteenth century, the Apocryphal stories of the childhood of Christ were revived and new episodes introduced. This first century of the printing press contributed to a greater familiarity with the story of the life of Christ. Popular interest led to the printing of books that dealt solely with individual anecdotes about his childhood and in which illustrations, though often crude, made up for the poverty of the texts.[1] Meditation on the sufferings of the Christ Child—as analogous to the sufferings of Christ in the Passion—was a characteristic devotional practice in the seventeenth century. This practice was represented in the visual arts not only by images of the Christ Child with the instruments of the Passion but also by scenes from Christ's early years in Nazareth. The most frequent scenes depicted the adolescent Jesus helping his adoptive father in his carpentry shop; there, he was sometimes shown assembling beams into the prophetic shape of the cross.[2] These intimate family scenes intended for pious meditation may be found in art throughout Europe in the post-Tridentine period. From the Middle Ages on, subjects based on the childhood and the Passion of Christ—the earliest and the last events of his life—were those that the faithful found most compelling. Seventeenth-century theologians consistently pointed to the parallels between these events, because the suffering accepted by the Christ Child—which was often associated with that of his mother—was seen as a model of the virtue of patience.[3]

The scene painted by Zurbarán, a sort of pendant to the more usual scene in Joseph's workshop, probably had its source in the imagination of a contemporary mystic. It was certainly approved by the Church, for among the decretals established by the Council of Trent was the requirement that all subjects introduced to the repertory of religious art be submitted to the authority of the bishops, or, in questionable cases, to

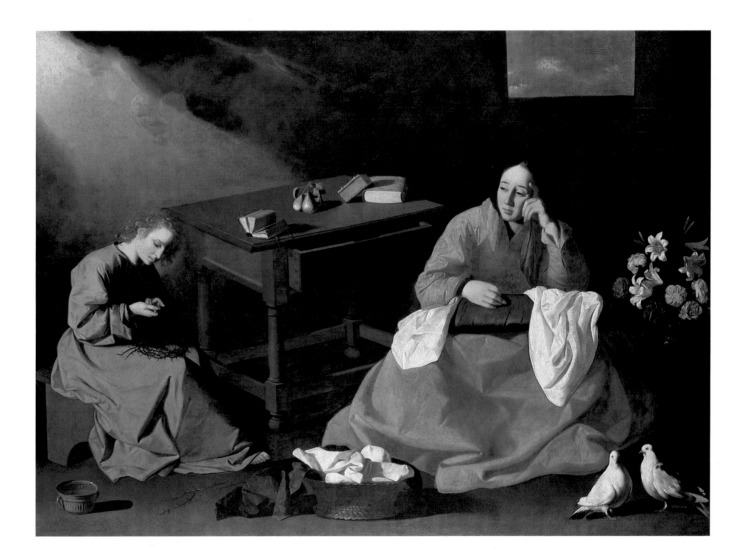

the Vatican itself.[4] Zurbarán's depiction of Jesus pricking himself with the crown of thorns that he himself had made became an extremely popular model, judging by the many surviving copies and imitations. The figure of Jesus in the Cleveland picture is enhanced by the meditative figure of the Virgin, which became a popular independent subject often represented by Zurbarán and his workshop.

The novel iconography of this subject, which appears first in paintings by Zurbarán, has been studied by two authors. Henry S. Francis analyzes the symbolism of the familiar domestic objects and proposes as a possible source (at the suggestion of Margaret Marcus) the prophecy of Zechariah: "And one shall say unto him, What are these wounds in thine hands? Then he shall answer, Those with which I was wounded in the house of my friends" (13:6).[5] Francisco López Estrada finds analogies in contemporary authors, such as Salazar de Alarcón and José Valdivieso, concluding that the iconography can be associated with Carthusian devotional practices.[6] He also discusses the meaning of the still-life objects, which are similar to those in the Young Virgin in The Metropolitan Museum of Art (cat. no. 47), and evoke the themes of the Redemption (the fruits), the purity of the Virgin (the lily and the water vessel), love and the rosary (the rose), and study and work (the book and the Virgin's sewing). The presence of the two doves refers to two episodes in the Gospels, the Purification of the Virgin and the Presentation of Jesus in the Temple. The latter was one of the oldest and most solemn themes of devotion in the Marian cult; it was celebrated by a feast on February 2, forty days after the Nativity. In accordance with the law of Moses, Mary brought her child to Jerusalem to offer the traditional sacrifice of "a pair of turtledoves, or two young pigeons" (Luke 2:24). There, the pious Simeon, who had been told by the Holy Spirit that he would not die until he had seen the Lord, took the Child in his arms and announced to Mary that he was a "light to lighten the Gentiles" (Luke 2:32) and prophesied that "a sword shall pierce through thy own soul also" (Luke 2:35). The scene represented by Zurbarán takes place when Jesus is ten or twelve years old, but it includes many symbolic references to his Presentation in the Temple. The Virgin's melancholy is thus explained by Simeon's prophecy: she meditates on the future suffering of her son, whom she offers, together with the pair of turtledoves, to God in the Temple. The figure of Christ is washed by a golden light, a reference to the "light to lighten the Gentiles" he would become.

According to present research, it would seem that we owe the discovery of this magnificent painting to Paul Guinard, who published it for the first time in 1960.[7] Many different copies or imitations exist, and it was first known in 1905 through a rather weak version of smaller dimensions (84 × 112 cm) that was in the collection of Gustavo Morales in Madrid.[8] It is significant that in the catalogue of the first Zurbarán exhibition, held in Madrid in 1905, Viniegra exhibited it with the title the Child Christ Pricking Himself with the Crown of Thorns and not the Virgin and Child in the House of Nazareth. The latter title was generally given to representations of Joseph's carpentry workshop.

The theme of the Christ Child pricking himself with the crown of thorns in the presence of the Virgin seems to have been treated in Andalusia solely by Zurbarán. Indeed, the subject of the House of Nazareth with the Christ Child, Mary, and Joseph was seldom represented in Spanish painting in the first half of the seventeenth century. The only clue to the origin of the Cleveland picture is provided by the iconography, for, as López Estrada has shown, the symbolism of this work is closely related to Carthusian themes.[9] Certainly the picture was not part of a series on the life of Christ, nor can it be placed among the hagiographic scenes; rather, it is an image of devotion that could well have decorated the oratory of a prior, which explains how it would have escaped the attention of eighteenth-century connoisseurs.

The Virgin and Child in the House of Nazareth is a signal masterpiece; indeed, it is one of the finest paintings to emerge from Spain's Golden Age. It is thus astonishing that it was lost sight of from 1821 to 1960. It is not unlikely that it was the picture that appeared in the Paris sale of the collection of the Count of Walterstorff in 1821, because the description and dimensions given in the sale catalogue match those of the Cleveland painting.[10] The author of that catalogue, J. L. Laneuville, wrote: "This work may be considered one of the monuments of painting; it combines grace of execution with that magic and power of color that produces illusion." This opinion is particularly interesting because Laneuville was himself an accomplished painter, and had studied with Jacques-Louis David.

Much research has been devoted in recent years to the problem of Zurbarán's possible models. Pita Andrade has pointed out the similarity between the pose of the Virgin in the Cleveland painting and that of the figure of Melancholia in Dürer's famous engraving.[11] In our opinion, it would also be worth looking to the work of Jusepe Ribera, for many of Ribera's figures, in particular those of Saint Peter meditating (which were probably inspired by Michelangelo's Jeremiah in the Sistine Chapel), show the same position of the hand supporting the head. The graceful Magdalen

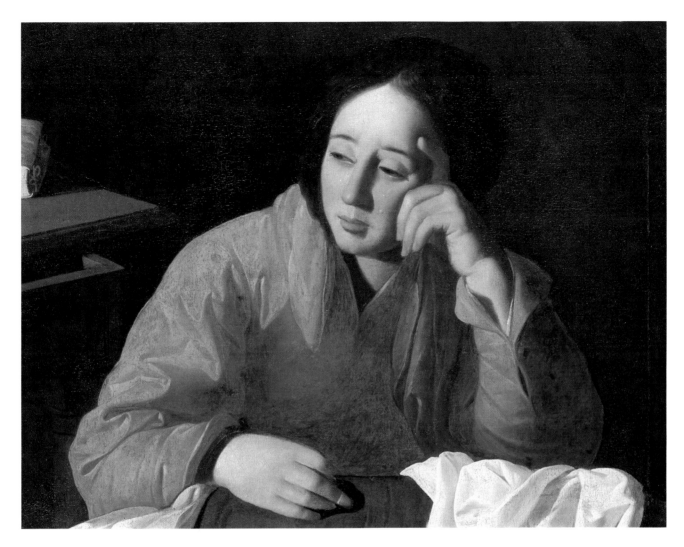

by Correggio (present whereabouts unknown) also presents analogies—in the position of the head of the Virgin—and the *Mary Magdalen in Penitence* that was formerly attributed to Ribera but is now ascribed to Luca Giordano (Museo del Prado, Madrid), although inverted in relation to the figure of the Virgin in the Cleveland painting, suggests that this type of model must have been in circulation in the Neapolitan school of the seventeenth century; but we do not know how it made its way to Seville.

The reversed perspective of the tabletop, which gives maximum visibility to the symbolic objects, and the figures shown close up and in the same plane, were most likely specifications made by Zurbarán's ecclesiastical patrons, who wanted the scene to have a dimension of truth that would increase its symbolic significance and mystical impact. Julián Gállego has rightly noted the poetic power with which Zurbarán charged the scene: "[The] popular-sententious tone seems fairly similar to that of unwritten Andalusian poetry."[12] The basically cool color scheme of blues, whites, an intense but transparent pink, sharp green,

and bright red recalls the palette of Orazio Gentileschi. Unlike the works of Zurbarán's first period in which, without chiaroscuro, light and shadow are shown in dramatically contrasting opaque blacks, grays, ochers, and whites, here Zurbarán uses a softer treatment. The penumbra effects worthy of a Lombard master and the skillful shading of the colors attest to the artist's knowledge of Italian works of the first third of the seventeenth century, especially those of the Bolognese and Florentine schools. The lightened Caravaggism that Zurbarán was able to study *de visu* in the work of Juan Bautista Maino and Carlo Saraceni strongly marks the evolution of his painting (but not of his style), so that, contrary to most critics, we would be inclined to suggest a date of execution of about 1640 or later.

Color reproductions cannot do justice to the picture. Here we see the perfect fusion of the painter's technical mastery and the spirituality with which he endows the tranquil and grandiose scene, in which the Divine presence is manifest in the most humble object and which well deserves the term "magic," used by

Laneuville. The figure of the Virgin, in its expression of contained and prophetic suffering, presents one of the most dramatic images in the entire history of Spanish painting, to which the angelic profile of the Christ Child provides a masterly counterpoint.

NOTES
1. *Dictionnaire de spiritualité*, 1960, IV, 1, col. 661.
2. Mâle 1932 (1972 ed.), p. 311.
3. Arias 1599, p. 916.
4. *Canons and Decrees of the Council of Trent*, 25th session, Dec. 3, 1563; Hervet 1606, pp. 220–21.
5. Francis 1961, pp. 48–49.
6. López Estrada 1966, pp. 25–50.
7. Guinard 1960a, no. 67. According to the 1982 catalogue of The Cleveland Museum of Art, there are many versions and copies of this painting; the version in a private collection in Boston seems closest to the original in quality; there is another version in a private collection in Valencia. Several copies are known in collections in Madrid. Three others are in Mexico.
8. Viniegra, in Madrid, Museo del Prado, 1905, no. 42.
9. López Estrada 1966, p. 45.
10. Walterstorff 1821, no. 65.
11. Pita Andrade 1965, p. 247.
12. Gállego and Gudiol 1977, p. 47.

PROVENANCE
Collection of the Count of Walterstorff, minister from Denmark to the French court; Walterstorff sale, Paris, Mar. 26–27, 1821, no. 65, to Laneuville; François Heim, Paris; acquired by The Cleveland Museum of Art in 1960.

LITERATURE
Guinard 1960a, no. 67; Francis 1961, pp. 46–50; Torres Martín 1963, no. 154a; López Estrada 1966, pp. 25–50; Gregori and Frati 1973, no. 65; Brown 1974, p. 80; Guinard and Frati 1975, no. 67; Gállego and Gudiol 1977, no. 247; Véliz 1981, pp. 271–85; Cleveland Museum of Art, 1982, pp. 514–17.

EXHIBITED
Cleveland 1960, no. 70.

49.
Saint John the Baptist in the Wilderness

ca. 1635–40
Oil on canvas, 65⅓ × 62¼ in. (166 × 158 cm)
Cathedral, Seville

Saint John the Baptist, after the Virgin Mary, occupies the second highest place in the hierarchy of the saints. His importance is reflected in Luke 7:28: "For I say unto you, Among those that are born of women there is not a greater prophet than John the Baptist." He is especially venerated by the Church as the Pre-cursor (Matthew 11:9) and then the Witness of Christ (John 1:24). He appears twice in the liturgical calendar: on June 24, to celebrate his birth, as announced to his father, Zacharias, by the Archangel Gabriel (Luke 1:11–20), and again on December 27, to commemorate his beheading by Herod at the request of Salome (Matthew 14:3–11). He is also the first martyr listed in the canon of the Mass.

Francisco Pacheco, in his *Arte de la pintura* (Seville, 1649), provided very specific instructions for the representation of the Baptist.[1] Zurbarán's depiction conforms to Pacheco's directives only generally; instead, his portrayal is based on an iconographic type elaborated by post-Renaissance artists in Italy. The saint is shown as a youth rather than at the age of twenty-nine or thirty, as Pacheco had prescribed, and he wears a short tunic of fur rather than the haircloth garment described in Matthew 3:4: "John had his raiment of camel's hair, and a leathern girdle about his loins."

Pacheco, the Counter-Reformation exegete, like Cardinal Paleotti in Italy, was concerned with historical truth and with *decoro*, considerations that Zurbarán scrupulously respected here. As the cousin of Christ, John was to be represented with fine features, in keeping with his noble lineage, but he was also "tostado y moreno" (tanned and dark) from having lived so long in the wilderness.

Zurbarán retains the Baptist's traditional attributes: John holds the cross, symbolic of Christ's sacrifice, as though it were the key to the Kingdom of Heaven.[2] He points to the lamb, his traditional companion in art, which signifies his words of exclamation when first he recognized Christ: "Behold the Lamb of God" (John 1:29). This type of representation was sometimes controversial, but it was approved by Johannes Molanus in his treatise on iconography, which reflected the dictates of the Council of Trent.[3] Molanus was often cited by Pacheco as an irrefutable reference.

Nothing is known of the history of the *Saint John the Baptist in the Wilderness* before the eighteenth century. According to correspondence between Antonio Ponz and the Count of Aguila from 1779 to 1781, the painting was given to the Cathedral of Seville by Don Pedro Curiel.[4] In 1800, Ceán Bermúdez mentions it as above the door of the cathedral baptistery, whence it was moved later in the century.

Prototypes for this work may be found among the Italian Caravaggesque painters. Saint John the Baptist is depicted by Zurbarán as a handsome adolescent, nude to the waist, just as Caravaggio had represented him. He is also shown as a youthful figure, though standing and clothed in an animal skin, in the famous sculpture, dating to 1616–20, executed

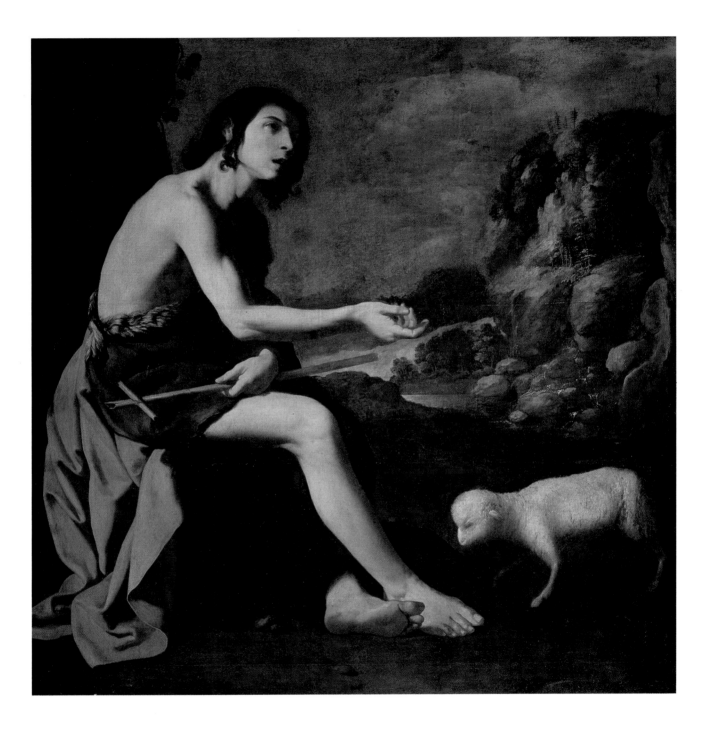

by Juan Martínez Montañés for the Carthusian Monastery of Las Cuevas in Seville. In 1634, Alonso Cano sculpted a very fine version of the Baptist, with the figure seated, his right leg partly uncovered, and his head bent slightly forward; the sculpture was originally in San Juan de la Palma. Zurbarán's Saint John the Baptist has affinities with Cano's sculpture, except for the raised head. Zurbarán inverted this figure in his representation of the Virgin and Child with Saint John the Baptist, the painting-within-a-painting in the *Saint Hugh in the Refectory* (cat. no. 37).

The figure of the Baptist in the Seville Cathedral painting is well proportioned, and his pose is more supple than is characteristic in Zurbarán's works from 1626 to 1630. Lights and darks are still strongly contrasted, but the progressively shaded modeling argues for a later date of execution. The lighting, which is less harsh and more diffuse than before, creates a shaded effect, in the Italian manner. John the Baptist and the lamb are well integrated into the rectangular format; and the violets, the ochers, and the white of the lamb's wool are perfectly harmonized. Zurbarán succeeds in rejuvenating a frequently represented subject by infusing it with vitality and a poetry that is devoid of sentimentality. The anxiety in the expression of the youth convinces by its sincerity. The figure is strongly silhouetted against the mysterious shadows of the landscape.

NOTES
1. Pacheco 1649 (1956 ed.), II, pp. 305–13.
2. *Ibid.*, p. 311.
3. Molanus 1570, book 2, chap. 11.
4. Carriazo 1929, p. 174.

PROVENANCE
Collection of Pedro Curiel, Seville, who donated it to the Cathedral of Seville in the eighteenth century (Count of Aguila 1779, published in Carriazo 1929); the painting was placed in the baptistery, above the door, and later transferred to the old sacristy (González de León 1844).

LITERATURE
Ceán Bermúdez 1800, VI, p. 48; Ceán Bermúdez 1804, p. 80 and appendix, p. ix; González de León 1844, II, p. 81; Matute 1886b, p. 161; Carriazo 1929, p. 174; Soria 1944a, pp. 158–61; Guinard 1946, pp. 258–59; Soria 1953, p. 105; Guinard 1960a, no. 133; Torres Martín 1963, no. 128; Guinard and Frati 1975, no. 248; Gállego and Gudiol 1977, no. 232; Valdivieso, in Seville, Museo de la Catedral, 1978, no. 450; Valdivieso and Serrera 1985, p. 416.

50.
Salvator Mundi

1638
Oil on canvas, 39 × 28 in. (99 × 71 cm)
Signed and dated: Fran^{co} de Zurbaran, faciebat 1638
Museo del Prado, Madrid

The figure of Christ as Salvator Mundi, or Saviour of the World, is shown here with his right hand raised in blessing and his left hand resting on a globe crowned by a cross. The unchanging, iconic type of the idealized figure of the Salvator Mundi, with an elongated face with regular features and the right hand raised in benediction, originated in the Byzantine tradition, and was established by the end of the Middle Ages. The image appears in fifteenth-century woodcuts, where it is most often framed by the symbols of the Evangelists, because it is the life of Christ on earth that they recount in the Gospels. As late as the seventeenth century, the Salvator Mundi is shown at the beginning of the New Testament in illustrated Bibles. The Jesuit Antoine Girard, in his treatise *Les Peintures sacrées sur la Bible* (Paris, 1653), explained the use of the image: "The Son of God teaches us that he came into the world for three reasons: to be Saviour, to be Master, and to be model for mankind."[1] In his Epistle to the Colossians (1:12–19), Saint Paul recommends "Giving thanks unto the Father . . . Who hath . . . translated us into the kingdom of his dear Son: In whom we have redemption through his blood, even the forgiveness of sins: . . . all things were created by him, and for him . . . For it pleased the Father that in him should all fullness dwell." Here Paul emphasizes Christian belief in the sovereignty of Christ over all creation and his prime role in redemption. The globe Christ holds symbolizes both his absolute sovereignty and his universal dominion, reflecting the prophecy of Daniel (7:14): "And there was given him dominion, and glory, and a kingdom."

Although the painting is signed and dated, its original provenance is not known. Its known history begins when it was restored early in this century by the Sevillian painter Alejo Vera. It then found its way into two Madrid collections, first that of a Señora Iturbe and then that of the Duquesa de Parcent. In 1939, it entered the collection of Felix Millet in Barcelona, and in 1980 it was acquired by the Prado.

Besides its iconographic interest, the painting is important evidence of the extent to which Zurbarán in 1638 was receptive to Italian influences. The sobriety and solemnity of the composition bring to mind the Bolognese school. Although still bright,

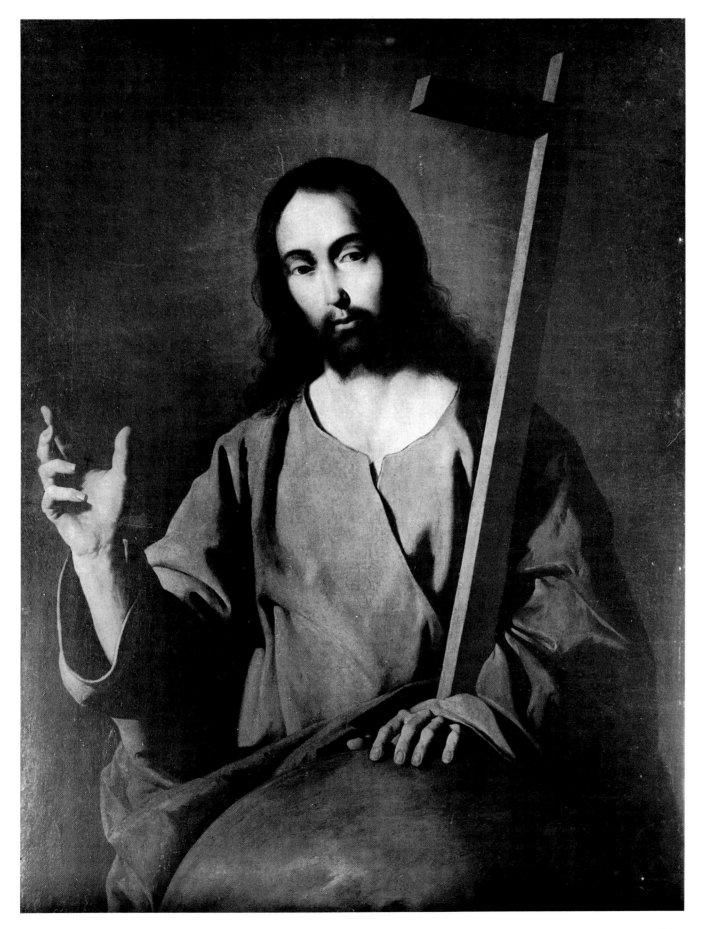

Zurbarán's lighting has become more nuanced, creating an interaction between the reds and grays. There is a notably increased suppleness in the forms. The face, gently framed by the flowing hair, bends forward slightly. Clearly defined as always, the drapery folds are better adapted to the movement of the arms and the nobly restrained gesture. The face of Christ is somewhat conventionally rendered, but the hands are forcefully treated. The right hand unfolds majestically, recalling hands painted by Annibale Carracci.

The painting, Zurbarán's only Salvator Mundi, has a restrained spiritual power that encourages meditation. It offers stylistic evidence that Zurbarán could change his way of working in response to the subject and function of the painting he was called on to produce. Thus, the large canvases of the same year, 1638–39, in the sacristy at Guadalupe are executed with scarcely modeled broad, flat planes, which render them legible from a considerable distance. The *Salvator Mundi* is a small picture meant to be seen close up, as in an oratory; in it we thus find the softly nuanced sfumato usually thought of as typical only of Zurbarán's late period.

NOTE
1. Girard 1653, p. 392, and pl. XLIX.

PROVENANCE
Collection of Señora Iturbe, Madrid; collection of the Duquesa de Parcent, Madrid; collection of Felix Millet, Barcelona, 1939; acquired by the Museo del Prado, Madrid, in 1980.

LITERATURE
Cascales y Muñoz 1911, pp. 108, 112; Kehrer 1918, p. 97; Soria 1944a, p. 162; Soria 1953, no. 146; Guinard 1960a, no. 121; Guinard and Frati 1975, no. 247; Gállego and Gudiol 1977, no. 121; Pita Andrade, in Madrid, Casón del Buen Retiro, 1981, no. 20; Madrid, Museo del Prado, 1984, no. 6074.

EXHIBITED
London 1920–21, no. 58; Madrid 1981–82a, no. 20.

51.
The Supper at Emmaus

1639
Oil on canvas, 89¾ × 60⅝ in. (228 × 154 cm)
Signed and dated: Fran de / Zurbaran / 1639
Museo de San Carlos, Mexico City

Among the appearances of the resurrected Christ to his disciples, that at Emmaus, on the evening of Easter Sunday, is one of the most frequently represented in art. The event is told in the Gospel of Saint Mark (16:14–19) and is related in detail in Luke (24:13–53). The recognition of Christ by his disciples during the supper at Emmaus was a subject often used to decorate the refectory of a monastery. The disciples had journeyed with Christ on their way to Emmaus, taking him to be an ordinary traveler. Because it was late when they arrived, they pressed him to stay and share their supper in the village. "And it came to pass, as he sat at meat with them, he took bread, and blessed it, and brake, and gave to them. And their eyes were opened, and they knew him" (Luke 24:30–31).

Certain seventeenth-century Spanish artists, such as Velázquez, following sixteenth-century Venetian representations, depicted Christ as transfigured, emphasizing his state of resurrection. As always, however, Zurbarán scrupulously respects the text of the Gospel. Christ is shown dressed as a traveler, with no sign of his divinity, which explains why the disciples did not initially recognize him. Zurbarán introduces no secondary figures, neither servants nor witnesses; instead, he creates a composition of great clarity, to facilitate the reading of the picture, in accordance with the recommendations of the Council of Trent. The sacramental tableau emphasizes the meaning of this second Last Supper, reminding the viewer of the institution of the Eucharist and of the resurrection of Christ.

The painting comes from the church of the Monastery of San Agustín in México City, where it hung on the transept wall as pendant to the *Incredulity of Saint Thomas*, by Sebastián de Arteaga (Pinacoteca Virreinal, Mexico City).[1] We do not know how the painting came to the capital of New Spain. It may have been commissioned by the Augustinian monastery itself, or chosen in Seville by one of the many agents specializing in the export of works of art to Latin America. The importance of the painting and the fact that it is signed and dated suggest that it was a direct commission. Documents prove that Zurbarán worked for the colonial market as early as April 1638, when he sent receipts of payment to Latin America for paintings already completed. Many such receipts date from the following decade. The picture entered the Academia de San Carlos, Mexico City, in 1861 in the wake of government confiscation of Church property.

The scene is impressive both for the simplicity of the composition and for the lighting effects. The three figures, centered in the foreground, are disposed symmetrically around the table, which suggests the mysterious and solemn nature of the repast. The brilliant light on the white tablecloth focuses attention on the frugal supper and the symbolic gesture of Christ's hand as he breaks the bread.

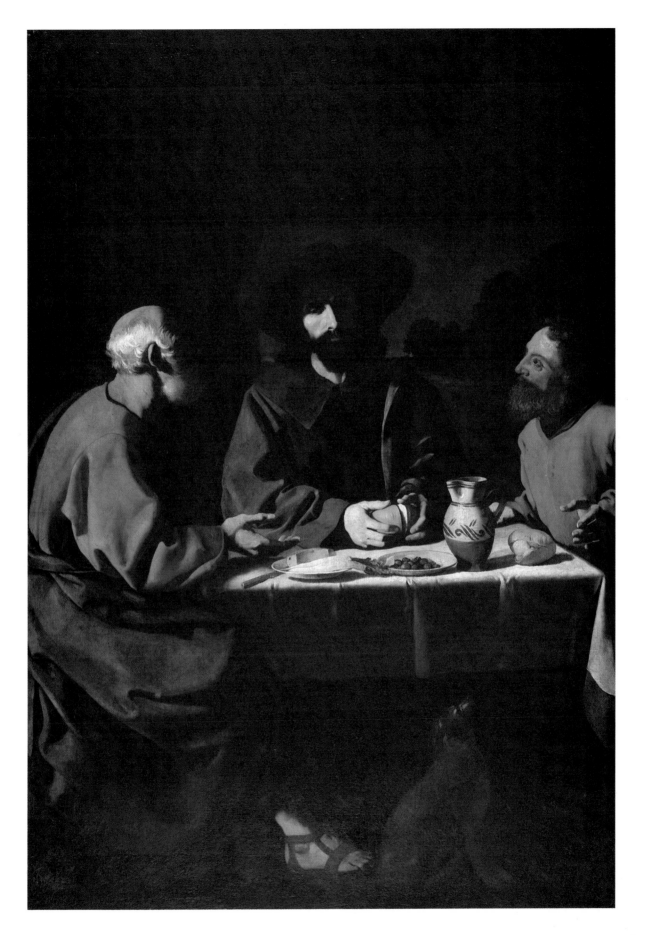

Few artists before Zurbarán treated this subject with such sobriety and reserve. The disposition and poses of the figures may be borrowed from the woodcut *Christ at Emmaus* of about 1510 in Dürer's *Small Passion*,[2] but the luminous effect is obviously tenebrist. The outdoor setting is unusual; here again, Zurbarán rejects anecdotal detail (the table, for example, is not shown beneath a trellis, as in the *Supper at Emmaus* by Marco Marziale, in the Bode Museum, East Berlin).

The painting is somewhat abraded, so that the contrasts are harsher than they originally would have been. The landscape background has been darkened by the brownish red ground that has worn through, but it can be deciphered with the aid of an anonymous eighteenth-century engraving discovered by Federico Cantú and published by Soria in 1953.[3] The wooded background, caught by the rays of the setting sun, recalls that of Zurbarán's *Saint Francis* of the same year, 1639 (National Gallery, London). Despite some repainting of the faces of the disciples, the figures, treated in broad strokes, have retained a sculptural force, and the admirable still-life elements have survived intact. The food and vessels are aligned in a frieze along the edge of the table, in the manner of Zurbarán's independent still lifes. The light simultaneously defines the contours of the objects and suggests the density of their volumes.

The *Supper at Emmaus* was much admired in Mexico. Two early copies of smaller dimensions are known. In one, measuring 168 × 113 centimeters (Vega Díaz collection, Madrid), only the center of the picture is devoted to the figures and there are variations in the disposition of the still life (the utensils are not aligned, and the knife handle extends over the edge of the table). The other, measuring 177 × 140 centimeters, was taken from Mexico by the Durán family and offered by them in 1895 to the Church of Saint-Sever d'Assat (Pyrénées-Orientales); it was only recently made known by M. Lavit.

NOTES
1. Couto 1947, p. 69.
2. Bartsch 1980, x, part 1, p. 143. Dürer is first mentioned as a source in Soria 1953, no. 176.
3. Soria 1953, p. 177, fig. 123.

PROVENANCE
Monastery of San Agustín, Mexico City, probably since the seventeenth century; Academia de San Carlos, Mexico City, since 1861.

LITERATURE
Revilla 1893, p. 147; Alvarez, in Mexico City, Academia de San Carlos, 1917, p. 35; Icaza 1922; Angulo Iñiguez 1935, pp. 54–56; Carrillo y Gariel, in Mexico City, Academia de San Carlos, 1944, pp. 44, 69; Soria 1944a, p. 162; Soria 1949, p. 74; Angulo Iñiguez 1950a, 1, p. 403; Soria 1953, no. 176; Rudrauf 1956, 1, p. 198; Gaya Nuño 1958, no. 3100; Guinard 1960a, no. 118; Torres Martín 1963, no. 129; Obregón 1964, pp. 7–8; Guinard and Frati 1975, no. 308; Gállego and Gudiol 1977, no. 169.

52.
Agnus Dei

ca. 1636–40
Oil on canvas, 14 × 20½ in. (35.6 × 52 cm)
Inscribed, at bottom: TANQUAM AGNUS
San Diego Museum of Art. Gift of Misses Anne R., Irene, and Amy Putnam

Zurbarán painted several small pictures of lambs with legs bound, such as the offering brought to the newborn Jesus in the Jerez *Adoration of the Shepherds* (cat. no. 27). Such representations, whether or not they include explicit Christian symbols, are charged with symbolic meaning.[1] An emblem of sweetness, innocence, and obedience, the lamb served as a sacrificial victim in many ancient Mediterranean religions. For Christianity, its immaculate whiteness is a metaphor for the triumph of renewal, the victory of life over death. The blood of the lamb, symbolizing the redeeming blood shed by Christ on the cross, is also associated with the blood of the sacrificed lamb with which the ancient Jews anointed the doorposts of their houses to ward off evil. In his epistle, Peter (1 Peter 1:19) affirms that the death of Christ is analogous to the sacrifice of the paschal lamb. And John (1:29) refers to the son of God as a lamb. The Evangelists thus refer back to Isaiah's mysterious prophecy (53:7) of a suffering Messiah symbolized by the sacrifice of the lamb.

In Early Christian sculpture illustrating scenes from the Gospels, the lamb is often represented instead of Christ himself. The confusion that ensued with the imagery of pagan cults and beliefs resulted in a decree, propagated at a council held in Constantinople in 692, that in Christian art Christ must be represented only in his incarnation as a man.

During the Middle Ages, the representation of the lamb included a cruciform nimbus and the banner of the Resurrection, so that the image was unambiguously Christian. By the time the ancient symbolic image reappeared in Zurbarán's art, it had already appeared in the writings of the mystics. In the posthumous edition of Luis de León's explication of Christological figurations *De los nombres de Cristo*, the word

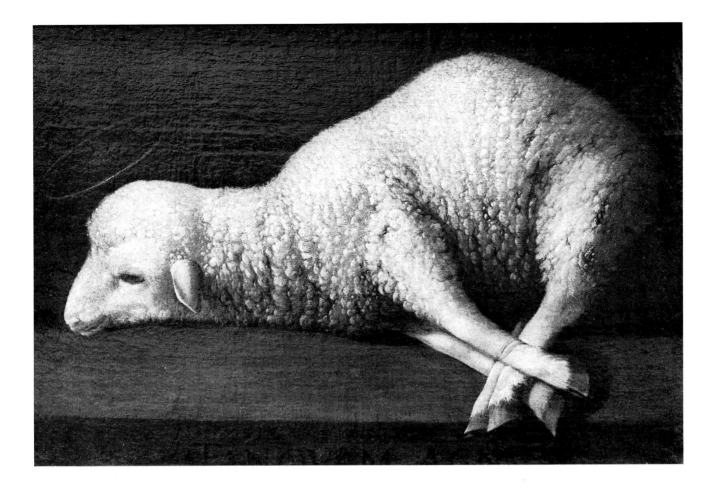

"lamb" was added, and it emphasized the analogy between Christ and the lamb as signifying "meekness of condition, innocence and purity of life, and fulfillment of sacrifice";[2] and in his treatise on painting, Vicente Carducho approved of the representation of the lamb as a metaphor for Christ.[3]

In the San Diego *Agnus Dei*, the bound legs, the halo, and above all the inscription TANQUAM AGNUS (as a lamb) dispel all doubt that the little animal symbolizes Christ delivered up for the salvation of mankind. The inscription is from a verse in the Acts of the Apostles (8:32): "He was led as a sheep to the slaughter; and like a lamb dumb before the shearer, so opened he not his mouth."

Of unknown provenance, the painting may be the *Study of a Lamb* sold at the time of the first dispersal of the Oudry collection (Hôtel Drouot, Paris, 1869). It was at one time in the Arthur Kay collection, Edinburgh, and was then twice put up for auction at Christie's, London, in 1929 and in 1943. In 1947, it entered the San Diego Museum of Art.

Among Zurbarán's versions of the theme, this painting is the most explicit in meaning. In the two earliest examples, of 1631 (private collection, Madrid) and 1632 (formerly Plandiura collection, Bar-celona), Zurbarán seems to be striving for a balance between the dark background and the pale mass of the animal. This aim is fully achieved in the two undated smaller paintings of the lamb, the present picture and that in the collection of the Marquesa del Soccoro, Madrid; both are very similar to the lamb in the Jerez *Adoration of the Shepherds*, of 1639, and may therefore date to about the same time.

The lamb seen here, lying on the sacrificial block, is brilliantly lighted and placed dramatically against a dark background, reflecting the approach to still-life painting inaugurated by Juan Sánchez Cotán and taken up by Zurbarán in 1633, notably in his still life of orange blossoms, oranges, and lemons, in the Norton Simon Foundation, Pasadena. The image is one frequently seen in a sheep-breeding country such as Spain. The lamb, shown lying on its side, with legs bound and neck resting on a table, with wool like tiny packets of granules, is depicted in all its physical reality, demonstrating Zurbarán's great talent as a painter of animals.

NOTES
1. Díaz Padrón 1981, p. 66.
2. León 1595, fols. 249–50.
3. Carducho 1633 (1979 ed.), p. 348.

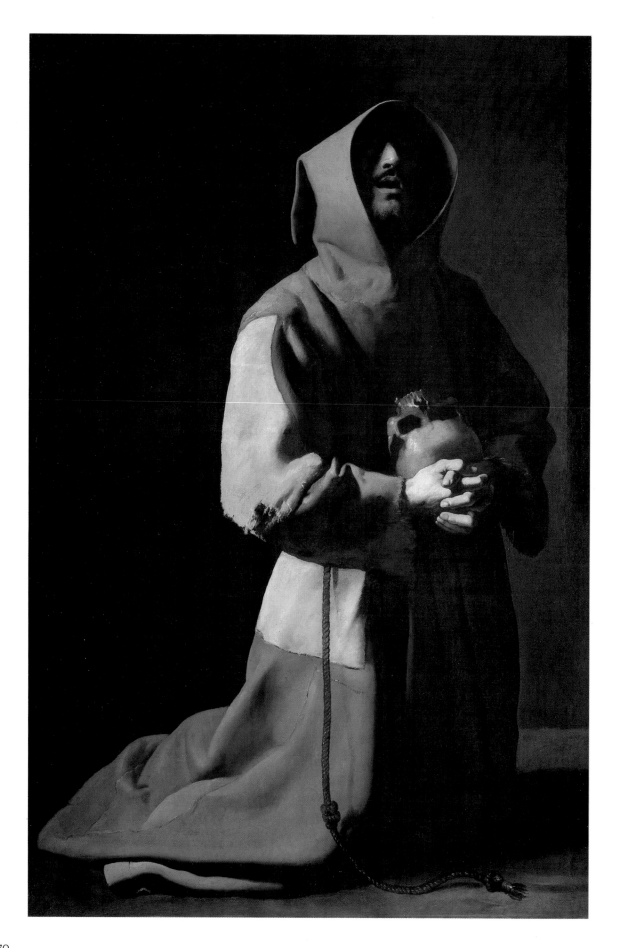

PROVENANCE
Collection of Alphonse Oudry, Paris (?); Oudry sale, Hôtel
Drouot, Paris, Apr. 16–17, 1869, no. 129 (?); collection of Arthur
Kay, Edinburgh, until 1943; up for sale twice, Christie's, London,
Mar. 22, 1929, and Apr. 8, 1943; donated by Misses Anne R.,
Irene, and Amy Putnam to the San Diego Museum of Art in 1947.

LITERATURE
Palomino 1724 (1947 ed.), p. 938; Andrews, in San Diego, San
Diego Museum of Art, 1947, p. 88; Soria 1947, pp. 66–69; An-
gulo Iñiguez 1950b, pp. 77–78; Soria 1953, no. 75; Gaya Nuño
1958, no. 3012; Guinard 1960a, no. 129; Guinard and Frati 1975,
no. 249; Gállego and Gudiol 1977, no. 281; Young 1982,
pp. 436–37.

EXHIBITED
Syracuse and Atlanta 1957, no. 20; Los Angeles and San Diego
1960, no. 13; New York 1961, no. 14.

53.
Saint Francis in Meditation

ca. 1635–40.
Oil on canvas, 60 × 39 in. (152 × 99 cm)
The Trustees of The National Gallery, London

Saint Francis of Assisi, a mystic and a poet, was also
the founder of a mendicant order that, along with
the order established by Saint Dominic, played an
important part in the reform of the Church in the
thirteenth century. The son of Pietro di Bernardone,
a rich merchant of Assisi, Francis decided at the age
of twenty-five to lead a life of poverty in the service
of Christ. He became known as Il Poverello, "the little
pauper," and attracted a large number of disciples to
whom he gave a monastic rule in 1209; but the essence
of what he transmitted was his radiant spirit of char-
ity. Exhausted by his intense apostolic activity, and
nearly blind, Francis devoted the last years of his life
to meditating on the sufferings of the crucified Christ.
In 1224, he became the first saint to receive the stig-
mata of the Passion, reflecting the wounds received
by Christ at the Crucifixion. He died October 4, 1226,
at the age of forty-five, leaving behind some five thou-
sand Franciscan monks. He was canonized in 1228 by
Gregory IX; his feast is celebrated October 4.

In 1585, Cardinal Cesare Baronius secured the
consent of the Franciscan pontiff Sixtus V to include
the miracle of the stigmata in the martyrology of the
saint. Also at this time, the iconography of Saint
Francis underwent a fundamental change. The image
of the gentle, often beardless monk of the poetic legend
so frequently depicted in art became the ascetic figure
of a mystic more in keeping with the post-Tridentine
ideal and with the very detailed description written
nearly three and a half centuries earlier by Tommaso
da Celano, his first biographer: "[He was] short . . .
his face slightly elongated . . .[with] average eyes,
brown and simple . . . thin lips, black beard but
sparse . . . [and was] extremely thin, his clothing
coarse."[1]

Like their Italian counterparts, the Spanish painters,
following the example set by El Greco—who was
praised by Pacheco for introducing this new image
"more in keeping with what history tells us"[2]—strove
to represent the saint more accurately.[3] His monk's
habit varies according to the patrons, as we can see
from the pictures that have remained in their original
sites; each branch of the large Franciscan family wished
to see the founding saint represented in its own habit.
Originally, the Franciscans wore a simple, cruciform,
ash-colored robe made of coarse wool, girdled by a
thick knotted rope, and with a pointed hood attached.[4]
Later, the hood became more rounded and was sepa-
rated from the robe, forming a sort of collar or moz-
zetta. This style became the accepted habit in the
iconography—despite Giotto's hesitation—and is still
worn by Franciscans today. When a Capuchin Order
was founded in 1525, artists began to depict Saint
Francis in the characteristic style of this reformed
branch: barefoot, bearded, and wearing a pointed hood
without a mozzetta. The Franciscan reform had a
considerable influence in Spain, and in the seventeenth
century many reformed branches were created. Apart
from the Capuchins, the Discalced Friars Minor, or
Recollects ("of strict observance"), and the Alcan-
tarians ("of strictest observance"), all wore a "close-
fitting patched habit."[5] In all likelihood, the two
paintings that show Saint Francis kneeling—the pres-
ent picture, in The National Gallery, London, and
that in the Arango collection (cat. no. 67)—were
executed by Zurbarán for a community of Discalced
Friars, as indicated by the habit made up from patches
of coarse wool.

We know nothing of the history of this remarkable
painting before its appearance in the Galerie Espagnole
of Louis-Philippe in 1838. The National Archives in
Paris has receipts from Baron Isidore Taylor and his
agents concerning about thirty paintings by Zurbarán,
the titles of which are not always specified; no pictures
of Saint Francis are mentioned. Taylor purchased
works for the king primarily in Seville, from the
English consul Julian Williams and from Canon
López Cepero, Aniceto Bravo, and Antonio Domine;
the receipts from Madrid cite Federico de Madrazo,
José Bueno, and the Duke of Hijar. We do not know,
therefore, if the present painting came from Seville,

Cádiz, or Madrid. As it is not mentioned in any early documents, it was most likely inaccessible before the expropriations of 1835.[6] In 1838, there were seven paintings in the Galerie Espagnole that represented Saint Francis. For many years, the London *Saint Francis* was thought to correspond either to no. 346 or to no. 351 in the catalogue,[7] but it has recently been determined that it was in fact no. 356 (in the fourth edition).[8] While archives and sale catalogues have given us much information on the other paintings by Zurbarán in the Galerie Espagnole, no trace of the origins of this painting has been found. From the costume, one might suppose that it was painted for the famous Capuchin monastery founded in Seville in 1627, whose church was inaugurated in 1631. Murillo painted some of his greatest works there between 1665 and 1680. Ponz and Ceán Bermúdez both mention the presence in this monastery of two paintings by Zurbarán representing Christ on the cross, which proves that he worked for the Capuchins before Murillo.[9]

Curiously, the Alcázar inventory of 1810, which lists all the works by Murillo from the Franciscan establishments and from the Hospital de la Caridad, mentions only four pictures by Murillo in the Capuchin monastery;[10] yet Vivant Denon, writing in 1810, reported that "the Capuchins rolled up their seventeen Murillos and buried them (the barbarians!) or put them in private houses."[11] We know that the Capuchins later gave some of their paintings to those who had helped them during the French occupation. Presumably, they also hid works by other artists in their possession, perhaps including those by Zurbarán. In any case, the 1810 inventory records only one painting of Christ on the cross by Zurbarán, apart from the one from San Pablo (cat. no. 2), and two paintings of Saint Francis, both small. One of these appears in the catalogue as no. 352 (painted on panel); the other picture, the only one whose origins are known, came from the Carmelite Monastery of San Alberto (cat. no. 18).

The execution and style of the London *Saint Francis* argue for a dating between 1635 and 1640, which suggests that it was painted in Seville. Restoration in 1980 not only brought out the transparency, brightness, and intensity of the colors but also showed that there was little overpainting and that the state of preservation was excellent. X rays show that the canvas was enlarged on both sides and at the bottom by several centimeters.

One cannot strictly speak of tenebrism here, for the transparent bluish penumbra of the church or cell in which Saint Francis is represented suggests depth. In contrast to the violent oppositions of dark, opaque shadows and stark, flat light of the works of the first period, here the figure is modeled in the sfumato manner. The painting is a remarkable pictorial exercise in the rendering of variations of ocher tones, from tan to reddish brown. The tightly crossed hands are smoothly modeled despite their coarseness.

The figure of Saint Francis, which is life-size and shown close up, occupies most of the otherwise bare pictorial space. This "cinematographic" disposition, unusual for the seventeenth century, creates a striking, almost intolerable, image of the saint and makes us participate intimately in his mystical ecstasy. This way of focusing attention on a figure by isolating it is in keeping with Counter-Reformation aesthetics as defined by such theologians as Ignatius of Loyola and Cardinal Federico Borromeo, who prescribed directness and realism in the representation of religious subjects. Here, rather than producing an image of the Divine by idealizing the model's features, Zurbarán evokes the Divine in his rendering of the intensity of Saint Francis's ecstatic expression as he meditates on the vision of death; one can almost hear his halting breath.

This extraordinary work held a great fascination both for art critics and for the general public in the mid-nineteenth century. It inspired Théophile Gautier to write both verse and prose.[12] Richard Ford was quite enthusiastic about the painting when it was acquired by The National Gallery at the Louis-Philippe sale.[13] (Ford, however, was more knowledgeable about Spain than about Catholic culture, for he thought that the saint's trances were due to remorse.) Impressed by the great realism of the picture, he spoke of it as a "daguerreotype," not realizing that the mystical spirituality of Spain called for such directness and detail in the representation of its saints in order that the faithful could see the work of art as a reflection of Divine intelligence.

NOTES
1. Celano, cited in Facchinetti 1926b, pp. 376–77.
2. Pacheco 1649 (1956 ed.), p. 344.
3. *L'immagine di San Francesco nella Controriforma*, 1982–83.
4. Hélyot and Bullot 1718, VII, p. 35.
5. *Ibid.*, pp. 120, 137.
6. The National Gallery, London, owns another *Saint Francis*, signed and dated 1659, in which the saint is shown bareheaded, kneeling in meditation in a landscape setting (see fig. 19, p. 19).
7. Stirling-Maxwell 1848 (1891 ed.), III, p. 927.
8. Baticle and Marinas 1981, nos. 356, 361.
9. Ponz 1782 (1947 ed.), p. 799; Ceán Bermúdez 1800, VI, p. 50.
10. Gómez Imaz 1896, p. 126.
11. Lipschutz 1972, p. 44.
12. Quoted in Lipschutz 1982, p. 114:

> Tes moines Le Sueur près de ceux-là sont fades
> Zurbarán de Seville a mieux rendu que toi
> Leurs yeux plombés d'extase et leurs têtes malades.

Ibid., p. 112: "Il y a surtout un tableau de moine en prière qui est d'un effet saisissant; le moine est à genoux, la tête renversée en arrière par un spasme extatique, son capuchon a glissé sur ses yeux et lui cache la moitié de la figure, mais l'épaisseur de la grossière étoffe ne lui dérobe pas la vue du ciel; sa bouche entr'-ouverte et la tension de son cou indiquent une ardeur et une foi singulière. Je ne connais rien de plus ascétique et de plus profondément chrétien."

13. Ford 1853, May 14: "No. 50 for which 265£ was paid. The subject is St. Francis kneeling, with a skull in his hands; a cowl half conceals his wan, starved, and death-stricken features. The picture is first-class, and altogether well deserves the high reputation which it has always held on the Continent. The subject may not please all 'times' or tastes, but on this it is folly to dispute. He must be a bold man who affirms that this noble example does not contain the quintessence of Zurbarán:—nor can we conceive a more true or intense expression of the penitential, prayerful sentiment—the shadowing out of deep agonizing intensity of remorse—that is here realized. Nor is the material—the outward and visible form, the ghastly light on the countenance, the tattered robe, the threadbare garb of poverty and piety—less powerfully rendered. The picture is an absolute daguerreotype of originals with which Peninsular cloisters were once peopled, and which we have often seen when Spain was 'as it was.'"

PROVENANCE

Galerie Espagnole, Musée Royal au Louvre, Paris, 1838; Louis-Philippe sale, Christie's, London, May 6, 1853, no. 50, for £265, to The National Gallery, London.

LITERATURE

Paris, Musée du Louvre, 1838, no. 346 (1st ed.), no. 356 (4th ed.); Stirling-Maxwell 1848 (1891 ed.), III, p. 927; Ford 1853; Waagen 1854, III, p. 67; Gueulette 1863, pp. 38–39; Blanc *et al.* 1869, pp. 5–6; Soria 1953, no. 166; Guinard 1960a, no. 354; MacLaren and Braham, in London, National Gallery, 1970, no. 230, pp. 137–38; Guinard and Frati 1975, no. 169; Gállego and Gudiol 1977, p. 258; Baticle and Marinas 1981, no. 356.

EXHIBITED

Paris 1838–48, no. 346 (1st ed.), no. 356 (4th ed.); London 1981, no. 33.

54.
The Veil of Saint Veronica

ca. 1635–40
Oil on canvas, 27½ × 22¼ in. (70 × 56.5 cm)
Nationalmuseum, Stockholm

EXHIBITED IN NEW YORK ONLY

According to an old legend, on the road to Calvary Christ met a pious young woman (called Berenice in the Apocryphal Gospel of Nicodemus), who may have been the wife of Zaccheus. Out of compassion, she gave him the white veil from her head to wipe his face, and as reward, he left the imprint of his face on the thrice-folded veil. The precious cloth came to be known as a *veron ikon*—"true image" in Greek; hence the woman came to be called Veronica. This episode was commemorated by the Church in one of the Stations of the Cross.[1]

At the Church of San Silvestro in Rome, an image of the face of Christ on a cloth was venerated from at least the tenth century as the Veil of Veronica, or Sudarium. According to the legend, Veronica left the precious relic to the pope when she died, and so the cult of the Sudarium originated in Rome. Eventually, there were many such representations of the face of Christ in churches throughout Europe, all of them highly venerated. In Andalusia, the Cathedral of Jaén was constructed to house one of these relics, which was considered to have miraculous powers.

Beginning in the fourteenth century, perhaps as a result of the influence of the Mystery plays in which the story of Veronica was reenacted, artists painted images of a woman presenting to the faithful a cloth imprinted with the portrait of Christ. The Sudarium is included among the instruments of the Passion in depictions of the Mass of Saint Gregory, in which it is often shown hanging by two nails on the wall above the altar. This unusual subject, a Netherlandish invention, became especially popular in fifteenth-century Spain but is rarely seen after the Council of Trent.

In the sixteenth century, the Veil of Veronica is shown held by two angels in an engraving by Dürer, and it appears as a sort of miraculous portrait in versions by El Greco. Zurbarán painted this subject several times, striving to depict what was then considered historical truth: instead of a hieratic, iconic image, he created portraits of a suffering Christ faintly imprinted on the cloth.

The *Veil of Saint Veronica* painted by El Greco between 1577 and 1579 for the center of the altarpiece of Santo Domingo el Antiguo in Toledo (now Caturla collection, Madrid) was framed in a gilded oval wood

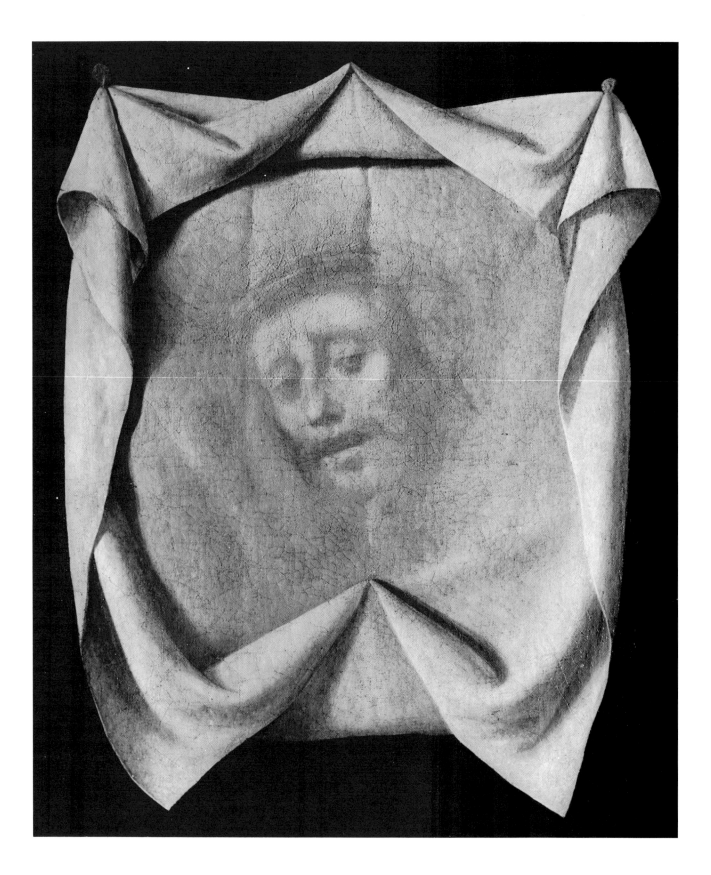

274

medallion in order to have the appearance of a venerable relic. Half a century later Zurbarán, who probably did not know the version by El Greco, intensified the devotional nature of the subject by a careful disposition of the cloth and by the finely detailed image of the face. The cloth is shown with neat folds disposed symmetrically around the face, as in a reliquary. It seems to be attached to the wall by two small ropes knotted at the ends and two pins holding triangular flaps that form "gables" above and below the head of Christ.

The lateral lighting brings out the volume of the folds, and the dark background heightens the illusion of relief so much that Caturla describes the picture as a "trompe l'oeil a lo divino."[2] Mystification of a subject is foreign to Zurbarán's artistic temperament. On the contrary, his treatment of draperies and still-life elements shows that he strove consistently to render objects as tangible as possible. In contrast, then, this face, shown in three-quarter view, delicately tilted to the side and modeled with light brushstrokes of gray and yellow, takes on the transparency of an apparition. The pained but handsome features express a profound sadness.

The twelve known versions of this theme, autograph and workshop productions, are characterized by variations that allow us to construct a rough chronology. The first group (Angel Aviles collection, Madrid; Church of San Miguel, Jerez de la Frontera) can be related to a painting formerly in the Pacheco collection in Madrid (now private collection, Argentina). These are characterized by a cloth with fairly angular folds and a clearly modeled face. The picture in Argentina is dated 1631 and considered an original work, although the authenticity of the signature (placed vertically along the right edge) has been questioned. Other versions, such as the one in the Caturla collection in Madrid, in which the face is more emaciated, are contemporary with the Stockholm picture and were executed between 1635 and 1640. In this group, the face of Christ is sometimes shown with the crown of thorns.

The recent discovery in the province of Valladolid of another *Veil of Saint Veronica*, dated 1658 (cat. no. 65), attests to the continued popularity of this medieval theme, which Zurbarán renewed with such skill and emotion.

NOTES
1. *Vies des saints et des bienheureux*, 1936, II, p. 84.
2. Caturla 1965, pp. 202–5.

PROVENANCE
Collection of Frank Hall Standish, Paris; bequeathed to Louis-Philippe in 1842, shown in the Musée Royal au Louvre; Louis-Philippe and Standish sale, Christie's, London, May 27, 1853, no. 230, to William Stirling-Maxwell of Keir; acquired by the Nationalmuseum, Stockholm, in 1957.

LITERATURE
Standish 1842, no. 183 (as "Unknown," 42 × 32 cm); Soria 1953, no. 64a; Stockholm, Nationalmuseum, 1958, no. 5382; Guinard 1960a, no. 87; Torres Martín 1963, no. 72; Caturla, in Madrid, Casón del Buen Retiro, 1964, p. 36; and no. 21; Caturla 1965, pp. 202–5; Brown 1974, p. 112; Guinard and Frati 1975, no. 75; Gállego and Gudiol, 1977, no. 558.

EXHIBITED
Paris 1842–48, no. 183; Manchester 1857, no. 861; London 1895–96, no. 174; Edinburgh 1951, no. 43; Madrid 1964–65, no. 21.

55.
The Virgin of the Immaculate Conception

ca. 1640–50
Oil on canvas, 68½ × 54⅜ in. (174 × 138 cm)
Museo Diocesano de Arte, Sigüenza

With the exception of Antonio Mohedano, who painted an *Inmaculada* dressed entirely in white (Museo de Bellas Artes, Seville), Sevillian artists up to the 1630s represented the Virgin of the Immaculate Conception wearing a gown of deep rose and a blue mantle. This costume was gradually replaced by a white gown and a sky-blue cloak, the costume worn by Mary in her apparitions to the Blessed Beatriz da Silva at the end of the fifteenth century.[1] Beatriz da Silva, a Benedictine nun, founded the Order of the Conception of Our Lady, which was later placed under Franciscan rule; its purpose was to honor the Virgin of the Immaculate Conception. In 1636, the proceedings for the beatification of Doña Beatriz recalled to the faithful her visions of the Virgin.[2] This was also the time when Francisco Pacheco was writing the *Arte de la pintura* (not published until 1649), in which he recommended that artists depict the *Inmaculada* in blue and white (though he himself had used rose and blue in the *Inmaculadas* he had painted between 1615 and 1630).[3] In the same passage, he demonstrates the orthodoxy of representing the *Purísima* without the Child, because it had thus appeared as early as the beginning of the sixteenth century on Franciscan medals approved by Pope Leo X.

Pacheco, who was charged by the Holy Office of the Inquisition with certifying the propriety and decorum of religious art commissioned in Seville, deemed it fitting and proper that the Virgin Immac-

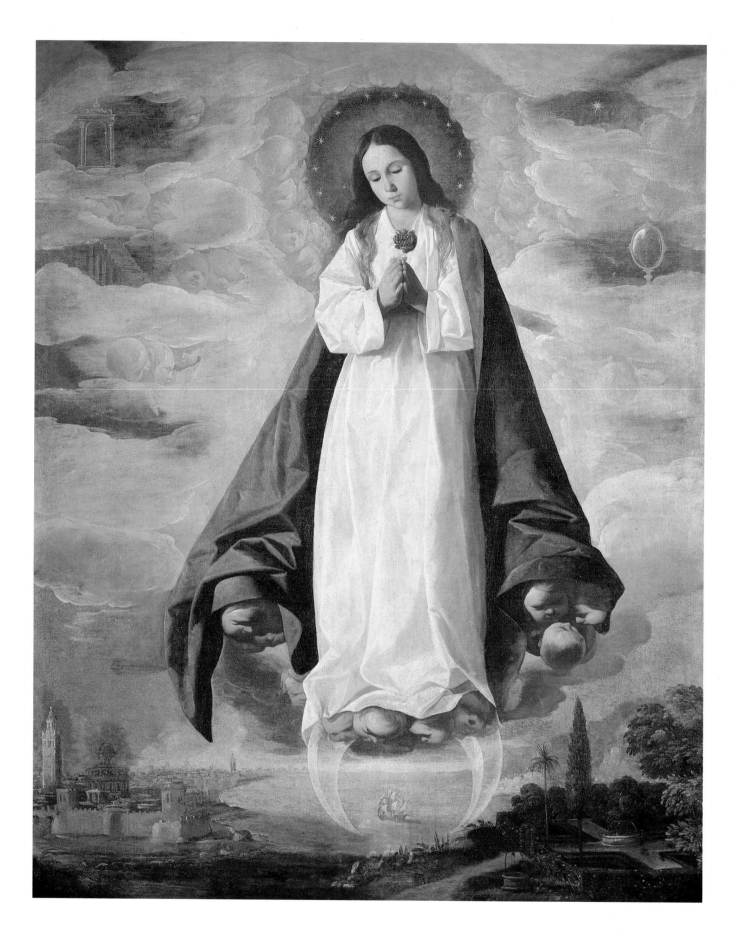

ulate be portrayed as a girl of twelve or thirteen with long golden hair, enveloped by the sun and crowned with stars.[4] She should wear an imperial crown and be shown standing on a transparent crescent moon with the horns pointing toward earth. Pacheco then proceeds to pride himself on being "the first to lend . . . majesty to those adornments."[5]

If Pacheco did indeed invent the motif of the transparent moon and was the first to paint the crescent with its horns pointing downward, he was far from the first to represent the Virgin's attributes in the landscape.[6] Engravings of the Virgin dating to the beginning of the sixteenth century, as well as the first painted *Inmaculadas*, show her in a heaven strewn with symbols from the Marian litany. In 1603, Juan Pantoja de la Cruz painted for the Franciscan Monastery of Jesús y María in Valladolid a large *Purísima* haloed by the sun above a landscape with symbols; other attributes could be read in the clouds. And Juan de Roelas, in his *Virgin Immaculate with the Jesuit Fernando de Mata*, of about 1612 (Staatliche Museen Preussischer Kulturbesitz, Berlin), followed the same motif. The landscape with Marian symbols probably derived from Italian models made known through the engravings of Schiaminozzi, in which angels are depicted bearing symbols framing the Virgin.[7] Between 1615 and 1630, celestial attributes were not always represented, but the exegetes, in the interest of clarity, probably recommended that the symbols of the Marian litanies be clearly represented to the left and right of the Virgin. Thus, for the solemn and magnificent feast of the Immaculate Conception celebrated by the Franciscans in 1615 at the Monastery of San Francisco in Seville, there was installed on the high altar an image of the Virgin of the Immaculate Conception, dressed in white and blue silk, resting on a crescent moon with horns pointing upward (the treatise recommending downward-pointing horns was not published until 1618), crowned by twelve stars, and with long blond hair unbound. Five of her attributes were placed at either side,[8] and she wore sumptuous jewels, as in her appearance to Saint Teresa.[9] Zurbarán, in the present *Virgin of the Immaculate Conception*, in Sigüenza, and in the 1632 version, now in the Museu d'Art de Catalunya, Barcelona, adorned the Virgin with an imposing pendant, on which jewels form the initials of the angelic salutation.

Reading the landscape details from left to right, one sees the Giralda Tower of Seville—the ivory tower of the litanies, the City of God of Psalm 87:3, the "tower of David builded for an armoury" of the Song of Solomon 4:4.[10] Shown on the river, between the two horns of the crescent moon, is a caravel referring to the Virgin's protection of sailors. To the right,

the "garden inclosed . . . [the] fountain sealed" (Song of Solomon 4:12), and the "well of living waters" (Song of Solomon 4:15) with the cedar of Lebanon, the cypress of Zion, and the palm tree of Engaddi (Ecclesiasticus 24:13–14). Through the clouds at left are seen Jacob's ladder and the gate of heaven (Genesis 28:12, 17), and at right the morning star (Ecclesiasticus 50:6) and the unspotted mirror (Wisdom 7:26).

Discovered in Jadraque (Guadalajara) at the beginning of this century by A. de Beruete on one of his excursions in Castile, this *Virgin of the Immaculate Conception* was nonetheless absent from most catalogues of Zurbarán's oeuvre until 1964, when it appeared in public for the first time in the monographic exhibition at the Casón del Buen Retiro, Madrid.

Juan Arias de Saavedra, the patron and friend of Gaspar Melchor de Jovellanos, the famous statesman and student of the Spanish Enlightenment, lived in Jadraque around 1800. In 1952, a great-granddaughter of Arias de Saavedra, María Cristina Perlado y Verdugo, willed the painting to the religious community she had founded in her family home (which had been the home of Arias de Saavedra) and where that same year a convent of Ursuline nuns was established.[11] According to Consuelo Sanz Pastor, the Saavedra family owned nine paintings by Zurbarán.[12] It may be that Arias de Saavedra or one of his descendants acquired from a former monastery in that town an ensemble of works by Zurbarán, because it is a strange coincidence that the parish church of the town also has a *Christ after the Flagellation* signed by Zurbarán and dated 1661. Unfortunately, the parish archives were destroyed in the civil war, making this impossible to verify.

To date, there is no documentary evidence that the Jadraque *Virgin of the Immaculate Conception* is in fact the painting which belonged to Jovellanos and which he is said to have bequeathed to Arias de Saavedra. Arias de Saavedra died in February 1811, ten months before Jovellanos. In a *memoria* of 1802, Jovellanos bequeathed to Arias de Saavedra a portrait of himself painted in 1798 by Goya.[13] But neither the *memoria* nor Jovellanos's last will (drawn up in 1807 on Mallorca, where Jovellanos was in political exile) mentions a painting by Zurbarán.[14] However, there exists a document in which a "boceto de la Asunción" (sketch of an Assumption) is given to one Posada, an ivory knife to one Meléndez Valdés, and a painting to one Cabarrús; it is also known that in 1884, another of Arias de Saavedra's descendants, Antonio Botigo y Saavedra, owned Goya's portrait of Jovellanos.[15]

But in any case, it is known that Jovellanos owned a *Virgin of the Immaculate Conception* by Zurbarán. In a letter to Manuel Bayeu (1804?), Jovellanos's secre-

tary, Manuel Martínez Marina (who often wrote and signed for Jovellanos), stated that Jovellanos had in his collection, in addition to eight or ten paintings of Virgins of "varios misterios," "two original *Concepciones*, one by Zurbarán and the other by Goya."[16] It is evident that Jovellanos must have acquired the painting by Zurbarán during his sojourn in Seville; if the *Virgin of the Immaculate Conception* bequeathed by Doña Perlado y Verdugo is indeed the one that Jovellanos left to Arias de Saavedra, the provenance of the painting could be resolved.

The Jadraque *Virgin of the Immaculate Conception* cannot be the painting commissioned in 1630 by the City Hall of Seville because its style and treatment belong to a later period, when Zurbarán had renounced tenebrism (without, however, abandoning the powerful effects of full relief, which he suggested through his adroit exploitation of light). Moreover, the Virgin in his first *Inmaculadas*, those in the Prado and in the Museu d'Art de Catalunya, Barcelona, are attired in the traditional rose, whereas beginning in 1636 it became customary in Seville to show her in a white gown.

NOTES
1. Bivar 1618, fol. 3.
2. Hornedo 1953, p. 181.
3. Pacheco 1649 (1956 ed.), p. 209.
4. *Ibid.*, pp. 210–11.
5. *Ibid.*, p. 211.
6. *Ibid.*, p. 212.
7. Bartsch 1983, XXXVIII, fig. 36.
8. Lugones 1615, fols. 8–9.
9. Gállego 1968, p. 207.
10. The analogy with Seville was noted by Carrascal Muñoz 1973, pp. 92–94.
11. Herrera Casado 1974, p. 299.
12. Sanz Pastor, in Madrid, Casón del Buen Retiro, 1964, no. 103.
13. Fuentenebro 1911, p. 251.
14. Somoza 1885, p. 121.
15. *Ibid.*
16. *Biblioteca de autores españoles*, 50 (1889), p. 159.

PROVENANCE
Collection of María Cristina Perlado y Verdugo, great-granddaughter of Juan Arias de Saavedra; bequeathed by her to the parochial school of Nuestra Señora del Carmen, Jadraque, in 1952; deposited at the Museo Diocesano de Arte, Sigüenza.

LITERATURE
Guinard 1949, p. 9; Gaya Nuño 1958 (1976 ed.), p. 66; Sanz Pastor, in Madrid, Casón del Buen Retiro, 1964, no. 4; Díaz Padrón, in Madrid, Instituto Central de Restauración, 1968, no. 34; Gudiol 1965, pp. 148–51; Brown 1974, p. 24; Guinard and Frati 1975, no. 66; Gállego and Gudiol 1977, no. 28; Díaz Padrón, in Brussels, Palais des Beaux-Arts, 1985, no. C57.

EXHIBITED
Madrid 1964–65, no. 4; Madrid, 1981–82c, no. 69; Brussels 1985, no. C57.

56.
The Holy Family with Saints Anne and Joachim and John the Baptist

1650–60
Oil on canvas, 53½ × 50⅜ in. (136 × 128 cm)
Collection of the Marqués de Perinat

The key to the symbolism in this painting is to be found in the prominently placed basket of roses that the infant Saint John the Baptist presents to the Virgin and on which their gazes converge. Flowers have always been used symbolically in visual representations, their meanings relating to their beauty, their fragility, and their perfume. The red, orange, and pale pink roses depicted here allude to the practice of the Rosary, named after the medieval *rosarium*, meaning rose garland. The long form of the Rosary consists of fifteen sets of ten recitals of the prayer Ave Maria, accompanied by meditation on the joys and sorrows of the Virgin. The floral symbolism associated with the Marian cult—white or pink roses for the mysteries of joy; red roses, the color of the blood of Christ, for the mysteries of sorrow; and golden roses for the mysteries of glory—dates from the fourteenth century. The recitation of the Rosary is the sinner's offering to Mary as redeemer, with Christ, of mankind. The Virgin is here represented giving to her son the apple symbolizing the Fall of Man. The Christ Child holds a passionflower, a plant that was discovered in America in the seventeenth century and adopted by missionaries as a symbol of the Passion because of the fancied resemblance of parts of the flower to the instruments of the Crucifixion.

The Carthusians claimed to have received the Rosary as a gift from Mary before the Dominicans. Thus, Zurbarán painted for the Carthusian monastery at Jerez de la Frontera the representation of Dominique Hélion about to receive the chaplet from the rose-crowned Virgin (Muzeum Narodowe, Poznań); the ground is strewn with roses, and an angel presents the Virgin with a basket of flowers, as does the infant Saint John in the present painting. The *Virgin of Mercy of Las Cuevas* (cat. no. 38) probably combines the theme of the Rosary with the theme of Mary's protection of the Carthusians. Carthusian patronage thus would explain the presence of the symbolic roses in the *Holy Family*, as well as the unusual presence of Saint Anne and of Saint Joachim, who died, according to Ribadeneyra, when Mary was eleven years old.[1] John the Baptist and Mary were the first and principal patron saints of the Carthusian Order, but the Carthusians were also especially dedicated to the parents of the Virgin.

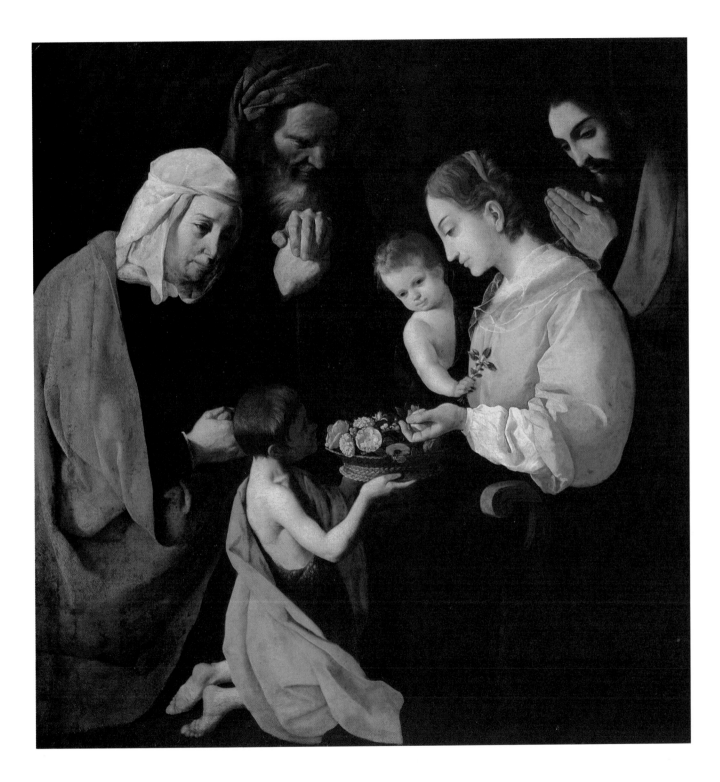

Ponz mentions a *Holy Family* by Zurbarán in the library at the Carthusian Monastery of Las Cuevas, and Ceán Bermúdez reports having seen a painting of this subject in the prior's cell.[2] Guinard suggests that the present *Holy Family* may have come from the same monastery.[3] His idea is supported by the fact that it is the only known representation of the Holy Family as such by Zurbarán (the Budapest picture, cat. no. 68, depicts the Rest on the Flight into Egypt). Further evidence in favor of a Carthusian provenance is the iconographic elements mentioned above. The figures of Saints Anne and Joachim have in the past been mistakenly identified as Saints Zacharias and Elizabeth.

It would seem that, once again, Zurbarán used Italian models, which he transposed into his own individual style. The medallion-like profile of the Virgin recalls the work of both Parmigianino and Simon Vouet, and the little Saint John the Baptist is closer to the putti of Caravaggio than to the urchins of Murillo; and yet, the disposition of the figures is far removed from the sophisticated designs of Italian painters. In spite of Zurbarán's effort to create a linear rhythm, the group of Saint Joseph, the Virgin and Child, and Saint John the Baptist is inscribed in a triangle that divides the composition along an oblique axis. The graceful poses, the blend of sincerity with a realism devoid of vulgarity, and the profound religious feeling that emanates from this work give it a highly original character which rejuvenates the theme. Zurbarán here renders in comprehensible form the Christian rebus that his monastic patrons surely asked him to represent. Having reached artistic maturity, he knew, as Picasso was to learn three centuries later, how to decompose forms in order to give them more significance. The resulting stylization, which derives from the close observation of nature and light, may disconcert those who favor classical forms, but for the initiated eye it reveals the originality of an elaborate and deliberate effort.

NOTES
1. Ribadeneyra 1624 (1983 ed.), III, p. 319.
2. Ponz 1780 (1947 ed.), p. 769; Ceán Bermúdez 1800, VI, p. 49.
3. Guinard 1960a, no. 53.

PROVENANCE
Monastery of Las Cuevas, Seville (?); collection of Alberto Bergas Gasteriano, Madrid; acquired by the Marquesa de Perinat, grandmother of the present marqués; collection of the Marqués de Perinat, Madrid.

LITERATURE
Gaya Nuño 1948, no. 74 (as *Adoration of the Shepherds*); Caturla, in Granada, II Festival Internacional de Música y Danza, 1953, pp. 35, 52; Soria 1953, no. 12; Guinard 1960a, p. 140 and no. 53;

Torres Martín 1963, no. 9; Guinard and Frati 1975, no. 68; Gállego and Gudiol 1977, no. 56.

EXHIBITED
Granada 1953, no. 19; Madrid 1964–65, no. 26.

57.
Saint Jerome with Saints Paula and Eustochium

1635–40
Oil on canvas, 8 ft. ½ in. × 5 ft. 8¼ in. (245 × 173 cm)
National Gallery of Art, Washington, D.C.
 Samuel H. Kress Collection

Sophronius Eusebius Hieronymus, known as Jerome, was born about 340–45 at Stridon, in Dalmatia, and was baptized in Rome. Drawn to the hermit's life, he went to the Holy Land, south of Antioch, and lived as an ascetic struggling against powerful temptations. He devoted himself to scriptural studies, for which he learned Hebrew, and he studied the Greek writings of Origen on the Scriptures, which he translated into Latin. Ordained a priest, he returned to Rome in 382 and became secretary to Pope Damasus, as well as a much sought-after spiritual adviser. Because his satirical tongue had irritated a good many Romans, he found it wise after the pope's death to return to the East. He was followed there by several Roman ladies, among them Paula and her daughter Eustochium, whom he had served as spiritual guide. In Bethlehem, assisted by the two women, he founded a convent that he placed under Paula's care and a monastery that he himself directed. There he led a life of austere penitence devoted to meditation and to the translation of the Bible into Latin. Paula died about 404 and her daughter about 418, two years before Jerome himself.

Saint Jerome is one of the four Doctors of the Latin Church. His feast is celebrated on September 4. It was Jerome who gave definitive form to the Latin text of nearly the entire Bible. His translation, known as the Vulgate, was adopted officially by the Roman Church and again declared the authentic text at the Council of Trent, following which Jerome was often represented as a man of learning.

Zurbarán shows Jerome as an old man, teaching Paula and Eustochium. The three figures wear the habit of the Hieronymite Order (named after Jerome), which suggests that the setting must be their home of later years, in Bethlehem. Over his white tunic and black scapular, Jerome wears the red cape of a

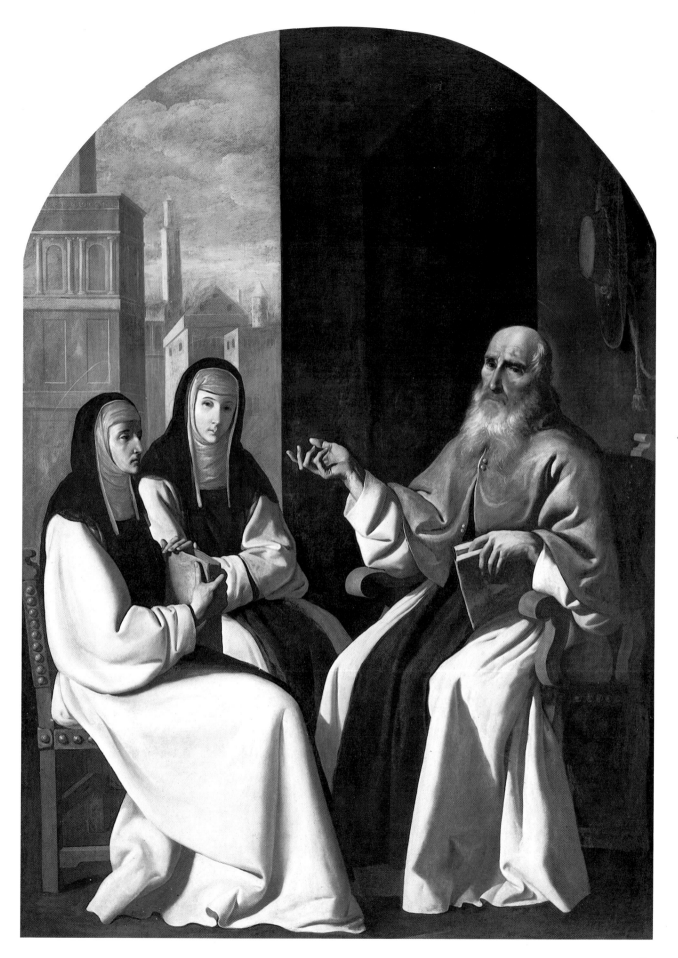

cardinal, and a cardinal's hat hangs behind him. These are ahistorical elements, since Jerome was a papal secretary, not a cardinal, an office created only at the end of the eleventh century. Even José de Sigüenza, the learned historian of the Hieronymite Order, held that Jerome deserved to be a cardinal.[1] Pacheco agreed with Sigüenza, but digressed at length about the anachronistic use of the costume and red hat, since these were not adopted for cardinals until the mid-thirteenth century. Nonetheless, Pacheco sanctioned this contemporary costume as a means of enlightening the "unpolished people for whom painting is a great aid."[2] The remark applies to other saints as well, and explains the apparent lack of concern for historical accuracy in Zurbarán's paintings, even when they correspond to historical fact as required by the Church.

According to Soria, the first to publish the painting, *Saint Jerome with Saints Paula and Eustochium* comes from the Convent of Santa Paula, in Seville.[3] Between 1635 and 1640, the cloistered nuns undertook major renovations of the convent and commissioned a number of altar paintings. In Seville, the picture was acquired by Frank Hall Standish, who bequeathed it, with his collection, to Louis-Philippe in 1842. It was then displayed in the Louvre until 1848 and was one of the few pictures that the French historian Michelet remarked on (with characteristic inaccuracy) after visiting the Galerie Espagnole on March 14, 1845 ("Zurbarán: Saint Dominic and two nuns"). Alphonse Oudry bought it for £21 at Christie's, London, in 1853, and it figured in the two sales of the Oudry collection in Paris, in 1869 and in 1876, when it was sold for 715 francs. Taken to the United States, it was purchased in 1952 by the Samuel H. Kress Foundation, and donated four years later to the National Gallery of Art, Washington, D.C.

The composition of this unusual subject derives from formulas that Zurbarán developed in the portraits of Hieronymites done for the Monastery of Guadalupe in 1639. Monumental figures fill the foreground and stand out against an architectural background that abruptly juxtaposes the dark wall of a monastic cell and the brilliantly lit view of a city, as in the *Vision of Fray Pedro e Salamanca*, in Guadalupe. Jerome's emaciated countenance, his thinning beard, and his bony hands suggest, along with his very natural gestures, the spiritual discourse of a learned hermit. His stark presence is emphasized by contrast in the depiction of the two nuns, who are painted in a much drier, more linear style, which is accentuated by the cold bright light. The city view in the background is particularly interesting. The massive edifice at the left, with its Doric gallery and frieze, is related to the Renaissance palaces depicted in Zurbarán's *Apotheosis of Saint Thomas Aquinas* (Museo de Bellas Artes, Seville) or the colonnade in the *Mass of Fray Pedro de Cabañuelas*, in Guadalupe (see fig. 9, page 10), and demonstrates the artist's interest in architecture. The sharply defined cubic shapes of the adjoining buildings epitomize his taste for clear and simple forms, and the landscape, with its monochromatic treatment, has affinities with the cityscapes of the Italian Renaissance.

In all, the composition attests to Zurbarán's efforts from 1635 to 1640 to integrate monumental figures of saints into quiet, though not static, tableaux.

NOTES
1. Sigüenza 1605, fol. 269, cited in Pacheco 1649 (1956 ed.), II, p. 337.
2. Pacheco 1649 (1956 ed.), II, pp. 338–39.
3. Soria 1953, no. 198.

PROVENANCE
Convent of Santa Paula, Seville; collection of Frank Hall Standish, Paris; bequeathed to King Louis-Philippe in 1842, shown in the Musée Royal au Louvre; Louis-Philippe and Standish sale, Christie's, London, May 27, 1853, no. 105, for £21, to Alphonse Oudry, Paris, 1853; Oudry sale, Hôtel Drouot, Paris, Apr. 16–17, 1869, no. 157; second Oudry sale, Hôtel Drouot, Paris, Apr. 10, 1876, no. 60, for 715 francs; M. Knoedler and Co., New York, 1951; Samuel H. Kress Foundation, New York, 1952; donated to the National Gallery of Art, Washington, D.C., in 1956.

LITERATURE
Standish 1842, no. 161; Soria 1953, no. 198; Gaya Nuño 1958, no. 3123; Guinard 1960a, no. 485; Guinard and Frati 1975, no. 310; Eisler 1977, p. 216; Gállego and Gudiol 1977, no. 324.

EXHIBITED
Paris, 1842–48, no. 161.

58.
The Annunciation

1650
Oil on canvas, 7 ft. × 10 ft. 3¼ in. (213 × 314 cm)
Signed and dated on a cartouche, lower left: Fran^{co} de Zurbaran 1650
Philadelphia Museum of Art. W. P. Wilstach Collection

This canvas was painted twenty years after the *Annunciation* at the Carthusian monastery at Jerez de la Frontera (cat. no. 26). The composition, in a horizontal oblong format, is similar to that of the Jerez *Annunciation*, but the placement of the figures is reversed. The spirit of the work is entirely different

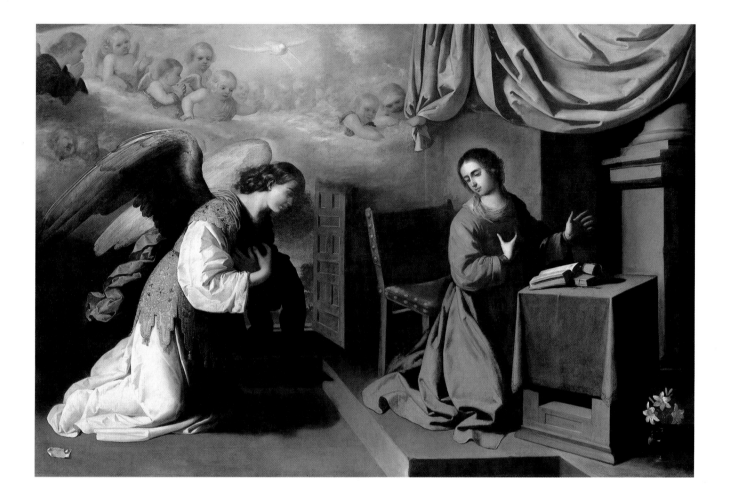

from the triumphal scenes adopted by Catholic Europe of the seventeenth century; instead, it evokes the intimate and touching mystery of fifteenth-century Netherlandish paintings of the subject. Both the format and the setting, which is less open to the exterior than in the earlier painting, accentuate the liturgical character of the scene. The angel, kneeling directly on the flagstone, is no longer borne on fleecy clouds as in the Jerez painting. On his immaculate alb, symbol of his purity, he wears a heavy dalmatic in gilded brocade, gold signifying joy, salvation, and justice.[1] Here again, he kneels in meditation before Mary. He holds no lily, but, as in the earlier painting, to emphasize Mary's triple virginity (before, during, and after the birth of her son), there are three lily blossoms in a vase. The horizontal composition enhances the importance of Gabriel, with his thick, curly hair, richly gilded tunic, and superb many-colored wings. The Virgin's head, though charming, displays a more superficial expression than that of the Virgin in the Jerez painting, which suggests that, on this point, Zurbarán's patron was less exacting than the Carthusians. In 1630, Eugenio Cajés painted an *Annunciation* (parish church, Torrelaguna) whose iconography is very close to that of the present work.[2]

The character of familiarity, further accentuated by the absence of haloes, invites the viewer to participate directly in the mystery. The summons of the faithful to close contemplation of the angelic annunciation to Mary was fully in line with the *devotio moderna*, the spiritual renewal at the end of the fourteenth century, which favored a life of elevated sentiment and readiness for illumination in the manner of the Franciscans. That current of thought reappeared in Spain in the sixteenth and seventeenth centuries in the form of a spiritual illuminism which took various guises, including that of the condemned movement of the *alumbrados*.

Palomino, writing in 1715–24, stated that he had seen, in the sacristy of the Church of San Miguel, in Peñaranda de Bracamonte (Salamanca), "a picture [by Zurbarán] of the Annunciation which no one knew was by him."[3] Ponz does not mention the painting, and Ceán Bermúdez cites only "an *Annunciation* in the sacristy."[4] The picture reappeared in 1834 in the hands of the collector Valentín de Carderera; it was sold in Paris, in 1867, with the collection of the Marqués de Salamanca; and it was donated to the Philadelphia Museum of Art in 1900. The early biographers of Zurbarán discussed the painting without having seen it, which resulted in erroneous claims about its date. In the 1970s, Jonathan Brown examined the canvas and discovered that it was not only signed but dated 1650 on the cartouche in the lower left corner.[5] Caturla had earlier published a receipt she had discovered in the registers of the vestry of San Miguel de Peñaranda, dated July 4, 1658, which recorded the delivery of "two large paintings with their frames, one a *Nativity*, the other an *Annunciation*, both of which the count [Gaspar de Bracamonte, 3rd Count of Peñaranda] had sent."[6] Caturla also discovered in the sacristy of the church a nineteenth-century copy of the Philadelphia *Annunciation*, signed by S. Tayama.

The inscribed date of 1650, which laboratory examination shows is original, is proof that Zurbarán painted the present canvas eight years before it was sent to Peñaranda, thus while he was either in Seville or in Madrid. The possibility that he was in Madrid suggests that he may indeed have made a second visit there in 1650, as Caturla had "suspected without being able to prove,"[7] because—quite rightly, as it turns out—she considered the Philadelphia *Annunciation* earlier in style than 1658.

Here again, we find the sfumato treatment that Zurbarán had adopted some time back and which he would develop during his last ten years, though he remained sensitive to the directives of his patrons and to the nature of the commission he was working on. Thus, he would at times return to a less vaporous treatment of forms, although he always managed to preserve his own style and use of dramatic lighting.

There is in a Madrid private collection a painting that appears to be a first version of the Philadelphia *Annunciation*.[8] It has the same composition and tenebrist effects, but is less soft in treatment. Curiously, the bouquet of flowers in the present painting is very similar to the one in the *Virgin of the Annunciation* in the Fundación Juan March, Palma de Mallorca, in which the figure of the Virgin is a replica of that in the first version.[9] In the *Virgin of the Annunciation*, where the Virgin is shown alone, the terra-cotta vase is similar to the one shown at the right in the Prado *bodegón* that is generally dated to between 1630 and 1635, while in the Philadelphia *Annunciation* the vase is crystal. A systematic study of the way Zurbarán adapted compositions and compositional details, ten or even fifteen years after introducing them, would be of value for a better understanding of his working methods. The Philadelphia *Annunciation* is a landmark in the catalogue of Zurbarán's work; the painting has only recently been extensively documented.

NOTES
1. Aigrain 1930, p. 325.
2. Angulo Iñiguez and Pérez Sánchez 1969, I, pl. 185.
3. Palomino 1724 (1947 ed.), p. 938.
4. Ceán Bermúdez 1800, VI, p. 52.

5. Brown 1974, p. 140.

6. Caturla, in Madrid, Casón del Buen Retiro, 1964, p. 54. Gaspar de Bracamonte (d. 1676) occupied high positions during the reigns of Philip IV and Carlos II, in particular that of plenipotentiary at the Congress of Münster. He was the son of Alfonso de Bracamonte Dávila, captain general of Seville and tutor of the Infante Don Carlos, the brother of Philip IV. Alfonso de Bracamonte became well known in Seville, where, during the floods of 1618, he fought heroically against the disaster and contributed aid for the victims from his personal funds. This offers indubitable proof of Sevillian contacts with Castilian nobility. We will perhaps better understand why many paintings by Zurbarán dating to 1650–60 can be found in the region between Salamanca and Guadalajara when the relations between, for example, the Medinaceli and the Mendoza families and the Dukes of Infantado and their Andalusian fiefs are studied in more detail.

7. *Ibid.*, p. 55.

8. Gállego and Gudiol 1977, no. 529.

9. *Ibid.*, no. 530.

PROVENANCE

Donated by Gaspar de Bracamonte to the Church of San Miguel, Peñaranda de Bracamonte, in 1658; sold in 1824 and replaced by a copy by S. Tayama, which is still in the old frame in the sacristy; collection of Valentín de Carderera, Madrid, 1834; collection of the Marqués de Salamanca, Madrid; Salamanca sale, Paris, June 3, 1867, no. 48, for 20,000 francs, to Count Dudley; Dudley sale, Christie's, London, June 16, 1900, no. 54, for £231, to Colnaghi & Co., London; collection of W. P. Wilstach, 1900; donated with the Wilstach Collection to the Philadelphia Museum of Art in 1900.

LITERATURE

Palomino 1724 (1947 ed.), p. 938; Ceán Bermúdez 1800, VI, p. 52; Cascales y Muñoz 1911, p. 219; Soria 1948a, pp. 149–51; Guinard 1949, pp. 31–32; Soria 1953, no. 210; Gaya Nuño 1958, no. 3219; Guinard 1960a, p. 153, note 40, and no. 35; Caturla, in Madrid, Casón del Buen Retiro, 1964, p. 54; Brown 1974, pp. 140–43; Guinard and Frati 1975, no. 480; Gállego and Gudiol 1977, no. 528; Véliz 1981, p. 277.

EXHIBITED

Leeds 1868, no. 2933; London 1871, no. 405.

59.
The Virgin of the Immaculate Conception

ca. 1640–50
Oil on canvas, 29⅞ × 39⅜ in. (76 × 100 cm)
Collection of Plácido Arango

With a much broadened silhouette, arms spread wide with palms raised toward heaven in an attitude of prayer and supplication[1]—a gesture taken up again in the Budapest *Virgin of the Immaculate Conception*, dated 1661—this *Purísima* shows marked development in comparison with the *Purísima* of Sigüenza (cat. no. 55). Above all, the Virgin is repre-

sented as the betrothed of the Song of Solomon, she who "cometh out of the wilderness" (3:6), who "looketh forth as the morning, fair as the moon, clear as the sun" (6:10).

As noted earlier, from 1640 on it was no longer deemed necessary to represent explicitly symbols of the Immaculate Conception because the doctrine had been completely assimilated. In 1632, for example, in the *Immaculate Conception with Two Young Clerics* (Museu d'Art de Catalunya, Barcelona), two angels hold tablets bearing words from the Song of Solomon. Here, in contrast, the symbols of the Marian litany are barely discernible, and the background of solar brilliance suffices to express the essential idea: present eternally in the thought of God, Mary existed before creation emerged from nothingness; "I was set up from everlasting, from the beginning, or ever the earth was" (Proverbs 8:23, the text read in the Lesson of the Mass of the Immaculate Conception).

The Virgin is here represented, as in other paintings of the Virgin of the Immaculate Conception by Zurbarán, haloed with blond light and with an aureole composed of the faces of seraphim bathed in golds. But, more than the other examples, this one corresponds to the descriptions furnished in the *Mística ciudad de Dios* (Madrid, 1670), by María de Agreda, abbess of the Convent of the Immaculate Conception at Agreda: "The Very Holy Trinity revealed to the angels how the woman it had shown to them garbed in sunlight would at last take her place in creation to give it its chief and its redeemer. . . . One Sunday . . . the first day of creation, there took place the formation of her body. . . . Everything was very pure, very supernatural. . . . Never had any human body been nor would it be shaped with such perfection, delicacy, and beauty."[2]

The Virgin is here depicted very young, with a fresh face and an almost naïve expression, as in Zurbarán's other works on the subject, but her pose and attitude differ. Of less elongated proportions, she is represented in three-quarter view facing to the left, inscribed in a sort of triangle. This disposition seems to have been inspired, probably by way of an engraving, by an *Assumption* (1584–88) by Giuseppe Valeriano and Scipione Pulzone in the Church of Il Gesù in Rome, where, however, the Virgin is turned to the right.

Unlike Zurbarán's early *Inmaculadas*, the Virgin no longer has the look of a columnar statue, with hands joined, perfectly centered in the middle of the composition. The representation is now influenced by the Baroque, in which the strict rules imposed by the Counter-Reformation are progressively abandoned. The blue cloak is thrown back to leave the

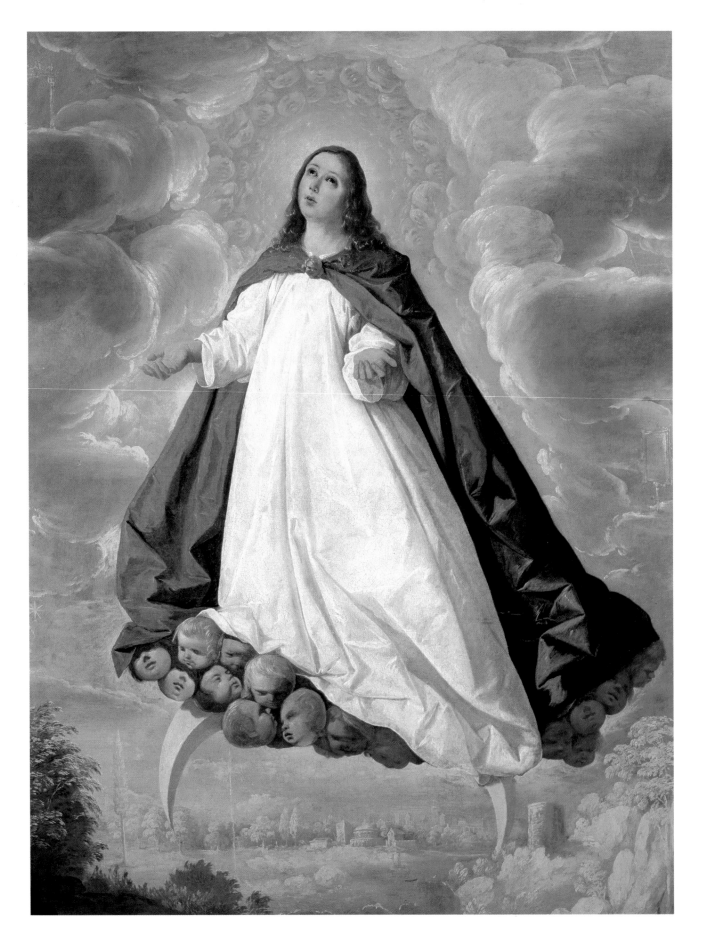

white tunic completely visible; the rumpled folds of the light silk mantle are very different from the somber, heavy fabric seen, for example, in the Prado version of the theme. Her arms spread wide, with half-opened hands tensely held, the Virgin seems to be conversing passionately with God. From the modest and consenting young woman in Zurbarán's first works, she has become an image of youth and purity reflecting the newly triumphant spirit of the Catholic Church in the Baroque period.

Zurbarán's craftsmanship in this painting is miraculous, his brushwork light and opalescent; the economy of his palette—with white, blue, and gold predominating—attains a rare perfection. It would appear that in executing a work probably less official than those which preceded it (one destined perhaps for a private oratory), the artist indulged in the sheer joy of painting, without constraining his natural genius. The symbolic landscape appears lit as if by rays of an iridescent rainbow, so finely are the effects of light observed and rendered. Here the artist's love of nature is forcefully expressed, for he knew by this time that the light of the sun can produce effects of relief that are in fact more powerful than the violent contrasts of light and dark created by the tenebrists. Unfortunately, the thematic constraints imposed on Zurbarán by his religious clientele lead us too often to forget the kind of modern approach that is so evident here.

NOTES
1. Garnier 1982, pp. 174, 224.
2. Agreda 1670 (1976 ed.), pp. 30–31.

PROVENANCE
Private collection, northern England; sold at Christie's, New York, Jan. 15, 1985, no. 96, to Plácido Arango.

LITERATURE
Young 1972, pp. 161–66; Gállego and Gudiol 1977, no. 74.

60.
The Young Virgin Asleep

ca. 1640–50
Oil on canvas, 42⅞ × 35⅜ in. (109 × 90 cm)
Cathedral of San Salvador, Jerez de la Frontera

María de Agreda experienced visions of the life of the Virgin which enabled her to recount details of Mary's childhood: "Her praying was continuous. Even her sleep did not interrupt it, for understanding does not need the senses to function."[1] This was perhaps an allusion to the verse in the Song of Solomon: "I sleep, but my heart waketh" (5:2). María de Agreda added that the Virgin showered her with a celestial light, a visionary element which Zurbarán included in this representation of the young Virgin asleep. Her head rests on her left hand in the traditional pose of meditation, as described by Cesare Ripa.[2] Since the Middle Ages, this pose was understood to express "attention to the movements of the inner life."[3]

The Virgin's appearance as a little girl in this painting may be considered a variation on the youthful Virgin depicted in representations of the Presentation in the Temple. Her image here echoes the many songs and poems composed in Seville in the sixteenth and seventeenth centuries honoring the Virgin. One example is the verse by Diego Contes, written in 1592, that begins:

> I am a little brown-haired girl, and I am lovelier
> than the iris, the rose, or the lily. . . .[4]

In the *Young Virgin* in the Metropolitan Museum (cat. no. 47), Zurbarán shows the Virgin at her embroidery, absorbed in prayer; here, she is more elegantly dressed in a rose-vermilion gown and a blue mantle. Red is traditionally the color of love and charity. In this context it may also be understood as the royal hue, alluding to the Virgin's role as Queen of the Angels. Blue refers to fidelity and hope. Here, in association with the red of royalty, it may express the authority and love of God the Father, who conferred upon the Virgin the honor of bearing his son. The flowers in the painting may also contribute to our understanding of it: the lily of innocence and purity, the red roses of love, and the pink carnation symbolizing the fresh and pure love of filial piety.[5]

In the seventeenth century, only three collegiate churches depended on the archdiocese of Seville: Santa María in Osuna, El Salvador in Seville, and San Salvador in Jerez de la Frontera.[6] Relations between the archdiocese of Seville and the collegiate church of Jerez were therefore very close. According to Ponz,

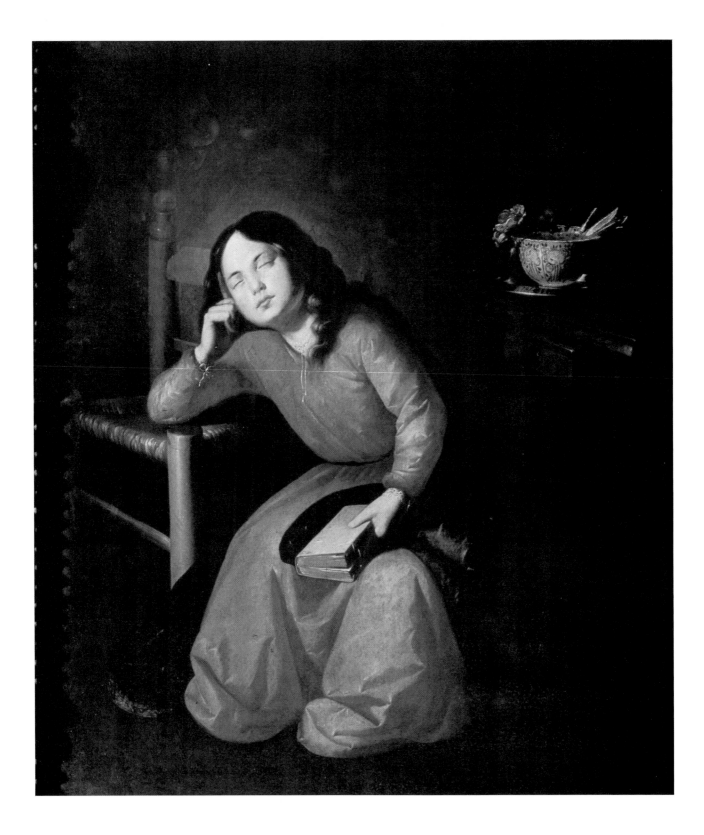

this church was rebuilt in the late seventeenth century. This does not preclude the possibility that Zurbarán painted the *Young Virgin Asleep* for the cathedral in which it is preserved today.

However, its provenance before it was deposited in the cathedral at the beginning of the twentieth century is not known. It has been suggested that it may have been part of the ensemble described by Ponz at the Capuchin monastery in Jerez, which included seven paintings by Zurbarán representing the Virgin and the "Jubilee of the Portiuncula." [7] This last picture, the "Jubilee of the Portiuncula," is preserved in the Museo de Cádiz, but the other works described by Ponz have not been located. It is, however, probable that the Capuchins were established in the monastery only at the end of the seventeenth century, so that even these pictures may have come from elsewhere.

The *Young Virgin Asleep* was probably painted much later than has generally been supposed. The painting has been described as a tenebrist work, that is, composed with extremes of light and dark. But, on the contrary, the shadows are transparent and only the straw chair placed diagonally and the table on the right indicate depth.

The soft face of the model, shown frontally and in full light, enveloped in an airy sfumato; the delicate and artfully graded tones; the intense rose color sometimes used by Zurbarán in the 1650s; and the rounded, less angular folds of the gown all indicate a date after 1640, rather than during his earlier, tenebrist period. Furthermore, the face of this figure bears a certain resemblance to that of Mary in the *Virgin of the Immaculate Conception* of 1656 (cat. no. 64). The model could possibly have been the same—perhaps the artist's own daughter. A close study of certain faces in Zurbarán's late work suggests a family resemblance.

The vase and flowers on the right are typically realistic and poetic still-life details. This intimate devotional picture is free of anecdotal content, combining a religious ideal and human nature. Few artists of his time succeeded as well as Zurbarán in representing the fleeting expression of a sleeping child dreaming of angels. It is in this very truth to nature that he achieved a transcendent spirituality.

NOTES
1. Agreda 1670 (1976 ed.), p. 46.
2. Ripa 1603, p. 309.
3. Garnier 1982, p. 181.
4. Contes, cited in López Estrada 1966, p. 34.
5. Droulers [1949], pp. 129, 159.
6. Palomero Páramo 1983, p. 9.
7. Ponz 1792 (1947 ed.), p. 1542.

PROVENANCE
Cathedral of San Salvador, Jerez de la Frontera.

LITERATURE
Mayer 1928, p. 181; Romero de Torres 1934, I, p. 405; Soria 1953, no. 18; Guinard 1960a, no. 27; Torres Martín 1963, no. 16a; Díaz Padrón, in Madrid, Instituto Central de Restauración, 1968, no. 40; Gudiol 1965, p. 151; Guinard and Frati 1975, no. 33; Gállego and Gudiol 1977, no. 30; Díaz Padrón, in Brussels, Palais des Beaux-Arts, 1985, no. c56.

EXHIBITED
Madrid 1964–65, no. 8; Brussels 1985, no. c56.

61.
Christ Carrying the Cross

1653
Oil on canvas, 6 ft. 4¾ in. × 3 ft. 6½ in. (195 × 108 cm)
Signed and dated on a cartouche, at bottom: Fran[co] de Zurbar[an] / 1653
Cathedral, Orléans

Of the four Evangelists, only Saint John reported that Christ "bearing his cross went forth into a place called the place of a skull, which is called in the Hebrew Golgotha" (19:17). Images of Christ carrying the cross, based thus on the Gospel According to Saint John, became one of the most popular artistic themes from the Passion of Christ. The cult of the Stations of the Cross was established in Flanders and in the Rhineland about the fifteenth century, when the spiritual movement known as the *devotio moderna* flourished. The definitive form of the devotion was not established until about 1750, when the number of the Stations of the Cross was set at fourteen. However, the cross had long been a favored image for meditation on the Passion of Christ. Franciscan influence on Spanish spirituality during the seventeenth century favored a life of fervent prayer and contemplation of the sufferings of Christ. Long before emphasis was given to quiet contemplation by the *devotio moderna*, Saint Bonaventure had recommended to the Franciscans that meditation on the Passion be part of their daily prayer practice. This mystical current spread in Spain, particularly through the work of Francisco de Osuna, one of the great mystics of the sixteenth century, whose theories probably influenced Saint John of the Cross, and certainly Saint Teresa of Avila. The Spanish Capuchins continued the Franciscan tradition of piety centered on Christ and the Virgin, which had been introduced by Saint Bonaventure. They espe-

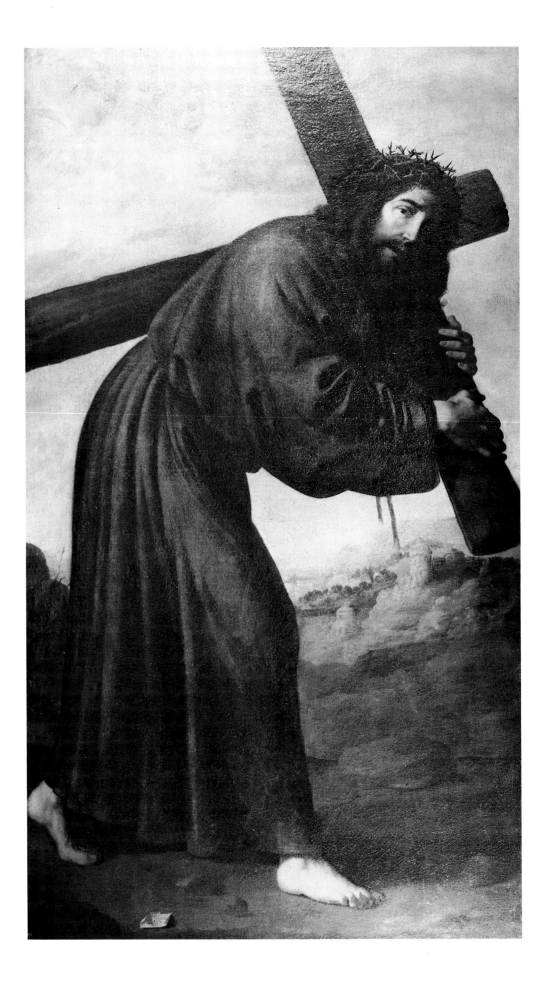

cially emphasized meditation on and contemplation of the sufferings of Christ. Jerónimo de Segorbe recommended the life and Passion of Christ, along with the writings of Saint Bonaventure, Luis de Granada, Pedro de Alcántara, and Alfonso de Madrid.[1] The *Exercitia spiritualia* of the Jesuit Ignatius of Loyola were inspired by the *Meditations* of Saint Bonaventure and the *Vita Christi* of Ludolf of Saxony. Furthermore, the Carthusian author Antonio de Molina, in his *Exercicios* (Burgos, 1613), recommended the use of images from the life of Christ as an aid to meditation.[2]

In the *Christ Carrying the Cross*, Zurbarán represents the figure of Christ alone on the road to Calvary, without the crowd that usually accompanies him. He omits such anecdotal details as the brutality of the soldiers, the commiseration of the three Marys, and the episode in which Simon of Cyrene relieves Christ of his burden. This radical simplification deviates from all earlier depictions of the subject.

"The melancholy beauty of this solitary and suffering figure, the broad curve of the humiliated body," to cite Guinard's fine description, is repeated in the *Christ Gathering His Vestments after the Flagellation*, painted in 1661 (parish church, Jadraque).[3] Here, the ample mass of the purple robe stands out against the muted tones of a crepuscular sky, and the gentle lighting softens the contours and folds of the drapery.

This more vaporous manner already noted in the *Annunciation* of 1650 (cat. no. 58) is further developed in this work, painted three years later. The brushwork is lighter and the paint more fluid in such passages as the three angel heads seen above and the landscape dissolved in the haze of the distance.

We know that Jean-Auguste-Dominique Ingres was shown through the Cathedral of Orléans by Monseigneur Dupanloup and that he admired this work. The date of its arrival in France has not been established. It must have been purchased in Madrid by J. B. P. Lebrun, because it was put up for sale on February 2, 1813, along with a *Virgin of Sorrows with Saint John* (no. 82), of the same dimensions. Shortly afterward, the *Christ Carrying the Cross* was offered to the Church of Saint Pierre du Martroi in Orléans, then transferred to the cathedral.[4] No reference to this painting has been found in Seville. Both Ponz and Ceán Bermúdez mention the presence in Madrid of two paintings of this subject by Zurbarán in the Monastery of the Discalced Carmelites: one, a half-figure, in the Chapel of Saint Teresa; and the other, dated 1661, in the sacristy.[5] If there is an error in the reading or in the transcription of the date in Ceán, then this could be the Orléans picture.

NOTES
1. Jerónimo de Segorbe, cited in *Dictionnaire de spiritualité*, 1964, v, cols. 1359–65.
2. Molina 1613 (1671 ed.), p. 45.
3. Guinard 1960a, p. 143.
4. Danton, in Orléans, 1876, p. 10.
5. Ponz 1776 (1947 ed.), pp. 482, 483; Ceán Bermúdez 1800, VI, p. 52.

PROVENANCE
Collection of J. B. P. Lebrun, Paris; Lebrun sale, Paris, Feb. 2, 1813, no. 63; donated to the Church of Saint Pierre du Martroi, Orléans; transferred to the cathedral, Orléans.

LITERATURE
Ponz 1776 (1947 ed.), pp. 482, 483; Ceán Bermúdez 1800, VI, p. 52; Danton, in Orléans, 1876, p. 10; Chennesseau 1925, p. 97; Guinard 1949, pp. 28–29; Soria 1953, no. 204; Baticle 1960, p. 546; Guinard 1960a, pp. 58, 143, and no. 80; Guinard 1962, p. 361; Baticle, in Paris, Museé des Arts Décoratifs, 1963, no. 102; Torres Martín 1963, no. 262a; Brown 1974, p. 144; Gállego and Gudiol 1977, no. 297.

EXHIBITED
Orléans 1876; Paris 1963, no. 102.

62.
Saint Peter's Vision of Christ at the Column

ca. 1650–60
Oil on canvas, 7 ft. 2⅝ in. × 5 ft. ⅝ in. (220 × 154 cm)
Palacio Arzobispal, Seville

In Early Christian times, Saint Peter's denial of Christ was depicted on more than fifty sarcophagi. It was even then thought to illustrate one of the basic tenets of Christian faith: the promise of forgiveness and the remission of sins.[1] After the Council of Trent, theologians related Saint Peter's repentance for having thrice denied his master to the sacrament of confession, a Catholic practice considered superfluous by the Protestants. All the Gospels recount how Christ foretold Peter's denial of him. At the Last Supper, Christ warned Peter that he would deny knowing his master three times before dawn—before the cock's crow. In the early hours, when Jesus had been arrested and taken to the house of the high priest, Peter was asked three times whether he knew Christ; three times he answered no. "And immediately, while he yet spake, the cock crew. And the Lord turned, and looked upon Peter. And Peter remembered the word of the Lord, how he had said unto him, Before the cock crow, thou shalt deny me thrice. And Peter went out, and wept bitterly" (Luke 22:60–62).

The scene depicted by Zurbarán does not show precisely the moment when Christ, in the presence of Caiaphas, turned his compassionate gaze upon his disciple. Instead, Christ is shown tied to the low column prescribed by Counter-Reformation scholars for representations of his Flagellation; the column represented is the one said to have been brought from Jerusalem to Rome in the thirteenth century and venerated there in the Church of Santa Prasseda. This image, a conflation of the Flagellation of Christ and the Repentance of Saint Peter, was known in Spain.[2] Artists such as the Extremaduran Luis de Morales often depicted Peter repentant before Christ at the column (as in the painting in the sacristy of the Church of San Isidro, Madrid). Their patrons were undoubtedly familiar with the account of the Passion and with the *Flos sanctorum* by Juan Basilio Santoro, many editions of which appeared between 1580 and 1678. Santoro's text for the second Station of the Cross tells of the denial of Saint Peter, adding a miraculous apparition of the suffering Christ to his disciple: "Where with his bodily eyes he was able to see Him."[3] This vision of the Man of Sorrows reminds Peter of his weakness and presumption and prompts his own bitter sorrow and repentance.

This superb picture was discovered in the Palacio Arzobispal (Archbishop's Palace) in Seville by Enrique Valdivieso, who correctly identified it as a work by Zurbarán.[4] The subject was not often represented by Sevillian painters of the first third of the seventeenth century. There are, however, several other pictures on the same theme in Seville, including the *Christ and Saint Peter* in the Museo de Bellas Artes, formerly attributed to Francisco Pacheco and reassigned to Juan del Castillo by Juan Miguel Serrera.[5] Another painting, in the Cathedral of Seville, is attributed to a student of Alonso Cano. Neither of these paintings displays the expressive force of the *Saint Peter's Vision of Christ at the Column* by Zurbarán.

A document recently discovered by Duncan Kinkead reveals that in 1659 Zurbarán gave over twenty pictures in his possession to Sebastiano de Villanueva, vicar of the Monastery of San Jerónimo de Buenavista in Seville.[6] These must have been paintings from his own workshop, because the document mentions twelve images of Patriarchs, and we know that he painted one, if not two, such series. Among the paintings listed in the 1659 document is a "Nuestro Señor con la columna con San Pedro."

This picture is the first known depiction of this subject by Zurbarán. It is said to have come from the Calced Carmelite College of San Alberto, which commissioned works from Zurbarán, although there is no mention of it in the 1810 inventory of the Alcázar,

where the paintings of San Alberto were deposited.

The painting is in Zurbarán's late style. The figure of Saint Peter, in its execution and coloring, is similar to that in the painting of the main altarpiece of the Church of San Esteban, in Seville (cat. no. 39). The emaciated body of Christ presents certain analogies, in the anatomical forms and in the position of the left leg, with the *Saint Sebastian* formerly in the Monastery of San Agustín, in Seville (now private collection, San Sebastián). The face of Christ recalls the tragic masks of the Ecce Homo figures painted by Luis de Morales, many versions of which existed in Seville, in particular in the cathedral and in this same Augustinian monastery.

On the other hand, the noble architecture, the column on the left, the kneeling figure of Saint Peter, and the treatment of the draperies are all typical of Zurbarán's style. The tension in the gestures and attitudes that so vividly animates the composition, the distribution of light, the feeling for space and volume, the silvery and transparent tonality, and the harmonies of gray, black, and white are characteristic of Zurbarán's work executed between 1640 and 1658.

NOTES
1. Mâle 1958, p. 103.
2. Mâle 1932 (1972 ed.), p. 265.
3. Santoro 1580 (1604 ed.), fols. 353–54.
4. Valdivieso, n.d.
5. Valdivieso and Serrera, in Seville, Palacio Arzobispal, 1979,
6. Kinkead 1983b, p. 310.

PROVENANCE
Calced Carmelite College of San Alberto, Seville (?); Palacio Arzobispal, Seville.

LITERATURE
Valdivieso and Serrera, in Seville, Palacio Arzobispal, 1979, no. 88; Valdivieso, n.d.

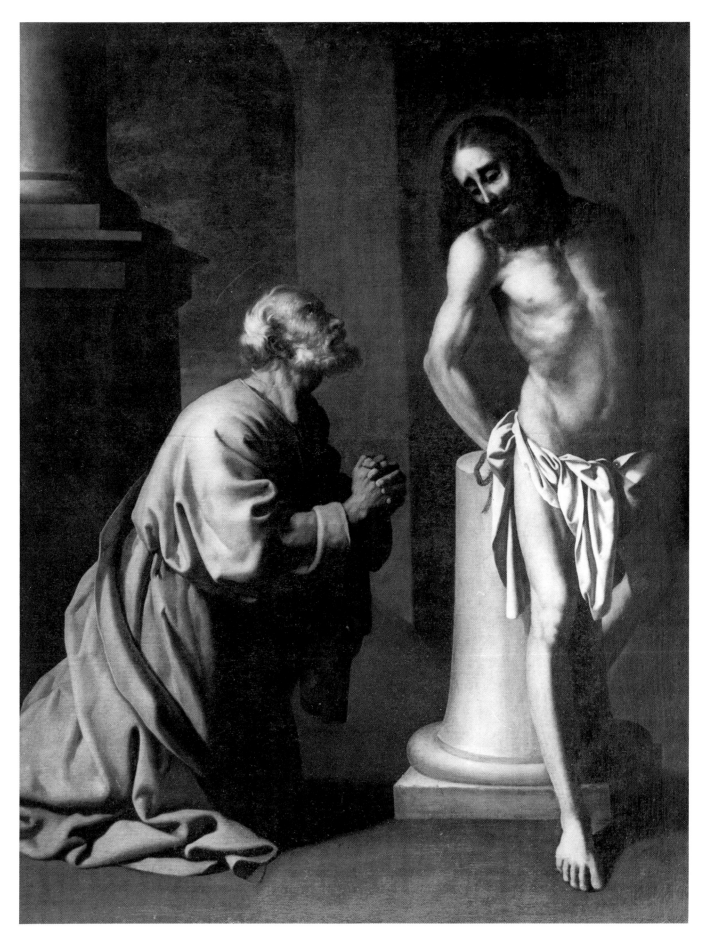

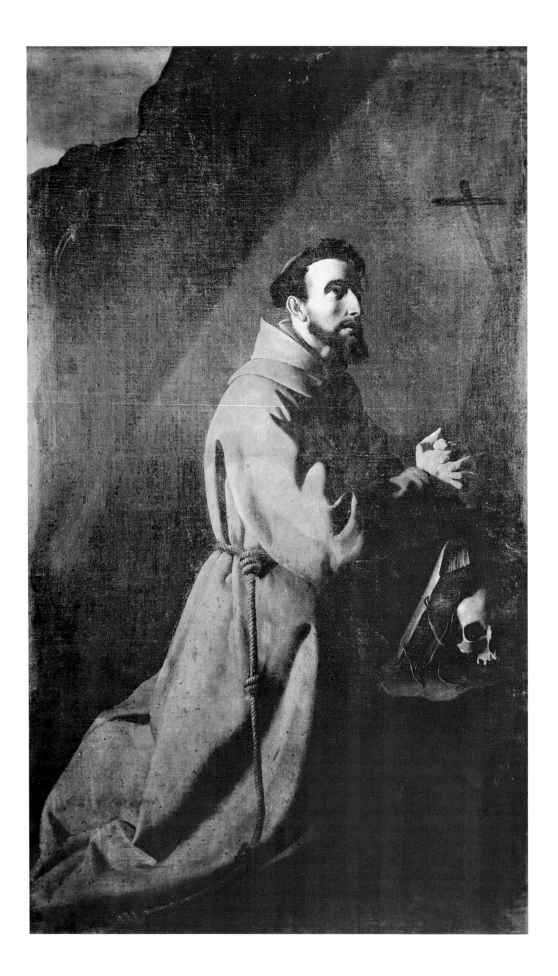

63.
Saint Francis in Prayer

ca. 1640–50
Oil on canvas, 6 ft. 2¾ in. × 3 ft. 7¼ in. (190 × 110 cm)
Church of Santos Justo y Pastor, Madrid

Saint Francis is painted here in accordance with Ribadeneyra's description of him as "somewhat swarthy and worn down by great labors, austerities, and infirmities."[1] He wears the traditional Franciscan habit.

Sevillian painters of the first third of the seventeenth century did not often portray Saint Francis; in Castile, however, in the wake of El Greco, many works were painted to glorify the humble saint of Assisi. This is true of Zurbarán as well; only a single painting of Saint Francis by Zurbarán is known from the years before 1634, the signed and dated *Saint Francis Kneeling* of 1632 (private collection, Buenos Aires), in which the saint is shown wearing the pointed hood. The small *Saint Francis Standing with a Skull* from the Monastery of San Alberto in Seville (cat. no. 18) was probably executed between 1635 and 1640, and the magnificent *Penitent Saint Francis* (National Gallery, London; see fig. 19, page 17), showing the saint unhooded, is dated 1639. It would seem that a number of Zurbarán's pictures of the saint were painted in the last fifteen years of his life, several of them for patrons in Madrid, since many come from that city.

The beautiful *Saint Francis in Prayer* is nearly two meters high. In the strongly vertical format, the saint holds his upper body tall and straight, his head raised heavenward instead of lowered in prayer as in Zurbarán's frequent depictions using that traditional formula. Its companion painting in its present home is a *Saint Diego de Alcalá*, which has the same dimensions but is more tenebrist in style.

The history of the present parish church of Santos Justo y Pastor, known as the Church of Las Maravillas, and of the artworks it contains, is fairly complicated.[2] The church began as the sanctuary of an old Carmelite monastery that was rebuilt in the eighteenth century. In 1869, the Carmelites were expelled, but while the monastery was destroyed, the church was preserved. About 1892, the church was assigned to the old parish church of Santos Justo y Pastor. The original parish church of Santos Justo y Pastor, on Calle San Justo, was rebuilt between 1734 and 1745. It is a superb edifice in Rococo style situated in the old quarter of Madrid down from the Plaza de Villa and not far from Calle Sacramento. In 1892, it

was transferred to the jurisdiction of the apostolic nunciature in Madrid as the pontifical church of San Miguel, and the parish was moved to the present Church of Las Maravillas. The history of the works of art in Las Maravillas is further complicated because the parish of Santos Justo y Pastor had come to incorporate the parish of San Miguel de los Octoes when that church burned down in 1790. It is necessary to review these changes to understand how the two paintings by Zurbarán could have come from the old parish church on Calle San Justo. From Ponz we learn that in 1776 the Church of Santos Justo y Pastor had over the two side doors of the choir "paintings of value of saints of the Order of Saint Francis."[3] On the other hand, he mentions in the Church of San Miguel de los Octoes works by Pereda and Escalante but not a single painting connected with the Franciscan legend.

This picture of Saint Francis, with its rather elongated proportions, must belong to the second half of Zurbarán's career. In spite of the chiaroscuro effects inherent in the subject—the setting is a grotto—the tenebrism is not nearly so pronounced as in the 1630s. The paler tonality and the lighter application of paint suggest a date close to 1640–50. Guinard notes the resemblance between the features of the saint in the London painting of 1639 and those of the saint in the present work.[4] Both images are somewhat more idealized than in the earlier period, further support for a later dating than is generally suggested.

NOTES
1. Ribadeneyra 1624, p. 683.
2. Tormo y Monzó 1927 (1972 ed.), pp. 78–83, 178–79.
3. Ponz 1776 (1947 ed.), p. 447.
4. Guinard 1960a, p. 252.

PROVENANCE
Church of Santos Justo y Pastor, Madrid.

LITERATURE
Tormo y Monzó 1927 (1972 ed.), p. 179; Caturla, in Granada, II Festival Internacional de Música y Danza, 1953, no. 46; Soria 1953, no. 91; Guinard 1960a, no. 368; Torres Martín 1963, no. 104; Guinard and Frati 1975, no. 133; Gállego and Gudiol 1977, no. 211.

EXHIBITED
Granada 1953, no. 46.

64.
The Virgin of the Immaculate Conception

1656
Oil on canvas, 6 ft. 4 in. × 5 ft. 1¾ in (193 × 156 cm)
Signed and dated on a cartouche, bottom left: Fran⁽ᶜᵒ⁾ De
 Zurbaran fac / 1656
Collection of Plácido Arango

In 1961, José Gudiol wrote about this *Virgin of the Immaculate Conception*, said to be dated 1616: "This painting, in fact, does not seem to be the work of a youth of eighteen; the eminently Baroque treatment of the cloud landscape, into which almost monochrome heads of angels are integrated, reappears in a much later period of Zurbarán's career and calls for a certain caution in appraising this work. It is hoped that an adequate cleaning of this canvas will clarify a date that is dimly seen under an old restoration."[1]

One can only praise Gudiol's sagacity. Recent examinations reveal that the second *1* in the date, 1616, was an overpainting, something the majority of specialists could have discovered had they looked carefully at the catalogue of the Zurbarán exhibition held in 1905 at the Prado, where a facsimile of the signature and date is reproduced.[2] The facsimile makes it perfectly clear that the date is 1656 and not 1616, the *5* having been written in the manner of an elongated *S*, in accordance with seventeenth-century practice. Sometime after 1905, a *1* in stick form was painted over the *5*, just as Zurbarán himself wrote that number. Recently consulted paleographers have all independently recognized a *5* on the facsimile. It is regrettable that Tormo was not attentive to the experts, but it was tempting to see Zurbarán starting out his career with a *Virgin of the Immaculate Conception* showing the Virgin as a child.[3] In 1964, Angulo Iñiguez also expressed doubts about the date 1616: "It is surprising that at such an early date the manner of rendering fabrics should already be that typical of [Zurbarán] in his years of maturity."[4]

Unfortunately, not all Zurbarán scholars have the experience and authority of Gudiol and Angulo. Most begin their catalogues of Zurbarán's oeuvre with the present painting. What is more, they say that they cannot understand how Zurbarán could have started out painting in the Florentine manner, with moderated lighting and sfumato, and then returned in 1627 to the violent tenebrism of the San Pablo *Christ on the Cross* (cat. no. 2), something that would have been completely illogical and contrary to the normal development of seventeenth-century artists, best exemplified by Velázquez.

The present exhibition offers the opportunity to view this late *Virgin of the Immaculate Conception*, not shown since 1905, in a new context, and the discovery of the true date will surely allow us to better understand the evolution of the artist's style.

Zurbarán here exhibits neither stiffness nor awkwardness. He remains the obedient and consenting interpreter of Spanish aesthetic conventions of the first half of the seventeenth century, when there was generally a preference for the representation of simple and solid forms, without superfluous gesticulation. He shows a young girl whom he doubtless asked to stand up very straight, in a dignified manner, and who, impressed by the role she was asked to play, remained serious and still, her tiny hands crossed on her breast, eyes raised to heaven, respectful of decorum and befitting the image of a Virgin of the Immaculate Conception. One is almost tempted to say that here the father took over from the painter. Of the six children borne to Zurbarán by his third wife, only one daughter, Manuela, survived. Manuela was about seven years old in 1657.[5] After so many occasions for mourning, Zurbarán probably felt for this child a grandfatherly affection, clearly expressed in this painting.

Zurbarán is in every way the painter of "truth to nature"; even when he takes the work of Guido Reni as inspiration, as in the little singing angels at the bottom of the canvas, he is not a servile copyist but seems to paint live models who are assuming poses.

Facsimile of Zurbarán's signature as published by Salvador Viniegra, *Catálogo oficial ilustrado de la exposición de las obras de Francisco de Zurbarán* (Madrid, Museo del Prado, 1905)

Detail of signature as it exists today

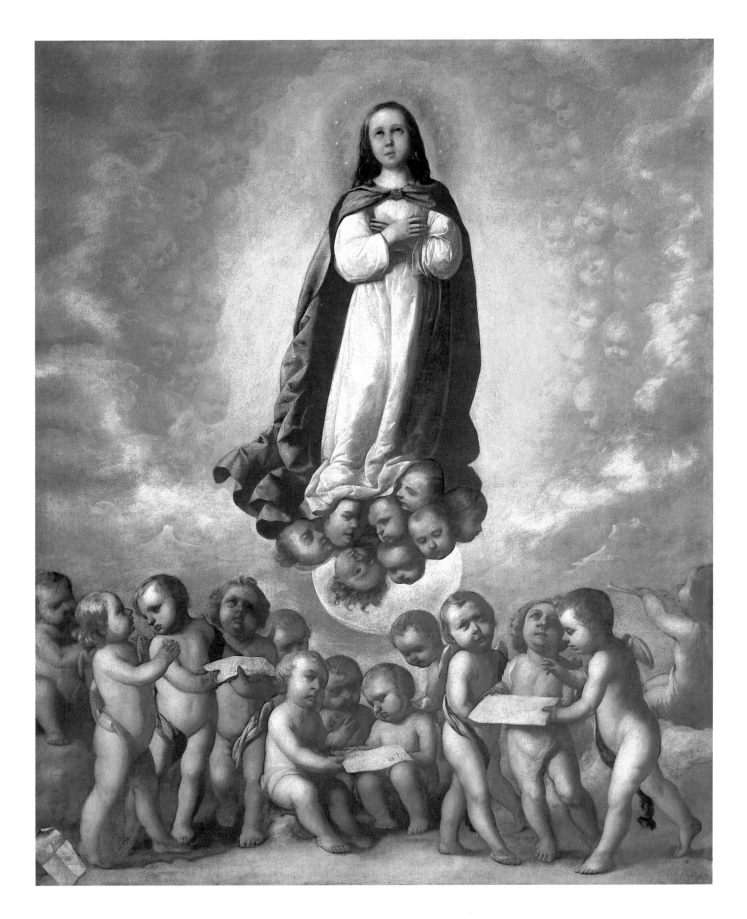

Alfonso E. Pérez Sánchez was the first to point out that Zurbarán's source for the angels was Reni's *Coronation of the Virgin*, in the Prado.[6] Again according to Pérez Sánchez, Jusepe Martínez had known Reni in Rome, probably in 1626–27, and was therefore the same Jusepe Martínez whose engravings Zurbarán had used for his scenes from the life of Saint Peter Nolasco (see cat. nos. 6, 7). Also comparable to Reni are the draperies, with the cloth forming loops. The brush defines the forms without harshness, and the modeling is carefully tapered in the hands and in the faces and bodies of the infants, a transposition of the Italian sfumato so characteristic of Zurbarán in the 1650s. The effect of light and clarity predominates, despite the worn surface, which in places allows the brown underpainting to show through.

In 1656, Zurbarán was still in Seville and must have painted this canvas there. It is not listed in the 1844 inventory of Zurbarán's paintings in the possession of Canon López Cepero, compiled by Amador de los Ríos, but it appeared in the sale of that collection in 1860. In 1838, the Galerie Espagnole of Louis-Philippe included a *Virgin of the Immaculate Conception* dated 1658 that, according to the sale catalogue of 1853, was said to have been purchased from a canon in Seville, probably López Cepero. That work, also a late example of the subject, is today in Great Britain.[7]

Ponz in 1776 remarked that Don Luis de Bourbon, in the Palace of Villaviciosa at Odón (Madrid), had a "Concepción niña" (*Virgin of the Immaculate Conception as a Young Girl*) by Zurbarán. We know that the palace belonged to the crown because Ferdinand VII died there. Was the "Concepción niña" sold in the nineteenth century by Don Luis's descendants? It is generally assumed that the painting is the *Virgin of the Immaculate Conception* now in Budapest, although that picture shows a much older girl, and not a *niña*, a term that in Spain applies to a much younger child.

Thus, problems remain concerning this extraordinary *Purísima* of 1656. Yet it possesses an exquisite charm, something indefinable, that Zurbarán—like Velázquez and, later, Goya—knew how to transpose onto canvas, with no less truth than delicacy.

NOTES
1. Gudiol 1967, col. 969.
2. Madrid, Museo del Prado, 1905, no. 31.
3. Tormo y Monzó 1905b, p. 5.
4. Angulo Iñiguez, in Madrid, Casón del Buen Retiro, 1964, p. 67.
5. Kinkead 1983b, p. 309.
6. Pérez Sánchez 1965a, p. 273.
7. Baticle and Marinas 1981, no. 446.

PROVENANCE
Collection of Canon López Cepero, Seville; collection of Mariano López Cepero, Seville; López Cepero sale, Seville, May 15–30, 1860, no. 66; collection of Dolores Muni (widow of López Cepero), Seville, 1911; collection of Fernando Labrada, Madrid; collection of Félix Valdés, Bilbao; acquired by Plácido Arango, Madrid, in 1985.

LITERATURE
Tormo y Monzó 1905b, p.5; Viniegra, in Madrid, Museo del Prado, 1905, no. 31; Cascales y Muñoz 1911, pp. 103–4; Mayer 1911, pp. 147, 150–51; Tormo y Monzó 1914 , p. 192; Kehrer 1918, pp. 32–33; Mayer 1947, p. 328; Soria 1953, no. 1; Guinard 1960a, no. 3; Torres Martín 1963, no. 1; Gudiol 1967, col. 969; Brown 1974, pp. 17–18; Guinard and Frati 1975, no. 1; Gállego and Gudiol 1977, no. 1; Merchán Cantisán 1979, pp. 74–76.

EXHIBITED
Madrid 1905, no. 31.

65.
The Veil of Saint Veronica

1658
Oil on canvas, 41⅜ × 32⅞ in. (105 × 83.5 cm)
Signed and dated on a cartouche, lower left: Fran^co de Zurbarán / 1658
Museo Nacional de Escultura, Valladolid

EXHIBITED IN PARIS ONLY

This painting was discovered and identified in 1968 by Juan José Martín González in the hermitage near the village of Torrecilla de la Orden, during an inventory of the artworks of the province of Valladolid. As the many ex-votos placed in this chapel indicate, the painting must have been offered in thanksgiving to the Virgen del Carmen, the local patron saint, and incorporated in the attic story of the altarpiece built at the beginning of the eighteenth century.[1]

The crowning of an altarpiece with a representation of the Veil of Veronica is not infrequent in Spain. Besides the version by El Greco, done for the altarpiece of Santo Domingo el Antiguo in Toledo (now Caturla collection, Madrid; see cat. no. 54), Ponz described in the Church of Santa Cruz a *Veil of Saint Veronica* that surmounted the *Descent from the Cross* by Pedro de Campaña, which probably disappeared when the *Descent* was transferred to the Cathedral of Seville. Also, above the tabernacle of the main altarpiece of the Capuchin monastery in Cádiz, there was a *Veil of Saint Veronica* by Murillo.[2]

The present work is signed and dated on a small cartouche that cannot be read at a distance, which suggests that it was not intended for an altarpiece; however, some of the other versions of this subject painted by Zurbarán may well have been made for this purpose.

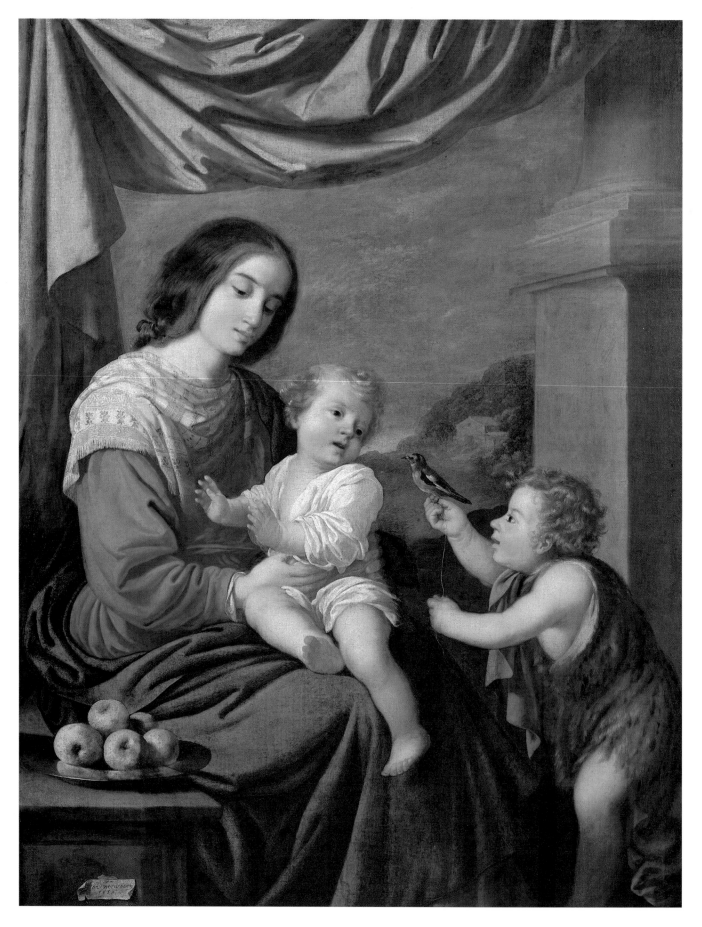

This representation of the Veil of Saint Veronica is much simpler and more natural than the version in Stockholm (cat. no. 54). The cloth, held by two cords and a single, clearly rendered nail, falls freely downward. The face is very lightly painted; thin layers of ocher mixed with carmine define the beard and hair and just barely indicate the modeling of the nose and mouth. The canvas is in its original state. Considering the place and circumstances in which it was found, Martín González believes that it had never been cleaned or restored before being deposited in the Museo Nacional de Escultura, Valladolid;[3] the unaltered condition of the painting suggests by comparison that some of the other versions of this subject may have been reworked or repainted. Dated 1658, the year of Zurbarán's departure for Madrid, this very sensitive and delicate picture is among the most meditative and poetic of the artist's last works.[4]

NOTES
1. Martín González 1970a, p. 291.
2. Ceán Bermúdez 1800, II, p. 61.
3. Martín González 1970b, p. 12.
4. The *Veil of Saint Veronica* recently acquired by the Museo de Bellas Artes de Bilbao, contemporary with or immediately preceding the present work, also came from a collection in Valladolid. In that work, Christ's mask of sorrow, modeled in the same ocher tones, is more clearly defined and more dramatic. See Pérez Sánchez 1964, pp. 193–96, pl. 1.

PROVENANCE
Hermitage of Torrecilla de la Orden; deposited at the Museo Nacional de Escultura, Valladolid, in 1970.

LITERATURE
Martín González 1970a, p. 291; Martín González 1970b, pp. 11–12; Guinard and Frati 1975, no. 479 *bis*; Gállego and Gudiol 1977, no. 516.

66.
The Virgin and Child with Saint John the Baptist

1658
Oil on canvas, 53⅞ × 40⅞ in. (137 × 104 cm)
Signed and dated on a cartouche, lower left: Fran^co de Zurbaran / 1658
San Diego Museum of Art. Gift of Misses Anne R., Irene, and Amy Putnam

In this image of motherhood, the grave expression of the Virgin reflects the hidden meaning of the objects represented. Mary foresees the loss of her son and the ensuing pain, the "sword [that] shall pierce

through [her] soul," as prophesied by Simeon (Luke 2:35). The plate of apples in the foreground alludes to the sin of Adam, which was redeemed by the blood of Christ. In this scene of childhood innocence, the Christ Child is shown drawing away from a goldfinch, which, being fond of thistles (reminiscent of the crown of thorns), was a symbol of the Passion; according to an old legend, the feathers near the beak were dyed red by the blood of Christ. The column serves as a link between heaven and earth.

The painting is related to a type of meditation on the Passion that is in turn related to the cult of the Virgin. Most of the great religious orders practiced such meditations, and the subject appeared early in Northern European art. Zurbarán seems to have been the painter preferred by patrons interested in medieval formulations of New Testament subjects, such as the Virgin and Child with a Bird, of which there was an enormous number produced in the Middle Ages. In the Renaissance, Raphael created a famous example of the theme in his *Madonna with a Goldfinch* (Museo degli Uffizi, Florence), but in general the subject was rarely depicted in the seventeenth century.

Zurbarán's remarkable picture is composed with Raphaelesque rigor and bathed in a clear light worthy of Giovanni Bellini. It is signed and dated 1658—not 1653, as Kehrer believed when he discovered it in Munich in 1918.[1] Like the Budapest *Rest on the Flight into Egypt* (cat. no. 68), it was in the collection of the Count of Altamira, which was sold in London in 1827. The Altamira family had inherited the property and ancestral house of the Dukes of Villamanrique in Seville. The Duke of Villamanrique, a great admirer of Murillo, was the president of the Academy of Seville in 1673. A study of the inventories of these great families may someday help us to retrace the history of this series of works painted by Zurbarán between 1658 and 1662.

In Zurbarán's harmonious composition, the three figures are inscribed in a right triangle; their disposition recalls Rubens's portrait *Helena Fourment and Her Children* in the Louvre, as well as Venetian *sacra conversazione* pictures—especially those by Palma Vecchio. Italianate characteristics abound in this painting. The Virgin, in three-quarter view and turned to the right, her face framed by dark hair, presents a gracious and dignified mien reminiscent of Venetian examples. The drawing of the blond, curly haired Christ Child reflects a variety of Italian models as translated by Van Dyck. Similarly, the figure of John the Baptist derives from Lombard or Florentine antecedents. However, Zurbarán alone created the scarlet curtain, the still-life elements, the column, the landscape, and the lighting, skillfully combining

these heterogeneous elements into an original composition. The Virgin sits easily, gazing with dreamy tenderness at her beautiful child. The Baptist, though drawn from stereotyped models, is entirely believable as a small boy pleased to show his cousin the bird he has just caught. The perfectly harmonized colors are more intense than in earlier works, and the expertise of the distribution of light over forms is unsurpassed by any other Spanish painter save Velázquez.

Zurbarán became toward the end of his career one of the few artists of his generation able to assimilate fully the lessons of the Italian Renaissance and yet retain a highly individual style. Earlier in his career, engaged as he was with monastic commissions, he produced few pictures of the Holy Family or of the Virgin and Child, so there is little to compare with those of his later years. Twentieth-century critics have generally preferred the "virile" Zurbarán, as Guinard describes him—the portrayer of monastic heroes—to Zurbarán as a painter of the more intimate subjects of Christian devotion. This has led to an unjustified depreciation of the works dating from the last years of Zurbarán's life. Modern preference for the earlier pictures is better and more fairly understood as a preference for the more "virile" subject matter of the earlier works over what is today perceived as the pious sentimentality of the later works.

NOTE
1. Kehrer 1918, pp. 117–18.

PROVENANCE
Collection of the Count of Altamira, Madrid, 18th century; Altamira sale, London, June 1, 1827, no. 55, to the Marquess of Stafford; collection of the Duke of Sutherland, Stafford House, London; Sutherland sale, Christie's, London, July 11, 1913, no. 143, for £525; acquired by Cureau; collection of Dr. C. Göttler, Munich; Reinhardt Galleries, New York; Lilienfeld Galleries, New York; purchased by Anne R., Irene, and Amy Putnam for the San Diego Museum of Art in 1935.

LITERATURE
Waagen 1838, II, p. 67; Stirling-Maxwell 1848, III, pp. 927–28; Cascales y Muñoz 1911, p. 219; Kehrer 1918, pp. 117–18; Andrews, in San Diego, San Diego Museum of Art, 1947, pp. 86–87; Mayer 1947, p. 343; Soria 1953, no. 206; Gaya Nuño 1958, no. 3126; Guinard 1960a, no. 50; Guinard and Frati 1975, no. 479; Gállego and Gudiol 1977, no. 513.

EXHIBITED
London 1838, no. 10; New York 1934, no. 24; San Diego 1935, no. 591; San Diego 1936, no. 366; Los Angeles 1937, no. 114.

67.
Saint Francis Kneeling with a Skull

1659
Oil on canvas, 50 × 38¼ in. (127 × 97 cm)
Signed and dated on a cartouche, lower right: Franco de Zurbaran / 1659
Collection of Plácido Arango

This painting, though shorter by twenty centimeters, is in the same scale as that of the *Saint Francis in Meditation* in The National Gallery, London (cat. no. 53), and may be considered the daytime version of that painting. The interval of fifteen to twenty years that separates them brings out clearly the evolution of Zurbarán's art, not only from the technical point of view—in the brushwork and lighting—but also in the expression of religious feeling. In the London version, the figure is somewhat coarse and the features express a brutal, direct ecstasy, while the Saint Francis of 1659 has a more refined bearing. The supple pose, the elegant hand placed against the chest, the intense yet mild expression of the young face, which shows none of the effects of age or asceticism, indicate that Zurbarán's patrons wanted a more spiritualized portrayal of the founder of their order. It shows the influence not of Murillo, who had painted this subject once or twice before 1658, but of Italian art of the Counter-Reformation, in particular that of the Carracci or of Guido Reni, although Zurbarán did not retain the emphatic gestures or the position of the head of those models.

This work is part of the large series of signed pictures executed between 1658 and 1662, of which there were four each in 1658, 1659, and 1661, and one in 1662. They were signed probably because they were private commissions or of a less strictly traditional religious character.

Zurbarán often represented solitary saints in landscape settings, but rarely did he achieve such coloristic fullness as here. He placed Saint Francis in a realistic landscape naturally illuminated by sunlight that perfectly harmonizes the blue-gray sky and the ash-colored wool robe, a palette worthy of Velázquez. Compared with Velázquez, however, the forms are obtained by very different means, being modeled by a skillful contrast of light and shade.

Before a work of such inwardness and pictorial refinement, it is no longer possible to maintain that the work of the last years of the artist's life was characterized by archaism. When we consider the evolution of styles in painting in the last third of the seventeenth century, a period when in France and Italy the Ba-

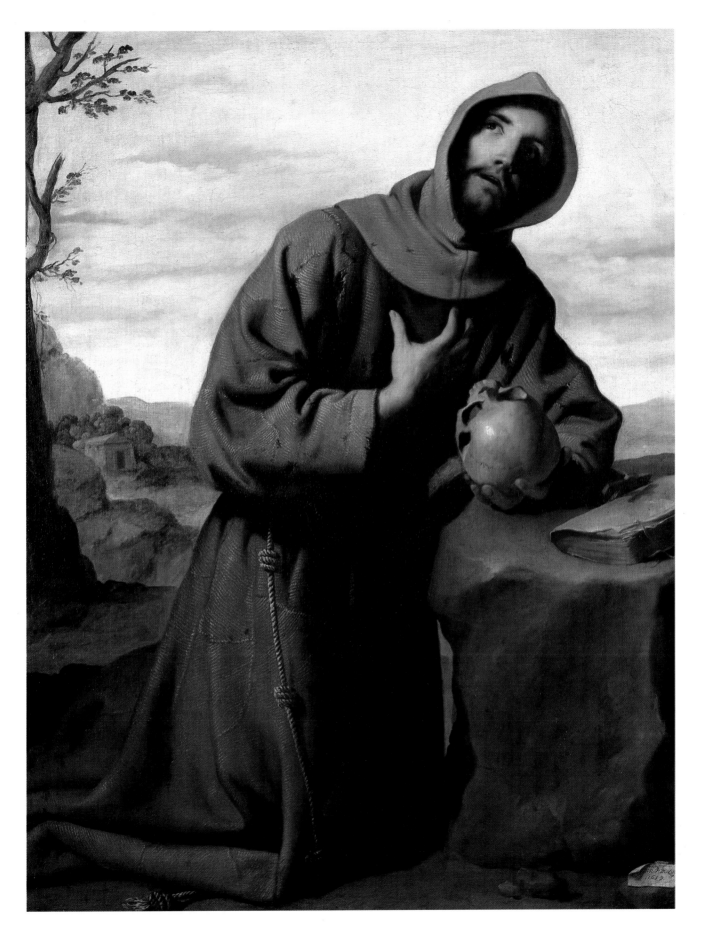

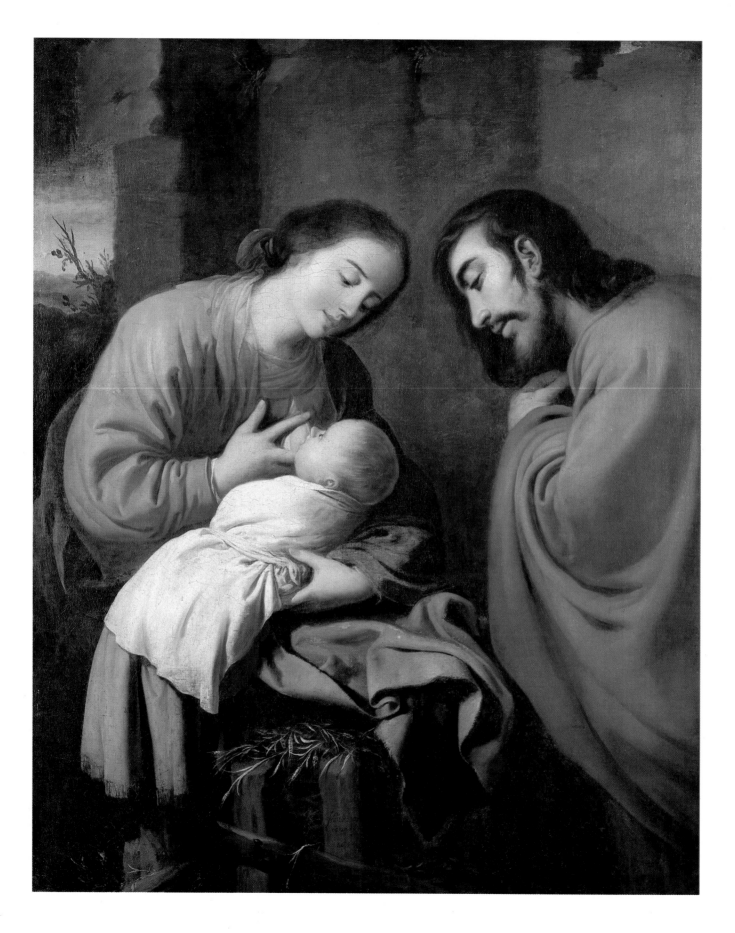

roque was soon to give way to a new classical rigor, we are justified in asserting that Zurbarán stands out as an innovator among his contemporaries—all the more decisively because he owed his first triumphs to the tenebrist style that prevailed in the early part of the century.

PROVENANCE
Collection of Aureliano de Beruete y Moret, Madrid, 1905; collection of Félix Valdés, Bilbao, ça. 1945; acquired by Plácido Arango, Madrid, in 1983.

LITERATURE
Viniegra, in Madrid, Museo del Prado, 1905, no. 44; Cascales y Muñoz 1911, p. 110; Mayer 1911, p. 159; Kehrer 1918, p. 124; Mayer 1947, p. 343; Soria 1953, no. 216; Guinard 1960a, no. 359; Guinard and Frati 1975, no. 484; Gállego and Gudiol 1977, no. 520.

EXHIBITED
Madrid 1905, no. 44; Munich 1911, no. 54; London 1920–21, no. 62; Madrid 1927, no. 34.

68.
The Rest on the Flight into Egypt

1659
Oil on canvas, 47⅞ × 38⅛ in. (121.5 × 97 cm)
Signed and dated, lower center: Fran.co de Zur / baran f. / 1659
Szépmüvészeti Múzeum, Budapest

Pacheco estimated that it would have taken the Holy Family two months to travel from Bethlehem to Egypt, especially given the precarious conditions of the journey.[1] This "educated guess" was probably based on the commentaries of Francisco Arias, an eminent sixteenth-century Sevillian Jesuit whom he may have known personally and whose writings he often used. The thirteenth-century *Meditations on the Life of Christ*, then attributed to Saint Bonaventure, which nourished the popular devotions inspired by the Franciscans, gave this journey into Egypt as a subject for compassion, for "He who is Lord of the earth and all that it contains chose for himself, his mother, and his provider such a confining poverty!"[2]

In this painting, Zurbarán depicts one of the respites in the arduous flight into Egypt, a moment when Mary stops to nurse her child while Joseph watches protectively, wrapped in a traveler's cloak to ward off the cold. The family has taken shelter behind the cracked wall of a stable; a few sheaves of wheat, symbols of the Bread of Life, cushion the infant in his sleep. The extreme attentiveness that the Virgin shows toward her precious burden served to incite even the poorest of the faithful to imitate the Virgin in the "virtue of hope."[3] This is the only known version of the *Rest on the Flight into Egypt* among Zurbarán's authenticated works.

In Spanish painting of the post-Tridentine period, the Virgin is rarely represented breastfeeding her child, as in this picture. The subject seems to have been considered indecorous in Seville, and it is therefore notable that the painting was executed when Zurbarán was living in Madrid. He had treated this subject only once before, in the *Virgin Nursing the Christ Child*, signed and dated 1658 (Pushkin Museum of Fine Arts, Moscow). It should be noted that it was never represented by either Murillo or Valdés Leal.

Another example of the nursing Virgin is the *Virgin and Child* by Alonso Cano in the Diputación, Guadalajara, datable to either 1657 or 1660.[4] According to Tormo, all the works assembled in the patio of the Diputación came from the monasteries of the city.[5] The Carmelite Church of Las Vírgenes, also in Guadalajara, owned a sixteenth-century panel representing a Virgin nursing, from a time when the so-called Virgin of Humility was still a frequent subject.

The figures in the *Rest on the Flight into Egypt*, shown in half-length, are almost life-size. Although an important work, the painting has never before been included in a monographic exhibition. It was shown in Madrid in 1981–82, at the Prado, but was rarely exhibited before that date. Thus, until very recently, many specialists had seen it only in reproduction; nor had they had the opportunity to compare it with other paintings by Zurbarán. This probably explains the negative terms in which it has been discussed.

The grace, reserve, and emotional intensity that were salient characteristics in the scenes of the birth of Christ done for the altarpiece of the Carthusian monastery at Jerez are found here again, twenty years later. Few artists, even in Spain, had succeeded in representing a Virgin of such tenderness and feminine beauty without straying into sentimentality. The face of the Virgin bending over her child is marked by individual truth and character; in spite of the classical features, it cannot be traced to any Italian or Flemish model. In his later years, in an art of great simplicity, Zurbarán attained supreme mastery of his means. The resulting formal harmony, subtly refined lighting, delicate and firm modeling, and expertly orchestrated color schemes attest to his capacity for constant self-renewal.

Three representations of the Holy Family by Zurbarán are mentioned in early sources: one at the Carthusian Monastery of Las Cuevas in Seville (in the

prior's cell, mentioned by both Ponz and Ceán Bermúdez),[6] another in the Monastery of the Discalced Carmelites of San Hermenegildo in Madrid, and the third in the collection of the Count of Trastamare, the son of the Count of Altamira, in 1808.[7] The Budapest version was painted in Madrid in 1659. It is unlikely that it would have been moved to the Carthusian monastery in Seville. And the 1786 inventory of the Monastery of San Hermenegildo lists dimensions (40 × 40 cm) that differ from those of the Budapest picture.[8] The *Rest on the Flight into Egypt* appeared at the Altamira sale in London in 1827. A lithograph by Florentino de Craene was published in 1825 in Madrid.

NOTES
1. Pacheco 1649 (1956 ed.), p. 263.
2. Pseudo-Bonaventure (1958 ed.), p. 66.
3. Arias 1630, p. 89.
4. Wethey 1983, p. 83.
5. Tormo y Monzó 1919, p. 75.
6. Ponz 1780 (1947 ed.), p. 741; Ceán Bermúdez 1800, VI, p. 51.
7. Archives, Musée du Louvre, Paris, z4: 1808–10.
8. Polentinos 1933, p. 60.

PROVENANCE
Auctioned at Laneuville, Paris, June 27, 1825, no. 99; collection of the Count of Altamira, Madrid; Altamira sale, London, June 1, 1827, no. 39; collection of Viscount Clifden, London; Clifden sale, Christie's, London, May 6, 1893, no. 32, for £24, to Colnaghi & Co., London; Porgès collection, Paris; Kleinberger & Co., Paris; purchased by the Szépmüvészeti Múzeum, Budapest, for 7,672 francs in 1904.

LITERATURE
Cascales y Muñoz 1911, p. 53; Kehrer 1918, p. 125; Guinard 1949, pp. 4–5; Soria 1953, no. 209; Gaya Nuño 1958, no. 3128; Guinard 1960a, no. 54; Soehner, in Munich, Alte Pinakothek, 1963, p. 220; Haraszti-Takács, in Budapest, Szépmüvészeti Múzeum, 1966, no. 29; Pigler, in Budapest, Szépmüvészeti Múzeum, 1967, p. 787 and no. 2536; Angulo Iñiguez 1971, p. 133; Guinard and Frati 1975, no. 486; Gállego and Gudiol 1977, no. 519; Nyerges, in Madrid, Museo del Prado, 1981, no. 50.

EXHIBITED
Hamburg 1935, no. 25; Budapest 1965, no. 54; Madrid 1981–82b, no. 50; Munich and Vienna 1982, no. 105.

69.
Saint Francis Standing

ca. 1650–60
Oil on canvas, 6 ft. 10¼ in. × 3 ft. 7¼ in. (209 × 110 cm)
Musée des Beaux-Arts de Lyon

It is not known when this picture of Saint Francis in uncorrupted state entered the Lyons convent of Terceline nuns (known as Colinettes), which had been founded in 1665 by the Marquise de Coligny. Although the nuns of the Order of Saint Elizabeth were part of the immense Franciscan family, by the eighteenth century they had no doubt forgotten the significance of this astonishing painting, which they had hidden away, describing it as a "frightening object."[1] The image of the body of the founding saint uncorrupted, in an ecstatic pose and standing upright in his tomb, corresponds to a singular tradition transmitted orally since the thirteenth century,[2] which made its first appearance in art in the early seventeenth century. In his *Legenda maior* (1266), Saint Bonaventure states that Saint Francis was interred in the basilica at Assisi. Not long thereafter, the conviction grew that his body remained uncorrupted and standing upright, and many who had visited the crypt swore to having seen him thus. The discovery of the saint's true relics in 1818 proved the tales unfounded, but they had once been believed by even the most objective chroniclers of the Counter-Reformation, such as Luke Wadding, author of the monumental *Annales minorum*. The first volume of Wadding's history of the Franciscans, published in 1625, tells of some of the visits, notably those of Nicholas V (1397–1455) and Sixtus IV (1414–1484), who witnessed the body "intact and standing," in rapt devotion even after death. The visit of Nicholas V in 1449 is also recounted at length in volume two of the *Acta sanctorum* (Antwerp, 1748).[3]

A description furnished by a cardinal in the escort of Nicholas V appeared in Spanish in 1562 in the *Chrónicas* of Fray Marcos da Lisboa.[4] The description was reprinted in the *Chrónica de nuestro seráfico padre San Francisco* (Seville, 1598), by Luis de Rebolledo, and it turned up again in Ribadeneyra's *Flos sanctorum* (Madrid, 1624): "He was standing upright. . . . He had his eyes open, like a living person, and calmly raised to heaven. The whole and entire body was without corruption. . . . His hands were covered with the sleeves of the habit and in front of his chest."[5] This precise description of the saint's miraculous appearance in death served as a model for many seventeenth-century artists in their representations of the

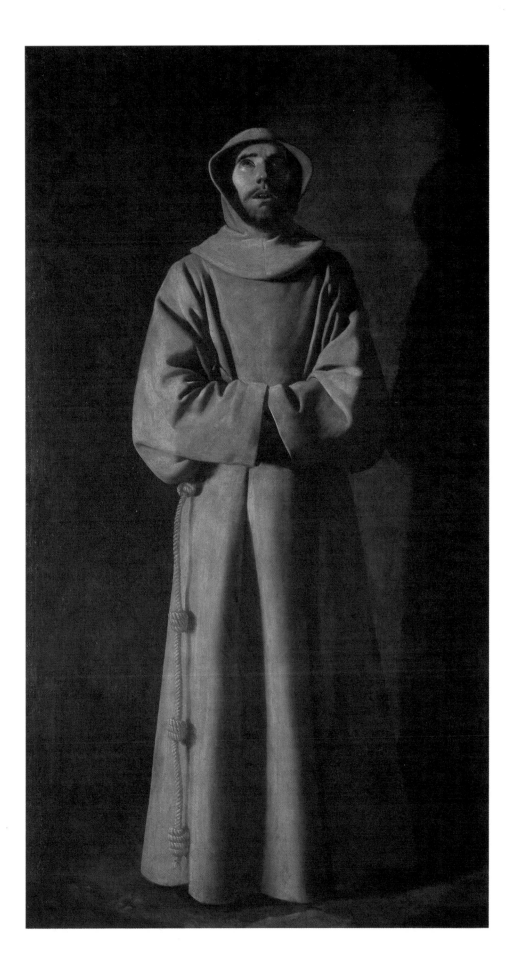

subject. An especially popular theme was the witnessing of the saint's body by Nicholas V,[6] as in the engraving by Thomas de Leu of about 1600–1610.[7]

Palomino speaks with admiration (as does Pacheco) of a painting in the Franciscan convent in Madrid by Eugenio Cajés that depicts the witnessing of the intact body by Nicholas V in 1449 (a painting executed before 1613, and now lost). The most celebrated version of this subject is that by Laurent de la Hyre, painted in 1630 for the Capuchins of the Marais district in Paris (Musée du Louvre, Paris).

The Capuchins, reformers of the Franciscan Order, promoted this theme in Spain, though stripped of all merely anecdotal content. In the painting executed in 1626 by Alejandro de Loarte for the Capuchins of Toledo, for example, the saint is pictured standing and alone, in the ecstatic attitude described by the Counter-Reformation hagiographers and as depicted at a later date by Zurbarán. But, in fact, the subject is rare in seventeenth-century Spanish painting. The favored representations of Saint Francis were based on the Stigmatization and on the miracle at Portiuncula. Perhaps we can deduce from this that the present painting was commissioned by a Capuchin convent and, on the basis of its style and workmanship, probably executed in Madrid after 1658.

Two original replicas of the painting were made. One, purchased in Madrid in 1823, is now in the Museum of Fine Arts, Boston; the other, which differs only in the habit (patched homespun rather than gray cloth) and in the position of the head (inclined to the left), is in the Franciscan Convent of the Descalzas Reales, in Madrid. The third example, identical to those in Lyons and Boston, was in the collection of Fernández Pintado before being acquired in 1905 by the Museu d'Art de Catalunya, Barcelona.

The Lyons Saint Francis was owned by the Colinettes before 1789. When it crossed the Pyrenees is much debated. Because the convent was founded in 1665, it can be assumed that the canvas appeared there after that date. (Zurbarán would have had to have painted it at the most seven or eight years earlier.) Possibly it was part of a donation by the wife of Philip IV, Mariana of Austria, made through her stepmother, Marie-Thérèse of France. In 1676, Mariana—at the urging of Louis XIV's Jesuit confessor, Père de La Chaise—intervened with the Carmelites in Brussels to secure a relic of Saint Elizabeth of Hungary for the Colinettes of Lyons, whose reverend mother, Marguerite Saint Ignace de La Chaise, of Aix, was the sister of Père de La Chaise.

After the death of Philip IV, although she served as regent during the minority of her son Charles II, Mariana, in the tradition of noble widows, virtually took the veil. She was particularly interested in joining the Franciscan Convent of the Descalzas Reales, which had been founded by an archduchess of the House of Austria in the sixteenth century and had served since that time as a refuge for other illustrious personages. An illegitimate daughter of Emperor Rudolph II, Ana Dorotea, the aunt of Mariana, had from 1665 to 1690 been a sponsor of the Descalzas convent, and so it is not impossible that the Lyons Saint Francis came from that religious house, which not incidentally owned a rich art collection. The queen's confessor, Father Nithard, a German by birth, was a Jesuit, and for a time held the post of first minister. The interrelationships of Queen Mariana of Spain, Queen Marie-Thérèse of France, King Louis XIV, Père de La Chaise, his sister Mother Marguerite Saint Ignace in Lyons, and Father Nithard in Madrid may explain how a painting by Zurbarán came to be in the region of Lyons, home of the La Chaise family and of the Colignys, who were themselves protected by the Villeroys.

According to legend, Jacqueline de Settesoli, a Roman noblewoman who was a faithful disciple of Saint Francis, had been miraculously advised of the saint's imminent death and had brought to Assisi an ash-colored funerary cloth to serve as his shroud.[8] In the Lyons painting, Saint Francis is shown wearing gray cloth rather than brownish homespun as in most of Zurbarán's other depictions. This detail may suggest that the painting was done for a convent of nuns and not for a monastery of friars.

The powerful effects of chiaroscuro, called for by both the subject and the sepulchral setting, differ from the tenebrist approach of the artist's early years. The way the light falls on the gray robe is skillfully contrived. While the modeling is firm, it is by no means comparable to the way the forms are cut out in juxtaposed planes in the canvases of the Saint Bonaventure series of 1628–29 (see cat. nos. 3, 4). Like Velázquez, Zurbarán—with a perfect observation of painterly values—now renders space convincingly. The transparent penumbra evokes a feeling of mystery and contributes to the intense poetry that emanates from a representation that is impressive—even sensational—but from which Zurbarán dispels all funereal character; with both force and subtlety, he transposes to another plane the ecstatic expression of the saint pursuing beyond the grave his mystic and impassioned dialogue with God.

The painting may have been shown in 1786 at the first art exhibition organized by the Sallon (sic) de Peinture in Lyons, which included works by the painter J.-J. de Boissieu. In 1797, Boissieu appears to have bought the painting and reproduced it in an etch-

ing, the *Fathers of the Desert*, in which he placed the figure of Saint Francis in a landscape.

NOTES

1. Ternois 1975, p. 228.
2. Facchinetti 1926b, pp. 714–16.
3. *Acta sanctorum* 1748, II, p. 921.
4. Sánchez Cantón 1926, p. 41.
5. Ribadeneyra 1624, p. 684.
6. Réau 1959, III, p. 533.
7. Bibliothèque Nationale, Paris, Cabinet des Estampes, Rd. 65a.
8. Celano, ca. 1228, cited in Facchinetti 1926b, pp. 354–56.

PROVENANCE

Convent of the Colinettes, Lyons, before 1793 (François Artaud, Bibliothèque de l'Académie de Lyon, ms. 104, fol. 212, published in Ternois 1975); public sale, Place Saint-Pierre, Lyons (?); acquired by J.-J. de Boissieu in 1797; purchased from Boissieu by the Musée des Beaux-Arts de Lyon for 1,200 francs in 1807 (Lyons, Municipal Archives, XIV, ser. R2).

LITERATURE

Artaud, in Lyons, Musée des Beaux-Arts, 1808, no. 17 ("L'Espagnolet"); Thierriat, in Lyons, Musée des Beaux-Arts, 1850, no. 268 (Zurbarán); Cascales y Muñoz 1911, p. 53; Kehrer 1918, pp. 121–23; Mâle 1932 (1972 ed.), p. 483; Mayer 1947, p. 343; Demerson 1953, p. 69; Soria 1953, no. 183; Gaya Nuño 1958, no. 3106; Guinard 1960a, no. 373; Baticle, in Paris, Musée des Arts Décoratifs, 1963, no. 103; Guinard and Frati 1975, no. 369; Ternois 1975, p. 228; Gállego and Gudiol 1977, no. 234.

EXHIBITED

Bordeaux 1955, no. 82; Paris 1963, no. 103.

70.
The Virgin of the Immaculate Conception

1661
Oil on canvas, 55⅛ × 40½ in. (140 × 103 cm)
Signed and dated on a cartouche, lower left: Fran de
 Zurbaran f / 1661
Church of Saint Gervais et Saint Protais, Langon

In 1661, Pope Alexander VII, taking one step further Gregory XV's ban on the teaching of the doctrine of sanctification (see cat. no. 25), decreed that the rite of the Immaculate Conception be maintained in the Roman Catholic Church; he further decreed that any attack on the doctrine, its feast day, and its cult would be severely punished.[1] Zurbarán's last two representations of the Virgin of the Immaculate Conception—the painting in the Szépmüvészeti Múzeum, Budapest, and the present work, in Langon—also date from 1661, and it was perhaps in anticipation of the pope's rulings that Zurbarán was commissioned (by unidentified patrons) to paint these two versions of what was for him a familiar theme. It may be supposed that they were painted in Madrid, where Zurbarán had established himself in 1658.

In the first version, the Virgin stands absorbed in her Divine mission, with her hands open and her eyes turned toward heaven; below her feet are cherubs and a thin lunar crescent; she floats above a lightly painted landscape against which Marian symbols are inscribed. In the second, the traditional attributes are absent, leaving only the Virgin, an incarnation of the Divine will, bathed in a somber golden light, intensely absorbed in the mystery that is taking place. In this period of renewed mystical fervor, her attributes are no longer necessary; her image alone suffices to symbolize the Immaculate.

No record exists of Zurbarán's character or personality, but he was obviously a pious man, like most of his contemporaries, and his devotion to the Virgin is attested by the first words of his last will and testament, which was written on the eve of his death, August 26, 1664: "Alavado sea el SS Sacramento y la pura y límpida Concepción de nra Señora la Virgen María conzevida sin mancha de pecado original. Amen" (Praised be the Most Holy Sacrament and the pure and spotless Conception of Our Lady the Virgin Mary, conceived without stain of original sin. Amen).

All that we know of the provenance of these pictures is that the one in Budapest was recorded in 1820 as in the collection of the Esterhazy princes, while the Langon picture appeared in the 1837 catalogue of the collection of Aniceto Bravo in Seville,

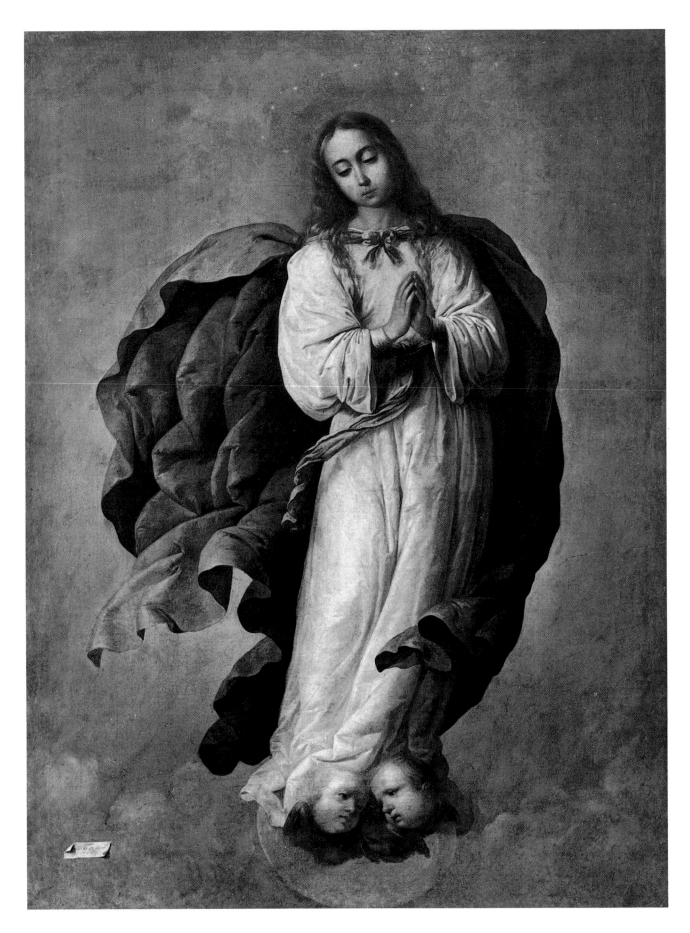

and in 1844, Amador de los Ríos provided the information that it was signed in 1661.[2] Angulo Iñiguez published an engraving by C. Santigosa after the Bravo canvas to illustrate a work by Alvarez Miranda entitled *Glorias de Sevilla*, published in 1849. The engraving served as proof that the painting in the Bravo collection was not the work now in Budapest, as had been claimed by Soria.[3] Angulo's argument was further confirmed by Gilberte Martin-Méry, who discovered, in the parish church at Langon, the present *Virgin of the Immaculate Conception* by Zurbarán, signed and dated 1661 and with a composition identical to that in the Santigosa engraving. A detail contributed by González de León in 1844 concerning the Bravo collection appears relevant here. He states that most of the paintings that decorated the chapel of the Sevillian painters' Confraternity of Saint Luke, in the Church of San Andrés—works that had been given by members of the confraternity—had ended up in the Bravo collection.[4] The Academia de Bellas Artes, Seville, was founded in 1660 by Murillo, and, according to Angulo, the manuscript statutes and records of that institution were found in this same chapel.[5] Given the coincidence in dates, one might speculate whether Zurbarán was not commissioned by the members of the confraternity to paint the present *Virgin of the Immaculate Conception* for their chapel.

In any event, the painting is a work over which Zurbarán obviously took great care, in both composition and execution. The body of the Virgin is harmoniously inscribed within the arc of a circle, with her hands joined, eyes lowered, and head inclined to the left; her features—small mouth, round cheeks, and even the hairline—bear a striking resemblance to those of the little girl represented in the *Virgin of the Immaculate Conception* of 1656 (cat. no. 64). Her white tunic is loose-fitting, and the folds of the cape are animated in a Baroque manner.

The brushwork and coloring show that Zurbarán was by this time completely converted to the prevailing Baroque style, although without sacrificing his personal manner. Amador de los Ríos, like most nineteenth-century critics, regretted that "the Virgin's face was perhaps not the most ideal."[6] And yet, what differentiates Zurbarán from his contemporaries is this very capacity to capture from life such expressions of childlike candor and purity, instead of reproducing the stereotyped forms of the academic approach.

NOTES
1. Hergenröther 1892, p. 130.
2. Amador de los Ríos 1844, p. 422.
3. Angulo Iñiguez 1964, p. 313.

4. González de León 1844, p. 237.
5. Angulo Iñiguez 1981, p. 56.
6. Amador de los Ríos 1844, p. 422.

PROVENANCE
Collection of Aniceto Bravo, Seville, 1837; engraving by C. Santigosa published in 1849; Church of Saint Gervais et Saint Protais, Langon.

LITERATURE
Amador de los Ríos 1844, p. 422; Angulo Iñiguez 1964, pp. 313–14; Martin-Méry 1965, p. 203; Martin-Méry 1966, p. 5; Guinard and Frati 1975, no. 490; Gállego and Gudiol 1977, no. 524.

71.
The Virgin and Child with Saint John the Baptist

1662
Oil on canvas, 66¾ × 50 in. (169.5 × 127 cm)
Signed and dated on a cartouche, lower left: Fran^{co} de Zurbaran / 1662
Museo de Bellas Artes de Bilbao

There is no mention in the canonical Gospels of a visit by the young Saint John the Baptist to the Holy Family. The first representations of this theme, which appeared in Siena about 1260–70, were based on Apocryphal texts dating from the second and fourth centuries. In the thirteenth century, the *Meditations on the Life of Christ*, by the Pseudo-Bonaventure, proposed this encounter as a theme for devotional contemplation.[1] By the seventeenth century, Saint John's visit to the Holy Family was routinely accepted as historical fact and included in religious treatises.[2] Although the Baptist's visit to his little cousin, who was six months younger than he, was not recorded in the Gospels, the episode, with its many artistic reflections, was considered "at once gracious and sadly prophetic."[3]

All the elements in Zurbarán's depiction of the subject prefigure the Passion of Christ: from the meek lamb, symbol of the Paschal victim, and the small cross held by the young saint, instrument of the death of Christ, to the fruits on the table, symbols of salvation (the apple, which caused the Fall of Man, also evokes the mystery of the Redemption). The Infant Christ blesses his cousin, who kisses his hand in adoration. The Virgin, who holds a closed book, expresses sad resignation to her son's destiny. All the elements of this seemingly domestic scene are traditional to the theme dating to the Middle Ages.

The *Virgin and Child with Saint John the Baptist*, signed and dated 1662, is Zurbarán's last known work; he died in 1664. We know nothing of its history until the nineteenth century. Along with the other depictions of the Virgin and Child of the late period (in particular, the one in the Barnuevo collection), the painting belongs to the trend toward rather sentimental images of the Virgin and Child which, from the middle of the seventeenth century, found its most perfect expression in Italian paintings by Sassoferrato and Carlo Dolci and in French paintings by Eustache Le Sueur and Pierre Mignard, all of them ultimately derived from Raphael's Florentine examples. In this case, Zurbarán based his graceful and dreamy image of the Virgin on an engraving by Dürer, as Angulo Iñiguez has pointed out,[4] but probably also on a sixteenth-century engraving by G. G. Caraglio. This composition was known in Seville in the seventeenth century through a copy of Caraglio's print, inscribed "Raphael Urbinas Inventit," that reproduced the composition of a small *Holy Family* (Musée du Louvre, Paris) today attributed to Giulio Romano, a follower of Raphael.[5] Zurbarán derived from the print the position of the Virgin's head and her melancholy expression, the style of her hair, the shape of her figure, and the gesture of Christ touching the head of Saint John the Baptist. The picture by Romano is small, while the figures in the *Virgin and Child with Saint John the Baptist* are closer to life-size and treated with the simplicity and starkness characteristic of Zurbarán's style.

We could aptly apply Pierre Rosenberg's remark about Le Sueur to the late Zurbarán: "With nobility and natural grace [he] renews, without imitating, the Renaissance ideal of perfection."[6] Indeed, Zurbarán did not attempt to imitate Romano here, fascinated as he was in his later years by the power and beauty of Renaissance classicism; rather, he managed to transpose the Italian master's composition into his own idiom. In this, he reflects contemporary taste, not simply the example of Murillo, as has been thought. Romano excluded picturesque elements from his aesthetic vocabulary, but Zurbarán addressed the tastes of his Sevillian patrons by including certain symbolically charged still-life elements: the apples evoking the Fall placed next to the Virgin, who was interpreted as the new Eve, and, on the left, the lamb of the Redemption. In the engraving after Romano, Jesus caresses the cheek of Saint John the Baptist. Zurbarán, with a very Spanish sense of *decoro*, shows the Child Jesus instead placing one hand on his cousin's head and proferring the other for his kiss.

Although we do not find here the impeccable drawing and solidly constructed forms that charac-

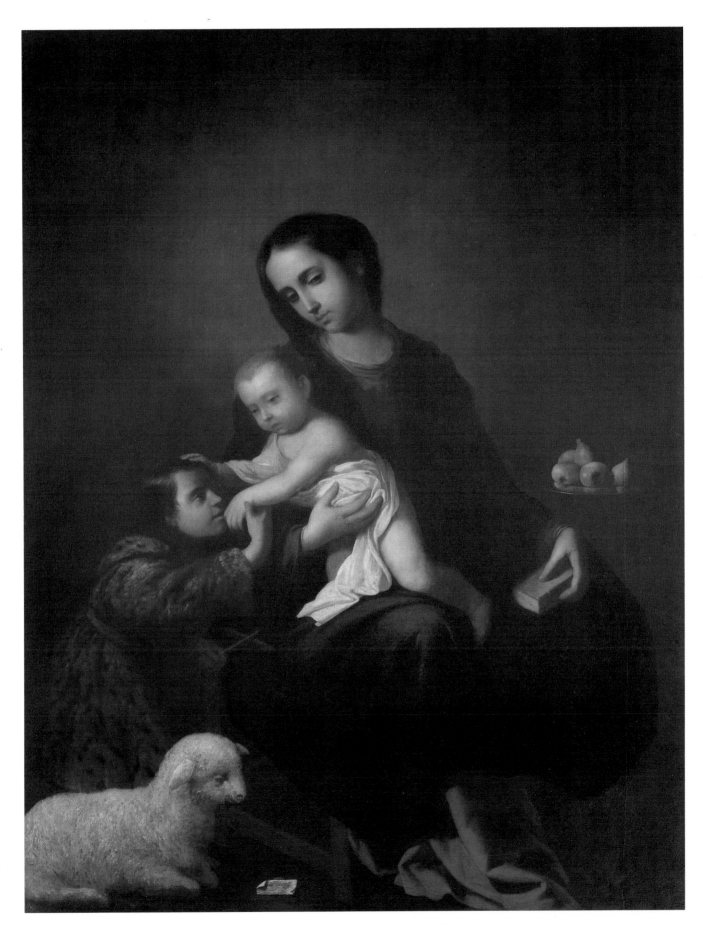

terize the followers of Raphael, the rich brushwork, the discreet palette inspired by Florentine and Roman blues and reds, the melancholy softness of the faces, and the mystic dialogue between the protagonists of the scene (which Zurbarán always established so naturally) infuse this last painting with a rare power.

In his late style, Zurbarán sacrifices none of his sense of realism. Although the composition was provided by Romano, Zurbarán seems to have worked from real models posed in the attitudes seen in the engraving, so that his figures would appear perfectly natural, observed from life. The whole is bathed in a soft, even light that firmly defines the forms.

NOTES
1. Aronberg Lavin 1955, pp. 85–90.
2. Nieva Calvo 1625, fol. 169.
3. Pascal 1856, I, p. 134.
4. Angulo Iñiguez 1944, p. 8.
5. Béguin, in Paris, Grand Palais, 1983, p. 107.
6. Rosenberg, in New York, Metropolitan Museum of Art, 1982, no. 54.

PROVENANCE
Collection of the Count of Canillas, Madrid; collection of José de Madrazo, Madrid, 1856; collection of the Marqués de Salamanca, Madrid; Salamanca sale, Paris, June 3–6, 1867, no. 50, for 1,700 francs; collection of the Marqués de Camarines, Madrid; inherited by the Marqués de Nerva, Madrid; collection of María Martín de Oliva; bequeathed by her to the Museo de Bellas Artes de Bilbao in 1936.

LITERATURE
Madoz 1847, X, p. 861; Madrazo 1856, no. 450; Mayer 1928, p. 181; Angulo Iñiguez 1944, pp. 7–9; Soria 1953, no. 223; Guinard 1960a, no. 52; Torres Martín 1963, no. 266 (1); Brown 1974, pp. 154–55; Guinard and Frati 1975, no. 504; Gállego and Gudiol 1977, no. 525.

EXHIBITED
Granada 1953, no. 52; Bordeaux 1955, no. 86.

BIBLIOGRAPHY

Acta sanctorum quotquot toto orbe coluntur. . . . 67 vols. Antwerp and Brussels, 1643–1925.

Agreda, María de. *Mística ciudad de Dios.* 3 vols. Madrid, 1670; ed. of 6 vols. Perpiñan, 1684; new ed. Madrid, 1970. French translation by V. Viala, Saint-Cénéré, 1976.

Aguado, Alexandre. *Catalogue des tableaux des écoles espagnole, flamande, hollandaise, allemande, française exposés dans la galerie du Marquis de las Marismas.* Paris, 1839.

———. *Catalogue des tableaux anciens . . . composant la galerie de M. Aguado.* . . . Sale cat., Paris, Mar. 20–28 and Apr. 18–22, 1843.

Aigrain, René. *Liturgia: Encyclopédie populaire des connaissances liturgiques.* Paris, 1930.

Albocacer, Augustín. "Influencia de la reforma capuchina en el modo de representar a San Francisco en la pintura." *Liber memorialis ordinis fratrum minorum S. Francisci capuccinorum,* suppl. vol. XLIV, pp. 176–229. Rome, 1928.

Aldea Vaquero, Quintín. *Iglesia y estado en la España del siglo XVII.* Comillas, 1961.

———. "Iglesia y estado en la época barroca." In *La España de Felipe IV.* Historia de España, vol. 25. Madrid, 1982.

Alfaura Valentin, Joaquin. *Omnium domurum Ordinis Cartusiani . . . origines, series, chronographica, et descriptione topographica.* Valencia, 1670.

Alonso Gamo, J. M. *Zurbarán: Poemas.* Madrid, 1974.

Altamira, Count of. *A Catalogue of Select Pictures by Italian, Spanish, and Dutch Masters from the Celebrated Altamira Collection.* Sale cat., London, June 1, 1827.

Alvarez, Arturo. "Madurez de un arte: Los lienzos de Guadalupe." *Mundo hispanico,* no. 197 (1964a), pp. 51–57.

———. "¿Porque no se llevaron los Zurbaranes de Guadalupe en el siglo XIX?" *Guadalupe* 47 (1964b), unpaged.

Alvarez Miranda, Vicente. *Glorias de Sevilla, en armas, letras, ciencias, artes, tradiciones, monumentos, edificios, caracteres, costumbres, estilos, fiestas, y espectáculos.* Seville, 1849.

Amador de los Ríos, José. *Sevilla pintoresca; ó, Descripción de sus más célebres monumentos artísticos.* Seville, 1844.

Amorós, J. "Bodegones de Zurbarán." *Boletín de la Sociedad Española de Excursiones* 35 (1927), pp. 138–42.

Angulo Iñiguez, Diego. "Miscelánea de pintura seiscentista." Part 2, "Una estampa de Cornelio Cort en el taller de Zurbarán." *Archivo español de arte y arqueología* 7 (1931), pp. 65–67.

———. "La Academia de Bellas Artes de Méjico y sus pinturas españolas." *Arte en América y Filipinas* (Universidad de Sevilla) 1 (1935), pp. 1–75.

———. "Cinco nuevos cuadros de Zurbarán." *Archivo español de arte* 17 (1944), pp. 1–9.

———. "El apostolado zurbaranesco de Santo Domingo de Guatemala." *Archivo español de arte* 22 (1949), pp. 169–70.

———. *Historia del arte hispano-americano.* 3 vols. Barcelona, 1950a.

———. "Una variante del *Agnus Dei* del Museo de San Diego (Estados Unidos)." *Archivo español de arte* 23 (1950b), pp. 77–78.

———. *Pedro de Campaña.* Madrid, 1951.

———. "Algunos cuadros españoles en museos franceses." *Archivo español de arte* 27 (1954), pp. 315–25.

———. "Murillo: Varios dibujos de la *Concepción* y de *Santo Tomás de Villanueva.*" *Archivo español de arte* 35 (1962), pp. 231–36.

———. "La *Concepción* de Zurbarán, de 1661, de la colección de Aniceto Bravo." *Archivo español de arte* 37 (1964), pp. 313–14.

———. *Pintura del siglo XVII.* Ars hispaniae, vol. 15. Madrid, 1971.

———. "Zurbarán." In *Colloquio sul tema Caravaggio e i Caravaggeschi* (Rome, 1973), pp. 139–47. Rome, 1974.

———. *Murillo: Su vida, su arte, su época.* 3 vols. Madrid, 1981.

Angulo Iñiguez, Diego, and Alfonso E. Pérez Sánchez. *Historia de la pintura española.* Vol. I, *Escuela madrileña del primer tercio del siglo XVII.* Vol. II, *Escuela toledana de la primera mitad del siglo XVII.* Vol. III, *Escuela madrileña del segundo tercio del siglo XVII.* Madrid, 1969–83.

———. *A Corpus of Spanish Drawings.* Vol. III, *Seville School, 1600–1650.* Oxford, 1985.

Année dominicaine; ou, Vies des saints, des bienheureux, des martyrs et des autres personnes illustres ou recommandables par piété, de l'un et de l'autre sexe, de l'Ordre des Frères-Prêcheurs, distribuées suivant les jours de l'année. New ed. Lyons, 1886.

Arana de Varflora, Fermín [Fernando Díaz de Valderrama]. *Compendio histórico descriptivo de la ciudad de Sevilla.* Seville, 1766; 2d ed. Seville, 1789; reprint, Seville, 1978.

Arias, Francisco. *Libro de la imitación de Christo, Nuestro Señor.* 2 vols. Madrid, 1599.

———. *Traicté de l'imitation de Jésus-Christ.* Paris, 1625.

———. *Traicté de l'imitation de Nostre Dame, la glorieuse Marie Mère de Dieu.* Rouen, 1630; new ed., with ten additional chapters, Rouen, 1656.

Arias Montano, Benito. *Humanae salutis monumenta.* Antwerp, 1571.

Aronberg Lavin, Marilyn. "Giovannino Battista: A Study in Renaissance Religious Symbolism." *Art Bulletin* 37 (1955), pp. 85–101.

Askew, Pamela. "The Angelic Consolation of St. Francis of Assisi in Post-Tridentine Italian Painting." *Journal of the Warburg and Courtauld Institutes* 32 (1969), pp. 280–306.

Bago y Quintanilla, Miguel de. "Aportaciones documentales." *Documentos para la historia del arte en Andalucía* 2, 1928 (1930), pp. 5–104.

Bago y Quintanilla, Miguel de, José Hernández Díaz, and Antonio Sancho Corbacho. "Arquitectos, escultores, y pintores sevillanos del siglo XVII." *Documentos para la historia del arte en Andalucía* 5 (1932).

Banda y Vargas, Antonio de la. "El pintor Juan Gui Romano en Sevilla." *Archivo hispalense,* no. 159–64 (1970), pp. 175–81.

Barnard Castle. Bowes Museum. *Four Centuries of Spanish Painting,* by Eric Young. Exhib. cat., 1967.

Barocchi, Paolo. *Trattati d'arte del cinquecento, fra manierismo e controriforma.* 3 vols. Bari, 1960–62.

Baronius, Cesare. *Annales ecclesiastici.* 12 vols. Rome, 1588–1607. French translation, *Les Annales de l'église.* Vol. 1. Paris, 1614.

Bartsch, Adam von. *The Illustrated Bartsch*. Vol. X, *Sixteenth Century German Artists: Albrecht Dürer*. Edited by Walter L. Strauss. New York, 1980. Vol. XXXVIII, *Italian Artists of the Sixteenth Century*. Edited by Sebastian Buffa. New York, 1983. Vol. XLV, *Italian Masters of the Seventeenth Century*. Edited by Mark Carter Leach and Richard W. Wallace. New York, 1982.

Baticle, Jeannine. "Les Peintres de la vie de Saint Bruno au XVIIᵉ siècle: Lanfranc, Carducho, Le Sueur." *La Revue des arts: Museés de France* 8 (Jan.–Feb. 1958), pp. 17–28.

———. "Recherches sur la connaissance de Velázquez en France de 1650 à 1830." In *Varia velazqueña*, edited by Antonio Gallego y Burín, I, pp. 532–52. Madrid, 1960.

———. "Le Portrait de la Marquise de Santa Cruz par Goya." *Revue du Louvre et des musées de France*, no. 3 (1977), pp. 153–63.

———. "L'Age baroque en Espagne, la peinture espagnole de la seconde moitié du XVIᵉ à la fin du XVIIᵉ siècle." In *L'Age baroque en Espagne et en Europe septentrionale*. Geneva, 1981.

Baticle, Jeannine, and Cristina Marinas. *La Galerie Espagnole de Louis-Philippe au Louvre, 1838–1848*. Notes et documents des musées de France, vol. 4. Paris, 1981.

Baumann, Emile. *Les Chartreux*. Paris, 1928.

Beaugrand, Augustin. *Sainte Lucie, vierge et martyre de Syracuse: Sa vie, son martyre, ses reliques, son culte*. Paris, 1893.

Benjumea Fernández de Angulo, José M. "Descubrimiento en Sevilla de un Zurbarán, un Herrera, y un Murillo." *Bellas artes* 3, no. 16 (1972), p. 57.

Berlin. Staatliche Museen Preussischer Kulturbesitz. Gemäldegalerie. *Catalogue of Paintings, 13th–18th Century*. 2d ed. Translated by Linda B. Parshall. Berlin, 1978.

Bernales Ballesteros, Jorge. "Mateo Pérez de Alesio, pintor romano en Sevilla y Lima." *Archivo hispalense*, no. 171–73 (1973), pp. 221–71.

Beroqui, Pedro. "Apuntes para la historia del Museo del Prado." *Boletín de la Sociedad Española de Excursiones* 40 (1932), pp. 7–21, 85–97, 213–20. Republished as *El Museo del Prado: Notas para su historia*. Madrid, 1933.

Biblioteca de autores españoles, desde la formación del lenguaje hasta nuestros días. . . . 71 vols. Madrid, 1846–1923.

Bivar, Francisco de. *Historias admirables de las más ilustres, entre las menos conocidas santas que ay en el cielo*. Valladolid, 1618.

Blanc, Charles, *et al*. *Histoire des peintres de toutes les écoles: Ecole espagnole*. Paris, 1869.

Blanlo, Jean. *L'Enfance chrétienne*. . . . Paris, 1665.

Bleiberg, Germán. *Diccionario de historia de España*. Madrid, 1952; new ed. 3 vols. Madrid, 1963.

Bonaventure, Saint. *Itinerarium mentis in Deum* (ms. 1259). Cologne, 1472.

———. *Legenda maior S. Francisci* (ms. 1266). Milan, 1477.

———. *Opera omnia*. 10 vols. Quaracchi, 1882–1902.

Bonet Correa, Antonio. "Obras zurbanescas en Méjico." *Archivo español de arte* 37 (1964), pp. 159–68.

Bonnefoy, J. F. *Quand Séville fêtait la "Purísima," 1614–1617*. Nicolet, Quebec, 1954.

Borromeo, A. "Il Cardenale Cesare Baronio e la corona spagnola." In *Baronio storico e la Controriforma, atti del Convegno Internazionale di Studi* (Sora, 1979). Sora, 1982.

Borromeo, Federico, *De pictura sacra*. Milan, 1625; new ed. by C. Castiglioni, Sora, 1932.

Bosarte, Isidoro. *Viaje artístico a varios pueblos de España*. Madrid, 1804; reprint, Madrid, 1977.

Boston. Museum of Fine Arts. *Catalogue of Pictures Belonging to H.R.H. the Duke de Montpensier, and of Other Pictures, also Loaned to the Museum of Fine Arts*. Boston, 1874.

Bottineau, Yves. "L'Alcázar de Madrid et l'inventaire de 1686: Aspects de la cour d'Espagne au XVIIᵉ siècle." *Bulletin hispanique* 58 (1956), pp. 421–52; 60 (1958), pp. 30–61, 145–79, 289–326, 450–83.

———. "La Cour d'Espagne et l'oeuvre de Velázquez dans la première moitié du XVIIIᵉ siècle." In *Varia velazqueña*, edited by Antonio Gallego y Burín, I, pp. 553–60. Madrid, 1960.

———. *Les Chemins de Saint Jacques*. Paris, 1964; new ed. Paris, 1985.

———. *L'Art de cour dans l'Espagne des lumières, 1746–1808*. Paris, 1986.

Bottineau, Yves, and Pietro M. Bardi. *Tout l'oeuvre peint de Velázquez*. Paris, 1969.

[Boule, J. C.] *Histoire abrégée de la vie, des vertus et du culte de Saint Bonaventure par un religieux cordelier*. Paris, 1747.

Bourgoing, Jean-François de. *Nouveau voyage en Espagne; ou, Tableau de l'état actuel de cette monarchie*. 3 vols. Paris, 1788.

———. *Tableau de l'Espagne moderne*. 3 vols. 2d ed. Paris, 1797.

Bover, Joaquin María. *Noticia histórico-artística de los museos del eminentísimo Señor Cardinal Despuig existentes en Mallorca*. Palma, 1845.

Bravo, Aniceto. *Memoria de los cuadros de D. Aniceto Bravo*. Seville, 1837.

Bravo, Luis. "La cartuja de Jerez y los cuadros de Zurbarán." *La voz del sur*, Mar. 27–28, 1980, pp. 1–2, 5, 7.

Bravo, Luis, and César Pemán. ¿*Cuando pintó Zurbarán los cuadros de la Cartuja de las Cuevas?* Badajoz, 1963a.

———. "¿Cuando pintó Zurbarán los cuadros de la Cartuja de Jerez de la Frontera?" *Revista de estudios extremeños* 19 (1963b), pp. 121–29.

Brejon de Lavergnée, Arnauld. "La Peinture italienne au XVIIᵉ siècle." In *Baroque et classicisme au XVIIᵉ siècle en Italie et en France*. Geneva, 1979.

Breviarum romanum ex decreto sacrosanti Concilii Tridentini restitutum S. Pie V, jussu editum et Clementii VIII . . . Urbani Papae VII auctoritate recognitum insertis novarum festorum officiis. Antwerp, 1590. French translation, Paris, 1679.

Brown, Jonathan. *Francisco de Zurbarán*. New York, 1974.

———. *Images and Ideas in Seventeenth-Century Spanish Painting*. Princeton, 1978. Spanish translation, *Imágenes e ideas en la pintura española del siglo XVII*. Madrid, 1980.

———. "La problemática zurbaranesca." In *Symposium Internacional de Murillo y su época*. Seville, 1982.

———. *Velázquez: Painter and Courtier*. New Haven and London, 1986.

Brown, Jonathan, and J. H. Elliott. *A Palace for a King: The Buen Retiro and the Court of Philip IV*. New Haven and London, 1980. Spanish translation, *Un palacio para el rey: El Buen Retiro y la corte de Felipe IV*. Madrid, 1985.

Brussels. Bibliothèque Royale Albert Iᵉʳ. *Les Estampes de Wierix conservées au Cabinet des Estampes de la Bibliothèque Royale Albert Iᵉʳ: Catalogue raisonné, enrichi de notes prises dans diverses autres collections*, by Marie Mauquoy-Hendrickx. 2 vols. Brussels, 1978.

Brussels. Palais des Beaux-Arts. *Splendeurs d'Espagne et les villes belges, 1500–1700*, by Jean-Marie Duvosquel and Ignace Vaudevivere. 2 vols. Exhib. cat., 1985.

Budapest. Szépmüvészeti Múzeum. *Spanish Masters*, by Marianna Haraszti-Takács; translated by Eva Rácz. Budapest, 1966.

———. *Katalog der Galerie alter Meister [im] Museum der Bildenden Künste, Budapest*, by Andor Pigler. Budapest, 1967.

———. *Spanish Masters from Zurbarán to Goya*, by Marianna Haraszti-Takács. Budapest, 1984.

Buendia, José R. "La estela de Zurbarán en la pintura andaluza." *Goya*, no. 64–65 (1965), pp. 276–83.

Bulwer, John. *Chirologia; or, The Naturall Language of the Hand . . . Chironomia; or, The Art of Manuall Rhetoricke*. . . . London, 1644.

Cabello Lapiedra, Luis M. "La Cartuja de Jerez." *Boletín de la Sociedad Española de Excursiones* 26 (1918), pp. 241–54.

Cádiz. Museo Provincial de Bellas Artes. *Catálogo del museo de pinturas y grabados formado . . . 1876 . . . (edición oficial)*. Cádiz, 1876.

————. *Catálogo de las pinturas*, by César Pemán y Pemartín. Cádiz, 1952.

————. *Catálogo del Museo Provincial de Bellas Artes de Cádiz: Pinturas*, by César Pemán y Pemartín. Guías de los museos de España, no. 18. Madrid, 1964.

Cahier, Charles. *Caractéristiques des saints dans l'art populaire; énumérées et expliquées*. 2 vols. Paris, 1867.

Calvo Serraller, Francisco. *La teoría de la pintura en el siglo de oro*. Madrid, 1981.

Calzada y Echevarría, Andrés M., and Luys Santa Marina. *Estampas de Zurbarán*. Barcelona, 1929.

Camón Aznar, José. "Modernidad de Zurbarán." *Goya*, no. 64–65 (1965), pp. 306–11.

————. *La pintura española del siglo XVII*. Summa artis, vol. 25. Madrid, 1977.

Canones et decreta, Concilii Tridentini. Rome, 1564. English translation by Theodore A. Buckley, *The Canons and Decrees of the Council of Trent*. London, 1851.

Carducho, Vicente. *Diálogos de la pintura: Su defensa, origen, esencia, definición, modos, y diferencias*. Madrid, 1633; new ed., with notes by Francisco Calvo Serraller, Madrid, 1979.

Carrascal Muñoz, José M. *Francisco de Zurbarán*. Madrid, 1973.

Carriazo, Juan de Mata. "Correspondencia de Don Antonio Ponz con el Conde de Aguila." *Archivo español de arte y arqueología* 5 (1929), pp. 157–83.

Cascales y Muñoz, José. *Francisco de Zurbarán: Su época, su vida, y sus obras*. Madrid, 1911; 2d ed. Madrid, 1931. English translation by N. S. Evans, *Francisco de Zurbarán: His Epoch, His Life, and His Works*. New York, 1918.

Castillo, Alberto del. "La Anunciación de Zurbarán en la sala Pares." *Diario de Barcelona*, Dec. 29, 1949, p. 4.

Castillo, Diego del. *Defensa de la venida y predicación evangélica de Santiago en España*. Saragossa, 1608.

Caston, F. "Zurbarán y la casa de los Morales-Llerena." *Revista de Extremadura* 3 (1947), pp. 438–39.

Castro, Adolfo de. *Historia de Xerez de la Frontera*. Cádiz, 1845.

Caturla, Maria L. "New Facts on Zurbarán." *Burlington Magazine* 87 (1945a), pp. 302–4.

————. "Zurbarán en el Salón de Reinos." *Archivo español de arte* 18 (1945b), pp. 292–300.

————. "Zurbarán at the 'Hall of Realms' at the Buen Retiro." *Burlington Magazine* 89 (1947a), pp. 42–45.

————. "Zurbarán en Llerena." *Archivo español de arte* 20 (1947b), pp. 265–84.

————. *Bodas y obras juveniles de Zurbarán*. Granada, 1948a.

————. "Noticias sobre la familia de Zurbarán." *Archivo español de arte* 21 (1948b), pp. 125–27.

————. "Conjunto de Zurbarán en Zafra." *A.B.C.* (Madrid), Apr. 20, 1948c.

————. "Lectura." *A.B.C.* (Madrid), Apr. 1950.

————. "Zurbarán exporta a Buenos Aires." *Anales del Instituto de Arte Americano e Investigaciones Estéticas*, no. 4 (1951), pp. 27–30.

————. "A Retable by Zurbarán." *Burlington Magazine* 94 (1952), pp. 44–49.

————. *Don Juan de Zurbarán*. Madrid, 1957a.

————. "Don Juan de Zurbarán." *Boletín de la Real Academia de Historia* (Madrid) 141, no. 1 (1957b), pp. 269–78.

————. "Ternura y primor de Zurbarán." *Goya*, no. 30 (1959), pp. 342–45.

————. "Cartas de pago de los doce cuadros de batallas para el Salón de Reinos del Buen Retiro." *Archivo español de arte* 33 (1960a), pp. 333–55.

————. "Velázquez y Zurbarán." In *Varia velazqueña*, edited by Antonio Gallego y Burín, I, pp. 463–70. Madrid, 1960b.

————. "Zurbarán, las casas de Morales y la pleiteadora Paula." *Revista de estudios extremeños* 17 (1961), pp. 231–45.

————. *Fin y muerte de Francisco de Zurbarán. Documentos recogidos y comentados . . . ofrecidos en la conmemoración del III centenario*. Madrid, 1964a.

————. "Sobre la ordenación de las pinturas de Zurbarán en la sacristía de Guadalupe." *Archivo español de arte* 37 (1964b), pp. 185–86.

————. "Zurbarán en San Pablo de Sevilla." *Revista de estudios extremeños* 20 (1964c), pp. 289–301.

————. "Zurbarán en Llerena ¿Camino de Guadalupe?" *Guadalupe*, no. 551 (May–June 1964d), unpaged.

————. "La Santa Faz de Zurbarán: 'Trompe l'oeil' a lo divino." *Goya*, no. 64–65 (1965), pp. 202–5.

————. *El conjunto de Las Cuevas*. Forma y color, no. 41. Granada, 1968.

Ceán Bermúdez, Juan Agustín. *Diccionario histórico de los más ilustres profesores de las bellas artes en España*. 6 vols. Madrid, 1800; reprint, Madrid, 1965.

————. *Descripción artística de la catedral de Sevilla*. Seville, 1804a; new ed. Seville, 1981.

————. *Descripción artística del Hospital de la Sangre de Sevilla*. Valencia, 1804b.

Celano, Tomaso da. *Vita prima S. Francisci Assisiensis et eiusdem legenda ad usum chori* (ms. ca. 1228). Quaracchi, 1926.

Chartres. Musée des Beaux-Arts. *Catalogue*. Introduced by Maurice Jusselin. Chartres, 1931.

————. *Catalogue sommaire*. Introduced by René Gobillot. Chartres, 1954.

Chavin de Mallan, François E. *La Vie et les lettres du bienheureux Henry de Suzo*. Paris, 1842.

Chenesseau, Georges L. *Monographie de la cathédrale d'Orléans, notice historique et guide du visiteur*. Orléans, 1925.

Cherry, Peter. "The Contract for Francisco de Zurbarán's Paintings of Hieronymite Monks for the Sacristy of the Monastery of Guadalupe." *Burlington Magazine* 127 (1985), pp. 374–81.

Chevalier, Jean, and Alain Gheerbrant. *Dictionnaire des symboles*. Paris, 1982.

Chicago. Art Institute of Chicago. *Paintings in the Art Institute of Chicago: A Catalogue of the Picture Collection*. Chicago, 1961.

Chicago. University of Chicago. David and Alfred Smart Gallery. *Blue-and-White Chinese Porcelain and Its Impact on the Western World*, by John Carswell. Exhib. cat., 1985.

Christian, William A. *Local Religion in Sixteenth-Century Spain*. Princeton, 1981.

Cid, Miguel. *Coplas de alabanzas de la Inmaculada Concepción de la siempre Virgen María. . . .* Seville, 1625.

Cincinnati Art Museum. *Spanish Paintings in the Cincinnati Art Museum*, by Millard F. Rogers. Cincinnati, 1978.

Cleveland Museum of Art. *The Cleveland Museum of Art Catalogue of Paintings*. Part 3, *European Paintings of the 16th, 17th, and 18th Centuries*. Cleveland, 1982.

Clifden, Viscount. *Collection of Viscount Clifden*. Sale cat., London, May 6, 1893.

Clop, Eusèbe. *Saint Bonaventure (1221–1274)*. 2d ed. Les Saints, no. [97]. Paris, 1922.

Coe, Ralph T. "Zurbarán and Mannerism." *Apollo* 96 (1972), pp. 494–97.

Collantes de Terán y Caamano, Francisco. *Memorias históricas de los establecimientos de caridad de Sevilla*. 2 vols. Seville, 1884–89; new ed. Seville, 1980.

Collantes de Terán y Delorme, Francisco. *Patrimonio monumental y artístico del Ayuntamiento de Sevilla*. Seville, 1970.

Collection de tableaux anciens, surtout de l'école espagnole [de L . . . A . . . , Séville]. Sale cat., Paris, Dec. 20, 1867.

Colón y Colón, Juan. *Sevilla artística*. Seville, 1841.

Comes, Francisco-Tomás. "250 fichas bibliográficas." *Mundo hispánico*, no. 197 (1964), pp. 91–94.

Corzo Sánchez, Ramón. "La cartuja de Jérez." *Enciclopedia gráfica gaditana* 1, no. 2 (1984), pp. 17–32.

Couto, João B. *Diálogo sobre la historia de la pintura en México (1860–61)*. Edited by M. Toussaint. Mexico City, 1947.

———. "A proposito do Apostolado de Zurbarán existente no Museu de Arte Antiga de Lisboa." *Revista de estudios extremeños* 17 (1961), pp. 415–21.

Croche de Acuña, Francisco. *La Colegiata de Zafra (1609–1851): Crónica de luces y sombras*. Prologue by D. A. Camacho Mácias. Zafra, 1984.

Cruz Valdovinos, J. M. "Sobre Juan de Arfe y Francisco de Zurbarán." *Archivo español de arte* 48 (1975), pp. 271–76.

Cuadra, Luis de la. *Catálogo-inventario de los documentos del Monasterio de Guadalupe*. Madrid, 1973.

Cuartero y Huerta, Baltasar. *Historia de la Cartuja de Santa María de las Cuevas, de Sevilla, y de su filial de Cazalla de la Sierra*. 2 vols. Madrid, 1950–54.

Cunningham, Charles C. "*Saint Serapion*, by Francisco de Zurbarán." *Art Quarterly* (Detroit Institute) 14, no. 4 (1951), pp. 354–57.

Dabrio González, Maria Teresa. *Estudio histórico-artístico de la parroquia de San Pedro*. Seville, 1975.

Dacos, Nicole. "Pedro Campaña dopo Siviglia: Arazzi e altri inediti." *Bolletino d'arte*, ser. 6, no. 8 (1980), pp. 1–44.

Daniel-Rops, Henry. *La Bible apocryphe; Evangiles apocryphes*. Texts chosen and presented by H. Daniel-Rops; translations by F. Amiot. Paris, 1952.

Delacroix, Eugène. *Journal de Eugène Delacroix, 1822–1863*. Introduction and notes by André Joubin. 3 vols. Paris, 1931–32.

Delgado Varela, J. M. "Sobre la canonización de San Pedro Nolasco." *Estudios* 12 (1956), pp. 265–95.

Demerson, Georges. "A propos du Saint François d'Assise de Zurbarán au Musée de Beaux-Arts de Lyon." *Bulletin des musées lyonnais* 4 (1953), pp. 69–80.

Deslandres, Paul. *Le Concile de Trente et la réforme du clergé catholique au XVIᵉ siècle*. Paris, 1906.

Díaz del Valle y de la Puerta, Lázaro. "Origen yllustración del nobilíssimo y real arte de la pintura y dibuxo . . ." (1656). In *Fuentes literarias para la historia del arte español*, by Francisco J. Sánchez Cantón, II, pp. 337–93. Madrid, 1933.

Díaz Padrón, Matías. "Una quinta repetición inédita del *Agnus Dei* de Zurbarán." *Goya*, no. 164–65 (1981), pp. 66–69.

Dictionnaire de spiritualité ascétique et mystique, doctrine et histoire, by M. Viller *et al.* 12 vols. in 15. Paris, 1932–80.

Dictionnaire de théologie catholique. Edited by A. Vacant, E. Mangenot, and E. Amman. 16 vols. in 33. Paris, 1923–72.

Documentos para la historia del arte en Andalucía. 10 vols. Seville, Universidad de Sevilla, 1927–46.

Domínguez Ortiz, Antonio. *Orto y ocaso de Sevilla: Estudio sobre la decadencia de la ciudad durante los siglos XVI y XVII*. Seville, 1946; 2d ed. Seville, 1974.

Domínguez Ortiz, Antonio, and Francisco Aguilar Piñal. *Historia de Sevilla*. Vol. IV, *El barroco y la ilustración*. Seville, 1976.

Dorival, Bernard. "Velázquez et la critique d'art française aux XVIIᵉ et XVIIIᵉ siècles." In *Varia velazqueña*, edited by Antonio Gallego y Burín, I, pp. 526–31. Madrid, 1960.

———. "Obras españolas en las colecciones francesas del siglo XVIII." In *Actas del XXIII Congreso Internacional de Historia de Arte* (Granada, 1973), III, pp. 67–94. Granada, 1978.

Droulers, Eugène [Eugène de Seyn]. *Dictionnaire des attributs, allégories, emblèmes, et symboles*. Turnhout [1949].

Duchesne, L. "Saint Jacques en Galice." *Annales du Midi*, no. 46 (1900), pp. 145–79.

Duranty. "Promenades au Louvre: Remarques sur le geste dans quelques tableaux," part 2. *Gazette des Beaux-Arts*, ser. 2, 15 (1877), pp. 172–80.

Edinburgh. National Gallery of Scotland. *Catalogue of an Exhibition of Spanish Paintings from El Greco to Goya*. Exhib. cat., 1951.

———. *Italian and Spanish Paintings in the National Gallery of Scotland*, by Hugh Brigstocke. Exhib. cat., 1978.

Eisler, Colin T. *Paintings from the Samuel H. Kress Collection*. Vol. IV, *European Schools Excluding Italian*. London, 1977.

Elliott, J. H. *Imperial Spain, 1469–1716*. London, 1963; New York, 1964; New York, 1966. Spanish translation by J. Marfany, *La España imperial*. Barcelona, 1965.

———. *The Count-Duke of Olivares: The Statesman in an Age of Decline*. New Haven and London, 1986.

Enciclopedia universal ilustrada europeo-americana. 70 vols. in 72. Barcelona, 1905–30. *Suplemento anual*. Madrid, 1934–80.

Espinosa de los Monteros, Pablo. . . . *Historia, antigüedades, y grandezas de la muy noble y muy leal ciudad de Sevilla*. 2 vols. Seville, 1627–30.

Esteve Guerrero, Manuel. *Notas extraídas del protocolo primitivo y de la fundación de la cartuja jerezana*. Jerez de la Frontera, 1934.

Facchinetti, Vittorino. *San Francesco d'Assisi nella storia, nella leggenda, nell'arte*. . . . Université Catholique, Louvain, Recueil de travaux, no. 46. Milan, 1921; 2d ed. Milan, 1926a. French translation by Countess de Loppinot, *Saint François d'Assise dans l'histoire, dans la légende, dans l'art*. Paris, 1926b.

Farinelli, Arturo. *Viajes por España y Portugal desde la edad media hasta el siglo XX, nuevas y antiguas divagaciones bibliográficas*. Reale Accademia d'Italia, Studi e documenti, no. 11. 3 vols. Rome, 1942–44.

Faure, Elie. *Histoire de l'art*. 4 vols. Paris, 1909–21. English translation by Walter Pach, *History of Art*. 5 vols. New York, 1921–30.

Fernández Bayton, Gloria. *Testamentaría del Rey Carlos II, 1701–1703*. 3 vols. Madrid, Museo del Prado, Inventarios reales, vols. 1–3. Madrid, 1975–85.

Ferrand Bonilla, Manuel. "Alonso Vázquez." *Anales de la Universidad Hispalense* 12 (1951), pp. 133–47.

Florence. Palazzo Vecchio. *Da El Greco a Goya: Il secolo d'oro della pittura spagnola*, by Manuela B. Mena Marqués. Exhib. cat., 1986.

Fonseca, Cristóbal de. *Primera parte de la vida de Christo, Señor nuestro*. Toledo, 1596.

Ford, Richard. *A Handbook for Travellers in Spain and Readers at Home; Describing the Country and Cities, the Natives and Their Manners . . . with Notices on Spanish History, 1830–1832*. London, 1845; 3d ed. London, 1855; reprint, 3 vols. Arundel, 1966.

———. "Sale of Louis-Philippe's Spanish Pictures." *Athenaeum* (London), May 14, 21, 28, 1853.

Fort Worth. Kimbell Art Museum. *Spanish Still Life in the Golden Age, 1600–1650*, by William B. Jordan and Sarah Schroth. Exhib. cat., 1985.

Francis, Henry S. "Francisco de Zurbarán: *The Holy House of Nazareth*." *Bulletin of the Cleveland Museum of Art* 48 (Mar. 1961), pp. 46–50.

Fuentenebro, Q. *Documentos para escribir la biografía de Jovellanos*. Madrid, 1911.

Gállego, Julián. "El color en Zurbarán." *Goya*, no. 64–65 (1965), pp. 296–305.

———. *Vision et symboles dans la peinture espagnole au siècle d'or*. Paris, 1968. Spanish translation, *Visión y símbolos en la pintura española del siglo de oro*. Madrid, 1972.

Gállego, Julián, and José Gudiol. *Zurbarán, 1598–1664*. Barcelona, 1976. English translation, New York, 1977.

Gallegos, Manuel de. *Obras varias al Real Palacio del Buen Retiro*. Madrid, 1637.

Garas, Claire. "Un Nouveau Tableau de Zurbarán au Musée Hongrois des Beaux-Arts." *Bulletin du Musée Hongrois des Beaux-Arts*, no. 3 (Sept. 1949), pp. 24–27, 46–47.

García Barriuso, Patrocinio. *San Francisco el Grande de Madrid: Aportación documental para su historia*. Madrid, 1975.

García Carraffa, Alberto, and Arturo García Carraffa. *Enciclopedia heráldica y genealógica hispano-americana.* 88 vols. Madrid, 1952–69.

García de Loaysa, Pedro. *Collectio conciliorum hispaniae.* Madrid, 1593.

García Gutiérrez, Pedro F. *Iconografía mercedaria: Nolasco y su obra.* Madrid, 1985.

Garnier, François. *Le Langage de l'image au Moyen-Age: Signification et symbolique.* Paris, 1982.

Gassier, Pierre. "Découverte de Guadaloupe." *L'Oeil,* no. 19–20 (1956), pp. 36–43.

Gautier, Théophile. *Poésies complètes.* Edited by René Jasinski. 3 vols. Paris, 1932.

Gaya Nuño, Juan Antonio. "El Museo Nacional de la Trinidad." *Boletín de la Sociedad Española de Excursiones* 51 (1947), pp. 19–77.

———. *Zurbarán.* Barcelona, 1948; new ed. Barcelona, 1976.

———. *Zurbarán en Guadalupe.* Obras maestras del arte español, vol. 9. Barcelona, 1951.

———. *La pintura española fuera de España: Historia y catálogo.* Madrid, 1958.

———. "Bibliografía crítica y antológica de Zurbarán." *Arte español* 25 (1963–66), pp. 18–68.

———. "Treinta obras en Norteamerica." *Mundo hispánico* 17, no. 197 (1964), pp. 64–71.

———. "Zurbarán y los Ayala." *Goya,* no. 64–65 (1965), pp. 218–33.

Gazul, A. *Divagaciones sobre la vida y la obra de Zurbarán en Llerena.* Llerena, 1953.

Geneva. Musée d'Art et d'Histoire. *Les Chefs-d'oeuvre du Musée du Prado.* Introduction by Fernando Alvarez de Sotomayor. Exhib. cat., 1939.

Gestoso y Pérez, José. *Sevilla monumental y artística: Historia y descripción de todos los edificios notables, religiosos, y civiles. . . .* 3 vols. Seville, 1889–92.

———. *Ensayo de un diccionario de los artífices que florecieron en Sevilla desde el siglo XIII hasta el XVIII inclusive.* 3 vols. Seville, 1899–1908.

———. *Una requisa de cuadros en la catedral de Sevilla.* Seville, 1909.

———. *Curiosidades antiguas sevillanas.* Seville, 1910.

Ghilarov, S. A. "Juan Zurbarán." *Burlington Magazine* 72 (1938), p. 190.

Girard, Antoine. *Les Peintures sacrées sur la Bible.* Paris, 1653.

Gómez, Ildefonso M. *Escritores cartujanos españoles.* Scripta et documenta, vol. 19. Montserrat, 1970.

Gómez Castillo, Antonio, and Alfonso Grosso Sánchez. *Discursos leídos ante la Real Academia de Bellas Artes de Santa Isabel de Hungría de Sevilla . . . en la recepción pública del primero el 28 de mayo de 1949.* Madrid, 1950.

Gómez Imaz, Manuel. *Inventario de los cuadros sustraidos por el gobierno intruso en Sevilla en el año de 1810.* Seville, 1896; 2d ed. Seville, 1917.

González de León, Felix. *Noticia artística, histórica, y curiosa de todos los edificios públicos, sagrados, y profanos de esta muy noble, muy leal, muy heroica e invicta ciudad de Sevilla y de muchas casas particulares.* 2 vols. Seville, 1844.

González Zubieta, Rafael. *Vida y obra del artista andaluz Antonio Mohedano de la Gutierra (1563?–1626).* Córdoba, 1981.

Gourdel, Y. "Le Culte de la très sainte Vierge dans l'Ordre des Chartreux." In *Maria: Etudes sur la Sainte Vierge,* vol. II. Paris, 1952.

Gracián de la Madre de Dios, Jerónimo. *Josephina, summario de las excelencias del glorioso S. Joseph, esposo de la Virgen María, recopilado de diversos autores.* Brussels, 1597; Brussels, 1609; Brussels, 1629.

Granada. II Festival Internacional de Música y Danza. *Zurbarán: Estudio y catálogo de la exposición celebrada en Granada en junio de 1953,* by María L. Caturla. Exhib. cat., 1953.

Granada, Luis de. *Vita Christi.* Cologne, 1591. Spanish translation by Justo Cuervo, *Obras de Luis de Granada.* Madrid, 1906. French translation by B. M. Cuissinier, *Traité de la vie de N. S. Jésus-Christ.* 2d ed. Paris, 1868.

Gregori, Mina, and Tiziana Frati. *L'opera completa di Zurbarán.* Milan, 1973.

Grenoble. Musée de Peinture et de Sculpture. *Catalogue des tableaux, statues, bas-reliefs, et objets d'art exposés dans les galeries du Musée de Peinture et de Sculpture.* Grenoble, 1911.

Gretser, Jacob. *Opera omnia.* Vol. I, *De Sancta Cruce. . . .* Ederiano, 1616.

Grimal, Pierre. *Dictionnaire de la mythologie grecque et romaine.* Paris, 1951; new ed. Paris, 1979. English translation by A. R. Maxwell-Hyslop, *The Dictionary of Classical Mythology.* New York, 1985.

Gruys, Albert. *Cartusiana: Un instrument heuristique; A Heuristic Instrument; Ein heuristischer Apparat.* Paris, 1976.

Gudiol, José. "Current and Forthcoming Exhibitions: Francisco de Zurbarán in Madrid." *Burlington Magazine* 107 (1965), pp. 148–51.

———. "Zurbarán." In *Encyclopaedia of World Art,* XIV, cols. 969–74. New York, 1967.

Guénébault, Louis Jean. *Dictionnaire iconographique des figures, légendes, et actes des saints. . . .* Encyclopédie théologique, vol. 45. Paris, 1850.

Gueulette, C. *Les Peintres espagnols.* Paris, 1863.

Guinard, Paul. "Zurbarán et la 'découverte' de la peinture espagnole en France sous Louis-Philippe." In *Hommage à Ernest Martinenche,* pp. 22–33. Paris, 1939.

———. "Los conjuntos dispersos o desaparecidos de Zurbarán: Anotaciones a Ceán Bermúdez." *Archivo español de arte* 19 (1946), pp. 249–73; 20 (1947), pp. 161–201; 22 (1949), pp. 1–38.

———. "Zurbarán: Le ténébrisme et la tradition espagnole." *Cahiers de Bordeaux* 2 (1955), pp. 45–52.

———. *Zurbarán et les peintres espagnols de la vie monastique.* Paris, 1960a. Spanish translation, *Zurbarán y la pintura española de la vida monástica.* Madrid, 1967.

———. "Zurbarán: État des problèmes." *Information d'histoire de l'art* 5, no. 5 (1960b), pp. 127–37.

———. "Zurbarán en France." *Revista de estudios extremeños* 17 (1961), pp. 363–77.

———. "Tesoros de la pintura española." *Goya,* no. 49 (1962), p. 361.

———. "Zurbarán en la exposición de Paris." *Goya,* no. 54 (1963), pp. 355–64.

———. "Aportaciones críticas de obras zurbaranescas." *Archivo español de arte* 37 (1964), pp. 115–28.

———. "¿Zurbarán, pintor de países?" *Goya,* no. 64–65 (1965), pp. 206–13.

———. *Dauzats et Blanchard, peintres de l'Espagne romantique.* Bibliothèque de l'Ecole des Hautes Etudes Hispaniques, no. 30. Paris, 1967.

———. "A propos de *Saint Bruno et le Pape* de Zurbarán." *Mélanges de la casa de Velázquez* 11 (1975), pp. 585–91.

Guinard, Paul, and Tiziana Frati. *Tout l'oeuvre peint de Zurbarán.* Paris, 1975.

Gutiérrez, Bartolomé. *Historia de Jerez de la Frontera* (ms. 1787). Jerez de la Frontera, 1886.

Gutiérrez de Quijano y López, Pedro. *La cartuja de Jerez.* Jerez de la Frontera, 1924.

Haraszti-Takács, Marianna. "Berichte: Ungarn, Budapest." *Pantheon,* 3d ser., 24 (1966), pp. 62–66.

Harris, Enriqueta. "Spanish Painting at the Bowes Museum." *Burlington Magazine* 109 (1967), pp. 483–84.

Hefele, Karl Joseph von, and Joseph Adam G. Hergenröther. *Conciliengeschichte.* 10 vols. in 9. Freiburg im Breisgau, 1855–90.

French translation of 2d ed., *Histoire des Conciles d'après les documents originaux*. Edited by Henri Leclerq. Paris, 1907–52.

Hélyot, Pierre, and Maximilien Bullot. *Histoire des ordres monastiques, religieux, et militaires, et des congrégations séculières de l'un et l'autre sexe, qui ont été établies jusqu'à présent*. 8 vols. Paris, 1714–19.

Hergenröther, Joseph Adam G. *Histoire de l'église*. Translated by P. Bélet. 8 vols. Paris, 1880–92.

Hernández Díaz, José. "Materiales para la historia del arte español." *Documentos para la historia del arte en Andalucía* 2, 1928 (1930), pp. 105–226.

———. "Arte y artistas del Renacimiento en Sevilla." *Documentos para la historia del arte en Andalucía* 6 (1933).

———. *Arte hispalense de los siglos XV y XVI*. Seville, 1937.

———. "Los Zurbaranes de Marchena." *Archivo español de arte* 26 (1953), pp. 31–36.

———. "Bernabé de Ayala, pintor." *Archivo hispalense*, no. 162 (1972).

———. "La parroquia sevillana de Santa María Magdalena." *Boletín de bellas artes de la Academia de Santa Isabel de Hungría de Sevilla* 8 (1980), pp. 205–36.

Hernández Díaz, José, Antonio Sancho Corbacho, and Francisco Collantes de Terán. *Catálogo arqueológico y artístico de la provincia de Sevilla*. 4 vols. Seville, 1939–55.

Hernández Perera, Jesús. "Zurbarán y San Diego." *Goya*, no. 64–65 (1965), pp. 232–41.

Herrera Casado, Antonio. *Monasterios y conventos en la provincia de Guadalajara*. Guadalajara, 1974.

Hervet, Gentian. *Le Sainct, sacré, universal, et général Concile de Trente*. Translated from the Latin by Gentian Hervet d'Orléans. Rouen, 1606; Rouen, 1656.

Herzog, Erich, and Ursula Schlegel. "Beiträge zu Francisco de Zurbarán." *Pantheon* 18 (1960), pp. 91–101.

Hoog, James. "La Cartuja de Jerez de la Frontera." *Analecta cartusiana* (Salzburg), no. 42 (1978), p. 2.

———. "La Cartuja de las Cuevas." *Analecta cartusiana* (Salzburg), no. 47 (1983), p. 3b.

Hornedo, F. "La pintura de la Inmaculada en Sevilla." *Miscelánea comillas* 19 (1953), pp. 169–98.

Hornedo, R. M. de. "El arte de Trento." *Razón y fe*, Jan. 1945, pp. 203–33.

Icaza. [Untitled.] *Mundial* (Mexico City), Nov. 2, 1922.

L'immagine di San Francesco nella Controriforma. Rome, 1982–83.

Interián de Ayala, Juan. *Pictor christianus eruditus*. Madrid, 1730. Spanish translation by Luis de Durán y de Bastero, *El pintor christiano y erudito*. 2 vols. Madrid, 1782.

Jedin, H. "Entstehung und Tragweite des Trienter Dekrets über die Bildverehrung." *Theologische Quartalschrift* 116 (1935), pp. 143–88, 404–29.

Justi, Karl. "Das Leben des Hl. Bonaventura gemalt von Herrera d. Ä. und Zurbarán." *Jahrbuch der preussischen Kunstsammlungen* 4 (1883), pp. 152–62.

———. "Zurbarán und kein Ende." *Zeitschrift für bildende Kunst* 47 (1911), p. 25.

———. *Diego Velázquez und sein Jahrhundert*. Rev.ed.Zurich, 1933. Spanish translation by Pedro Marrades, *Velázquez y su siglo*. Revised, and with the appendix "Después de Justi: Medio siglo de estudios velazquistas," by Juan A.Gaya Nuño. Madrid, 1953.

Kehrer, Hugo. *Francisco de Zurbarán*. Munich, 1918.

———. "Neues über Francisco de Zurbarán." *Zeitschrift für bildende Kunst* 55 (1920), pp. 248–51.

Kinkead, Duncan T. "Francisco de Herrera and the Development of the High Baroque Style in Seville." *Record of the Art Museum, Princeton University* 41, no. 2 (1982), pp. 12–23.

———. "Artistic Trade between Seville and the New World in the Mid-17th Century." *Boletín del Centro de Investigaciones Historicas y Estéticas* (Caracas) 25 (1983a), pp. 73–101.

———. "The Last Sevillian Period of Francisco de Zurbarán." *Art Bulletin* 65 (1983b), pp. 305–11.

———. "Juan de Luzón and the Sevillian Painting Trade with the New World in the Second Half of the Seventeenth Century." *Art Bulletin* 66 (1984), pp. 303–12.

Kleinschmidt, Beda. "Das Leben des Hl. Bonaventura in einem Gemäldezyklus von Francisco Herrera dem Älterem und Francisco Zurbarán." *Archivum franciscanum historicum* 19 (1926), pp. 3–16.

Konopleva, M. S. *Dom-muzei b. Shuvalovoí* (Guide to the House-Museum formerly owned by Shuvalova). Moscow, 1923.

Kubler, George, and Martin S. Soria. *Art and Architecture in Spain and Portugal and Their American Dominions, 1500 to 1800*. 2d ed. Harmondsworth, 1959.

Labat, Jean B. *Voyage en Espagne et en Italie*. 8 vols. Paris, 1730.

Laborde, Alexandre de. *Voyage pittoresque et historique de l'Espagne*. 4 vols. in 2. Paris, 1806–20.

Lafond, Paul. *Ribera et Zurbarán*. Paris, 1909.

Lázaro Galdiano, I. *Catálogo de la colección de I. Lázaro Galdiano*. 2 vols. [Madrid] 1800.

Le Bras, Gabriel, ed. *Les Ordres religieux: La Vie et l'art*. 2 vols. Paris, 1979–80.

Le Flem, Jean P., *et al. La frustración de un imperio (1476–1714)*. Historia de España, vol. 5, edited by Manuel Tuñon de Lara. Barcelona, 1982.

Lefort, Paul. "Zurbarán." *Gazette des Beaux-Arts*, ser. 3, 7 (1892), pp. 365–82.

León, Luis de. *De los nombres de Cristo*. Salamanca, 1583; Salamanca, 1595; Salamanca, 1603.

Lexikon der christlichen Ikonographie. Edited by Engelbert Kirschbaum and Gunter Bandmann. 8 vols. Fribourg, Basel, and Rome, 1971–78.

Lipschutz, Ilse H. *Spanish Painting and the French Romantics*. Cambridge, Mass., 1972.

———. "Théophile Gautier, le musée espagnol, et Zurbarán." In *Actes du Colloque International Théophile Gautier: L'Art et l'artiste*, I, pp. 107–20. Montpellier, 1982.

Lisboa, Marcos da. *Primera parte de las chrónicas de los frayles menores. . . .* Translated by Felipe de Sosa. Alcalá de Henares, 1562.

Lleó Cañal, Vicente. *Arte y espectáculo: La fiesta del Corpus Christi en la Sevilla de los siglos XVI y XVII*. Seville, 1975.

———. *Nueva Roma: Mitología y humanismo en el renacimiento sevillano*. Seville, 1979.

Loga, Valerian von. "The Spanish Pictures of Sir William Van Horne's Collection in Montreal." *Art in America* 1 (1913), pp. 92–104.

———. *Die Malerei in Spanien*. Berlin, 1923.

London. National Gallery. *The Spanish School*, by Neil MacLaren. London, 1952; 2d ed., revised by Allan Braham, London, 1970.

———. *El Greco to Goya: The Taste for Spanish Paintings in Britain and Ireland*, by Allan Braham. Exhib. cat., 1981.

London. Royal Academy of Arts. *The Golden Age of Spanish Painting*, by Alfonso E. Pérez Sánchez. Exhib. cat., 1976.

Longhi, Roberto. "Un San Tomaso del Velázquez e le congiunture italo-spagnole tra il '5 et il '600." *Vita artistica*, no. 1 (1927), pp. 4–11.

López Cepero, Manuel. *Catálogo de los cuadros y esculturas que componen la galería formada por el Exmo. Sr. Doctor D. Manuel López Cepero . . . que a voluntad de sus herederos se sacará a pública subasta . . . en la casa no. 7 de la Plaza de Alfaro. . . .* Sale cat., Seville, May 15–30, 1860.

———. *Catalogue des tableaux anciens de la galerie de feu son excellence M. López Cepero de Séville. . . .* Sale cat., Paris, Feb. 14, 1868.

López Estrada, Francisco. "Pintura y literatura: Una consideración estética en torno de la *Santa Casa de Nazaret* de Zurbarán." *Archivo español de arte* 39 (1966), pp. 25–50.

López Martínez, Celestino. *Notas para la historia del arte: Arquitectos, escultores, y pintores vecinos de Sevilla.* Seville, 1928a.

———. *Notas para la historia del arte: Retablos y esculturas de traza sevillana.* Seville, 1928b.

———. *Notas para la historia del arte: Desde Jerónimo Hernández hasta Martínez Montañés.* Seville, 1929.

———. *Notas para la historia del arte: Desde Martínez Montañés hasta Pedro Roldán.* Seville, 1932.

López-Rey, José. "An Unpublished Zurbarán: The Surrender of Seville." *Apollo* 82 (1965), pp. 23–25.

———. "Zurbarán as a Portrait Painter." *Apollo* 93 (1971), pp. 120–25.

———. *Velázquez: The Artist as a Maker.* Lausanne and Paris, 1979. French translation, *Vélasquez: Artiste et créateur.* Lausanne and Paris, 1981.

López Torrijos, Rosa. *La mitología en la pintura española del siglo de oro.* Madrid, 1985.

Louis-Philippe. *Pictures Forming the Celebrated Spanish Gallery of His Majesty the Late King Louis-Philippe.* Sale cat., Christie's, London, May 6–21, 1853.

Loyola, Ignatius. *Exercitia spiritualia.* Rome, 1548.

Lozoya, Marqués de [Juan Contreras y López de Ayala]. "Zurbarán en el Perú." *Archivo español de arte* 16 (1943), pp. 1–6.

———. [Untitled.] *A.B.C.* (Sevillian ed.), Mar. 22, 1950.

Ludolph of Saxony. *Vita Christi.* 4 vols. Strasbourg, 1474. Spanish translation, 4 vols. Seville, 1543–51.

Lugones, Damián de. *Carta al . . . Señor Cardenal Çapata . . . dandole cuenta de la solemnissima fiesta de la Inmaculada Concepción. . . .* Málaga, 1615.

Luna, Juan José. "Inventario y almoneda de algunas pinturas de la colección de Isabel de Farnesio." *Boletín del Seminario de Estudios de Arte y Arqueología* (Universidad de Valladolid) 39 (1973), pp. 359–69.

———. "Zurbarán en el Museo de Bellas Artes de Bilbao." *Uztekaria,* 1986, pp. 9–17.

Lyons. Musée des Beaux-Arts. *Notice des antiquités et des tableaux du Musée de Lyon,* by François Artaud. Lyons, 1808.

———. *Notice des tableaux exposés dans les musées de Lyon,* by A. Thierrat. Lyons, 1850.

Madariaga, Juan de. *Vida del seráfico padre San Bruno, patriarca de la cartuxa; con, El origen y principio y costumbres desta sagrada religión.* Valencia, 1596.

Madoz, Pascual. *Diccionario geográfico-estadístico-histórico de España y sus posesiones de Ultramar.* Vol. X. Madrid, 1847.

Madrazo, José de. *Catálogo de la galeria de cuadros del excmo. Sr. Madrazo.* Madrid, 1856.

Madrid. Casón del Buen Retiro. *Exposición Zurbarán en el III centenario de su muerte.* Exhib. cat., 1964.

———. *Museo del Prado: Adquisiciones de 1978 a 1981,* by José M. Pita Andrade. Exhib. cat., 1981.

Madrid. Instituto Central de Restauración. *Catálogo de obras restauradas, 1964–66,* by Matías Díaz Padrón. Madrid, 1968.

Madrid. Museo del Prado. *Catálogo provisional, historial, y razonado del Museo Nacional de Pinturas,* by Gregorio Cruzada Villaamil. Madrid, 1865.

———. *Catálogo descriptivo e histórico de los cuadros del Museo del Prado en Madrid.* Vol. I, *Escuelas italianas y españolas,* by Pedro de Madrazo y Kuntz. Madrid, 1872.

———. *Catálogo oficial ilustrado de la exposición de las obras de Francisco de Zurbarán,* by Salvador Viniegra. Exhib. cat., 1905.

———. *Catálogo de los cuadros,* by Francisco J. Sánchez Cantón. Madrid, 1933; 1942; 1949; 1952; 1963; 1972.

———. *Pintura española de los siglos XVI al XVIII en colecciones centroeuropeos.* Exhib. cat., 1981.

———. *El niño en el Museo del Prado, Madrid,* by Alfonso E. Pérez Sánchez. Exhib. cat., 1983a.

———. *Pintura española de bodegones y floreros, de 1600 a Goya,* by Alfonso E. Pérez Sánchez. Exhib. cat., 1983b.

———. *Guide to the Prado,* by Consuela Luca de Tena and Manuela B. Mena Marqués. Madrid, 1984.

Madrid. Real Academia de San Fernando. *Catálogo de los cuadros, estatuas y bustos que existen en la Real Academia de San Fernando en este año de 1819. . . .* Madrid, 1819.

———. *Inventario de las pinturas,* by Alfonso E. Pérez Sánchez. Madrid, 1964.

Maigreto, G. *Vie de Saint Augustin,* with illustrations by Schelte à Bolswert. Paris, 1624.

Mailes, J. de. *Histoire de la domination des Arabies et des Maures.* Paris, 1854.

Maisons de l'Ordre des Chartreux: Vues et notices. Vol. 3. Parkminster, 1916.

Mâle, Emile. *L'Art religieux de la fin du Moyen-Age en France.* Paris, 1908; new ed. Paris, 1969.

———. *L'Art religieux de la fin du XVIᵉ siècle, du XVIIᵉ siècle, et du XVIIIᵉ siècle: Etude sur l'iconographie après le Concile de Trente; Italie—France—Espagne—Flandres.* Paris, 1932; 2d ed. Paris, 1951; reprint, Paris, 1972; new ed. Paris, 1984.

———. *Les Saints compagnons du Christ.* Paris, 1958.

Malitzkaya, Kseniya. "Zurbarán in the Moscow Museum of Fine Arts." *Burlington Magazine* 57 (1930), pp. 16–21.

———. *Ispanskaya Shiwopis XVI–XVII wekow.* (Spanish painting of the 16th–17th centuries). Moscow, 1947.

———. "Zurbarán en los museos rusos." *Archivo español de arte* 37 (1964), pp. 107–14.

Manzano Garías, Antonio. "Aportación a la biografía de Zurbarán: Nuevos y curiosos documentos." *Revista de Extremadura* (Badajoz), suppl. 1947.

Marcille, Camille. *Catalogue des tableaux et dessins formant la collection de feu Camille Marcille.* Sale cat., Hôtel Drouot, Paris, Mar. 6–9, 1876.

Marco Dorta, Enrique. *Fuentes para la historia del arte hispanoamericano.* Vol. II. Seville, 1960.

Martin, J. B. *Histoire des églises et chapelles de Lyon.* Vol. II. Lyons, 1908.

Martín González, Juan J. *Inventario artístico de Valladolid y su provincia.* Valladolid, 1970a.

———. "La Santa Faz: A propósito de un inédito de Zurbarán." *Goya,* no. 97 (1970b), pp. 11–12.

———. *El artista en la sociedad española del siglo XVII.* Madrid, 1984.

Martin-Méry, Gilberte. "Una Inmaculada de Zurbarán, recobrada." *Archivo español de arte* 38 (1965), pp. 203–6.

———. "Le Dernier Zurbarán découvert." *Connaissance des arts,* no. 177 (1966), p. 5.

Martínez Ripoll, Antonio. *La iglesia del Colegio de San Buenaventura: Estilo e iconografía.* Seville, 1976.

———. *Francisco de Herrera "el Viejo."* Publicaciones de la Excma. Diputación Provincial de Sevilla, sección arte, ser. 1, no. 9. Seville, 1978.

Matrod, H. "Deux tableaux espagnols au Musée du Louvre." *Chronique des arts et de la curiosité,* Dec. 3, 1922, pp. 164–65.

Matute y Gaviria, Justino. *Hijos de Sevilla señalados en santidad, letras, armas, artes, ó dignidad.* 2 vols. Seville, 1886–87a.

———. "Adiciones y correcciones de D. Justino Matute al tomo IX del *Viaje de España* por D. Antonio Ponz, anotadas nuevamente por D. Gestoso y Pérez." *Archivo hispalense,* nos. 1 and 2 (1886b); no. 3 (1887b); no. 4 (1888).

———. *Anales eclesiásticos y seculares de la muy noble y muy leal ciudad de Sevilla . . . desde el año de 1701 . . . hasta él de 1800. . . .* 3 vols. Seville, 1887c.

Maugham, W. Somerset. "Zurbarán." In *The Vagrant Mood: Six Essays,* pp. 51–90. London, 1952.

Mayer, August L. *Die Sevillaner Malerschüle.* Leipzig, 1911.

―――. "Die Sammlung Sir William Van Horne in Montreal." *Der Cicerone* 8 (1916a), pp. 1–9.

―――. "Zurbarán in America." *Arts and Decoration* 6 (Mar. 1916b), pp. 219–22.

―――. *Geschichte der spanische Malerei*. Leipzig, 1922.

―――. "*The Education of the Virgin*, by Zurbarán." *Burlington Magazine* 44 (1924), p. 212.

―――. "A Still Life by Zurbarán." *Burlington Magazine* 49 (1926), p. 55.

―――. "Notas sobre algunas pinturas en museos provinciales de Francia." *Boletín de la Real Academia de Historia*, 1927a, p. 32.

―――. "Still Lifes by Zurbarán and Van der Hamen." *Burlington Magazine* 51 (1927b), p. 320.

―――. "Some Unknown Works by Zurbarán." *Apollo* 7 (1928), pp. 180–81.

―――. "Anotaciones a cuadros de Velázquez, Zurbarán, Murillo, y Goya en el Prado y en la Academia de San Fernando." *Boletín de la Sociedad Española de Excursiones* 44 (1936), pp. 41–46.

―――. *Historia de la pintura española*. 2d ed. Madrid, 1942; 3d ed. Madrid, 1947.

Melida, José R. *Catálogo monumental de España: Provincia de Badajoz*. 3 vols. Madrid, 1925–26.

Memoria de las admirables pinturas que tiene este convento, casa grande de Ntra. Sra. de la Merced, redentora de cautivos de la ciudad de Sevilla. Seville, 1732. Only a copy made by Manuel de Ayora, Oct. 1789, exists; Biblioteca Colombina, Seville, Papeles varios, 40.

Mercey, Frédéric. "La Galerie du Maréchal Soult." *Revue des deux mondes*, n.s. 6, no. 14 (May 15, 1852), pp. 807–16.

Merchán Cantisán, Regla. *El Deán López Cepero y su colección pictórica*. Seville, 1979.

―――. "La colección pictórica del Deán López Cepero." Dissertation, Universidad de Sevilla, n.d.

Mesa, José de, and Teresa Gisbert. *El pintor Mateo Pérez de Alesio*. La Paz, 1972.

Mexico City. Academia de San Carlos. *Las pinturas de la Academia*, by Alvarez. Mexico City, 1917.

―――. *Las galerías de pintura de la Academia de San Carlos*, by Abelardo Carrillo y Gariel. Mexico City, 1944.

Michelet, Jules. *Journal*. Vol. I *(1828–1848)*. 6th ed. Paris, 1959.

Migne, Jacques P. *Patrologiae cursus completus . . . : Series Graeca. . . .* 161 vols. Paris, 1844–65.

Milicua, José. "El Crucifijo de San Pablo, de Zurbarán." *Archivo español de arte* 26 (1953), pp. 177–86.

―――. [Untitled.] *Diario de Barcelona*, Apr. 7, 1955.

―――. "Observatorio de ángeles." Part 2, "Los ángeles de la perla de Zurbarán." *Archivo español de arte* 31 (1958), pp. 1–16.

―――. *Zurbarán*. Barcelona, n.d.

Molanus, Johannes. *De picturis et imaginibus sacris*. Louvain, 1570; Louvain, 1574; Louvain, 1590. Reissued in *Theologiae cursus completus*, vol. XXVIII, edited by Jacques P. Migne. Paris, 1843.

Molina, Antonio de. *Instrucción de sacerdotes. . . .* Burgos, 1608; Burgos, 1612.

―――. *Exercicios espirituales muy provechosos para personas ocupadas deseosas de su saluación*. Burgos, 1613; new ed. Madrid, 1671.

Molina, Tirso de [Gabriel Téllez]. *Historia general de la Orden de Nuestra Señora de las Mercedes*. Madrid, 1639; new ed. by Manuel Penedo Rey, 2 vols. Madrid, 1973–74.

Montoto, Santiago. "Zurbarán: Nuevos documentos para ilustrar su biografía." *Arte español* 5 (1921), pp. 400–404.

Montpellier. Musée Fabre. *Le Musée de Montpellier, Musée Fabre (peintures et sculptures)*, by André Joubin. Paris, 1929.

Montpensier, Duke of [Antoine Marie Philippe Louis d'Orléans]. *Catálogo de los cuadros, dibujos, y esculturas pertenecientes a la galería de Duque de Montpensier, en su palacio de Sanlucar de Barrameda*. Seville, 1866.

Morales, Alfredo J., *et al. Guía artística de Sevilla y su provincia*. Seville, 1981.

Morales Padrón, Francisco, ed. *Memorias de Sevilla (1600–1678)*. Córdoba, 1981.

Moscow. Pushkin State Museum of Fine Arts. *Katalog Kartinnoĭ galerei* (Guide), by I. A. Kouznetsova. Moscow, 1986.

Mota Arevalo, Horacio. "Interesantes documentos sobre Zurbarán." *Revista de estudios extremeños* 17 (1961), pp. 257–69.

Moyssén, Xavier. "La *Casa de Nazareth*; o, Los presagios de la Virgen." *Anales del Instituto de Investigaciones Estéticas* (Universidad Nacional Autonoma de México), no. 44 (1975), pp. 49–58.

Munich. Alte Pinakothek. *Gemäldekataloge*. Vol. I, *Spanische Meister*, by Halldor Soehner. Munich, 1963.

Munich. Haus der Kunst. *Von Greco bis Goya: Vier Jahrhunderte spanische Malerei*. Exhib. cat., 1982.

Muñoz de Ortiz, J. de. *Collection J. de Muñoz de Ortiz de Valence*. Sale cat., Berlin, Dec. 12, 1911.

Muñoz y Manzano, Cipriano. "Zurbarán." In *Adiciones al Diccionario histórico . . . de D. Juan Augustín Ceán Bermúdez*. Vol. IV, pp. 71–72. Madrid, 1894.

Muro Orejón, Antonio, ed. "Artífices sevillanos de los siglos XVI y XVII." *Documentos para la historia del arte en Andalucía* 4 (1932).

New Catholic Encyclopedia. 15 vols. New York, 1967.

New York. Metropolitan Museum of Art. *A Catalogue of Italian, Spanish, and Byzantine Paintings*, by Harry B. Wehle. New York, 1940.

―――. *Masterpieces of Painting in the Metropolitan Museum of Art*, by Edith A. Standen and Thomas M. Folds. New York, 1970.

―――. *France in the Golden Age: Seventeenth-Century French Paintings in American Collections*, by Pierre Rosenberg. Exhib. cat., 1982.

Nieva Calvo, Sebastián de. *La mejor Mujer, Madre, y Virgen: Sus excelencias, vida, y grandezas repartidas por sus fiestas todas*. Madrid, 1625.

Obregón, Gonzalo. "Zurbarán en Méjico." *Revista de estudios extremeños* 20 (1964), pp. 425–38.

Orléans. *Album de l'exposition rétrospective d'Orléans en 1876*, by J. D. Danton. Exhib. cat., 1876.

Orozco Díaz, Emilio. "Retratos a lo divino: Para la interpretación de un tema de la pintura de Zurbarán." In *Temas del barroco*, pp. 29–36. Granada, 1947.

―――. "Cotán y Zurbarán." *Goya*, no. 64–65 (1965), pp. 224–31.

Ortiz de Zúñiga, Diego. *Annales eclesiasticos y seculares de la muy noble y muy leal ciudad de Sevilla . . . desde el año de 1246 hasta el de 1671*. Seville, 1677; annotated and enlarged by Antonio M. Espinosa y Carzel, 5 vols. Madrid, 1795–96.

Ortiz Lucio, Francisco. *Horas devotíssimas para cualquier Christiano. . . .* Madrid, 1605.

Oudry, Alphonse. *Catalogue des tableaux anciens des écoles italienne, espagnole, hollandaise, et flamande*. Sale cat., Hôtel Drouot, Paris, Apr. 16–17, 1869.

―――. *Catalogue des tableaux anciens appartenant à la succession Oudry*. Sale cat., Hôtel Drouot, Paris, Apr. 10, 1876.

Pacheco, Francisco. *Libro de descripción de verdaderos retratos de ilustres y memorables varones*. Seville, 1599; facsimile edited by José M. Asensio, Seville, 1881–85; facsimile with a prologue by Diego Angulo Iñiguez, Seville, 1984.

―――. *Arte de la pintura: Su antigüedad y grandezas* (ms. 1638). Seville, 1649; new ed. with notes by Francisco J. Sánchez Cantón, 2 vols. Madrid, 1956. French translation by Lauriane Fallay d'Este, Paris, 1986.

Palau de Nemes, Graciela. "De Zurbarán y San Juan de la Cruz." *Insula*, no. 209 (1964), pp. 1, 12.

Paleotti, Gabriele. *Discorso intorno alle imagine sacre e profane. . . .* 2 vols. Bologna, 1582. Reissued in *Trattati d'arte del Cinquecento*, by Paola Barocchi, II, pp. 117–509. Bari, 1960–62.

Palomero Páramo, Jesús M. *El retablo sevillano del Renacimiento: Análisis y evolución.* Publicaciones de la Excma. Diputación Provincial de Sevilla, sección arte, ser. 1, no. 18. Seville, 1983.

Palomino de Castro y Velasco, Antonio. *El museo pictórico y escala óptica.* 3 vols. Madrid, 1715–24; reprint, Madrid, 1936; reprint, Madrid, 1947.

————. *An Account of the Lives and Works of the Most Eminent Spanish Painters, Sculptors, and Architects; and Where Their Several Performances Are To Be Seen.* London, 1739. French translation, *Histoire abrégée des plus fameux peintres, sculpteurs, et architectes espagnoles. . . .* Paris, 1749.

Pardo Canalis, Enrique. "Zurbarán." *Revista de ideas estéticas* (Madrid. Instituto Diego Velázquez) 23 (1965), pp. 59–76.

Paris. Grand Palais. *Raphaël dans les collections françaises,* by Sylvie Béguin. Exhib. cat., 1983.

Paris. Musée de l'Orangerie. *Les Chefs-d'oeuvre du Musée de Montpellier.* Preface by Paul Valéry; catalogue by Michael A. Faré. Exhib. cat., 1939.

Paris. Musée des Arts Décoratifs. *Trésors de la peinture espagnole: Eglises et musées de France.* Preface by Robert Mesuret and Paul Guinard. Paris, 1963.

Paris. Musée du Louvre. *Notice des tableaux de la Galerie Espagnole exposés dans les salles du Musée Royal au Louvre.* 4 eds. Paris, 1838.

————. *Notice des tableaux exposés dans les galeries du Musée National du Louvre.* Vol. I, *Ecoles d'Italie et d'Espagne,* by Frédéric Villot. Paris, 1849.

————. *Description raisonnée des peintures du Louvre.* Vol. I, *Ecoles étrangères: Italie et Espagne,* by Seymour de Ricci. Paris, 1913.

————. *Catalogue des peintures exposés dans les galeries.* Vol. II, *Ecole italienne et école espagnole,* by Louis Hautecoeur. Paris, 1926.

————. *La Peinture au Musée du Louvre: Ecole espagnole,* by M. Nicolle. Paris, 1929.

————. *Catalogue sommaire illustré des peintures du Musée du Louvre.* Vol. II, *Italie, Espagne, Allemagne, Grande-Bretagne, et divers,* by A. Brejon de Lavergnée and D. Thiebault. Paris, 1981

————. *Inventaire général des dessins: Ecole française.* Vol. II, *Dessins d'Eugène Delacroix,* by Maurice Sérullaz. Paris, 1984.

Paris. Petit Palais. *La Peinture espagnole au siècle d'or: De Greco à Velázquez,* by Alfonso E. Pérez Sánchez. Exhib. cat., 1976.

————. *Collection Thyssen-Bornemisza: Maîtres anciens,* by Allen Rosenbaum. Exhib. cat., 1982.

Pascal, J. B. E. *Institutions de l'art chrétien pour l'intelligence des sujets religieux.* 2 vols. Paris, 1856.

Pascual, Pedro. "Visita al refectorio." *Arriba,* Nov. 29, 1964.

Passeri, Bernardino. *Vita et miracula sanctissimi patris benedicti.* Rome, 1579.

Pemán, César. "La serie de los hijos de Jacob y otras pinturas zurbaranescas." *Archivo español de arte* 21 (1948), pp. 153–72.

————. "Nuevas pinturas de Zurbarán en Inglaterra." *Archivo español de arte* 22 (1949), pp. 207–13.

————. "La reconstrucción del retablo de la Cartuja de Jerez de la Frontera." *Archivo español de arte* 23 (1950), pp. 203–27.

————. "Zurbaranistas gaditanos en Guadalupe." *Boletín de la Sociedad Española de Excursiones* 55 (1951), pp. 155–87.

————. "Identificación de un Zurbarán perdido." *Archivo español de arte* 30 (1957), pp. 327–29.

————. "Juan de Zurbarán." *Archivo español de arte* 31 (1958), pp. 193–211.

————. "Un nuevo Juan de Zurbarán." *Archivo español de arte* 32 (1959), pp. 319–20.

————. "Sobre bodegones zurbaranescos." *Archivo español de arte* 34 (1961a), pp. 274–76.

————. "Zurbarán en la hora actual." *Revista de estudios extremeños* 17 (1961b), pp. 271–85.

————. "¿Cuando pinto Zurbarán los cuadros de la Cartuja de Jerez de la Frontera?" *Revista de estudios extremeños* 18 (1962), pp. 126–29.

————. *Zurbarán en la hora actual.* Badajoz, 1963a.

————. "Contestación a Fray Luis Bravo." *Revista de estudios extremeños* 19 (1963b), pp. 127–29.

————. "Miscelánea zurbaranesca." *Archivo español de arte* 37 (1964), pp. 93–105.

————. "La exposición homenaje a Zurbarán en el museo de Sevilla." *Goya,* no. 64–65 (1965), pp. 312–15.

Peña Gómez, M. P. de la. [Untitled.] *Revista de estudios extremeños.* Forthcoming.

Perdrizet, Paul. *La Vierge de Miséricorde: Etude d'un thème iconographique.* Paris, 1908.

Pérez, Pedro Nolasco. *San Pedro Nolasco, fundador de la Orden de la Merced (siglo XIII).* Barcelona, 1915.

Pérez Escolano, Victor. *Juan de Oviedo y de la Bandera (1565–1625): Escultor, arquitecto, e ingeniero.* Seville, 1977.

————. "El Convento de la Merced Calzada de Sevilla a la luz de la *Relación* de Fray Juan Guerrero (mediados del siglo XVII) y la planta aproximada de 1835." In *Homenaje al Profesor Hernández Díaz,* I, pp. 545–61. Seville, 1982.

Pérez Sánchez, Alfonso E. "Nuevas papeletas para el catálogo de Zurbarán." *Archivo español de arte* 37 (1964), pp. 193–96.

————. *Pintura italiana del siglo XVII en España.* Madrid, 1965a.

————. "Dos nuevos Zurbaranes." *Archivo español de arte* 38 (1965b), pp. 261–63.

————. "Torpeza y humildad de Zurbarán." *Goya,* no. 64–65 (1965c), pp. 266–75.

————. "La crisis de la pintura española en torno a 1600." In *España en las crisis del arte europeo.* Madrid, 1968.

————. "Nuevos Zurbaranes." *Archivo español de arte* 49 (1976), pp. 73–80.

————. "Une Vision nouvelle de la peinture espagnole du siècle d'or." *Revue de l'art,* no. 70 (1985), pp. 53–64.

Pérez Villanueva, J. "Baronio y la Inquisición española." In *Baronio storico e la Controriforma, atti del Convegno Internazionale di Studi* (Sora, 1979). Sora, 1982.

Pétin, L. M. *Dictionnaire hagiographique; ou, Vies des saints et des bienheureux. . . .* 2 vols. Encyclopédie théologique Migne, vol. 40. Paris, 1850.

Petrangeli Papini, Francesco. "Il Dottore Serafico nelle raffigurazioni degli artisti." In *S. Bonaventura 1274–1974: Volumen commemorativum anni septies centenarii a morte S. Bonaventurae Doctoris Seraphici, Grottaferrata,* I. Rome, 1974.

Picault, Jeanne. "Iconographie de Saint Bonaventure." *Cahier des Cordeliers* (Paris), no. 1 (1946), pp. 51–90.

Pita Andrade, José M. "El arte de Zurbarán en sus inspiraciones y fondos arquitectónicos." *Goya,* no. 64–65 (1965), pp. 242–49.

Placer, G. "Estampas de San Pedro Nolasco." *Boletín de la Provincia de Castilla de la Orden de Ntra. Sra. de la Merced* 15 (1977), pp. 53–59.

Polentinos, Count of. "El Convento de San Hermenegildo, de Madrid." [Inventory of the painting collection in 1786]. *Boletín de la Sociedad Española de Excursiones* 41 (1933), pp. 36–61.

Pompey Salgueiro, Francisco. *Zurbarán: Su vida y sus obras.* Madrid, 1948.

Ponz, Antonio. *Viaje de España.* 18 vols. Madrid, 1772–94; reprint prepared by Casto María del Rivero, Madrid, 1947; facsimile, Madrid, 1972.

Pseudo-Bonaventure. *Meditationes vitae Christi* (ms. ca. 1280–1310). French ed., *Méditations sur la vie du Christ,* Paris, 1958.

Quilliet, Frédéric. "Collection des tableaux de S. A. S. le prince de la paix" (ms. 1808). Archivo Historico Nacional, Madrid, Estado L. 3227, no. 1. Cited in I. J. R. Wagner, "Manuel Godoy . . . ," pp. 423–52. Madrid, 1983.

————. *Dictionnaire des peintres espagnols.* Paris, 1816.

Quintero y Atauri, Pelayo. "La Anunciación de Zurbarán en Arcos de la Frontera." *Boletín del Museo Provincial de Bellas Artes de Cádiz* 7 (1925), pp. 29–31.

Rallón Mercado, Esteban. *Historia de Xerez de la Frontera* (ms. before 1640). Jerez de la Frontera, 1926.

Réau, Louis. *Iconographie de l'art chrétien.* 3 vols. Paris, 1955–59.

Rebolledo, Luis de. *Parte primera [y segunda] de la chrónica de nuestro seráfico padre San Francisco y su apostólica orden.* 2 vols. Seville, 1598–1603.

Remón, Alonso. *Historia general de la Orden de Nuestra Señora de la Merced; redención de cautivos.* 2 vols. Madrid, 1618–33.

———. *Discursos elógicos . . . de San Pedro Nolasco. . . .* Madrid, 1627.

Réveil, Etienne A., and Jean Duchesne, aîné. *Musée de peinture et de sculpture; ou, Recueil des principaux tableaux, statues, et bas-reliefs des collections particulières et publiques de l'Europe, dessiné et gravé à l'eau-forte par Réveil, avec des notices descriptives, critiques, et historiques par Duchesne aîné.* 16 vols. Paris, 1828–33.

Reverdy, J. "L'Entretien de Saint Bruno et du Pape Urbain II de Zurbarán: Essai d'analyse." In *Mélanges de la Casa de Velázquez* 11 (1975), pp. 578–83.

Revilla, Manuel G. *El arte en Mexico en la época antigua y durante el gobierno virreinal.* Mexico City, 1893.

Reynaud, F. "Contribution à l'étude des danseurs et des musiciens des fêtes du Corpus Christi et de l'Assomption à Tolède aux XVI et XVII siècles." *Mélanges de la Casa de Velázquez* 10 (1974), pp. 133–68.

Ribadeneyra, Pedro de. *Primera parte del Flos Sanctorum; o, Libro de las vidas de los santos.* Madrid, 1599; Madrid, 1624. French translation by M. l'abbé Daras, *La Fleur des saints.* 13 vols. Vailly-sur-Sauldre, 1982–84.

Ripa, Cesare. *Iconologia; overo, Descrittione di diverse imagini cavate dall'antichità et di propria inventione trovate et dichiarate da Cesare Ripa . . . di nuovo rivista e dalmedesimo ampliata di 400 epiu imagini.* Rome, 1603.

Roa, Martín de. *Santos Honorio, Eutichio, Estevan, patronos de Xerez de la Frontera, nombre, sitio, antigüedad de la ciudad, valor de sus ciudadanos.* Seville, 1617.

Robinson, Francis W. "Notes on a Painting by Zurbarán." *Bulletin of the Cincinnati Art Museum* 7, no. 1 (1936), pp. 16–27.

Rodríguez Codolá, Manuel. *Zurbarán.* Barcelona, 1943.

Rodríguez de Rivas, Mariano. "Autógrafos de artistas españoles." *Revista española de arte* 1 (1932), pp. 229–38.

Rollin. *Catalogue d'une fort belle collection de tableaux anciens des divers écoles.* Sale cat., Laneuville, Paris, Apr. 1–2, 1853.

Rome. Galleria Nazionale d'Arte Moderna. *Los antiguos pintores españoles de la colección Contini-Bonacossi: Catálogo critico,* by Roberto Longhi and August L. Mayer. Exhib. cat., 1930.

Romero de Torres, Enrique. "Los Zurbaranes del Museo de Cádiz." *Boletín de la Comisión Provincial de Monumentos de Cádiz* 1 (1908), pp. 97–108.

———. *Catálogo monumental de España: Provincia de Cádiz, 1908–1909.* 2 vols. Madrid, 1934.

Roux, L. E. *Du logos à la scène: La Dramaturgie de la comédie sainte dans l'Espagne du siècle d'or (1580–1635).* Lille, 1975. Originally presented as the author's thesis, Université de Nice, Mar. 4, 1974.

Rudrauf, Lucien. *Les Disciples d'Emmaüs: Etude d'un thème plastique.* Paris, 1956.

Sáez Piñuela, María J. "Las modas femininas del siglo XVII a través de los cuadros de Zurbarán." *Goya,* no. 64–65 (1965), pp. 284–89.

Salamanca, Marquis de. *Catalogue des tableux anciens des écoles espagnole, italienne, flamande, et hollandaise composant la galerie de M. le Mis. de Salamanca; vente en son hôtel à Paris, rue de la Victoire.* Sale cat., Paris, June 3–6, 1867.

Salas, Xavier de. "Cartas y notas de Richard Ford sobre pinturas españolas." *Archivo español de arte* 23 (1950), pp. 229–34.

———. "Un cuadro de Zurbarán." *Archivo español de arte* 27 (1954), pp. 332–33.

———. "Crónica." *Archivo español de arte* 37 (1964a), pp. 362–64.

———. "La fecha de las historias de la cartuja y alguna minucia más sobre Zurbarán." *Archivo español de arte* 37 (1964b), pp. 129–38.

———. "Proyección en Europa." *Mundo hispánico,* no. 197 (1964c), pp. 29–38.

———. "Spanish Paintings." In Unesco. *An Illustrated Inventory of Famous Dismembered Works of Art: European Painting.* Paris, 1974.

Salmerón, Marcos. *Recuerdos históricos y políticos de los servicios que los generales y varones ilustres de la religión de Nuestra Señora de la Merced, redención de cautivos. . . .* Valencia, 1646.

Saltillo, Marqués del [Miguel Lasso de la Vega y López de Tejada]. "Un retrato del Museo del Emperador Federico, de Berlin, por Zurbarán: Datos para su identificación." *Investigación y progreso* (Madrid) 2 (May 1928), pp. 33–34.

———. *Frédéric Quilliet: Comisario de Bellas Artes del gobierno intruso, 1809–1814.* Madrid, 1933.

———. "El gobierno intruso y la riqueza artística de Sevilla." *Boletín de la Real Academia Sevillana de Buenas Letras* 10, no. 53 (1956).

Salvago de Aguilar, J. "El juramento de la Limpia Concepción en Marchena (5 de septiembre de 1616)." *Archivo hispalense,* no. 57 (1953), pp. 227–34.

San Diego Museum of Art. *A Catalogue of European Paintings, 1300–1870,* by Julia G. Andrews. San Diego, 1947.

San Jerónimo, Alonso de. *Vida, virtudes, y milagros de la prodigiosa virgen y madre Ana de San Agustín, Carmelita Descalza. . . .* Madrid, 1668.

Sánchez Cantón, Francisco J. "La vida de San Pedro Nolasco: Pinturas del claustro del refectorio de la Merced Calzada de Sevilla." *La Merced* 5, no. 42 (Jan. 24, 1922), pp. 209–16.

———. *Fuentes literarias para la historia del arte español.* 5 vols. Madrid, 1923–41.

———. *San Francisco de Asís en la escultura española.* Madrid, 1926.

———. *La colección Cambó.* Barcelona, 1955.

Sancho Corbacho, Antonio. *Edificios religiosos y objetos de culto.* Seville, 1937.

———. *Iconografía de Sevilla.* Seville, 1975.

Sancho Corbacho, Heliodoro. "Contribución documental al estudio del arte sevillano." *Documentos para la historia del arte en Andalucía* 2, 1928 (1930), pp. 227–317.

———. "Arte sevillano de los siglos XVI y XVII." *Documentos para la historia del arte en Andalucía* 3 (1931).

Sancho de Sopranís, Hipólito. "Alejandro de Saavedra, entallador." *Archivo hispalense,* no. 10 (1945), pp. 5–75.

———. "La arquitectura jerezana en el siglo XVI." *Archivo hispalense,* no. 40 (1964), pp. 9–73.

———. *Historia de Jerez de la Frontera desde su incorporación a los dominios cristianos.* 2 vols. Jerez de la Frontera, 1964–69.

———. "Más sobre Alejandro de Saavedra, entallador." *Archivo hispalense,* no. 136 (1966), p. 121.

Santoro, Juan B. *Flos Sanctorum y vidas de los santos del yermo del Nuevo Testamento.* 2 vols. Bilbao, 1580; Bilbao, 1604.

Santos, Reynaldo dos. "El 'Apostolado' de Zurbarán en Lisboa." *Archivo español de arte* 17 (1945), pp. 189–92.

Santos y Olivera, Balbino. *Guía ilustrada de la catedral de Sevilla.* Madrid, 1930.

Scannelli, Francesco. *Il microcosmo della pittura.* 2 vols. in 1. Cesena, 1657; facsimile, Milan, 1966.

Schiller, Gertrude. *Iconography of Christian Art.* Translated by Janet Seligman. 2 vols. Greenwich, 1971.

Schoonebeek, Adriaan. *Histoire des ordres religieux de l'un et de l'autre sexe, où l'on voit le temps de leur fondation, la vie en abrégé, de leurs fondateurs, et les figures de leurs habits. . . .* 2d ed. Amsterdam, 1700.

Sebastián, Santiago. "Zurbarán se inspiró en los grabados del aragonés Jusepe Martínez." *Goya,* no. 128 (1975), pp. 82–84.

———. "Grabado inspirador de un Zurbarán de la Academia de San Carlos." *Anales del Instituto de Investigaciones Estéticas,* no. 46 (1976), pp. 67–69.

———. *Contrarreforma y barroco: Lecturas iconográficas e iconológicas.* Madrid, 1981.

Sebastián y Bandarán, José. "Un Zurbarán desconocido." *Boletín de la Real Academia Sevillana de Buenas Letras* 5 (1921), pp. 19–21.

———. "Una Inmaculada de Francisco Zurbarán." *Archivo hispalense,* no. 64–65 (1954), pp. 1–3.

Seckel, Helmut P. G. "Francisco de Zurbarán as Painter of Still Life." *Gazette des Beaux-Arts,* ser. 6, 30 (1946), pp. 279–300.

Sedulius, H. *Imagines sanctorum Francisci et qui ex tribus ordinibus relati sunt . . . eum elogiis.* Antwerp, 1602.

———. *Imagines Bmi. P. Francisci Assisiatis illustriumq. virorum . . . repraesentatis.* Antwerp, 1614.

Sentenach y Cabañas, Narciso. "Francisco de Zurbarán, pintor del Rey." *Boletín de la Sociedad Española de Excursiones* 17 (1909), pp. 194–98.

Serra y Pickman, Carlos. "Los cuadros del Monasterio de las Cuevas: Fecha en que los pintó Zurbarán." *Archivo hispalense,* no. 43–44 (1950), pp. 209–14.

Serra y Pickman, Carlos, and José Hernández Díaz. *Estudio histórico de los cuadros de la Cartuja de Santa Maria de Las Cuevas.* Seville, 1934.

Serrera, Juan M. "Aldegrever y Zurbarán: Los evangelistas del Museo de Bellas Artes de Cádiz." *Gades: Revista del Colegio Universitario de Filosofía y Letras de Cádiz,* no. 7 (1981a), pp. 107–14.

———. "Influencias de grabados germanicos en la pintura española del siglo XVII: Aldegrever y Zurbarán." In *Primero Congreso Español de Historia del Arte* (Trujillo, 1977, Section I). Trujillo, 1981b.

———. *Hernando de Esturmio.* Seville, 1983.

———. "Pintura y pintores del siglo XVI." In *La catedral de Sevilla.* Seville, 1984a.

———. "Datos para la historia de la Pentecostés de Zurbarán del Museo de Bellas Artes de Cádiz y su vinculación americanista." *Archivo hispalense,* no. 203 (1984b), pp. 179–87.

———. "Vasco Pereira: Un pintor portugués en la Sevilla del último tercio del XVI." *Archivo hispalense.* Forthcoming.

Seville. *Catálogo de las obras que formaron la exposición retrospectiva de la pintura sevillana celebrada en esta ciudad,* by José Gestoso y Pérez. Exhib. cat., 1896.

Seville. Museo de Artes y Costumbres Populares. *Sevilla en el siglo XVII,* by A. Pleguezuerlo Hernández. Exhib. cat., 1983.

Seville. Museo de la Catedral. *Catálogo de las pinturas de la catedral de Sevilla,* by Enrique Valdivieso. Seville, 1978.

Seville. Museo Provincial de Bellas Artes. *Catálogo de las pinturas y esculturas. . . ,* by José Gestoso y Pérez. Madrid, 1912.

———. *Museo Provincial de Bellas Artes, Sevilla,* by José Hernández Díaz. Guías de los museos de España, vol. 30. Madrid, 1967.

Seville. Palacio Arzobispal. *Catálogo de las pinturas del Palacio Arzobispal de Sevilla,* by Enrique Valdivieso and Juan M. Serrera. Seville, 1979.

Sigüenza, José de. *Historia de la Orden de San Jerónimo.* 3 vols. Madrid, 1605; 2d ed. 2 vols. Madrid, 1907–9.

Somoza, Julio. *Jovellanos: Nuevos datos para su biografía.* Madrid, 1885.

Soria, Martin S. "Francisco de Zurbarán: A Study of His Style." *Gazette des Beaux-Arts,* ser. 6, 25 (1944a), pp. 33–48, 153–74.

———. "Zurbarán: Right and Wrong." *Art in America* 32 (July 1944b), pp. 126–41.

———. "A Zurbarán for San Diego." *Art Quarterly* 10 (1947), pp. 66–69.

———. "Sobre una Anunciación de Zurbarán." *Boletín de la Sociedad Española de Excursiones* 52 (1948a), pp. 149–51.

———. "Some Flemish Sources of Baroque Painting in Spain." *Art Bulletin* 30 (1948b), pp. 249–59; and "Letter to the Editor" [German prints as sources for Zurbarán]. *Art Bulletin* 31 (1949), pp. 74–75.

———. "Zurbarán's Altar of Saint Peter." *Art Bulletin* 33 (1951), pp. 165–73.

———. *The Paintings of Zurbarán.* London, 1953; 2d ed. London, 1955a.

———. "Algunas fuentes de Zurbarán." *Archivo español de arte* 28 (1955b), pp. 339–40.

———. "Zurbarán's *Crucifixion,*" *Art Institute of Chicago Quarterly* 49 (Sept. 1955c), pp. 48–49.

———. "A Life-Size St. Francis by Zurbarán in the Milwaukee Art Center." *Art Quarterly* 22 (1959a), pp. 148–53.

———. "Notas sobre algunos bodegones españoles del siglo XVII." *Archivo español de arte* 32 (1959b), pp. 273–80.

Soult, Marshal Nicolas Jean de Dieu. *Catalogue raisonné des tableaux de la galerie de feu M. le Maréchal Général Soult, . . .* Sale cat., Galerie Lebrun, Paris, May 19, 21, 22, 1852.

———. *Catalogue des tableaux provenant de la galerie de feu M. le Maréchal Général Soult. . . .* Sale cat., Hôtel Drouot, Paris, Apr. 17, 1867.

Standish, Frank H. *Seville and Its Vicinity.* London, 1840.

———. *Catalogue des tableaux et gravures . . . de la collection Standish légués au roi.* Paris, 1842.

Standish, Frank H., and Louis-Philippe. *Pictures Forming the Celebrated Standish Collection.* Sale cat., Christie's, May 28–30, 1853.

Steinberg, Leo. *The Sexuality of Christ in Renaissance Art and in Modern Oblivion.* New York, 1983.

Steingräber, E. "Die Grablegung der Heiligen Katharina von Alexandrien auf dem Berg Sinaï von Francesco Zurbarán: Eine Neuerwerbung für die Alte Pinakothek in München." *Intuition und Darstellung,* Mar. 24, 1985, pp. 129–31.

Sterling, Charles. *La Nature morte de l'antiquité à nos jours.* Paris, 1952; Paris, 1959; Paris, 1985. English translation, *Still-Life Painting from Antiquity to the Twentieth Century.* 2d rev. ed. New York, 1981.

Stirling-Maxwell, William. *Annals of the Artists of Spain.* 4 vols. London, 1848; new ed. London, 1891.

Stockholm. Nationalmuseum. *Aldre utländska malningar och skulpturer; Peintures et sculptures des écoles étrangères antérieures à l'époque moderne.* Stockholm, 1958.

———. *Stora spanska mästare.* Exhib. cat. 1959.

Stratton, Suzanne. "The Immaculate Conception in Spanish Renaissance and Baroque Art." Ph.D. diss., New York University, 1983.

Stubbe, Achilles. *La Madone dans l'art,* Brussels, 1958.

Sullivan, Edward J. "Josefa de Ayala: A Woman Painter of the Portuguese Baroque." *Journal of the Walters Art Gallery* 37 (1978), pp. 22–35.

Surius, Laurentius. *De probatis sanctorum historiis. . . .* 6 vols. Cologne, 1570–75; Cologne, 1576–81.

———. *Vita S. Brunonis, cartusiensium institutoris primi commentario illustrata.* Brussels, 1639.

Sussman, V. "Maria mit dem Schutzmantel." *Marburger Jahrbuch für Kunstwissenschaft* 5 (1929), pp. 285–381.

Sutherland, Duke of [Sir Cromartie Sutherland-Leveson-Gower]. *Catalogue of Ancient and Modern Pictures. . . .* Sale cat., Christie's, London, July 11, 1913.

Sutton, Denis. "A Master of Austerity: Francisco de Zurbarán." *Apollo* 81, no. 38 (1965), pp. 322–25.

Taylor, Baron Isidore. *Voyage pittoresque en Espagne, en Portugal, et sur la côte d'Afrique.* Paris, 1826–60.

Ternois, Daniel. "Les Tableaux des églises et des couvents de Lyon." In *L'Art baroque à Lyon* (1972). Lyons, 1975.

Thacher, John S. "The Paintings of Francisco de Herrera, the Elder." *Art Bulletin* 19 (1937), pp. 325–80.

Toledo, Ohio. Toledo Museum of Art. *Spanish Painting*, by José Gudiol. Exhib. cat., 1941.

Tomás y Valiente, Francisco. "El gobierno de la monarquía y la administración de los reinos en la España del siglo XVII." In *La España de Felipe IV*. Historia de España, vol. 25, pp. 1–214. Madrid, 1982.

Tormo y Monzó, Elías. *El monasterio de Guadalupe y los cuadros de Zurbarán*. Madrid, 1905a.

———. [Untitled.] *La época*, Mar. 31, 1905b, p. 5.

———. "El despojo de los zurbaranes de Cádiz, el viaje de Taylor, y la efímera Galería Española del Louvre." *Cultura española* 13 (1909), pp. 25–39.

———. "Carta de D. Elías Tormo y Monzó sobre los *Trabajos de Hercules*" (May 30, 1911). In *Francisco de Zurbarán*, by José Cascales y Muñoz, appendix 3, pp. 207–20. Madrid, 1911a.

———. "Velázquez: El Salón de Reinos del Buen Retiro y el poeta del palacio y del pintor." *Boletín de la Sociedad Española de Excursiones* 19 (1911b), pp. 22–44, 85–111, 191–217, 274–313; and 20 (1912), pp. 60–63.

———. "La Inmaculada y el arte español." *Boletín de la Sociedad Española de Excursiones* 22 (1914), pp. 108–32, 173–218.

———. "Cartillas excursionistas 'Tormo': Guadalajara." *Boletín de la Sociedad Española de Excursiones* 25 (1917), pp. 70–80.

———. *Las iglesias del antiguo Madrid*. 2 vols. Madrid, 1927; new ed. Madrid, 1972.

———. *La visita a las colecciones artísticas de la Real Academia de San Fernando*. Cartillas excursionistas, vol. 7. Madrid, 1929.

———. "Velázquez: El Salón de Reinos del Buen Retiro y el poeta del palacio y del pintor." In *Pintura, escultura, y arquitectura en España: Estudios dispersos de Elías Tormo y Monzó*, pp. 127–246. Madrid, 1949.

Torre Farfán, Fernando de la. *Fiestas de la Sta. Iglesia . . . de Sevilla al culto nuevamente concedido al Señor Rey San Fernando III de Castilla y Leon*. Seville, 1671.

Torres Martín, Ramón. "El tema de la Santa Faz en Zurbarán." *El correo de Andalucía*, Dec. 3, 1958.

———. *Zurbarán, el pintor gótico del siglo XVII*. Seville, 1963.

———. "Algo sobre los discipulos y seguidores de Zurbarán." *Revista de estudios extremeños* 20 (1964), pp. 85–92.

———. "La pintura de Zurbarán en los museos y colecciones de la Gran Bretaña." *Goya*, no. 64–65 (1965), pp. 290–95.

Townsend, Joseph. *A Journey through Spain in the Years 1786 and 1787. . . .* London, 1791.

Tramoyeres Blasco, L. "La Purísima Concepción de Juan de Juanes: Origenes y vicisitudes." *Archivo de arte valenciano* 3, no. 1 (1917), pp. 113–28.

Trapier, Elizabeth du Gué. "Zurbarán's Processions of Virgin Martyrs." *Apollo* 85 (1967), pp. 414–19.

Trens, Manuel. *María: Iconografía de la Virgen en el arte español*. Madrid, 1947.

Twiss, Richard. *Travels through Portugal and Spain*. London, 1775.

Unesco. *Inventaire illustré d'oeuvres démembrées célèbres dans la peinture européenne*. Paris, 1974.

Valdivieso, Enrique. *Juan de Roelas*. Seville, 1978a.

———. "Pinturas de Juan de Roelas para el Convento de la Merced de San Lucar de Barrameda." *Boletín del Seminario de Estudios de Arte y Arqueologia* 44 (1978b), pp. 293–302.

———. "Aportaciones al conocimiento de Juan de Zurbarán." In *Primero Congreso Español de Historia del Arte* (Trujillo, 1977, Section I). Trujillo, 1981.

———. "La pintura en la catedral de Sevilla; siglos XVII al XX." In *La catedral de Sevilla*. Seville, 1984.

———. *Historia de la pintura sevillana*. Seville, 1986.

———. [Untitled.] *A.B.C.*, n.d.

Valdivieso, Enrique, A. González, and J. Morales Martín. *Sevilla oculta*. Seville, 1980.

Valdivieso, Enrique, and Juan M. Serrera. *La época de Murillo: Antecedentes y consecuentes de su pintura*. Seville, 1982.

———. *Historia de la pintura española: Escuela sevillana del primer tercio del siglo XVII*. Madrid, 1985.

Valeriano Bolzani, Giovanni Piero. *Hieroglyphica sive de sacris aegyptiorum literis commentarii*. Basel, 1556. French translation by Gabriel Chappuys Toumangeau, *Commentaires hieroglyphiques ou images des choses. . . .* 2 vols. Lyons, 1576.

Valles, José de. *Primer instituto de la sagrada religión de la cartuxa. Fundaciones de los conventos de toda España, mártires de Inglaterra, y generales de toda la orden*. Madrid, 1663; 2d ed. Barcelona, 1792.

Vallier, Gustave. *Sigillographie de l'Ordre de Chartreux et numismatique de Saint Bruno*. Montreuil-sur-Mer, 1891.

Vargas, Bernardo de. *Chronica sacri et militaris ordinis B. Mariae de Mercede redemptionis captivorum*. 2 vols. Palermo, 1619–22.

Varia velazqueña: Homenaje a Velázquez en el III centenario de su muerte, 1660–1960, edited by Antonio Gallego y Burín. 2 vols. Madrid, 1960.

Vázquez, Guillermo. "San Pedro Nolasco en Sevilla." *La Merced*, Jan. 24, 1922, pp. 203–4.

———. "Un cuadro inedito de Zurbarán." *La Merced*, Aug. 15, 1929, pp. 286–89.

Véliz, Zahira. "A Painter's Technique: Zurbarán's *The Holy House of Nazareth*." *Bulletin of the Cleveland Museum of Art* 68 (1981), pp. 271–85.

Viardot, Louis. *Notice sur les principaux peintres de l'Espagne*, with engravings by Gavard. Paris, 1839. Enlarged 3d ed., *Les Musées d'Espagne: Guide et memento de l'artiste et du voyageur, suivi de notices biographiques sur les principaux peintres de l'Espagne*. Paris, 1860.

Vida de la gloriosa Santa Isabel de Portugal, translated from the Italian by Antonio de Vera y Zúñiga. Madrid, 1625.

La Vie du bien-heureux Père Reginald . . . de l'Ordre Sacré de S. Dominique. Paris, 1608.

Vies des saints et des bienheureux selon l'ordre du calendrier, avec l'historique des fêtes, by J. Baudot and L. Chaussin. 13 vols. Paris, 1935–59.

Villanueva, Jaime L. *Viage literario a las iglesias de España*. 22 vols. Madrid, 1803–52.

Villegas Selvago, Alonso de. *Flos sanctorum, segunda parte; y, Historia general en que se escrive la historia de la Virgen . . . y de los santos antiguos que fueron antes de la venida de Nuestro Salvador al mundo . . . va en impresión añadida una tabla muy util . . . para los predicadores*. Barcelona, 1589.

———. *Flos sanctorum; y, Historia general de la vida y hechos de Iesu Christo Dios y Señor nuestro y de todos los sanctos de que reza y haze fiesta la Iglesia cathólica, conforme al breviario romano reformado por el decreto del Sancto Concilio Tridentino, junto con las vidas de los sanctos proprios de España y de otros extravagantes*. Barcelona, 1593.

Voragine, J. de. "Legenda sanctorum quam compilavit" (ms. ca. 1260). Spanish translation by J. Bayo, *La leyenda dorada*. 2 vols. Paris, 1913. French translation by J. B. M. Roze, *La Légende dorée*. 2 vols. Paris, 1967.

Waagen, Gustav F. *Works of Art and Artists in England*. 3 vols. London, 1838.

———. *Treasures of Art in Great Britain*. 4 vols. London, 1839–57.

Wadding, Luke. *Anales minorum . . . ab anno 1208 ad annum 1540*. 16 vols. 2d ed. Rome, 1625–54.

Wagner, I. J. R. "Manuel Godoy, patron de las artes y coleccionista." 2 vols. Ph.D. diss., Universidad Complutense, Madrid, 1983.

Walterstorff, Count of. *Cabinet de son Exc. le lieutenant Général Comte Walterstorff, Ministre du Danemark*. Sale cat., Laneuville, Paris, Mar. 26–27, 1821.

Wehle, Harry B. "A Painting by Zurbarán." *Bulletin of the Metropolitan Museum of Art* 15 (1920), pp. 242–45.

Wethey, Harold E. "El testamento de Alonso Cano." *Boletín de la Sociedad Española de Excursiones* 57 (1953), pp. 1–11.

———. *Alonso Cano: Painter, Sculptor, Architect*. Princeton, 1955. Revised and translated into Spanish, *Alonso Cano: Pintor, escultor, arquitecto*. Madrid, 1983.

Wormser, S. "Tableaux espagnols à Paris au XIX^e siècle." Ph. D. diss., Université de Paris, n.d.

Young, Eric. "Four Centuries of Spanish Painting at the Bowes Museum." *Connoisseur* 166 (Sept. 1967), pp. 28–33.

—————. "Una desconocida Inmaculada Concepción de Francisco de Zurbarán." *Archivo español de arte* 45 (1972), pp. 161–66.

—————. "Shorter Notice: An Unknown St. Francis by Francisco de Zurbarán." *Burlington Magazine* 115 (1973), pp. 170–75.

—————. "Zurbarán's Seven Infants of Lara." *Connoisseur*, no. 800 (1978), pp. 100–105.

—————. "Spanish Painting: From International Gothic to Goya." *Apollo* 115 (1982), pp. 433–39.

Zervos, Christian. "Révisions: Francisco Zurbarán." *Cahiers d'art* 2 (1927), pp. 85–92.

Zoido Díaz, Antonio. "El tesoro zurbaranesco de Zafra y María Luisa Caturla, su descubridora." *Hoy* (Badajoz), Nov. 5, 1961.

LIST OF EXHIBITIONS

Austin 1953. *Texas Fine Arts Festival: Masterpieces.* Apr. 18–26, 1953

Barcelona 1983. *L'época del barroc.* Palacio de Pedralbes, Mar. 8–Apr. 10, 1983

Bordeaux 1955. *L'Age d'or espagnol.* Galerie des Beaux-Arts, May 16–July 31, 1955

Boston 1874. *Pictures Belonging to H.R.H. the Duke de Montpensier, and Other Pictures, also Loaned to the Museum of Fine Arts.* Museum of Fine Arts

Boston 1970. *Masterpieces of Painting in the Metropolitan Museum of Art.* Museum of Fine Arts, Aug.–Oct. 1970

Brussels 1985. *Splendeurs d'Espagne et les villes belges, 1500–1700.* Palais des Beaux-Arts, Sept. 25–Dec. 22, 1985

Budapest 1919. *Exposition d'oeuvres d'art devenues propriété de l'état.* Szépmüvészeti Múzeum

Budapest 1965. *Spanyol mesterek.* Szépmüvészeti Múzeum, Aug.–Oct. 1955

Cleveland 1960. *Year in Review.* Cleveland Museum of Art, Dec. 1960

Detroit 1951. *Thirty-eight Great Paintings from the Metropolitan Museum of Art.* Detroit Institute of Arts, Oct. 2–28, 1951

Edinburgh 1951. *An Exhibition of Spanish Paintings from El Greco to Goya.* National Gallery of Scotland, Aug. 19–Sept. 8, 1951

Florence 1986. *Da El Greco a Goya: Il secolo d'oro della pittura spagnola.* Palazzo Vecchio, Sept. 25–Dec. 14, 1986

Geneva 1939. *Les Chefs-d'oeuvre du Musée du Prado.* Musée d'Art et d'Histoire, June–Aug. 1939

Granada 1953. *Zurbarán.* II Festival Internacional de Música y Danza, Palacio de Carlos V, June 1953

Hamburg 1935. *Alte und neue spanische Kunst.* Kunstverein, Aug.–Sept. 1935

Leeds 1868. *National Exhibition of Works of Art*

Leningrad and Moscow 1975. *One Hundred Paintings from the Metropolitan Museum.* Hermitage Museum, May 22–July 27, 1975; Pushkin State Museum of Fine Arts, Aug. 28–Nov. 2, 1975

London 1836; 1837; 1838; 1853. *Pictures by Italian, Spanish, Flemish, Dutch, and French Masters.* British Institution

London 1870; 1871; 1876; 1890. *Works by the Old Masters.* Royal Academy of Arts

London 1895–96. *Exhibition of Spanish Art.* New Gallery

London 1920–21. *Exhibition of Spanish Paintings.* Royal Academy of Arts, Nov. 1920–Jan. 1921

London 1947. *An Exhibition of Spanish Paintings.* Arts Council of Great Britain, National Gallery, Feb. 11–Mar. 23, 1947

London 1976. *The Golden Age of Spanish Painting.* Royal Academy of Arts, Jan. 10–Mar. 14, 1976

London 1981. *El Greco to Goya: The Taste for Spanish Paintings in Britain and Ireland.* National Gallery, Sept. 16–Nov. 29, 1981

Los Angeles 1937. *Loan Exhibition of International Art.* Los Angeles Art Association, Oct. 15–Dec. 15, 1937

Los Angeles and San Diego 1960. *Spanish Masters.* University of California Art Galleries, Jan. 25–Mar. 6, 1960; San Diego Fine Arts Gallery, Mar. 25–May 1, 1960

Lugano 1985. *Capolavori da musei ungheresi: Collection Thyssen-Bornemisza.* Villa Favorita, June 15–Oct. 15, 1985

Madrid 1905. *Exposición de las obras de Francisco de Zurbarán*. Museo del Prado

Madrid 1927. *Exposición franciscana: VII centenario de la muerte de San Francisco de Asís*. Sociedad Española de Amigos del Arte, May–June 1927

Madrid 1964–65. *Exposición Zurbarán en el III centenario de su muerte*. Casón del Buen Retiro, Nov. 1964–Feb. 1965

Madrid 1981–82a. *Museo del Prado: Adquisiciones de 1978 a 1981*. Casón del Buen Retiro, from Apr. 24, 1981

Madrid 1981–82b. *Pintura española de los siglos XVI al XVIII en colecciones centroeuropeos*. Museo del Prado, Dec. 1981–Jan. 1982

Madrid 1981–82c. *El arte en la época de Calderón*. Palacio de Velázquez, Dec. 1981–Jan. 1982

Manchester 1857. *Art Treasures of the United Kingdom Collected at Manchester*. City Art Gallery

Milwaukee 1953. *Milwaukee Home Show Masterpieces*. Mar. 7–14, 1953

Montreal 1933. *A Selection from the Collection of Paintings of the Late Sir William Van Horne, K.C.M.G., 1843–1915*. Art Association of Montreal, Oct. 16–Nov. 5, 1933

Munich 1911. *Altspanische Ausstellung*. Galerie Heinemann, Jan. 1911

Munich and Vienna 1982. *Von Greco bis Goya: Vier Jahrhunderte spanische Malerei*. Haus der Kunst, Feb. 20–Apr. 25, 1982; Künstlerhaus, May 14–July 11, 1982

New York 1934. *Exhibition of Paintings: Six Countries and Centuries*. Lilienfeld Galleries, Jan. 11–31, 1934

New York 1961. *Loan Exhibition of Paintings and Drawings; Masterpieces: A Memorial Benefit for Adele R. Levy*. Wildenstein, Apr. 6–May 7, 1961

Orléans 1876. *Exposition rétrospective de beaux-arts*. Halle Saint-Louis, from May 1, 1876

Paris 1813. *Musée Napoléon*

Paris 1838–48. Galerie Espagnole, Musée Royal au Louvre

Paris 1925. *Exposition d'art ancien espagnole*. Hôtel Jean Charpentier, June 6–July 6, 1925

Paris 1935. *Les Chefs-d'oeuvre du Musée de Grenoble*. Petit Palais, Feb.–Apr. 1935

Paris 1939. *Les Chefs-d'oeuvre du Musée de Montpellier*. Musée de l'Orangerie, Mar.–Apr. 1939

Paris 1963. *Trésors de la peinture espagnole: Eglises et musées de France*. Musée des Arts Décoratifs, Jan.–Apr. 1963

Paris 1976. *La Peinture espagnole au siècle d'or: De Greco à Velázquez*. Petit Palais, Apr.–June 1976

Paris 1982. *Collection Thyssen-Bornemisza: Maîtres anciens*. Petit Palais, Jan.–Mar. 1982

Saint Louis 1952. *Old Masters from the Metropolitan*. City Art Museum of Saint Louis, Jan. 14–Feb. 14, 1952

San Diego 1935. *California-Pacific International Exposition*. San Diego Fine Arts Gallery, May 29–Nov. 11, 1935

San Diego 1936. *Official Art Exhibition*. San Diego Fine Arts Gallery, Feb. 12–Sept. 9, 1936

Seattle 1952. *Masterpieces from the Metropolitan Museum of Art*. Seattle Art Museum, Mar. 1–June 30, 1952

Seville 1866. *Cuadros, dibujos, y esculturas pertenecientes a la galería de Duque de Montpensier en su palacio de Sanlucar de Barrameda*

Seville 1896. *Exposición retrospectiva de la pintura sevillana celebrada en esta ciudad*

Seville 1964. *Exposición homenaje a Zurbarán*. Museo Provincial de Bellas Artes

Seville 1982. *La época de Murillo: Antecedentes y consecuentes de su pintura*. Caja de Ahorros Provincial San Fernando de Sevilla, May–June 1982

Stockholm 1959–60. *Stora spanska mästare*. Nationalmuseum, Dec. 12, 1959–Mar. 13, 1960

Syracuse and Atlanta 1957. *Goya, Zurbarán, and Spanish Primitives*. Syracuse Museum of Fine Arts, Feb. 3–24, 1957; Atlanta Art Association Galleries, Mar. 10–25, 1957

Tokyo and Kyoto 1976. *Masterpieces of World Art from American Museums: From Ancient Egyptian to Contemporary Art*. National Museum of Western Art, Sept. 11–Oct. 17, 1976; Kyoto, Nov. 2–Dec. 5, 1976

Toledo, Ohio, 1941. *Spanish Painting*. Toledo
Museum of Art, Mar. 16–Apr. 27, 1941

Toronto 1951. Art Gallery of Toronto, Nov. 14–
Dec. 12, 1951

Toulouse 1950. *L'Espagne des peintres*. Musée des
Augustins, May 27–Oct. 1, 1950

Zurich 1946. *Aus Museum und Bibliothek der Stadt
Grenoble*. Kunsthaus, July–Aug. 1946

WORKS IN THE EXHIBITION

In the column at right are catalogue numbers.